THE SPIRIT OF BRITAIN

A Narrative History of the Arts

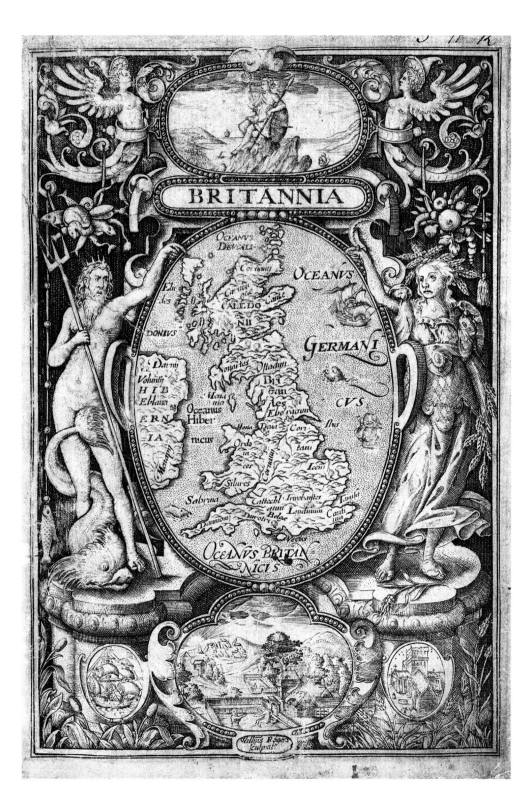

BRITANNIA

ROY STRONG

THE SPIRIT OF BRITAIN

A Narrative History of the Arts

HUTCHINSON
in association with
JULIA MACRAE
LONDON SYDNEY AUCKLAND JOHANNESBURG

First published 1999

1 3 5 7 9 10 8 6 4 2

© 1999 Oman Productions Ltd

Roy Strong has asserted his right
under the Copyright, Designs and Patents Act, 1988
to be identified as the author of this work

First published in the United Kingdom in 1999 by
Hutchinson, in association with Julia MacRae
Random House, 20 Vauxhall Bridge Road, London SW1V 2SA

Random House Australia (Pty) Limited
20 Alfred Street, Milsons Point, Sydney
New South Wales 2061, Australia

Random House New Zealand Limited
18 Poland Street, Glenfield
Auckland 10, New Zealand

Random House South Africa (Pty) Limited
Endulini, 5A Jubilee Road
Parktown 2193 South Africa

Random House UK Limited Reg. No. 954009

Designed by Douglas Martin
Picture research: Juliet Brightmore
Indexer: Douglas Matthews

A CIP catalogue record for this book
is available from the British Library

ISBN 1-85681-534-X

Printed in Singapore by
Tien Wah Press (Pte) Ltd

The two central traditions of British civilisation, the classical and Christian, meet in this detail from a fourth-century Roman mosaic pavement at Hinton St. Mary, Dorset. Behind a head, almost certainly meant to be Christ, there appears the chi-rho symbol, the first two letters of Christ's name in Greek.

Frontispiece illustration: frontispiece to William Camden's Britannia *(1600). The great Elizabethan antiquarian firmly located the country's cultural roots as the civilisation of Rome.*

Lest We Forget

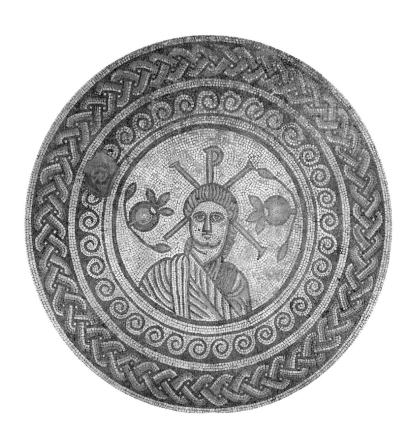

CONTENTS

Preface ix

1. Prologue: Fairest Isle 1

2. Pax Romana 4

3. Through a Glass Darkly 20

4. The Twelfth Century Renaissance 38

5. Castles, Cathedrals and Abbeys 46

6. Faith, Reason and Light 60

7. Camelot 74

8. A Medieval Patron: William of Wykeham 91

9. Purchasing Paradise 98

10. Magnificence 111

11. End of an Era: Thomas, Cardinal Wolsey 121

12. Classical Interlude 130

13. A Cultural Revolution 140

14. Dynasty 151

15. The Faerie Queene 170

16. All the World's a Stage 202

17. Removed Mysteries 218

18. The Virtuoso: Thomas Howard, Earl of Arundel 239

19. Isolation 252

20.	The Mechanistic Universe	273
21.	Apocalypse Now	288
22.	Pomp and Circumstance	306
23.	The Crown Eclipsed	328
24.	The Rule of Taste: Richard Boyle, 3rd Earl of Burlington	344
25.	Babylon	358
26.	The Grand Tour and After	392
27.	Forging a Culture	415
28.	Sensibility	432
29.	'A Little Gothic Castle': Horace Walpole	446
30.	Light North of the Border	460
31.	Revolution, Reaction and Romance	473
32.	A New Nation	512
33.	Albertopolis: The Prince Consort	548
34.	Land of Hope and Glory	561
35.	Fragmentation	602
36.	Consensus Arts	636
37.	Lord Civilisation: Kenneth Clark	666
38.	Epilogue: Consumer Culture	674
	Selected Further Reading	686
	Picture Credits	694
	Index	695

PREFACE

This book was already in my mind as I reached the final stages of writing *The Story of Britain*. The need for some comprehensive introductory overview of the arts in this country seemed to me to be an urgent one. And by overview I mean a book by a single author in one volume, written as a continuous unfolding narrative.

There are, of course, other overviews but generally they are of this or that period or for one aspect of a particular period, like music or literature. Most books of this kind are by several authors who each contribute a chapter on their special field. In the writing of this book these publications have been of immense value in guiding me into areas about which I am only too happy to admit my limitations. All I can claim in defence is that I have spent half a century looking, reading and listening to everything connected with the arts in Britain, both past and present. In addition I have directed two major national collections, the National Portrait Gallery and the Victoria & Albert Museum, both of which have enshrined within them much of what any educated person would regard as the essence of our civilisation.

The time for the book seemed apposite not so much in the light of the approaching millennium but more rather for the uncertainties which firstly the European Union and secondly devolution to Wales and Scotland have brought into our minds. Although this book is called *The Spirit of Britain* it is in fact essentially about England, and parallel books could no doubt be written about Wales and Scotland. The word Britain has been used so often to mean England that its use here seems defensible. Defensible too, for it is English civilisation which has impinged on the cultures of those other two countries more than in reverse. The same could equally be said of Ireland, which remains outside my terms of reference.

This is the story of one part of Europe's response to both the classical and Christian traditions. While writing it I became increasingly aware of the fragility of that inheritance. The thought premises to which the vast majority of this volume relates have either been eroded or else are in the process of erosion. Once lost they will not be easy to put back, so perhaps this text may prove to be a timely reminder to those, obsessed, for instance, by political correctness, of what they are throwing away.

Central to the book's concept has been the placing of each phase of creativity in relation to the social and ideological movements of the time of which they were

quintessential expressions. That is emphasised and developed from time to time by exploring the impact of the life of one individual on the direction of the arts. Untold books exist on individual creators and to have even attempted to make a selection would have been an invidious task. Of equal importance was the enormous influence of patrons and trendsetters, those who gave work to artists and set style and taste within each era. In this way we can trace how in earlier ages the individual could un-trammelled live out his own fantasies, like a Wolsey or an Arundel, in sharp contrast to the diminished and truncated role of such a person today as exemplified by Kenneth Clark, struggling in an age of Everyman and committee-speak to open the doors of high culture to the newly enfranchised masses.

I could not have written this without drawing on a plethora of work by many scholars in many fields. My gratitude to them, and my admiration for their work, is boundless. It has been an especially enriching experience to explore periods about which I know little. By bringing the fruits of their studies together the aim has been to open a door for general readers, enabling them to get their bearings in a subject which has been broken into fragments too much on the wheel of specialisation.

As in the case of *Story* my debt to my editor Julia MacRae has been incalculable. In an era when editors are shed from publishing houses like dinosaurs it is important to be reminded of their centrality in the life of any author. Together we have lived through every century, our minds bent on the destination ahead. To her I must add Delia Huddy and also Keith Perry, both of whom have made extremely pertinent suggestions as the text has progressed, and steered me clear of error which, if it has occurred, must be laid firmly at my own door. My gratitude also goes for a second time to Douglas Martin for his superb design, always responsive to the placing of visual material and equally to the flow of the text to draw the reader on. In the case of the illustrations I owe a debt to Juliet Brightmore who has built to effect on my initial selection of illustrative material. Add to them others, like Alan Lee, and Nancy Webber, who have assisted me on the way with their commitment to the project.

In writing this book I recall Kenneth Clark's subtitle to his landmark television series *Civilisation*, 'A Personal View'. However hard I have tried to synthesise the conclusions of current scholarship the result cannot quite avoid being idiosyncratic. That view will be coloured by someone who is not only an unashamed élitist but also a monarchist, a practising Christian, and a committed European. Inevitably the book is affected by what one has lived through, my earliest memories being of the isle beleaguered in a great war. My first glimpse of the country's artistic inheritance came after that in trips by Green Line bus and by train to Verulamium, St. Alban's Cathedral, and Hatfield House. I grew up amidst a heritage under threat with books

reminding me constantly of all things quintessentially English. My two earliest school prizes were Batsford books, *English Castles* and *English Cathedrals*, and I have them still. The first great ballet and opera productions I ever saw were *The Sleeping Princess* and Purcell's *The Fairy Queen* at Covent Garden. Both were glimpsed from afar from the amphitheatre. A love of Shakespeare dawned on me from the gallery of the Phoenix Theatre early in the fifties on seeing John Gielgud and Diana Wynyard in *The Winter's Tale*. Need I say more? Thereafter my life and work has been entwined with everything English both past and present. This book is in its way a thank-offering for all the delight, pleasure and inspiration that the arts of England have brought me over so many decades, with, I hope, a few more yet to come.

ROY STRONG

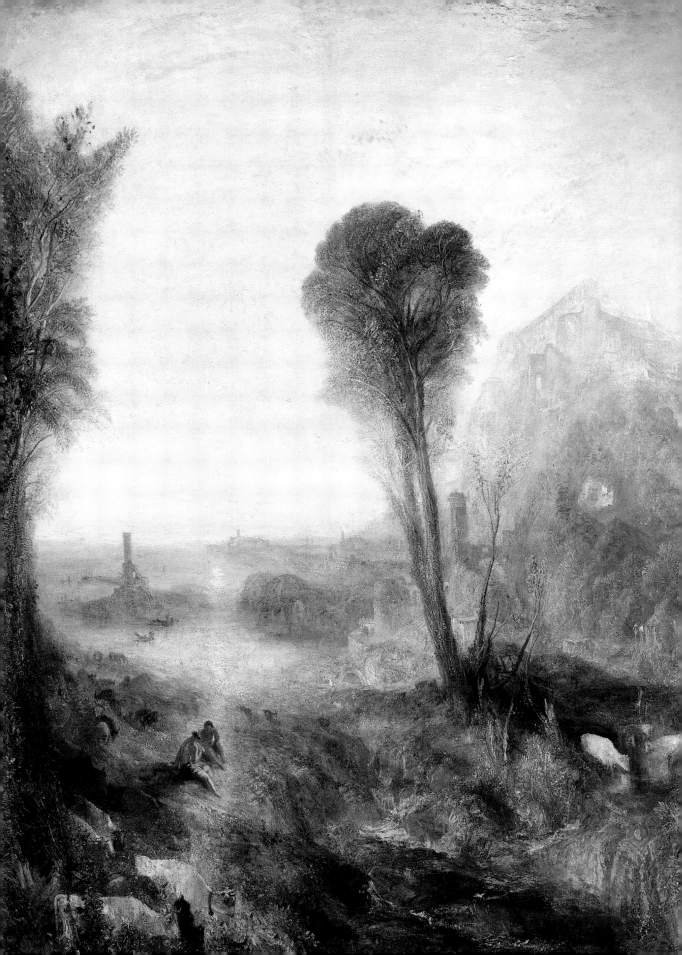

Chapter One

PROLOGUE: FAIREST ISLE

The earliest reference to the island of Britain in a great work of literature comes in the Roman poet Virgil's *First Eclogue*. The line reads as follows: *Et penitus toto divisos orbe Britannos*. The context is a pastoral poem with political overtones in which a dispossessed countryman laments his eviction from his land. His is one of a number who intend to seek their fortunes elsewhere, some in Africa, others in Scythia, yet 'others to join the Britons, cut off as they are by the whole width of the world.' When Virgil wrote this in the second half of the first century B.C., Britain had not yet been brought within the confines of the Roman Empire. Julius Caesar had made a landing in 55 B.C. and a reconnaissance in force the following year, but no conquest followed. But that line was to echo down through the centuries in British poetry, the idea conjuring up to successive generations that somehow Britain was different, something more than just an offshore island floating on what was then the fringe of the mainland of Europe.

Virgil also places the country firmly into another context as part of the classical tradition. That was rooted first in the civilisation of Ancient Greece and then its successor Ancient Rome, in both its Republican and Imperial phases. The inheritance of Greece and Rome was to haunt the imagination of Western Europe until our own century. England was to be only one of many geographical areas occupied directly by the Romans and hence significantly touched by the classical tradition. The Roman influence stretched north into what is modern Germany and Belgium and south into the Iberian peninsula and Africa. Each area of Europe was to produce its own response to the tradition and, as a consequence, what unites us in cultural terms far outweighs what divides us. Our civilisations descend from the same stem, one which embraced every aspect of the arts: literature, both prose and poetry, theatre, architecture, painting, sculpture and music. Even if, for example, ancient music and dance did not survive, the quest to re-create them from the classical texts was there, leading to our modern opera and ballet.

If the earliest glimpse of the island in a great work of

Turner's canvas of Mercury and Argus, exhibited at the Royal Academy in 1836, bears testimony to the centrality of the classical inheritance in the formation of British civilisation.

literature is Virgil, its first appearance in a great work of art must surely be in the Wilton Diptych. Painted at the close of the fourteenth century for Richard II, it depicts him as a young king kneeling in adoration before the Virgin and Child encompassed by a throng of angels, one of them holding a staff bearing the flag of St. George, patron saint of England. On the orb at the top of that staff is a green island, England, with trees and a white turreted castle on it, all set within a sea which was once silver but now through age tarnished and blackened. We are looking at what seems like an anticipation of John of Gaunt's speech eulogising the 'scepter'd isle'.

But it is more than that for, like Virgil's poem, the image has a wider connotation: it places England and therefore Britain into its second great civilising tradition, Christianity. The Christian faith had penetrated the island as early as the second century A.D., although mythographers would later try to make its arrival even earlier, via St. Joseph of Arimathea. As in the case of the art and literature of Greece and Rome, those giving aesthetic expression to the tenets of the Christian faith were likewise to remain central to the culture of Britain until the twentieth century, a belief in God made man in Jesus Christ, in an afterlife, and in a present one in preparation for it through the practice of virtues. Even the great divide of the Reformation in the sixteenth century was not to shake this, although it meant that more than ever before English Christianity took its own identity even more intensively in the form of the Church of England.

In a sense what follows merely charts the rise and fall of these two great centralities of English civilisation. More than one generation has grown up with little if any awareness of either, so crucial for understanding virtually everything around them. This book sets out to trace that story and its starting point is the inevitable one, the arrival of the Romans.

Right-hand wing of the Wilton Diptych, a portable altarpiece painted about 1396-97 in which Richard II is depicted presenting his kingdom to the Virgin. That action is represented by the banner with the flag of St. George held by an angel. The silver finial, left, at its summit carries the island of Britain afloat in what was once a silver sea but now, through time, tarnished black.

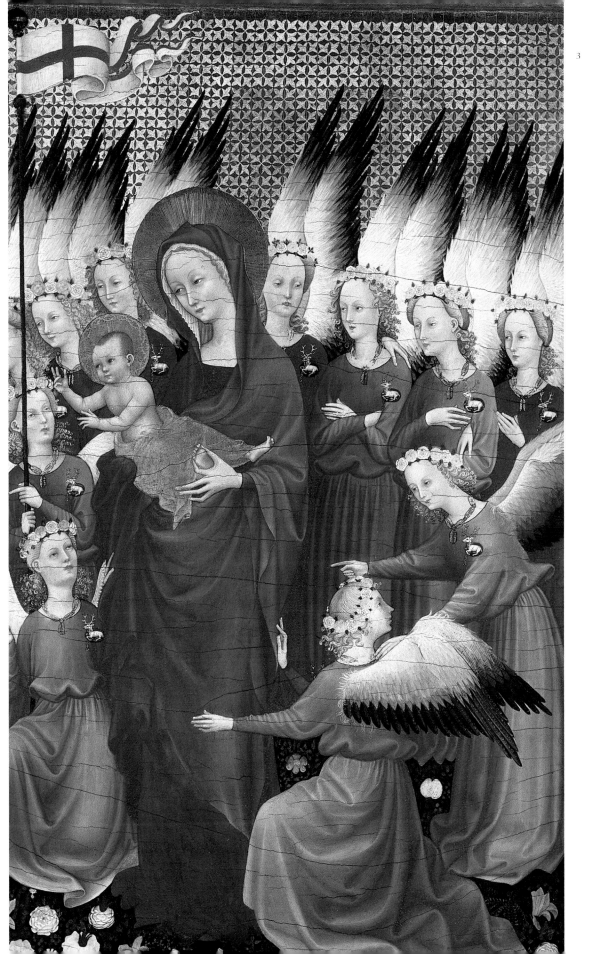

Chapter Two

PAX ROMANA

It is not until shortly before the Romans officially left Britain that we get tantalising glimpses as to just how complex their civilisation may have been. The fourth century A.D. witnessed an extraordinary renaissance in that quintessential feature of Roman life, the villa, of which the sites of some thousand, large and small, have so far been discovered. Some of those in Britain during this period appear to have been of a richness and splendour to compare with any within the rest of the vast Roman Empire. That is captured in the unique series of mosaic floors which have been uncovered as villa ruins have been excavated by modern archaeologists. Elaborate geometric designs vie with those whose subject matter is figural depicting the seasons, the days of the week, the hunt or more literary subjects. Using local materials like limestone, chalk, shale, fired clay, along with the occasional pieces of glass and pottery, they establish at floor level a glistening opulence (they are likely to have been waxed or oiled) which cannot have stopped suddenly at where the feet trod. Fragments of wall painting, like the praying figures in pearl-bespangled robes at Lullingstone, Kent, indicate that the walls could also be adorned with subject matter as interesting as that on the mosaic floors. At one time England must have been dotted with villas decorated in a manner which can only be captured today by a visit to Pompeii.

To these fragments evoking the structural mise-en-scène of a civilisation largely obliterated by what followed it we can add the evidence of some dazzling hoards of gold- and silversmiths' work, like the ones from Hoxne and Mildenhall in Suffolk. These also conjure up the elegance and sophistication of upper class Romano-British life in the fourth century. The Hoxne hoard was buried some time after 407 and includes seventy-eight silver spoons and twenty ladles, not to mention the silver-gilt statuette of what is likely to represent the British mother of the first Christian emperor, Constantine, as well as those of a prancing tiger and Hercules wrestling with Antaeus. The great dish from the Mildenhall hoard which forms its most spec-

Virgil's great poem the Aeneid, *one of the foundation stones of the Western literary tradition, was certainly known in Roman Britain. It has recently been suggested that this famous fourth-century illuminated text, the* Virgilius Romanus *in the Vatican, was possibly executed here. This scene shows Iris with her rainbow appearing to Turnus, King of Ardea, who in the end is killed by Aeneas.*

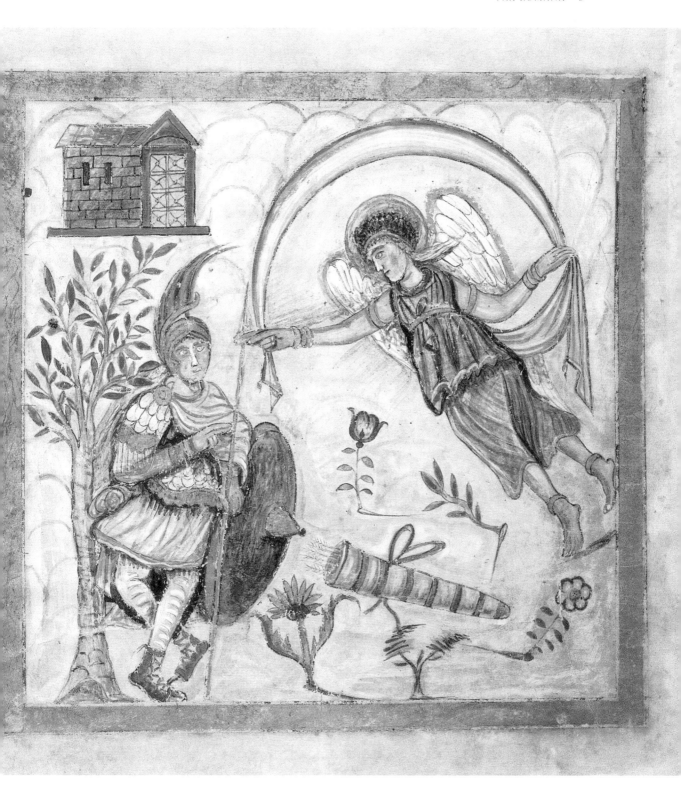

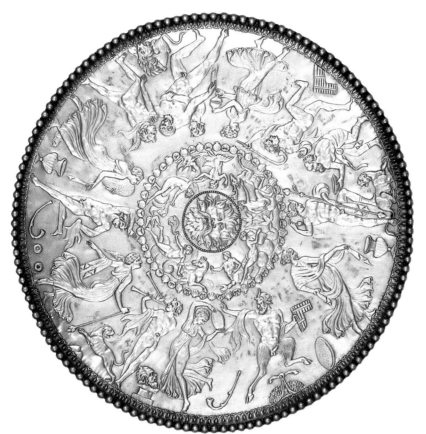

The Oceanus Dish, one of thirty-four silver objects dating from the fourth century which make up the Mildenhall treasure from Suffolk. Nearly two feet in diameter it weighs eighteen-and-a-quarter pounds. At the centre is a mask of the sea-god Nereus encircled by nereids, sea-centaurs and marine creatures. The outer concentric ring is filled with Bacchic revels. It is thought that the dish was used in connection with some ritual relating to a late Roman mystery cult.

tacular piece depicts the sea-god Oceanus encircled by nereids and sea monsters. The reverse of the dish bears the name Eutherius, prompting the suggestion that he is to be identified with a top official at the court of the Emperor Julian the Apostate (360-63 A.D.) and that the magnificent silver dish had been sent by him as a gift to the Christian general in Britain, Lupicinus.

By that date Britain was part of the Roman Empire moved east to Constantinople or Byzantium, which was founded by Constantine in 324 A.D. and officially inaugurated six years later. The island indeed figures quite often in the political annals of the Empire during this century, being used as a base for power bids. All of this gives an indication that Roman Britain should not be dismissed merely as some awkward provincial echo of a far greater culture, which it is easy to do. By the close of the fourth century it had been under the rule of the Romans for over three hundred years. That rule had brought internal peace and stability, precisely the conditions in which the arts flourish, and these artefacts tell us that this is what must have happened. They indicate that within the walls of these villas life was not just feasting and hunting on

the estate, but also concerned with the cultivation of religion and letters. The subject matter of the mosaics, expensive commissions, cannot have been arbitrary. They include scenes which are taken from two of the greatest masterpieces of Latin literature, Ovid's *Metamorphoses* and Virgil's *Aeneid*. Both works lie at the heart of the European classical tradition. The latter is the great poem of empire, foretelling its founding by Aeneas and prophesying its destiny. At Low Ham in Somerset there is the story of Dido and Aeneas from Books II and IV on the bath-house floor. The scenes are in a style typical of the period in which the Late Antique begins to slip over into what was to become the hieratic art of the Byzantine Empire. This is reflected in the staring eyes, the minimum use of detail and the deployment of bold, formalised significant gesture. Such scenes must have been manifestations of the literary learning of the owner of the villa who is likely to have turned to his library to show the mosaicist what was required of him.

A great Roman villa like that at Woodchester in Gloucestershire must have had a library. In any villa of this size the master or *dominus* would have been able to read and write and his children would have been taught by a tutor and educated in the Latin classics. His wife is also likely to have been literate. A remarkable cache of wooden tablets from Vindolanda (Chesterholm, Northumberland) from the period 90–130 A.D. preserves letters written by scribes with additions by the senders, both women and men. Recent discoveries like these only heighten the difficulties of reconstructing lost levels of civilisation. All we have to work from is what survives and what is newly discovered and, as discoveries are constantly being made by archaeologists, a major one can quite suddenly change

A wall painting from the fourth-century Christian chapel at Lullingstone, Kent. The frieze depicts figures with their arms outstretched in what was then the position of prayer. This is a rare surviving instance of what must have been a widespread form of villa decoration.

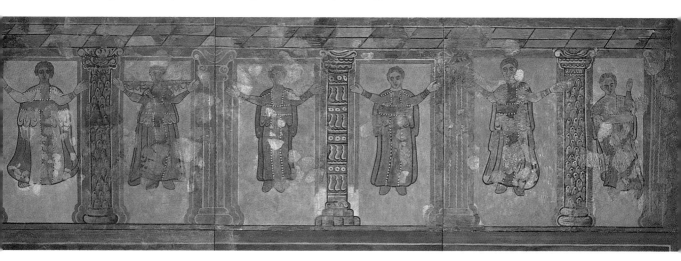

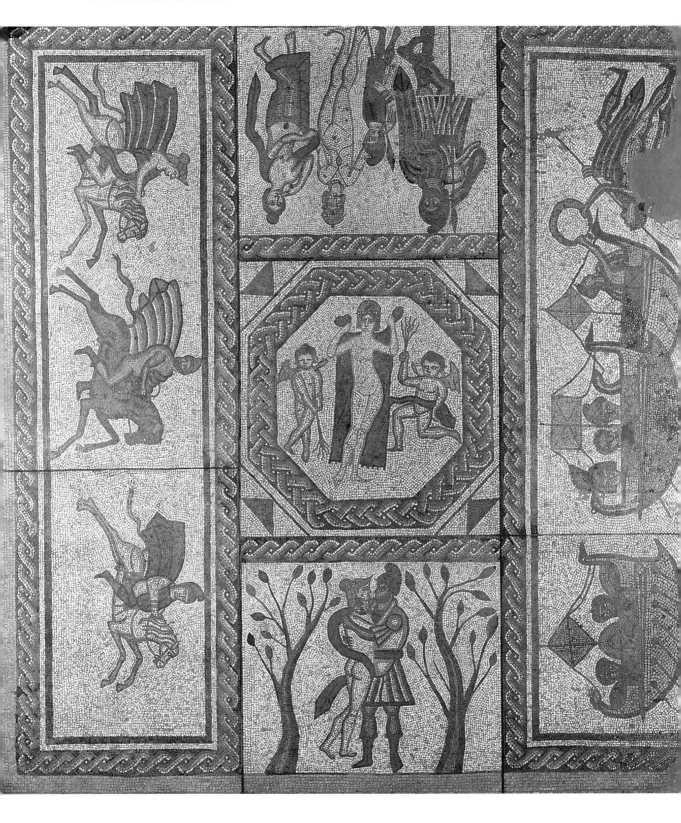

our whole perception of a period. And that is what has happened in the case of Britain in the fourth century for which the evidence would now suggest the existence of a fairly large sophisticated literate society with scribes and illuminators to keep it supplied with books. Working from this, recent scholarship has suggested that one of the most famous illustrated manuscripts of the poet Virgil's works, the *Vergilius Romanus* in the Vatican, could have been written and illuminated in Britain in the late fourth century as it shares features characteristic of those which appear in mosaics executed in the area of Dorchester.

All of this only goes to demonstrate how little we know about the opening centuries of civilisation within the island. Of the Romans' predecessors, the Celts, even less is known. The Celts left no written records, being almost wholly an oral people, and what references to them we have come only from hostile sources. Otherwise, as in the case of the Romans, all we have is the evidence of archaeology, which is inevitably subject to chance and constantly calling for revision. As the Celts used neither brick, tile nor stone we are reduced to what survives in durable media like gold, silver, iron and bronze. So little is firmly known about the Celts that there is not even a simple definition of the word. It began as a name applied by the Ancient Greeks to what they regarded as the barbarian peoples of Iron Age Europe. The Celts appear to have had no uniting ethnic or linguistic features but by the sixth century B.C. the word Celt was being given to people who led a certain kind of tribal life in Northern Europe. Oddly enough the name was never used for the inhabitants of the island of Britain, although the people here were certainly what we would now understand to have been Celts. They migrated from the mainland to Britain but whether that migration took the form of an invasion or a quiet prolonged filtering across the Channel no one knows. Nor is it known when any of these movements took place.

The Celts were a tribal farming people ruled by a warrior class and by a priestly one of druids. What little is known of their religion comes from Roman sources and from the fact that many of the Celtic cults survived into the Roman era. They focused

Fourth-century mosaic pavement from Low Ham Villa, Somerset, depicting scenes from Virgil's Aeneid *telling the story of Aeneas and Dido, Queen of Carthage. To the right the Trojan fleet arrives on the African coast. At the top Aeneas meets Dido while between them Venus, goddess of love, introduces Cupid, disguised as Aeneas's son, Ascanius, to inflame their love. The second long panel to the left presents the lovers hunting during which they get caught in a storm and shelter in a cave and, as the bottom scene records, surrender to their impulses. In the central octagon Venus appears again flanked by a Cupid holding a flaming torch downwards, alluding to Dido's suicide, and the other upwards celebrating Aeneas's victory over passion.*

First-century Celtic bronze horse-trapping with enamel inlay from a hoard found in the Polden Hills, Somerset. In their mastery of metal-work technique and linear design the Celts were equal to any.

on the spirits of rivers, streams and lakes, which accounts for the discovery of Celtic artefacts which had been offered in sacrifice in those locations. Certain animals, like bulls and snakes, were part of their religion which also included human sacrifice, the one aspect of the Celtic religion which the Romans suppressed. Timber temples it seems were erected within rectangular enclosures. Otherwise the Celts lived in settlements in crude circular huts, almost exclusively of wood, wattle and daub, and with thatch or turf roofs.

Celtic art is that of the metalworker and in that medium the Romans could teach them nothing, for they were highly skilled. Celtic craftsmen produced weapons, armour, horse-gear, cauldrons, buckets, torcs (a form of necklace), drinking vessels, jewellery and mirrors. These smiths were clearly highly valued and are likely to have moved around exercising their skills for what in the main was the manufacture of status symbols for a warrior aristocracy. Whether, for instance, some of the superb shields were intended for use or merely for display remains open to question. What is certain is that these smiths had a strong design sense, making use of compasses to lay out complex symmetrical patterns of great beauty and elegance.

Celtic art was non-naturalistic, basically concerning itself with abstract and linear pattern which could incorporate masks and formalised animal images which

Two early first-century Celtic bronze mirrors, the first found at Desborough, Northamptonshire, and the second at Aston, Hertfordshire.

may or may not have had a meaning. In its early stages the Celts owed much to the Greeks, but by the third century B.C. they had evolved a style of their own which, in the case of Britain, was to become equally idiosyncratic during the first century B.C. Two of their quite outstanding formats were the bronze mirror and the torc. The shape of the mirrors is based on classical prototypes, the reverses adorned with meticulously planned and executed linear designs making use of basketry cross-hatching. The torcs have a barbaric magnificence which impressed even their conquerors, for the Roman historian Dio Cassius describes how the warrior queen of the Iceni, Boudicca, who had led a revolt against Rome in 60–61 A.D., wore a 'great twisted golden necklace'.

The Celts were also far from resistant to the influence of Rome. By the early first century A.D. their chiefs in the south-east were already beginning to undergo voluntary Romanisation. Roman artefacts were acquired for which the trade route was via the Rhône, Saône and Rhine to the Thames. Celtic coinage appeared, based directly on Roman prototypes. So that much was in place to make the Roman conquest when it came more of an accelerated evolution than a revolution. The Celts, however, remain an enigmatic people, although it is true to say that they left as their legacy one enduring feature central to the art of the island, a deep preference for two as against three dimensions, expressed above all in a love for flat linear pattern.

The Roman conquest, which began in 43 A.D., represented something very different, the arrival of what we would for the first time describe as a civilisation, for that is what the Roman army brought in its knapsack. They were a people with a mission, one which is vividly described in Virgil's great epic the *Aeneid*. In Book VI Aeneas descends to Hades where he encounters the shade of his dead father, Anchises, who proceeds to endow the empire, which his son will found, with a universal mission: 'To rule the nations under your sway, to impose peace with law, to spare the vanquished and to put down the proud.' The creation of the *Pax Romana*, the Roman

First- or second-century B.C. Celtic ceremonial shield with glass or enamel inlay found in the River Thames at Battersea, Middlesex.

Peace, was designed to enable those peoples subject to its sway not only to trade and prosper but also to apply themselves to the arts of civilised living.

Pivotal to that was the spread of the written word in the form of the Latin language which was used throughout the Empire for its bureaucracy and as a vehicle for imperial propaganda. Rome itself in the century when it conquered Britain was the home of a highly developed urban culture which had been derived from Ancient Greece. From that country stemmed their concern with the imitation of nature and the pursuit of ideal form, which remained central to their art. Their architecture was similarly concerned with ideals of harmony and proportion, governed by geometry and mathematics based on ideal human form. For the Romans the arts of government, war, and cultural activities were all interconnected. What was required of Roman administrators of the kind who were to rule over Britain as governors was not only loyalty to the emperor and private probity but, in addition, the attribute enshrined in the word *litterae*, that is someone cognisant with the whole world of ancient literary culture, both Greek and Latin. To the Romans, taking on a tradition from the Greeks, there was no distinction between bureaucratic and cultural literacy. Prestige projects and public benefaction were also held up as ideals, accounting for the proliferation of architecture, literature, music and painting, as well as the more transitory arts such as festivals and theatre. Through this kind of public munificence the emperor and the aristocracy bound themselves to the classes below them.

Britain was colonised just at the time when Roman culture had reached an apogee. Indeed its greatest literary works were to remain integral to the western tradition for centuries to come. These include, for example, those by Cicero which set models for rhetoric, by Lucretius whose *De Rerum Natura* (54 B.C.) expanded the Epicurean explanation of the universe, by historians like Plutarch and Tacitus, not to mention the great poets, Virgil, Ovid, Propertius and Martial. It should not be assumed that such texts were virtually unknown in Britain during almost four centuries of Roman rule just because all the evidence we have today is confined to a few references in mosaics and wall paintings. Support for a more widespread familiarity with Roman literary culture comes from passages like the one in the historian Tacitus's account of the Romanisation of the Celts during the governorship of Julius Agricola (78–84 A.D.): 'The sons of the leading men [i.e. Celts] were educated in the liberal arts, and he stated his opinion that the natural ability of Britons was superior to the studied industry of the Gauls. The result was that the refusal to learn Latin was replaced by a desire to excel in it.'

The Roman army was not made up only of men who could fight. It included those who could read and write, administer, mine and quarry, lay out military camps and

towns, design and construct bridges, roads and aqueducts, deal with hydraulics, survey, make tiles and bricks, forge weapons and armour and also act as shipwrights. And those would not be the only skills of what was not only a powerful organised military force but a whole culture on the move. The arrival of the Romans in Britain brought for the first time cities and towns, public art, the world of letters and of ideas, as well as the notion of civilised living.

The army was therefore central to the Romanising process. Britain usually had four legions in residence making in all between eighteen and twenty-four thousand

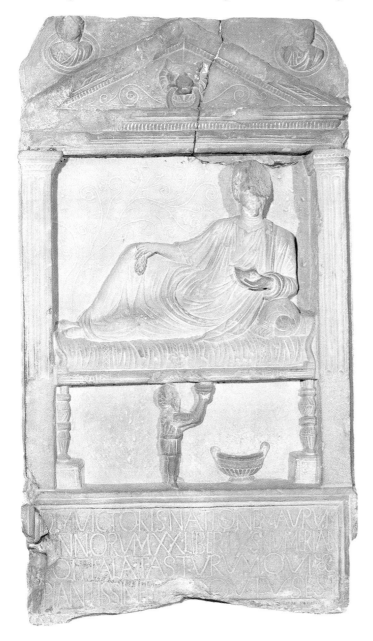

This third-century sculptured grave-relief from South Shields, Durham, bears testimony to the arrival of the classical repertory in Roman Britain. The dead man is Victor, a Mauretanian stationed with the First Asturian (Spanish) Horse on Hadrian's Wall at Benwell. He is shown probably at the soul's celestial banquet in the other world. He was twenty.

men. They quickly established three major legionary bases at York, Chester and Caer-leon. In addition there were up to sixty-five ancillary regiments. The legionaries' commanding officer would have been of the high equestrian rank who brought with him, as did other members of the upper orders, his wife and children. The forts built by the Romans, which can still be seen in the layout of York and Chester, bear witness to their skill in military architecture. Each was laid out on a grid system with barracks, a granary, a hospital, a parade ground, baths and accommodation for senior officers and their families, with temples outside the confines. The task of the army called for the exercise of the practical arts, architecture for building, metalwork for armour and weapons, stone carving for memorial stones, reading and writing to administer. Their greatest military monument remains Hadrian's Wall (begun 121 A.D.) built for defence against, and also to overawe, the barbarians beyond it.

Along with forts came towns, a major innovation and the driving force in the Romanisation of the Celtic tribes. For them it meant, for example, a tribal centre like that of the Catuvellauni graduating into the Roman town of Verulamium. Others were founded for legionary veterans or indeed around markets or springs like Aquae Sulis (Bath). As in the case of the forts their layout was on a rational grid system of streets with public spaces and buildings at the heart: the governor's palace, a market, baths and temples. Theatres were always built outside the walls. There was for the first time public art in the form of triumphal arches, commemorative inscriptions, and statues and busts of emperors. The towns were encircled by banks or walls both for display and defence, setting them sharply apart from the surrounding countryside. London was by far the largest city with a population of some 30,000. Other places like Cirencester (Corinium) had some 20,000. In the towns there were craftsmen, metalworkers, sculptors and mosaicists, whose work became so distinctive that it is possible to group it as being that of a particular workshop operating in a certain area of the country. In the towns too schools provided education in the Latin language so that eventually even artisans could write Latin. What we do not know is how many of the Romano-British spoke it, or whether they may have been bi-lingual.

The majority of the population, however, lived in the countryside which supplied the towns with foodstuffs and raw materials. Here a new building type was intro-duced, the villa. Villas were the focus of farming estates occupied by officials, merchants and landowners. They could range from the simplest barn-like aisled struc-tures to ones which were virtual palaces built around one or more courtyards. Even by the close of the first century A.D. extremely grand villas were being const-

Cast bronze head of the Emperor Hadrian (117-138) found in the River Thames at London Bridge. The cult of the emperor was mandatory, and this head was probably part of a life-size figure which stood in a public building like the forum.

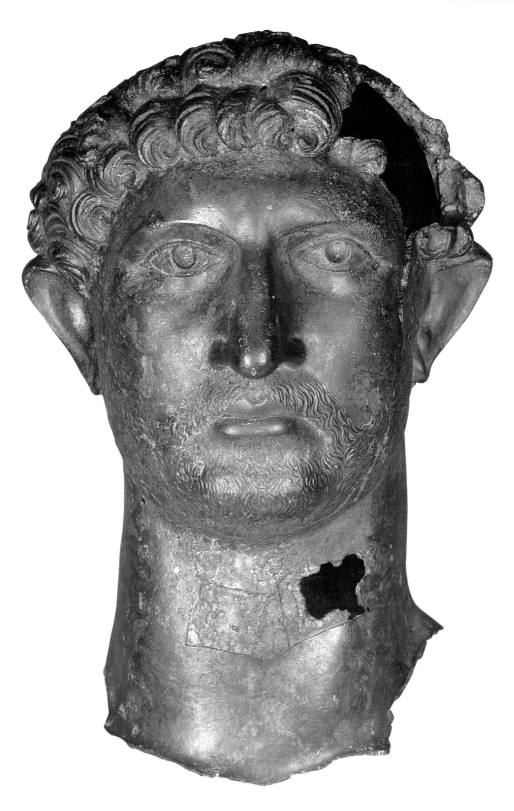

ructed. Fishbourne near Chichester is an instance, built probably as the residence of a Romanised Celtic chief called Cogidubnus. The villa had a handsome colonnaded entrance which gave on to a large quadrangle planted as a formal garden, while inside the walls were lined with veneers of marble brought from as far away as Turkey and the Pyrenees.

The majority of villas adopted the typical wing formula with a central porticoed entrance leading to a series of public rooms with wings reached by way of a veranda, incorporating on one side a dining-room and suite of baths and, on the other, domestic quarters. The wall paintings which have survived indicate that they followed the styles seen at Pompeii, albeit with a time lag. The greatest impression of the richness of some villas, which must also have extended to perishable artefacts in leather, wood and textiles, comes today from the surviving mosaic floors.

The mosaicists must initially have been imported, but they taught their skills to the Celts and several regional schools can be detected. Over four hundred mosaic floors have so far come to light, most of them in the first phase in the south-east of England. This flurry of activity was followed by a recession in the third century and by a renaissance in the fourth, with new workshops active in the west. The majority of the floors are made up of linear patterns, chequers, key patterns and scrolls, reflecting the influence of Celtic preferences. There was also a taste for rural subjects appropriate to the country: the seasons, the days of the week, the winds, rivers and springs. But there could from time to time be subject matter, as we have already seen, which was literary and highly sophisticated.

The arrival of the Romans brought art which was not only in the service of religion but also of the State. Statues of the emperor stood in town *fora* and monumental inscriptions celebrated imperial deeds. Victories would be marked by triumphal arches like the one of which parts survive at Richborough, Kent, probably erected by Agricola and best interpreted as a celebration of the conquest of all Britain at the very gateway to the island. At Colchester stood the altar of the imperial cult which next to that of the three great Roman deities, Jupiter, Juno and Minerva, was fundamental to the Empire. Apart from suppressing druidic human sacrifice the Romans had no difficulties about accepting the Celtic gods and accommodating them, along with their own, into a single pantheon. At Bath the temple was dedicated to a combination of the Roman goddess Minerva and the Celtic water deity Sulis.

The change from Celtic to Romano-British seems to have been a process of symbiosis rather than revolution. The one moved almost effortlessly into the other. Certain aspects of Celtic art lived on, the desire for pattern and simplification, the preference for shallow relief rather than three-dimensional modelling and the ten-

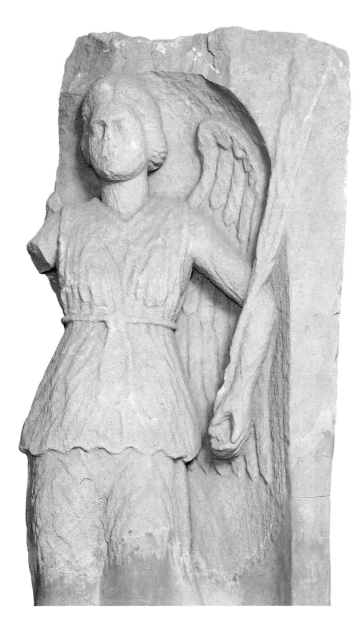

Second- or third-century winged figure of Victory from Housesteads, the Roman Vercovicium, on Hadrian's Wall. Although provincial the figure is firmly in the classical style.

dency to treat the human anatomy not as a thing to be carefully observed and rendered but rather as elements which could be rearranged into a pattern. But there were significant changes. Dates and words appear for the first time along with a repertory of images whose source could only ever be the classical world. These new forms arrived not only by way of foreign craftsmen but as much through that major agent of imperial propaganda, the coinage. Coins spread both ideas and style, although to read them called for literacy. On a small surface a message was conveyed

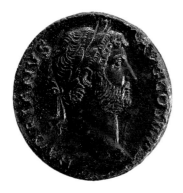

Coin of the Emperor Hadrian (117-138) with the figure of Britannia on the reverse. The contents of the reverses of Roman coins were not only vehicles for imperial propaganda but a means whereby the classical style and imagery was spread.

by a combination of the emperor's portrait on one side and a symbolic image and Latin text on the other. Personification entered British art, for the coins show figures such as Victoria or Fortuna or Pax, each bearing their attributes. Britannia herself made her debut as a lady seated on a pile of rocks.

The fourth century is the last great age of Roman Britain. It is one during which the country was percolated by new mystery cults from the east, Egyptian cults like that of Osiris, Syrian ones like that of Astarte, as well as those centred on Mithras and Orpheus, not to mention Christianity. Mosaic pavements from this century often depict Orpheus in the middle with birds and mammals revolving in separate registers around him. This is the god presented as a still, eternal centre in the midst of a shifting world. What was probably the stock of a merchant or jeweller buried at Thetford, Norfolk, around 380–90 contains over eighty items, amongst which are many establishing that at the time in that part of the country there was a fairly flourishing cult of the Roman god of the agricultural landscape and woodlands, Faunus. In much the same way as Orpheus, the head of Christ appears at the centre of a mosaic in a villa at Hinton St. Mary, Dorset, with the Christian *chi-rho* sign behind him (the monogram of the Greek letters *chi* and *rho*, the first two letters of *Christos*, the Anointed One: Christ).

The very visible emergence of Christianity sets the fourth century apart. In 313 with the conversion of the Emperor Constantine, Christianity became the official state religion of the Empire. The following year the bishops of York, London and Lincoln went from England to a Council of the Church held at Arles. That establishes that Christianity was organised along the lines of Roman Britain based firmly on an episcopate in its major towns and cities. But how widespread it was in Romano-British society is not known. In fact it has been argued that paganism was stronger. Nonetheless it is likely that many later Anglo-Saxon churches in fact go back to the Roman period. Canterbury Cathedral and St. Paul in the Bail, Lincoln, are two certain

instances. One of the recently discovered hoards of Late Antique silver at Water New-ton, west of Peterborough, is likely to have been the plate of the local *ecclesia*, hidden at some moment of dire urgency around 350. Among the vessels are two jugs, a wine-strainer and four cups, one with two handles like a later chalice. Together they represent a service of plate for an early Christian communion service.

In 409 the Emperor Honorius sent his famous directive that henceforth the people of Britain must look to their own defence. By then the legions had departed and we enter those centuries called the Dark Ages, dark because it is not known what happened. Even archaeology has failed to shed that degree of light on to them. As there was no longer an imperial coinage there ceases to be even a means of dating archaeological finds with any exactitude. All the indications are of a civilisation which progressively faltered and disintegrated, as wave after wave of barbarian in-vaders ravaged and pillaged and then eventually settled. Villas during the early fifth century began to be abandoned, too isolated to defend against marauders. Towns contracted in size but struggled on. When the Romans officially withdrew, certain skills went gradually into abeyance like working stone and making bricks and tiles. There is growing evidence though for the survival through it all of some kind of literacy.

But the Romans had left an indelible legacy, one which contributed to the shape of what was to become English civilisation, for the Romans never quite conquered the Celtic fringes of Cornwall or Wales or Scotland. That fact still affects us today. The English language is unique amongst its Germanic cousins for the very large number of words which have come into it from Latin. When Rome and Latin culture were significantly to impinge again on England it was to be in the form of a very different kind of empire, a spiritual one, embodied in an emissary of the Church of Rome, St. Augustine, who was to land on the Kentish shores in 597.

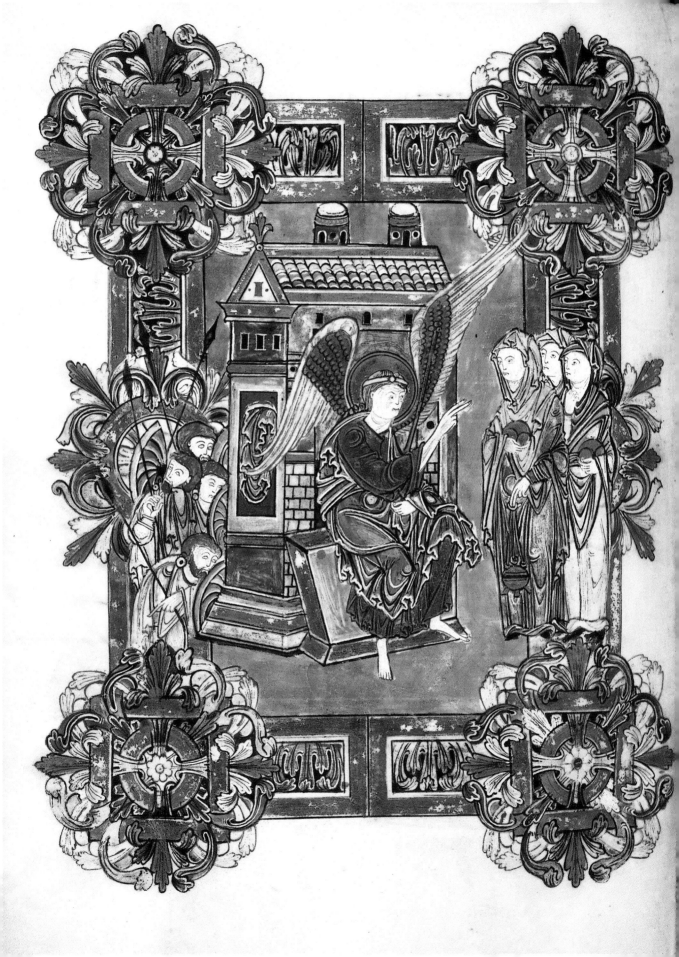

Chapter Three

THROUGH A GLASS DARKLY

Towards the close of his *Ecclesiastical History of the English People* the great scholar Bede, 'a servant of Christ and priest of the monastery of the blessed apostles Peter and Paul, which is Wearmouth and Jarrow', described his life in the following terms:

> 'I was born on an estate of the same monastery and when I was seven years old my kinsmen entrusted me for my education to the most reverend abbot Benedict and later to Ceolfrith. Since then I have passed the whole of my life within the walls of this same monastery and devoted all my time to studying the Scriptures. Amid the observance of monastic discipline and the daily charge of singing in the church, my delight has always been in learning, teaching and writing.'

He goes on to say that he became, exceptionally, a deacon at the age of nineteen (twenty-five was the norm) and was ordained priest at thirty. He then lists some sixty books he has written.

Bede wrote that in 731, three centuries on from the Roman withdrawal from Britain. By then a new civilisation was in full flower, one which centred on a new institution, the monastery, a Christian community which lived according to a strict rule but whose central activity was the performance of the *Opus Dei*, the daily round of chant and prayer in the church. But the monastery was to embody much else besides, music, painting, architecture, writing manuscripts, as well as teaching the young and pursuing sacred scholarship. Bede's foundation housed one of the greatest libraries in western Europe, all the more startling when it is realised that it was located in remote Northumbria, thousands of miles from the main European centres of learning. Anglo-Saxon schools and scholarship together were in

The Three Marys at the Sepulchre of Christ, a scene illustrating the Easter benediction from the Benedictional of St. Aethelwold *written by the monk Godeman in the Old Minster, Winchester. c.970-80. The book, at the command of Aethelwold, Bishop of Winchester, a poem at the opening tells us, was to be embellished with 'many frames well adorned and filled with various figures decorated with numerous beautiful colours and with gold.' The idiom in which frames and figures are interwoven is characteristically English.*

fact to represent one of the most astonishing phenomena in the whole history of western civilisation. During the eighth century England was to play a vital role in the transmission of the culture of classical antiquity through into the Middle Ages.

That such a crucial role was possible is all the more extraordinary in the face of what had preceded it. The fifth and sixth centuries still remain ones of impenetrable obscurity, fully justifying their designation as the Dark Ages. Britain was only one of many countries which suffered the consequences of the collapse of the Roman Empire. In England's case the effect was far more dramatic, for there was no continuity as two-thirds of the eastern parts of the island passed into the hands of German pagan and illiterate warrior tribesmen. Urban society collapsed, and the Latin language was gradually abandoned in favour of British or primitive Welsh. Under the aegis of the British church some form of Latin learning survived, but in the east a series of Anglo-Saxon petty kingdoms emerged whose cultural status can only be categorised as barbarian.

But even they were not wholly untouched by the mighty legacy of imperial Rome. The Sutton Hoo treasure, excavated from a vast burial mound in East Suffolk, reveals a pagan art of savage magnificence whose stylistic sources are a German world already influenced for centuries by Rome. These splendid objects are generally accepted as having belonged to Raedwald, king of East Anglia, who died in 625. The metalwork alone is of the highest quality, gold inlaid with niello, garnets, and coloured

Shoulder-clasp from the burial hoard of a Saxon king found at Sutton Hoo, Suffolk, dating from about 625. The clasp is of gold set with garnets and millefiori *glass arranged in the interlacing patterns and chequers which recur in Anglo-Saxon art.*

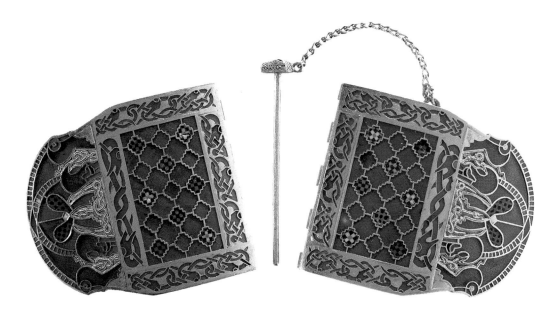

pieces of *millefiori* glass in chequer patterns. They speak forcefully of a pagan aristocratic warrior art which is non-figural, obsessed with surface pattern and the glitter of gold.

These are the artefacts of the kind of society so strikingly depicted in the only secular epic in Old English to survive, *Beowulf*. Although first written down c.975–1025, the poem was already by that date centuries old, and earlier manuscripts certainly once existed. This is the work of an English poet who is writing about a common heroic past in a poem which holds up to its audience an example for its aristocratic warriors to emulate. We have no conclusive evidence as to its date or its place of composition and it survives in only one version in West Saxon dialect. But just as Sutton Hoo is Anglo-Saxon pagan art, *Beowulf*, although written down in a Christian era and therefore touched by it, is Anglo-Saxon pagan literature.

The poem evokes a fierce warrior aristocracy whose highest virtue was that of courage, and for whom renown could only be won on the field of battle. Such epics were sung to a stringed instrument for recitation before what was in effect a barbarian court. *Beowulf* is set in a misty and remote past when men not only struggled with their fellow men but even more with mysterious supernatural forces. In this epic it is the monster Grendel who makes his entrance into a regal hall on the floor of which Beowulf and other thanes slumber:

> The demon delayed not, but quickly clutched
> A sleeping thane in his swift assault,
> Tore him in pieces, bit through the bones,
> Gulped the blood, and gobbled the flesh.
> Greedily gorged on the lifeless corpse,
> The hands and the feet. Then the fiend stepped nearer,
> Sprang on the Sea-Geat lying outstretched,
> Clasping him close with his monstrous claw.
> But Beowulf grappled and gripped him hard,
> Struggled upon his elbow; the shepherd of his sins
> Soon found that never before had he felt
> In any man other in all the earth
> A mightier hand-grip . . .

It was to such a fierce primeval society that Pope Gregory the Great decided to send forty Christian missionaries in 596, headed by St. Augustine. They landed in Kent, ruled by Aethelbert who was married to a Christian Gaulish princess. Aethelbert converted, and soon after dioceses were established at Canterbury, Rochester and

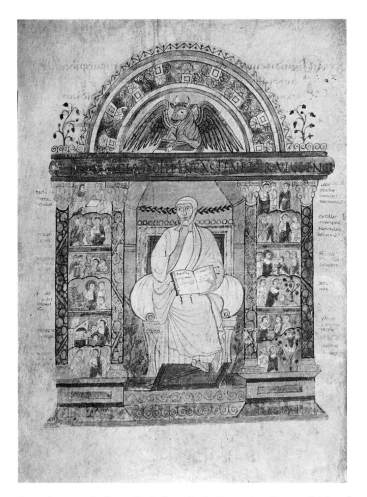

The Gospels of St. Augustine, *a sixth-century Italian manuscript. This is virtually certainly one of the books supplied to Augustine by Pope Gregory the Great for his mission to England in 596. It is even today used on the occasion of the enthronement of a new Archbishop of Canterbury.*

London and, for a brief period, East Anglia and Northumbria also responded with conversion to Christianity. But this early phase was a fragile one, ebbing and flowing as petty kingdoms and their rulers rose and fell. In spite of that England, by the close of the seventh century, had become Christian, a conversion which was achieved from the top downwards.

That growth of Christianity through the seventh century did not come from only one initiative but two, and both had profound cultural implications. The first impulse was the revitalisation of the Roman mission in the south by the arrival in 669 of Theodore of Tarsus as Archbishop of Canterbury. Theodore was one of the most learned men in western Europe, someone who had studied in Syria, attended university in the imperial capital of Byzantium, and worked in Rome for the pope. With him he brought an African scholar, Hadrian, and together they established a school at Canterbury which taught not only Latin but Greek. In addition he set up a scrip-

torium to produce books. Theodore's reorganisation of the English church into thirteen or fourteen dioceses was to last virtually intact until the Reformation. They also provided the network whereby what had been achieved at Canterbury could be duplicated elsewhere.

The second thrust came from the north. The Northumbrian king, Oswald, had been converted to Christianity in exile and brought back with him in 634–35 Aidan, from the monastery of Iona, to convert his realm. This was Christianity of a different kind, one which stemmed from Ireland and ultimately Britain, for Ireland had been evangelised by the British St. Patrick in the fifth century. Irish Celtic Christianity developed a strong commitment to learning and its monasteries had scriptoria capable of producing manuscripts of the quality of the Book of Durrow (c.675) in which a unique form of decoration emerged, consisting of interlacing ribbons, formalised animals, and rectilinear patterns filling what is called a 'carpet' page. But the main commitment of the Irish was to missionary work both on the continent and in Britain. In 563 St. Columba had founded Iona and it was from there that Aidan travelled to found the celebrated monastery on the island of Lindisfarne in 635. As the missionaries from north and south crossed each other's paths, the differences between the two churches began to emerge, above all over the date for the observation of Easter. These were finally resolved in 664 when a synod was held at Whitby, one of the earliest of Northumbrian monastic foundations, at which a declaration was made in favour of following Rome.

The conversion of England to Christianity was to act as a catalyst for the transformation of a Germanic pagan culture through a revival and recovery of the classical heritage. Christianity is a book-based religion and its arrival reinstated a literary Latin culture which had been destroyed. Regardless of wherever the missionaries came from they brought books with them, Bibles, especially copies of the Gospels, liturgical and patristic works as well as textbooks whereby to train the clergy. The Gospels, which contained the Christian message of salvation, were crucial, fully explaining why they were the first texts to be accorded elaborate decoration. Shimmering with gold and jewels they were used as a tangible symbol of the new faith when paraded before a recently converted and largely illiterate congregation.

No one knows how St. Augustine set about creating schools but by 630 he had enough teachers at his disposal to send some to work in East Anglia. As a result, within two generations England was capable of producing scholars of European fame who wrote works which were to be used throughout the Middle Ages. That this

Cross-carpet page and major initial page at the beginning of St. Mark's Gospel in the Book of Durrow *from the second half of the seventh century. Scholars disagree as to whether this was executed in Northumbria, Iona or in Ireland.*

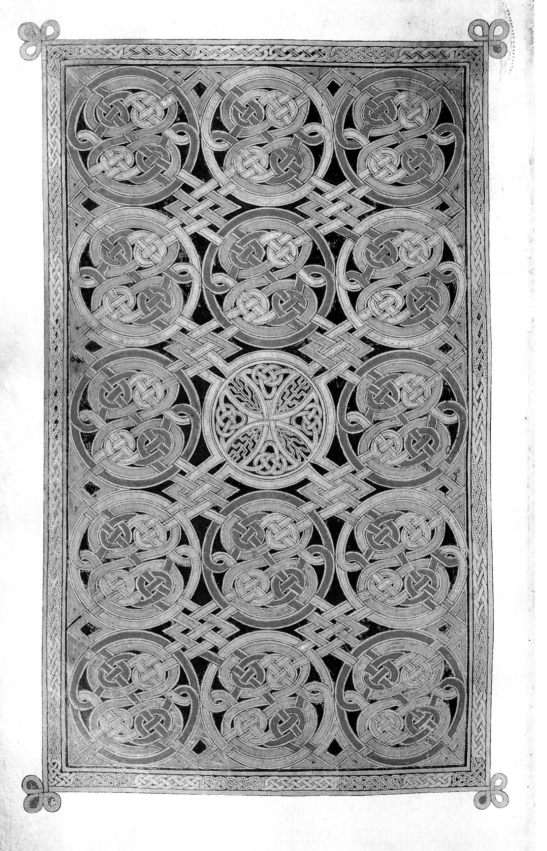

torium to produce books. Theodore's reorganisation of the English church into thir-
teen or fourteen dioceses was to last virtually intact until the Reformation. They also
provided the network whereby what had been achieved at Canterbury could be dup-
licated elsewhere.

The second thrust came from the north. The Northumbrian king, Oswald, had
been converted to Christianity in exile and brought back with him in 634–35 Aidan,
from the monastery of Iona, to convert his realm. This was Christianity of a different
kind, one which stemmed from Ireland and ultimately Britain, for Ireland had been
evangelised by the British St. Patrick in the fifth century. Irish Celtic Christianity dev-
eloped a strong commitment to learning and its monasteries had scriptoria capable
of producing manuscripts of the quality of the Book of Durrow (c.675) in which a
unique form of decoration emerged, consisting of interlacing ribbons, formalised
animals, and rectilinear patterns filling what is called a 'carpet' page. But the main
commitment of the Irish was to missionary work both on the continent and in Brit-
ain. In 563 St. Columba had founded Iona and it was from there that Aidan travelled
to found the celebrated monastery on the island of Lindisfarne in 635. As the mis-
sionaries from north and south crossed each other's paths, the differences between
the two churches began to emerge, above all over the date for the observation of
Easter. These were finally resolved in 664 when a synod was held at Whitby, one of
the earliest of Northumbrian monastic foundations, at which a declaration was made
in favour of following Rome.

The conversion of England to Christianity was to act as a catalyst for the trans-
formation of a Germanic pagan culture through a revival and recovery of the classical
heritage. Christianity is a book-based religion and its arrival reinstated a literary Latin
culture which had been destroyed. Regardless of wherever the missionaries came
from they brought books with them, Bibles, especially copies of the Gospels, litur-
gical and patristic works as well as textbooks whereby to train the clergy. The Gospels,
which contained the Christian message of salvation, were crucial, fully explaining
why they were the first texts to be accorded elaborate decoration. Shimmering with
gold and jewels they were used as a tangible symbol of the new faith when paraded
before a recently converted and largely illiterate congregation.

No one knows how St. Augustine set about creating
schools but by 630 he had enough teachers at his dis-
posal to send some to work in East Anglia. As a result,
within two generations England was capable of produc-
ing scholars of European fame who wrote works which
were to be used throughout the Middle Ages. That this

Cross-carpet page and major initial page at the beginning of St. Mark's Gospel in the Book of Durrow *from the second half of the seventh century. Scholars disagree as to whether this was executed in Northumbria, Iona or in Ireland.*

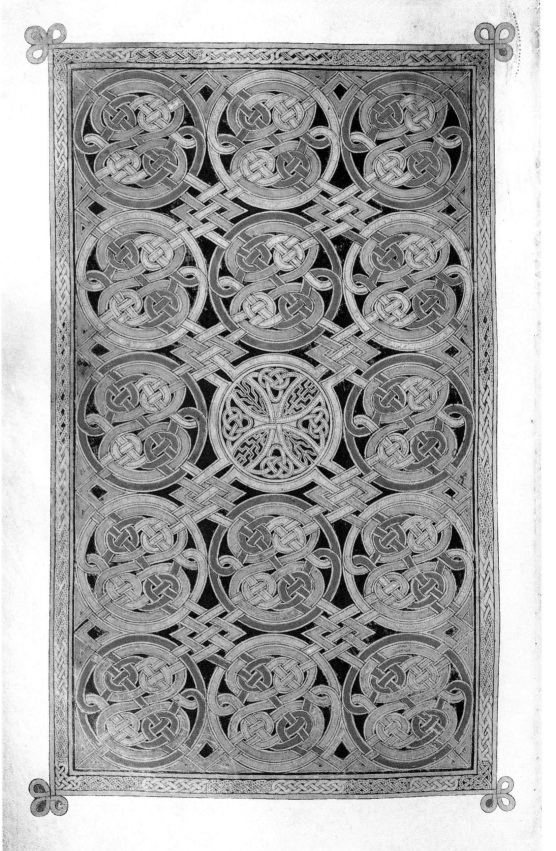

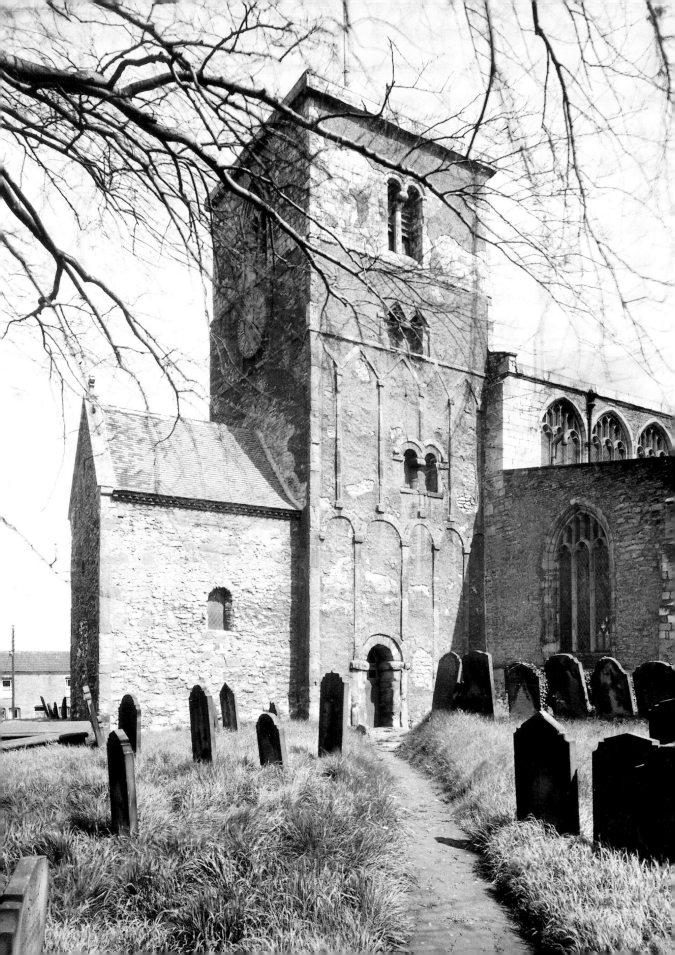

set by the Carolingian court and the fount of what was a new style in Anglo-Saxon art was Winchester, a rich bishopric and a major seat of the royal court. From it the style was to spread across country and, in the succeeding generations, begin to diverge and take on its own insular idiosyncratic character.

This found its quintessential expression in manuscript illumination. Artists were sometimes called upon to illustrate manuscripts with a series of large pictures for which they had no models and, as a consequence, had to innovate, drawing on a large number of sources. As a result whole sequences of historical scenes from the Old and New Testaments appeared in psalters in a way totally unknown on the continent. The greatest masterpiece of the new style was the *Benedictional of St. Aethelwold*, begun some time after 971. It is boldly linear in the insular tradition, florid with a strong taste for sumptuous colour and a lavish use of gold and silver, but its inspiration is continental for St. Aethelwold had sent one of his monks to Fleury to study the Rule of St. Benedict. The Winchester School also went in for line drawing, again derived from Carolingian exemplars, in which artists indulged in lively and naturalistic renderings of the human figure. Similarly, to this era belongs the great flowering of ivory carving in a style which is monumental, grandiose, making abundant use of dramatic gesture and drapery whose agitated folds and crinkled edges directly echo the flamboyant fluttering decoration typical of the *Benedictional*. Simultaneously church building was renewed and the bell-tower, unknown before c.1000, made its first appearance as an essential element of the English parish church.

Edgar's golden age was followed by almost thirty years of catastrophe under a weak and vacillating king, Aethelred. The country was bled white paying taxes to hold back a new incursion of invaders who in the end conquered the kingdom but in a very different way, for their leader, Canute, married Aethelred's widow and reigned as an ideal Anglo-Saxon king within the existing system. Canute died in 1035 to be followed briefly by his son Harold and then by Harold's half-brother, Edward the Confessor. By then the great glories of Anglo-Saxon civilisation were departing and the Confessor's new abbey of Westminster was inspired by the great Romanesque abbeys of the state which was to conquer England, the duchy of Normandy.

It remains one of the ironies of history that one of the

Anglo-Saxon ivory of the Nativity, late tenth or early eleventh century.

newal in the seventh century, that task of starting again fell to the kingdom of Wessex at the close of the ninth century. Alfred, king of Wessex, defeated the Dane Guthrum, who converted to Christianity, in 878. Eight years later he took London and the fortunes of what was eventually to become the single kingdom of England revived. Under Alfred's aegis during the 880s there was a deliberate renewal of learning. In the king's mind the defeat of the Vikings was indissolubly linked to the woes which had befallen the country, for the invaders were viewed as God's judgement on a fallen people. Unlike its predecessors this was a renaissance initiated not in a monastery but in a royal court, by a king who was also uniquely educated himself and capable of translating from Latin into Anglo-Saxon. To his court he summoned scholars: Archbishop Plegmund of Canterbury, Bishop Asser of St. David's, Grimbald of Rheims and John from Saxony. In this group fuse British, Anglo-Saxon and Carolingian learning aimed at countering the situation found by Alfred when he came to the throne in 871 and it was said that not one person could be found south of the Thames who could read or translate Latin.

But knowledge of Latin was in such a state of decay that it led the king to promote the use of the vernacular. In his preface to his translation of Gregory the Great's *Pastoral Rule* he wrote of his intention to turn 'into the language which we can all understand some books which it may be most necessary for all men to know, and bring it to pass that all the youth now in England born of free men may be devoted to learning until they can read English. One may then teach further in Latin those whom one wishes to bring to Holy Orders.' So Alfred was responsible for what was a unique promotion of the use of the vernacular in early medieval Europe. A copy of his translation of the *Pastoral Rule* was sent to each bishop for his instruction and along with it some kind of pointer. The famous Alfred Jewel is thought to be the handle of one of these bookmarks, a splendid object betraying the influence of Carolingian court art in its richness combining rock crystal, *cloisonné* enamel and exquisite goldwork.

Alfred's reign was to be the preface to the rise of the kings of Wessex to be kings of England. In 910 Edward the Elder defeated the Vikings in the north thereby creating one state. The subsequent reigns of Aethelstan and Edgar, who died in 975, witnessed another cultural resurgence, this time one which stemmed ultimately from the great abbey of Cluny in south-eastern France, via the abbey of Fleury which was visited by Anglo-Saxon clerics. In these monasteries the Rule of St. Benedict was strictly adhered to and it was that which, under the aegis of Edgar, was introduced by way of three great reforming churchmen, Dunstan, Archbishop of Canterbury, Aethelwold, Bishop of Winchester and Oswald, Bishop of Worcester. Once again monasteries became major seats of learning and culture. The model they followed was one

led cross whose decorations fall away to reveal the bloodstained wood beneath. The cross then tells its story:

> Long years ago (well I remember)
> They hewed me down on the edge of the holt,
> Severed my trunk; strong foemen took me,
> For a spectacle wrought me, a gallows for rogues.
> High on their shoulders they bore me to hill top,
> Fastened me firmly, an army of foes!
> Then I saw the King of all mankind
> In brave mood hasting to mount upon me.
> Refuse I dared not, nor bow nor break,
> Though I felt earth's confines shudder in fear.
> All foes I might fell, yet still I stood fast . . .
> Black darkness covered with clouds God's body,
> That radiant splendour. Shadow went forth
> Wan under heaven; all creation wept
> Bewailing the King's death. Christ was on the Cross.

Christ has been transmuted here into an athletic Anglo-Saxon warrior chieftain in a poem in which Christian, Germanic and classical sources mingle to produce a new literary and religious sensibility.

The seventh and eighth centuries represent the summit of the Anglo-Saxon achievement. Northumbria was to disintegrate into internal feuds in the late eighth century, one which was marked by the dominance of the midland kingdom of Mercia about whose culture far less is known. Brixworth church in Northamptonshire, built in the 670s by monks from Peterborough, bears witness to a Mercian flowering which, in the 700s, was to include the cathedrals of Worcester, Lichfield and Leicester and the abbeys of St. Albans, Peterborough and Ely. By then the link between England and the Roman inheritance had become so strong that rulers claimed descent from Caesar, who, along with Romulus and Remus, the legendary founders of Rome, was featured on their coinage. But the days of this Anglo-Saxon civilisation were numbered, threatened by a new wave of invaders from the north, the Vikings, who were pagan and illiterate. They had no respect for churches or monasteries or for the sanctity of the treasures within them. The result was wave after wave of destruction as they gradually overran the country and then settled. Their impact can be measured by the fact that between 835 and 885 not a single traceable work was written.

In the same way that Kent and Northumbria had been spearheads of a cultural re-

The figure of Christ as Judge trampling underfoot a lion and a snake from the eighth-century Bewcastle Cross offers vivid evidence as to how styles could cross Europe for it presupposes examples of Byzantine art must have reached England.

A prophet from a sixth-century Byzantine mosaic in the church of S. Apollinare Nuovo, Ravenna. Ravenna remained part of the Byzantine Empire and was one source whereby its art travelled west.

imported into Britain from across a vast distance.

On the Ruthwell Cross there are not only Latin inscriptions in Roman script but also Anglo-Saxon runes, quoting lines from the most famous Anglo-Saxon vernacular poem, *The Dream of the Rood*. Anglo-Saxon England was to produce the most extensive vernacular literature of any country in the early Middle Ages. Originally this was transmitted orally, only being written down later. What is certain is that the poetic gift was held in high esteem and that the singer of tales with his harp was an important member of any noble household. Anglo-Saxon poetry resembled Anglo-Saxon art, delighting also in the use of repeat patterns, revelling in complexity and loving ornament. Gradually some of these poems gained a status which demanded that they outlive a single performance but what survives is arbitrary. Of the major poet Caedmon only nine lines exist, but he was hugely influential, paraphrasing sacred writings into metrical prayer. But the only substantial poem is the anonymous *The Dream of the Rood*, a composition striking for its freshness, for its deep religious sensibility, and for its richly visual quality. It opens with the speaker contemplating a large bejewel-

cised in respect of his sources as to their accuracy, able to reach even into the archives of the Vatican. In the circumstances the achievement only becomes even more extra-ordinary.

Monkwearmouth and Jarrow were not alone. St. Wilfrid also had a predilection for all things Roman, modelling his two great foundations of Hexham and Ripon on Roman basilicas. Nor was Bede a solitary figure in the world of learning, for St. Ald-helm of Malmesbury, his contemporary, matched him in terms of classical and patristic learning, something which he owed to instruction in the Canterbury school set up by Theodore of Tarsus. By the eighth century there were some two hundred monasteries scattered across the country including Glastonbury, Abingdon, Peter-borough, Winchester, Worcester, Ely and Whitby. York had the first cathedral school established by one of its archbishops, with a library which contained its full comp-lement of the Church Fathers, and all the major grammarians, together with a wide selection of works by the Christian and classical poets. By then Anglo-Saxon monks were acting as missionaries to the continent taking with them insular manuscripts and works of art which survive today, whereas so much in England was to be des-troyed either by the Vikings or at the Reformation in the sixteenth century. The fame of English learning was such that when the Emperor Charlemagne (who created what was the Holy Roman Empire in the West in 800 when he was crowned in Rome by the pope) wished to establish a court school he sent, in 782, for Alcuin of York. Al-cuin had been taught by a pupil of Bede's and was to become a major figure in what is known as the Carolingian Renaissance. Alcuin was one of the foremost grammar-ians, liturgists and theologians in Europe. In this way what England had received from the continental mainland in the seventh century was given back to it in the eighth.

Christianity brought stone-built architecture, the earliest churches being simple rectangular buildings with an apse at the eastern end, a number of which survive in Kent and Essex. It also brought figural sculpture, the most famous instances being the high crosses. No other stone monuments on this scale were erected in Europe at the time and no scholars agree as to their precise dating, although it is likely to be during the eighth century. The two most famous are at Ruthwell, Dumfries, and Bewcastle, Cumberland. Such crosses combine Irish forms with Germanic interlacing patterns and figures and vine-scroll decoration from the Mediterranean. These are monu-ments to the Anglo-Saxon Christian renaissance and the models for the figural sub-jects are likely to have been works of art brought to England from Italy. The figure of Christ, for example on the Bewcastle Cross, directly echoes one of the standing fig-ures in the great Byzantine mosaics at Ravenna, a striking instance of what had been

gorgeous carpet patterns, making use of both compass and ruler. But it is the portraits of the evangelists which are the most innovative in the Anglo-Saxon context. Through its Greek and Roman heritage, Christian art used human form as a natural means of expressing the supernatural. That tradition was now transmitted to the Anglo-Saxons who had not hitherto attempted to depict the outside world. The Church utilised painting and sculpture to illustrate biblical history and the lives of saints and that tradition now arrived in England, from manuscript sources; for example, the figure of St. Matthew derived from a seventh century Italian gospel which must have been brought to Lindisfarne from Italy. From henceforth the human figure was to become an essential element in Anglo-Saxon art.

The greatest of all monastic foundations was Monkwearmouth and Jarrow, twin monasteries established under royal aegis by a Northumbrian nobleman, Benedict Biscop, who was their first abbot. They were founded in 674 and 682 and together formed a quite extraordinary island of Mediterranean culture amidst what was still largely a barbarian sea. Over a period of some thirty years Benedict Biscop visited Rome bringing back each time not only manuscripts (these included a large part of Cassiodorus's library from Vivarium) but relics, vestments, altar furnishings and pictures. In 680 he even returned with John, the Archcantor of St. Peter's, who taught the monks how to perform the liturgy correctly as well as to read aloud properly. His instructions were written down and passed on to other monasteries. From the outset Benedict Biscop was determined to follow all things Roman, modelling the monastery and its churches on those he had seen in Rome and Gaul. The Anglo-Saxons only ever built in wood and so he imported stone-masons and glaziers from Gaul in order to build a church, it is recorded, 'in the Roman manner which he always loved'.

The library and scriptorium must have been remarkable judging from a surviving manuscript, the *Codex Amiatinus*, a thousand-page manuscript of the Bible. This was sent to the pope in 716, one of three, the other two being for use in the twin monasteries. Only a major library could account for the emergence in such a remote part of Europe of a scholar of the standing of Bede. Here was a great teacher whose works were concerned with clarity of expression in order to transmit what he taught, who also delighted in music, being himself skilled in the recitation of English songs and poetry. Bede produced more works of scholarship than anyone since St. Augustine of Hippo. They covered a wide range of subjects: biblical exegesis, computus, Latin metrics and teaching manuals, all of which remained in use throughout Europe for centuries. But his masterpiece remains the *Ecclesiastical History of the English People* completed shortly before his death. Still eminently readable, this is a vivid and dramatic account of the conversion of the English, written with a strong critical faculty exer-

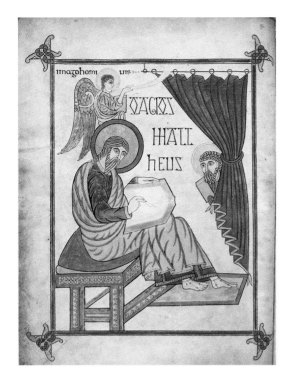

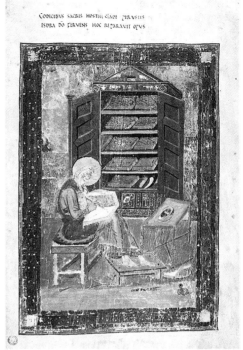

Portrait and symbol of St. Matthew from the Lindisfarne Gospels *which were written and illuminated about the year 698 at the monastery of Lindisfarne by a monk called Eadfrith. This manuscript is one of the greatest of Anglo-Saxon works of art in which Roman, Celtic and Anglo-Saxon influences can be traced. For this portrait of the evangelist the artist must have copied one in a Bible in the library at Monkwearmouth and Jarrow like the* Codex Amiatinus.

The Codex Amiatinus *is one of the three great Bibles made at Monkwearmouth and Jarrow around the year 700. This one was taken by the abbot, Ceolfrith, in 716 as a gift to the pope, but he died on his journey. This miniature shows the prophet Ezra and must have been based on an illumination found in one of the manuscripts from Cassiodorus's library at Vivarium which had been brought to England.*

east from Gaul and Rome. That is vividly captured, for instance, in what little we know about the monastery of Lindisfarne as embodied in the relics of St. Cuthbert, its abbot, who died in 687, and in the great Gospels made on the occasion of the translation of the saint's body in 698. Cuthbert's pectoral cross is a coarser version of goldsmiths' work of exactly the same kind found in the Sutton Hoo treasure, but put to Christian use. His wooden coffin, with its inscribed carved images of the Virgin and apostles, looks over the seas to Ireland. A gospel book tucked into it is in a script whose source is Italian. In the case of the famous Gospels we see the interlacing patterns familiar from Sutton Hoo, again put to use for the glory of God but this time in the form of manuscript illumination. The Gospels were written and illuminated by the monk Eadfrith 'for God and St. Cuthbert', the pages laid out in intricate, rich and

happened was entirely due to the spread of monasticism and to the monastery succeeding the Roman villa of antiquity as the new centre of cultural activity.

Monasticism had spread from eastern to western Europe during the fourth century. Various rules emerged, but the most famous was that of St. Benedict, drawn up in the sixth century and in the end to supersede all the others. In the Benedictine Rule the monk not only performed the *Opus Dei* in church but was expected also to read holy works. That provision for studying the Bible became the vital channel whereby an educated and literate element was recreated in what was a pagan society. With this provision monasteries could become the means for the classical system of education, formulated by the Romans in the first century B.C., to be revived. This system was made up of instruction in the seven liberal arts: grammar, logic, rhetoric, arithmetic, geometry, astronomy and music (mainly theory). Latin grammar was its foundation for it was viewed as the gateway to reading the word of God. Chronology was also important in order that the correct date for Easter could be calculated, also those of the great feasts of the Church, but in addition it was of use in deciphering the eschatological meaning of the mystical numbers found in the Apocalypse. In this new Christian context works by pagan classical authors were regarded with suspicion and certainly viewed as inferior. Nonetheless they slipped through on the grounds that they contained useful information, and knowledge of them would sharpen the mind and make it more acute for studying the scriptures.

In establishing this fragile bridge from classical to Christian learning a crucial role was played by the fifth century Roman writer Cassiodorus whose monastery at Vivarium in southern Italy set a pattern as a seat of learning, in particular as a place for copying and distributing texts. Cassiodorus codified the intellectual rule for his monastery in a book, the *Institutiones*, which was to have a huge effect on early English monasticism. In what was a short encyclopaedia and bibliography of Christian and secular studies, he cast reading, a knowledge of the seven liberal arts, and copying as pivotal activities in monastic life. The fact that a substantial part of Cassiodorus's library was to be acquired for Bede's monastery at Monkwearmouth and Jarrow in Northumbria seems curiously appropriate.

The seventh century was to be a monastic golden age, especially in Northumbria which became a meeting place for influences stemming from the west from Ireland, from the south from Canterbury, and from the

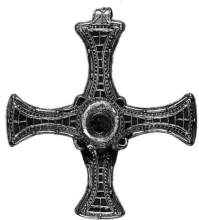

Cross belonging to St. Cuthbert dating from the second half of the seventh century. The cross is gold inset with garnet, glass and shell in the style found in the Sutton Hoo treasure but now used on a Christian artefact.

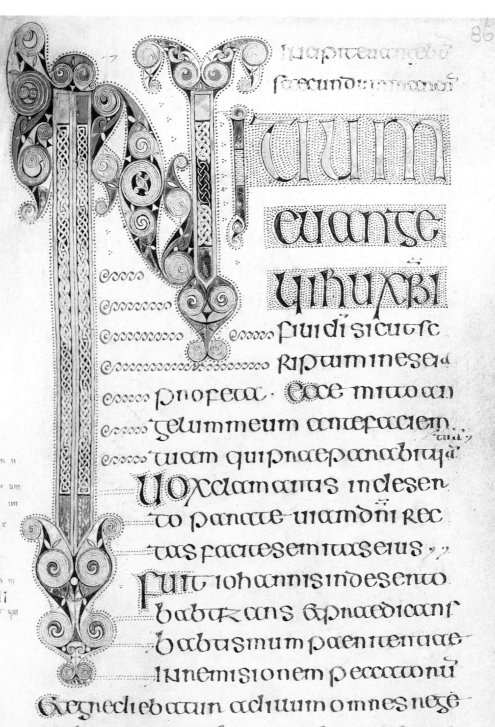

Incipit euange‑
lii secundum marcum

INITIUM
euange‑
lii xpi

filii di sicut sc
riptum ines a
propheta · Ecce mitto an
gelum meum antefaciem tuam;
uiam qui praeparabit ua
UOX clamantis indeser
to parate uiam dni rec
tas facite semitas eius ·,
Fuit iohannis indeserto
babtizans & praedicans
babtismum paenitentiae
inremisionem peccatorum
Egrediebatur adillum omnes rege
iudeae regio & hierusolimitae uni
uensi & babtizabantur abillo inior
dane flumine confitentes peccatasua·,
Et erat iohannis uestitus pilis cam
eli

mediators between the living and the dead, appeased by a holy life of prayer and sacrifice. Their role was crucial to the functioning of society, so much so that the custom arose of families offering a child to be a monk as a kind of insurance. Monks acted out the liturgy on behalf of everyone, a ritual which also called for praise to God through architecture and ornament. Seven times a day the monks, re-enacting Christ's entry into Jerusalem, processed to the church to sing God's praises, the *Opus Dei*. As wealth poured into the monasteries the liturgy became ever more elaborate, the architecture more spacious through the addition of aisles and ambulatories to accommodate processions. In this scheme of things the monks' choir chanting God's praises prefigured the heavenly choir, heaven again come down to earth, for they identified the seven notes of the musical scale with the seven planets who, beneath God, ruled the actions of men and were the key to the harmony of the entire universe.

Clergy and laity were strictly separated, occupying different parts of any church. The sanctuary and altar were the prerogative only of the ordained clergy. The laity occupied the nave and even then women's access in a monastic church could be further limited. As in earlier centuries the stone altar stood at the eastern end, empty except for a solitary candlestick at one side and a crucifix at the other. The priest stood behind the altar facing the congregation. When absent, there was a clear vista through to the bishop's throne. That was how the twelfth century began but by its close the celebrant had moved round to the other side facing the eastern end, with a crucifix before him flanked by two candlesticks, behind which arose a pierced screen, or reredos, through which could be glimpsed the saint's shrine. It was then that the priest began to hold aloft the consecrated wafer or host at mass for the congregation to see, and soon he came to do the same with the chalice. A screen divided the nave from the choir, over which there was a gallery from which the gospel was proclaimed to the people in the nave. Above the screen was hung a huge wooden crucifix or rood.

With such attitudes dominating men's minds it is little wonder that there was an ecclesiastical building boom. The Normans started no fewer than thirty cathedrals and major abbey churches. William, a monk of Malmesbury, wrote: 'With their arrival the Normans breathed new life into religious standards, which everywhere in England had been declining, so that now you may see in every village, town and city churches and monasteries rising in a new style of architecture.' Much was owed to the impulse of the Conqueror's Archbishop of Canterbury, Lanfranc, who came from the Norman abbey of Bec and reorganised the Anglo-Saxon Church, moving sees away from places of minor importance to towns like Norwich or Old Sarum.

A French manuscript, c. 1250, depicting the building of the Tower of Babel but incorporating a typical scene of medieval stone masons at work, showing a high degree of sophistication in the use of wheels, ropes and pulleys. Below right there is a mason using a set square.

century citizens were securing royal charters granting them privileges and self-government. Commercial prosperity was expressed in the building of town walls and stone-built merchants' houses with a shop or store-room at ground level and living quarters above. London had a population of eighteen thousand, York of five; most towns were little more than overgrown villages, but everywhere there was a huge surge of commercial activity. Over two hundred new towns came into existence and landowners anxious to cash in deliberately laid out new boroughs, with the monastic proprietors leading the way. Much was owed to the energy of men like Henry I's justiciar, Bishop Roger of Salisbury, the greatest building magnate of his period, who rebuilt his cathedral at Old Sarum, reconstructed the castle, built a palace at Sherborne and a castle at Devizes which, according to Henry of Huntingdon, was 'the most splendid in Europe.' All of these projects encouraged the expansion of urban life for they needed a small army of masons, carpenters, joiners and other craftsmen, offering them and their descendants seemingly never-ending employment.

The sole function of what we now call art was to offer to God the riches of the visible world. These offerings were made to monks who within their monasteries acted as mediators between earth and heaven. Rulers laid homage at God's feet in the form of churches, altar adornments, reliquaries and illuminated manuscripts. Kings, too, occupied an intermediary role being, through their anointing at coronation, *rex et sacerdos*, both king and priest. Munificence was one aspect of being royal, in this case an important one, for it attracted the benevolence of supernatural powers on the monarchy. The complex strata of the new feudal society ushered in by the Conquest demanded outward show reflecting hierarchy in both Church and State. As God was the supreme lord of kings he was to be seen as the richest lord of them all. In this way the great cathedrals and abbey churches accumulated gold and jewels either for performing the liturgy or to adorn the relics of a saint, the tangible remains of someone who had been touched by God on earth, and whose remains as a consequence were exceptionally potent. Following the example set by the king, the Church also persuaded great lords, before they died, to give their gems and jewellery to adorn some shrine.

All art was sacred, with the purpose of presenting on earth a prefiguration of the realities which would be revealed to all humanity once it had passed over into death, through resurrection, down to the Day of Judgment. To enter a church, in particular any great one which was part of a monastery, was to enter what was viewed as a halfway house between this life and the next and hence such buildings were both built and looked upon as images of heaven on earth.

Monasteries were power-houses to avert the wrath of God which monks, as

social change, the transformation of the mounted warrior of 1066 into the knight, a soldier admitted by dint of a formal ceremony to an élite dedicated to the defence of God, Holy Church, the weak, and his lady. The change occurred during the first half of the century, brought about by myriad influences but essentially by the Church which had to come to terms with warfare, sanctifying righteous wars such as the Crusades. The ceremony of admission was the central moment in any knight's life, when he was girded with his sword in the sight of his peers and then offered it on the altar, dedicating both it and himself to the service of God. In this way the brute warrior of old was gradually seen to assume the attributes of the knight, cultivating an array of manners and morals conducive to life in a royal court: affability, measured conduct, gentleness, a temperate mood and reticence about himself.

This taming of men of violence was also an expression of another new sentiment, courtly love. In the rich and luxurious courts of Provence in the warm south, powerful women had become objects of celebration in a new kind of song, that of the *troubadours*, one which was in the vernacular and which idealised women as almost divine beings, with total power of command over men's hearts. A knight now had to worship also at the shrine of his chosen lady, whose favour lent strength to his arm, skill to his horsemanship and accuracy to his aim. At the same time a new arena emerged in which this relationship was to find its ideal setting, the tournament. The tournament was legalised fighting but of a kind in which the aim was not to kill but to train and demonstrate skill. In 1194 Richard I designated five places in England as official tournament sites. The cult of the Virgin Mary, increasingly seen as the smiling mother nursing her child, together with the new idealisation of women, were the two great sea-changes which widely affected the whole of secular society rendering it gentler and more civilised. It was in time to produce a literature and an art, that of chivalry.

This was an age in which towns re-emerged for the first time since the Roman period. By the close of the

A tympanum from over the church door of the church of St. Mary, Fownhope, Herefordshire, c.1140. This is a typical work of the flourishing school of sculptors working in this area of England. They owed their style to a sculptor who had visited the great pilgrimage shrine of Santiago and made sketches of what he saw on the journey, which he and his followers used as models on his return. The Virgin as patron of the church supports a large Child, his hand lifted in blessing. They are enthroned amidst the Tree of Life with the grapes of the eucharist and a winged lion and bird, symbols of the evangelists Mark and John.

experimentation with its shape, the result of what had been seen in the eastern Mediterranean. Henry II's engineer Alnoth designed the first of these new towers at Orford (Suffolk) in 1163-73, a tower which was eighteen-sided but round within. It had two central halls, one above the other, well lit and with side fireplaces. The turrets on three of the sides had suites of rooms each with its own hall, bedchamber and *guardaroba*. What this reflected was that the king's outlawing of private fortresses had rendered the old earthwork castle a thing of the past for a society which knew exactly how to assail and take such a castle, and now much preferred to settle its differences in the law courts. By the second half of the century the castle had already become primarily a domestic residence but with built-in precautions for protection against social unrest. The king's brother Hammeline Plantagenet's castle at Conisborough near Sheffield, built about 1180, reflects this new era. Erected under the influence of the castles of the Crusader kingdom it introduced one major new feature, a stone curtain wall incorporating solid half-round towers along its length. The wall-base was splayed as protection against mining and also for bouncing out missiles on assail-ants. Rings of concentric defences were henceforth to be the future of the castle form. The improved order of Angevin England had rendered the castle of the post-Conquest period redundant.

The making of a knight from a mid-thirteenth century manuscript depicting the history of the eighth century king, Offa. The sword, blessed on the altar just before the Gospel was read, is here girded on the knight by a king while attendants tie on his spurs.

These buildings provided the setting for a huge

ulixpendentes. mestimabili gaudio perfusi moliebatur cu filus suis iuuenibz suolu uise

and although a second generation became bi-lingual in order to deal with the conquered, to all intents and purposes England was divided between a French-speaking ruling class and a subject people speaking Anglo-Saxon. Vast tracts of the country like Windsor and Sherwood were designated royal forests, protected by harsh laws for hunting wild boar and deer. Only the south-east had any degree of population: villages of thatch, wattle, clay and turf, primitive huts huddled around a church and a manorial hall. But the conquerors were rich from their spoils, anxious to establish themselves as the focal point of a new order of things. William fitzOsbern, for example, who fought at Hastings, thrust his way into Wales, building Chepstow Castle and close to it a Benedictine priory as well as establishing a profitable colony of merchants reflected in the name of the place, Chep-stow, that is, 'trading place'. And the castle, placed on a narrow ridge overlooking the Wye, was not only a monument to defence and subjection but also included the comforts of a hall and a lord's chamber.

The castle was to be the focus of this new society, the seat of a lord who could guarantee peace and protection to a particular area of the country through the military might of his knights. These formed a warrior caste which included bishops, who also rode out to battle. The world of the knights which dominated the century was at the outset a violent one, illiterate, glorying in heroic exploits, and dominated by rites and symbols. It called for courage and physical strength, its supreme virtues were generosity and loyalty and its quintessential one was honour. Intellectual attributes as such had no place in this scheme of things.

Its base was the new architectural form of the castle, the most innovatory feature of which was the tower to which gradually was added an enclosure and access gates. Forms varied and there was much improvisation incorporating, for instance, older earthworks or even parts of Roman forts, but most had what is called a motte, that is a mound, and a bailey, a fortified outer wall. Over three thousand such mottes can be identified today. Initially the castles were of wood but that was gradually replaced by stone. The earliest were built in a style which was brought from Normandy, single defensive four-storey towers with store-rooms and a well below, a two-storey hall above that, with private rooms for the lord over the hall, and a projecting entrance building with a chapel. The most famous was the White Tower of London begun about 1078 but there were many others, including Richmond (Yorkshire), Rochester (Kent) and Norwich (Norfolk). Slightly later came circular shell-keeps like that at Windsor Castle (Berkshire) or Arundel (Sussex), both from the 1130s.

But this style was to change in the middle of the twelfth century under the impact of the Crusades. The tower was retained fulfilling a function as a lordly residence, as a vantage point as well as a potent symbol on the landscape, but there was much

that can be seen, for instance, in the 'Corinthian' cap-
itals in the choir at Canterbury Cathedral.

But although the century was marked by what was in
one stream a classical revival the major influence was
that of the Byzantine court. That was exerted firstly by
way of Sicily, whose Norman rulers were planning a
Mediterranean empire. Henry II's daughter was married
to William II, King of Sicily, and the splendours of the
Norman court at Palermo were therefore known about
in England. The legendary love-nest which Henry II

*Left: St. Paul shaking off the viper, a
wall painting in St. Anselm's Chapel,
Canterbury Cathedral, probably
commissioned by Archbishop Thomas
Becket to mark the translation there
in 1163 of the saint's relics.*

*Right: The painter must have been
familiar with Byzantine mosaics such
as this one depicting the conversion of
St. Paul in the Capella Palatina,
Palermo in Sicily, executed in the late
twelfth century.*

built for his mistress at Woodstock, 'Rosamund's Bower', was a complex of courts,
pools and fountains of exactly the type built in Sicily in emulation of those of
Byzantium and Islam. Then there was the influence of the Crusades. In 1095 Islam
conquered the Holy Land, leading to the First Crusade in which the English king
William II's brother and the Duke of Lorraine established the Latin kingdom of
Jerusalem. A Second and then a Third Crusade followed in 1147 and 1189, the latter
including Richard I amongst its leaders. Throughout the century and especially in its
second half the Crusades were hot news at the English court. As a result, experiences
of the civilisation of the Byzantine empire ceased to be second-hand and instead
became direct, having huge consequences for everything from castle building to
manuscript illumination.

The Normans dominated their new country. Norman-French was their language

Chapter Five

CASTLES, CATHEDRALS AND ABBEYS

T he Conquest not only changed the minds of men, it also altered the physical appearance of the country as the secular and ecclesiastical revolution the Normans embodied found expression in monumental buildings in stone. The landscape was to be punctuated in a way which was to compose the medieval world picture, by the castle, the cathedral and the abbey. Together they were to make up the visual infrastructure of society for five centuries, until the second Tudor king swept much of it away, leaving us today with only the ruins.

The Normans were conquerors by instinct and England after 1066 was ruled as a province of the duchy of Normandy. With the accession of Henry II in 1154 the country became part of a vast Angevin empire which covered more than half of France, including the south-western province of Aquitaine. That explains why, at the close of the century, the new Gothic style crossed the Channel so quickly. The king and his court were always on the move. So too were the bishops, abbots and clerical officials, deeply observant of all the latest styles of building they saw or, in the case of their visits to the papal court in Rome, the classical architecture of the imperial city. The impact of

A series of capitals in the choir at Canterbury Cathedral, 1178-82, using the antique Corinthian form reflecting classical influences reaching England from France.

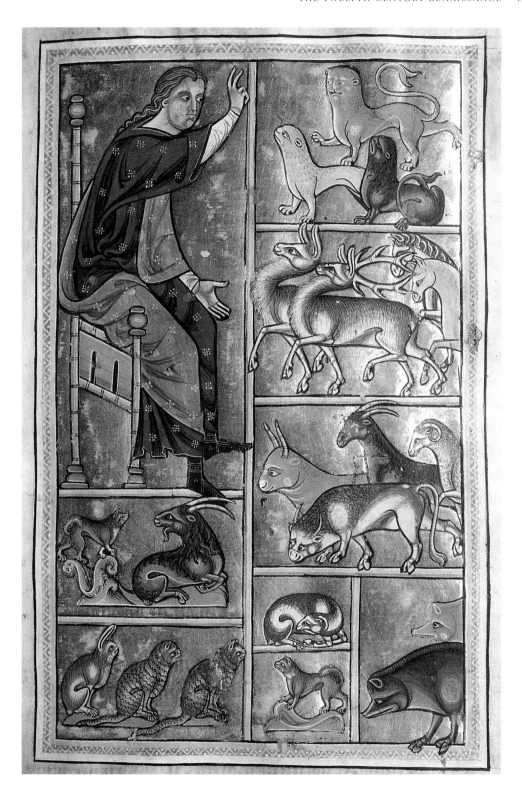

in depictions of 'Marvels of the East' and, a little later, the wonders of the Apocalypse.

History could cross over with ease into fabricated fantasy, but equally the fact that it had been hung upon a firm chronology pushed it in another direction, towards the study of mathematics and astronomy and hence the sciences. A preoccupation with the calendar and technical chronology had been a subject of permanent interest in monastic circles since the time of Bede. Through it in the twelfth century was to be laid the foundation stone of a scientific tradition which first stirred amongst such scholars in the West Country as Adelard of Bath and Walcher, prior of Malvern, who was the first man in England to use the Arabic astronomical instrument known as an astrolabe. Such men played an important part in the transmission of the scientific knowledge of the Greeks, in spite of the fact that the natural sciences had no ostensible role to play in the programme of scholastic thought. Detailed knowledge of botany, physiology, astronomy and physics was deemed unnecessary. As they had no part in the system in the long run they were to bring about its demise.

This was an age which moved in two divergent directions. The first was in response to the recapturing of lost parts of the Greco-Roman inheritance from classical antiquity. This was to lead to methods of thinking which would ultimately characterise the West: clarity of thought, scientific investigation, and faith in man's intelligence. The second, typified by the new ascetic Cistercian order founded in 1098, focused on a renewal of mysticism and self-denial. Those who represented the first of these traditions were beginning to gather at Oxford by the second half of the century. Like the capital London, Oxford had many roads converging on it and it was close to the court at Woodstock. Theobald, appointed Archbishop of Canterbury in 1138, came from the abbey of Bec and brought with him scholars including one Vicarius who founded a school of civil law at Oxford. Its status as a centre of learning was to be accelerated in the second half of the century by the quarrel between Henry II and Thomas Becket when the claims of Church and State were brought face to face. In 1167 Henry summoned all clerks home from their schools abroad on pain of losing their benefices. They went to Oxford. The universities were about to be born.

Adam names the animals, from a bestiary c.1200. Bestiaries were compilations of fantastic descriptions of both real and fabulous birds and beasts used to illustrate moral lessons and Christian allegories. The style reflects a strong Byzantine influence, giving a new realism to faces and a new naturalism to the folds of the drapery. The image is a powerful one, indicating man's central role in God's creation due to his being endowed with powers of reasoning. Adam not only names the animals, but also allocates to each of them a role.

people. Government increasingly called for men with the ability to express legal transactions in clear and grammatical Latin.

England in fact threw up problems which were peculiar to it. The great monasteries like Canterbury, Bury St. Edmunds and Malmesbury survived the Norman Conquest but they had to prove their status through documentation. This explains their obsession with chronology and the writing of history, and also gave rise to a growth in forged documents which vividly reflected a changing reality, the supremacy of the written word. An oral tradition could be discounted as unprovable, so in the absence of the necessary document one was manufactured. The need by the monasteries to prove their legitimacy triggered a series of historians who recorded the Anglo-Saxon past; this rehabilitation of pre-Conquest England in the chronicles was to be one of the great achievements of the twelfth century.

It was indeed a golden age of history writing as monastic historians demonstrated a passion for the past not to be matched again until the seventeenth century. The line between history and story was a blurred one as the role of such chronicles was not only to instruct but also to entertain. William of Malmesbury's writings are a monument to his investigative powers and fine craftsmanship but also to his abilities as a storyteller. Geoffrey of Monmouth's *History of the Kings of Britain* created a mythological history of Britain notable for its inclusion of the legendary figure of King Arthur (who had first appeared in Welsh literature of the sixth century); this was to exert a powerful hold on the imagination for five centuries, an invention which was accepted as fact and used by rulers to political advantage as well as by men of letters for a rich literary tradition.

There was another side to English history writing apart from the chronicle, and that was what might be described as the tradition which incorporated a word picture of a person. In this way a great scholar like St. Anselm had his conversation recorded, establishing a literary form which echoes down the centuries to Boswell and Dr. Johnson.

The stream of fantasy which was so strong in Geoffrey of Monmouth's fabulous account of the island's history was also a peculiarly English contribution to the Renaissance. England became the nodal point for the dissemination of the literature of legends and marvels across the whole of Europe, re-exporting the fantastic tales from the East, and making substantial contributions to the literature of visions, which gave the reader a picture of the other world, and from which also stemmed the massive compilations of legends about the miraculous acts of the Virgin Mary. The illuminated manuscripts of the period tell their own story of this preoccupation with the extraordinary and with enchantments revealed in bestiaries, herbals, lapidaries,

tradition were now drawn together and reconciled into a single coherence. A typical English contribution to this task was the work of Stephen Langton, professor at Paris and later cardinal and Archbishop of Canterbury. His biblical studies and commentaries reached their scholastic climax in a series of glosses, commentaries, expositions and treatises on virtually all the books of the Old Testament.

Such knowledge was to be achieved through a study of the liberal arts, the *trivium* of grammar, rhetoric and dialectic, and the *quadrivium* of mathematics, music, geometry and astronomy. And this could only have occurred within the new urban context. Inside the walls of the monastery classical texts had been studied in the interests of grammar but monks, bound by a vow of silence, certainly had no room for exercising the arts of rhetoric or dialectic. Many of the works compiled as a consequence of this intense intellectual activity were to have a lifespan of centuries. Gratian's *Decretum*, first issued in 1140 and which systematised canon law, remained in use until the twentieth century. Peter the Lombard's *Sentences* became a fundamental theological textbook into the seventeenth century. The result of this renaissance was to give structure to a way of life and also to lead to the creation of a body of works of piety and devotion of great imaginative force.

In this way scholastic thought cast man as uniquely endowed, being the conscious and co-operative link between the created universe in space and time and the divine intelligence in eternity. Mankind's role was seen to be bringing the created universe into harmony with the divine will. This was a vastly enhanced view of humankind's capabilities which led to an increasing interest in self-knowledge, the sharing of knowledge, and the cultivation of friendship. Everywhere as the century progressed there was a new humanity, reflected in a theological revolution which was to transform the art of the age and its subject matter. Jesus Christ was recognised as being God made man, and seen for the first time as the companion and mirror of ordinary men and women. The cross was no longer a cosmic sign which bore a Christ crowned and triumphant but instead carried the figure of a man undergoing horrendous torture. As God the Creator and Judge gave way to the humanity of the Son and Redeemer as an expression of God's fellowship with men, so the mother of Christ melted into approachable womanhood.

England was on the fringes of all this, firmly a part of it but at a remove. Nothing like the cathedral schools of northern France emerged, learning instead moving almost directly out of the monasteries and into a new institution, the university. The country did not lack schools, whose existence was continuous, providing teaching in reading, Latin grammar and the chants. Licences for schools and teachers lay with the bishop but as the century progressed not only the Church was to need educated

Rochester but in fact spent his time teaching in the schools of Paris, ending up in Rome as chancellor of the Holy Roman Church. Such a career catches the nomadic quality of the age and also the new demand for educated people to run government.

All learning was still essentially a backward-looking process, for it was recovering what had been lost from classical antiquity. In the West only certain parts of that had been fitfully transmitted through the monasteries, but the majority of Greek learning had gone East and been absorbed by the Arabic world. The means whereby this was recovered for the West focused on those parts of Europe where the two cultures met, in Byzantium, Sicily and Spain, where translations were made either from the original Greek or from Arab translations of the Greek. These filled the gaps left in Western Europe covering subjects like medicine, mathematics and astronomy. The excitement this engendered is caught by one Englishman, Daniel Morley, who states that in Paris he found 'only savages', hastening on to learn from Arab scholars in Toledo. The transmission of this knowledge was slow, taking most of the century. It included major works like Euclid's *Elements*, the foundation stone of geometry, which was translated from an Arabic version by Adelard of Bath. Knowledge of the Greek philosopher Plato also increased. To the *Timaeus*, which dealt with physics, were added two of his philosophical works, the *Meno* and the *Phaedo*. Aristotle, whose work had hitherto only been known through the writings of the fifth century Roman, Boethius, now had his logical and metaphysical writings studied and, later in the century, his scientific ones to be followed in the thirteenth century by those on politics.

All of this vast accumulation of knowledge had not only to be assimilated but put into order within the framework of Christian belief. Until the twelfth century, energies had been directed into prayer and penance, ritual, and the manifestation of the miracles of the saints. Now there emerged the potential of ordering all knowledge to recapture what man had known before the Fall, a movement which triggered a renewed faith in human abilities. The goal of a single system of assured knowledge in which everything found in the texts of the Bible, the writings of the Church fathers and those of the pagan authors of classical antiquity, could be systematised seemed a possibility within reach.

The place of the Bible, as the revealed Word of God, was central. Here God had uttered truths to mankind not only through words but symbols, objects and events. All of the interpretations of those within the Christian

Boethius's book The Consolation of Philosophy *was a major human-ising influence on the early Middle Ages. It was written while the author was in prison in Pavia in Italy await-ing his execution in 524/5. This illumination, painted in the West Country c.1130-40, shows him sitting with a chain around his neck in his cell. Two Muses to the right, blowing the trumpets of Fame, are put to flight by Lady Philosophy, left, to whom the author turns for comfort.*

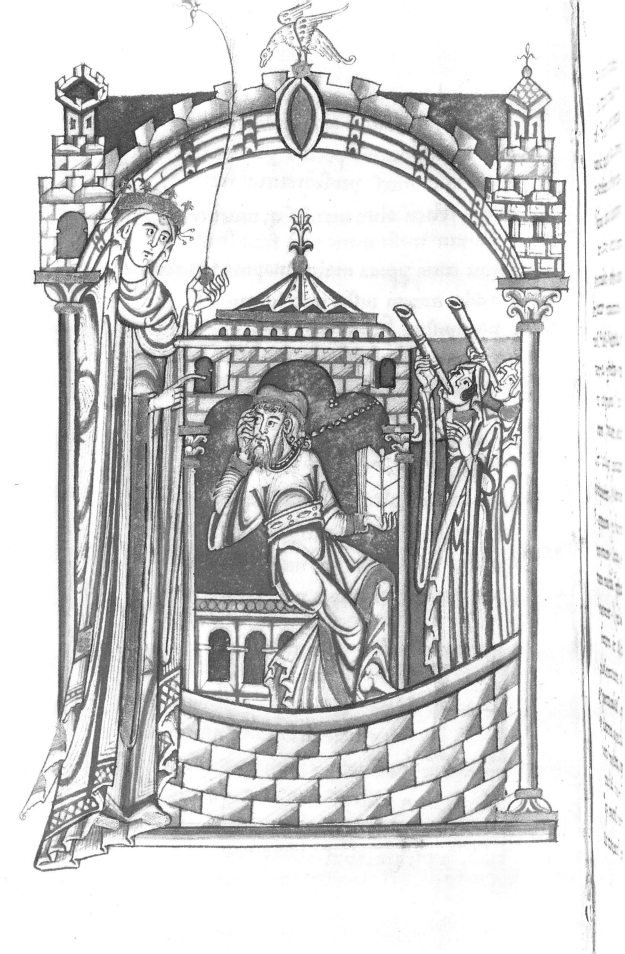

tela, or because the workings of government, both lay and ecclesiastical, which became increasingly complex, demanded it.

In this way the Norman Conquest of England in 1066 was eventually to mark a new era not only politically but culturally. Less than ten thousand men, headed by the Duke of Normandy, had taken control of a country with a population of almost two million. The Anglo-Saxons had been defeated in one major battle, a rebellion in the north was savagely put down and the indigenous aristocracy went under. The majority of the conquered country was then divided up between a hundred and seventy leaders, the remaining land being given to the Church or held by the Crown respectively. In this way the Anglo-Saxons were reduced to being a subject people and their civilisation was demoted in favour of one which was in many ways far less sophisticated. But that was only in the initial phases. By the opening years of the following century the country was responding and contributing to the ferment of intellectual endeavour embodied in the twelfth century renaissance.

The greatest expression of that was the emergence of scholastic thought, the main lines of which were fashioned during the century's opening decades. Until then the way to the divine was believed to be through the exercise of prayer, the *Opus Dei*; any intellectual activity that there was centred on reading signs and portents and certainly not through the exercise of reason. Now all that was to change under the burgeoning influence of the schools in northern France with Paris, the Papal Curia in Rome, and Bologna emerging as major centres of a new intellectual energy, which set out to create a body of systematic doctrine about the nature of God and of the universe, one in which man dwelt midway between the hierarchies of the eternal beings above and the creatures ruled by instinct below. Within the context of the age it was forward-looking and optimistic.

Behind all this development of thought was the migration of intellectual life out of the monasteries into the expanding towns, to which students flocked from all over Europe to sit bareheaded at the feet of this or that famous master, whose role was not only to think but also to teach. Paris was the new Mecca as John of Salisbury records: 'I . . . turned my face towards Paris. And there I saw such quantity of [intellectual] food . . . and marvelled at it, as Jacob marvelled at the ladder whose summit reached to heaven . . .' He was not alone, for the practice arose of sending children to one or more of the schools in France to acquire knowledge in preparation for high office in the State. Another student was Robert Pullen who came from a family of landowners near Sherborne in Dorset. After studying law at Laon early in the century he moved to Oxford, then emerging as the English equivalent of the French schools, and became the earliest lecturer there in theology. Later he became archdeacon of

Chapter Four

THE TWELFTH CENTURY RENAISSANCE

In 1159 at the close of his *Metalogicus* John of Salisbury wrote of the travails to which scholars such as himself were subject: 'I have been distracted by other tasks, not different merely but inimical to study . . . Ten times I have crossed the chain of the Alps since I left England first; twice I have travelled through Apulia; I have done business in the Roman court on behalf of my superiors and friends; and on a variety of counts I have traversed England, and France too many times . . .'

In this reminiscence, written in the middle of the century, John of Salisbury encapsulates two characteristics which were to make up the dynamics of an age which witnessed the greatest and most rapid expansion in population and wealth in Western Europe before the nineteenth century. John describes himself as first and foremost a scholar, but he was also clearly a man active on behalf of others in public affairs, of a kind which took him across the continent as well as all over his own country. He was, in fact, a typical example of what was a new cultural impetus, scholasticism, which was to form what we think of as the medieval world picture and provide the framework of thought for the whole of society for the next two centuries. It was from the outset international, with Britain forming just one part of an intellectual network which stretched across the whole of Western Europe but whose powerhouse was northern France, above all Paris, and Italy. It was an explosion of knowledge to which our own century has given the name of the twelfth century renaissance.

The career of a person like John of Salisbury himself was even then a novelty. Such men owed their new-found status to their intellectual prowess and knowledge and not to either birth or riches, which until then had formed the normal route to a position of substance within society. This is the first age since classical antiquity when the intellectual re-emerges as a driving force. John's account of constant wanderings captures something else, that this new civilisation was cosmopolitan and knew no boundaries. Everyone was on the move either in the form of the Crusades, or through pilgrimages to places as distant as Rome, the Holy Land and Santiago de Compos-

greatest works of Anglo-Saxon art was commissioned to justify William I's con-quest of England in 1066. This stupendous embroidery was made sometime before 1082 for Bishop Odo of Bayeux and almost certainly in workshops in Canterbury. It is utterly unique, although other hangings of this kind are known to have existed. Some seventy metres long and fifty centimetres wide it takes the form of stitching in coloured wools on to linen. In it we see set before us the downfall of Saxon England in a picture sequence which depicts the consequences of perjury following an oath taken over holy relics. Harold, the last Saxon king, had taken such an oath in recog-nition of Duke William's right to the English throne on the demise of Edward the Confessor. His failure to keep it is seen to lead to God's judgement being finally passed as the dead body of Harold slumps to the ground at the battle of Hastings. In the Bayeux Tapestry the great civilisation of Anglo-Saxon England passes away in a final sunburst of glory.

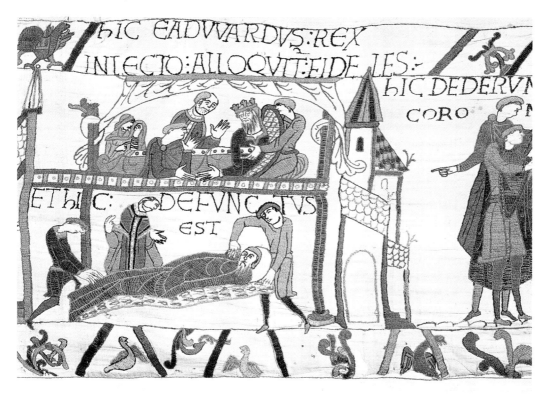

Above: The death of Edward the Confessor from the Bayeux Tapestry. Although embroidered during the decade 1070-80 for Odo, Bishop of Bayeux,

brother of William the Conqueror, this is the only surviving example of an art form which flourished long before the Norman Conquest.

Left: St Peter's Church, Burton-on-Humber was built about 990 with strongly articulated linear decoration on its tower.

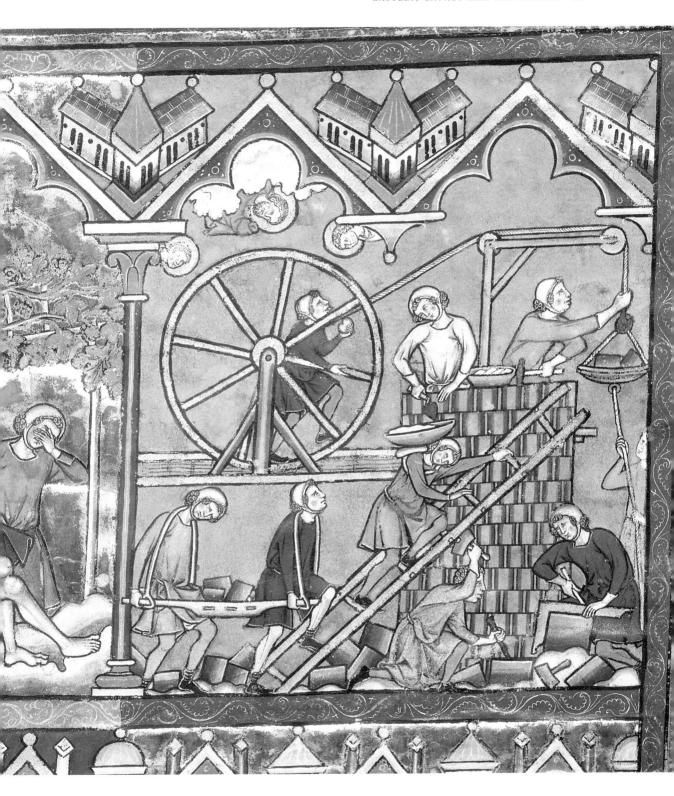

He himself set the pace at Canterbury, building a new cathedral as well as the abbey of St. Augustine close by. But it was the reformed Benedictine monks who arrived from Cluny and established a priory at Lewes who were to put their stamp on English monastic architecture. They introduced the cloister as the focus around which were ranged the dwelling quarters, along the eastern side the chapter house and dormitory, along the south the refectory, and along the west the prior's lodgings, rooms for storage and for guests. As in the case of castles it was the scale of these ecclesiastical buildings which was and still is so utterly overwhelming. Nothing like them had been seen since Roman Britain.

St. Alban's which arose in the 1070s and 1080s is the earliest surviving example. Two other cathedrals followed, Durham in 1093 and Norwich in 1096. These buildings were in stone, in a style which stretched back to the churches which had been built during an earlier renaissance, that initiated by the Emperor Charlemagne in the eighth century and thence to the architecture of ancient Rome, hence the name of the style, Romanesque. These great English cathedrals were among the largest and most daring put up in Europe. The most famous remains Durham, built to house the relics of the Anglo-Saxon saint Cuthbert and thus a symbol of reconciliation, linking conquerors and conquered in the enterprise. Shrines of saints triggered the boldest architectural experiments. The nave of Durham was completed in 1133, its large rib-scale vaulting being an innovation anticipating the Gothic. So too were the great carved drum columns incised with zig-zag ornament, a feature which was to filter down into parish churches.

These were buildings about space and proportion on the grand scale. Within, the walls were plastered and occasionally painted. Internal space expanded to accommodate the splendour of the liturgy as it was enacted by the reformed Benedictine monks of the Cluniac order. Their priory of Lewes imported the architecture of Cluny which spread to its daughter houses and soon the influence of the great Norman monastery began to impinge everywhere, reflected in the emergence of decoration and story-telling, whether in sculpture, in painting, in stained glass or illumination.

It was the craftsmen who came over from Cluny too who probably inaugurated the great period of decorative carving which developed from about 1130. A whole repertory emerged which we label Norman; as well as the zigzagged chevron often used in multiple bands on arches, there were other patterns like fish scales and ornately sculpted capitals to columns. Then came foliage, rosettes and diaper patterns and by the second half of the century figure sculpture began to assume importance. Such carving was a teaching instrument. The images of hell carved at the entrance of a church acted as a threat to the laity. There Christ was often depicted seated in

majesty, reminding everyone who entered the building that it was but an earthly image of the realities of heaven to come. Suddenly sculptors were seen to be capable of depicting other worlds than the present one, able to conjure up heaven and hell for an audience which was sophisticated as well as for those who remained un-educated and crude.

A rare survival, an altar cross, c. 1170-80, from the church of St. Mary, Monmouth, one of the only two to survive from this period. Christ is depicted crowned and victorious in a format which was already established in England by 1066. Only one of the three antique gemstones set in the four arms of the cross is still there, evidence of the continued admiration for them in the medieval period.

These developments reinforced the native tradition of pattern. Even in figure sculpture the impulse was always to flatten and form a series of compartments whose function was to create decorative pattern. There was always a deep preference for the small-scale, expressed in items in bronze and ivory like candlesticks and crucifixes.

During the second half of the century the new humanity brought about by the theological revolution began to permeate from France, where its prime exponent was Abbot Suger of St. Denis who inaugurated in his church the new style, the Gothic,

and also initiated a new mastery of the play of light and shade to create sculpted images catching human emotion reflective of the stress on God as man. Tenderness and a fleeting smile were almost within reach.

Under the influence of Cluny the walls of churches began to be covered with cycles of paintings telling the salvation story. In this way churches were transformed into sacred theatres, in which the worshippers were present in their imagination at the events depicted on the walls. This relationship of art to reality was reinforced by the re-enactment at the font and on the altar of many of the same events in symbolic ritual. The new impulse towards story-telling found expression too in a whole spate of luxurious bibles, psalters and lives of saints, in which new subjects appeared. Sacred reading was mandatory for Benedictine monks and a book was read aloud during meals in the refectory. It was under their aegis that libraries began to be formed in the monasteries, the books being kept in a cupboard in the corner of the cloister. Christ Church, Canterbury, in about 1170, had between five and six hundred books which included not only the works of the Christian fathers, theologians and the lives of saints, but a whole range of legal works, Latin grammars and books by classical authors such as Virgil, Cicero and Ovid, as well as astrological, medical and herbal treatises.

But the richest and most splendid of these books were those used in the sacred liturgy. Two of the most famous to survive are the St. Alban's Psalter and the Winchester Bible. Both, like large-scale painting and sculpture, owe their basic style to the hieratic art of the eastern Byzantine empire. The earlier of the two is the St. Alban's Psalter (c.1120), prepared for the abbot's protégée, Christina, anchoress and prioress of Markyate. Christina had been married against her will when she was young but the marriage was annulled and, after untold adventures, she ended up as a respected nun and spiritual mother. The fame of the book rests on its biblical scenes in which we see Anglo-Saxon outline, the solidity of Byzantine art and the rich colour of German come together to produce a new style of illumination. Byzantium was, however, the dominant influence as it was in the Winchester Bible (c.1160-80), two of whose artists must have been to Sicily and seen the magnificent mosaics at Monreale. Such a book is also a monument to the continuity of a culture, for the Normans admired Anglo-Saxon illumination, especially their painted initials which combined plant forms with human, animal and grotesque figures. In this way the pre-Conquest Winchester School continued to flourish as did also those at Glastonbury, Canterbury and Ely. These great liturgical books occupied a

A page from the Winchester Psalter, another of the most famous of mid-twelfth century manuscripts, demontrates the new storytelling impulses of the era with vivid scenes depicting the betrayal and flagellation of Christ. It is crammed with incident and contains some of the earliest evidences of the English delight in caricature.

central place in early medieval society. It is no accident that in them the space accorded to the illuminations was equal to that accorded to the text, for on these pages written and visual culture met to produce an object which embodied divine revelation, enabling it to be re-enacted daily through ritual.

So far the great cathedrals and abbeys have been glimpsed, but what of the thousands of ordinary churches scattered across the countryside? Some nestled within the castle bailey, others were sited near a castle or manor house, evidence of what was still an evolving parish system. The Anglo-Saxons had founded too many churches and some had to be pruned. In the towns there was a huge proliferation with the result that there were many and small, rather than few and large. But overall there was a revolution as the Normans demolished the Anglo-Saxon buildings, mainly wooden, and replaced them with ones of stone. They remained simple, a single arched nave with an apsed chancel at the east end, but everywhere there was a move towards ornamentation and decoration. Here too contact with the East brought its impact, as in the round churches modelled on that of the Holy Sepulchre. These churches were built by the lord of the manor or by the abbot of the local monastery, their size and decoration reflecting the richness or otherwise of the economy and the success of the landlord in exploiting and developing the profitability of his estates. Benedictines, for instance, were in the forefront, clearing forests and draining marsh and fenland to produce crops and therefore increased income, which supported not only their own grandiose building projects at the abbey but those for the parish churches under their sway. John of Ford's life of Wulfric paints a picture of an ordinary parish priest at Haselbury in Somerset. Wulfric was still a married man with a wife and son who was to succeed him (celibacy was not yet wholly enforced). His task was to spend the day in church chanting the psalms and saying the mass when God's presence became real on the altar. The nave acted as a public space used for meetings, councils and other social gatherings.

In spite of all this seeming drive towards ever more ecclesiastical opulence the heart of the century lay in the opposite direction, for kings and great lords, including Henry II and David I of Scotland, favoured in their benefactions the ascetic. The Cistercian order embodied precisely the holy life which was most admired. It was not the only ascetic order for there were also the Praemonstratensians and the Carthusians who shared a common commitment to 'pitiable poverty' and 'abundant want'. The Cistercian rule was strict, for the monks settled only in the remotest places, grew their own food, maintained the *Opus Dei* with plainchant and ate but one meal a day. One of their governing injunctions laid down that learning was not to be part of their vocation. The first Cistercian house in Britain was at Dyfed in Wales in 1115. Their

great achievement was the revival of the north, devastated by the Conqueror, through a great series of abbeys: Rievaulx (1132), Fountains (1133), Kirkstall (1152), Jervaulx (1156) and Byland (1177). From there they moved north again into Scotland at the behest of David I who founded Melrose. The Scottish king had been brought up in England and Normanised his lowland kingdom, so that it was written that he 'illumined in his days his land with kirks and abbeys'.

This was a gospel of poverty, prayer and labour set amidst buildings which deliberately turned away from what had gone before. Aelred of Rievaulx describes the Cistercian monk in his *Mirror of Chastity* as '. . . happy enough to say his prayers in a little chapel of rough, unpolished stone, where there is nothing carved or painted to distract the eye; no fine hangings, no murals that depict ancient history or even scenes from Holy Scripture, no blaze of candles, no glittering golden vessels.' Puritanical their buildings may initially have been but their scale from the outset was monumental, for every monastery housed two communities and therefore had two of everything, one for the monks and one for the lay labour force. The complex included a church, a cloister, a parlatorium, dormitory, refectory, warming-room and washroom, as well as stone water-closets. Their initial architectural restraint, however, did not take long to falter. Cistercian abbots travelled, and the almost predatory management of their estates, for which they became notorious, gave them wealth, permitting them to indulge themselves in the vanguard of building fashion. And it was in their abbeys that all that was new in France was soon taken up, above all the style which was to dominate the coming century, the Gothic.

In 1174 the choir of Canterbury Cathedral burned down and that same year a French master mason, William of Sens, was summoned 'on account of his lively genius and good reputation' to begin what is recognised as the earliest essay in the new style. The transition to the Gothic was by no means abrupt. Distance was involved and also projects were mid-stream, but spread it did at remarkable speed, traceable in its earliest phase by a mingling of the two styles called Transitional. But by 1200 the nuns of Romsey, midway through building their nave, abandoned the Romanesque and went over wholly to the Gothic, signalling the arrival of a new age.

Chapter Six

FAITH, REASON AND LIGHT

The thirteenth century was an age of images. Whether painted or sculpted they were to multiply and continue doing so for the next three centuries. Tiers of them arose in serried ranks on the west front of any great church, proclaiming God's triumph and man's redemption through Christ. Old Testament prophets and kings, apostles and martyrs, together with the saints of more recent times, jostled in polychrome profusion not just across such exteriors but also inside along naves and into chancels and side-chapels, onto the walls in the form of painting and in the translucent glory of the vast stained glass windows which the century's new style of Gothic made possible for the first time.

Medieval England at its height was dominated by the image occupying as potent a role in men's lives as the word, for the majority of the population more so. Only the cataclysm of the Reformation was to shatter this pattern of perception. Until then the dominance of the image was natural in a society where only a few could read; books were scarce and where they did exist people were read to. In that scheme of things memory played a central role not only in order to retain texts in the mind but also to store images. In this way the visual image functioned not as mere illustration but as a form of social language, and one which applied as much to secular images as to religious ones.

But for the majority the focus was inevitably on holy images, and the single fact that the divine could be represented by an image was to account for most of medieval art. Centuries before, at the time of St. Augustine of Canterbury, Pope Gregory the Great had sanctioned their use in churches: 'Pictures should be had in churches, in order that those who are ignorant of letters should at least read with their eyes upon the walls what

The west front of Wells Cathedral. c.1230-50, one of exceptional width flanked by two towers which would have been intended for spires. The façade houses the most extensive display of sculpture on any English cathedral with a Virgin and Child over the central door surmounted by the Coronation of the Virgin and, in ascending order, tiers of statues depicting the Resurrected, the Orders of Angels, the Twelve Apostles, culminating in Christ in Majesty. On either side of this central tableau there are scenes from the Old and New Testaments and statues of prophets, patriarchs, martyrs and confessors, as well as local saints. All of it was once painted and gilded, a glittering vision of the Heavenly Jerusalem.

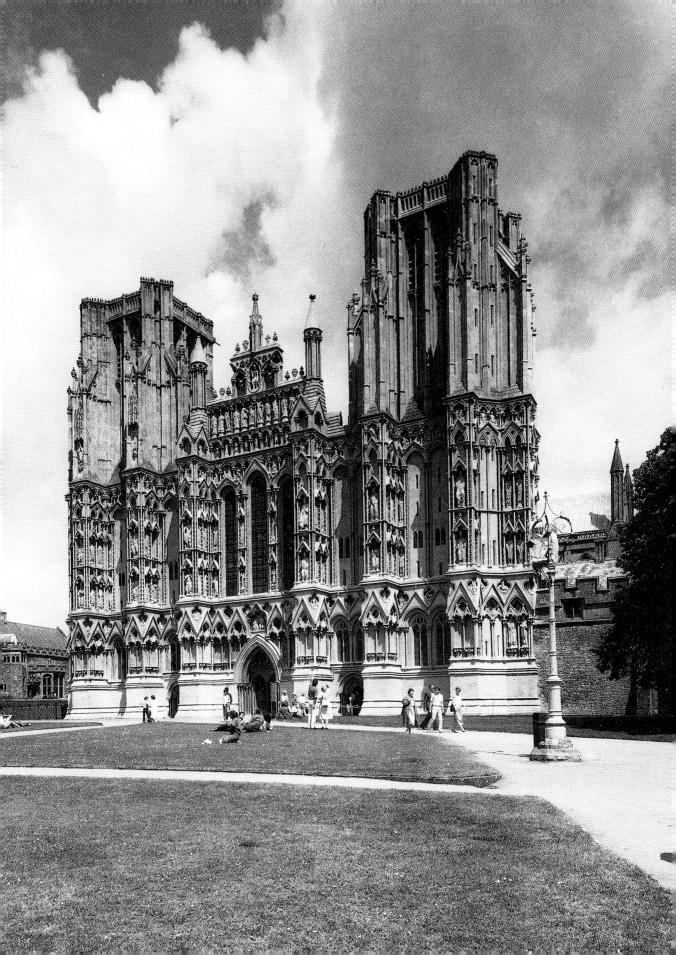

they were not able to read in books.' How this worked in practice is caught in a late medieval English sermon:

> . . . When we come into any church we should kneel upon the ground, and when you see the cross think with great sorrow and compunction of heart what death he [Christ] suffered for mankind, and so before the cross that moveth thee to devotion worship thou Christ with all thy might. And thus by images and paintings made by man's hand you may see and know how holy saints of Heaven loved Almighty God . . .

What had begun as a means of teaching the faith to the unlettered laity, however, began increasingly to take on a life of its own as the illiterate all too easily failed to make the important, if subtle, distinction between the worship accorded to God, inspired by the sight of a holy image, and the making of the image itself into a cult.

That development was also aided by the fact that sanctity and divinity should by their very nature only be represented in the most precious materials, gold, silver and jewels, and also by the most elegant and beautiful workmanship executed in a style worthy of conveying to the worshipper the full majesty of the Godhead. The result was a paradox: ostentatious displays of wealth in a religious setting aimed at evoking a sense of awe and reverence for a Christianity whose focus was very much the opposite, the contemplation of Christ the suffering man or helpless child and his Virgin mother exalted as woman and queen.

A Benedictine monk-artist painting a statue of the Virgin and Child from a manuscript of the Apocalypse, probably executed in London, c.1260-67.

The characters in the gospel story were more and more regarded as human beings. That they were so was evidenced by tangible relics. The Crusades, and above all the sack of the imperial city of Constantinople in 1204, resulted in a flood of relics entering Western Europe. Relics of Christ's passion, thorns from his crown or fragments from the cross, brought a new verity to the gospel story. In 1220, for instance, a relic of the Holy Blood was given to the abbey of Hailes (Gloucestershire) precipitating a cult. Such relics, like the Holy House at Walsingham (Norfolk) or the bones of St. Cuthbert at Durham or St. Kentigern at Glasgow, attained huge pulling power on the populace as the practice of pilgrimage proliferated. The great churches and abbeys vied with each

other in the accumulation of vast arrays of holy relics, an activity vividly caught in an account of the later sainted Bishop Hugh of Lincoln visiting the abbey of Fécamp in Normandy. There '. . . he extracted by biting two fragments of the arm of the most blessed lover of Christ, Mary Magdalene. We thought,' the horror-stricken chronicler continues, '. . . that the bishop had asked to see this holy and venerable relic for reasons of devotion, and he has stuck his teeth in it and gnawed it as if he were a dog.'

It was Abbot Suger at St. Denis in Paris who first brought the relics of a saint up from the crypt to create a shrine worthy of veneration behind the high altar. For two centuries every major church in Britain was to re-model its east end in response to this. It began at Canterbury for the shrine of St. Thomas Becket, but this was to be duplicated during the following seventy years in a whole succession of massive building projects to accommodate and display, for instance, the bones of St. Swithin at Winchester, those of St. Edward the Confessor at Westminster or of St. Oswald at Salisbury. Only Westminster and Hailes were

The young king Henry VI kneels at the golden shrine of St. Edmund, king of East Anglia. These shrines of saints were located behind the high altar and consisted of a stone plinth or throne with niches or recesses, in which pilgrims crouched to make their petitions, supporting the feretory, a portable coffin which could be lifted down and taken in procession on feast days. This was covered in gold plate and jewels so that often a cover would be lowered over it for protection.

A university class, the master reading his text from a lectern with his students seated at his feet, an illumination from an encyclopaedia, c.1350.

exactly to duplicate the French arrangement of a curved ambulatory with radiating side chapels, the English preference instead being for a rectangular end. All, however, followed the precedence of Canterbury in using Purbeck marble and applying a riot of rich decoration.

As relics multiplied, so equally did the splendour of the liturgy and this had consequences for the shape of church buildings. The priest now faced the east end, and the altar was set against a towering reredos which, like the church front, provided yet another vehicle for the display of tiered ranks of holy images. Most churches progressively adopted the customs of the diocese of Salisbury, ones which were almost certainly compiled by Dean Richard Poore at the turn of the century. Altars proliferated, and as each had to be sprinkled with holy water before high mass so interiors increasingly developed as vast processional ways. And the introduction of a full sung high mass of the Virgin, a reflection of her escalating cult, led to the addition of Lady Chapels.

These were the pious impulses central to the age which created a sublime and confident ecclesiastical art and culture, but they were equally visible expressions of the optimistic phase of the scholastic movement, which had begun in the previous century and which was to reach its climax during the first half of the thirteenth. This movement was to leave a permanent legacy in the form of a new institution, the university, in England represented by the emergence of Oxford and Cambridge. Oxford was already well established by 1200, situated as it was at a major junction of

routes and with the royal palace of Woodstock hard by. Cambridge was to spring to life in 1209 when a group of scholars dispersed from Oxford settled there. Both gained royal favour, for the State now needed educated men to run what was an increasingly complex government machine.

The new universities met a need for knowledge of a kind which could not be provided by the cathedral or by monastic schools. By 1250 both universities were highly organised, with guilds of masters who taught what amounted to apprentice students. It took four years to become a bachelor, three more to become a master, and sixteen in all to attain the status of doctor. The subjects embraced the liberal arts, both *trivium* and *quadrivium*, canon law and theology. Although Oxford and Cambridge embodied scholarship in the service of religion, no one could escape the fact that learning had left the cloister and was now beginning to spread not only to all branches of government but also to the higher reaches of society.

The universities had an immediate practical impact, creating an entirely new demand for texts, hence triggering the emergence of the book trade, one made up of copyists, binders, stationers and parchment-makers. Book production spread from Oxford and Cambridge north to York and south to London which, in the following century, was to eclipse every other centre. This new wave of learning called for a far different kind of book from the huge liturgical tomes of earlier centuries. Books were now required to move around and hence had to be smaller in format. They also needed to be easily accessible as working tools, leading to the introduction of pagination, lists of contents and the adoption of an alphabetical sequence to enable users to find their way around with ease. Note-taking at lectures called for a speedy script, so the cursive reappeared for the first time since the eighth century. The reed was abandoned in favour of the quill pen, and a minuscule closely-packed Gothic script came into currency, making maximum use of the expensive parchment. This was all evidence of a communications revolution as the role of writing changed. Government legislation was now written and records were kept.

But what was taught? Scholasticism depended on a system of instruction which was based on the explication of texts regarded as authorities. It was founded therefore on grammar, the belief that words were endowed with power. As a result there was a quest to define the relationship of the word to its concept and being. This was done through the laws of demonstration or dialectics, an ensemble of processes which turned the object of knowledge first into a problem, then exposed it, then defended it, then disentangled it, and finally convinced both listener and reader.

The student worked from texts which were in fact the means whereby the past knowledge of Western civilisation, now recovered, was digested. But scholasticism

moved from the premise that such authorities, the Bible, the fathers, Plato, Aristotle and the works of the Arabs, could be reconciled and harmonised by an exercise of the laws of reason and the arguments of science. In its initial phases this approach was enormously exhilarating. Every proposition went through a series of set processes. These began with the *lectio* in which the text of such an authority was subjected to every form of commentary, grammatical, logical and exegetical. This led on to the star event, the debate, an exercise in dialectic based on the *quaestio* or question. These sometimes took the form of a major public event, the *disputatio*, which could be thrilling occasions in which the great intellects of the era tourneyed. At the close came the *determinatio* or conclusion.

For half-a-century it seemed that this quest and this method of pursuing it could resolve the assimilation of antique thought into Christian civilisation. But as the century progressed it became apparent that there was a basic contradiction in seeking to rationally explain Christianity by appealing to pre-Christian thinkers. This was further undermined by the arrival of newly discovered texts which revealed Aristotle the physicist, the moralist as well as the metaphysician, not to mention the commentaries on these new texts by the great Arabic scholars, Avicenna and Averroes. These increasingly threw up problems which eventually led to the breakdown of the scholastic system. The contradictions between reason and experience also began to loom ever larger. Robert Grosseteste, Chancellor of the University of Oxford and Bishop of Lincoln, was among the first to essay the problem out of which came some of the earliest developments in the direction of experimental science manifested in the work of Roger Bacon. Surgeons, physicians and opticians also came up against the discrepancy between theory and practice. By 1300, their findings more and more were to lead scholasticism to turn in on itself.

But what we see today in the great cathedrals which went up during this century all over the country are expressions not of the coming era of doubt but of scholasticism in its optimistic phase, when it seemed that faith could indeed be reconciled with reason. A great church was the most magnificent building medieval people ever entered. Cathedrals were conceived as symbols not only of the whole Church of Christendom but of the Heavenly Church too. Gothic was able to give vivid expression to this image through its use of two of the basic ingredients of its style, the canopied niche and the window. Each sculpted inhabitant of heaven was placed beneath a canopy, a token of the Heavenly City, designating that space as enclosed and holy. As niches multiplied by the hundred all over a building so a church became an accumulation of heavenly mansions.

The Gothic style was typified also by ever-larger windows, a huge contrast to the

dimly lit churches of the Romanesque. These directly represented the church as the Heavenly City described in the Book of Revelation whose walls were 'of jasper . . . of pure gold, like unto clear glass . . . the foundations garnished with all manner of precious stones.' The same text provided sanction for items for liturgical use to be made of gold and silver and encrusted with jewels. The light infusing the stained glass heightened its kinship with precious stones, each one of which was held to possess its own mystical virtue.

The key to these churches is indeed light, and that preoccupation had its roots in the intellectual currents at the universities. Robert Grosseteste pioneered the new astronomy and was familiar with the work of the Arabic commentators. In his scheme of things God was still light and the universe a luminous sphere that radiated outward from a central source into the three dimensions of space. Christ was the centre from which all things emanated and recovered their light, and as a consequence each great church was a symbol of him: 'Physical light is the best, the most delectable, the most beautiful of all the bodies that exist. Light is what constitutes the perfection and beauty of bodily forms.' Into and on to these celebrations of God as light was inset the whole population of the Heavenly City, walls covered with human figures, no longer two-dimensional, but three. The front of Wells Cathedral had no less than a hundred and seventy-six statues apart from thirty half-length angels and one hundred and thirty-four Old and New Testament scenes. Such plastic imagery was painted and gilded both outside and in, rendering the church a gigantic reliquary with niches sprouting alongside a forest of gables and pinnacles. And, in accordance with scholastic method, each single image was sited as part of an argument, one in which the New Testament was presented as the fulfilment of the Old, Christ in the Tree of Jesse as the descendant of the Old Testament kings as well as the manifestation of the utterances of the prophets. And everywhere his mother, the Virgin Mary, the agent whereby came redemption, was seen as the welcoming intercessor for mankind, the gentle maiden who was submissive to God's will. And all of this encyclopaedia of Christian belief in visual guise was orchestrated by an architectural style whose basis sprang from the revival of geometry in the previous century. In accordance with scholastic thought both master mason and craftsman sought for the rational framework and hidden structure which was beneath the externals of things, governed, like the make-up of the universe, by geometry.

The new style radiated from Paris from the court of the kings of France. Paris in the thirteenth century dominated European culture in a way that no other city had since the Rome of classical antiquity. The great innovator Abbot Suger first translated God as light into the new architectural style as a response to his study of early writ-

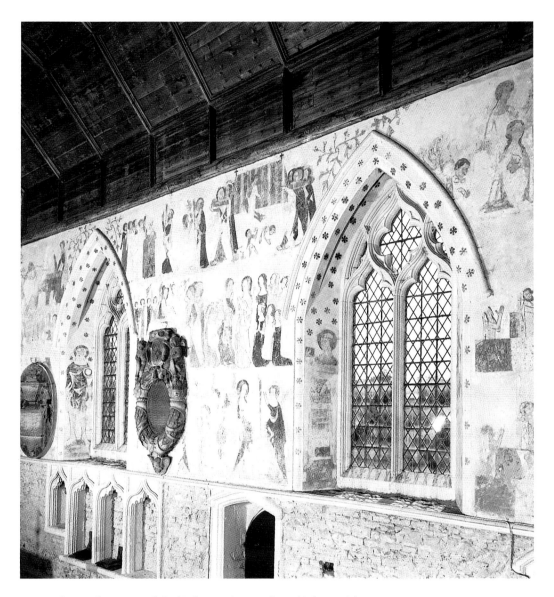

ings where the central belief was in God as light, with every creature stemming from that initial uncreated, creative light. Each creature in turn received and transmitted that divine illumination according to its capacity. Everything had its place in an ordered hierarchy whose binding force was love.

As a result, the great French Gothic cathedrals were constructed like gigantic glasshouses to be progressions

A rare survival of a virtually complete medieval decorative scheme for a parish church, St Mary, Chalgrove, Oxfordshire. Painted between about 1325-30 the scenes zigzag their way in three tiers around the walls with scenes from the life of Christ and of the Virgin, to whom the church is dedicated. The quality of the work is run-of-the-mill and probably typical.

towards the divine radiance, the culmination being the high altar at the east end where the sun rose. With this imperative the role of the master mason, the architect of the Middle Ages, was to get rid of the walls and to flood church interiors with light as the symbol of the mystical incarnation. These men, with their assured draughtsmanship and knowledge of applied geometry, were the new intellectuals, with social status enough to make them welcome at high table and fit to bear coats of arms.

The full Gothic style, which first appeared in England during the last few years of the twelfth century, quickly spread across country. That it did so can be explained by the peripatetic nature not only of the king and court together with the upper clergy but also of the craftsmen themselves. Add to that the apprenticeship system, and the ability of the Crown to call on craftsmen the length and breadth of England for any major royal enterprise. This meant that any new style was not only seen but was quickly taken up, and taught to men who moved from job to job carrying it along with them. In the middle of the century Henry III created what was to become by fits and starts a permanent government department for building, the Royal Works, to accelerate his massive project of Westminster Abbey. That represented the high point of the reception of the French Gothic in a manner which was untempered by the Channel crossing. As it gained momentum and permanence into the next and following centuries, the Royal Works was to develop into architecture's most influential patron. Later, under Edward I, at the close of the thirteenth century, it was to exert an impact on style in the great series of castles designed by James of St. George for the subjection of Wales including Harlech, Conway and Caernarfon, and in the exquisite series of memorial crosses which marked the progression through England of the coffin of the king's beloved queen, Eleanor.

Gothic, unlike Romanesque, was a style which embraced all the media. It had invaded manuscript illumination by 1250 as the pages were filled with elegantly posed gesticulating figures. The Westminster Abbey Retable, a rare survival of English medieval painting from the third quarter of the century, was equally as mannered with its delicate, modelled forms and attenuated figures with tiny hands. It is recognised as being of a quality unmatched in Western Europe at the time. Probably in place in the sanctuary of the Abbey in time for its consecration in 1269, it is a reminder of what was destroyed of English medieval art at the Reformation. What we see today is the little which has survived, but which has generally suffered much at the hands of iconoclasts.

Gothic may have been French in origin but what was so striking about the style was how conducive it was to the predilections of the English, for it revelled in two-dimensional outline and pattern. Architecturally the English were to reject the fun-

damental principles of French Gothic. Nowhere in this country did there appear the paper-thin walls of the French cathedrals with their stone rib vaults, the thrust of which was supported by myriads of external flying buttresses. Neither did the English share the French preoccupation with excessive height, preferring instead the long internal vista. Typically what the French had conceived of as a structural style the English turned into a vehicle for linear ornament. The thick Anglo-Norman walls were retained and if flying buttresses were called for they were deliberately hidden.

These were genuine expressions of insularity during a century when the conquerors and the conquered began to come together to form a single people in the face of a common enemy, France. Normandy was lost in 1204 and the French actually invaded in 1214. Both events fuelled anti-French sentiment which only went into cultural reverse with Henry III's tribute to the Gallic style in his great Abbey of Westminster. But even that expressed in its way this new-found unity of purpose, for its focus was the relics of an Anglo-Saxon saint, Edward the Confessor, and the king was to stress that link with England before 1066 by calling his son and heir Edward.

Canterbury heralded the rebuilding of the cathedrals in the new style. Its two greatest monuments were to be Salisbury and Westminster. Salisbury was begun in 1220 and finished in 1268, the expression of the decision by the bishop to abandon Old Sarum and move the episcopal town to a site more accessible to the new commercialisation typical of the age. As a medieval building Salisbury's unity and perfection remain unique with a new regularity, sharp and austere though elegant, gripping the place. The Gothic of Salisbury is however quintessentially English with its massive structural walls, angular massing and constrictions of space in nave and choir. Westminster Abbey was begun in 1245 by Henry III in emulation of his brother-in-law, the French king Louis IX. Henry of Reyns, an Englishman who had worked on the cathedral of Rheims, laid out its radiating system of chapels exactly on the lines of the coronation church of the French kings at Rheims. The rose window was copied from that of the cathedral of St. Denis and the exquisitely and richly ornamented interior was directly inspired by Sainte Chapelle. Nothing quite so French was to arise anywhere else, but that was because it embodied the taste of one man, the English king Henry III, and was paid for in its entirety by the Crown, costing the vast sum of £45,000. From the outset Westminster was seen as providing a setting for the coronation and burial of the priest-kings of England.

Cathedrals were fabulously expensive buildings and therefore are barometers of prosperity. They reflected

St. Peter, from part of what once made up the high altarpiece of Westminster Abbey, painted c.1270-80. Although damaged, it is a supreme example of sophisticated English court art under the influence of France, using the richest effects, the gilded frame being inlaid with imitation enamel plaques, gemstones, cameos and glass.

the enormous wealth of the episcopacy during this period, one during which monastic farming was at the height of profitability as a result of new farming methods, cheap labour, a long run of good weather and the benefits of innovative accounting procedures. The income of the Bishop of Worcester, for example, doubled between 1200 and 1260 and was to double again by the close of the century. The bishops were also able to tax the bourgeoisie who played an equally important part in the work of building. The cathedrals not only epitomised a triumph of faith in tangible form, they also expressed the rebirth of the cities, no other structures better proclaiming urban ascendancy as their walls and towers soared ever upwards, dominating not only the city skyline but the countryside around. Bishops and townspeople joined in what rapidly developed into a cross-country rivalry between cathedrals as each attempted to outvie the other.

Nor was the humble parish church to escape the building boom. In 1215 the Fourth Lateran Council instigated a reform of parish life. This was to mirror the increased status of the clergy as a caste apart. Until 1350 it was the chancels, the responsibility of the incumbent clergy, which were to be remodelled in accordance with this and also to accommodate a more elaborate liturgy. A screen was now introduced dividing the nave from the chancel, hiving the clergy off from the congregation, enclosing them within an area where they were viewed only partially, performing arcane rites whose progress could be measured by the occasional tinkling of bells. Into these newly enlarged chancels came sedilia on which the clergy could sit, a piscina for ablutions, and aumbries in which to keep sacred books and vessels. Every church had also to be furnished with a stone altar, a font, an image of the Virgin Mary and of the church's name-saint, a chalice, ciborium, censer, candlesticks, crosses, both processional and fixed, liturgical books as well as the necessary vestments for the seasons of the Church's year. Chancels ceased also to be caves of gloom becoming instead lanterns bathed in God's light. But not every church had the good fortune to undergo such a dramatic transformation. A line drawn from York in the north to Exeter in the south-west roughly divided the country into the haves and the have-nots. Those west of the line remained on the whole as they always had been.

This was a century whose cultural energies stemmed from an optimistic Christian faith. Its cathedrals even today radiate an optimism that God was in his heaven and all was right with the world. But it was to be a transient moment. As the century drew to its close the vision was to become an ever more clouded one. The Holy Land had been lost to the infidel and the Crusades had failed. Eastern Europe was being invaded by savage Mongol hordes. The age of faith began to falter. Aristotle was no longer seen to be an ally in squaring faith with the exercise of reason. But through

that quest humanity had been ennobled, for it was through man's eyes that the divine light was received but also it was man's gaze which was central to the light-filled metaphors of the theologians. That meant that ordinary men and women could rediscover the material world around them as evidence of God's creation. This sense of the rediscovery of the natural world and its joy was caught in the life of the greatest saint of the century, St. Francis of Assisi, who welcomed and indeed celebrated the beauties of nature. The visible world for the first time was seen to be a reflection of the divine and therefore worthy to be incorporated into the decoration, for instance, of churches. The bounties of nature revealed the divine image. No wonder that by the middle of the thirteenth century the soaring clustered columns of the new Gothic architecture began to burst into leaf and flower. Not only that but each leaf and each flower was of an identifiable species. The age of scientific observation was about to begin, and a new-found delight in God's created world offered the promise of happiness not only in the life to come but also in the here and now.

The new naturalism typical of the late thirteenth century is caught in these capitals in the chapter house of Southwell Minster, including buttercup and oak leaves.

Chapter Seven

CAMELOT

The chronicler Froissart, writing of Edward III under the year 1344, recounts how:

> . . . at that time it occurred to him to restore and reconstruct the great castle of Windsor, previously founded by King Arthur. There he formed and established the noble Round Table which produced so many valiant men, diligent in arms and prowess throughout the world. The king decided to create an order of chivalry . . . called the Knights of the Blue Garter. A festival would be commemorated year after year at Windsor on St. George's Day . . . At the festival there would be jousting . . . The queen of England would be there, accompanied by three hundred ladies in waiting and maids of honour, all of noble birth and similarly attired.

Here in a single passage Froissart sets apart what divided the civilisation of the fourteenth century from that of its predecessor. This was to be the high summer of medieval chivalry, a cult which had its roots firmly not in the clerical but in the secular world. One consequence of this was that cultural life ceased to be the exclusive preserve of the clergy. Art was no more reserved only for the sacred and began to be as much in the service of man as it was already of God. Above all, art and culture were to become the servants of the court. Artists, writers and musicians were no longer solely the companions of priests but of princes and courtiers and, as a result, the court was to become the prime agent for what was a huge social change. Prior to the fourteenth century there had been two separate worlds, that of the priest and that of the knight. The two now merged as the knight began to take up the mantle of learning and the cleric became increasingly more worldly. Display, hitherto almost exclusively reserved for the rituals of the Church, now began to substantially burgeon as an attribute of the ruler. And the means to achieve that was by art.

This was a century of extraordinary contradictions. Its greatest single event was a demographic cataclysm, the Black Death, the terrible plague which first appeared in 1348 and reappeared throughout the next thirty years decimating the whole of Western Europe and in which up to fifty per cent of the population perished. In

England only a quarter died, but the preceding decades had been marked by other disasters. After 1300 there was a dramatic climatic change ushering in violent storms, floods and cooler and wetter summers. Vines ceased to be grown and the harvest yields fell, exacerbated also by the previous century's intensive farming methods which had exhausted the land. Famine came and with it poverty, unleashing a crime wave. Moats, gatehouses and walls proliferated to secure both manor houses and farms. Nor did the imposition of heavy taxes to pay for the wars against Wales and Scotland ease the burdens on the population. In one sense the decimation of humanity brought about by the Black Death solved to some extent the problem of declining food production being unable to cope with the demands of what, until then, had been a rising population. What is so remarkable is that apart from the loss of many fine craftsmen these disasters did not impede the completion of major building projects. Indeed the century was to end not so much with a sense of doom as with one of cultural renewal.

The way for this was paved by the intellectual developments of the era. It was realised that the attempted reconciliation of faith and reason had run into the ground. Duns Scotus, thought to have been at one time professor of divinity at Oxford, showed that only a very limited number of dogmatic truths could ever be based on reason. William of Ockham, another Franciscan who studied at Oxford but whose career was to be on the continental mainland, believed that the very processes of abstract thought were perfectly useless as a means of reaching God or an understanding of the world. In his view there were only two ways forward, faith in what could not be demonstrated, like the existence of God, and truths which could be reached by observation of the created world.

The shift of focus to the real world coincided with a corresponding economic shift. For the first time the financial resources of the State began significantly to exceed those at the disposal of the Church. State taxation became more and more organised and, at the same time, more and more onerous. Its proceeds found their way into the coffers of rulers who spent ever increasing sums on luxury and display. As a consequence the Church ceased to be the only cultural driving force, although individual clerics could still thrive, but almost without exception only if they held office in government. This led to a radical shift in the nature of patronage. Patronage henceforward became more and more personal, even if it seemed on the surface to be collective. Works of art became the perquisites not of a community but of a single person, though their resting place was often a public space like a church. There their identity would be firmly endorsed by the addition of the owner's coat of arms, badge or donor portrait. Private ownership also called for smaller works of art like portable

devotional diptychs or jewels inset with relics. Art now carried with it social prestige.

That new secular display was expressed in the language of chivalry. By 1300 both the literature and etiquette of chivalry were firmly in place, ready to enter an efflorescence which was European in its dimensions. Prowess in arms and courtesy became the new liturgy of the fourteenth century which, for the privileged participants, was one long pageant of festivals, parades, battles, tournaments and midnight balls. Its imagery was the reverse of the devotional, a repertory which glorified fighting, hunting, the outdoor life and the joys of love and courtship. At root this exaltation of adulterous love and earthly delights was at total variance with the tenets of Christianity, but it was hugely creative in the aesthetic sense. Magnificence was one of the attributes to be cultivated by a knight. Wealth enabled him to show to the world the chivalric ideals in terms of courtly spectacle and largesse.

Courtly love was one ideal. Every knight would have been brought up on the romances of chivalry which taught him not only his role as a man-at-arms but also his part as a lover. Any man who wished to gain access to the closed world of chivalrous endeavour had to prove himself not only by feats of arms but by choosing a lady and serving her. Even Edward III, although happily married and the father of twelve children, chose the Countess of Salisbury. Froissart gives a memorable account of the king entering her chamber: 'Each beheld her in wonder and the king could not help gazing at her. Then a bright spark by mistress Venus through Cupid, the god of love, struck him at the heart and its effect lasted long.' But the attitude of chivalry to women remained at heart a paradox, for the role of the knight was to dominate his wife, and his prime duty was to be faithful to, and serve, his lady.

Chivalry was also an arm of the emergent State as the focus of chivalric loyalty was the monarch, something which was to survive even the upheavals of the Reformation. 'The Matter of England', the tales of King Arthur and his Round Table Knights, was perhaps the most popular of all the chivalric literature of the time throughout Europe. From these tales sprang a mighty literature which migrated west on to the mainland so that by the fourteenth century the majority of Arthurian romances were being re-exported back to Britain from France. Such books were the everyday reading of the courtly classes, and Edward III had a large library of them which he circulated. So obsessed was he with the Arthurian myth that at one tournament he even appeared disguised as Sir Lancelot.

Romances were, of course, recreational entertainment set as they were in a golden heroic past in which the castle, the forest and the occasional river seemed to be the only locations. The forests were full of monsters, wild animals or hermits, making a sharp contrast to the castles which were always set firmly in a recognisable present.

To those who listened as romances were read aloud on the long dark winter evenings their effect must have been akin to the thrill a modern audience gets from listening to episodes of a drama on the radio. But etched

A scene from an early fourteenth century copy of one of the hugely popular Arthurian romances read at the Plantagenet court, Lancelot du Lac.

within these fantasies there were serious lessons for the young knight to learn, for they described the adventures and the values of the aspirant, showing how a young man could seek and gain both status and fame within the feudal system. Romances in this way produced a whole new secular imagery with which to adorn palace, castle, pageant and domestic artefacts such as tapestries. A codification of heroic characters known as The Nine Worthies, for example, held up for emulation three groups of knights drawn respectively from the Old Testament, classical antiquity, and modern times. A parallel series of ladies exemplified that other chivalrous virtue, courtesy. But this apotheosis of the chivalrous world was to find its greatest expression in the flowering of the art of heraldry. Coats of arms were not only worn by the knight himself but could be emblazoned on vestments, ecclesiastical vessels, domestic plate, architecture, painting and stained glass. Heraldry had first emerged in the twelfth

century as a means of recognising a knight from afar, hence the shield shape. That distance meant that of necessity its repertory of images could only ever be very small. A coat of arms had to be bold and brightly coloured in order to be seen at all. Arms were at first adopted at will and by 1300 their use had spread across society to include knights and esquires. In the fourteenth century their use was to be extended yet again embracing

Above left: Jousts at Calais against Sir Colard Fynes in 1399. The earl is unseating his opponent with his lance across the tilt barrier in the middle of an arena crammed with spectators, including the king.

Above right: Jousts on the occasion of the marriage of Henry IV to Joan of Navarre in 1402. The king and queen look on from a gallery at Warwick and his opponent breaking lances, attended by their squires. To the left the master of the tournament examines lances before their use.

Left: Heraldic embroidery of the leopards of England executed before 1340 possibly for royal use as part of trappings for a horse. The velvet is sewn thick with silver and silver-gilt thread together with coloured silks inset with pearls and cabochon crystals, providing a fragmentary glimpse of the splendour of Plantagenet court pageantry.

townsmen and institutions like colleges. Only in 1417 did the Crown at last intervene and decide to control their proliferation via the heralds. In 1198 the first royal arms appeared, three leopards on a red ground, *lions passant guardant*. To these in 1340 Edward III added the lilies as an assertion of his claim to the French throne. It was the tournament, however, which led to the greatest elaboration of armorial bearings and also to the emergence of badges and supporters such as the lion, the griffin, dragon or antelope. Heraldry was a rich source of late medieval decoration. So too was that prime ritual of chivalry, the tournament.

Above left: The earl engaged in a foot combat with Sir Pandolf Malatesta at Verona in 1408 before Sir Galeot of Mantua. Warwick was on the point of killing his opponent when Sir Galeot cried 'Peace' and brought it to an end.

Above right: Four knights including the earl engage in another form of chivalrous combat, the tourney, a general mêlée.

From 'The Pageant of the Birth, Life and Death of Richard Beauchamp, Earl of Warwick', a series of drawings made c.1485-90, depicting scenes from the life of the earl, a perfect exemplar of medieval chivalry.

Edward III's grandfather, Edward I, had already made use of the myth of King Arthur to enhance the aura of the Plantagenet monarchy. In 1278 what were believed to be the bones of Arthur and his queen, Guinevere, were discovered at Glastonbury Abbey and re-interred in the king's presence. In 1284 and again in 1302 Edward held Round Table tournaments

but it was to be left to his grandson to usher in a chivalric golden age with a long series of spectacular tournaments. Such events lasted several days, bringing together the highest aristocracy in a festival which was prefaced by the masked combatants processing to church, accompanied by their squires. Then followed three days of combat, firstly jousting, which involved two knights attempting to unhorse each other with a lance, and finally the climax, which was a tourney or general mêlée.

Just as knights learnt much from romances of chivalry so fantasy began to permeate the tournament, adding a new *frisson* of delight. In 1331 ladies, dressed in red velvet tunics and white hoods, led in by silver chains knights disguised as Tartars, followed by squires and minstrels. At another tournament the knights wore green mantles embroidered with golden arrows expressing love's darts and the lovers' hopes. In 1342, on the betrothal of the king's three-year-old son Lionel to the heiress of the Earl of Ulster, the tournament colours were red, green and white. For this occasion both king and bridegroom had state beds, the infant Lionel's embroidered with true lover's knots and leaves, fretted and powdered with roses and other motifs with quatrefoils encircling his arms. The king's bore the motto: 'It is as it is.' Spectacle was piled on spectacle. The next year at Smithfield the challengers came disguised as the pope and his cardinals and this same spirit of perpetual masquerade, one beloved by the king, spilt over into the court's Christmas and Epiphanytide revels. Then the great hall would be reduced to mirth as king and courtiers arrived dressed as Dominican friars, merchants or devils. But at the heart remained the tournament, a perfect vehicle for revealing the king to his subjects as the liege lord of his knights.

The culmination of Edward's tournament passion was the establishment of the Order of the Garter. Its motto, *Honi soit qui mal y pense*, 'Shame be to him who thinks evil of it,' is popularly believed to reflect the king's chivalrous action in retrieving Lady Salisbury's garter which had fallen to the floor during a dance; it also challenged anyone who dared question the king's claim to France. It was used first on the banners and dress made for him in the Crécy campaign in 1346. His victory caused Edward to revise his earlier pledge to recreate the Arthurian Round Table and settle instead for an élite order of only twenty-five knights, a number making up two tournament sides. This was to be an annual celebration not only of chivalry but also embodying in perpetuity the king's claim to the French crown, with the commitment of the highest warriors in the land to support it. The Order of the Garter was romance in the service of power politics. In 1348 the College of St. George was founded at Windsor Castle and the next year the first annual feast was held. Following on that the castle itself underwent a massive reconstruction to create a many-towered

Camelot worthy of the king and his knights, all but two of whom had fought on the field of Crécy.

Edward endowed the English monarchy with a hitherto unknown glamour and his subjects revered him not only as the epitome of the chivalric virtues but also as King Arthur reborn. His eldest son, Edward the Black Prince, was likewise hailed by Froissart as 'the flower of chivalry of all the world'. He was to marry the Fair Maid of Kent, Countess Joan, and reign over a chivalrous court in Bordeaux. And Edward's queen, Philippa of Hainault, came herself from a sophisticated and chivalrous northern French court. For almost forty years Edward III represented the summit of medieval kingship, presiding over a court which lived and breathed the culture of chivalry.

This culture was expressed not only in the ephemeral of festival art but in the more lasting form of building. One contemporary observed that Edward was 'assiduous and eager in the construction of buildings most excellent in craftsman-ship, most elegant in design, most beautiful in location and in cost of great value'. Of those buildings the most influential was the new royal chapel of St. Stephen in the Palace of Westminster. This had been begun by Edward I but it was not completed until his grandson's reign in 1348 when a college of canons was established there. In its experiments with polygonal arrangements of interior space and in its exotic rep-

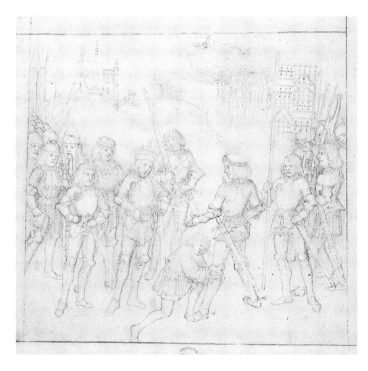

The earl receives the highest award of chivalry, the Order of the Garter. The exact date of the award is not known but the king is likely to be Henry V. From 'The Pageant of the Birth, Life and Death of Richard Beauchamp, Earl of Warwick'.

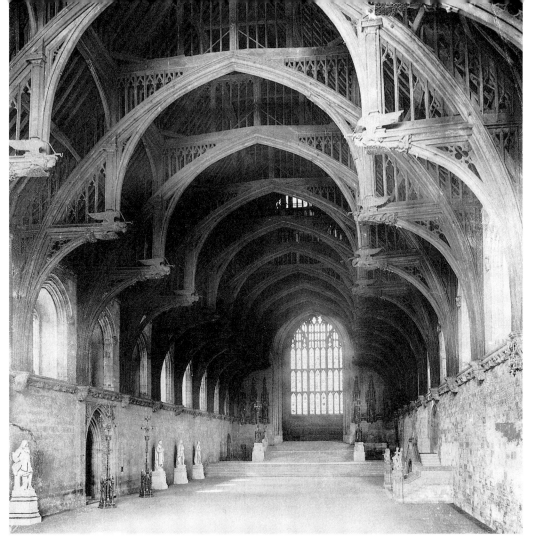

ertory of ornamental effects it was to inspire both masons and carpenters to greater heights of inventiveness in a new phase of the Gothic style, the Decorated. St. Stephen's Chapel was designed by Michael of Canterbury who was responsible for one of the Eleanor crosses and applied the same miniaturised architecture to the chapel. It was to be a hugely influential building, leading to triumphs such as the octagon lantern at Ely Cathedral, the work of the king's master carpenter, William Hurley. The upper chapel's canopy-encrusted interior was to have an almost immediate impact, its canopy-bedizened walls inspiring Ely's Lady Chapel which was begun in 1321. The tracery grid on its outside walls became the basis for the final phase of the Gothic style,

Above: The interior of Westminster Hall as it was remodelled between 1394 and 1401. Originally built at the close of the eleventh century it was then the largest hall in Europe. Its remodelling during the reign of Richard II made it the most splendid of all medieval halls, a reflection of the king's exaltation of the divinity of the monarchy, for in it, at certain times of year, he sat ceremonially crowned and enthroned. The hall is the greatest creation of medieval timberwork by the royal chief carpenter, Hugh Herland.

Right: The octagon of the tower of Ely Cathedral, 1322-53, the unique timber lantern being the work of Edward III's master carpenter, William Hurley. Originally the choir stalls were beneath it.

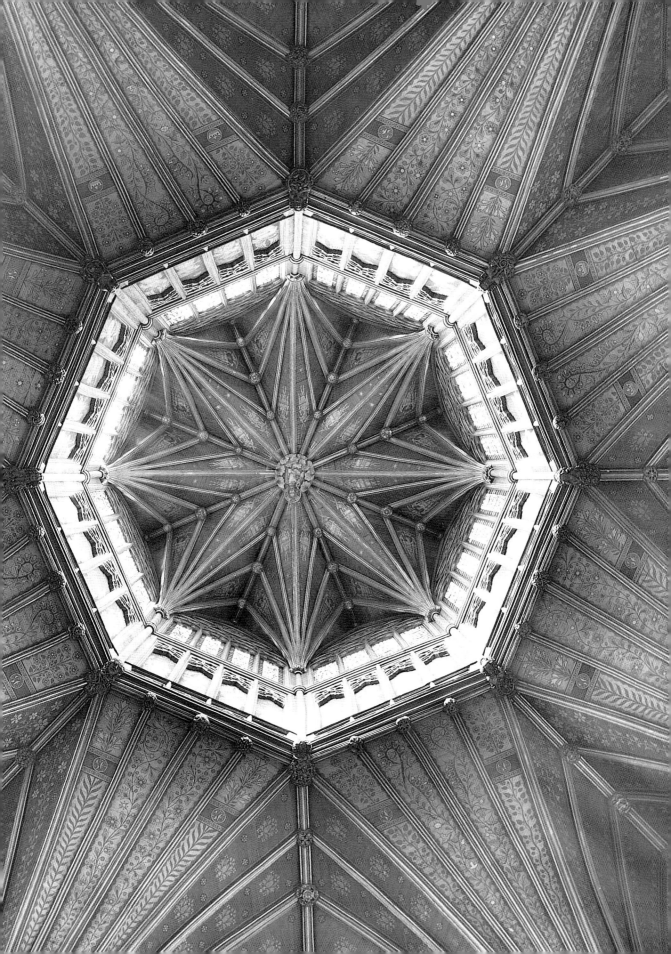

one idiosyncratic to this country, the Perpendicular. The earliest fan vaulting in that style occurs in the cloister of Gloucester Cathedral which was built in the 1350s, where the treatment of the choir too owed its inspiration to St. Stephen's.

In 1350 a formidable team of painters headed by Hugh of St. Albans began the interior decoration of the chapel, which was only ninety by thirty feet, endowing

Scenes from the Book of Job, *fragments from the decoration of St. Stephen's Chapel, Westminster Palace, c.1350-63. The decoration of the chapel was the most magnificent of the century, tiers of paintings inset into gilded and painted architecture. The scenes themselves reflect knowledge of all that was avant-garde in Tuscan art in the handling of space, light and modelling.*

it with a richness and intricacy which, had it survived, would have constituted England's riposte to the Sainte Chapelle. As it is, fragments and the records of

antiquarians can only give us an indication of its sophistication, one in which Gothic elegance was married to the new deployment of pictorial space used in Lombard painting. The scheme included cycles of Old and New Testament scenes, possibly ones from lives of the saints, as well as Edward, his queen, and all their children kneeling in adoration in what was perhaps the greatest masterpiece of English medieval painting.

The court of Edward III stands at the heart of fourteenth century cultural ideals. Alas, the king was never a subject for Shakespeare's pen which accounts for the focus being shifted onto the figure of his grandson, the ill-fated Richard II. He too presided over a brilliant court and was equally as passionately committed to the use of the arts as a means whereby to enhance the dignity of the Crown. The rebuilding of Westminster Hall, completed at the turn of the century as the greatest and most splendid of all medieval halls in the whole of Western Europe, is evidence enough of his concern to provide a setting worthy of himself enthroned. But it is the Wilton Diptych which more than any other work of art sums up the precious milieu of his court. In this Richard II is depicted attended by his patron saints, having presented the Virgin with England as her dowry. This is not a monument to a warrior prince but to an aesthete. In Edward III image and reality met to the acclaim of his people. In Richard II there remains only the image, self-proclaimed, assertive, elegant and supremely fashionable. He appears not as a hero of the battlefield or the tournament, roles which best befitted a medieval king, but as a ruler obsessed with his own divinity.

Over half a century after Richard's deposition in 1399 Sir John Fortescue was to write: 'The king's household is the chief academy for the nobility of England. It provides schooling in athletics, moral integrity and good manners, through which the kingdom flourishes, acquires honour and is protected against invaders.' Writing in 1460 he was recording what had long been a reality. The court's role in the training of the aristocratic classes was already well established in the fourteenth century, providing as it did an ideal setting for it was the centre of government, which demanded educated people, besides setting style and fashion. Both the households of the king and of the queen acted as schools for training aristocratic youth. The manners and accomplishments they learned and practised there are enshrined in the word *courtesy*. They had to study and master the rudiments of practising the Christian faith, be able to read to cope with both the law and administration, take part in military training in order to excel both on the battlefield and in the tournament arena, and also acquire the social graces of writing, dancing and making music. Up until the age of seven both sexes remained in the charge of the ladies of the household. At that age and until fourteen the boys were given over to tutors whose task was to teach them

how to become knights. The girls remained with the women, learning deportment, embroidery, how to read, and occasionally languages. Those not educated at court were able to receive a similar training in other noble households, to which it became the custom to send children.

This reflected the fact that the lay upper classes were becoming far more literate and cultivated, something which was equally reflected in the architectural changes of the century. Edward I might have built his mighty castles as engineering feats to subject a people, but the aristocracy in England now built theirs deliberately to accord with the ideals of chivalrous romance. Edward III had led the way. Windsor Castle was not rebuilt as an unassailable fortress but as a romantic and luxurious backdrop for his festivals of chivalry, theatre scenery for his magnificent court. And the same applies to wherever castles were being built. Where we see crenellation, moats and gatehouses as at Scotney (Kent), Saltwood (Kent) or Bodiam (Sussex), for example, they are no longer for defence but for show. Everywhere the accent was on comfort and suites of lodgings to accommodate guests of rank, expectant of comforts unknown to previous generations. At Middleham Castle (North Yorkshire), seat of the Nevilles, there are no fewer than twenty-four suites of lodgings; such comforts were to spread north of the border as the Duke of Albany's Doune (Perth) which arose during the 1380s bears testimony. The prime role of the castle was now residential, designed for entertaining guests in the grand manner. For this huge halls were constructed like those for Richard II's uncle, John of Gaunt at Kenilworth (Warwickshire) or John Holland, Duke of Exeter at Dartington (Devon). In the north a mighty series of new castles arose, Alnwick (Northumberland), Raby (Durham) and Wressle (Yorkshire) among them, tokens in the main of the rise to prominence of the Percys as Earls of Northumberland.

Everywhere, even in the average manor house, the move was away from the communal living of old as the long quest for privacy developed. The hall now always led to the lord's solar or bedchamber. At its opposite end it gave on to an increasingly complex series of service rooms: buttery, pantry and, later, kitchen. Penshurst Place (Kent), built in 1341 by the merchant, draper, and Lord Mayor of London, Sir John Pulteney, survives to demonstrate the new ideals of living, ones made possible not only by wealth but also by the mason and carpentry skills of late medieval England which were reaching their zenith. Nothing like the astounding roofs of the great halls, feats of timber engineering, was to be seen anywhere else in Europe.

By 1400 England was a very different society from what it had been in 1300. This was expressed in the increasingly universal use of the English language. No one agrees as to exactly when the upper classes abandoned their Anglo-Norman speech. They

would certainly have heard English spoken from birth by servants, but they would have been brought up to speak this variety of French by their parents, tutors and the clergy. After 1350, however, English was used for many more official and literary purposes. That, together with the court's demand for translations, led to English ceasing to be a series of local dialects, with none considered superior, and to the eventual dominance of London speech. Even then, court culture remained linguistically committed to the use of Latin and French until well into the fifteenth century.

One indicator of the rise of the English vernacular to prominence was the literary renaissance which marked the second half of the century. It produced a literature which can still be read today, chivalrous allegories like *Sir Gawain and the Green Knight* set at the court of King Arthur, or the visions of *Piers Plowman*, a critique of the contemporary social scene presented in the form of a series of dreams:

> In a somer season whan soft was the sonne,
> I shope [dressed] me in shroudes as I shepe were,
> In habite as a heremite unholy of workes,
> Went wyde in this world wondres to here.
> Ac [but] on a May mornyng on Malverne hulles
> Me byfel a ferly of fairy [a miraculous adventure] me thoughte.

The shift in literary initiative was increasingly from the Church to the court. It was at Richard II's instigation that John Gower wrote his *Confessio Amantis*, a lover's confession in English. Above all this was the age of Geoffrey Chaucer, courtier, poet and civil servant who was recognised as having made English a literary language.

> In his dayes hath so well him borne
> Out of our tongue t'avoyden [remove] al rudenes
> And to reforme it with colors of swetenes.

Thus wrote one of Chaucer's immediate successors, John Lydgate. In his time Chaucer was regarded as first and foremost an inspired poet of love in his translation of the medieval chivalrous epic *Le Roman de la Rose* and his great poem *Troilus and Criseyde* which, to its audiences, when first read to them, must have had all the qualities of a bestselling novel. In *The Canterbury Tales*, his last unfinished work and the one read more than any other today, he brought together all sorts and conditions of people with a sense of dramatic reality reflected in their contrasting characters and stories. To do this, Chaucer used a pilgrimage to the shrine of St. Thomas Becket at Canterbury as a vehicle for a panorama of late fourteenth century society which embraced the landed gentry, the professional classes, the lower bourgeoisie, the clergy

and the peasantry. Each member of the company was committed to tell two tales, although only just over twenty were ever written. Chaucer was a sharp satirist with a wry sense of humour and the General Prologue still remains a marvel six centuries later, along with the link passages between the tales which contain some of the finest quasi-dramatic writing outside of Shakespeare.

This is how the much married Wife of Bath introduces her tale:

"If there were no authority on earth
Except experience, for what it's worth,
And that's enough for me, all goes to show
That marriage is a misery and a woe;
For let me say, if I may make so bold,
My lords since I was but twelve years old,
Thanks be to God Eternal evermore,
Five husbands I had at the church door . . .
. . . I'll have a husband yet
Who shall be both my debtor and my slave
And bear his tribulation to the grave
Upon his flesh, as long as I'm his wife . . ."
The Pardoner, as she was going on,
Started and said, "By God and by St. John
Madam, that's preaching no one could surpass!
I was about to marry, but alas
If I shall have to pay for it so dear
There'll be no marrying for me this year!"

So Chaucer's characters parade their emotions before our eyes in a century which can almost be said to have rediscovered them. During the fourteenth century religion called on personal emotion as never before. This was the work above all of the friars, Dominican and Franciscan, new orders from the previous century, mendicants who made it their task to go into the towns preaching a gospel which appealed directly to the personal responses of the listener. The Bible story was more and more humanised as men were encouraged to focus their thoughts on the events of the passion in order to learn that it was through suffering that Christ had secured man's salvation. This approach only multiplied the demand for images, for the eyes were cast as the gateway to the human heart. The demand for objects of personal piety, like small devotional paintings and Books of Hours, increased. So did collective lay expressions of faith such as guilds and confraternities whose members shared a common discipline

and who took part together in religious exercises and works of charity. All of this brought religion out of the cloister and into the street, where it could also find expression in the great cycles of mystery plays which were enacted at Corpus Christi or at Whitsun and which appealed headlong to the emotions of the onlookers. No town or major village was to be without some kind of collective theatrical expression of the new personal piety.

The personalisation of religion as a quest of the soul for its wedding with the spirit more and more called for lay access to, and knowledge of, the scriptures, the Word of God. About 1340 a Yorkshire hermit put the psalter into Middle English and half a century later two teachers at the University of Oxford produced versions of the Gospels. But they were committed as heretics, Lollards, followers of John Wyclif, who had earlier in the century recast the religious life, denouncing many aspects of the

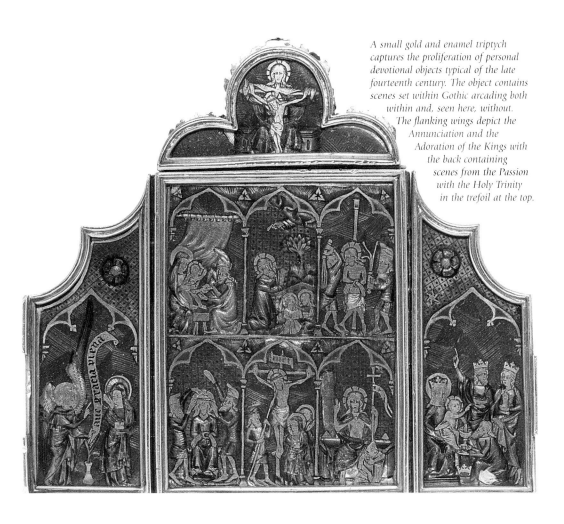

A small gold and enamel triptych captures the proliferation of personal devotional objects typical of the late fourteenth century. The object contains scenes set within Gothic arcading both within and, seen here, without. The flanking wings depict the Annunciation and the Adoration of the Kings with the back containing scenes from the Passion with the Holy Trinity in the trefoil at the top.

priesthood and advocating a direct worship of Christ the brother, nourished by the reading of the Bible.

In an era which lived with the perpetual threat of the return of the terrible pestilence, which indeed it continued to do, a morbid preoccupation with death, personal salvation and the afterlife set in. This was encouraged by a fundamental change in the Church's teaching. In 1274 at the Council of Lyons, purgatory, that third place which was neither heaven nor hell in which the shriven soul was purged, was officially recognised. It cast the Church's role into one of prayer to alleviate the suffering of the departed. In 1300, which the pope declared to be a jubilee, he granted a plenary indulgence to all who came on pilgrimage to Rome. That meant that the papacy had extended its powers to purgatory, and through granting indulgences could shorten the time or liberate the soul from the rigours of purgatory where punishment was meted out for sins committed in this world. By the middle of the fourteenth century this had resulted in a boom in indulgences but it also led to an ever-growing belief in the efficacy of intercession for the dead, especially through the medium of the mass.

The repercussions of this for the next century and a half were to be enormous. Chantries were founded, built for the sole purpose of praying for the departed founder. These began with clerics like Bishop Grandisson of Exeter who in 1347 established a collegiate body of forty at Ottery St. Mary in what was a hugely expensive church. Chantries and private chapels proliferated both as separate entities and within cathedrals and churches, where they often usurped a place close to the high altar or in proximity to a shrine. At the same time funeral ceremonies not only for royalty but also for the aristocracy became far more elaborate. The funeral was transformed into life's last and greatest festival of chivalry with the tomb as a bed of state on which the sculpted image of the deceased reposed, awaiting the Day of Judgment. In the case of a knight above it was hung his helm, his crest and his surcoat. No tableau could better encapsulate what was the age of chivalry.

Chapter Eight

A MEDIEVAL PATRON: WILLIAM OF WYKEHAM

A man like Geoffrey Chaucer who was a poet yet whose chief occupation was that of government official is indication enough that society at the close of the fourteenth century was changing. Another such was William of Wykeham, the son of a Hampshire peasant family who rose, through service to the Crown, not only to be at the heart of political life but also, as Bishop of Winchester and Chancellor, to become one of the greatest patrons in the history of Britain. The dramatic contrast between the humble obscurity from which this great politician, churchman and educator sprang and his eventual grandeur and wealth was rarely to be equalled, and certainly never surpassed, in late medieval England.

The Church in this period offered virtually the only way up for anyone of humble origins. Born in 1324 in the village of Wickham, William's talents must have been spotted by someone of the landowning classes who saw to it that he was sent to Winchester to be educated. There he attracted the attention of the bishop, William of Edington. With the bishop's help, William entered into royal service in 1356 and in October of that year he was made surveyor of the castle and park of Windsor. So indispensable did he become to Edward III that within three years he was put in charge of virtually all the king's major building projects which was in itself an innovation. At Windsor, William of Wykeham was responsible for carrying through the construction of the new royal lodgings in the upper ward of the castle, a scheme which included an arrangement which he was to copy in his own foundations, the format of hall and chapel back to back. The chronicler, John Malverne, wrote that he '. . . was of very low birth yet he was very shrewd, and a man of great energy. Considering how he could please the king and secure his goodwill, he counselled him to build the said castle of Windsor in the form which appears today to the beholder.'

In this way William of Wykeham became an intimate of Edward III, so much so that in 1361 the king made him his secretary followed two years later by the office of Keeper of the Privy Seal, on which occasion he resigned his Windsor surveyorship.

Simultaneously he began to be showered with church preferments which he held in plurality, meaning that he drew the revenues but paid someone else to carry out the job. It was a meteoric career and the reason why it was so was neatly summed up by Froissart: 'Everything was done by him and without him nothing was done.' Naturally William of Wykeham came to be resented by the old royal clerks belonging as he did to the new flexible, competitive, mobile section of medieval society which included people like the king's financiers, both Italian and English, and other commercially minded entrepreneurs. William of Wykeham combined being a calculating politician with being also a shrewd man of affairs, capable and efficient.

In 1367 he was made Bishop of Winchester and Chancellor, in effect the king's chief minister, an office which he held until forced out four years later. In the middle of the 1370s he was disgraced for supposed financial misconduct and went into internal exile which included the loss of his revenues. Then, on the accession of Richard II, he was restored both to favour and to his temporalities. By then he was old in medieval terms and assumed the status of a venerable figure. He was to return again for three years as Chancellor in 1389 and died in 1404. It is not his political career for which he is remembered today but for his remarkable benefactions.

The see of Winchester was the richest in Christendom. It stretched from the Channel Islands to Southwark embracing the most prosperous area of southern England and therefore generated substantial income from feudal dues and vacant benefices as well as those William chose to hold in plurality. But it did not end there. William of Wykeham poured time and energy into money-lending, into the sale and exchange of property, and into the wool market. The scale of his financial operations was enormous and the rewards were those of an ambitious and astute businessman, with money to spend at will.

In setting about this he responded to the long-established tradition that the rich should found an ecclesiastical institution. At first he considered founding a monastery but as none were properly observing their pristine rules he dismissed the idea. He noticed instead the dramatic fall in the number of ordinands in the aftermath of the Black Death. To remedy that he proposed a twin operation in which the students from a grammar school in Winchester should proceed to a university college in Oxford, whose main emphasis was to be on the teaching of theology. The college was to have seventy theological students but only twenty studying law, two medicine and, uniquely, two astronomy. The prime objective was to prepare men for the parochial ministry but he was also aware that the Oxford college could produce people of his own kind for service to the State. Or, as the statutes framed it: 'Men of great learning fruitful to the Church of God and to the king and the realm.'

The two major projects were Winchester College and what was to be known as New College, Oxford. William of Wykeham was blessed with longevity so that he was to enjoy the abundant temporalities of his see for no less than thirty-seven years. As a result both foundations were indeed splendid but not so splendid that they could not be virtually finished within his own lifetime. They remain monuments not only to the bishop's imaginative flair in conceiving such institutions but also to his organisational skills in seeing them built, not all at once but one by one. As each project neared its end the next started up.

That all this worked so efficiently was a reflection that from the outset William had assembled around him what was in effect his own version of the Royal Office of Works. The same team of craftsmen carried through all his projects, moving from one place to the next as was needed. There was Simon of Membury who acted as clerk of works, seeing that the project was carried through on budget and on time, occupying the role William of Wykeham once had at Windsor, where in fact he must have first met Simon and the two master craftsmen, William Wynford, the mason, and Hugh Herland, the carpenter. In the medieval period there was no such person as an architect in the modern sense of the word. Each master craftsman was in control of the design and execution of his own area of expertise. Whether carpenter, glazier, mason or smith he would have designed and executed his own part of the work, albeit in response to the dictates of the patron. William of Wykeham met his team regularly for they are recorded as dining at his table in his palace at Winchester.

Wynford was a West Country man who came from Winford six miles south of Bristol, an area rich in quarries with a long tradition of producing masons. He is likely to have met William of Wykeham in 1360 and was to work for him for four decades. Hugh Herland is first recorded in London in the same year and in 1375 became king's carpenter, his most famous royal commission being Westminster Hall. These were men who knew the court and its taste in architecture, so that William of Wykeham's buildings are an emanation of the new Perpendicular style as it had evolved under the royal master mason, Henry Yevele. This was Perpendicular in its most restrained phase in which spaces of plain wall were retained as a contrast to the massive buttresses, ornamental niches or windows with strong but not over-elaborate mouldings and simple window tracery.

Oxford at the close of the fourteenth century was in a bad way. The population had contracted by a quarter due to the plague and the run-down north-east area in which it was decided to site the new college was 'full of filth, dirt and stinking carcases'. Even the acquisition of the necessary land was not to be a straightforward operation, for it involved purchasing no less than twenty-six different sites. Although

A posthumous portrait from the middle of the fifteenth century of William of Wykeham as the founder of New College, Oxford, surrounded by some of its distinguished alumni, including four bishops.

William of Wykeham began acquiring land as early as 1369 it was not to be until a decade later that building actually began, the process also delayed by his period of temporary disgrace. In 1386, however, it was complete enough for the warden and fellows to move in.

For all its shortcomings this was to be a revolutionary foundation, establishing what was to become the norm for both universities thereafter. Before New College, Oxford had no public buildings, nor was there any visible difference between what was town and what was gown. New College changed all that. The concept of the college was huge, its quadrangle being the largest building to go up in the city since the twelfth century and its seventy fellows nearly equalled the sum total of fellows in the six older existing colleges providing for secular clergy. It was also showered with favours. The Crown bestowed on it exemption from taxes and the pope accorded it parochial status which meant that high mass could be celebrated in the chapel on Sundays and that there could be a cloister with a burial ground within it.

But New College was to be even more than that. Here was the first fully developed quadrangle plan, one in which it is thought that Henry Yevele may have had a hand, for he had built colleges in Kent and Sussex with a similar layout. Here also was a whole new repertory which was to be repeated time and again in the coming centuries in both Oxford and Cambridge: the hall and chapel placed back to back in one range (as at Windsor), the T-shaped chapel (the ante-chapel being used for disputations and meetings), the cloister and bell-tower, and the front-gate tower with the warden's lodgings over it plus the typical arrangement of mixed senior and junior fellows' rooms. It was, in addition, the earliest building in Oxford to be entirely faced in stone and it was in a style, the Perpendicular, which was to dominate the city's architecture for the next hundred years.

New College was an asymmetrical and strongly functional building and its most important feature was that all the essential buildings for the life of the foundation were grouped around one enclosed space. Its influence was to be immediate. It was imitated in Henry VI's twin foundations of Eton College and King's College, Cambridge. The king even poached the headmaster of Winchester College for Eton. William Waynflete, however, was soon made Bishop of Winchester and he

Winchester College, its staff and pupils, as recorded in a mid-fifteenth century manuscript.

embarked on his own Oxford foundations of Magdalen College and School. Another pupil of both Winchester and New College, Henry Chicheley, Archbishop of Canterbury, was again to follow the format in his foundation of All Souls. What is so extraordinary is that there is no record that William of Wykeham ever visited New College.

The same could not be said of his second foundation which arose outside Winchester's city gates just south of the cathedral and his own episcopal palace. He had already established a school there in 1373 but as work on New College reached its end that on Winchester College began. On 26 March 1387 the foundation stone was laid and seven years later the college was ready for occupation. The statutes provided for seventy 'poor and needy scholars', sixteen choristers, and only ten

commoners or sons of rich families. Winchester remains one of the cardinal mon-
uments to the Perpendicular style, designed by Wynford with Herland carrying out,
for example, the chapel roof. Again the quadrangle form was used, this time two in
succession with the gateway to the inner providing a vista to the block which housed
the hall and chapel back to back. And here too there was the work of another per-
manent member of the team, Thomas Glazier of Oxford, some of whose glass sur-
vives in both foundations.

And then, as work on Winchester College neared its end, William of Wykeham
turned his attention to Winchester Cathedral where the nave still retained its Norman
arcading. Again Wynford was employed, to suppress the triforium and superimpose
the elegant arches which now make up the nave and support the new stone vault
which replaced the wooden Norman roof. The result is an interior excelled only by
Henry Yevele's nave at Canterbury Cathedral.

What we do not know is how much of all this reflected the patron's own taste.
William of Wykeham was no scholar but a man of affairs and a great educator. Part

of the statutes of New College would seem to place him
firmly in a line of descent from Abbot Suger as a pas-
sionate believer that richness and adornment redoun-
ded to the glory of God. The description of the chapel
refers to 'the image of the Holy and undivided Trinity,
the Holy Cross with the image of the Crucified, the
images of the Blessed Virgin Mary and many other
Saints, the sculptures, the windows filled with glass, the
divers paintings, all curiously wrought and ornamented
throughout with various colours, to the praise, glory
and honour of God, and of the Virgin Mother'.

To her he had an especial devotion and indeed New
College was the College of St. Mary the Virgin with
William depicted no less than three times on its exterior
kneeling present in adoration at the Annunciation. A
statue of the Virgin also adorns the outer gate of Win-
chester College and is on the pinnacle of the west gable
of New College Chapel, not to mention her appearance
in the stained glass windows. When he was a boy Wil-
liam of Wykeham had knelt to hear mass each morning
before an image of the Virgin that stood against a pillar
half-way down the nave of Winchester Cathedral on the

*Statue of the Virgin and Child,
c.1400, on the outer gate of
Winchester College.*

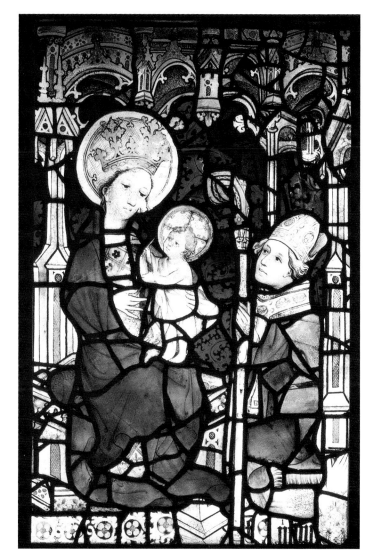

William of Wykeham kneeling in adoration before the Virgin and Child, c.1393. One of the stained glass windows by Thomas Glazier of Oxford made for the chapel of Winchester College.

south side. It is there that he fittingly chose to erect his chantry chapel and his tomb, an enclosure between pillars, an innovation in itself.

William of Wykeham's chantry chapel was to secure rest for his soul through prayer and the saying of mass for its repose. But so also were his other two great foundations whose statutes provide for his soul and those of his family and friends to be prayed for in perpetuity. And in that he was touching upon something which was to dominate the thoughts of those in the century at the opening of which he died. William of Wykeham's munificence was his passport to paradise.

Chapter Nine

PURCHASING PARADISE

Towards the end of the reign of Elizabeth I a Suffolk gentleman attempted to write down what he remembered of a world which had by then gone, that of the culture of the pre-Reformation Church. Roger Martin recalled what Long Melford church, still one of the glories of late medieval English architecture, had looked like before the holocaust. He describes the rood-screen, which divided the nave from the chancel, with its painted dado of brightly coloured saints, and, above it, the figure of Christ on the cross flanked by the Virgin and St. John. Inside the chancel at the east end there was a stone high altar with a huge retable behind it 'carved very artificially with the story of Christ's Passion', flanked by two tabernacles, one containing an image of the Trinity, the other one of the Virgin Mary. The retable had doors, and remained closed except at great festivals when they were opened '. . . which was then a very beautiful show.' To the north, within the chancel, there was an Easter Sepulchre, a repository in which, as part of the Good Friday rites, the remaining consecrated Host was laid to rest along with the cross which the congregation had venerated. Moving into the main body of the church there was the family chapel in the south aisle with another altar, this time with a retable bearing a crucifix over it, flanked by two more images, one of Christ holding the globe of the world as *Salvator Mundi* and the other of the Virgin as Our Lady of Pity, 'having the afflicted body of her dear Son, as he was taken off the Cross lying along her lap, the tears as it were running down pitifully upon her beautiful cheeks.' All of this had vanished decades before, burnt or smashed to pieces under government instructions, as had equally the rituals of late medieval Catholic Christianity. These Roger Martin also lovingly recounts, which could spill out from the church on to the village green. This was a faith which appealed to the emotions through the senses, above all that of sight, and therefore was inextricably bound into art in the form of architecture, sculpture, painting, music and drama.

During the century and a half before the events of the 1530s which brought this world to an end, the laity was caught up as never before in a tide of piety. More than ever religion exerted an enormously strong, diverse and vigorous hold over the imagination and the loyalty of the people. Religious thought, which had progres-

sively humanised the Bible story, extended its sway over far greater numbers of the population as the flood of devotional literature, which reached a torrent with the advent of printing in the 1470s, and art, witnessed by a building boom, bear testimony. This was an inward-looking faith whose focus was firmly on the passion of Jesus, the events of which dominated the art of the age. The pious were urged to relive its every moment, making use of pictorial representations as an aid to meditation. Hence the multiplication of pictures of Christ depicted as the Man of Sorrows, Jesus arising from the tomb crowned with thorns and displaying his wounds surrounded by the instruments of the passion. Equally, devotion to Our Lady of Pity flourished, a form of worship in which the worshipper followed the events of the passion through the eyes of the Virgin Mary.

The desire to share in Christ's sufferings was exactly reflected in the almost obsessive reality of the art of the period, epitomised by its greatest master, the Flemish painter Jan van Eyck, in whose pictures the tears can be seen to glisten on the cheeks of the grief-stricken Virgin as she nurses the ashen body of Christ. Van Eyck worked for the court of the Dukes of Burgundy in the Low Countries, and Burgundy was to be the dominant cultural force moulding both fashion and style in the England of the Wars of the Roses. Such a style came partly out of Italy, where by looking back at classical antiquity a new modernism of illusion came about, the rendering of pictorial space and attention to accuracy in the portrayal of the physical world, but married to the Gothic linear preciousness of the chivalrous courts of northern Europe. The result was a triumph of *trompe-l'oeil*, bringing about a religious art which set the figures of the Bible story, and especially the passion narrative, in the world of the present. This was religion for the masses.

So it was that in fifteenth century England the emphasis shifted away from the monastery. The attack by the Lollards at the close of the previous century on the wealth of the Church continued to exert an influence, especially when it was seen that comforts for monks increased to include such privileges as private bedrooms with fireplaces. As comforts multiplied, respect decreased. Only the strictest of orders like the Carthusian continued to enjoy popular veneration. The result was that there were virtually no new monastic foundations and the laity turned its attention more and more to its own parish churches.

This newly discovered lay piety found its expression in an efflorescence of guilds and confraternities which sprang up in enormous numbers from 1350 onwards. A city like London had as many as a hundred and fifty and virtually no village was devoid of one. All had the same basic function, a group of lay people under the patronage of a particular saint, the Trinity, the Virgin Mary or Corpus Christi, which

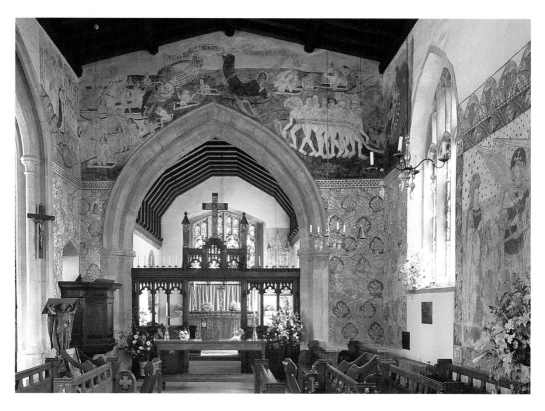

undertook to provide for its members a good funeral with prayers and mass-saying for the departed. In addition there were corporate acts of worship, including an annual gathering with a feast, and the maintenance of candles or lights before the image of their patron within the church. Such guilds were also active in charitable work, some even running schools and almshouses. And it was to be these groups of pious lay people who were to be the powerhouses not only behind massive church building projects but the explosion onto the streets of the Bible story brought to life as theatre.

The driving force behind these activities was an obsession with the safe transition of the soul from this world to the next. It was recognised that those committed to hell were beyond hope, but those assigned to purgatory could have their torments mitigated by the living through prayer, penance, alms-deeds and the

South Leigh Church, Oxfordshire. The Last Judgment or Doom *was usually painted over the chancel arch framing what is missing here, the figure of Christ on the cross flanked by the Virgin and St. John.*

Souls being weighed by St. Michael with an onlooking devil. Detail from a Doom *painting at Wenhaston Church, Suffolk. These formed the background to three dimensional representations, missing here, of Christ on the cross and the Virgin and St. John.*

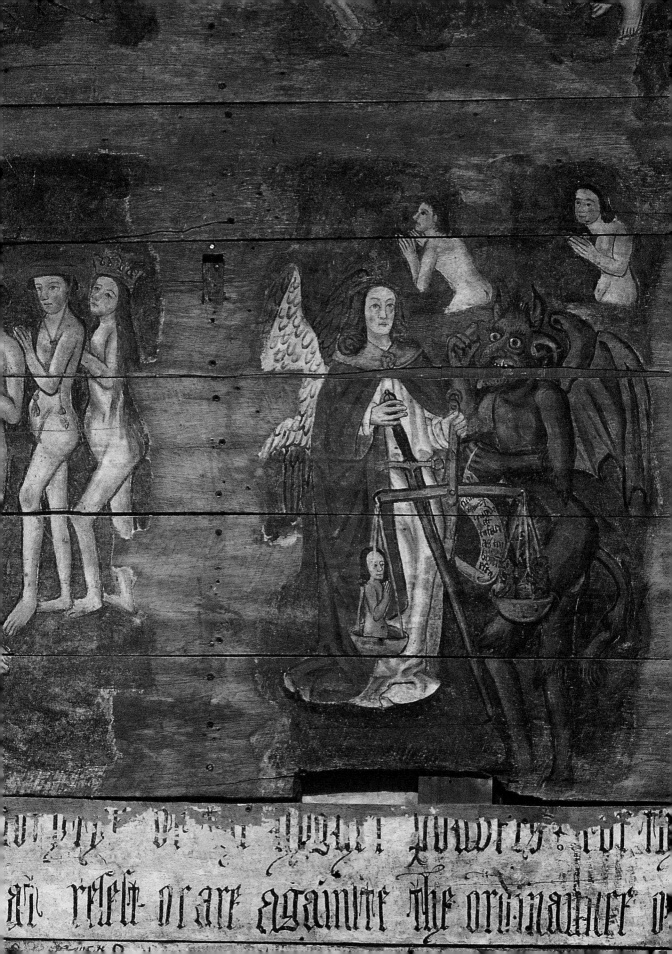

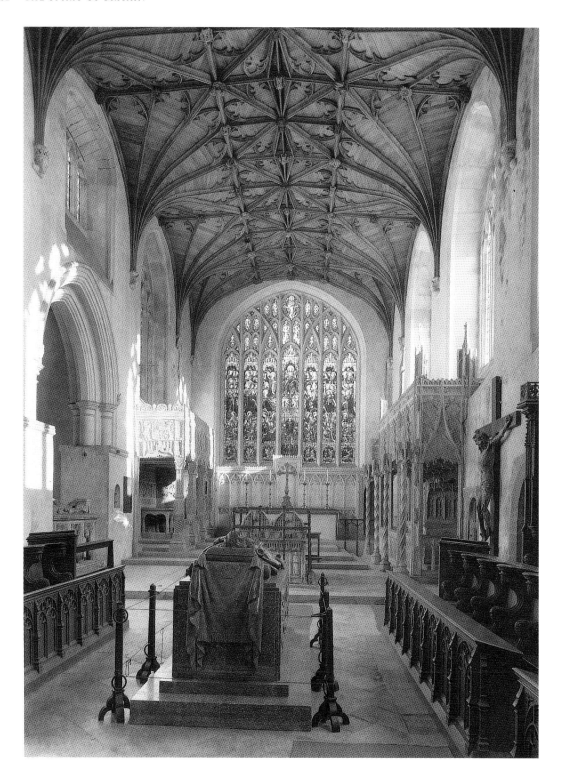

saying of masses. More than anything else purgatory accounted for the new wave of church adornment. The laity knew what purgatory was like for visionary saints had described it, priests dwelt on it in their sermons, and its cruel torments were graphically depicted in the great Doom or Day of Judgment painting over the chancel arch in which people could be seen frozen in ice, boiled in vats of liquid metal or impaled on meat hooks, in punishments neatly attuned to each particular vice.

All, however, was not lost because it was recognised that with careful planning much could be, if not averted, at least ameliorated. One method was by setting money aside for masses to be said for the soul. King Henry V provided for twenty thousand such masses, and the purchase of requiems by the thousand was widely expected of any great nobleman. A gentleman like John Clopton of Long Melford made provision in 1494 for two thousand to be said daily during the first month following his demise. Such provisions inevitably had an impact on the physical appearance of churches as family and fraternity chapels and chantries sprang up. There was also a keen desire to be buried close to the altar or in proximity to the Easter Sepulchre or the image of a favourite saint. As a consequence, tombs increased in number and, as brasses became cheaper and began to be mass-manufactured, the ability to leave a permanent memorial spread down the social scale to include the merchant classes. Everywhere the eye fell there was some artefact which prompted the living to utter a prayer for the dead. In spite of the fact that this was a period of economic stagnation it was one in which parish churches were enriched as never before. There was a lavish investment in the fabric and furnishings of churches; as many as two-thirds of them in England were either restructured or totally rebuilt. That accounts for the fact that between a third and a half of the ten thousand or so churches of any architectural merit in the country are mainly in the Perpendicular style. These include such masterpieces as St. Mary Redcliffe (Bristol) and the churches at Chipping Campden (Gloucestershire), Cirencester (Gloucestershire), Halifax (Yorkshire), Newark-on-Trent (Nottinghamshire), Saffron Walden (Suffolk) and Wakefield (Yorkshire). To that random list must be added the glories of the great wool churches of East Anglia. Everywhere the laity, either as single benefactors or, as was more often the case, part of a communal act of patronage, added western towers or spires, demolished and rebuilt naves or superimposed onto them clerestories, constructed massive new timber roofs (from which angels looked down with wings outspread) or extended the fabric by building new aisles or porches. These features we can still see today, but we need to remind ourselves of Roger Martin's description of Long Melford

The FitzAlan Chapel in the church of St. Nicholas, Arundel. The chancel of the church captures the peopling of it by tombs during the fifteenth century, in this instance those of the Dukes of Norfolk.

church to recall all that was given, but not long after-wards destroyed. Parish churches were already well equipped by the fourteenth century, so that the money was now spent on new images, or gilding, painting and

The magnificent timber roof of the nave of the church of St. John the Baptist, Needham Market, Suffolk, a late fifteenth-century masterwork.

embellishing existing ones. Equally there were gifts of new altars, new sets of vestments, stained glass windows or sacred vessels. As a result the visual texture of the average parish church became infinitely richer. And each and every single item had but one end in view, a means to ensure for ever the remembrance of the dead by those who remained.

But it was not only to be the visual element that was enhanced. Music was also seen as a means to reinforce and intensify prayer, and provision for its performance in the form of choirs often became an important part of chantry foundations, not only those at Oxford and Cambridge colleges or such places as Eton but also in collegiate establishments like that at Tattershall (Lincolnshire), where the early Tudor composer John Taverner began his career. The new polyphonic music, which consisted of an interweaving of melodic lines and called for many voices, had developed in court circles earlier in the century in the work of the composers John Dunstable and Lionel Power. This gradually spread into parish churches funded by pious parishioners and wealthy guilds. And the new wave of lay piety prompted new services. Vespers, originally a monastic observance, was taken up by secular churches, thus

prompting settings of the *Magnificat*. But the popularity of the new music also stemmed from its ability to present a ready means whereby to offer devotion to a particular saint, above all the Virgin, which often took the form of a votive antiphon sung by the choir before the image of the saint followed by a prayer by the officiant. By 1500 the settings for such antiphons had multiplied. The Eton choir book, the key score for music around 1500, contains no less than forty of them.

The emphasis on vivid mental imaginings of the life of Christ as a means to individual inner spirituality produced a growing demand for images, since religion emphasised the representational as a means whereby to approach God. Primers, or Books of Hours, taught the laity how to look even at the mass in terms of each gesture and movement of the priest re-enacting a particular moment in the passion narrative. The crucial moment was the elevation of the consecrated Host, the body of Christ come down from heaven. The priest held it aloft for the adoration of a congregation which, except for the most pious, received communion only annually, at Easter. Such a way of looking at things sustained, for example, the Nottingham alabaster trade. The workshops, which were at their peak from 1450 onwards, not only supplied both whole altarpieces and single scenes for churches but also maintained an export trade, which explains their presence today in churches as far apart as Spain and Iceland. They met, too, the demands of an ever-growing domestic market needing images for

A Nottingham alabaster of the Resurrection carved between 1400 and 1430. These were the subject of a large export trade to the Continent besides providing devotional pieces for prosperous households.

private devotion. In 1539 one Anne Buckenham of Bury St. Edmunds left 'to the chapel in the manor of Buckenham in Lyvermere Magna, my table of alabaster with the image of the Trinity, Saint Peter and Saint Nicholas, there to remain as long as it may endure'. In her case it was to vanish within a decade.

This universal quest for the soul's mystical union with the spirit embodied a shift of religion out of the cloister into the street and the home. The increasing availability of books and the spread of lay literacy were to accelerate this even further. That spread was driven by practicalities. Men now needed to read and write for business and administration in what was becoming an ever more complex society. To be literate meant that they had control over their own affairs and could deal with letters, bills, wills and ledgers, but it brought with it other benefits: the ability to read tales of chivalry and romance for entertainment, and to use words to aid the salvation of the soul. The languages they learnt to read and write in were, firstly, English and then a little French but not Latin, which, placed in the context of the Latin Book of Hours universally used by the literate for prayer, calls for some explanation. Such books, even before the advent of printing in the 1470s, were produced on a production line. They included collections of psalms, the liturgy of the monastic Hours, the Little Office or Hours of the Blessed Virgin Mary, but all in Latin. Their use by the laity indicates some knowledge at least of church Latin, but equally such books were pictorial and therefore aids for contemplation. And many of the pictures, like the one of Christ as the Man of Sorrows, carried with them an indulgence for the souls tormented in purgatory. Up until the Reformation the printing presses poured forth no less than a hundred and fourteen editions of the Book of Hours.

This was a world of belief which pulled in two seemingly contradictory directions, but ones which, if examined, were in fact complementary. The first led towards the privatisation and fragmentation of religion evidenced, for instance, in the architecture of churches, where the unity of vision of earlier centuries gave way to the breaking up of space into a series of visual incidents. Chantry chapels, tombs, images and screens intruded onto what had once been a whole. Everywhere there was an exuberance to which the insular Perpendicular style was admirably attuned with its delight in complex linear pattern serpentining across vaults, and its predilection for exotic broken skylines pierced by a forest of turrets. But approached from the second direction these were also reflections of a vigorous community spirit, which was to find its most profound expression in the corporate exercise of the mystery play.

The renaissance of religious drama had its roots

An illuminated page from the Book of Hours *of John of Lancaster, Duke of Bedford, c.1430. The duke, a member of the Order of the Garter, kneels in adoration before its patron, St. George, attired in a Garter mantle. In the borders are scenes from the saint's life.*

firmly in the seasonal rituals which every village, with local variations, enacted an-
nually. The year was a cycle in which the great festivals of the Church, above all those
of Christmas and Easter, were meshed into the labours of the agricultural year, Christ-
mas coinciding with the winter solstice and Easter with spring. The fifteenth century,
with its ever greater emphasis on actually re-living sacred events, saw liturgy move
towards becoming sacred performance. The ceremonies on Good Friday, the day of
the crucifixion, catch just such an escalation. After the congregation had crept bare-
foot to venerate it, the cross, together with the remaining consecrated Host from the
mass of Maundy Thursday, was 'buried' in the Easter Sepulchre on the north side of
the chancel. Such sepulchres were generally temporary structures and became more

and more elaborate. The one at St. Mary Redcliffe (Bris-
tol) was adorned in the 1470s with an image of the risen
Christ, hell with its devils, and four sleeping soldiers be-
side God the Father and the Holy Spirit 'coming out of
Heaven into the Sepulchre.'

Such scenic elaboration could, in the case of the
Palm Sunday processions, lead to lay people donning
costume and assuming the guise of biblical characters.
These ceremonies, which commemorated Christ's entry
into Jerusalem, began with a procession of the congre-
gation bearing branches of sanctified evergreen out of
the church to the stone cross in the churchyard. There it
awaited a second procession, that of the clergy bearing
the Host together with the church's relics beneath a
silken canopy, attended by singers dressed as Old Tes-
tament prophets. The congregation at the cross knelt
and kissed the ground at its approach after which the
two processions merged and circled the church to the
south side, where they were met by choristers who gree-
ted the Host with the anthem *Gloria, Laus et Honor*,
showering it with flowers and with unconsecrated waf-
ers. At the west door the Host and the relics were held
aloft, while the congregation entered the church be-
neath them. As the people entered, the curtain or veil
which had hidden the rood through Lent was drawn
back to reveal the figure of Christ on the cross while the
anthem *Ave Rex Noster* was sung. The mass followed.

*The fourteenth century Easter
Sepulchre in the church of St. Andrew
at Heckington, Lincolnshire, surroun-
ded by scenes of the Resurrection: the
sleeping soldiers, the three Marys at
the tomb and the risen Christ.*

Such theatricality developed hugely around what was the most spectacular addition to the late medieval liturgical year, the feast of Corpus Christi, a celebration of the doctrine of transubstantiation, that the bread and wine in the mass actually became Christ's body and blood. On that occasion the Host was again borne in procession out of the church attended by banners, flower garlands and lights. In the case of towns, the civic dignitaries, craft guilds, and confraternities were marshalled in order of precedence to walk through the streets. By the close of the fourteenth century the enthusiasm of the laity for biblical re-enactment was to generate the great cycles of mystery plays staged on that day. The earliest is recorded at York in 1376, Beverley the following year, King's Lynn in 1384 and Coventry in 1392.

Nothing was to impede their popularity until they were eventually killed off by Protestantism in the reign of Elizabeth. Medieval religious drama covered a wide range of formats from single plays which celebrated the life of a saint to morality plays, like *Everyman*, which were designed to teach right conduct. But its greatest expression was found in the mystery plays. These were utterly unique in their range, embracing in a sequence of cyclic episodes the complete Christian view of mankind from Creation to Doomsday. Such plays were arguably the most truly popular theatrical achievement of all time, staging the largest action attempted of any drama in the world, and they can still emotionally affect an audience when performed today. The plays were gigantic community projects, staged by and for the community itself. They were also triumphant reviews of Christian belief designed to move the audiences as profoundly as any image in a church or a Book of Hours. The York mystery plays embraced as many as forty-eight separate plays. All worked from a strong narrative drive, were episodic in their plot, and peopled by characters who were vivid types of an age. But there was always space within them for homespun humour, like Joseph's suspicions concerning the Virgin Mary's expectancy of a child:

> . . . Whose is it? as fair mote thee befall!
> MARY: Sir, it is yours and God's will.
> JOSEPH: Nay, Ine have nought ado withal –
> Name it no more to me, be still!
> Thou wot as well as I,
> That we two sam fleshly
> Wrought never swilk works with ill.
> Look thou did no folly
> Before me privily
> Thy fair maidenhead to spill.
> But who is the father? Tell me his name.

MARY: None but yourself.
JOSEPH: Let be, for shame.
I did it never, thou dotest dame, by book and bells!

Such humanity echoes down the centuries in honest Yorkshire, but the supreme moments were always reserved for the passion itself. What is not known is how these spectacles, which called for some three hundred players, were actually staged. In the case of York each play was played upon a pageant car propelled by human hands but capable of quite complex scenic effects. These all met at a certain point and then wended their way via an S-shaped route over the river Ouse and through the city to the great minster. There were special stopping places assigned to them en route but it is not known what for. It is usually accepted that they were for performing a certain play but others have argued that the plays were all performed in one open space at the close of the journey, or indeed not in public at all but under cover. No one knows. But what no one disagrees about is their quite extraordinary dramatic power. These are great sprawling chronicles held together by the doctrinal pattern of the Fall and Redemption told with a compelling and moving sensitivity, keenly aware too of the importance of juxtaposing light and shade, calm as against noise, silence in contrast to clangour. They take their place as one of the supreme achievements of English drama.

No one in 1500 could have foreseen that all of this world was to be swept away, that the churches were to be emptied and whitewashed, their images burned or smashed to pieces, the flickering candles before untold holy images snuffed out for ever. The days when the parish church was the laity's sole experience of architecture, painting, sculpture, music and theatre, fulfilling a deep spiritual need, were numbered. In contrast the cult of magnificence by the secular power of the State, using the arts as its handmaid, was about to enter a period of ascendancy which has lasted into our own age.

Chapter Ten

MAGNIFICENCE

Sir John Fortescue wrote about the monarch in his *The Governance of England* (1470) in the following way:

> . . . it shall need that the king have such treasure, as he may make new buildings when he will, for his pleasure and magnificence; and as he may buy him rich clothes, rich furs . . . rich stones . . . and other jewels and ornaments convenient to this estate royal. And oftentimes he will buy rich hangings and other apparel for his houses . . . for if a king did not so, nor might do, he lived then not like his estate, but rather in misery, and in more subjection than doth a private person.

In this way, in the third quarter of the fifteenth century, a fundamental change was articulated which was to become the driving force behind the arts for the next two centuries: the monarchy. And this was a change which was not necessarily to depend on either a ruler's taste or genuine interest. Such predilections were, of course, a bonus and could produce great works and remarkable collections, but the core was the system itself which sprang from the premise that lavish externals were essential to any successful exertion of political power. These externals in the main took the form we categorise as art: palaces, gardens, gold and silver plate, tapestries and jewels, indeed every kind of work of art, not to mention entertainments and festivals, literature, both prose and poetry, as well as music, both secular and ecclesiastical. Everything henceforth was to hinge upon the court as the ultimate arbiter of style and fashion.

Such a development was brought about by a number of converging factors, ones with a European context as well as ones which were peculiar to Britain. The latter sprang from the decline in esteem for the Crown which had marked the middle decades of the century, when the two great houses of York and Lancaster had struggled for its control in the Wars of the Roses. By then the lustre of Edward III had long gone and the country was saddled with a ruler, Henry VI, who had the makings of a monk and not a monarch. By the time that Fortescue wrote, the need to restore the dominance of the Crown was increasingly recognised. To achieve that, a king needed to establish distance not only from his humbler subjects but above all from the great

aristocratic families. He had immediately to be seen to be richer and more magnificent than anyone else. And that effect could only be achieved by conspicuous consumption on a scale unequalled in previous ages.

But it was a stance which had to be reconciled with the prevailing Christian ethic. For that justification there was a return to the philosophy of Aristotle who had written in his *Ethics* that '. . . great expenditure is becoming to those who have suitable means to start with, acquired by their own efforts or from ancestors or connections, and to people of high birth and reputation, and so on; for all these things bring with them greatness and prestige.' From this premise St. Thomas Aquinas was to classify magnificence as a virtue posed between the two extremes of excess and miserliness. Rulers were thus provided with a philosophical basis for display. Henceforth a prince must be seen to live magnificently, to dress splendidly, to furnish his palaces richly and to build sumptuously, for in so doing he was enacting a virtue.

Thus a political need was endowed with a moral justification and, in addition, across the Channel there was an example of the exercise of courtly magnificence to copy, the Valois dukes of Burgundy. They ruled over a kingdom in the making (which in the end never happened) which embraced virtually the whole of the Netherlands and Belgium as well as part of France. It was an area of untold commercial prosperity, providing the dukes with ample financial means whereby to make their court the most lavish in Western Europe. Through it they developed the outward trappings of late medieval chivalry to an extreme of complexity and ostentation, making an inventive use of allegory, pageantry and symbolism to enhance a new dynasty in pursuit of a crown. Everything was designed to impress. And that called for the patronage of an army of artists and craftsmen, musicians and men of letters, as well as those skilled in ceremonial and etiquette who together created a *mise en scène* of dazzling splendour which set the dukes apart from ordinary mortals. Their urban palaces developed into expansive complexes to accommodate a new court ritual through the addition of courtyards, gardens, and galleries, as well as provisions for diversions such as the tiltyard. Whether it was the performance of the choir at mass in the ducal chapel, the quality of illuminations in the books in the ducal library or the display of plate at a banquet, it had to outshine anything which existed elsewhere.

The Burgundian court also exalted a new upper class ideal, that of learned chivalry. The role of a knight was now to be attendance on the duke at court. He was not only, as in the past, expected to shine on the battlefield and tiltyard but to be educated, so that he might serve his prince in council, in embassies, and in government. It was a culture in which virtue and learning were intertwined with chivalry and in which the lines demarcating history from romance were blurred, both

providing examples for the emergent courtier to emulate in terms of stirring chivalric deeds and touching noble sentiments.

This was a court and a civilisation whose links with England were direct. The wool trade ensured that. But, in 1468, Edward IV's sister Margaret was to marry the future Duke of Burgundy, Charles the Bold. The English aristocracy attended the event in force and were quite overwhelmed by what they experienced. The new duchess

Massive displays of heraldry were typical of the early Tudor court, deployed in architecture and pageantry. This Tudor heraldic manuscript records the arms and beasts borne by, amongst others, Henry VIII, Cardinal Wolsey and the French king, Francis I.

made a state entry into Bruges which was bedecked with pageants in her honour. At the wedding a working model of her husband's castle disgorged mechanical musical bears, wolves and asses, and during the week which followed there was the legendary *Pas de l'Arbre d'Or*. In this joust the Grand Bastard of Burgundy re-enacted the *Roman de Florimont* and each knight who entered the lists came in disguise, often attended by allegorical pageant carts. The tournament had been transformed into a major theatrical event with scenery and costumes, speeches, songs and music, all to one end, to make apparent the magnificence of the Grand Duke of the Occident.

And so the scene was set for the English court to follow the path of this alliance of art and power. Edward IV was the ideal monarch to set this in motion. Vain of person, he revelled in rich clothes and calculated display. His coronation festivities in 1461 lasted three days and when, five years later, his wife was churched after the birth of Elizabeth of York, it was done 'in such costly measure that it is unbelievable that it could be provided'. But the real change in direction only happened after his exile at the Burgundian court during the winter of 1470-71. That he spent in the household of the Seigneur de Gruthuyse whose house in Bruges, still standing, contained one of the finest libraries in Europe. On his return to England Edward began to build up a collection of expensive illuminated Flemish manuscripts, histories and romances. In 1474 he sent for a copy of the duke's household ordinances which formed the basis for his own, enshrined in the Black Book. This divided the household in two, the offices below stairs, which included the kitchen, cellar and bakehouse, and came under the Lord Steward, and those above, including the Great Wardrobe, Tents and Works, which the Lord Chamberlain directed, and whose main thrust was to ensure regal ostentation and display.

His expenditure on outward show was prodigious. In 1468 alone he spent almost £1,000 on textiles and tapestries at a time when such a sum was the average annual expenditure of a viscount's household and the daily wage of the labouring classes was five pence. Expenditure on royal building soared, and this represented another change. The court ceased to be itinerant and began to settle, moving from one residence to another along the Thames Valley. Eltham, Windsor, Sheen and Greenwich were all altered or enlarged along Burgundian lines, the hall at Eltham alone surviving. Edward's focus, however, was above all on Windsor where the Order of the Garter was revived as a riposte to the new ducal Order of the Golden Fleece. In 1477 St. George's Chapel began to be built in earnest as a dynastic burial church, and the choir was complete enough to receive Edward's body in 1483. A fortune was

The Dance of Mirth, a scene from the most famous of all medieval romances, the Roman de la Rose, *c. 1490-1500. This Flemish illumination depicts the lavish taste and style of the Burgundian court which the Tudor dynasty sought to emulate.*

spent on vestments, hangings, and statues in precious metals. Edward spent more on building than any king since Edward III and in St. George's he left an architectural legacy which remains among the last and most perfect achievements of the English Gothic style.

Edward also modernised the choir itself at St. George's, adding nine clerks to the existing four and seven choristers to the existing six. This was in response to the greater demands of the new polyphonic music. Earlier in the century the English style of John Dunstable and Lionel Power had influenced the Burgundian court whose musical inventiveness was now in the vanguard. By the 1470s English music had lapsed into conservatism, but even then by 1500 the two-octave range of the early part of the century had increased to three, demanding four kinds of voice for its performance, treble, alto, tenor and bass, and the number of parts had increased from three to five. Nonetheless Edward IV had begun to lay the foundations for the heyday of the Chapel Royal, which was to come in the next century.

The Yorkist court, too, exulted in chivalry. The histories and romances which the king collected reflected that, so too does the only major literary composition of the period still readable today, Sir Thomas Malory's *Morte d'Arthur*, a prose romance of exactly the type devoured at the court of the king's sister. Chivalry was equally to the forefront in the new art of printing. It was Duchess Margaret who urged William Caxton to finish his translation of the *History of Troy* whose author was secretary to her father-in-law, Duke Philip the Good. When Caxton moved to England in 1476 he was to supply Edward's court with the same kind of books which the atelier of David Aubert had provided for the dukes of Burgundy.

Edward IV set the style which his Tudor successors were to develop into a high art form. In fact the Lancastrian Henry VII, the first Tudor, who took the crown by force of arms in 1485, only systematised what his Yorkist predecessor had begun. When he died over twenty years later he was to leave a household staff which exactly reflected the new role art played in the assertion of regal power. It included a royal librarian, a court portrait painter, a chronicler, and a deviser of festivals as well as glaziers, poets, musicians and players. The new division at court into two spheres, a public and a private, expressed by officers being either of the Presence or the Privy Chamber, added further to the mystique of monarchy. And artists were servants of the household, whose task it was to enhance the Crown through magnificent visual display and political eulogy. Even more than Edward IV, Henry VII, whose claim to the throne was remote and tenuous, needed to establish himself both nationally and internationally. This campaign was to reach its climax in 1501 when his eldest son married the king of Spain's daughter, Catherine of Aragon. All the artistic resources at the disposal of the court were orchestrated to celebrate this acceptance of the House of Tudor among the ruling dynasties of Europe.

Henry VII established the first royal library at Richmond Palace. Flemish illuminated manuscripts continued to be purchased as well as handsome printed ones which looked like manuscripts, those produced by the Paris press of Antoine Vérard. In 1485 Henry VII created the office of Stationer to the King and later came a King's Printer. Caxton died before that happened, but he received royal favour in his last years, dedicating romances to members of the royal

The first great Tudor palace, Richmond, seen across the Thames in a drawing made by Anthonis van Wyngaerde, c.1550. To the right stretch its gardens, encompassed by covered galleries.

RICHEMONT

Ant.° van den Wyngaerde fecit ad

family. The court chronicler was Bernard André, the blind poet of Toulouse, and the court's literary train included two Italians in the new humanist mode as well as two native writers, John Skelton and Stephen Hawes. Their task was to glorify the king and his policies. Stephen Hawes's *The Example of Virtue* (1504) and *The Pastime of Pleasure* (1509) are allegorical romances in the Burgundian manner.

Tudor magnificence was all about showy effect. Externals of any form had to look expensive, had equally to be seen to have called for high skill in their creation, and finally, their success was also measured by their ability to astonish and amaze those who saw them. These criteria applied as much to a pageant as to a palace. In 1497 the old royal palace of Richmond was burned down and within four years a new one had arisen from its ashes. It was of red brick in the Netherlandish manner with court-yards, galleries and gardens in the Burgundian style. It was to be the setting for the splendid dynastic festivities of 1501. These opened with a great pageant sequence for Catherine of Aragon's entry into London, based on a Burgundian poem. Then fol-lowed the entertainments at Richmond. By that date a permanent Master of the Revels had emerged and his task was to emulate the spectacles across the Channel. In one of these, eight maidens entered in a simulation of the Castle of Castile to be followed by a fully-rigged ship representing England, in which rode Hope and Desire who wooed the ladies on behalf of the Knights of Love. They arrived on what was a symbolic hill, the Rich Mount of England, stormed the castle, and took the maidens out to dance before the court.

The building programme of the first Tudor went on to include Greenwich (which was also based on a Burgundian ducal house), a reanimation of work on Henry VI's King's College, Cambridge, and the continuation of St. George's, Windsor. At King's College another new court officer, the King's Glazier, the German Bernard Flower, executed a masterwork in the new naturalistic Netherlandish stained glass style. These chapels were typical expressions of the piety of the period, with its eye on the passage of the soul to the next world. The most important of them was to be the Tudor dynastic chapel at Westminster Abbey. This was designed to receive the body of Henry VI, a king it was hoped would be beatified by the pope, thus endowing the Tudors with an aura of sanctity. No one in 1512, when it was completed, could have foreseen that it was to be the last, and in some ways the most magnificent, statement in the English Perpendicular style.

Henry VII had adhered to Burgundian ideals of learned chivalry but his successor was to enact them. The first twenty years of Henry VIII read like one long pageant. He was indeed to be learned chivalry personified, for he was trained in academic skills as well as being adept at music and in the tiltyard. Henry saw himself as a new

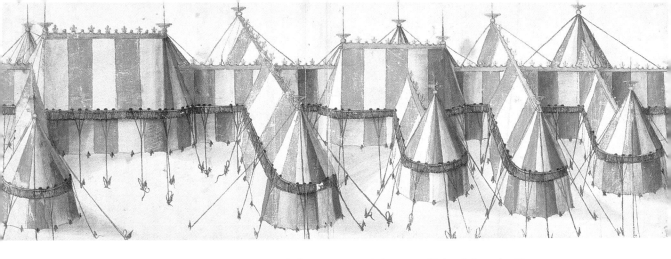

Edward III, a king of Camelot returned, bent on reviving English claims in France, and displaying his prowess in the joust and on the field of battle. The court style set four decades before by Edward IV reached its climax in the greatest pageant of Henry VIII's reign, the Field of Cloth of Gold in 1520 when he met the French king, Francis I, outside Guisnes. This gigantic festival epitomises all that the arts in service of magnificence had come to be. Some six thousand people crossed the Channel for the event. A temporary palace was erected for the king and queen, and was of such fairy tale fantasy that an Italian who saw it thought that not even Leonardo da Vinci could have conceived of such a thing. Over £6,000 was lavished on it; it was studded with Tudor badges and cognizances and the interior was hung with rich tapestries. The gateway was flanked by statues of appropriate heroes, Alexander and Hercules, and in front of the palace were two fountains dedicated to Cupid and Bacchus spouting beer and wine. There were banquets and entertainments and dancing. Indeed the ball given by the English was delayed while the French king kissed all the ladies, all that is except four or five who were 'old and not fair standing together'. The lavishness can be measured by the scale of one masque in which Henry VIII took part, for which the costumes were of cloth of gold garnished with white silks and lined with green sarsenet and visors were worn with beards fashioned of pure gold wire. The tournaments were staged in a vast arena which, on the last day, was transformed into a

Two designs for royal tents probably for the Field of Cloth of Gold in 1520, one in the Tudor colours of white and green, the other, far more splendid, in crimson and gold and crowned with the royal beasts holding heraldic pennons.

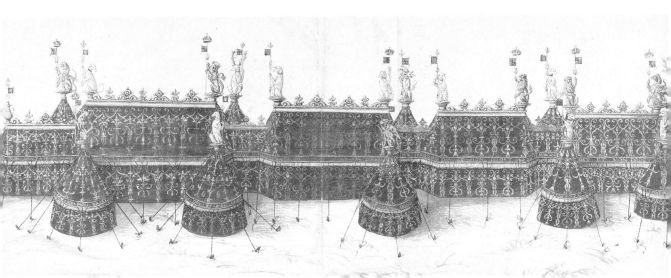

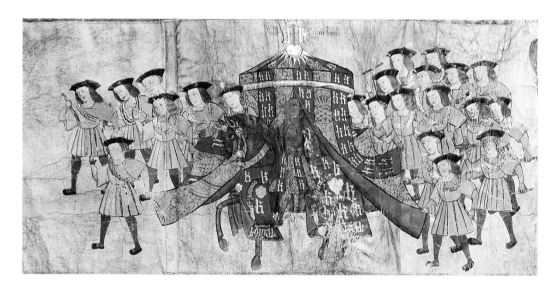

chapel for the final mass sung by the choirs and instru-
mentalists of the Chapel Royal. During this, a great arti-
ficial dragon belching fire was seen to fly across the
arena, much to everyone's amazement. No one caught
up in this never-ending round of revelry could have
guessed that the king's conclusion, in 1527, that he had

*Henry VIII enters the tiltyard at West-
minster disguised as the knight* Coeur
Loyal *at a tournament staged on the
birth of an heir in 1511. The elaborate
canopy borne over him is decorated
with the initials of his first wife,
Catherine of Aragon. The child died
shortly after.*

committed a sin by marrying his deceased brother's widow, Catherine of Aragon,
would bring the curtain down, changing not only the political but the cultural direc-
tion of the country. If the Tudors had already become prime exponents of the art of
magnificence it was as nothing compared with the unbridled splendour achieved by
the time of Henry VIII's death in 1547. By then his handful of residences had multi-
plied to almost sixty and it was to take four folio volumes to list the hundred thou-
sand possessions he was to leave behind. That transformation was made possible by
wiping out the medieval church, beginning with the man who had dared to eclipse
his sovereign's magnificence, Thomas, Cardinal Wolsey.

Chapter Eleven

END OF AN ERA: THOMAS, CARDINAL WOLSEY

In October 1529 Thomas, Cardinal Wolsey, was forced to resign as Lord Chancellor, an event to be followed a few weeks later by his indictment in the King's Bench of *praemunire*, that is, of being someone who had exercised an alien, in his case a papal, authority within the realm of England. Signing an admission of his guilt he surrendered all his goods to the king. His gentleman usher, George Cavendish, describes the memorable scene that then ensued at the cardinal's London residence, York Place:

> Then went my lord and called all the officers of his household before him, to take account of all such stuff as they had in their charge. And in his gallery there were set up divers tables, whereupon were laid a great number of rich stuffs of silk, in whole pieces of all colours, such as velvet, satin, damask, caffa, taffeta, grosgrain, sarsenet, and other not in my remembrance . . . Furthermore there were also all the walls of the gallery hanged with cloths of gold and tissue of divers makings and cloth of silver in likewise on both sides, and rich cloths of baudkin [brocade] of divers colours. There hung also the richest suits of copes of his own provision . . . that ever I saw in England. Then had he two chambers adjoining the gallery, the one called the gilt chamber, and the other called, most commonly, the council chamber. In each were set two broad and long tables upon trestles, whereupon was set such a quantity of plate of all sorts as was almost incredible. In the gilt chamber was set out upon the tables nothing but all gilt plate; and a cupboard standing under a window was garnished wholly with plate of clean gold, whereof some was set with pearl and rich stones. And in the council chamber was set all white plate and parcel gilt. And under the tables, in both the chambers, were set baskets with old plate, which was not esteemed but broken plate and old, not worthy to be used.

The picture Cavendish conjures up is one of the dismantling of magnificence, something to which Cardinal Wolsey's life had been a major monument.

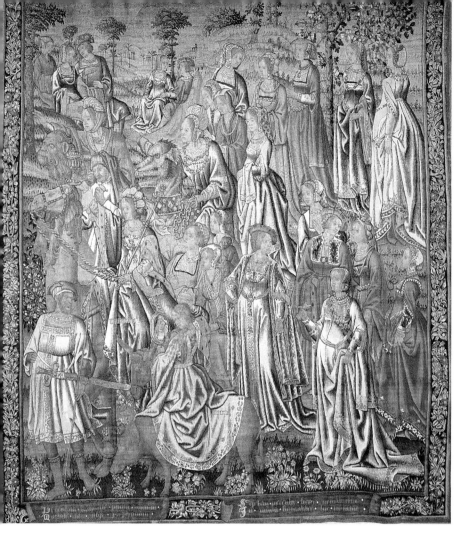

Born in the early 1470s, the son of an Ipswich tradesman, probably a butcher, Thomas Wolsey's intelligence was such that it took him to Magdalen College, Oxford, thus treading the only pathway of social ascent open to a man of his origins. Young Wolsey was clearly not only hugely talented but also supremely ambitious. At Oxford he quickly proved himself and entered the service of the Marquis of Dorset. From there he made his most significant step into royal service as one of Henry VII's chaplains. The king used him for diplomatic missions but it was only on the accession of the eighteen-year-old Henry VIII to the throne in 1509 that Wolsey's rise was dramatically to accelerate. Here was a king uninterested in the day-to-day business of government and here equally was an enormously capable and efficient man who could lift that burden from his shoulders. Wolsey swiftly established a hold over Henry VIII which led to the king showering upon him an unprecedented accumulation of offices both in Church and State. In 1514 he was made Bishop of Lincoln, to be followed a few months later by the archbishopric of York. The next year he received the prime office in government, the Lord Chancellorship. The see of Canter-

bury, however, was to prove elusive, its holder outliving him, but that was circumnavigated by making him first a cardinal and then papal legate, a position which gave him supreme authority over the English church, exceeding that of the Archbishop of Canterbury.

For almost a decade and a half Wolsey was to dominate both Church and State. In the former he interfered virtually everywhere, ostensibly in the interests of reform. In the latter his chief role was to raise money for Henry VIII's wars against France and to ensure his master a prominent place on the international stage. Such power could only attract enemies and provoke bitter satire. John Skelton catches the resentment stored up by those who had to bend the knee to the butcher's son at his grand country house at Hampton Court. 'Why come ye not to court?' he asks:

> To which court?
> To the King's court
> Or to Hampton Court?
> The King's court
> Should have the excellence,
> But Hampton Court
> Hath the pre-eminence.

Wolsey was a churchman on the grand scale, not unprecedented in European terms, but he was to be his country's last. His combination of benefices and political office, and the profitable exploitation of his legatine jurisdiction, gave him an income on a scale unheard of in the history of the English church. He would always hold at least one other bishopric along with his own of York at any one time, and he also appointed three non-resident Italians to others so that he could pocket the profits.

Here was a self-made man who needed to invent and project an image of himself and this he did by deploying art in its role as bestowing magnificence. Wolsey had building megalomania. From the outset money was poured into anything that was calculated to impress, from tapestries glinting with gold thread on the walls of his chambers to his processional presentation of himself attired in crimson satin and wearing jewelled slippers, escorted by noblemen and gentlemen and preceded by the great seal of England, his cardinal's hat, two huge silver crosses, and two weighty pillars of silver, symbols of his legatine authority. Ostentation, opulence, and luxuriousness were to be the *leitmotifs* of his patronage. Taste the cardinal may have lacked, but fashion, on the whole, he resolutely followed. Even with that judgment, his position as one of the great patrons of the arts cannot be denied.

Wolsey's building programme alone was the most expensive and magnificent of

its time. It was the sheer scale and multiplicity of his undertakings which were a source of constant wonder, rather than their style. At the time of his fall in 1529 his works organisation was larger than that of the king. Small armies of men were working on his London residence, York Place, his two main country houses, The More (Rickmansworth, Hertfordshire) and Hampton Court (Surrey), not to mention his other houses at Tyttenhanger (near St. Albans), Esher, Southwell and Cawood in the north. Add to that formidable list Cardinal's College, Oxford, and its feeder grammar school at Ipswich, and some insight can be gathered as to the sheer magnitude of Wolsey's building enterprises.

Behind it all lay a restless energy which drove things relentlessly forward. No sooner was one phase over than another, even more grand, was set into motion. York Place, the medieval town house of the Archbishops of York, was upgraded immediately Wolsey gained possession of it, but after 1520 he was to expand it, adding a vast long gallery as well as replacing the great hall and the chapel, and adding another gallery encircling its garden. But his two key properties were Hampton Court and The More, for they were rebuilt to receive the court and house the royal family and were hence a part of the cardinal's strategy whereby he kept the king's favour. Henry VIII was to visit The More eight times and Hampton Court no less than sixteen. Enough remains of Hampton Court to catch Wolsey's style. When he acquired it, it was a typical early Tudor courtyard house with a moat; he then proceeded to upgrade the house, adding a long gallery and service areas. In the 1520s, he launched into a far grander phase, adding a second court with a magnificent set of lodgings for the royal family stacked one upon the other as at Richmond Palace, with a processional staircase as an approach.

There was little, in fact, which was original in his domestic architecture. That was not for lack of interest, which could be intense, as is indicated by a recorded incident pertaining to his Ipswich foundation when he was shown 'the whole platte [design] of the college, to his pleasure therein'. His houses followed the familiar pattern of the period, being moated, constructed of red brick and with a succession of courtyards. Novelty can be registered only in the occasional addition of decoration in the new Renaissance manner, which stemmed from Italy, where during the fifteenth century a rediscovery of classical antiquity had revived the repertory of classical decoration, which was to cross Northern Europe at the opening of the sixteenth century. It had already begun to percolate England in the 1460s, but it was to accelerate in the 1520s, both because Italian sculptors had come to work in England and also because Wolsey and others had seen the introduction of such antique motifs at the French court. For Hampton Court the Italian Giovanni da Maiano was commissioned to fashion terra-

cotta roundels of Roman emperors. They remain still, inset into its red brick walls.

Within such houses richness of effect was achieved by a lavish deployment of stained glass, tapestries and plate. Wolsey was to employ the king's glazier Bernard Flower for York Place. Later he was to make use of another major glazier, a Fleming called John Nicholson. For the windows of his new chapel at Hampton Court the cardinal even ordered a design from abroad from Erhard Schon, a minor member of the circle of the German artist, Albrecht Dürer. In it Wolsey, attended by his patron saints, kneels, facing the royal family at prayer, thus raising himself to an equality of status. Cavendish vividly captures the splendour of his chapel: 'But to speak of the furniture of his chapel passes my capacity, or to declare the number of the costly ornaments and rich jewels that were occupied in the same continually. I have seen worn there, in procession, forty-four copes of one suit, very rich, besides the sumptuous crosses, candlesticks and other ornaments . . .' Wolsey's domestic apartments likewise attempted to dazzle, with plate set out *en tableau* to impress. When he entertained the French ambassadors in 1527 it was recorded that '. . . none of the same plate was used or stirred during this feast, there being sufficient besides.' His tapestry collection was deployed in a similar ascendancy of richness, as any visitor would experience as he walked through rooms hung with ever more splendid hangings, culminating in those which made a lavish use of gold thread framing the

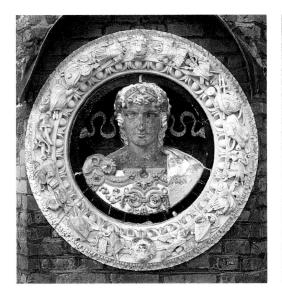

Terracotta roundel by Giovanni da Maiano, 1521, one of a series which originally decorated the inner courtyard of Wolsey's Hampton Court.

Terracotta panel at Hampton Court with two putti *in the Renaissance manner supporting Wolsey's coat of arms surmounted by his cardinal's hat.*

presence of the cardinal. Vast purchases were made. In 1522 he acquired twenty-two complete sets amounting to one hundred and thirty-two pieces. At its apogee, his collection of six hundred tapestries surpassed even that of the king.

In the same way, Wolsey's chapel at its height out-shone the Chapel Royal. No secular grandee or great churchman could avoid being a great patron of music. Its presence, represented by the finest musicians and singers, promoted an aura and an image of great wealth, diplomatic potency, and political weight. At its peak, Wolsey's chapel choir contained forty singers, thirty-two men and eight boys, the number required in order to perform the spectacular, expansive and virtuosic repertory of liturgical and para-liturgical choral polyphony which was one of the glories of late medieval English music. Wolsey scoured the country for the best voices and com-posers, and in his chapel could be heard the final flower-ing of the music of the period, in all its obsession with sheer expansive luxuriance and grandeur. Such music mil-itated against the adoption of the new principles of mus-

Design for three of the lights in the window for the chapel at Hampton Court by Erhard Schon or his work-shop, c.1520-29. Wolsey wears his cardinal's hat.

ical concision and responsiveness to natural rhythm and the meaning of the text which was already in vogue across the Channel. Nor, though he had experienced it, did Wolsey adopt from the Burgundian and French courts the addition of instrumental music to the liturgy thus adding an extra layer of splendour. Far from being a failure to

Three tapestry borders (see over, pp. 128-29) incorporating Wolsey's cardinal's hat, archiepiscopal cross, the arms of the see of York and his personal motto. Such borders were added to the tapestries he bought in quantity from Flanders.

keep up with musical trends, it was deliberate. Both king and cardinal cherished what set English music apart, a predilection for an abundance of florid melody and an indifference, in the main, to the text.

Music, too, was to figure largely in his major Oxford foundation, Cardinal College, where he established a choir of forty-two with the composer John Taverner as master of the choristers. His appointment again signalled Wolsey's commitment to the insular tradition. Cardinal College was an educational enterprise designed to eclipse in scale and quality the works of all his predecessors from William of Wykeham onwards. It was to be fed by no less than fifteen grammar schools scattered across the country, of which only one, that at his home town of Ipswich, was ever begun. This was self-apotheosis, for he named the college effectively after himself. Its role was to produce an educated clergy in an era when the Church was under increasing attack and, in Germany, the Lutheran Reformation was already under way. Cardinal College was begun in 1525 and by 1530, when work stopped, there was a staff of two hundred and the vast sum of £22,000 had been spent. Its annual income, achieved by suppressing no less than twenty monasteries, was more than twice that of its nearest rival. The building, which was never finished, still remains one of the last great works in the Gothic style, well described by Wolsey's servant, Thomas Cromwell, in a letter to his master: 'The like was never seen for largeness, beauty, sumptuous, curious and substantial . . .' The chapel, never built, was to have been larger than that of King's College, Cambridge. The hall, which was completed, was a quarter

larger than that in any other Oxford college. Once again the unspoken aim was to outshine royalty.

Cardinal College was Wolsey in his role as patron of learning, but of what kind? Its founding statutes provided for six public lecturers in theology, humanity, canon law, civil law, philosophy and medicine. The appearance of the humanities indicates Wolsey in his role as patron of the new humanism. This movement began in Italy over a century before, and the term 'humanist' described a teacher committed to the progressive educational movement known as *studia humanitatis*. Wolsey's appointment achieved a massive injection of classical literature into what was otherwise a programme heavily weighted towards traditional scholasticism. Indeed in 1523 he secured the services of a famous humanist scholar, the Spaniard John Vives. Such a policy, however, sat awkwardly with the cardinal's continued bias towards the scholastic method in theology, which he believed to be the only means of rebutting the spread of the Lutheran heresy.

Everything connected with Wolsey was over life-sized. Even his tomb, built, as was customary, during his own lifetime, was designed to cast into the shade those by the Florentine sculptor Pietro Torrigiano for Henry VII and Elizabeth of York in Westminster Abbey. Such sculptors were sought all over Europe, their clients recognising their virtuosity and the novelty of their style in comparison with that of their Gothic peers. Wolsey employed Benedetto da Rovezzano to build him what, if it had survived, would have been the first wholly Renaissance monument in England on the grand scale. Made of marble, bronze and gilt, materials usually reserved for royalty, it had Wolsey's recumbent effigy surrounded by four massive tall pillars, emblems of his legatine status, topped by angels holding huge candelabra.

But it was not to be. Everything worked, as long as the cardinal could humour the king's slightest whim. However, by the close of the 1520s, Henry VIII had not only decided that his marriage to his deceased brother's wife was sinful but also had fallen in love with Anne Boleyn and wanted a divorce in order to marry her. Wolsey sup-

ported the king in his desire and worked for a papal dispensation for the marriage. In that quest he failed, the pope sending Cardinal Campeggio to preside over a legatine court which decided nothing, the case being recalled to Rome. By then Wolsey had incurred the enmity of the rising Boleyn faction and by the close of the year he had been stripped not only of his offices but all his worldly goods. He still held the archbishopric of York and so set off for the north but was arrested not long after. He died on the journey south, one which would only have ended in execution.

The king had already taken Hampton Court from him in 1528, and was later to transform York Place into Whitehall Palace, adding to it Wolsey's long gallery from Esher. Even the cardinal's tomb was taken over, to be remodelled to accommodate the king. Wolsey's household staff were dispersed, his college at Ipswich was suppressed, and Cardinal College, re-named King Henry VIII's College, dwindled to being an ecclesiastical college of secular canons. It was only at the close of the reign that it was to be refounded again by the king as Christ Church and five regius chairs endowed. What Wolsey initiated led nowhere, and everything he did laid him open to the charge of false pride and pomp. To those on either side of what was soon to become, with the advent of the Reformation, the theological divide, he came to represent everything that was wrong with the late medieval church. The events which followed his death were to ensure that he was to have no successors. Never again was a churchman to be a patron on such a scale. Henceforward the arts were to serve solely the Crown and the aristocracy. In the gross figure of Wolsey we move out of the Middle Ages and into the Renaissance.

Chapter Twelve

CLASSICAL INTERLUDE

In December 1499 the great Dutch humanist, Desiderius Erasmus, wrote of his delight at what he regarded as a flowering of learning in England:

> When I listen to Colet it seems to me that I am listening to Plato himself. Who could fail to be astonished at the universal scope of Grocyn's accomplishments? Could anything be more clever or profound or sophisticated than Linacre's mind? Did Nature ever create anything kinder, sweeter, or more harmonious than the character of Thomas More? But why need I rehearse the list further? It is marvellous to see what an extensive and rich crop of ancient learning is springing up here in England.

Erasmus was encapsulating in one paragraph the prime exemplars of what was one of the great revolutions of the sixteenth century, a new programme of education based on the humanities. In it he lists those who were to be the beacons of that change: John Colet, Dean of St. Paul's and founder of the famous school, the Greek scholars William Grocyn and Thomas Linacre, and Sir Thomas More, Lord Chancellor to Henry VIII and author of *Utopia*. All four, like Erasmus, represented a new type of scholarship, humanism.

The humanist movement is at the heart of what we recognise as Renaissance civilisation. It sprang out of an existing tradition, the classical *studia humanitatis*. In one aspect this had been a continuous thread within Western European civilisation since classical antiquity. It was evident in what was the rhetorical tradition, which used classical authors as a basis for the theory and practice of letter and speech writing, as opposed to their customary use by the schoolmen of scholasticism solely as quarries for information. Such texts offered lessons in grammar, the writing of poetry, history, letters and speeches, as well as lessons in moral philosophy. But these studies were marginalised within the medieval curriculum, only moving to the centre in Italy when a new educational movement got under way in the fourteenth century with the advent of the humanist, who taught a curriculum which embraced the humanities: grammar, rhetoric, history, poetry, and moral philosophy. Gradually the medieval tension between Christian and pagan thought gave way to an approach which cast

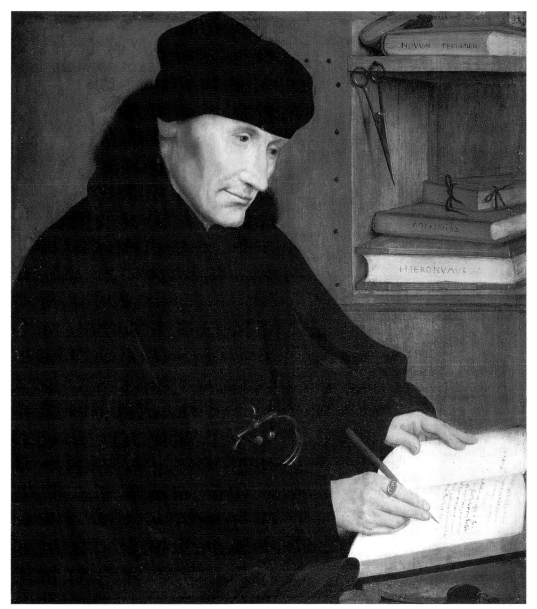

antiquity as anticipatory of the Christian revelation. This was accompanied by a huge return to, and search for, classical texts, both ones unknown and ones which, although known, had been corrupted over the centuries.

Portrait of the great Dutch humanist Desiderius Erasmas seated in his study, by Quentin Massys, 1517. The portrait was sent as a memento to Thomas More.

What sets this humanist programme of study apart was that its focus was not necessarily clerical but lay. In Italy it was initially the product of a rich urban society anxious for a new and virtuous way whereby to express wealth and power, finding it in the patronage of men of letters, assembling libraries, and commissioning works of

art and architecture. Humanists were to depend for a living on patronage and it was not long before they migrated to what was to become the lodestar of the coming centuries, the court. Humanist scholars and writers became essential adjuncts of the courts of the new princely dynasties emerging in Italy during the fifteenth century, the Este of Ferrara, the Gonzaga of Mantua or the Sforza of Milan. The humanists in return endowed their patrons, by means of their poetry and prose, with the glories of the rulers of classical antiquity, which for the first time was seen as a separate civilisation, one whose letters and art now needed to be recaptured and recreated. This was to be the driving force which created the Renaissance, one which produced not only the new educational system but also new styles in painting, architecture and sculpture. All of these were to cross Europe and eventually make their way to Britain, where the educational thrust was the one to be more quickly absorbed than the aesthetic for the reason that it was perceived to be useful to the new political classes.

During the fifteenth century the clerical basis for administration in government had begun to crumble. Increasingly, offices passed into the hands of the laity. Already by 1400 literacy was required by the aristocratic and gentry classes, and often of their women too, in order to run their estates and households or exercise the offices of Justice of the Peace, Member of Parliament, or sheriff. But as time passed they, in turn, needed educated people to assist them and more and more they started to look towards lay people rather than clerics. The reason for this was a very simple one: clerics enjoyed a degree of immunity. A layman, on the other hand, could be made, or indeed broken, at the behest of a superior. On the lay aspirant's side, such a career began to offer a way up for the first time without taking holy orders and being bound to celibacy. Instead it could be a path to ennoblement and the founding of a dynasty. So through the fifteenth century the scene was gradually being set for the reception of the humanist educational programme by a laity which had already acquired a smattering of law necessary for a litigious society, plus sufficient arithmetic to engage in trade, commerce and estate management, and enough knowledge of letters to fit it for administrative service to the king, a great aristocrat, or a bishop.

So the impetus can be seen from the outset to have been above all utilitarian. But in the early stages the arrival of humanism was in the main confined to the closed world of learning. During the fifteenth century its percolation was to be piecemeal and cumulative, achieved in fits and starts by an erratic stream of patrons, with individual English and Italian scholars acting as the bridgeheads. It was Henry V's brother Humphrey, Duke of Gloucester, who was the first Englishman to appreciate humanism and to collect a library of both classical and neo-classical texts. That library included newly discovered classical works as well as those by more recent Ital-

ian authors who epitomised the new cultural energy, Dante, Boccaccio and Petrarch. Duke Humphrey also employed Italians as Latin secretaries, who could write in the elegant new neo-classical style acquired through studying authors such as Cicero. Vain and ambitious, it is difficult to know what prompted the duke to pursue this path for he was no scholar, but the fact that he handed his library over in instalments to the University of Oxford ensured his lasting influence. On his death in 1447 the final volumes arrived to adorn, as they still do, that part of the Bodleian called Duke Humphrey's Library.

His successor within the aristocracy was John Tiptoft, Earl of Worcester. Unlike Duke Humphrey he had actually studied in Italy at the university of Padua and also under one of the great humanist teachers, Guarino of Verona. Tiptoft was to be a major patron but his notable library was dispersed on his execution in 1470. Duke Humphrey and John Tiptoft were princely luminaries in a firmament otherwise made up of lesser stars, individual scholars who made their way to Italy. The three most important ones also studied under Guarino: William Grey, later Bishop of Ely and Chancellor of Oxford, Robert Flemming, Dean of Lincoln, who was the first Englishman to learn Greek, and lastly Tiptoft's secretary, John Free, who was the most accomplished English, Latin and Greek scholar of the age. Simultaneously there was a steady stream of diplomatic exchange with the Papal Curia in the Vatican where the new humanist style reigned supreme. The standard of their Latin was such that it demanded an equal elegance of response, one which only a humanist could provide.

And it was that which prompted the entry of humanists into government service. Although the infiltration had begun under Edward IV, it was during the reign of Henry VII that the humanities really came to court for the first time. The king employed an Italian humanist, Pietro Carmeliano, as his Latin secretary and he was also to give his children a humanist education. The teachers of the eldest, Prince Arthur, included Thomas Linacre, those of the youngest, the future Henry VIII, the poet John Skelton. Henry VIII's accession in 1509 was indeed hailed by Erasmus as the advent of a humanist golden age: 'Heaven smiles, earth rejoices; all is milk and honey and nectar. Tight-fistedness is well and truly banished. Our king's heart is set not upon gold or jewels or mines of ore, but upon virtue, reputation and eternal renown.' His first queen, the Spanish Catherine of Aragon, was also humanist educated and so was their daughter, Mary, and the king's two other children by later marriages, Edward and Elizabeth, were to be likewise.

Until the close of the 1520s nothing was to disturb this alliance of the new humanism and the Tudor dynasty, ensuring its firm infiltration into both universities. At the outset it embodied no seeming threat to scholasticism but was viewed

rather as a means whereby it might be reinvigorated. Late medieval scholasticism had witnessed the divorce of reason and faith under the aegis of the two great Franciscan doctors, Duns Scotus and William Ockham. Scotus had argued that God was so free that he escaped from human reasoning. Ockham completed the separation by arguing that reason could no longer support or confirm belief. Scholasticism thereafter tore itself asunder in battles between adherents of Aristotle and Thomas Aquinas and those of Ockham. Out of this academic débâcle came a complex of currents of thought which included the logical and scientific work of William Heytesbury and Richard Swineshead, both fellows of Merton College, Oxford, as well as a retreat into anti-intellectualism typified by late medieval mysticism. Overall, scholasticism was in irretrievable decline.

The humanist invasion of Oxford and Cambridge was achieved by a whole series of new foundations which incorporated both the existing scholastic, and the new, humanistic, forms of curriculum. These included St. John's College, Cambridge, founded by John Fisher, Bishop of Rochester, assisted by Henry VII's mother, Margaret Beaufort, Countess of Richmond, and Richard Fox, Bishop of Winchester's Corpus Christi, Oxford. The public lectures in Greek at the latter were to produce such a violent reaction from the schoolmen that Henry VIII called on Thomas More in 1518 to defend the new teaching. 'I need hardly mention,' he wrote, 'that the New Testament is in Greek or that the best New Testament scholars were Greek and wrote in Greek.' Cardinal Wolsey's great college had it proceeded would have been the crowning glory, ensuring a humanist education for the clergy of the whole country, but it was not to be. Instead as the 1530s progressed the events of the Reformation were to dislocate both universities, canon law as a result disappearing. But, by the close of the reign, lectures in Greek and Latin were an established fact and the education of the clergy was provided for by the two new royal foundations of Trinity College, Cambridge and Christ Church, Oxford.

The stars in the English humanist firmament were few and they all knew each other. William Grocyn, Thomas Linacre and John Colet all studied Greek and Latin and taught at Oxford. The greatest of these was Colet whose series of lectures on the New Testament in 1496, when he was barely thirty, inaugurated a revolution in biblical study and scholarship. The whole scholastic accretion of commentaries, notes and summas, was swept away; instead Colet went directly to the original Greek text, setting it into its historical context. Colet's influence as a teacher was to be

Presentation copy of Pandolfo Collenuccio's Apologues *and Lucian's* Dialogues *to Henry VIII. The manuscript was a gift from one Geoffrey Chamber who had commissioned the most famous of Italian scribes, Ludovico degli Arrighi, to execute it. The decoration is by the celebrated Florentine illuminator, Attavante degli Attaventi. Together they epitomise a new style, both humanist and Renaissance.*

PANDVLPHI
COLLENVCII PISAVRENSIS
APOLOGVS
CVI TITVLVS
AGENORIA

NER
tiam natu in
ter filias mi
norem, fatuã
alioquin atqʒ
inſtrenuam
fœminam, Sed cui blanda ſpecies atqʒ al
lectrix eſſet, Labori, commuui gentium
Deo, Orcus pater vxorem dedit, In=
gentes (ut eſt locuples deus) dotis nomi=
ne diuitias pollicens, ſi ex ea liberos gi

immense. He brought to England the humanism of Renaissance Florence, where he had studied, taking it first to Oxford and then to London, where he refounded St. Paul's School. This was a landmark event in the history of education, for it was to be the model for every reformed grammar school that followed. Erasmus was involved in framing its constitution and its first High Master was William Lyly whose Latin grammar was in 1540 to be accorded the style of King's Grammar, and as such to be used in every school in the realm.

St. Paul's catered for the sons of courtiers, gentlemen, and city merchants. They had come already fluent in reading and writing, both in the vernacular and in Latin. The teaching was based solidly on classical texts, such as Terence, Virgil, Cicero, Horace and Ovid, and modern neo-classicists, such as Erasmus. In this way students were prepared for their encounter with scholasticism when they moved on to the universities. Colet's revolution was to sweep through Eton and Winchester and on through the lesser grammar schools of the country.

What was framed was a system of instruction which was based on the belief that training in virtue and good letters prepared a man for public service. It was to be the educational norm until the twentieth century, one which saw a thorough competence in Latin grammar and practice in using the language for speaking and writing as the foundation stone of an informed intellect. Its bedrock was the absorption of the classical rhetorical writings of Cicero and Quintilian with the aim of producing an elegance of literary composition. Piety and morality were instilled through the study of good literature, and the eloquence thus attained was to become one of the most cherished attributes of the new Renaissance gentleman.

One book was to sum up this new ideal for the layman, Sir Thomas Elyot's *The Boke Called the Governour* (1531). This incorporated a humanist programme of study into one which also called for training in the other gentlemanly pursuits, the mastery of the art of war, the hunt, sport, and the social accomplishments of music and the dance. Elyot's book also incorporated the new qualities called for in two other publications which had a European impact on the refashioning of the educated layman, Erasmus's *The Institution of a Christian Prince* and the Italian Castiglione's *The Courtier*. By 1550 the ideal gentleman was expected to have a knowledge of Latin and Greek, have read the scriptures, the classics and modern humanist works, have studied eloquence, acquired a good and fluent literary style, and even to write poetry. As this study of the humanities began to influence the vernacular, the English Renaissance came into flower. This was instruction of a kind that was to produce Edmund Spenser, Sir Philip Sidney and William Shakespeare, the products of the Merchant Taylors' School in London, Shrewsbury School, and the grammar school at Stratford-upon-Avon respectively.

Not everything, however, was forward-looking about this revolution. It was in a sense strongly élitist and hermetic. Scholasticism had belonged to the hurly burly of the city, whereas humanism pertained to the solitary life of the study or to exclusive groups like academies or the glittering world of the court. It also led to a divorce between theory and practice, science and technology, increasing an already incipient divide even more sharply. But these shortcomings were not to evidence themselves until much later.

The humanist education which formed the Tudor upper classes (which could in this early phase include women) was deeply Christian, founded on a belief that the ancient Romans and Greeks had developed an ethical system compatible with the Christian faith. Its earliest exponents were all profoundly committed to a reform of the Church. They attacked scholastic theology as arid and denounced much of the paraphernalia of late medieval religion, the cult of saints and relics, pilgrimages and

EPISTOLAE PAVLI APOSTOLI, AD
GRAECAM VERITATEM ET VE/
TERVM LATINORVM CODI/
CVM FIDEM RECOGNITAE
PER ERASMVM ROTE/
RODAMVM SACRAE
THEOLOGIAE
PROFESSOREM.

Erasmus's translation of the Greek New Testament into Latin, the first to be published, printed in Basel in 1516.

indulgences. Their simple, if naive, belief was that if the scriptures were placed before the people in their pristine purity Christian renewal would automatically ensue.

All of this reflected the enormous impact of Erasmus, who had visited England on several occasions and secured major patrons. He was to lecture on St. Jerome at Cambridge and even write his celebrated *Praise of Folly* here. Colet was to point him in the direction of biblical translation which led, in 1516, to his new Greek text and Latin translation of the New Testament, a publication which was greeted with acclaim in England. Already, even by the 1520s, Erasmus's works were being translated into English and his particular brand of Christian humanism was to leave a lasting imprint.

Perhaps his closest English friend was Thomas More, whose life, which ended in tragedy, was to typify the early Tudor ideal, a man who combined legal and classical studies with a deeply spiritual existence. More was a brilliant Latinist with a persuasive, witty and subtle prose style. His *Utopia* (1516), which describes a visionary country without poverty, crime or injustice, was written in response to an economic and social crisis and also with the urgent need for a reform of the Church in mind. It received international acclaim and was printed in Paris, Basel and the Netherlands. Its format was the classic humanist one of the dialogue, with its sense of quest and

inquiry. More's life epitomised the humanist dilemma. Was the true good to be pursued in the solitude of the study and pious exercises, or was it to be found in government service and the conduct of public affairs? In 1517, when he became a member of the king's council, the die was cast in favour of the latter, although he was never quite to relinquish his contacts with the humanist world. Nothing was to disturb what was a brilliant career in royal service, culminating in his appointment as Lord Chancellor, until the king moved to divorce his wife and then, during the early 1530s, to go on and break with the universal Church of Rome, leading England into schism. More was opposed to both and on the day after the clergy, in May 1532, submitted to Henry VIII, acknowledging him as Supreme Head of the Church, he resigned the chancellorship. Nothing would shake More's commitment to the unity of the Church and to the validity of tradition. As a consequence, on 6 July 1535, he was executed.

He was not the only humanist to suffer this fate, for it was also meted out to the saintly John Fisher. It was to be the Reformation which was to split the humanist ranks. Initially many had shared the criticisms of the Church which the German reformer Martin Luther made but when, in 1521, Luther defied not only the pope but also imperial authority they began to draw back. The humanists during the opening phases of the Reformation attacked Luther. Then came the problem of Henry VIII's royal divorce, followed soon after by the Acts which set in train the English Reformation. The humanists divided down the middle. There were those, like More and Fisher, who remained loyal to the old scheme of things. The price they paid was obliteration. But there were others, evangelical humanists, who embraced the king's cause. Patronised by the new queen Anne Boleyn and her circle, they formed a network at court which was never quite dislodged. And it was to be these men who were to set the style of English humanism. It was to be Protestant and fiercely patriotic. But also, because of the break with Rome, it was to be cut off from the original source of its inspiration, Italy. That break was to last until the opening years of the next century, delaying thereby the reception of the fruits of the Renaissance revolution in the field of the visual arts. But its literary seeds, firmly planted within the new educational system, were to bear abundant bloom, heralding a civilisation whose focus henceforth was to be the word rather than the image. That obsession with the word was to be emphasised as never before because of another traumatic event precipitated by the Reformation, iconoclasm.

Chapter Thirteen

A CULTURAL REVOLUTION

Philip Howard, Earl of Arundel, was to die a prisoner in the Tower in 1595 for his adherence to what was by then the old pre-Reformation Catholic faith. Through four decades, from 1530 to 1570, the Tudor government set out to destroy a whole way of life in what was the greatest revolution of the century. It was one which was also profoundly cultural for it swept away, in successive tides of destruction, the art of centuries, not only physical artefacts, like statues or stained glass, but art as expressed through ritual and the spoken and sung word. In a lament for the passing of the great pilgrimage shrine of Our Lady of Walsingham in Norfolk, traditionally written by Arundel, we catch the poignancy felt for what for most must have been an irretrievable loss:

> O level, level with the ground
> The towers do lie,
> Which their golden glittering tops
> Pierced unto the sky.
> Where were gates no gates are now,
> The ways unknown
> Where the press of peers did pass
> While her fame far was blown
> Owls do shriek where the sweetest hymns
> Lately were sung;
> Toads and serpents hold their dens
> Where the palmers did throng.
> Weep, weep, O Walsingham . . .

This was a shrine to which Henry VIII had once walked barefoot. By the time that he died it had vanished, been stripped bare and demolished, reduced to a pile of stones and rubble silhouetted against the East Anglian sky.

When Arundel wrote this poem all the great shrines of medieval England had already gone, so had all the monasteries and the monks, so too had every sculpted and painted image from every parish church. So had the Latin mass, processions, the

cult of the saints, purgatory, and the cycle of saints' days which since time immemorial had framed the year for everyone. The ladder from earth to heaven by means of physical artefacts and symbolic acts had been swept away. The church as a holy place where God, under the form of the reserved sacrament, dwelt in the pyx suspended above the altar had gone. Instead the building stood as a whitewashed shell in which believers gathered to hear the word of God read from the lectern or expounded from the pulpit.

In the 1520s every aspect of late medieval traditional Catholicism was still in place. Through the rites of the Church, as administered by its priests, the Lord conveyed his life to the believing community through the seven sacraments. These marked the passages of each person's life: birth, confirmation, marriage and death. They also fixed the pattern of the year, which was punctuated by days like Christmas, Easter and Whitsun, besides a host of feast days and, in addition, the weekly Sunday mass. The dead remained at one with the living, their memory etched into the church both in its ritual and prayer life as well as in the very fabric of the structure in the way of memorials. This was a religion which called for the attributes of art, for images, pictures, books, vessels, vestments and banners. Everything worked from the premise that the spiritual world could be communicated with via the material. And it was that view of things which was to be obliterated, having in the long term a profound impact on the structure of people's minds and imaginations. All of this was to be cast aside not through popular demand but by order of government. Rebellions did occur but they were ineffective because of people's deep sense of obedience to higher authority. That, plus a progressive erosion over time, led finally to resignation to the inevitable.

This change of attitude to late medieval Christianity had been set in motion by the humanists, above all Erasmus. They had increasingly demanded the pruning of what they viewed as its unnecessary and corrupting externals. Their demands, however, over the veneration of relics and images or the practice of pilgrimage, were never for their total abolition but for their reform. But all of that was to change as reformers in the wake of the German Reformation movement of the 1520s began to articulate a far more radical approach. Already, in 1531, William Tyndale, the translator of the Bible into English, had written that since God is spirit he should be worshipped in spirit: 'Sacraments, signs, ceremonies, and bodily things can be no service to God in his person . . .' In just one line Tyndale had pronounced the death knell of traditional religion. Increasingly, to reformers, the text or word of God became everything and the sign or symbol nothing. In their view the sacramental world of late medieval Catholicism was opaque, bewildering and meaningless. In what was to form in the

coming decades the new Protestant ethic, real objects were to be preferred as against simulated ones, that is, true good works rather than works of art. In the reformers' view the superiority lay in God's own creation manifested in the world of nature and not in images made by man. Christ was to be the sole mediator between God and man, rendering obsolete not only the role of the Virgin Mary and the saints but all tangible signs and ceremonies. In its extreme form of Puritanism, Protestantism came to distrust all man-made objects of beauty. The new ethos was to have a profound effect on the cultural evolution of the country.

But the opening phases of the Reformation had seemingly little immediate effect on traditional religion. England went into schism and a new Archbishop of Canterbury, Thomas Cranmer, granted the king his divorce from his first wife and he married Anne Boleyn. The attack only gained momentum with the fall of the humanist chancellor, Sir Thomas More, in 1534. More had realised that if the onslaught increasingly mounted by the reformers on images in churches was successful the whole structure of traditional religion would in the end follow. And in this he was to be proved right.

Until 1547, when Henry VIII died, that attack went in two phases: the first, running to 1540, was to be savage with the evangelicals in the ascendant; the second, which lasted until the end of the reign, was to be ambiguous as reformers and conservatives were locked in a struggle to gain the king's support, either for further change or to maintain the status quo. In 1534 William Marshall's *Primer* in English was

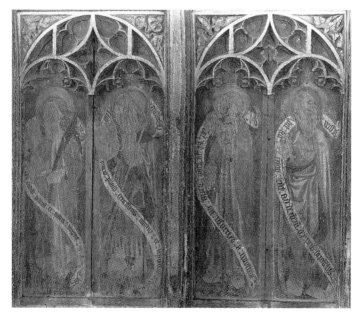

Iconoclasm in action. The faces, hands and feet of the Apostles have been gouged off the wood on this rood screen in the church of St. Peter at Ringland in Norfolk.

published which contained an implicit assault on the cult of the saints, but that only affected the population when, in 1538, all shrines which were centres of pilgrimage were ordered to be destroyed. During these years the evangelical attack under the patronage of Thomas Cromwell, by then the king's chief minister, was to reach its zenith. Down went the great shrines such as those of St. Thomas Becket at Canterbury, St. Cuthbert at Durham and St. Edmund at Bury. The commissioners' carts took away the gold and jewels for the king's treasury where the gold was melted down while the structures themselves were razed to the ground. An example of what was destroyed is caught in an account by a former monk, written in the Elizabethan period, of the shrine of St. Cuthbert which had 'most curious workmanship of fine and costly marble, all limned and guilted with gold.' The cover or feretory which concealed the saint's body must have been a major work of medieval art, something to which those bidden to destroy it would have been totally oblivious:

> All gilded over, and eyther side was painted fower lively images curious to the beholders; and on the east end was painted the picture of Our Saviour sittinge on a rainbowe to give judgment, very lively to the beholders; and on the west end of itt was the picture of our Lady and our Saviour on her knees. And on the topp of the cover from end to end was most fyne carved worke, cutt owte with dragons and other beasts, most artificially wrought . . .

At the same time, the suppression of the monasteries was set in motion, some three hundred of the smaller ones going first, to be followed by the rest by 1540. A way of life which had existed for a thousand years was suddenly extirpated. The contents of the monasteries were carried away for the Crown, or sold. The buildings could be sold to be adapted for use as houses or tenements, or they were simply demolished. First the roofs would be stripped of lead, then the roof beams and choir stalls would be used to make a fire to melt it into pig. In the south-east of England few ruins are visible today as there was such a demand for the stone. In some places where the laity had a right to use the nave or an aisle, that was left standing. Sometimes townspeople would actually purchase the church building to act as their own parish church. Away from the south-east the ruins to this day are only too visible on the landscape. Two centuries were to pass before they were to be rediscovered and recast as romantic evocations of a lost medieval world.

Although the monasteries had long since ceased to be power-houses of learning they nonetheless retained some of the country's major libraries. These were now dispersed. Even monastic houses which became new cathedral priories lost their books. The Austin Friars at York, for example, had a library of nearly six hundred and

fifty volumes. Of these only three have ever been traced. Worcester, too, had six hundred volumes; only six found their way into the Royal Library. Worse depredations were to come in the next reign.

Ordinary parish churches remained at first unscathed, although there were verbal attacks on those customs which would in the end change their appearance. In 1536 Henry VIII's 'Ten Articles' dealt the first blow. The number of saints' days was drastically curtailed, decimating the ritual year. Holy images were reduced to powerless symbols: '. . . as laymen's books to remind us of heavenly things.' Cromwell meanwhile had staged public burnings of the major holy images, shipping them to London for that purpose. In 1538 a series of injunctions called upon the clergy to instruct their parishioners in the creed, the Ten Commandments, and the Lord's Prayer in English. An English Bible was also to be placed to be read in every church and the people were to be exhorted 'not to repose their trust and affiance in any other works devised by men's phantasies besides Scripture; as in wandering to pilgrimages, offering of money, candles or tapers to images or relics, kissing or licking the same, saying over a number of beads not understood or minded on.' Orders went out that all cult images were to be demolished, that all external manifestations of the cult of the saints were to be removed, and that henceforth candles should only be lit by the rood, the sacrament, or Easter Sepulchre.

In this way a dramatic erosion of externals was decreed, but just how radical that erosion was to be depended entirely on the leanings of individual bishops across the country. In 1539 another set of Articles appeared, this time far more conservative in character, and Cromwell fell from power soon after, bringing to an end the first onslaught on traditional religion. Although nothing more was to happen while Henry VIII was alive, much had already gone or been undermined.

Until 1547 the belief that artefacts could provide an ascent to things spiritual was never officially challenged. With the accession of the boy king Edward VI came further changes and for the first time the fundamental belief that images were teaching aids for the illiterate was to be rejected. Indeed, images were to be wiped out in every church and parishioners were 'to do the like within their several houses'. The Epistle and Gospel were to be read in English, processions were abolished along with holy bread and holy water, and the only candles to be lit were the two on the altar. In 1548 the use of candles, ashes and palms was forbidden and the feast of Corpus Christi went, together with reservation of the sacrament. And then in the next year came Thomas Cranmer's first *Book of Common Prayer*. All the old feasts vanished, save Christmas, Easter and Whitsun, plus a handful of biblical saints' days. Everything a congregation would have remotely known or recognised as part of the weekly Sunday

mass effectively disappeared. It was now a truncated ritual performed in the ver-
nacular in a whitewashed building adorned with texts from scripture. A centuries-old
accumulation of visual artefacts vanished while the new service rendered the entire
musical tradition obsolete.

None of these changes passed without upheavals. In Henry VIII's reign there had
been the Pilgrimage of Grace, a rebellion from the north which was brutally put
down. Under Edward VI there was an uprising in the south-west which was also cruel-
ly suppressed. Everywhere those things which had held a rural society together as a
community were violated. The chantries and guilds, lively vehicles of lay piety and a
major source of church funds, were dissolved. In the reformed scheme of things the
dead could no longer be helped by the living.

Then, in 1550, came an even more savage Act: 'For the defacing of images and the
bringing in of books of old service in the church.' A holocaust of medieval liturgical
books followed. John Bale, a reformer and also an early antiquary, records with hor-
ror the tide of destruction of books in a preface he wrote to a book published the year
before:

> But to destroy all without consideration, is and will be unto England for ever,
> a most horrible infamy among the grave seniors of other nations. A great

*A Tree of Jesse. c.1470, with twenty
niches stripped of its statuary and the
recumbent figure of Jesse hacked off, in
the church of St. Cuthbert, Wells,
Somerset.*

number of them which purchased those superstitious mansions, reserved of those library books, some to serve their jakes, some to scour candlesticks, and some to rub their boots. Some they sold to the grocers and soapsellers, and some they sent overseas to the bookbinders, not in small number, but at times whole ships full, to the wondering of the foreign nations.

By the end of June 1550 it was ordered that all 'images of stone, timber, alabaster or earth, graven, carved or painted, which . . . yet stand in a nych or chapel' had to be smashed. In November all altars had to be demolished

The cultural revolution in action. At the top images are burnt and the churches emptied. Below Edward VI hands the Bible to his kneeling subjects. To the right there is a reordered church, devoid of images, in which the focus is the pulpit to which the congregation turns, the altar being reduced to a table placed in the body of the building.

and in the following year any remaining plate was confiscated. In 1552 came a second, far more Protestant, Prayer Book, bent on seeing that nothing should be left which might evoke even a reminiscence of what had been done away with. All that each church was now left with was a wooden communion table, two tablecloths, a cup for communion, a bell and a surplice, for vestments were thrown out too.

During seven years of devastation the mass went, as did books, breviaries, altars, vestments, banners, veils, hangings, candlesticks, images, pictures, along with the burning or defacing of images and whitewashing over of wallpaintings. Generations of private piety disappeared at the behest of radical reformers to meet the mid-Tudor war debt and the demands of an extravagant court. Injunction 28 of 1547 captures more than any other the merciless character of this assault with its instruction to '. . . take away, utterly extinct and destroy all shrines, covering of shrines, all tables, candlesticks, trindles or rolls of wax, pictures, paintings and all monuments of feigned miracles, pilgrimages, idolatry, and superstition; so that there remain no memory of the same.'

For five years there was to be a reprieve during the reign of Edward's Catholic sister Mary. The grass roots resurgence for the old ways provides abundant evidence that had she lived longer or produced a child things would have taken a very different course. But the accession of her sister Elizabeth in 1558 was to decree otherwise. The new queen, as the daughter of Anne Boleyn, was born into the Reformation and however much her personal inclinations veered towards a return to 1547 or 1549, she was bound to the reformist cause. The Act of Uniformity of 1559 was to be the foundation stone of the Church of England. It was effectively to establish a liturgy and a form of church life which was to continue, albeit with breaks and modifications, until the close of the twentieth century. The Elizabethan settlement was as much about the future cultural direction of the country as it was about belief.

It went back to the Prayer Book of 1552 with elements from that of 1549. The result was ambivalent but just how ambivalent was only to emerge as time passed. The use of copes, bowing at the name of Jesus, the sign of the cross at baptism, and the ring at marriage were all retained. In its initial phases these did not impinge on the activities of the new reformist bishops and clergy who embarked on a vigorous suppression of any lingering externals of Catholic practice. This was intensified after 1570 when the pope excommunicated the queen, declaring her a heretic. As the 1570s progressed, any hopes that the clock could be put back began to vanish. And it was during this period that those prime vehicles of popular religious instruction, the miracle plays, were suppressed. The Norwich cycle was silenced in 1564, the York Corpus Christi plays in 1569 and the Chester cycle was last performed in 1575. The

Cornish miracle plays, which attracted audiences of up to two thousand, survived into the 1590s but by 1600 any form of religious drama had become a distant memory for both town and village. The new Protestant ascendancy made no attempt to inspire a drama for their own ends. Indeed they were soon to display a deep distrust of theatre. In addition, by the 1570s and 1580s, popular festivities like Plough Monday, Hocktide, May Day and the midsummer watch gradually ceased to be celebrated, victims to attacks on them as somehow containing Catholic vestiges and being events which could lead to public disorder, sexual licence, and lack of decorum, thus impairing the creation of a sober, orderly and godly society.

Within two generations most of the familiar rituals which had seen people through life had gone. Virtually everything had to start afresh, and yet, because of its ambiguity, Anglicanism gave birth to what by the close of Elizabeth's reign had become a new form of traditional religion. Gradually Protestantism took hold, above all devotion to the English Bible and to the words of the *Book of Common Prayer*. As Cranmer's sombrely magnificent prose was read out week after week it slowly permeated the minds and hearts of its hearers. It became the very fabric of their prayer life and gave verbal expression to life's most sacred moments. Instead of the weekly mass, it was morning prayer with its stately yet humane collects, prayers and responses which was to furnish the minds of the people and be their regular contact with something which in another sense was literature. Collects like the one for grace helped frame the style not only of the Elizabethan age but centuries beyond:

> O Lord, our heavenly Father, Almighty and everlasting God, who hast safely brought us to the beginning of this day: Defend us in the same with thy mighty power; and grant that this day we fall into no sin, neither run into any kind of danger but that all our doings may be ordered by thy governance, to do always that is righteous in thy sight . . .

The Prayer Book was a new traditional religion in the making and its texts were to have as incantatory a hold over its users as the Latin mass which had preceded it. This triumph of the vernacular in the liturgy heralded the great renaissance in the English language that was to follow.

The Bible and the Prayer Book were not the only books in each parish church which helped frame the minds of people. There was also Bishop John Jewel's *Apology*, a defence of the Church of England as being both Catholic and reformed. There were the *Homilies*, those texts read instead of a sermon which spelt out the necessity of obedience to higher powers. And then there was John Foxe's *Actes and Monuments*. This last volume propagated a new history for the country which was now seen as

having been rescued by the Tudor monarchs from the slavery and sin of the Church of Rome. The pope was cast as Antichrist, the mass as a mummery, and the Catholic past as corruption. The English were deemed God's chosen nation leading the struggle against the evil forces of the Church of Rome in an apocalyptic battle. The accession of Elizabeth was presented as the dawn of a new age which, as the reign progressed, was seen to be true.

So the scene was set for new departures. These were already being signalled during the Reformation decades as the pulpit replaced the altar and the church ceased to be a holy place. As a result churches began to fall into physical decay as laymen's priorities became secularised. Money once showered on chantries, church ornaments and maintenance now went into houses, even for the merchant, yeomen and non-gentry classes. By the 1570s their houses had already developed into buildings which were not only better lit but also beautified with wood carving, plasterwork and glass. The only money to be bestowed on the church interior was henceforth to be for tombs. For them a new imagery had to be found, one whose stress was no longer on the next world and release from purgatory but on the achievements in the present life. So while skulls, doused torches, and weeping cherubs spelt *memento mori*, obelisks of fame, trumpets, trophies and a phantasmagoria of armorial bearings proclaimed glories which were now purely secular.

Nonetheless a whole way of behaving and thinking is not so easily blotted out. Much lingered on, external gestures like kneeling, crossing oneself, or standing for the Gospel. The communion table stood where the altar had once been and the cleric wore a cope. The next century was to reveal that the settlement of 1559 left the door firmly open for images and ritual to return. In the meantime what had happened must have left an enormous gap in the minds and imagination of men and women. Evidence of wills indicates no immediate transfer from one form of the Christian faith to another, rather the broad mass of the population remained neutral and uncommitted. Catholicism had been a religion which accepted and made provision for the illiterate. Protestantism made seemingly none and most of the population was unlettered, relying on being read to. As they sat in their bare churches listening to the Word of God there was but one new image permitted that they could stare up at. Over the chancel arch, where there had once been the figure of Christ crucified, now hung the royal arms. By 1603, when Elizabeth I died, ritual had found a new expression in court spectacle and the festivals of State which apotheosised the success of her rule and images in her portraits. The cult of the Virgin Queen had successfully replaced that of the Queen of Heaven.

The triumph of the monarchy. The royal arms replaced the traditional rood and Doom painting over the chancel arch. Here the arms are those of Elizabeth I in the church of St. Margaret, Tivetshall in Norfolk.

Chapter Fourteen

DYNASTY

On 5 May 1527, after a solemn mass in the chapel of Greenwich Palace, what was billed as a treaty of eternal peace was signed with France. It was the climax of almost a decade during which England realigned itself away from its traditional ally, Spain, establishing an alliance which was to go on for another fifteen years. The cultural consequences for the court of Henry VIII were to be huge for it no longer aspired to emulate that of Burgundy as much as that of the court of the Valois kings across the Channel. On the following day this event was celebrated with jousts in the tiltyard, but they were as nothing to the succession of spectacles that were staged in the evening. To house these, two rooms had been constructed at each end of the palace gallery, looking down onto the tiltyard. The entertainment began with a banquet in the first of these. It was hung with costly tapestries below a range of clerestory windows, above which was a ceiling peppered with Tudor roses and pomegranates. Gilded sconces and candelabra lit a feast served on gold plate during which musicians, stationed in the upper part of a triumphal arch which straddled one end of the room, performed 'songs and minstrelsy'. The arch was decorated in the latest style with busts in the antique manner and 'sundry antiques and devices'.

The banquet over, Henry VIII led his guests out through the triumphal arch along the tilt gallery, tactlessly asking his French guests to glance backwards and admire its reverse on which the newly arrived painter, Hans Holbein, had painted the defeat of the French at the battle of Thérouanne. At the opposite end of the gallery the guests found a room which had been 'ordained to be made for pastime and to do solace to strangers.' It was arranged in the form of an amphitheatre, with tiers of seats on three sides for the guests who looked down on a second triumphal arch also decked with sculpture and reliefs in the classical style. When they looked up they would have seen the quite astonishing ceiling devised by the king's horologer, the German Nicolaus Kratzer, and also the work of Holbein, executed by him aided by a team of assistants. This depicted the whole world as it was known

The escalation in monarchical splendour is caught in these illuminations depicting the ceremonial observed in 1534 for the Order of the Garter. At the top right Henry VIII sits enthroned surrounded by his twenty-five Knights of the Garter in their robes. Across the bottom of both pages the Knights in armorial surcoats process to the chapel which is seen above on the left hand page.

in the early sixteenth century, surrounded by the planets and the twelve signs of the zodiac.

Eight choristers of the Chapel Royal then stepped forward and sang, after which a youth disguised as the god Mercury delivered a Latin oration in praise of the peace. Two figures personifying Love and Riches appeared and held a debate as to their respective merits, which led to a feat of arms fought across a barrier set up within the arch. The conclusion to the debate was that both attributes were ones necessary to a prince. At the far end of the room a curtain suddenly fell away revealing 'a goodly mount . . . with all things necessary to a fortress and all the mount was set full of crystal corals, and rich rocks of ruby curiously counterfeited and full of roses and pomegranates as though they grew'. On the mount sat eight damsels including the king's daughter Mary, betrothed in the treaty to the French king's second son. Young men held flambeaux to illuminate this tableau, from which the ladies descended to dance, then the men danced, and finally they joined forces to dance together. More maskers entered, the last invasion including the king and the leader of the French delegation, Turenne, in disguise. For a finale everyone processed back to the first room, where a second banquet was served.

Such an event epitomised what was to be the norm for over a century – spectacular cultural manifestations under the aegis of the court, in which every department in the royal household was stretched to its limits to stage a mixture of ceremony and theatre to enhance the monarchy. Such entertainments combined music, dance, both choreographed and social, the spoken and sung word, special décor and elaborate costumes. They demanded the services of professional actors and writers as well as the participation of members of the royal family and the court. They called on the resources of the Office of the Revels and the Royal Works as well as the Chapel Royal.

During precisely the period that the ceremonial of the pre-Reformation Church was swept away, eroded through the middle decades of the century, the theatre of the court not only replaced it but also consciously developed an ever more complex liturgy of State. This was art and culture as regal propaganda, fashioning a powerful image of the Crown as England cut itself adrift from the rest of Christendom and Henry VIII proclaimed that he reigned as emperor within his domains.

Henceforward the court was not only to be a centre of political power but the fount of patronage and style. Everyone at court spent their time worrying as to whether they would continue to stay in favour, and those who were not spent time trying to regain it. It was to be from the court that fashion and taste were to spread their way across country. The court was by no means a small organisation. Effectively it was the whole of the Tudor establishment, some fifteen hundred people, ranging

from kitchen boys to Yeomen of the Guard, from Gentlemen of the Privy Chamber to hangers-on. Members of the aristocracy, gentry and the landed and professional classes fought for positions, however menial, as long as they included that vital ingredient, proximity to the king and hence access to power, influence and preferment, not only for themselves but for a whole network of family and connection. At the great palaces of Whitehall, Hampton Court and Greenwich they assembled. Every day all fifteen hundred had to be fed. Elsewhere that shrank to the six hundred persons who travelled with the king on progress stopping both at his own lesser houses and, as a sign of favour, at those of his subjects. The court embraced everyone of any significance in sixteenth and seventeenth century England, and they in turn represented every part of the country from the Scottish Borders to the toe of Cornwall.

This was a bustling, busy, and highly competitive army, enmeshed into an organisation which included departments and people who were responsible for what can only be described as court art. There was the Office of the King's Works in charge of maintaining the royal palaces and houses including new building, both permanent as well as sometimes that for transitory fêtes. Every royal residence, too, was made up of a succession of spheres of influence. There was that under the Lord Steward, presiding over a supporting empire of practicalities beyond the screens of the great hall ranging from cooks to laundry maids. Next came the Lord Chamberlain who ruled over the public rooms, in particular the Great or Watching Chamber, where the

A Holbein sketch of Henry VIII dining in the Privy Chamber of one of his palaces provides evidence of the increasing elaboration in the visual and ritualistic presentation of the monarchy. Even though the king is in one of his private apartments he is still shown seated eating alone, on a dais with a canopy above him, served by his Gentlemen of the Privy Chamber.

Yeomen of the Guard stood, and the Presence Chamber where, from 1539, a hand-some regal escort known as the Gentlemen-Pensioners were in attendance along with the Gentlemen of the Presence Chamber. In the Presence thronged those at court anxious for a glance or word from the sovereign as he swept through in procession to the Chapel Royal or ate in public seated beneath the great canopy of State.

Beyond the Presence stretched a whole series of semi-private rooms of which the most important was the Privy Chamber where the king spent most of his day with his cronies. Beyond that lay the royal bedroom and the ultimate arcana, the sequence of chambers known as the Secret Places. The king was waited upon in this area by his Gentlemen of the Privy Chamber, a body modelled on the French court. As the reign progressed the number of private rooms multiplied. All of them fell under the orbit of the Groom of the Stole, in effect the royal lavatory attendant.

The 1530s and 1540s witnessed a stupendous transformation of the physical en-vironment of the monarchy, carried through on the vast wealth accrued to the Crown after confiscation from the Church. When Henry VIII came to the throne in 1509 he inherited thirteen palaces and houses. When he died in 1547 he left not only fifty-six residences but two thousand tapestries, a hundred and fifty paintings, over two thou-sand pieces of plate and almost the same number of books. By that date he had built and accumulated more than any other English monarch. The royal residences were densely concentrated in the south-east and included eleven former monasteries, seven ex-episcopal houses and those of three victims of the Reformation. In the main the king only tinkered with his many properties, but in the case of three he spent on an unprecedented scale: £62,000 on Hampton Court, over £43,000 on Whitehall, and at least £23,000 on his new palace of Nonsuch.

What was the driving force? Much of this new-found energy can be laid at the door of his second queen, Anne Boleyn. She had been educated both at the French and at the Burgundian courts. She was firmly francophile, a practitioner of evan-gelical piety and an active patron of reformers. She read the Bible in French and other French reformist devotional literature and poetry. Around her gathered a new kind of court culture which was incipiently Protestant but also drew into its orbit new direc-tions in literature of the kind epitomised by the poetry of Sir Thomas Wyatt. Anne also appears to have had a strong visual sense. Holbein drew her. He also designed a cradle for the future Elizabeth I as well as a table fountain which she gave to the king as a New Year's gift in 1534. But above all she seems to have had a passionate commitment to building.

The transformation of Wolsey's York Place into Whitehall, for example, was driven on by the need for it

Design attributed to Hans Holbein for a fireplace for a royal palace, c.1540, incorporating classical grotesquework as well as the royal arms and the king's monogram.

to be finished in time to receive Anne as queen after her coronation in 1533. To build it the king wiped out a whole suburb, not only in order to enlarge the palace but also to create an extensive entertainment complex for the use of the court including a tiltyard, a cockpit, four tennis courts and two bowling alleys. By the close of the reign the palace stretched over twenty-three acres. Next in splendour came another of Wolsey's former residences, Hampton Court, which acquired a whole new suite of rooms for the queen. Here the disposition of the royal apartments assumed for the first time an arrangement which was to become a norm, a grand suite on the *piano nobile* approached by a processional staircase.

Such palaces were essentially shells, resembling empty stages until king and court arrived. Only then did they spring to life as the tapestries were hung and all that was transported from one residence to another, from elaborate state beds to costly plate, was set in place. The purpose of these interiors was to dazzle the beholder by their sheer overwhelming opulence, for everywhere the eye fell it was on gold: cloth of gold hangings, gold thread running through the tapestries, gold embroidery on the cloths of estate, gilded ceilings and panellings, not to mention the displays of gold plate at every meal.

Design by Hans Holbein for an elaborate table fountain presented by Anne Boleyn to Henry VIII as a New Year's gift in 1534 and incorporating her badge of the white falcon.

To all this interior richness Hampton Court and Whitehall added another novelty, gardens on the grand scale. Richmond Palace had had a garden modelled on those of the Dukes of Burgundy, an enclosure surrounded with covered galleries looking towards raised geometric beds filled with flowers and topiary. Henry VIII's new palaces also had galleries but this time the inspiration was the gardens being laid out for the châteaux of the great nobles of the Valois court. Both Hampton Court and Whitehall had a grid of rectangular raised beds held in by boards painted the Tudor colours of white and green, but what was unique was the forest of painted posts dotted throughout them, upon which stood the Tudor dynasty's heraldic emblems, the lion, the griffin and the dragon. The garden was thus made into yet another manifestation of royal power through this flamboyant use of heraldry, which did not stop there but dominated the palace interiors and also erupted across the skyline in the form of

pinnacles on which sat the inevitable regal beasts clutching pennons adorned with coats of arms.

These two palaces, along with Greenwich and Richmond, were to provide the setting for the monarchy until the Civil War. Nonsuch, the palace which the king built from scratch, was in a somewhat different category. It was the grandest of royal hunting boxes, built for the king and his cronies in emulation of the châteaux of the Loire valley. It too was a dynastic celebration. It was begun on 22 April 1538, the thirtieth anniversary of Henry's accession to the throne, and six months after the birth of a male heir, the future Edward VI, by his third wife. This occasioned the ultimate apotheosis for which he razed the Surrey village of Cuddington to the ground. It was in essence a typically late medieval courtyard house but the inner courtyard was like nothing previously erected. At its corners there were two fantastic octagonal towers. Both inside and out the walls were covered with lavish stucco decoration, a complex programme of gods and goddesses and the rulers of antiquity paying homage to the Crown, framed by borders of carved and gilt slate. In places the decoration was sixty feet deep and overall it

Design, probably for a gallery at Whitehall Palace for Henry VIII, c.1545, in the style of Galerie François I^{er} *at Fontainebleau. The decoration includes the badge of Henry's last queen, Catherine Parr.*

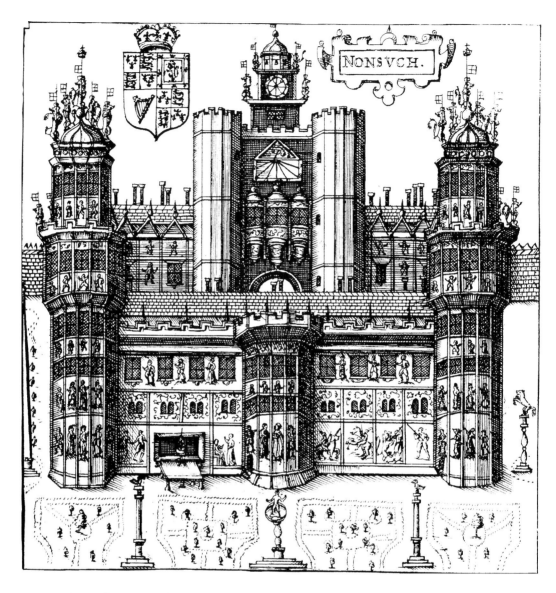

covered nearly twenty-three thousand square feet, all of it the work of Nicholas Bellin of Modena, an Italian by birth and training but whose crucial background was working on the great palace of Francis I, Fontainebleau, where stucco decoration of exactly this kind had reached a new sophistication and indeed set a new style.

France was to dominate Tudor culture. Everything which happened there was closely observed and reported upon. There was endless diplomatic to-ing and fro-ing

A Jacobean view of Henry VIII's last palace project, Nonsuch, showing the privy garden and the astonishingly elaborate decoration of the external walls with scenes and figures in high relief.

by men whose eyes were open for everything that was new. We catch this in a courtier like Sir John Wallop being taken on a tour of Fontainebleau by the French king who showed off to him its fabulous new gallery 'all antique' and in which 'betwixt every window stands great antical personages entire'. Francis I proffered the loan of 'divers moulds of antique personages' to Henry VIII. Whether they were sent we know not, but the desire to have something like it resulted in Nonsuch.

Italy was, of course, the ultimate source of this new style but it increasingly arrived in England via France, more so as the events of the Reformation effectively cut off dialogue with Italy until the next century. Before this cataclysm, contact had been direct. Thus the chronicler Edward Hall records in 1518 the importation of a new form of entertainment: 'The king with eleven other were disguised after the manner of Italy, called a mask, a thing not seen afore.' What was taken up was entirely a matter of selection. There was no flicker of an interest in or understanding of the fundamental underlying principles, for example, of Renaissance architecture. That was not to occur until almost a century later. Typically it was the new decorative repertory which the Italian rediscovery of classical antiquity reinstated which was taken over. Everywhere late Gothic foliage, festoons and garlands gave way to trophies of masks, weapons and antique vessels in the newfangled grotesquework. Only rarely can the source be sharply pinpointed for such decoration circulated in the form of prints and pattern books. In the case of the chapel ceiling in St. James's Palace, however, it is unequivocally based on an engraving in Sebastiano Serlio's *Regole generali di architettura* (1537), one of the great architectural books of the Italian Renaissance. But it was to be seventy years before the full impact of that publication was to have any serious effect on the island's architecture in the person of Inigo Jones.

Much of this stylistic and decorative revolution was the work of foreign craftsmen for although England was rich in raw materials, it was devoid of technical expertise. All through the sixteenth century it was to be a place of resort for craftsmen seeking work and often, along with it, refuge from religious persecution. In the case of Henry VIII, however, there was an unprecedented recruitment drive which lasted throughout the reign. Skilled woodworkers and glaziers were Doche, that is from the area now the Netherlands which stretched into north Germany. Sculpture in the new antique vein was the domain of the Italian Giovanni da Maiano, which passed later in the reign to Nicholas Bellin. In 1516 the Royal Armouries were set up at Greenwich with largely German craftsmen producing armour which was as good as any in the rest of Europe, although with a form of decoration, a mixture of badges and bands of scrolling foliage, which was idiosyncratic.

Music at court also depended on foreigners for performance. The royal musicians

were divided into two groups, those who served the Presence Chamber who played *haut* instruments like trumpets, fife and drums and those of the Privy Chamber who played the *bas* instruments suitable for small rooms, like lutes and the keyboard. During the reign there was a dramatic increase in the sheer number of royal musicians, reflecting the king's own passion for music as well as the change to the new polyphonic style which called for groups of four, five or six who could play on sets of instruments of different sizes. By 1540 the musicians had grown to include a twenty-four strong royal band. In the main they were foreigners like the five recorder-playing members of the Bassano family recruited in Venice in time for the king's fourth

marriage festivities. The Bassanos were to go on to found a musical dynasty. Add to these the gentlemen and choristers of the Chapel Royal. The choir there assumed even greater importance as those of the principal monasteries went under at the Dissolution. Eventually, too, composers had to respond to the sweeping changes in the liturgy. But during

Manuscript of Henry VIII's most popular composition, the song 'Pastyme with good company', a re-working of a popular song. The book also includes twenty vocal and thirteen instrumental pieces ascribed to him.

Henry's reign that problem did not arise for there were no changes at court and such musicians as Robert Fayrfax and William Cornyshe continued to compose for a

liturgy as yet unrevised. Both these English composers had been in attendance at the Field of Cloth of Gold ceremonies in 1520, the former as one of the 'singing men'.

Painting of any quality was another skill which was to a great extent imported. In the middle of the 1520s the king achieved his greatest coup recruiting three members of the Hornebolte family, Gerard and his two children Lucas and Susanna, from the Low Countries. Together they represented Flemish illumination at its zenith. Lucas was to become a King's Painter from the middle of the 1520s initiating what was to develop into a major British art form, the portrait miniature. In response to the arrival of miniatures sent by Francis I, Lucas began to paint a series of minute likenesses of

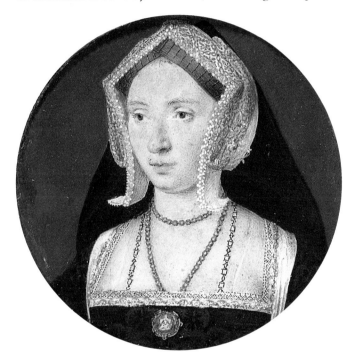

A miniature of Henry VIII's second queen, Anne Boleyn, by the court miniaturist, Lucas Hornebolte. It depicts her at the age of twenty-five and the jewel at her breast incorporates her device of the white falcon.

the king, his wives and other members of the royal family. Painted from life, these form some of the earliest and most startling portraits, executed in exactly the same manner as miniatures in an illuminated manuscript. Lucas, however, was to introduce another painter to this skill, one who was to far surpass him.

That artist was the German Hans Holbein whose depiction of members of the Henrician court still after five centuries formulates our visual perception of it. When Holbein set out for England at the close of 1526 with a letter of introduction from Erasmus to Sir Thomas More, the latter was far from optimistic: 'He will not find England such fruitful and fertile ground as he had hoped.' In that More was to be proved wrong for soon after arrival Holbein was taken up by the court to design and

paint some of the decorations for the 1527 fêtes. At the same time he executed a series of portraits of both courtiers and humanists connected with the More circle, and painted the first ever family group of the More family itself. The idea that a portrait could capture the very spirit of a human being indeed makes it first appearance here. Holbein was a genius in the technical sense for he was blessed with a photographic memory and the practical facility and knowledge to realise what he saw in two dimensions on the surface of a wooden panel. Travel in Italy and in the Low Countries had exposed him to all that was most innovative in the art of the Renaissance. The notion of a picture being a work of art did not exist in Tudor England but admiration for verisimilitude most definitely did.

Holbein went back to Basel where he lived for a time but he returned in 1532. Four years later he was certainly a King's Painter, one in a special category for he could also take commissions which were other than royal. For the next decade he and what must have developed into a studio poured out portraits as well as designs for engraving, jewellery and metalwork, and occasionally he painted miniatures. His greatest work, however, is lost, the wall painting in the king's Privy Chamber at Whitehall Palace celebrating the triumph of the Tudor dynasty depicting Henry VIII with his third queen Jane Seymour, Henry VII, and Elizabeth of York. In this, the royal portrait as political propaganda found its supreme expression in the over life-size image of the king, legs astride, the embodiment of regal defiance. Copies of it, from the head only to the whole, were to be produced throughout the century inaugurating a cult of the royal image which was to be the foundation stone of every country house picture collection.

The portrait was to be the new genre most to obsess the British. Holbein after all was not primarily a portrait painter on arrival but he was to become one. His work and that of his shadowy followers stand at the fount of a tradition which was to last until aristocratic culture faltered in the twentieth century. Also, whatever his Renaissance credentials, Holbein was not to escape the impact of his new environment, for the longer he stayed, the more his work moved away from being three-dimensional towards being flattened into two-dimensional pattern.

This efflorescence of activity was not only evidence that the arts had an essential role in the presentation of the monarchy but that they had become essential attributes also of that other phenomenon of the court, the courtier. One book acted as a landmark in that particular evolution, the Italian Baldassare Castiglione's *The Courtier* (1526). Castiglione in fact created a profession where previously there had been none, a new masculine ideal, the principal end of which was to achieve a union of arms and letters, knight and clerk, soldier and courtier. The newfangled courtier

was to be a warrior, athlete and lover as well as being fluent, musical, and artistic. Music, Castiglione wrote, was 'necessary for a courtier' and aristocratic children were brought up to play an instrument and sing. All the Tudors were musical, the king exceptionally so, writing arrangements of existing compositions like *Pastyme with good company*, a popular melody of 1529.

This change of the late medieval knight into the elegant cultured courtier only began to impinge during the 1530s, as a rising generation which had been exposed to the new humanist education and to the new courtly ideals came of age. The greatest impact was to be in the world of letters. George Puttenham, writing in the Elizabethan period, was to describe Henry Howard, Earl of Surrey, heir to the Duke of Norfolk, as being among 'a new company of courtly makers' having 'tasted the sweet and stately measures and style of the Italian poesie as novices newly crept out of the schools of Dante, Ariosto and Petrarch . . . greatly polished our rude and homely manner of vulgar poesie from that it had been before . . .' Surrey was among the first poets to naturalise the new Renaissance poetic modes, like the sonnet, into English. He was also the first writer to use blank verse (in which later both Shakespeare and Milton were to compose) in his translation of two books of Virgil's *Aeneid* into English. Surrey was a man at the heart of court politics as well as being a poet and his life was to end on the scaffold.

Sir Thomas Wyatt also only narrowly missed such a fate. Son of a councillor and a member of the avant-garde circle centering on Anne Boleyn, his poems, complex and ambiguous and which developed motifs and images from Petrarch, make up what are some of the earliest attempts to write in what is a recognisably modern style. These statements on the uncertainties of life and love embody a new flowering of the poetic spirit:

> My lute awake! perform the last
> Labour that thou and I shall waste,
> And end that I have now begun;
> For when this song is said and past,
> My lute, be still, for I have done.
>
> As to be heard where ear is none,
> As lead to grave in marble stone,
> My song may pierce her heart as soon:
> Should we then sigh, or sing, or moan?
> No, no, my lute! for I have done.

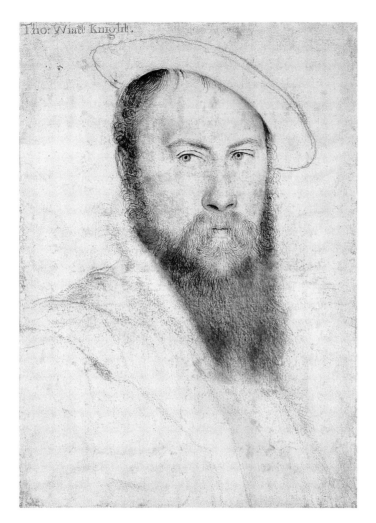

Tho: Wiatt Knight.

Sir Thomas Wyatt the Elder, poet and courtier, a drawing from the great series of members of the court by Hans Holbein.

When the Church went into eclipse as a patron the courtier and office-holder, be he aristocrat or gentleman, took over. Henceforward the landscape was to be punctuated no longer by great abbeys but great houses. The huge change in land ownership precipitated by the Reformation was to initiate a building boom. Monasteries were hastily adapted into houses or their stone was used to build the new mansion. The king bestowed these estates with care, making sure that he placed someone loyal to the Crown in crucial areas of the country. Such houses had to be capable of receiving the court on its annual summer progress, one which was part pleasure and part political expediency. Two major tours almost took the king to Bristol on one and did take him as far north as York on the other, an area of England deeply resentful of the Dissolution. His practice was to stop at the houses of those he looked upon with

favour, men such as Nicholas Poyntz who built a new royal wing on to his house at Iron Acton, Gloucestershire, to receive him.

Country houses were to be the quintessential architectural expression of the new post-Reformation cultural power structure. Increasingly they were to be sited away from village communities and placed in parkland. No longer patriarchal, the image projected by their owners was remote and managerial, the open hospitality of the great hall becoming a thing of the past, indeed rendering the great hall as a room redundant. In the *Institution of a Gentleman* published in 1555 it was lamented that: 'In the ancient time when curious building fed not the eye of the wayfaring man, then might he be fed and have good repast at a gentleman's place so called.' By the middle of the century that had gone.

But what was that 'curious building'? The early Tudor country house, in spite of its use of antique decoration, retained its late medieval format including a moat, crenellation and towers. Whether it was a brand-new house, a converted monastery or an updated castle these remained buildings of incident, with no sign of the Renaissance ideals of proportion and the creation of a unified whole. The eye was constantly led to dwell on isolated features like a tower or a bay window. Equally it was drawn towards an elaborate point of entry, a gatehouse or a highly decorated porch, or towards the skyline which was punctuated with chimney stacks, turrets and vanes. Such houses in no way spurned the new antique decoration or indeed new techniques of building construction, but essentially they clung to the past during an era of social revolution.

The aim was always to create an image of dignified age and authority embodying the power of olden time, although within providing every comfort of the present. This sense of looking back was to remain intense through what was a century of dramatic change. Indeed it was to become a *leitmotif* of British culture, retaining or reviving historical styles to provide a veneer of timelessness to a shifting scene. Such houses went up during an era in which the quest to establish a new national identity was intense in the face of the break with a united Christendom. History was rewritten to accommodate this new perspective, Edward Hall's *Union of the Noble and Illustre Famelies of Lancastre and York* (1542) culminating in the 'triumphant reign of King Henry VIII'.

Architecture, unlike music and poetry, had no place in the courtier's accomplishments. It was, however, the owners themselves who were essentially the designers. Houses like Layer Marney Hall, Essex, and Sutton Place, Surrey, were primarily expressions of their courtier owners, Henry, 1st Lord Marney and Sir Richard Weston. Only after Henry VIII's death was there to be a brief flirtation with a stricter form of

classicism, stemming from the circle of officials around the boy king Edward VI's Lord Protector, Edward Seymour, Duke of Somerset. His most important residence was Somerset House in the Strand which was to be the first building to use the classical orders with consistency. It was also built of stone, was low lying, and had a strictly symmetrical façade. As it was in the metropolis it was seen by everyone and was hugely influential on the development of the country house.

Somerset House and others like Lacock Abbey, Wiltshire, belong to a transitory group which demonstrates a desire for greater unity, order and proportion, looking forward to the renewed building wave of the 1580s. In the intervening years with three changes in religion, Protestant under Edward VI, Catholic under his sister Mary and reverting to Protestant again under the young Elizabeth I, together with the social

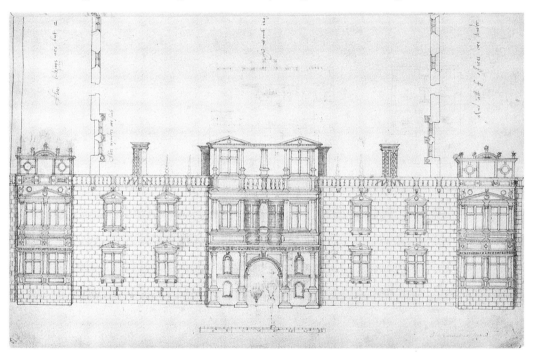

upheaval that entailed, things cultural were in retreat. One house, however, can act as a bridgehead, taking us into the civilisation of a new age and that is Longleat House, Wiltshire. Longleat was built by Somerset's secretary, Sir John Thynne. He began it in the 1540s and it was to go through three successive building phases to the close of the 1560s. Thynne had travelled in France and seen the work there of the Italian architect Serlio

A drawing of the Strand front of Somerset House built about 1550 and the first building in England to respond with any accuracy to the architectural tenets of the Renaissance. The central gateway is conceived as a triumphal arch derived from elements published by the Italian architect, Sebastiano Serlio.

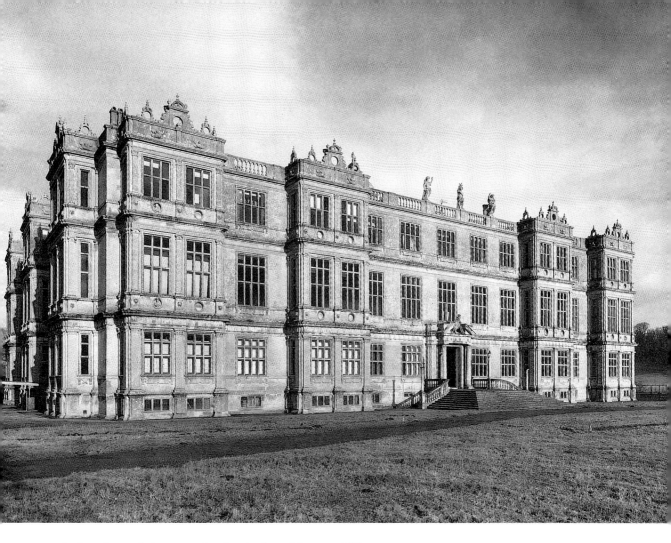

and also that of the French classical architect, Philibert de l'Orme. Longleat betrays the impact of those experiences. It deploys a single-minded application of classical ornament but more particularly its exterior is confident, with an exact balance of verticals and horizontals. And, for the first time, we are no longer looking at a courtyard house whose main orientation is inwards but one whose large handsome windows look assertively outwards on all four sides at the surrounding countryside. Longleat not only heralds the new country house culture of Elizabethan England but also that new direction in the arts will no longer come from the Crown but from those who serve it. With the death of Henry VIII in 1547 the monarchy was to opt out as an active patron for the rest of the century. In fact Elizabeth I was to be renowned for taking with both hands and giving with the little finger, and that miserly fact was to be the backcloth of what was to prove to be a golden age.

Longleat House, Warminster in Wiltshire, built by one of Protector Somerset's colleagues, Sir John Thynne, forms an architectural bridgehead from mid-Tudor classicism to the Elizabethan age.

Chapter Fifteen

THE FAERIE QUEENE

Three years after the defeat of the great Armada sent by Catholic Spain to subjugate the tiny island kingdom of England the greatest poem of the age was published. Edmund Spenser's *The Faerie Queene* (1591) signals in one epic work that a new civilisation was already in full flower. No other English poem of comparable scope or literary structure has inspired so many later poets from Milton and Dryden down to Keats and the Romantics. Interwoven into it is every aspect of what was the apogee of the English Renaissance, which reached its climax during the last twenty years of the sixteenth century. And the poem's pivot is one which provides the key to this extraordinary resurgence of creativity, an unmarried woman, Elizabeth I, daughter of Henry VIII and his second queen, Anne Boleyn. She it was who dominated the culture of her age. *The Faerie Queene* is suffused with her multi-faceted presence, the poet indeed opening his epic, one designed to immortalise the Tudor dynasty, with an invocation addressed less to a human being than to a sacred icon:

> . . . O goddesse heavenly bright!
> Mirrour of grace and Majestie divine,
> Great Ladie of the greatest Isle, whose light
> Like Phoebus lampe throughout the world doth shine,
> Shed thy faire beames into my feeble eyne,
> And raise my thoughtes, too humble and too vile,
> To thinke of that true glorious type of thine,
> The argument of mine affected stile . . .

It was recognised from the moment of publication that this was the supreme literary masterpiece of the age. The numerous dedicatory verses gather in virtually everyone of importance at court: the queen's glamorous new young favourite, the Earl of Essex; Lord Admiral Howard, who had commanded the fleet against the 'Castilian King'; Sir Walter Raleigh, 'the summer's nightingale'; the queen's Secretary of State, Sir Francis Walsingham, 'the great Maecenas of the age'; her First

Elizabeth I enthroned, supported by two of the virtues her rule personified to her subjects, Justice bearing the sword and Wisdom clasping her serpent. The illumination is by the queen's miniaturist, Nicholas Hilliard, and adorns the charter founding Emmanuel College, Cambridge, in 1584.

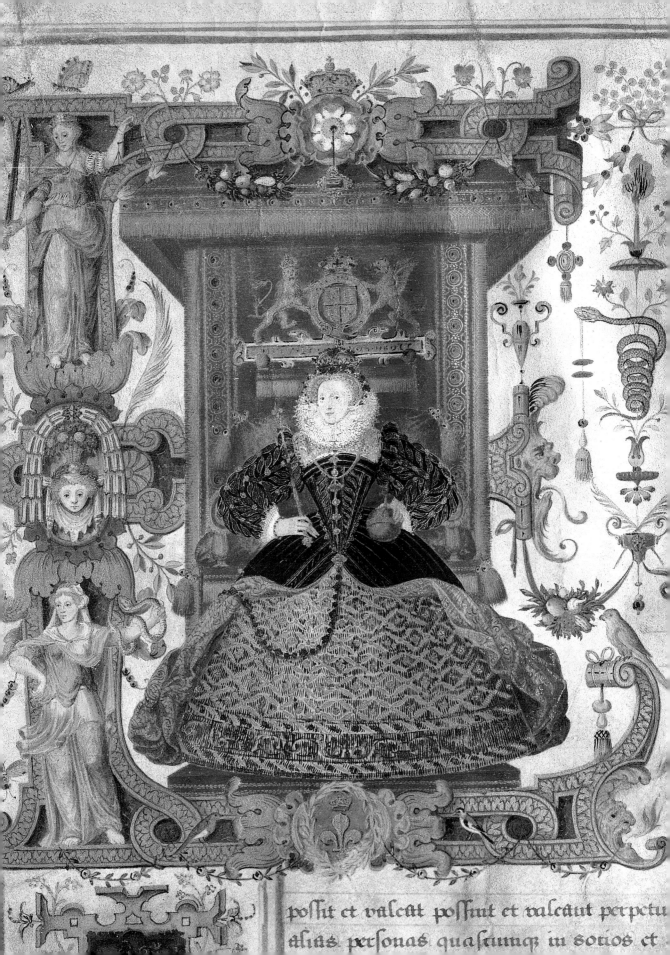

possit et valeat possint et valeant perpetu
alias personas quascumque in socios et

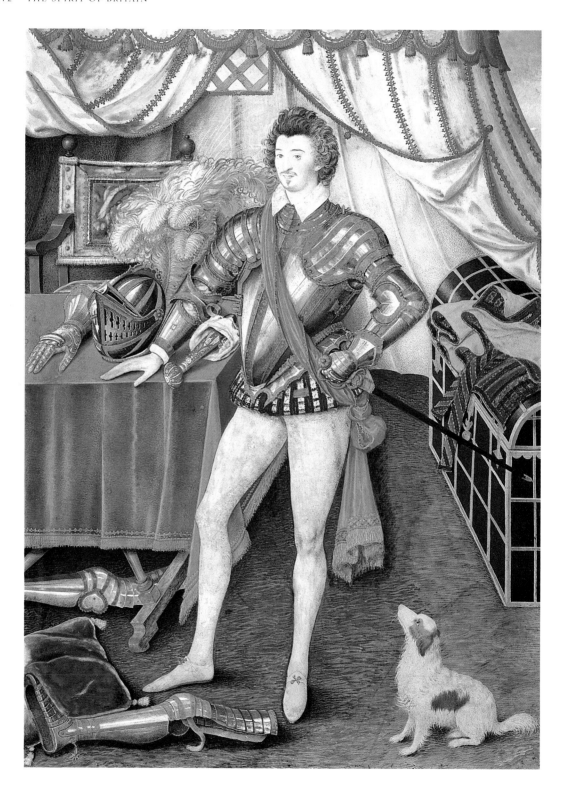

Cushion embroidered with the story of Diana and the hunter Actaeon. On the left Actaeon surprises the goddess and her nymphs while bathing, for which he is punished, right, by being transformed into a stag and torn to pieces by the goddess's hounds. The cushion bears the initials ES for Elizabeth, Countess of Shrewsbury, who embroidered it for her great house, Hardwick Hall. Such a scene would have been read as a warning against the violation of chastity.

Minister, Lord Burghley; her Lord Chancellor, Sir Christopher Hatton; her Lord Chamberlain, Lord Hunsdon. More are there but Spenser moves on to salute the ladies of the court including the sister of that flower of chivalry Sir Philip Sidney, the Countess of Pembroke, and concludes with a valedictory tribute: 'To all the gracious and beautiful Ladies of the Court.'

This was a new culture which had reached a sudden astounding zenith, one which was to go on with a relentless explosive drive past the year 1600 and spill over into the opening years of the reign of the queen's successor, James VI of Scotland and I of England. What was it that triggered this breathtaking phenomenon, which, four centuries later, still fills the world with wonder? *The Faerie Queene* will give us our bearings. Its lodestar is the queen, not her reality but her carefully composed image. Secondly it is of significance that the poem takes the form of a romance, a genre which looks back to the Middle Ages. It is one peopled by knights whose quest is virtue and its exercise; in other words, it is art as a vehicle for moralising to the reader. The poem in addition is one gigantic allegory, stuffed with signs and symbols, all of which call for a highly educated mind able to unravel its often esoteric allusions. Ease of access is foreign to its concept. Its inner message is deliberately a hidden one purveyed in a luxuriance of rich images not, as in pre-Reformation times, rendered in two or three dimensions, but in words. And this is a touchstone.

It is the emergence of a society which no longer expresses its innermost convictions and ideas by way of the visual arts but by way of the pen. The complex images Spenser paints in his poetry assail our mental subconscious through the text and not by means of a painted or sculpted verisimilitude. Everywhere in the Elizabethan age one senses this fear of the visual image,

The Elizabethan revival of chivalry. The new society of Protestant England clothed itself with the panoply of medieval knightly endeavour fused with the trappings of the Renaissance courtier. These aspirations are caught in Nicholas Hilliard's miniature of Sir Anthony Mildmay, painted about 1590.

at least fear of it in any deceptive optical sense. Images are now to be locked into the mind, into the visual imagination. If and when they took visual form, whether in architecture, painting or sculpture, they were to be abstract, diagrammatic, anti-naturalistic compilations, either pattern or symbols which called for reading. The visual image, in short, was turned into a text to be read. And this verbalisation of visual experiences was to become central to the island's culture until the television age. Even our landscape was to become literary.

The England of Elizabeth I was an insular nation state in the making. It was a country which for most of the reign was under siege, externally threatened by the mega-power of Catholic Spain and internally by those who remained either openly or covertly loyal to the old religion. But the incoming government in 1558 laid sure foundations both politically and economically. The new ruling classes consolidated their power, headed by great dynasties like the Cecils, the Russells and the Cavendishes. This was an élite society and an élite culture, which, through inter-marriage, spread its net not only across country but also across the social spectrum. The English aristocracy never became a caste, and never hesitated to indulge in lucrative trade and commerce or indeed to marry into it. And riches, the sure foundation of any aesthetic flowering, were well in evidence as almost half-a-century of peace brought a commercial boom. Never before had so many lay people been drawn into the creation of a new national identity, one in which the arts were seen to play a crucial role. Even then nothing could have quite prepared anyone for the explosive energy of creation which followed the defeat of the Spanish Armada in 1588.

This sense of cultural oneness reflected the unique alliance of monarch and people as expressed by the Crown in Parliament. In no other period of the nation's history was the role of the ruler to be so pivotal to a cultural renaissance. In Elizabeth I there occurred a unique fusion of art and power. Never a patron herself, she nonetheless dominated every form of literary and artistic endeavour. The vulnerability of the new state meant that it drew in the arts to affirm a vision of national unity expressed through a cult of the monarch both as sovereign and lady. In her, no dividing line could be drawn between her public ceremonial image and her private role. The two were as one. To achieve that, the arts paid a price for what in retrospect can be regarded as outright sycophancy on a scale far on the other side of idolatry which they paid the queen. In harnessing their creative powers to the State, artists inevitably had to forgo much that Renaissance art as it had evolved in Italy had been about. There was no such thing as freedom of expression in Elizabethan England. It was dominated by State-controlled censorship, but the price was worth the paying.

Sir Walter Raleigh, in his commemoration of the death of Sir Philip Sidney in

1586, mourns his loss as the 'Scipio, Cicero and Pet-rarch of our time'. In Sidney the new ideal for the upper class male finds its pattern, one which, thanks to the educational revolution of the first half of the century, changed both the attributes and the aspirations of the established classes. Most of those were based on Cicero's ideal of the orator as a cultivated man of affairs, whose role embraced not only the art of reasoning, dialectic, but that of persuasion, rhetoric. The major decisions in life were not, however, based solely on the exercise of reason but also on subjective factors, 'affections' in Tudor English, feelings and associations in the main fired by the emotions. And it was this factor which provided the key justification for the role of the arts. The arts, it was argued, educated people in political and moral virtue, which would result in action to the benefit of the State.

Sir Philip Sidney was wounded at the battle of Zutphen in 1586 and died a month later. His funeral was staged as a public spectacle to mourn the passing of a man looked upon as an ideal.

As a consequence the arts had a potent part to play in fashioning the new state and its servants. But they remained accessible to only a very small percentage of the population. Literacy was confined to a narrow band, by 1600 about 20% of men and 5% of women. Even then that represented a considerable increase. Protestantism, with its stress on the word, was to be a keen driving force, not to mention the ever-escalating demands of trade and commerce. Many could read, even if they could not write. A large percentage of north country gentry could certainly read but when it

came to a signature all they could do was make their mark. Literacy was far more widespread in the south-east so it is hardly surprising that it was to be English as it was written and spoken there which was to become standard. The dominance of London and of the court in linguistic terms set literary style, one which benefited from the huge expansion in vocabulary afforded by the inclusion of words adapted from classical, French, and Italian sources. The result was a new confidence in the language, earlier viewed as somehow inferior to either French or Italian as a literary vehicle, so much so that Francis Meres could write at the close of the century: 'The English tongue is mightily embroidered and gorgeously invested in rare ornaments and resplendent habilments.'

Such a renaissance depended on patronage. And that too emanated from the court where members of the newly educated Protestant humanist classes demonstrated their status by exercising patronage. Writers dedicated their work to a great lord in return for financial recompense or advancement to employment. The result was that authors found themselves part of this or that factional lobby, of which the two most significant were those centring around William Cecil, Lord Burghley, Chancellor of the University of Cambridge, and around the queen's first favourite, Robert Dudley, Earl of Leicester, Chancellor of Oxford.

Art was thus in the service of the State sustaining and helping to establish the mythology of a new society. But of what kind? The irony was that this new society was rooted in a cult of history and antiquity, both real and manufactured. Central to finding its new identity was the necessity to re-invent the past. Everywhere one looks this aggressive *nouveau* culture vests itself in the garb of bygone eras. Chivalry, far from slipping into oblivion, was revived, or at least its showy outward trappings. It provided surface glamour to the new rich who spent untold sums establishing the antiquity of their descent, on scattering their coats of arms over absolutely every form of artefact, from a cushion cover to a tomb, and seeing themselves depicted as medieval knights in their portraits. Even Elizabethan architecture looks firmly backwards, a continuation in bizarre guise of late medieval Perpendicular. Castles continued to be built, albeit ones more suited to the knights of poetic romance than the realities of contemporary warfare. Chivalry also provided the ideal vehicle for the heroine of the age, the queen. Virginal and unattainable, she it was for whom knights fought on the field of battle or circumnavigated the globe. The chivalric convention was paramount at the court, indeed its greatest expression was to be its annual festival of chivalry, the fancy dress tournament staged each 17 November, the day Elizabeth ascended the throne, when her knights came in disguise as the heroes of romance to pay her homage. This living out the life of today in terms of the romantic make-

believe of yesterday provides the key to the era, its literature, its architecture, its painting, even its music.

Fear of the wrong use and perception of the visual image dominates the Elizabethan age. The old pre-Reformation idea of images, religious ones, was that somehow they partook of the essence of what they depicted. Any advance in technique which could reinforce that experience for the viewer was embraced. That was now reversed, indeed it may account for the Elizabethans failing to take cognisance of the optical advances which created the art of the Italian Renaissance, ones like scientific and aerial perspective which increased verisimilitude and placed the viewer directly into the spatial experience. They certainly knew about these things but, and this is central to the understanding of the Elizabethans, chose not to employ them. Instead the visual arts retreated in favour of presenting a series of signs or symbols through which the viewer was meant to pass to an understanding of the idea behind the work. In this manner the visual arts were verbalised, turned into a form of book, a 'text' which called for reading by the onlooker. There are no better examples of this than the quite extraordinary portraits of the queen herself which increasingly, as the reign progressed, took on the form of collections of abstract pattern and symbols disposed in an unnaturalistic manner for the viewer to unravel, and by doing so enter into an inner vision of the idea of monarchy. As a result Elizabethan painting, apart from the miniature, may be unique but is a disappointment when set within a European context. This problem was not to arise in the case of either literature or music because their means of expression was through words and sounds. Sir Philip Sidney's *Apologie for Poetrie*, published in 1595 after his death, bills poetry along with painting in the classical canon as being sister arts, but this was never to happen in the Elizabethan period. Image-making was to be the prime function of the poet whose role was to purvey verbal images so compelling that they would remain stored within the memory, inciting the reader to virtue.

So images could exist in the mind but if they took two- or three-dimensional form they had to eschew reality for symbol. That explains why the Elizabethans had no difficulty in assimilating one crucial aspect of European Renaissance culture, the cult of emblems. Along with coats of arms, everywhere we look, from plaster ceilings to embroidered cushions, is covered with evidence of this lost language, one of the prime keys to the culture of the age. The approach is best summed up in Prospero's words when conjuring up the spectacle of a courtly masque in *The Tempest*: 'No tongue! all eyes! be silent!' This lost means of silent communication, which became a common language of the educated classes, continued and expanded for a new secular culture the medieval tradition of hidden meanings. Just as commentators had

argued that the Bible had complex layers of symbolic and allegorical meaning so that approach was extended to the writings of the pagan philosophers, who were cast as having had glimmerings of the coming divine revelation. Fired by Renaissance fervour for antiquity these texts and others were studied with a view to uncovering a lost secret wisdom which stemmed down from Creation via the classical world. The turning point was the discovery in 1419 of a book supposedly written by an Ancient Egyptian priest, Hor Apollo, which gave meaning to hieroglyphs. It confirmed that ancient secret wisdom had been transmitted by means of symbol. In it the reader could learn, for example, that a swan represented a musical old man or that a serpent biting its tail was eternity. The result was an escalation and expansion of the belief that the role of images was to purvey deep philosophical truths. In 1531 this discovery was re-invented for the present by Andrea Alciati whose *Emblemata* ignited a mania for emblems. The formula was an image which was a collection of naturalistic objects arranged in an unnaturalistic way, accompanied by a Latin motto. Together image and word, which were inseparable, embodied some particular moral truth. Thus a swarm of bees making a helmet a hive symbolised peace, or someone trying to scrub a black man white the impossible.

This initiated a flood of illustrated books of emblems which were to engulf Europe until the second half of the seventeenth century. Few were English, Geoffrey

The passion for emblems dominated the art and literature of the age. This one, showing a helmet transformed into a beehive as an image of peace, comes from one of the few English emblem books, Geoffrey Whitney's Choice of Emblemes *(1586).*

Whitney's *Choice of Emblemes* (1586) being the most important, but the continental ones were known and devoured in Elizabethan England. We see their impact in the decoration of houses and even on costumes, let alone their appearance in portraits or on jewels. Everywhere the eye fell there was this new secular silent vocabulary. The queen herself was a monument to it. Her imagery embraced globes, sieves, the phoenix, the pelican, the eglantine rose, the column, the rainbow and the moon, allusions to a whole range of the virtues attributed to her, chastity, constancy, peace and the nurturing of both church and state.

Emblems were general imagery. More tantalising were the devices, or *imprese* as they were called, adopted by individuals. These were again compilations of images with a motto embodying the aspirations and commitment of a particular person. They could be of extraordinary obscurity because their whole point was to hide, rather than to reveal, their meaning, except only to the intellectually initiated. Elizabeth I's sailor champion at the tilt, George Clifford, 3rd Earl of Cumberland, had one which depicted the earth betwixt the sun and moon in total eclipse with the motto *Hasta quando* meaning that he would wield his lance in defence of his sovereign until such a celestial configuration occurred. Nor did this obsession with symbols end there, for the whole pantheon of the classical world, its gods and goddesses, myths and legends, was systematically codified and glossed with meaning in a series of iconographical textbooks which were on the shelf of every educated person, especially those who were creators in the world of the arts. For the educated, knowledge of this sign language of abstract symbols was as important as being able to read, more important in one sense for it was more fully in accord with the prevailing philosophy of the age, Neoplatonism.

This revived Platonism (for Plato's works were known to the Middle Ages) stemmed from fifteenth century Florence. Its two most influential figures were the philosophers Marsiglio Ficino and Pico della Mirandola (of whom Thomas More wrote a life), and it

Impresa borne by the Queen's Champion at the tilt, the Earl of Cumberland. The earth is depicted on the pasteboard shield he would have presented to the queen in a state of total eclipse between sun and moon. The Latin motto, Hasta quando, *means that the earl will wield his lance in his sovereign's defence until such an heavenly configuration occurs.*

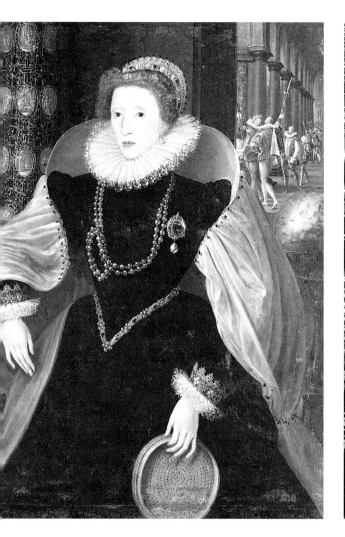

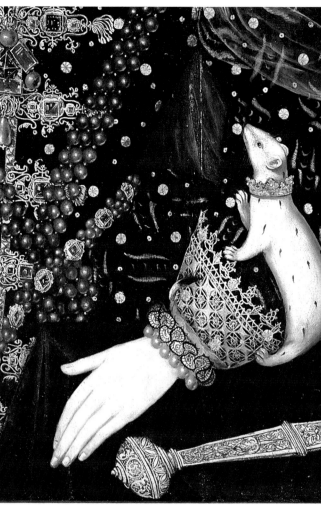

The elaborate imagery surrounding the queen apotheosised her both as the sovereign of her people and as the ideal heroine of her knight. This is caught in one portrait and details from three others from left to right.

The 'Sieve Portrait' c.1580-83. The queen bearing a sieve, the attribute of the Roman vestal virgin Tuccia, poses amidst a complex of symbols, including the globe of the world and the crown of the Holy Roman emperors, in one of the earliest pictures spelling out for her an imperial mission.

The 'Ermine Portrait', 1585. The dual aspect of the role of the queen is defined by the sword of justice resting close to her hand and the ermine with a jewelled collar which climbs up her sleeve. Just such a creature figured on the banner carried in the Italian poet Petrarch's Triumphs of Chastity in his Triumphs, a poem read widely in England.

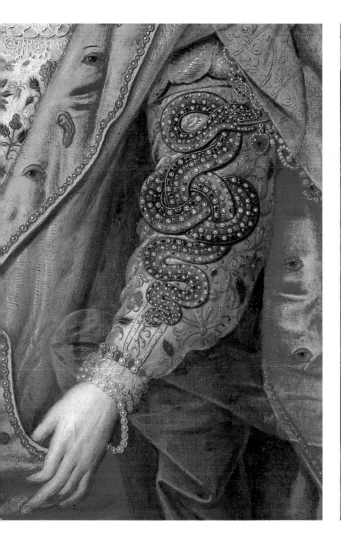

The 'Rainbow Portrait', c.1600-1603. On the queen's sleeve a bejewelled coiled serpent is embroidered from whose mouth hangs a heart and near which is suspended a celestial sphere. The serpent denotes the queen's wisdom which the other attributes amplify to tell the viewer that, guided by good counsel, she is wise in affairs of the heart as well as those of more universal import.

The 'Armada Portrait', c.1588. After the triumphant defeat of the Spanish armada the prognostications of an imperial destiny become a fictional reality as the queen's hand rests on the globe with the crown of empire hovering above.

Woodcut illustrating 'The March Eclogue' of Spenser's The Shepheardes Calendar, *published in 1579. 'Two shepherd boys taking occasion of the season, begin to make purpose of love and other pleasance, which to spring time is most agreeable.'*

predicated an immensely enhanced concept of man's place in the divine order of things. Man the microcosm, the mirror of the cosmos, was capable of rising to the stars or sinking to the level of the brute beasts. Through the exercise of reason and the will and the taming of the passions he could control his own destiny. More, because in the Platonic scheme of things the key to the universe lay in number. By attuning himself to its harmonious mathematical structure man could not only place himself at one with the universe, he could go further and control its workings. This endowed man, made in God's image, with tremendous power. Such beliefs not only account for the central place, for example, of music and dance, in the practice of which man placed himself in harmony with the music of the spheres, but also for the huge drive forwards in the realm of practical technology in which the mysterious forces of nature, which could, for example, make wheels move or water spurt, were harnessed.

Platonism rejected the material world as transient and believed in a higher eternal realm in which opposites could be reconciled in an ideal and ultimate truth. Everything in the arts reflects this preoccupation with the holding up for emulation of ideal types. Sir Philip Sidney, for instance, was made to approximate to heroic prototypes from both classical antiquity and the Christian tradition. The urge was always towards ideal types, abstract symbols in their human vesture. And nowhere was this impulse to be more clearly revealed than in the literature of the age.

What is so overwhelming is the sudden confidence. George Puttenham, reputed author of *The Art of English Poesie*, observed 'that there may be an art of English poetry as well as there is of the Latin and Greek.' Everyone was conscious of a language reaching a maturity, gaining all through the 1580s in rhythm and musicality until it was to burst upon the scene after the defeat of the Armada with a succession of uni-

versally recognised masterpieces. This was a literature with an agenda, a purpose, and it is that which gives it its incredible sense of passion and urgency. The role of literature along with the other arts was to relate the ideal world with the one of present actuality, a process to be achieved through the persuasive resources of art. The appeal was not only to reason but to the affections, in our terms the subconscious, and the end was to woo man to virtuous public political action and private moral virtue. Milton wrote in his *Areopagitica* (1644) that Edmund Spenser's *Faerie Queene* was 'a better teacher than Scotus or Aquinas.'

Spenser and Sir Philip Sidney dominate the literary scene. Poet, scholar, courtier, diplomat and soldier, Sidney was an ideal and an idealised figure. His social status was high. He was the heir to both the queen's favourite, the Earl of Leicester, and also the Earl of Warwick. Ardently Protestant, he was to cross Europe and be received like a minor prince. For over a century after his death his works, including the *Arcadia* and the sonnet sequence, *Astrophel and Stella*, were to be admired and read. The *Arcadia* was written during the 1570s but revised during the following decade. It was in this revised form that it was published after his death by his literary sister, the Countess of Pembroke, in 1593. The *Arcadia* is a complex story of passion and disguise about Basilius, Duke of Arcadia, told in prose interspersed with poetry. The Elizabethans loved it. For them it offered a perfect combination, marrying a classicised pastoral vision with the conventions which governed medieval chivalrous romance, all of it overlaid with a fashionable Neoplatonic gloss and touches of hidden political allegory. Here they could move in an imaginative world of their own ideals, ones which presented pictures of love and friendship, duty and conduct, and all expressed in prose which read as if it were music. Its style may be out of tune with our own age but it was one which entranced the Elizabethans, offering them a kind of verbal ballet filled with rhetorical set pieces and patterns of prose, through which the characters expressed both the argument as well as their own feelings:

'Unhappy eyes, you have seen too much, that ever light should be welcome to you. Unhappy ears, you shall never hear the music of music in her voice. Unhappy heart that hast lived to feel those pangs . . . Philoclea is dead, and dead is with her all goodness, all sweetness, all excellency. Philoclea is dead, and yet life is not ashamed to continue upon the earth. Philoclea is dead . . .'

Arcadia was a work which was to run through no less than thirteen editions and inspire two sequels and countless imitations, as well as being translated into every major European language. In the long run it contained elements which led directly on to its successor, the novel in the eighteenth century. And its evocation of the

pageantry of romantic chivalry was to inspire the Romantics.

Edmund Spenser knew Sidney and indeed his patron was Leicester. Most of Spenser's life was passed in Ireland where he lived as part of an English colony permanently under threat from the Irish. His *Shepheardes Calendar* which appeared in 1579 signalled the imminent maturity of the vernacular renaissance. In it he took the classical Greek pastoral form and welded it into traditional English folk traditions, using it as a vehicle for an at times scathing commentary on contemporary society. His other shorter works take us into the 1590s, above all his *Epithalamion* (1594) which exemplifies the quite remarkable fluency he had acquired in the handling of the English language. In this once again there is a mingling of traditions: allusions to antiquity, to English folklore, and to Christian doctrine, as well as to the new Platonism. The verse exudes total confidence even when Spenser is moved to the height of passion:

Now al is done; bring home the bride againe,
Bring home the triumph of our victory,
Bring home with you the glory of her gaine,
With joyance bring her and with jollity.

Never had man more joyfull day than this,
Whom heaven would heape with blis.
Make feast therefore now all this live long day,
This day for ever to me holy is . . .

But all of these works give way to the protean epic of the age, *The Faerie Queene*, which rises above its ostensible didactic purpose to being a supreme emancipation of the poetic imagination. This, like the *Arcadia*, is a teaching poem, a moral fable. In his letter to Sir Walter Raleigh with which he prefaces the poem Spenser writes that: 'The generall end . . . of all the book is to fashion a gentle man or noble person in vertuous and gentle discipline.' Its hero is Arthur, 'the image of a brave knight, perfected in the twelve private morall vertues.' The Fairy Queen is 'glory' figured in the person of 'the most excellent and glorious person of our soveraine the Queene.' Arthur personifies magnificence, the epitome of all the virtues that the poem sets out to celebrate. Only six books were completed, with fragments of a seventh. Each book explores a virtue by means of allegorical narrative. In Book I Holiness, in the form of the Red Cross Knight, seeks Truth; in Book VI Calidore as Courtesy represents action in an ideal courtly world.

This vast, unfinished allegorical poem is a work which moves from the premise that a poetic text can, through an exercise of the imagination, bestow and invent a

sense of nationhood. It is a monument to the queen whose presence is all-pervading, and the nation's identity is sustained partly through her and partly through a re-invention of British history, both legendary and actual. When Spenser recounts the descent of the queen from the ancient imperial stock of Troy the poetry takes on an incantatory quality:

> Thy name, O soveraine Queene! thy realme, and race,
> From this renowned Prince derived arre,
> Who mightily upheld that royall mace
> Which now thou bear'st, to thee descended farre
> From mighty kings and conquerours in warre,
> Thy fathers and great Grandfathers of old,
> Whose noble deeds above the Northern starre
> Immortall fame for ever hath enrold;
> As in that old man's booke were in order told.

This is a visionary sense of nationhood, which was to initiate a steady stream of epics celebrating the nation's past: Samuel Daniel's *The Civil Wars* (1609) and, later, Michael Drayton's *Poly-Olbion* (1612-22). All reflect the innate conservatism of an age which built its culture on the past reinterpreted.

The *Arcadia* and *The Faerie Queene* dwarf every other poetic achievement of that prolific era except for the sonnet. That format, with its roots in Petrarch and four-teenth century Italy, had a compulsive appeal for poets wishing to explore by way of its taut formula the potentialities of the English language for expressing the moods of love, ranging from exaltation to despair. This was a perfect vehicle for the idealised Platonic courtly love ethic that prevailed at court. Sidney's *Astrophel and Stella* (1591) was the harbinger of a long series of such sonnet sequences. In Sidney's case the ob-ject of his unrequited passion was Penelope, Lady Rich, immortalised as Stella, a star:

Woodcut illustrating the April Eclogue of Spenser's The Shepheardes Calendar *which was 'intended to the honor and prayse of our most gracious Queene Elizabeth.' This is the monarch as the bringer of spring, of the rebirth of the state.*

O eyes, which do the Spheares of beautie move,
Whose beames be joyes, whose joyes al vertues be,
Who while they make Love conquer, conquer Love.
The Schooles where Venus hath learn'd Chastitie.
O eyes, where humble lookes most glorious prove,
Only lov'd Tyrants, just in cruelty,
Do not, o do not from poore me remove,
Keepe still my Zenith, ever shine on me.
For though I never see them, but straightwayes
My life forgets to nourish languisht sprites;
Yet still on me, o eyes, dart downe your rayes:
And if from Majestie of sacred lights,
Oppressing mortall sense, my death proceed,
Wrackes Triumphs be, which Love (high set) doth breed.

Four years later followed Spenser's *Amoretti*, but the greatest sequence of sonnets was to be by William Shakespeare, published in 1609, although virtually all written before 1600. What sets them apart as the supreme apogee of the art is their dramatic quality. This is a sonnet sequence which embraces an opening series addressed to a wealthy aristocrat urging him to marry, then follows a long series to a man who betrays the playwright to a second poet and, finally, a group dedicated to a mysterious and unresponsive Dark Lady. They stand as an unequalled achievement:

Not marble, nor the gilded monuments
Of princes, shall outlive this powerful rhyme;
But you shall shine more bright in these contents
Than unswept stone, besmear'd with sluttish time.
When wasteful war shall statues overturn,
And broils root out the work of masonry,
Nor Mars his sword nor war's quick fire shall burn
The living record of your memory.
'Gainst death and all-oblivious enmity
Shall you pace forth; your praise shall still find room
Even in the eyes of all posterity.
That wear this world out to the ending doom.
 So, till the judgment that yourself arise,
 You live in this, and dwell in lovers' eyes.

Poetry, together with the drama (to which we shall come shortly), was the greatest

literary vehicle of the Elizabethan age. Prose, in contrast, never rose to quite those heights, not even when works as remarkable as Francis Bacon's *Essays* (first edition 1597) are taken into account. To them must be added a mighty stream which began with the highly contrived prose style of John Lyly in works like his romance *Euphues and his England* (1580) and moved on to include the chroniclers, such as John Stow and Raphael Holinshed (whose *Chronicles* provided sources for several of Shakespeare's plays), and the narrator of the voyages of exploration, Richard Hakluyt, not to mention a torrent of broadsides, pamphlets and translations, all evidence of a spreading literacy.

This is a literary inheritance which still remains at the heart of English national identity. It is fiercely patriotic but it was not alone in its glorification of insularity. That was reflected above all in what was thought apposite to assimilate into the native culture from across the Channel. Past commentators have seen this as an inability to understand what was taking place abroad in music or the visual arts, for example. Now it is clear that the Elizabethans knew perfectly well about such developments, however cut off they were, and, in the main, it was less the case of a failure to respond than of the exertion of choice. Pride in native traditions and what set English culture apart was deeply imbued within Elizabethan society. And in no other area can this be demonstrated so forcefully as in the case of another great renaissance, the musical one.

For the first time under the leadership of the royal family the making and patronage of music became an essential attribute of any well-educated member of the upper classes. The rudiments of music were taught in the grammar schools and tutors in music were hired in gentry households. 'I attained . . .' wrote Lord Herbert of Cherbury in his autobiography, 'to singing my part at sight in music, and to play on the lute with very little or no teaching . . .' This was a period during which music ceased to be the province solely of professionals, something which accounts for the boom in music publishing during the 1590s, for composers had to provide printed scores for use by amateurs. This was to include teaching manuals like Thomas Morley's *A Plain and Easy Introduction to Practical Music* (1591), and song-books, but not keyboard scores or tablature for the lute, as printing could not as yet reproduce the notation. But a huge mass of music was lost, and what we have today is merely a

An allegorical scene by the miniaturist Isaac Oliver, pupil of Nicholas Hilliard. Painted in the early 1590s the miniature exults the married state in the couple entering from the left looking towards the recumbent young man and his companions, given over to song and wanton revelry. No other pictorial source is so rich in social detail, including a boar hunt, hawking, duck shooting and music-making.

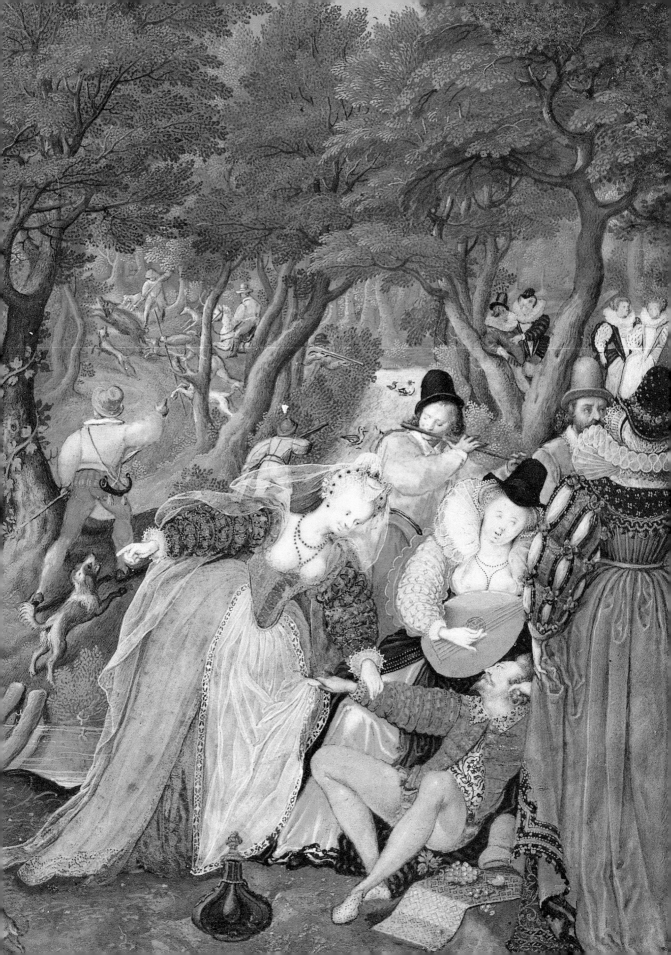

fragment of a mighty outpouring. We owe what we have to the fact that composers for the first time had to write the music down. The result of that has been to give a slightly false impression of the proliferation of music at the close of the century. There may have been as much music earlier but it was not recorded, often being only improvised. Nor should it be forgotten that this was music which, like the literature, was written for a narrow élite. For most of the population the Elizabethan age was peopled by ballads and folk songs and hymns in church. The music of Thomas Tallis's *Lamentations* or John Dowland's *Lachrymae* was for the few.

And, as in the case of literature, the role of the patron was all-important. Their tastes helped shape English music. Thomas Tallis's forty-part motet *Spem in alium* was written to meet a challenge by the Duke of Norfolk that he could surpass one of thirty parts by an Italian: 'Tallis (being very skilled) was felt to try whether he could under-take the matter – which he did, and made one of forty parts, which was sung in the long gallery of Arundel House; which so surpassed the other that the Duke, hearing it sung, took his chain of gold from his neck and put it around Tallis's neck and gave it to him.'

All of this was after the crushing blow of the Reformation. In Edward VI's reign Thomas Becon, chaplain to Thomas Cranmer, articulates the hostile mood of the reformers to church music, denouncing those who retained 'idle singing men to bleat in their chapels.' With the accession of Elizabeth the position began to stabilise, the church authorities prescribing in 1559 'a modest and distinct song . . . that the same might be as plainly understood as if it were read without singing.' That signalled the end of the flamboyance and extravagance of early Tudor church music and in its place composers had to come to terms with a new sobriety and economy of style whose stress was on a fidelity to the text, which was now sung in the vernacular. The role of the queen, and under her aegis of the Chapel Royal, cannot be over-emphasised. John Boswell wrote in 1572: 'If it were not for the queen's majesty, that did favour that excellent singing, singing men and choristers might go a-begging, together with their master the organ player.'

The master of the Chapel Royal for thirty years was one of the greatest of all composers, William Byrd, and his predecessor was Thomas Tallis. The Chapel was the centre of a network which stretched across country to those cathedrals and chapels which maintained singers and composers. Music in church nonetheless was per-petually under threat from the Puritans, but the established church was firmly in its favour. Richard Hooker, prime apologist for the Anglican settlement, wrote at the close of the reign that music 'delighteth all ages and becometh all states, a thing as seasonable in grief as in joy . . .' Thomas Tallis was early in having to respond to the

new liturgy and he did so by adapting for it the declamatory style used for secular part-songs. That, plus the influence of the Flemish composer Orlando de Lassus, brought by the 1560s a new expressiveness to English church music. By its very nature as a national church, such music could never be anything other than insular, but a distinctive Anglican liturgical style had emerged by 1600 in spite of the fact that both Tallis and his successor Byrd remained Catholics.

And that touches something central to the understanding of Elizabethan music. In none of the other arts is one so conscious of the echoes and nostalgia for the pre-Reformation world. Because music was aural and not verbal it could never be charged with disloyalty to queen and state. Both Tallis and Byrd composed their finest music for the Latin rite, but it is within their sacred songs or motets, with their choice of biblical texts dwelling on woes and oppression and hopes of deliverance, that we hear the lament for a Catholic England which had gone.

Music was not only called upon for church and chapel but for secular occasions both ceremonial and domestic. The madrigal was an Italian song form which became hugely popular, subsequent to Nicholas Yonge's madrigal translations published in his *Musica Transalpina* (1589). For composers like Thomas Weelkes, Thomas Morley and Thomas Tomkins, madrigals were to prove a lucrative sideline, and many books of them were produced for the domestic market. These compositions looked to no end other than to delight. Tuneful and rich in texture, they offered the performers an escape into an idyll set in a flower-bedecked pastoral arcadia. In 1601 virtually every major composer contributed to a collection in honour of the queen, *The Triumphs of Oriana*, which was to represent secular music at its height. Just as madrigal music was at its zenith in the 1590s so too was the composition of music for the lute. Composing for that, and for the cittern or bandora, called for special qualities requiring composers who were also skilled exponents of the instrument. In the case of the lute that was the troublesome John Dowland.

The viol, however, was probably the most popular of all instruments because it was relatively easy to learn; as a result voice and viol was to be one of the most characteristic combinations of Elizabethan chamber music, used for part-songs, motets, anthems and madrigals. For composers, it was the consort of viols which gave them the greatest freedom of expression. Devoid of the implications of words fantasy could run riot, as indeed it did in its greatest vehicle, the fantasia, in which, in the words of Thomas Morley, 'a musician maketh a point at his pleasure and wresteth and turneth it as he list . . .'

This was an extraordinary efflorescence of talent but one composer remains supreme, worthy to stand side by side with Sidney, Spenser and Shakespeare, and he

is William Byrd. Byrd joined the Chapel Royal in 1572 and lived to the enormous age of eighty. By the 1580s he had established a new musical style and no other composer was to match the breadth and grandeur of his conceptions nor the originality and variety of his invention. Deeply committed to the persecuted Catholic cause he nonetheless contributed, in his role as court composer, to the establishment of an Anglican musical tradition, one at first hesitant and then gaining in confidence, in seriousness and, as time passed, in splendour. Much of his work for the English liturgy is lost but his *Great Service*, composed for some unknown celebratory event, with its use of a double choir of five voices each with passages written for six, seven, eight and, in one place, ten voices is a masterpiece. But his heart lay in his work for the old Catholic liturgy and crypto-Catholic texts. In 1588 he produced his *Psalms, Sonnets, and Songs of Sadness and Piety* in which he wrote: 'To sacred words . . . there is such a profound and hidden power that, to one thinking upon things divine and diligently and earnestly pondering on them, all the fittest numbers occur and freely offer themselves to the world.' More followed, culminating in 1605 and 1607 with his *magnum opus*, settings for the whole Catholic liturgical year.

Catholic he may have been and yet Byrd remained patriotically English in all his music. English music was like nothing else in the Europe of the time. As in the case of the other arts, composers selected what they wanted from the work of their continental contemporaries and discarded the rest. The result was a deep insularity, conservative in character, honouring the forms and techniques inherited from the past. In no other country did music become a vehicle to express the pent-up feelings of a persecuted minority. That was what gave it its particular intensity. Somehow this fusion of a passionate commitment to the past with the necessity to respond to the demands of the reformist humanist present produced a uniquely vigorous hybrid which still exerts an enormous and haunting hold on the listener.

Nostalgia for yesterday pervades Elizabethan society but that nostalgia had many different motivations. The builders of Elizabethan England looked backwards to the era of the Perpendicular and to the palaces of the early Tudor monarchs, Richmond and Hampton Court. The chances which had been there in the middle of the century to go in a constricting classical direction went into reverse under Elizabeth, who was no patron of architecture herself. She lived within her father's palaces but she also expected to be received by members of her court in houses appropriate to her regal status. The long Elizabethan peace led to a building boom, which not only included the great houses but smaller gentry residences and the houses of yeoman farmers. The towns and villages of

A section of a painted frieze from a room created in about 1575 at Gilling Castle in Yorkshire. A man playing a viol and a lady a lute are seated in an arbour of vines and roses, their music books to hand.

England were in fact rebuilt. But the masterpieces were the great houses built under the aegis of the new dynasties, whose attitude to Renaissance classicism remained as it had been at the opening of the century, that here was another handy repertory of decoration to integrate into the existing native tradition. The result of this was to be a series of buildings of untold exuberance and originality unmatched in the rest of Europe.

Like Elizabethan poetry architecture revelled in hidden meaning and symbol. Houses could be symbolic, such as the triangular Longford Castle built for Sir Thomas Gorges in 1580 as an emblem of the Trinity, or Lyveden New Bield, a garden house erected by a recusant, Sir Thomas Tresham, in the form of a Greek cross bearing the symbols of the passion. Most, however, relied for their delight on the manipulation and rearrangement of an array of geometrical figures, houses with ground-plans which could be circular, triangular, even Y-shaped. Chantmarle House, Dorset, constructed in an E-shape in 1612, has the evidence of a contemporary diarist, John Strode: 'It is built in the form of a letter E, for Emmanuel: that is, our Lord in Heaven.'

It was to be the owners who set the pace and the style, and who also outvied each other with the novelty of the overall idea or device. The role of an architect like Robert Smythson was to render the patron's vision three-dimensional, in exciting combinations of window, gable and tower. Great Elizabethan houses read from afar like secular cathedrals, lanterns of glass shimmering across the countryside, assertions of power but also vehicles for fantasy. These houses are palaces of a kind which would not be out of place as castles for Spenserian knights. Wollaton Hall, Nottinghamshire, built for Sir Francis Willoughby in the 1580s, is almost certainly by Smythson. It is a house of unparalleled fantasy, soaring upwards with a prospect room at its summit floating like a crystal casket. Although the two grandest houses of the age, Lord Burghley's Theobalds and Sir Christopher Hatton's Holdenby, have gone, what is the unchallenged masterpiece still stands, Hardwick Hall, Derbyshire, built for the formidable Elizabeth, Countess of Shrewsbury.

Hardwick, which arose during the 1590s, embodies also the change from the old courtyard house to one compact, in which the servants lived at ground level, the family on the floor above, with the grand state rooms on the floor above even that. The relative status of these floors was reflected in the size of the windows which get larger and larger in each ascending floor, great walls of glass illuminating the high great chamber and the long gallery, rooms designed to be used by a visiting sovereign.

Part of the screen in the great hall at Burton Agnes in the East Riding of Yorkshire. Built between 1601 and 1610 by Sir Henry Griffiths it is a Protestant biblical phantasmagoria in wood and plaster that includes the four evangelists, the twelve tribes of Israel and the planets.

Designs for two symbolic houses by John Thorpe, c.1596-1603. Above left and right one for a house based on his own initials: 'These two letters J and T [being] joined together as you see is fit for a dwelling house for me.'

On the left the plan of a house as a triangle linked by circles is based on the abstract image used for representing the Trinity.

The hand of Smythson is apparent here too, evidenced in the supreme handling of the disposition of the external masses in perfect symmetry but yet with a dramatic use of recession. This is the house as both status and symbol, for the pierced skyline exhibits the builder's initials and coronet. Within in its decoration the countess is cast as the virtuous widow Penelope and the queen as the virgin huntress, Diana.

Wollaton Hall, Nottinghamshire, one of the most innovative of all Elizabethan great houses, was built for Sir Francis Willoughby between 1582 and 1588 under the aegis of Robert Smythson. Although the garden has been updated, this view painted a century later catches exactly the extraordinary dominance of these houses on the landscape.

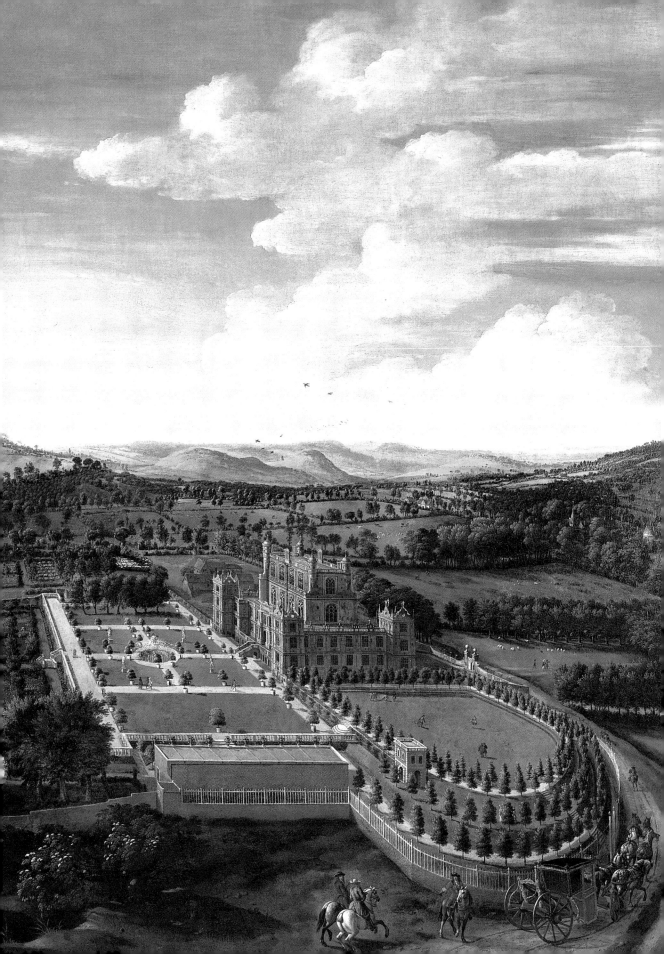

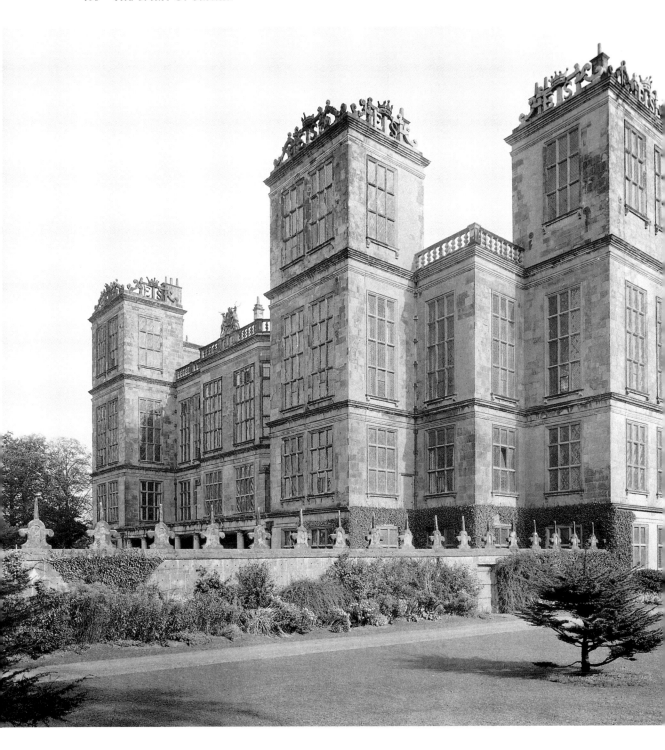

Hardwick can be taken as the touchstone for the visual arts of the era for it is decked with embroideries and hung with portraits. Neither is naturalistic. Both are flat, formalised, abstract patterns. The Elizabethans had no use for a visual art of the kind that existed in contemporary Italy. Although virtuosity and novelty were admired, the depiction of reality found no place in a society that looked to the ideal and called for images which were an accumulation of signs and symbols leading the viewer to an inner mental contemplation. Painting remains with a medieval aesthetic, concerned with outline and colour, so that it is hardly surprising that its greatest expression was found in a medieval format, the miniature, the old art of manuscript illumination secularised for portraiture, distanced from its origins, the book, cut out and set within a bejewelled locket. The only great master of Elizabethan painting is a man of Devon, Nicholas Hilliard. From the 1570s onwards until 1619 he produced a steady stream of miniatures depicting not only the queen but members of her court, and beyond that, even ladies of the City. Painted directly from life on to vellum mounted on card, with a lively freedom of brushwork, these portraits have a quality of immediacy akin to a snapshot photograph. They are unique. But the anti-naturalistic tendencies at the core of the Elizabethan age are evident in the introduction of mottoes and emblems, meaning that these images, too, are meant to be read. A young man set against a black background is declaring through that colour his constancy in love to his lady, or the young Earl of Northumberland is caught reclining in a garden at the summit of a mountain, above him, a feather outweighing the world on a balance hung from a tree, acting as a riddling *impresa*.

All in all this may have been one of the most glorious cultural eras in the history of the island, but it was a renaissance for the few, and with its ideological assumptions deliberately so. For the majority of the population what little that was left from the popular culture of pre-Reformation England, May games, church ales, plays, morris dancing, midsummer watches and the like, came under intensive pressure as the reforming zeal of evangelical pastors and gentry made itself felt across country reaching a climax around the year 1580. This was no suppression from on high. Indeed the queen revelled in all traditional sports and pastimes, which were often incorporated into entertainments staged in her honour as she progressed through her land. On the whole the established church had no official line against such festivities either. The problem lay in the fact that individual members of it did. For them a new godly society had to be created. Sunday, the Lord's Day, was to be made sacred and no longer profaned by wantonness and revelry. Faced with an abundance of texts from the Old Testament denoun-

Robert Smythson's masterpiece, Hardwick Hall, Derbyshire, built between 1592 and 1597 for the formidable Elizabeth, Countess of Shrewsbury, 'Bess of Hardwick', whose coroneted initials adorn its summit.

cing the worship of idols and licentiousness, the traditional secular festivals began to go under in both town and country. Thus, while upper class culture became increasingly literate, luxurious and complex, the mass of the population had their age-old forms of communal expression taken away from them. Not surprisingly, their suppression gave rise everywhere to resistance and resentment. On high, their disappearance met initially with indifference, until the closing decade of the reign. In 1586 William Warner produced his *Albion's England*, which ran into four editions, in which, for the first time, the whole pre-Reformation round of seasonal festivities was cast in a patriotic light as part of the country's heritage. By the time that Elizabeth died in 1603 a nostalgia had indeed set in for much that had been swept away. The old popular folk culture began to be looked upon in a new and benign light as part of the nation's identity. In its coming revival was to reside one aspect of the cultural divide of the new century.

'The Wizard Earl' by Nicholas Hilliard, c.1590-95. Henry Percy, 9th Earl of Northumberland is depicted as a melancholy young man attired in black reclining in the midst of what a contemporary poet described as the 'spacious pleasant fields / Of divine science and philosophy.' This is an image crammed with esoteric allusion calling for reading by a learned mind. The impresa of a balance in which a feather outweighs a sphere is based on one of the propositions by the Greek mathematician Archimedes but it also carries within it allusions to the sitter being torn between hope and affliction.

Chapter Sixteen

ALL THE WORLD'S
A STAGE

By the opening of the seventeenth century Sir Walter Raleigh, naval commander and writer, could cast man's life as being like an actor on a stage:

What is our life? a play of passion,
Our mirth the musicke of division,
Our mothers wombes the tyring houses be,
Where we are drest for this short Comedy,
Heaven the judicious sharpe spectator is,
That sits and markes still who doth act amisse,
Our graves that hide us from the searching Sun,
Are like drawne curtaynes when the play is done,
Thus march we playing to our latest rest,
Onely we dye in earnest, that's no jest.

Raleigh was, in fact, to die on the scaffold. During the same opening years of a new century one of Shakespeare's greatest tragic heroes, Macbeth, was likewise to muse gloomily: 'Life's but a walking shadow, a poor player, that struts and frets his hour upon the stage, and then is heard no more.'

These rueful, disillusioned meditations come as one of the greatest explosions in dramatic creativity the world has ever known was drawing to its close. But for half-a-century, from the opening of the first public theatre in 1576, there had occurred an unprecedented surge of dramatic activity during which companies of actors were formed for the first time, theatres were built, and both acting and the writing of plays established themselves as professional occupations. Some estimate of the scale of this activity can be measured by the single fact that between 1576 and 1613, the year in which Shakespeare retired to Stratford-upon-Avon, some eight hundred plays were written.

The Elizabethan drama was an astonishing and unique phenomenon equal in every way, and indeed exceeding in artistic achievement, all other aspects of that great

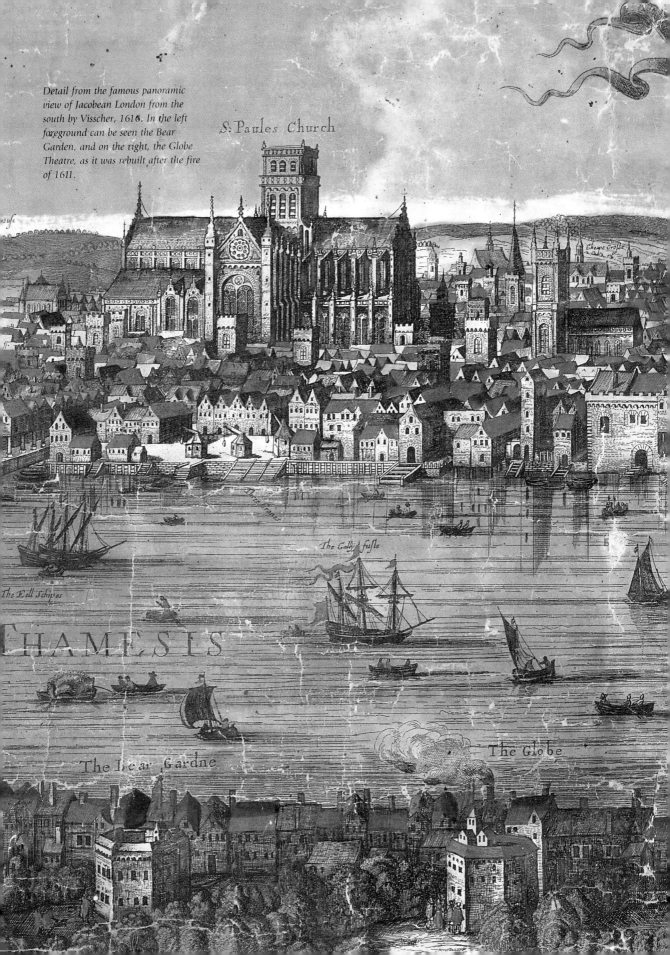

Detail from the famous panoramic view of Jacobean London from the south by Visscher, 1616. In the left foreground can be seen the Bear Garden, and on the right, the Globe Theatre, as it was rebuilt after the fire of 1611.

S. Paules Church

Cheape Crosse

The Gally fuste

The Eell Schipes

THAMESIS

The Bear Gardne

The Globe

cultural renaissance which occurred during the last twenty years of the sixteenth century, and was to stretch over into the first decade of the reign of James I who succeeded Elizabeth in 1603. That it happened at all was due to a quite exceptional set of circumstances, the foundation stone of which was the Renaissance recasting of the role of man as a being who had the ability to choose and fashion his own identity. The playwrights seized hold of this new-found freedom and explored it through the realm of their own imaginations in the form of drama. That exploration was made possible by the use of poetic verse, which enabled the playwright to transport his audience through space from Prospero's magic island to the arid plains of Tamburlaine's Asia. Such movement was not merely spatial but also embraced time, for again through his verse the playwright could take his audience backwards to the battle of Agincourt as easily as he could across the way to present-day Bartholomew Fair. These realms he then peopled with a myriad of human types caught up in plot and subplot, be it tragedy or comedy. In the drama, the playgoer had set before him man's highest aspirations as well as their betrayal, life's transience as well as the utter helplessness of humankind. What the Elizabethans put on stage was the way in which the new Renaissance man pursued power and self-fulfilment, by way of words and war, science and learning, politics and pleasure, as well as love.

Drama of this kind could only emerge out of the new humanistic outlook which had been inculcated through the educational revolution begun earlier in the century, one which embraced the rediscovery of the theatre of classical antiquity. Such a humanist strain led directly to Thomas Norton and Thomas Sackville's *Gorboduc* (1561) which was the earliest play to be modelled on the tragedies of Seneca. This new classicising influence was grafted on to elements from the past derived from miracle plays, mummers and the rituals of the seasonal year. Out of these evolved the interludes of John Heywood and those later by Nicholas Udall whose best known play was a boisterous popular comedy *Ralph Roister Doister* (c.1553).

But the birth of popular theatre was not to be without its pangs. Long-running opponents were the City Fathers, Puritan and reformist in commitment, who saw the theatres and their large audiences as a threat to social order and public morality as well as furthering the rapid spread of the plague. Actors and playwrights also had no place within the existing municipal craft system, worse, plays were put on when honest folk should be at work. The acting companies naturally wished to perform within the city walls but they were firmly rebuffed by a series of prohibitions forcing the theatres to be built in the suburbs or in areas designated as 'liberties', like Blackfriars, over which the City Fathers had no jurisdiction. Even then the theatres had to close for Lent, and in time of plague. In the end the City Fathers won, for when civil

war broke out in 1642 the theatres were shut, not to re-
open again until 1660.

Another important factor in the theatrical renais-
sance was the on-going patronage of the monarchy. The
royal household was indeed to be central to the emer-

*Detail from a drawing by Wenceslas
Hollar, c.1640, showing the west part
of Southwark towards Westminster
including three theatres, the second
Globe, the Hope and, faintly, the
Blackfriars.*

gence of the Elizabethan theatre. The queen demanded entertainment. The provision
of it was the task of the Office of the Revels under its Master, one of the officers of the
Lord Chamberlain's department. Christmas, Epiphany and Shrovetide were all trad-
itional times for the staging of plays before the queen and the role of the Master of
the Revels was to see that plays which would give her pleasure were put on. To achieve
that, his control extended beyond the confines of the court over the whole sphere of
dramatic activity, for he had the power 'to authorise and put down' all plays, players,
playwrights and theatres. In other words, he had power of censorship, along with the
ecclesiastical authorities, over what could be staged. In this way the court was to be
the nursery of the emerging genre, and indeed the official alliance of Crown and
theatre was formally manifested in 1583 when a royal company of actors was formed,
the Queen's Men. By then the new genre had successfully migrated from court to City.

Already by the 1570s great noblemen had begun to form acting companies not

only for their own entertainment but realising that through them they could gain the favour of the queen. The actors in their turn gained the protection of a great lord. By the close of the 1580s the Admiral's Men, the company attached to the hero of the Armada, Lord Howard of Effingham, was the leading company of the day. In 1594 they opened in a permanent theatre called The Rose. Their greatest actor was Edward Alleyn and their repertory included the plays of Christopher Marlowe, Thomas Kyd and Robert Greene. In the same year the Lord Chamberlain's Men were set up with Richard Burbage as their principal and with the plays of Shakespeare, Kyd, Ben Jonson and Beaumont and Fletcher. In 1599 they opened in The Globe. They now became the leading company, maintaining that position until the theatres were closed. On the accession of James I they were appointed the King's Men.

To these two major enterprises must be added the Earl of Worcester's Men who became the new queen Anne of Denmark's company and who opened in the Red Bull in 1606, specialising in domestic comedy and drama, history and adventure plays. There were also the companies in which the actors were all young boys: in 1576 the Children of the Chapel Royal began to give public performances and during the following decade the boys of St. Paul's also had a theatre.

The gentlemen and choristers of the Chapel Royal as they appeared in the funeral procession of Elizabeth I, 1603.

The playhouse was the greatest innovation of the age. In 1576 James Burbage, the father of Richard the actor, built the very first, The Theatre, in Shoreditch outside the city boundaries. It was followed by many others. As they developed, theatres became of two kinds, public and private, the first type either rectangular adapted from an inn-yard or, if they were purpose-built, polygonal. The private theatres were indoors, deriving their arrangement from great halls like those in a palace or in an Oxford

The interior of the Swan Theatre. A drawing by Arend van Buchell after a lost one by Johannes de Witt of c.1596.

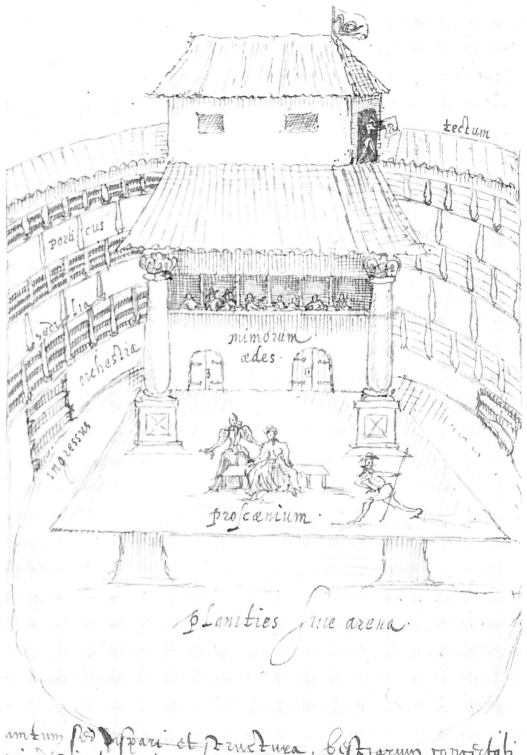

college. They were smaller, rectangular, lit by candles and seated around seven hundred as against the two to three thousand which could be crammed into the open-roof public theatres. Initially these private theatres were only used by the boy companies but all that changed in 1609 when the King's Men purchased the one at Blackfriars so that they could perform there during the winter months. In that single act we witness the shift to the direct ancestor of our present theatre: indoors, artificially lit, and for a far smaller and more select audience.

Both private and public theatres could, and indeed did, stage the same repertory but the more intense interest of posterity has always focused on the physical appearance of the public theatres. The only illustration which we have of the interior of one is of The Swan as it was recorded by a continental visitor and even then that is only a copy of a lost drawing. From this and other surviving evidence we know that there was a yard to stand in surrounded by galleries from which to look down on to the stage. That jutted out into the yard and was protected from the elements by a canopy supported by two massive pillars, the canopy within being sometimes painted with a representation of the heavens. At the back of the stage there were doors, probably two in number, used not only for entrances but possibly for framing inset scenes. Flying effects were possible and there were trapdoors in the stage floor indicating 'hell' below. The architectural form derived from any number of influences, including the mobile stages on which the miracle plays had been performed as well as the openings in the screens of any great hall. Nor can the possibility be eliminated that in the case of the polygonal playhouses the influence may have been the works of the first century Roman, Vitruvius, who describes the form of the classical theatre. In a sense the resulting structure was an analogy to the Renaissance cosmos, in which audiences saw the destiny of man played out beneath a representation of the heavens, the actors moving on earth with hell below them. This was popular theatre in every sense of the word for the audiences were huge. In 1605, out of a London population of about 160,000 about 13% went to the theatre. The audiences embraced every level of the social strata from the grandest grandee at court to the lowliest apprentice boy, with a tariff which ran from a penny to stand in the yard to threepence for the best gallery seats.

Theatres as permanent structures signalled the arrival of acting and writing plays as full-time professions. Early on great actors began to emerge, ones so gifted that parts began to be written with them in mind. Edward Alleyn was probably the first, embodying it seems a highly declamatory style but also with a gift for grotesque comedy. At the turn of the century Richard Burbage succeeded him with a more naturalistic manner, but both men had the range to play Hamlet as well as Tamburlaine.

Great comedians also appeared, the earliest being Richard Tarlton with his squint eyes, flat nose and curly hair, who became in his day something of a national figure. His successor was the comic genius, Will Kemp. Each major production would call for a part specially written for Kemp and he created that of Dogberry, as well, probably, as that of Bottom. The female parts were played by boys, basically for the reason that this offended contemporary convention less than if women played themselves. The demands made on actors were huge, each having to carry at any one time as many as thirty to forty roles in his head.

Just as actors emerged so did playwrights. That came to fruition with the arrival in the 1580s of the so-called 'University Wits', a group of young writers who had attended one of the traditional seats of learning where they underwent a humanist education, choosing afterwards to make their careers as playwrights. The 'University Wits' were John Lyly, who specialised in pastoral and mythological plays written in an intricate prose style for performance at court; Robert Greene, whose plots focused on social ills; George Peele, whose plays again catered for the court and included an admixture of pageantry; and Thomas Kyd whose *The Spanish Tragedy* (1587) spawned a progeny of revenge plays.

These were pioneers but the greatest writers, Chris-

Squint-eyed Richard Tarlton, one of the earliest great comedians, depicted in an historiated initial.

Woodcut from the 1615 edition of Thomas Kyd's The Spanish Tragedy.

The comedian Will Kemp from his Nine Daies Wonder *(1600), describing how he had morris-danced his way from London to Norwich.*

topher Marlowe, William Shakespeare and Ben Jonson, were to come in the nineties. Between them they created what we recognise as a form of drama which was quite distinct from that on the mainland of Europe. That it was so was due to the fact that the language used was not that normally deployed by literary convention but actually the one spoken in every late medieval English town and village. Not quite, for into it the playwrights introduced the fruits of the linguistic explosion precipitated by the forces of the Renaissance which resulted in a huge body of both new words and concepts. This dynamic expansion of the language was to pull in two directions. Handled in the wrong way the result was often vacuous and extravagant. But when deployed charged with depth of meaning the result was to be Shakespeare's most famous speeches. For the poet-playwright the play became an essay, in which action and the movements of the mind were conveyed by using a fusion of the words used in ordinary speech mixed up with ones derived from intellectual sources. The result was a spoken and visual action, unrealistic in its nature, but which called for the presence of an audience both as witness and participator.

These were plays which moved from an acceptance of the Renaissance universe, a view of the world as a great chain of being stretching down from God and the angels in one sweeping hierarchy to the lowliest beast of the field or pebble on the beach. It was a vision in which everyone and everything had its place and also its analogy within the system. God was to man what the king was to his subjects, a father to his family, the lion to the other animals or the sun to the planets. When everything was in its true place the result was divine harmony. And, as it was held that the universe was constructed in mathematical ratios in accord with the musical scale, the purest expression of that harmony was music and the dance. This overall vision of order is central to the understanding of the Elizabethan drama which so often traced the consequences of man's violation of it.

The plays all spring from a concept of man not only set within the cosmos but also within a framework of time. The very idea of history and nationhood was new in the sixteenth century. This was the age of national chroniclers like Raphael Holinshed, who saw the role of history as a means of confirming the present order of things, a sanctified progression to the rule of the Tudor dynasty. All the history plays adhere to this manipulation of the past, describing a cycle moving from disobedience leading to chaos, followed by redemption and reconciliation. Shakespeare and Marlowe alone might question the validity of such a simplistic view but they never overthrow it. What is surprising is that within that optimistic chronology censorship never interfered with putting on stage rebellion, civil war, even the deposition and murder of kings.

Placed within that world picture playwrights explored the two genres inherited from classical antiquity, tragedy and comedy. With the Renaissance release of the imagination the latter flourished, resulting, in the case of early Elizabethan comedy, in an almost unlimited expression of playfulness as to what could occur when the restraints of authority were removed and human impulses given unfettered rein. These comedies revel in a world devoted to pleasure, sex and money, peopled by a quite extraordinary variety of characters in what became a mingling of romance with low humour. John Lyly was to perfect and formalise romantic comedy for a courtly audience in plays like *Endymion* (1588). Shakespeare continued that elegant tradition in the nineties but heightened it with the comedy of human folly, and Jonson was to take it on from there early in the next century with plays which dwelt on the utter grotesqueness of humankind.

Tragedy drew on two classic prototypes. One is typified by Shakespeare's *Titus Andronicus* in which a man is hurled from prosperity to misery by a sudden spin of the wheel of fortune or falls victim to untold malevolence. In the second, man's misery can be self-inflicted by the exercise of the wrong choice like *King Lear* or Marlowe's *Dr Faustus*. Both forms were refined and given a far more complicated and realistic edge. After 1600 tragedy was to take a different path, finding its setting supremely in the poisoned atmosphere of corrupt courts like Hamlet's Elsinore. That preoccupation gave birth to a whole series of plays by George Chapman, John Marston, Cyril Tourneur and John Webster which are generally categorised as Jacobean tragedy. The scene is almost invariably an Italian court depicted as an unprecedented sink of iniquity, a smouldering concentration of power, sex, lust and passion which bursts forth in horrifying murders, sex, torture, dreams and mad hallucinations. Written in the main for performance in the small private theatres they work from a premise of fear, a mood endemic as the Elizabethan era drew to its close and the hopes of Renaissance man crumbled.

The works of Christopher Marlowe, William Shakespeare and Ben Jonson still hold the stage four centuries later, representing collectively an apogee of achievement within the world history of the drama. Marlowe, the son of a shoemaker, came first. He belonged to a group of free-thinking intellectuals and met his premature end in a tavern brawl. From the outset he staked a claim to deliberately creating a new form of drama. For him that centred on presenting on stage symbolic images of Renaissance man's aspirations. *Tamburlaine* (1587 or 1588) is an extreme instance of man's will to dominate and defy even the supernatural powers in a challenge which is a reversal of medieval man:

> I hold the Fates bound fast in iron chains,
> And with my hand turn Fortune's wheel about,
> And sooner shall the sun fall from his sphere
> Than Tamburlaine be slain or overcome.

In this epic the son of a Scythian shepherd rises to be ruler of the world, which for the onlooking audience was constructed by the Marlovian heroic line with its driving, determined, onward thrust, ever rising and falling suggesting unceasing movement and energy. The picture Marlowe paints is one in which Nature feels as man feels and becomes as a consequence a mirror.

Portrait of Tamburlaine from Robert Knolles's The Generall History of the Turkes *(1603). It has been suggested that this depicts Richard Burbage as he appeared in Marlowe's play.*

In *Dr Faustus* (c.1588-93) Marlowe explores another dream of Renaissance man, that of harnessing the powers of the cosmos. Faustus is an over-reaching hero who longs for absolute powers, ones without any compromise or concession to reality. The only way that he can attain these is through magic:

Woodcut from the titlepage of the 1624 edition of Marlowe's Dr Faustus.

> A sound magician is a demi-god;
> Here, tire my brains to get a deity!

Dr Faustus is a tragedy of choice for to achieve what he wants, dominion over the physical world, he must sell himself to the devil. The choice leads only to futility and absurdity and ultimately the realisation that something is needed outside himself by which to live.

Marlowe's achievement was to introduce a new order of imaginative power to the

stage. Ben Jonson's greatest theatrical contribution was to lie in his comedies (his tragedies are virtually never performed), satires on the vanity and idiocy of the urban middle classes. A classical scholar and a moral authoritarian Jonson burst on the scene in 1598 with his play *Every Man in his Humour* in which he set out with reforming zeal to put his contemporaries to rights, seeking to observe in his plays the classical unities of time and space. In the comedies the place is London and its crowded streets, and the purpose to 'shew an Image of the times' with the end in view to promote moral conduct by depicting bad. Jonson's comic world is swirling, dense and busy, his comedies calling for casts of up to forty, excluding the crowds and onlookers. His greatest plays, *Volpone* (1606), *The Alchemist* (1610) and *Bartholomew Fair* (1614) are turbulent tides of pulsating humanity spewing across the stage in a multiplicity of scenes so crammed with incident and detail that the plots almost get lost. Jonson presents to us a panorama of satiric characters out of late Elizabethan and Jacobean society, which catch its confidence and vigour but also those attributes which, unless controlled, can only lead to anarchy. These plays are about the disintegration which follows if both the moral and physical constraints which should govern society are thrown off. Nor does Jonson have much faith in authority itself, glimpsing forever beneath it only an abyss of nothingness.

But the protean genius of them all was William Shakespeare, son of a glovemaker from Stratford-upon-Avon. Towards the close of the next century, John Dryden was to write that '. . . of all modern, and perhaps ancient poets, [Shakespeare] had the largest and most comprehensive soul.' No other dramatist in the history of theatre has possessed such an ability to be re-invented for successive generations. It was his principal rival, Jonson, who alone at the time perceived his utter uniqueness, hailing him as 'not of an age, but for all time.'

Shakespeare, a conservative by instinct, only emerges as a playwright after 1592 with his long series of English history plays. These cover the period from the mid-fourteenth century, *Edward III* (1594-95), to the late fifteenth century, *Richard III* (1592-93), nine plays in all forming together an epic comparable in scale to those of Homer and Virgil. In them we see the medieval give way to the Renaissance mind, feudalism and hierarchy to the nation state, and individualism and a world which was closed opened up to embrace the concept of infinity. The series starts with a world order in place, with man at the centre, the king firmly seated on his throne, inherited customs and authorities as yet unchallenged or violated. Then follows the traumatic break-up of this world through death, unbridled passion and cruel reality, leading to the deposition and murder of a king and later to civil war and anarchy. The old world is seen to die with Richard II, unleashing forbidden powers and passions

214

Tamora pleadinge ... Henrike ... enj dele gentleman

Enter Tamora pleadinge for her sonnes
goinge to execution

Tam: Stay Romane brethren gratious Conquerors
Victorious Titus rue the teares I shed
A mothers teares in passion of her sonnes
And if thy sonnes were ever deare to thee
Oh, thinke my sonnes to bee as deare to mee
Sufficeth not that wee are brought to Roome
To beautifye thy triumphes and returne
Captive to thee and to thy Romane yoake
But must my sonnes be slaughtered in the streetes
for valiant doynges in there Cuntryes cause
Ohi if to fight for kinge and Common weale
Were pietye in thine it is in these
Andronicus staine not thy tombe wth blood
Wilt thou draw neere the nature of the Gods
Draw neere them then in beinge mercifull
Sweete mercy is nobilityes true badge
Thrice noble Titus spare my first borne sonne

Titus Patient your self madame for by her must
Taron do you likewise prepare your self
Aron: And now at last repent your wicked life
Ah now I curse the day and yet I thinke
few comes within the compasse of my curse
wherein I did not some notorious ill
As kill a man or els devise his death
Ravish a mayd or plott the way to do it
Accuse some innocent and forsweare my self
Set deadly enmity betweene too freends
Make poore mens cattell breake there neckes
Set fire on barnes and haystackes in the night
And bid the owners quench them wth their teares
Oft have I digd up dead men from their graves
And set them upright at their deere frends dore
Even almost when there sorrowes was forgott
And on their breastes as on the barke of trees
Have with my knife carved in Romane letters
Let not your sorrowe dy though I am dead
Tut I have done a thousand dreadfull thynges
As willingly as one would kill a fly
And nothing greives mee hartily indeede
For that I cannot doo ten thousand more &c

Henricus Peacham
Anno m̃ q̃o q̃q̃to

So far
from
Shakspeer
Titus
andronicu̇
Sc. 2

Alarbus

followed by an almost uninterrupted downward spiral until the harmonies are restored on the field of the battle of Bosworth, with the death of Richard III and the accession of the first Tudor king.

Simultaneously a long sequence of comedies fill the stage, ones with miraculous transformations, cross-dressing, twins and magic. As in the histories the natural world is a mirror to the confusion caused by the comic turn of events. Here, too, the plots move from a violation of the natural order of things by characters who exercise their passions without reference to established authority. Usually it is the young in revolt against the older generation, an explosion of freedom which, by the close of a play, exhausts itself when the young return refreshed to be reconciled to the old order, signalled by marriage, feasting and dancing. So two realities initially seemingly at variance with one another are seen as in fact compatible. These polarities are also expressed by location, the city embodying order and things as they are, and the forest or wood as freedom and the throwing off of constraint. *A Midsummer-Night's Dream* (1594-96) is the epitome of such a comedy with its two rulers, Duke Theseus presiding over Athens, the city, and Oberon, the Fairy King, as monarch of the wood. The play thus juxtaposes reason, law, tradition and the daylight of the city against the uncontrolled emotions, magic, night and randomness of the wood. In his later comedies, like *Twelfth Night* (1600-1601), Shakespeare concentrates on strong and witty women.

The tragedies open with *Titus Andronicus* (1594), a play of suffering on a scale so great that those caught up in the appalling tide of events actually find that they have no recourse against the injustices perpetrated. *Romeo and Juliet* (1595), *Julius Caesar* (1599), *Hamlet* (1601) and *Troilus and Cressida* (1602) follow, all dealing with man and his drive towards the fullest realisation of his own humanity. Each time an ideal is presented and then set against the world outside, which erodes, corrupts, and finally destroys it. In these plays the characters seek answers to the questions any audience would be asking but no answers are forthcoming. Existence is seen to be a mystery. Man asks questions, analyses, suffers and assumes many roles, but all we emerge with is the parallel of his life with acting in a play, man as a solitary character who has not been allowed to read the script and therefore knows not its ending.

From these Shakespeare moved on to the narrative tragedies, *Othello* (1604), *King Lear* (1605), *Macbeth* (1606), *Timon of Athens* (1607) and *Coriolanus* (1608). All deal with cause and effect with a central character flanked by contrasting groups. These are men of power,

The only known contemporary record of a Shakespeare play on stage, a drawing by Henry Peacham from a manuscript dated 1594. The scene is from Titus Andronicus *and depicts Tamora begging for her son's life. Crude though this sketch is, it captures the elaborate costuming and also the attempts at attire in the classical manner.*

courage and endurance, but they are also men who make the wrong choices, although in doing so they and we learn something of human hope and pity. The plays dwell on the paradox of late Renaissance man, godlike and human, but when everything else has been stripped away, what sets him apart from the beasts is his capacity for feeling and sympathy. But such attributes can only be attained through terrible suffering, which leads first to reaction and then to understanding. The question asked is whether in the midst of human tragedy there are any values or indeed any saving powers upon which humanity and civilisation may be rebuilt. Even in the darkest of these tragedies benign powers are there which gain strength as the story unfolds, affording glimmers of hope.

Finally come the late romances, plays like *Pericles* (1608) and, above all, *The Tempest* (1611). All have the same theme, the disruption of a family or a society by some savage unwarranted act. Characters are banished or lost in an alien land where their past is obliterated and their identity forgotten. There are storms, wreckages, journeys and passages of time on a scale long enough to allow a new generation to come of age who will be the agents of reconciliation. The pattern is a repeated one, loss leading to penitence and forgiveness followed by some miraculous resolution. In the greatest of them, *The Tempest*, there is a mysterious island where no man knows who he is or who has authority. It is a place of joy and beauty but also of terror and ugliness. The exiled Duke of Milan is the central figure in what is a symbolic journey by the characters from fear and despair to regeneration and reunion. In Prospero magician and poet are seen as one, as someone who can make real through the powers of his imagination the dreams of Renaissance man. As he lays down his magic staff Prospero conjures up all that Shakespeare and his fellow playwrights set out to achieve in the world of the theatre:

> . . . To the dread-rattling thunder
> Have I given fire, and rifted Jove's stout oak
> With his own bolt: the strong-bas'd promontory
> Have I made shake; and by the spurs pluck'd up
> The pine and cedar. Graves at my command
> Have wak'd their sleepers, op'd, and let them forth,
> By my so potent art. But this rough magic
> I here abjure; and, when I have requir'd
> Some heavenly music – which even now I do –
> To work mine end upon their senses that
> This airy charm is for, I'll break my staff,
> Bury it certain fathoms in the earth,

And, deeper than did ever plummet sound,
I'll drown my book.

Elizabethan drama opens with faith in man and ends with a shattered view of the Renaissance world. In it we see two forces pitted against each other, man's drive towards autonomy and absolute power and the stubborn real world outside which directly opposes human desire. For some inexplicable reason this dilemma was felt acutely by English playwrights but they found no answer to it, no resolution, just man locked in the dreadful isolation of his own mind. We catch that ruin of the Renaissance vision in *Hamlet*:

> 'What a piece of work is a man! How noble in reason! how infinite in faculty! in form, in moving, how express and admirable! in action how like an angel! in apprehension how like a god! the beauty of the world! the paragon of animals! And yet, to me, what is this quintessence of dust? Man delights not me . . .'

And yet even in this speech the lingerings of greatness and beauty are still there. Hamlet, like all the great characters of the drama, stands ultimately for eternal human values: love, honour, freedom, forgiveness, justice and art. In John Webster's most famous play, *The Duchess of Malfi* (1613), when the heroine, who is the epitome of the goodness and generosity of Renaissance womanhood, has been reduced to the depths of human despair she asks, 'Who am I?' To which comes the chilling reply: 'Thou art a box of worme-seede, at best . . .' And then follows one of the greatest of all affirmations of the life-giving forces of Renaissance civilisation: 'I am Duchess of Malfi still.' In these six words are summed up both the triumph and the tragedy of Renaissance man as they were lived out on the stages of Elizabethan and Jacobean England. Through art man was brought to a vision of great truths. The role of the playwright, using the powers of his imagination and the magic of poetry, was to present these truths on stage for Everyman.

REMOVED MYSTERIES

On Twelfth Night 1605 *The Masque of Blackness*, the first of the court masques written by Ben Jonson and designed by Inigo Jones, was staged in the great hall of Whitehall Palace before Elizabeth I's successor, James VI of Scotland and I of England. In it appeared his wife, the flaxen-haired Anne of Denmark, along with eleven aristocratic ladies as Ethiopian blackamoors, their faces, much to the dismay of some in the audience, blackened. In Jonson's plot these Ethiopians voyage in search of a land whose name ends in –*tania*. Ocean tells them that this could only refer to Albion or Britannia, a fact confirmed by the appearance of the moon goddess who launches into a eulogy of that country's monarch and the new age he has brought:

> Britannia, which the triple world admires,
> This isle hath now recovered for her name,
> . . . This blest isle
> Hath won her ancient dignity and style
> A world divided from the world . . .
> Ruled by a sun that to this height doth grace it,
> Whose beams shine day and night, and are of force
> To blanch an Ethiop, and revive a corse.
> His light sciential is, and, past mere nature,
> Can salve the rude defects of every creature.

What the audience saw, after a curtain painted with a landscape had fallen to the ground, was a huge seascape:

> 'The masquers were placed in a great concave shell
> like mother of pearl, curiously made to move upon
> those waters and rise with the billow . . . the scene
> behind seemed a vast sea . . . from the termination
> or horizon of which was drawn, by the lines of
> perspective, the whole shooting downwards from

Inigo Jones's design for the costumes of the Daughters of Niger in The Masque of Blackness, *1605.*

the eye; which decorum made it more conspicuous,
and caught the eye afar off with a wandering beauty.'

The Ethiopian ladies descended from their shell and advanced to the king at the other end of the room, each presenting him with a fan bearing an emblem. These spoke of the royal presence in terms of the waters of life, of paradise, of purification and of his revivifying powers. They then performed choreographed dances and finally drew in the onlookers to take part in general dancing, or the revels, as they were called.

If one had to choose a date on which the initiation of the cultural revolution ushered in by the new dynasty could be attached it would be 6 January 1605. Within this inaugural performance of what was a new theatrical genre all those themes are in place which it was to be the prime duty of the arts to celebrate: the divinity of the king, his creation of the new Empire of Great Britain and his bestowal of the gift of peace on his subjects. For four decades this was to be the pattern until all it stood for was swept away in a tide of civil war, although one which was to have a cultural dimension to it. But in 1605 it could not be foreseen that these innovative moves in the arts were to contribute to political divisiveness. Indeed the new reign opened with optimism. England and Scotland were united, reassuming the name bestowed on the island by the Romans, Britannia. The imperial theme inherited from Gloriana was thus intensified, so too was the magic of monarchy, the king's powers in the masque being described as superhuman, a sun who exercises an operative virtue over his land and people by means of his 'sciential light', that is, knowledge of a kind analogous to divine wisdom, a force above nature. Everything on stage was precipitated by the regal presence. These are the decades in which art and power were inextricably intertwined, but the style of art which was to buttress that power was to take on a progressively new and *avant garde* character, far removed from the norm familiar to the rest of the population in which the repertory inherited from the Elizabethan age continued to be deployed.

As time passed the new cultural impulses became increasingly associated with what rapidly became a divisive political creed, the Divine Right of Kings, that is, to use James I's own words, the belief that rulers were 'little gods' placed on earth by God to rule in his stead as his representatives. Not only was this novel but so also was the Crown's reinstatement as a leader of cultural innovation, a role last exerted by Henry VIII in the 1530s, though the ungainly if erudite James I showed little personal interest or taste beyond the sphere of learning. Indeed his greatest contribution was to be the Authorised Version of the Bible which was published in 1611 and was to remain in use within the liturgy of the Church of England until the close of the

twentieth century. The importance of that cannot be underestimated. But the king's wife and his two male heirs, the generally forgotten eldest son, Henry, Prince of Wales and his younger brother, the future Charles I, all posses-sed a strong aesthetic drive.

During the opening decades of the seventeenth cen-tury a highly complex reorientation of attitudes, values, assumptions, and modes of thought and feeling began to occur in society. These are seminal decades which can easily confuse just because of the multiplicity of cross-currents occurring simultaneously. In the simplest terms

The heroic Protestant king that never happened. Robert Peake's portrait of Henry, Prince of Wales presents him as a knight of Arthurian romance in an equestrian formula used for Roman emperors. The figure of winged Time walks by his side, his hair tied to the prince by ribbons, in his guise of Opportunity being seized by the forelock.

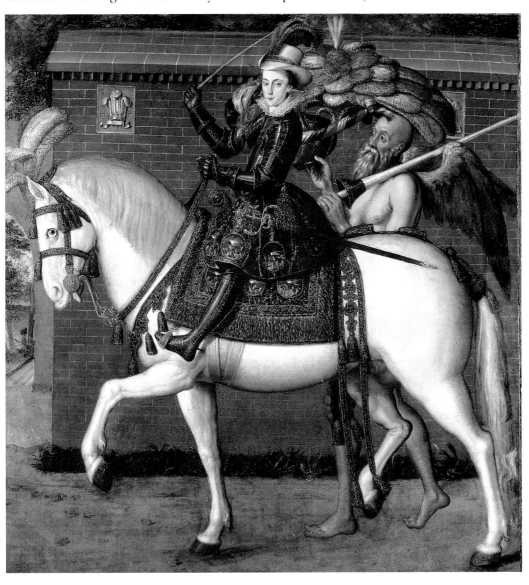

we see the replacement of one set of ideals and their aesthetic expression by another. This is easiest to observe in portraiture, where the still basically gaudy medieval knight of Protestant humanist chivalry was, in two decades, transformed into a sombre mixture of virtuoso, cavalier, and ancient Roman senator. Gaiety gave place to melancholy and sunshine to shade. Neo-medievalism was replaced by classicism, crenellation by the pediment.

The new reign quickly accelerated the change which had already been in the air in the 1590s. In the first place England was becoming an increasingly urbanised and cosmopolitan society whose focus was an ever-expanding London with a population of a quarter of a million. Successive Stuart governments were to struggle to put a stop to endless suburban sprawl. London became a cultural capital in every sense. Not only was the court at hand but the city itself also provided a permanent round of pleasure with its theatres and other entertainments, and its luxury trades, booksellers and portrait painters, tomb-makers and silversmiths, tailors and instrument makers. In short we see the gradual emergence of fashionable life and of a leisured class apart from the court.

The new king's role as peace-maker – he cast himself as the British Solomon – meant that after the treaty with Spain in 1604 the roads were open right across the continental mainland. Even that city of the Protestants' Antichrist, Rome, could be visited. In this way travellers were not only able to see but also to import everything that had happened, and was indeed currently happening abroad back to Britain. The long isolation since the 1530s was at an end. The full impact of that was not to be felt until a new generation came to maturity in the 1630s but during the preceding decades the new became ever more intrusive. But for a time old and new were to live side by side.

A high price was to be paid, however, for the eventual triumph of the new. The Elizabethan age had produced a one nation culture, held together by the external threat of Spain and the forces of the Catholic Counter-Reformation and bound in loyalty to a Virgin Queen, a monarch whose delight lay in her people. If James I and his successor Charles I had inherited that delight in the populace and dedication to the Protestant cause the incipient cultural polarisation between the new court culture and the rest of the country might have been averted. As it was, both kings contracted out of public appearances, opting for a court which epitomised cultural isolation. In the case of James this was exacerbated by scandal and by pursuing Catholic marriages for his sons. In the case of Charles I, a Catholic queen and a return of ritual and images to the Church of England were to contribute to alienation from the population. But the full consequences of this did not begin to bite deep until after about

1615, when the new thinking enters into the ascendant. In 1603 to all intents and purposes it was business as usual, although the warning signs were to come early.

What Stuart courtly culture did signal was the exaltation of the esoteric. That was already manifest in the king's state entry into London in 1604, when seven elaborate triumphal arches stood as visual incantations to regal mystery, piled high with images which called for extreme erudition: 'And for the multitude,' wrote Ben Jonson, 'no doubt but their grounded judgements did gaze, said it was fine, and were satisfied.' Jonson was to be the ideal poet for this new closed courtly civilisation. Thoroughly imbued in the Renaissance hermetic tradition of secret ancient wisdom, transmitted over the millennia by means of arcane images (the common language of man before the Babel of tongues), he was to write the masques for the court. Jonson was an embodiment of the belief that the role of poets and artists was to make manifest not the reality of kingship but its idea as it dwelt in the Platonic realm. Thus king and courtiers were made to approximate to universally recognised ideal types and not the monuments to time-serving, sycophancy and scandals that they actually were. Writing about his masque for 1605 Jonson states that it was not only a manifestation of the old Tudor princely virtue of magnificence but also about something else. Its aim, he says, was educative, to purvey to the onlookers 'the most high and hearty inventions to furnish the inward parts . . . which, though their voice be taught to sound to present occasions their sense doth or should always lay hold of more removed mysteries.' That was what was innovative about *The Masque of Blackness.* It was a regal mystery for pondering by the few.

But what was innovative about his collaborator, Inigo Jones, in that first masque? This was the earliest appearance of what was to develop into the picture-frame stage with the scenery concentrated at one end of a space and arranged according to the rules of Renaissance scientific perspective. Add to this moving stage machinery and a manipulation of artificial light, all things which were in use at advanced Italian courts at the close of the previous century but were totally unknown in England. This was a revolution in visual perception, replacing medieval polycentricity (a way of organising space in which things could be looked at from more than one angle at the same time) by a concept of space, reached by the application of the laws of mathematics and geometry, in which man was placed at the centre of a unified and harmonic cosmos. In particular, it cast the monarch at the focal point because in his eyes all the lines of perspective of the stage set met. It was to take time for the audience to grasp this. Even in the 1630s someone was to describe a perspective stage set as though he was looking at bookcases jutting out in a library. Like Jonson, Jones also regarded the masque as an educative vehicle, and by the 1630s perspective had invaded painting,

The earliest stirrings of interest in the antique in the visual arts prompted by the court of Prince Henry is reflected in this portrait of a courtier attired in classical dress by Marcus Gheeraerts, painted about 1610.

architecture, town planning, interior decoration and gardening. The new perspective and the tide towards absolute monarchy went in tandem.

Jones's masque sets over the years were also to educate his audiences towards a taste for classical antiquity and classical architecture. At first he was to mingle the new Renaissance style with the old Elizabethan neo-medievalism but gradually that was to disappear. Jones is a key figure, more so than Jonson, for what happened to early Stuart civilisation can almost be written in terms of this astounding man who was already thirty-five in 1605 and was not to design his first complete building until ten years later. Architect, mechanic, mathematician, artist, designer, antiquary and connoisseur, he was for years virtually alone in Britain in his knowledge of the modern arts of design. As a consequence his influence was to be unparalleled. Jones had been to Italy at the close of the 1590s and was recommended to the service of the new queen by her brother, Christian IV of Denmark. What set him apart is that he was the

first Englishman to lay claim to being an architect as conceived in the writings of the first century Roman, Vitruvius, and as revived by the great architects of the Italian Renaissance from Alberti onwards. In this scheme of things architecture was the queen of all the arts, whose task, by means of a series of mathematical ratios, was to reflect the proportioned cosmic harmony of the spheres in their heavenly placing, and also to be a microcosmic echo of those in the dimensions of the ideal man. Such a stance depended on the Pythagorean belief that the universe was mathematically constructed according to certain key ratios that were also the source of musical harmony. Through art, Jones brought the music of the spheres down to earth. For such a task, the architect needed also to have knowledge of mathematics, astronomy, music, geometry and philosophy (of a Platonic kind) as well as mastery of the practicalities of building. It was to take time and further study in Italy by Jones himself for the full consequences of this concept to strike root. For the most part, architecture was to remain as it had been in the Elizabethan age, an expression of the patron realised in consultation with master craftsmen and surveyors. Jones, however, had one skill which he was again the first to turn to advantage. He could draw, and thus present to his patrons his ideas on paper.

Jonson, together with Jones, gave the Stuart court its seminal art form, the masque, an entertainment which linked poetry and moral philosophy to art. Each masque used music, dance, poetry and lavish illusionistic scenic display to translate the doctrines of divine kingship into a seductive educational experience, engaging both the senses and the emotions. They were virtually always staged at Epiphanytide or to mark a great event like a dynastic marriage. The audience was presented with a series of mechanical scenic marvels culminating in the queen or one of the princes, attended by a group of aristocratic personages, being revealed in glory as gods, seemingly let down from heaven to earth. The scenery was the action, a series of visual emblems and allegories which dissolved before the spectator's eyes like a succession of baroque altarpieces, each transformation precipitated by the power of the royal presence which could bring, for example, spring in winter or the return of the Golden Age. Within the limitations of the age the impact on the audiences must have been quite awe-inspiring as these celestial tableaux, mysteriously masked and gorgeously attired, suddenly sprang to life, processing downstage into the auditorium, attended by musicians and torchbearers, to dance.

These were secular liturgies with Jonson and Jones as the high priests. Over the years Jonson perfected and elaborated the format, introducing what was called an anti-masque, a grotesque opening scene which satirized the enemies of king and court, figures like witches, furies or troublemakers, serving to heighten the splendour

of the masquers' victory over them. Jones developed his scenery from a revolving machine to a system of sliding shutters which allowed him any amount of changes of set. In addition he mastered celestial ascents and descents, so that by the close of the 1630s he was capable of staging an aerial ballet. All of this was in response to an ever more aggressive view of the powers of the monarchy. By 1617, in *The Vision of Delight*, spring was evoked in winter: 'Behold a king whose presence maketh this perpetual Spring.' 'Whose power is this? What God?' someone asks. This was art in the service of regal deification.

Inigo Jones's design for the main setting of Prince Henry's Barriers *in 1610 written by Ben Jonson. In this we catch an attempt to fuse old and new, the architecture of medieval England with that of ancient Rome and Renaissance Italy. To the right Lady Chivalry awaits awakening by the prince.*

The most important early patron of the new arts was that lost figure in British history, Henry, Prince of Wales. He came of age in 1610 and was to die of typhoid fever on 6 November 1612. If he had lived to succeed, British civilisation might have been far different. Henry was a youth of quite exceptional preciosity, one who, unlike his father, not only had a political programme but a cultural one aligned to it. He revivified the mythology of the Elizabethan era, casting himself as a prince whose aspirations lay in vanquishing Rome, adopting in the tournaments and masques roles such as Meliadus, a descendant of Spenser's Red Cross Knight, or Oberon, the Fairy Prince, heir to the Faerie Queene. At the same time he embarked on an ambitious artistic programme which embraced everything from collecting old master paintings to building in the new classical style. So the prince is in a sense Janus-faced, he simultaneously revives the old while at the same time taking up the mantle of the new.

His cultural policy is conveniently summed up in one spectacle, the *Barriers* of 1610, in which he made his first public appearance before the court. Here, amidst the ruins of the House Chivalry, seen as classical, Merlin conjures the prince up as heir to King Arthur and the knight who will revive Lady Chivalry. He appears to do just that in a scene which marries Elizabethan neo-medievalism with specific ancient Roman buildings:

> More truth of architecture there was blazed
> Than lived in all the ignorant Goths have razed.

For three years the prince was to preside over a court in which old and new were brought into synthesis, both seen to be serving a united and aggressive Protestant cause.

Henry was also the first member of the royal family to perceive the need for an artist of a kind which had become the norm at all late sixteenth century European courts, one whose prime task was to mastermind the spectacle of monarchy, someone who was an architect and interior decorator, designer of court festivals and triumphs, painter and deviser of gardens, and whose key role was to present royalty as Platonic ideals made visible. As we have seen, Inigo Jones was to play that role later for his brother, but Henry was to recruit just such a person, Constantino de' Servi, from that mecca of the arts of the Renaissance, the Medici court. Nothing of de' Servi's work in England has survived but we know from his letters that he was active in all of those areas: designing a new palace, scenery and costumes for masques and tourneys, painting portraits and devising grottoes for gardens. Also active in the prince's employ was another artist in a similar mould, Salomon de Caus, a Huguenot hydraulic engineer who began setting about transforming the gardens of Richmond

Palace into the equivalent of the Villa d'Este. This was to have been a garden in the late Renaissance mould in which art imitated nature with mysterious grottoes, islands in the form of giant river gods, and extraordinary water effects and automata, demonstrating man's harnessing of the irrational forces of untamed nature by making water spurt or figures move. De Caus was to dedicate the first book in England on perspective to the prince.

We have to add to this a huge list of other activities. Henry was the first person to systematically form an art collection, one which included pictures by Holbein and Tintoretto as well as fabulous bronzes by Giambologna, all of which were housed in a special gallery in St. James's Palace. There, too, was his collection of antique coins and medals as well as his huge library. Then there were his painters, including the miniaturist Isaac Oliver, who had mastered the arts of perspective and *chiaroscuro* and whose work had been affected by a visit to Italy, showing the influence of Leonardo.

This was a court which was committed as equally to every endeavour in the field of the sciences. Edward Wright, who set the seal on the supremacy of the English in the theory and practice of navigation, was amongst a roll-call of men in the sciences who were members of the household. The prince even maintained a friendship with that polymath Sir Walter Raleigh, in the Tower for conspiring against Henry's father, who wrote his *History of the World* for him. To Raleigh we can add other writers – George Chapman and Michael Drayton among them – and musicians – John Bull, Alfonso Ferrabosco and Angelo Notari, a Florentine who worked in the manner of Monteverdi. If Henry had not died, the cultural divide which was to emerge during the reign of his brother might have been averted.

The brilliance of that cosmopolitan court must have had a profound effect on

Inigo Jones who, although the prince's surveyor, was relatively low down in the aesthetic pecking order. It was therefore hardly surprising that he left England in the aftermath of the prince's death and travelled again to Italy in the train of Thomas Howard, Earl of Arundel (to whom we shall come shortly). The purpose of the journey was an in-depth study of ancient and modern architecture, starting in Venice where he saw the works of Palladio, Scamozzi and Sansovino. In September 1613 he arrived in Vicenza, the shrine of Palladianism, passing on to Florence and thence to Rome, where he measured the ruins, down to Naples and Trevi and back again to Vicenza and Venice. The fruits of this journey were to have a profound impact on British civilisation for over a century and a half. Inigo Jones's role model was Palladio, whose buildings were the one last expression of Renaissance humanism, an architecture based on the study of Roman models and of Vitruvius emphasising the supreme importance of symmetry and harmony of proportion. Jones's buildings were also to represent in stone the cosmic harmonies of the universe related to the human frame. On his return from Italy he again took up the post of surveyor-general to the Office of Works and began to give physical reality to all that he had learnt.

This was the turning point for all his buildings henceforth have no compromise, no neo-medieval lingerings. They represent a clean break with the past. Four were to be seminal for the future of British architecture, three of which still survive: the Queen's House, Greenwich, the Whitehall Banqueting House, the Chapel at St. James's Palace and (which does not survive) the Prince's Lodging at Newmarket. In 1616 he began work on the first for the queen. Although work stopped two years later after her

The first Thameside classical villa, Inigo Jones's Queen's House at Greenwich built astride the main Deptford to London road. Work began on it in 1616 but was only completed in the 1630s for Charles I's queen, Henrietta Maria.

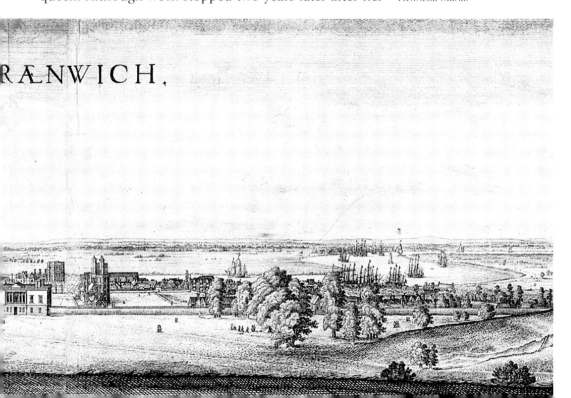

RÆNWICH.

death, only to be resumed for Charles I's consort after 1630, it was to be the first completely modern classical building to be erected in Britain, with a rusticated ground floor, a *piano nobile* flanked by loggias and pierced centrally by a Palladian window. This heralded the role of the Thames as the English Brenta, adorned with villas in the classical style.

The Banqueting House was an even more significant statement. This was the royal hall of state used for ceremonial audiences, masques, and the grandest appearances of the king before the court and visiting dignitaries. For this Jones conceived what can only be described as a temple in which sat enshrined members of the Stuart dynasty, a Roman basilica in the form of a double cube, Augustan in its majesty, restrained, elegant and refined. Its perfect exterior, adorned with the correct application of the classical orders, must have staggered the average Londoner of the 1620s as it arose amidst the rambling Tudor red brick of Henry VIII's palace.

The hall was built with speed after its predecessor had burned to the ground in 1619. The haste was oc-

The Whitehall Banqueting House as it appeared when just completed in 1623, an astonishing contrast to the Tudor brick on either side. The drawing is a design by Inigo Jones for the opening scene of the 1623 court masque.

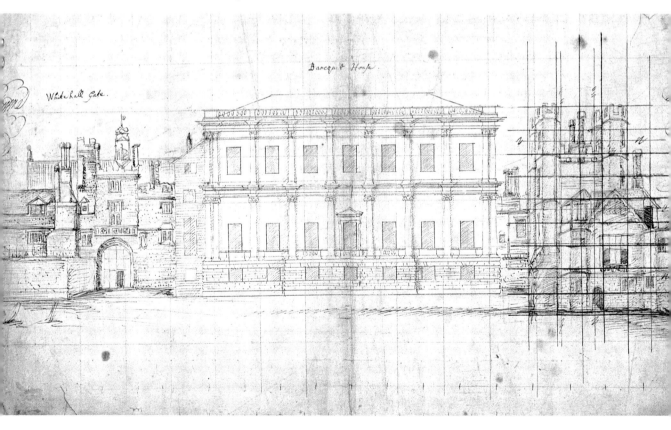

casioned by the need for it to be ready for a Catholic Spanish infanta to be received as a bride for the new Prince of Wales, Charles. That never happened, but it was another reason why the arts quickened at this period, and was responsible also for the Catholic chapel at St. James's which in the end was to be used by the French princess, Henrietta Maria. This chaste rectangle with its beautifully proportioned windows was to be a model for future generations of English churches.

A design by Inigo Jones for the Prince's Lodge at Newmarket, 1618-19. In this drawing the architect anticipates what was to become a format for country houses during the last decade of the century.

Inigo Jones's Lodging for Prince Charles at Newmarket has vanished but it too was to be a prototype, this time of the Palladian country house which was to remain an ideal well into the eighteenth century and, in its revivalist form, even today.

The prospect of a bride from one of the great Catholic courts hastened the aesthetic impulse around 1620 leading to the establishment of a tapestry works at Mortlake and to the recruitment of painters in the vanguard of the new style of the baroque, with its dramatic use of light and shade and swirl of incipient movement. The first of these was Paul van Somer followed shortly after by Daniel Mytens, both from the Low Countries. Their work heralded the death knell of the icons of Elizabethan portrait painting. For the first time the picture-frame became a proscenium arch through which the eye travelled into a world defined by linear perspective and the use of shadow to give the illusion of depth and movement. In 1621 the young Anthony Van Dyck came as prospective painter to the Crown and then promptly left to finish his training in Italy, not returning until a decade later.

These were dramatic pointers to a new era. As the 1620s progressed neo-medievalism declined so much that Jonson could dismiss it:

Of errant Knighthood, with the Dames, and Dwarfs,
The charmed boats, and the enchanted wharfs,
The Tristrams, Lancelots, Turpins and Peers,
And the mad Rolands, and sweet Oliveers.

Everywhere a new cultural scene was settling into position, one which looked back to the early Roman Empire and held up as ideals a sense of order and dynasty. A Latin aristocratic culture was rediscovered, a new ideal which Jonson set constantly before the court, one which stemmed from the Socratic dictum that virtue depends on knowledge not only of the world but of oneself. The courtier was now cast as a role model of virtue, with an image and aspirations far different from those looked to in 1600. Then the adoption of neo-medieval pageantry had established rank through conspicuous display; to be a monarch or a peer one had to be seen at a glance to be rich. Now this criterion was abandoned for a new and far more subtle and sophisticated language which expressed superiority and power through gravity of demeanour and austerity and restraint of appearance, together with a self-conscious elegance both in person and lifestyle. The shift in fashion within those years reflects this exactly. Surface glitter and display vanished in favour of wearing plain yet sumptuous fabrics and soft lace collars. Embroidery and massive displays of jewellery were dropped. At the same time the countryside began to embody an ideal as poets transmuted the English landscape into an anglicised version of the kind of rural life found in Virgil's *Georgics* or the *Odes* of Horace. And the country house began its long life as an icon in Ben Jonson's hymn to Penshurst:

Thou art not, PENSHURST, built to envious show,
Of touch, or marble; nor canst boast a row
Of polish'd pillars, or a roofe of gold
Thou hast no lantherne, whereof tales are told;
Of stayre, or courts: but stand'st an ancient pile,
And those grudg'd at, art reverenc'd the whole.
Thou joy'st in better markes, of soyle, of ayre,
Of wood, of water: therein thou art faire.

If one person can be taken to show how these new ideals were adopted it would be George Villiers, Duke of Buckingham. Considered to be the handsomest man of his time he caught the king's eye and was precipitated on a comet-like ascent: Viscount, 1616, Earl, 1617, Marquis, 1618 and, finally, Duke, 1623. These are precisely the years when change was in the air and Buckingham blatantly exploited every nuance of the new trappings. He employed as his equivalent of Inigo Jones a

Huguenot, Balthasar Gerbier, a man who had a 'good hand in writing, skill in sciences such as mathematics, architecture, drawing, painting, contriving scenes, masques, shows and entertainments for great princes.' Gerbier also helped Buckingham form a great art collection. The paintings were hung at York House, twelve by Veronese in the gallery, ten by Rubens in the great chamber and Titian's *Ecce Homo* in his closet. His collection of sculpture, over a hundred antique and modern pieces, was housed at his Chelsea mansion. In addition he supported a ducal orchestra, employed the poet Robert Herrick as his chaplain, and staged lavish masques. This was a man deliberately using the arts to project an image of himself far removed from the knight of arms of Tudor England. He met the great Flemish baroque painter Rubens and commissioned from him an equestrian portrait of himself (now destroyed) which sums up in one image the whole movement. No longer a static doll in a box he erupts across the canvas on a mighty galloping horse while angelic figures swirl in the heavens above him, banishing vices and showering him with celestial flowers. Although he had commissioned this years before his assassination in 1628 it was not delivered until after that event, by which time the cultural bridge into the new world was firmly in place.

In that new world the artist was to occupy a hugely enhanced status as a secular image-maker, making mortal men gods and heroes. That image-making, however, was achieved through what were perceived as the mastery and application of new technical abilities, and it was those which probably elevated his status more than his ability to make concrete Platonic truths. So the seeds of aesthetic visual sensitivity were sown by means of the sciences, and indeed the arts and sciences march in tandem with the same people deeply committed to both. Although these were years of flux in the sciences everyone shared a common fascination for understanding how to control the forces of the natural world. Approached in this way the new style in painting, for example, can be seen as a scientific advance, as it was based on the application of the science of perspective and a quest to understand the nature of light. The English had to learn how to look afresh at a painting, as a highly complex advance in the sciences, through which, once understood, man was in some way penetrating the mysterious secrets of the cosmos. Simultaneously what had been billed already as sister arts in the Elizabethan period, poetry and painting, came to be recognised as a fact. The whole century was to be dominated by Horace's dictum *ut pictura poesis*, that a poem was a speaking picture. Thus the function of both the poet and the painter was seen to be identical, both being artists who achieved their end, which was ethical, by means of images.

This was a sharp cultural break but what needs to be said is that what it replaced

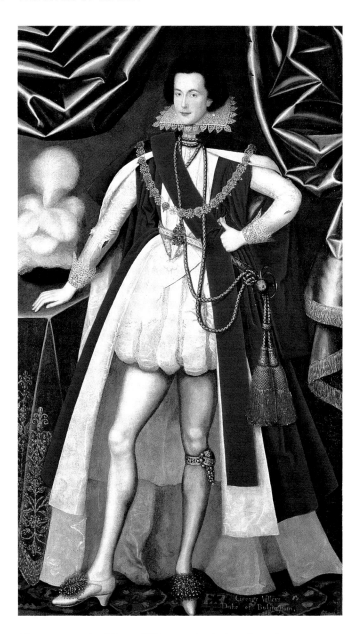

These two portraits of George Villiers, Duke of Buckingham, are vivid indexes of the stylistic revolution which took place during the decade 1615 to 1625. To the left Buckingham is painted by William Larkin in about 1616, when he was created a Knight of the Garter. The aesthetic is still Elizabethan, flat and two-dimensional. Shortly before his assassination in 1626 the duke commissioned Rubens to paint this equestrian portrait of him in his role as Admiral of the Fleet. The resulting image is high baroque with all its sense of movement and high drama.

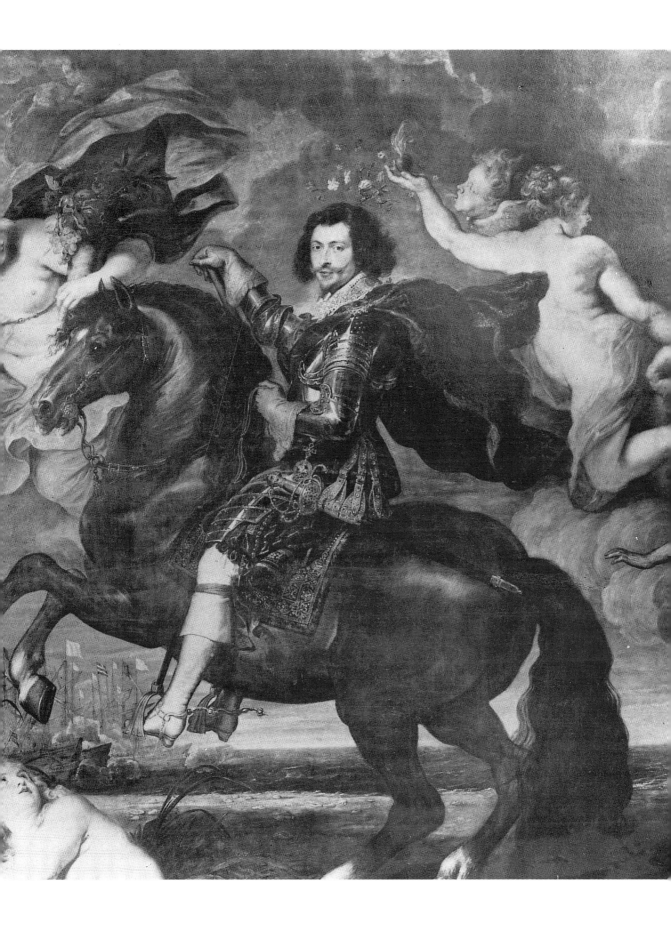

still had enormous vigour. In painting, William Larkin's magisterial renderings of the Jacobean court stand at the summit of that earlier aesthetic, full-lengths of astounding splendour which are quite unlike anything produced in the rest of Europe. In architecture, the exuberant and almost vulgar splendour of a Hatfield House or Audley End shows no signs of flagging in inventiveness. But change in taste and fashion, once begun, cannot be halted. In music, too, Elizabethan gaiety was giving way to Jacobean melancholy, haunting, troubled and introspective. The greatest of Jacobean church anthem writers, Orlando Gibbons, Thomas Tomkins and Thomas Weelkes, made way for a new generation whose interest now focused on secular music. This was not the only change. There was a shift from the lute to the viol which began to acquire its own solo repertory in the 1620s, using a simpler and more delicate idiom, the *style brisé* developed by French lutenists, some of whom were at the English court. At the same time composers such as Gibbons and John Coperario began to write new types of contrapuntal music using varied combinations of violins, viols and the chamber organ. The lute song, which had reached its apogee around 1600, went into decline in favour of declamatory songs influenced by Italian monody, the vocal lines reflecting the inflexions of speech.

In the case of literature Jonson dominates the era, with poetry deeply committed to the standing of the poet in society as a commentator on both social and moral issues. Conservative by nature he saw his role to be the ethical adviser to those in power, and although he indulged from time to time in almost shameless sycophancy that should not detract from a stance which put poetry at the centre of public life, where it was to remain for the rest of the century. Four hundred years later, however, it is easier to identify with those who did not submit to the overwhelming power of the establishment. John Donne was initially one such. He began as an ambitious young man applying his wit and flare for parody to the icons of Sidney and Spenser but was to end up Dean of St. Paul's and a pillar of the Anglican church. But not before penning poetry which, in the words of Thomas Carew, opened up new avenues of expression:

> Thou hast redeemed, and opened us a mine
> Of rich and pregnant fancy, drawn a line
> Of masculine expression.

Donne's was a poetry with shock value, using opening lines which startle, like 'For God's sake hold your tongue, and let me love.' He jettisons the Petrarchan eulogy of the lady for an exploration of his own mind

Rubens's commission to paint the ceiling of the Whitehall Banqueting House went back to the reign of James I, although the canvases were not finally put in place until the 1630s. The central panel in which James I ascends to heaven lifted by Justice and attended by Faith and Religion sums up all that the arts were designed to achieve for the Stuart kings.

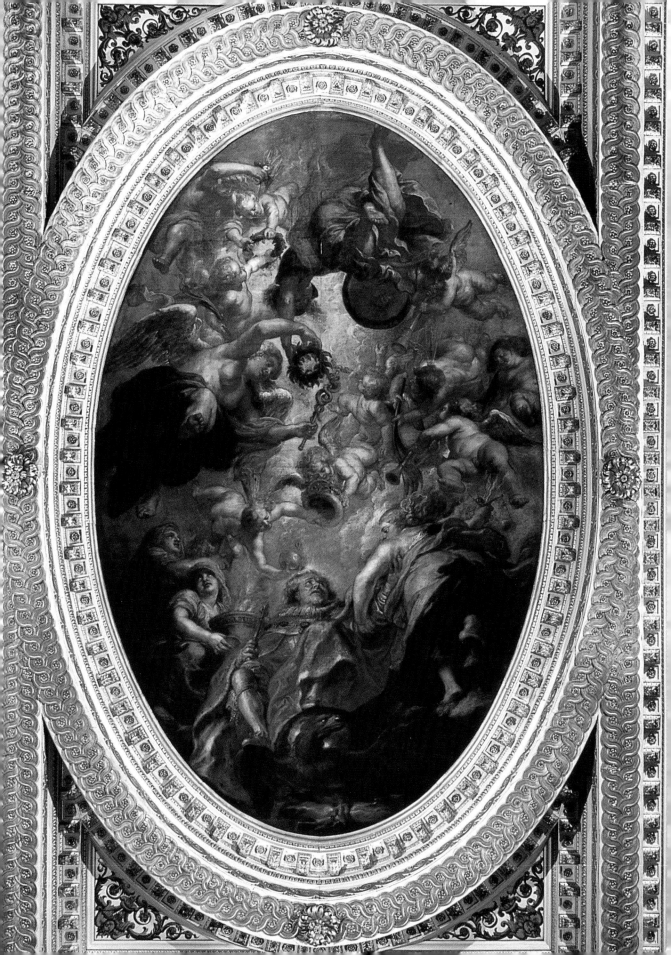

and emotions, which in fact were to find greater expression in his religious verse:

> Take me to you, imprison me for I
> Except you enthrall me, never shall be free,
> Nor ever chast, except you ravish mee.

In these extraordinary poems the inherited medieval responses to the life of Christ, above all his passion and crucifixion, are plunged into a sea of emotions; anger, resentment and doubt jostle with fear, faith and desire in an inextricable complexity of psychological reaction.

But these essentially private passions, which were to leave a potent legacy, were not at the heart of Stuart civilisation in its official public guise. The huge leap which had taken place since 1600 was to be summed up by one supreme work of art, the ceiling painted by Rubens for the Whitehall Banqueting House. That commission was given as early as 1621 but the canvases were only put in place some fourteen years later. In them we see applied to a Protestant king what on the mainland was reserved for the Virgin or some Counter-Reformation saint. In the central panel a baroque heaven opens, dissolving the roof seemingly out into the sky above. Floating in that empyrean are some of the regal verities which figured in the masques, Justice, Religion and Piety, who assist James I on his ascent to beatification. Here the new art, utilising perspective, light and movement as well as powerful esoteric images, has been orchestrated to deify the first Stuart king. This is a removed mystery in paint. Nothing could be further from how the century had started out but both the apotheosis and the glory were to prove to be all too short-lived.

Chapter Eighteen

THE VIRTUOSO: THOMAS HOWARD, EARL OF ARUNDEL

Edward Hyde, later Earl of Clarendon, who wrote the classic account of what he designated as the 'great rebellion', paints a memorable portrait of a seminal figure in the nation's cultural history. That person was one of ancient aristocratic lineage, Thomas Howard, 2nd Earl of Arundel:

'. . . he was generally thought to be a proud man, who always lived within himself, and to himself, conversing with any who were in common conversation; so that he seemed to live as it were in another Nation . . . it cannot be denied that he had in his person, in his aspect and countenance, the appearance of a great man, which he preserved in his gate, and motion. He wore and affected a Habit very different from that at the time, such as men only beheld in Pictures of the most considerable Men; all of which drew the eyes of most, and the reverence of many towards him, as the Image, and Representative of the Primitive Nobility, and Native Gravity of the Nobles, when they had been most Venerable.'

This is a portrait of an unlovable man, one whose *hauteur* most found insufferable although he could be not only passionately loyal but also loving to those few whom he cherished. In spite of so many off-putting characteristics this tall, gaunt man with his hooked nose and black eyes, was to set before his contemporaries a new ideal for the life of a gentleman. That side of him we catch in a far more favourable glimpse of the man afforded by his one-time secretary, Sir Edward Walker:

'He was the greatest Favourer of Arts, especially Painting, Sculpture, Designs [i.e. drawings], Carving, Building and the like, that this Age hath produced; his Collection of Designs being more than any Person living, and his Statues equal in Number, Value and Antiquity to those in the Houses of most Princes ... And he had the Honour to be the first Person of Quality that set a Value on them in our Nation.'

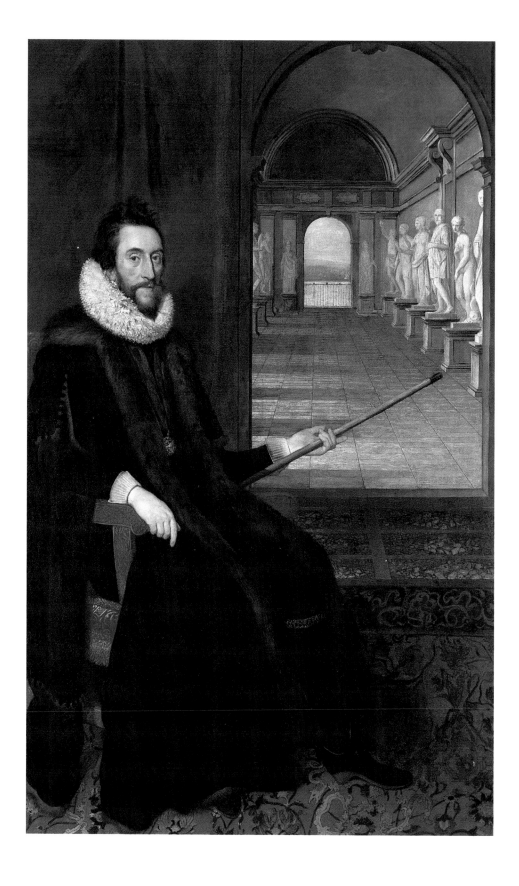

Thanks to Arundel, by the middle of the century the aristocratic and gentry classes were to seek a new ideal of civilised life.

The earl shares with his friend Inigo Jones the distinction of being the most influential person in the evolution of British civilisation during the decades which led to the outbreak of civil war in 1642. Although their origins could hardly have been more discrepant they shared certain characteristics. Both were touchy and difficult, both were isolated arrogant figures in their own particular way, traits only heightened by what many would have viewed as their promotion of an alien foreign Catholic culture, that of Renaissance Italy along with its ancestor, the world of classical antiquity. Both were to dedicate their lives to the spread of what those cultures represented, and both were to end their days clouded by defeat and tragedy.

If Arundel suffered from the vice of pride his life was to be a monument to unfulfilled ambition and to the bitterness that engendered in one who by birth should have been a duke. Thomas Howard should have been Duke of Norfolk if his grandfather had not plotted against Elizabeth I; as a consequence Norfolk was executed in 1572 and the title went into abeyance. Thomas's father, Philip, inherited the Arundel earldom through his maternal grandfather but his life too was blighted by disaster. Converting to Rome he ended his days in the Tower and he never even saw his son, who was born after his incarceration. The young Thomas Howard was to be brought up in obscurity by a disgraced recusant family, a childhood which was to leave an indelible mark. One consequence of this was a lifelong passion to be restored to full honours as duke. The other was to be an ambiguity towards religious creeds in an age rent by division. Art and not faith was to provide life's focus for a man whose reading and mental disposition led him to the philosophy of the Stoics.

The death of the old queen in 1603 heralded an upturn in the fortunes of his family. The Howards were to ride high in the favour of James I and Arundel cherished hopes of a restoration of full honours. What he lacked, however, was the physical glamour that drew the eye of the king. Instead Arundel saw those he viewed as upstarts showered with titles and rewards. But for an initial phase everything seemed full of promise. In 1606 he married one of the three coheiresses of Gilbert Talbot, 7th Earl of Shrewsbury. She brought with her a much-needed fortune, one which, on the death of her father in 1616, amounted to the stupendous annual income of £25,000. Aletheia was no beauty. Not even the flattering brushes of Rubens or Van Dyck could conceal the fact that she was plain. But she was educated, with a deep interest in architecture (her

Daniel Mytens's portrait of Thomas Howard, Earl of Arundel, about 1618 presents him as the Renaissance courtier in sombre black seated before an idealised version of the sculpture gallery Inigo Jones designed for Arundel House. This was the first such gallery ever built in England, strongly Italianate in feeling with its open vista to the Thames.

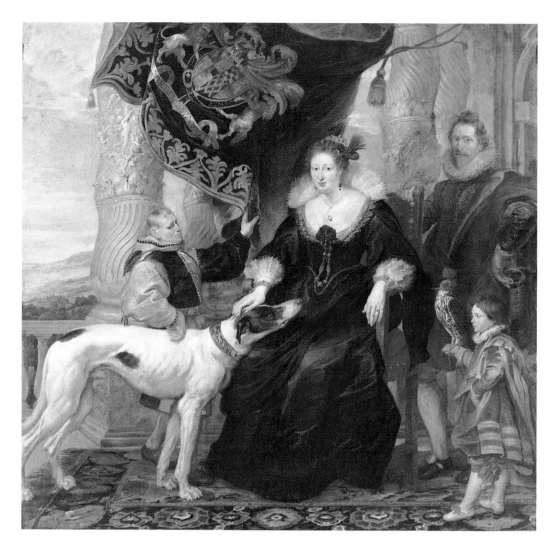

step-grandmother was Bess of Hardwick) and she shared many of her husband's aesthetic interests. In the end the marriage broke down and they lived apart, she turning Catholic, but all that lay in the future during the reign of James I when both took a prominent part in the round of masques and tournaments that made up court life.

Arundel was drawn to the circle of Henry, Prince of Wales, and it was there that he came into contact with his soul-mate, Inigo Jones. It was a friendship which las-

Rubens's portrait of Aletheia, Countess of Arundel, attended by the ambassador Sir Dudley Carleton and her fool and dwarf, epitomises the pretensions to grandeur of the countess and her husband. She is framed by the twisted columns of the Temple of Solomon and the Arundel arms are swagged above her. She sat for the artist in Antwerp en route for Italy in 1620.

ted, more or less, both their lifetimes. By then Arundel had already acquired an eye for pictures and, indeed, had sat for the young Rubens, prime exponent of the new

flamboyant baroque style in the north, when he had visited Antwerp in 1612. Arundel was in many ways the true inheritor of the ideals of that nascent Renaissance court. Shortly after the prince's death both he and the countess were assigned the task of escorting the king's daughter Elizabeth to Germany, after her marriage to the Elector Palatine. From there, accompanied by Inigo Jones, they went to Italy for the tour which has been recognised ever since as a cultural landmark.

On their return Arundel was to make his most persistent bid to achieve political status. In 1616 he conformed to the Church of England by taking communion in the Chapel Royal. The same year he was made a Privy Councillor. Four years later the king restored to him the ancestral office of Earl Marshal, head of the College of Arms, and therefore in charge of all grants of arms and likewise of all state ceremonies. Then, in 1623, came a blow which signalled his political eclipse. A man who in his eyes was an upstart provincial squire, George Villiers, was made Duke of Buckingham. James had indeed offered Arundel the dukedom of Norfolk but as a re-creation and not as the restoration of honours. He was too proud to agree to that. The death of James two years later did not improve matters, for the new king was also enslaved by Buckingham and Arundel was ostracised from the court. Worse, in 1626, he was sent to the Tower on account of his son's secret marriage to Lady Elizabeth Stuart. For that he was heavily fined, a financial blow from which he never quite recovered. Aided by his own prodigality Arundel was to end his days encumbered by a mountain of debt.

Buckingham's assassination in 1628 did remove the major impediment to his relationship with Charles I who through the 1630s was to employ him on a series of ceremonial embassies, to the Low Countries, to the Emperor Ferdinand, to Cologne, escorting the king's mother-in-law, and, finally, in 1642, the queen and her daughter to Holland. What Arundel regarded as his apogee was to be made commander of the army in the First Bishops' War in 1638, an appointment for which he was wholly unqualified. Mercifully for him a humiliating accommodation was reached with the rebels so that his shortcomings never came to light. By then he was hugely in debt and flirted with a madcap scheme to colonise Madagascar but the countess refused to countenance holding court in a jungle. With the outbreak of civil war Arundel stayed in the Low Countries, selling part of his collection to raise funds for the royalist cause. His health, never robust, began to give way. In truth the light had gone out of his life and his family had become one sea of disagreements and recriminations. In 1646 he made his way south again to Italy in the hopes of rescuing his grandson, Philip, from the embrace of Rome but he failed. John Evelyn, the diarist, visited him in Padua on Easter Monday six months before his death, leaving us a poignant picture of a broken man:

'I was invited to Breakfast at the Earle of Arundels; I tooke my leave of him in his bed, where I left that greate and excellent man in teares upon some private discourse of the crosses had befaln his illustrious family . . . the miserie of his countrie now embroiled in a Civil War . . .'

In one sense Arundel's life was a failure but in another what he came to represent was to be carried forward by men like John Evelyn into the second half of the seventeenth century and way beyond. And all of that was to stem from those seminal nineteen months in Italy in 1613 to 1614 which were to be a cultural watershed. Great aristocrats had travelled to Italy before. Arundel's father-in-law, Shrewsbury, had been there and his houses betray knowledge of Italian villa planning. So also had, for example, Thomas Cecil, Earl of Exeter, whose great house at Wimbledon, which bore the date 1588 over the porch, had an approach modelled on the Palazzo Farnese at Caprarola. But what was to set Arundel's voyage apart was a quest which was far broader than stylistic trends and detail. It was one for the components of the civilised life, in Italian summed up in the word *virtù*, with its connotation of civility, grace, elegant manners and interest in learning. Arundel returned to England speaking Italian and adopting the living style of that country even down to its table manners. His secretary, Sir Edward Walker, realised that the earl had come back from his journey with a vision which he was to attempt to instil into the sensibilities of the educated Englishman. This was one which recognised the arts as the fullest expression of nobility of spirit. By the close of the century what he first practised was universally shared by the aristocracy and gentry, profoundly affecting how they spent their time.

Arundel and his party began their Italian tour in Venice, always welcoming to the English, where they saw the finest buildings by Palladio, Sansovino and Scamozzi and the greatest masterpieces by Titian, Tintoretto and Veronese. From there they moved on to make a private visit to Vicenza to study the architecture of Palladio in depth and where the earl purchased drawings by both Palladio and Scamozzi. They wintered in Siena in a monastery, spending their time mastering the Italian language before arriving at their cultural mecca, Rome. There they were looked after by the Marchese Giustiniani, the most discerning patron of his day. Arundel was not only given a permit to excavate but also to ship the things he found to England. (These, it transpires, were deliberately planted antiques which were more than easily unearthed.) At the same time he purchased books and commissioned four more statues in the antique manner from a Roman sculptor. There was an excursion to Naples and Trevi and then the journey back via Florence, Genoa and France.

The impact of the arrival in England of these antiquities in 1615 cannot be

overestimated. Just as earlier relics from the Holy Land had made the Christian story a reality, so classical anti- quities made tangible ancient Rome and her civilisation. They were to signal a decade of aesthetic change and the onset of collecting mania. Arundel was not without pre- cursors as a collector in the broadest sense of the term. His great-uncle, John, Lord Lumley, had the greatest col- lection of pictures in England, over two hundred and fifty of them, including Holbein's *Christina of Denmark*. But the impulse behind it was iconographical and gene- alogical, the faces of ancestors and great contempor- aries. By the 1590s collecting on an aesthetic basis had begun to take off and Anne of Denmark, Prince Henry, and the king's favourite the Earl of Somerset, all accum- ulated pictures, both Flemish and Venetian. In the case of books again Lord Lumley had the second largest lib- rary and Arundel's relative, Lord William Howard of Naworth, had formed another huge library in the north of England. What was different about Arundel's collec- tion was not only its size and its scope but, above all, its intention. Although Charles I's collections were to sur- pass Arundel's in certain areas it was the earl's which was to set the pattern for future British art collections, inaug- urating a tradition which was to last for three centuries until the Heirlooms Act and the introduction of death duties at the close of the nineteenth century began their dissolution.

One of the imitation antique statues commissioned by Arundel while he was in Rome in 1614 from the sculptor Egidio Moretti.

Arundel's collections were almost entirely displayed at Arundel House which was situated between the Strand and the Thames next to the queen's residence, Somerset House. On his return from Italy, the rambling medieval residence was given an Italianate overlay of doors and windows and chimneypieces in the classical manner. A new two-storeyed gallery was built, designed by Inigo Jones and running down to the river. The gallery at ground level displayed the picture collection, that above, the sculpture. To mark this, in 1618, the earl and countess had their portraits painted by an artist who heralded the new baroque manner, Daniel Mytens, who inserted into the backgrounds idealised views of these two galleries. The classical statues can be seen standing in an elegant restrained room in the early

Renaissance manner leading to a balcony overlooking the river. Every attempt during these years was made to give the impression that somehow an Italian palazzo had sprung up beside the Thames.

Arundel was a manic collector, never letting up in his pursuit of certain works even if he had to wait for years before he finally landed them. Right up until the bulk of the collection was shipped to Antwerp in 1643 it continued to grow. The full extent of it remains even today unknown; including the drawings and prints it must have run not into hundreds but thousands. An inventory drawn up in 1655, when it had passed its zenith and Arundel had already been forced to sell, lists some six hundred paintings including portraits, mythological and religious scenes by Italian, German and Flemish masters. The collection was dominated by the work of Italians and by that of Holbein: thirty-six by Titian, nineteen by Tintoretto, seventeen by Veronese, sixteen attributed to Giorgione and a dozen or so Raphaels. Arundel was open in admitting his 'foolish curiosity in enquiring for the pieces of Holbein.' He accumulated over forty of them. That inventory took no account of the huge collection of antiquities which remained in England nor did it cover the thousands of old master drawings and prints, books and manuscripts. His secretary, Walker, indicated that his passion for drawings (those sketches which recorded the creative processes of artists) was unique at the time. His passion was such that he had a special room built in which to house them. Those who came to its inaugural party in 1637 were astounded to see two hundred volumes full of drawings by Michelangelo, Leonardo, Raphael and other great masters. These were not only preparatory works for pictures but actual designs for the decorative arts in which the earl took the keenest interest. By then he had appointed a German, Hendrik van der Borcht, as keeper of this collection.

Such a collection was evidence also of another phenomenon, dabbling in what had already become a highly organised art market. All over Europe and into the Middle East agents scoured the place in search of works of art. Ambassadors like Sir Henry

A fragment from the Trajaneum at Pergamon, one of the most notable pieces in the Arundel collection of antiquities.

Titian's The Mocking of Christ *was a famous picture in the Arundel collection, acquired for the earl in Italy by the agent, William Petty.*

Wotton and Sir Dudley Carleton in Venice played key roles in acting for collectors. Sir Thomas Roe, ambassador to the Sultan in Constantinople, was to write: 'Concerning antiquities in marble, there are many in diverse parts, but especially at Delphos, unesteemed here; and, I doubt not, easy to be procured for the charge of digging and fetching . . .' The rush was on, and both sharp and double dealing were to know no bounds. Arundel made extensive use of an unscrupulous north country cleric and antiquarian, William Petty, whom he trained to be his agent. In 1624 Petty was sent to the Middle East and a decade later to Italy. In both he was to become notorious. To him Arundel was to owe two hundred antique pieces of sculpture, a Neapolitan drawings collection which included no less than five hundred by Michelangelo, not to mention his acquisition of one of Titian's greatest final masterpieces, *The Mocking of Christ*.

Arundel was aggressively predatory. When his enemy Buckingham was assassinated he did not hesitate to step in and secure a ship loaded with Greek codexes and two hundred antique coins as well as a huge number of statues sent by Sir Thomas Roe. There were also the opportunities presented by his ambassadorial trips. On the 1636 embassy to Vienna he purchased the library of Willibald Pirckheimer, the wealthy Renaissance humanist and friend of Dürer, which included priceless books and *incunabula*, some illustrated by the great German artist.

But the true fame of the Arundel collection was to reside in its classical antiquities. Henry Peacham, who was tutor to the earl's children, wrote in the 1634 edition of his influential handbook *The Compleat Gentleman*:

'To [his] liberal charges and magnificence, this angle of the world oweth its first sight of Greek and Roman Statues, with whose admired presence he began to honour the Gardens and Galleries of Arundel House about twentie yeares agoe, and hath ever since continued to transplant old Greece into England . . .'

The effect must have been startling, for no one before had created what was in effect a museum garden in the Italian Renaissance manner. Its impact on the scholar and essayist Francis Bacon is recorded thus: 'Coming into the Earl of Arundel's Garden, where there were a great number of Ancient Statues of naked Men and Women, made a stand, and as astonish'd, cryed out: "The Resurrection."'

The influence on contemporary sculpture was immediate, as evidenced in the work of Nicholas Stone. But Arundel's interest was not merely aesthetic for the great scholar, Sir Robert Cotton, had led Arundel to appreciate the significance of the antiquities as evidence of a lost civilisation. When the large consignment from Petty came in 1627 Cotton was so excited that, in spite of the fact that it was the middle of

the night, he sent for John Selden, the antiquary. Sel-
den, together with two other scholars, was to produce
a year later *Marmora Arundelliana*, the first direct study
of classical archaeological material by an Englishman,
a book which made the collection celebrated throughout Europe.

Arundel House from across the Thames,
a drawing by Wenceslaus Hollar. The
flat roofed classical building to the left
running down to the river contained the
picture and sculpture gallery.

By 1630 it included thirty-seven statues, a hundred and twenty-eight busts, two
hundred and fifty inscriptions, besides a large number of sarcophagi, altars and frag-
ments. Together they symbolised in Roe's words Arundel's love of 'the lights and
reliques of ancient learning or noble sciences.'

But what was the purpose of such a collection? To answer that question we have
to turn to Francis Junius who was Arundel's librarian. Realising the criticisms which
could be levelled at such an ostentatious accumulation of art treasures in the midst
of Puritan London he was to write *The Painting of the Ancients* (1637). This was not
only a major compendium of all that could be found in the classical writers on the
visual arts but a polemic as to their status within society. Their role depended, he
wrote, on their power to inspire noble and virtuous deeds. His argument was based
on their moral efficacy.

Junius was a member of what can be described as the Arundel circle, for the earl
understood the importance of scholarship. That circle included some of the greatest
luminaries of the day: John Selden, whose learning encompassed Roman and British
history, religious history, commercial law, comparative religion and philology be-
sides English and international law and jurisprudence; Sir Robert Cotton, a pioneer
of Anglo-Saxon studies, who owned the finest private library in the country, rich in

medieval manuscripts; William Camden, the greatest of Elizabethan historians and the progenitor of antiquarian studies in England; Sir Henry Spelman, the ecclesiastical historian; William Oughtred, the foremost mathematician of the age; and William Harvey, the discoverer of the circulation of the blood. Arundel was at the heart of everything which was pushing forwards the boundaries of knowledge, and his circle was to lead directly to the formation of the Royal Society.

In one field of endeavour Arundel fell short and that was in attracting any artist of great stature from abroad, apart from Van Dyck, to England. Blame can of course be accorded to its geographical position away from the cultural mainsprings. Highly successful artists simply did not want to settle in what was in their eyes a backwater, one which was also Protestant. Inevitably Arundel's sights had to be levelled not at Italy but north of the Alps. In 1618 he was successful in persuading Daniel Mytens to come and may equally have been responsible for Van Dyck in 1620. The countess was to sit in 1620 to Rubens for a canvas of astounding splendour in which she was depicted in the full-blown baroque manner. The earl sat for him nine years later, dressed in armour as Earl Marshal and in a pose lifted from one of Titian's series of Roman emperors which had just arrived in England. He also sat for Van Dyck more than once and there was even a project for a pretentious family group. Arundel was, however, successful in attracting a middle-of-the-road sculptor in the baroque manner, François Dieussart, who produced portrait busts, but the artist he will most be remembered for is Wenceslaus Hollar whom he recruited while in Cologne. Hollar was a superb engraver and he was to leave a panorama of Caroline England including engravings of Arundel's houses and items from his collections. Indeed the plan of publishing engravings of pictures and drawings was aimed at making the collection accessible to a whole range of scholars, gentlemen, and practising artists and craftsmen.

Hollar's engraving of part of the grounds of Arundel's country house at Albury in Surrey recording a grotto in the classical style glimpsed across the river.

In the end Arundel's collections were to fall victim to his own insolvency, divisions within his family and the tragedy of the Civil War. The pictures and drawings are scattered today among the great museums and galleries of the world. The collection of antiquities suffered appalling depredations. Nonetheless a small corpus of it survives in the Ashmolean Museum, Oxford. But it was less the reality of the collections than what they and their owner represented which was to be so important. With Arundel we see an expansion and extension of the previous century's definition of the orbit of the gentleman. To his existing sphere of activities he now had to add the role of dilettante or *virtuoso* in the arts and sciences, to be a person who was interested in, and probably take part in, experiments and inventions, was able to identify classical imagery and delight in assembling a cabinet of rarities or judge a work of art. Henry Peacham's *The Compleat Gentleman* (1622 and 1634) embodied the new educational programme for the upper classes. It includes a chapter *Of the dignitie and necessitie of Learning in Princes and Nobilitie*:

> 'Since learning then is an essential part of Nobility, as unto which we are beholden, for whatsoever dependeth on the culture of the mind; it followeth, that who is nobly born, and a Scholar withal, deserveth Double Honour being both . . .'

So a dramatic change in attitude to studies and learning has taken place. They are now billed as attributes conducive to fame and worthy of admiration. The word *virtuoso* indeed makes its debut in Peacham's work. That new concept, allied to the Horatian ideal of the quiet country life, brought about what amounted to a secularised version of the ancient ideal of the contemplative life for a Protestant society. It was to be one which would see the defeated royalist gentry through the gloomy years of the Protectorate when, cut off from either political or military activity, their energies could be absorbed in the cult of rural meditation and of the attributes of the *virtuoso*. That they owed to Arundel, designated over a century later by another great arbiter of taste, Horace Walpole, as 'the father of *virtu* in England.'

Chapter Nineteen

ISOLATION

In 1629 the great baroque painter Peter Paul Rubens came to England on a diplomatic mission to mediate a peace which was to inaugurate the eleven years of the personal rule of Charles I without Parliament. The artist, honoured by the king with a knighthood, wrote of what he found here:

> 'This island . . . seems to me to be a spectacle worthy of the interest of every gentleman . . . not only for the splendour of the outward culture, which seems to be extreme, as of a people rich and happy in the lap of peace, but also for the incredible quality of excellent pictures, statues and ancient inscriptions which are to be found in this court . . .'

Rubens was a man of the utmost aesthetic sophistication, someone familiar with the riches of Italian Renaissance culture besides being a courtier at one of the most advanced courts in Western Europe, that of the Habsburg archdukes in Brussels. His judgement was one which could not have been passed fifteen or twenty years earlier, a huge indication of the cultural shift which had been achieved by 1630.

That shift had already been accelerated by the change of ruler in 1625. Throughout the seventeenth century politics and religion were affected by a king's character, so too was taste as refracted through his court, thus conditioning the main lines of expression not only in literature but also the visual arts. Both were to remain inextricably linked to royal apotheosis. Literature's role was to create adulatory myths to glorify the ruling dynasty as much as the task of the visual arts was to set forth its triumphs in things seen. The difference in the content and in the context whereby these aims were to be achieved between the Jacobean and Caroline courts was to be highly significant, however. The cultural ethos of the old Jacobean court was still based, as Elizabeth I's had been, squarely on contact with the real world which lay beyond the confines of Whitehall Palace. James I had been viewed as a cross between an Old Testament king and a Roman emperor.

One of Van Dyck's most famous portraits of the king. The painter's brush transmutes the diminutive sovereign into a commanding figure, emperor of Great Britain and knightly hero rolled into one.

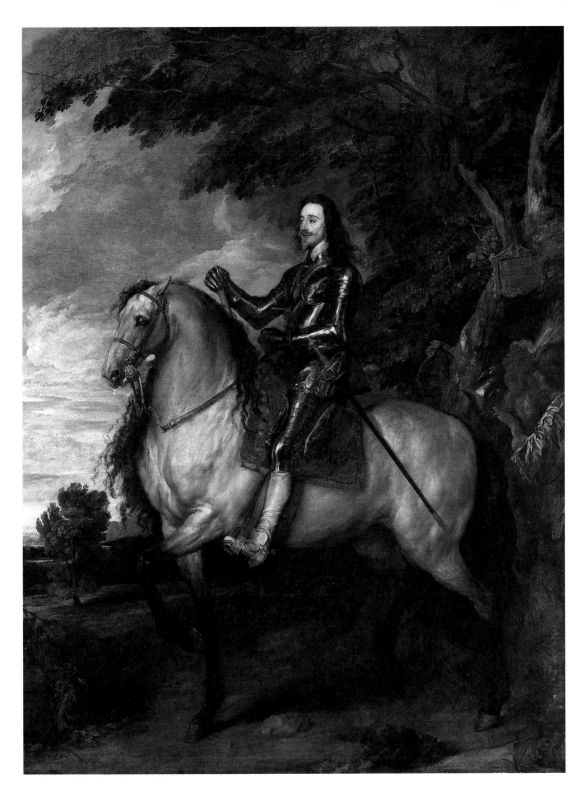

Both roles were robust and, although he could be, and indeed was, sleazy, there was in fact nothing effete about him. In the same way the tone of his court could sink into moral turpitude but it retained its intellectual vigour, thanks not only to the monarch himself but to the presence of people of the distinction of the writer and philosopher Francis Bacon. And, although James had sought Catholic brides for his sons, which was hugely unpopular with his subjects, he remained stoutly Protestant, a monarch whose learning enabled him to take part in the theological debate which raged against the Antichrist of Rome.

Now all of that was to change. Charles I was a cold and remote ruler, an aesthete whose idea of a court had been affected by his encounter with the stiff grandeur of that of the Spanish Habsburgs which he had visited in 1623. He was a virtuoso king who, although he could speak with knowledge on theology, philosophy, music and antiquities, remained first and foremost a connoisseur and collector of pictures. He liked artists and indeed was at ease visiting their studios. Even more he was pre-occupied with theatre, suggesting plots for comedies and reading the texts of plays and, in the case of the court masques, not only contributing to their subject matter but acting and dancing in them.

What is more, whereas the arts under his father had paid tribute to the regal divinity of Stuart rule, their role was never a sharply defined one. Now the Muses were openly cast by the Crown as an arm of government, as promoters and sustainers of the magic of monarchy. That statement was made very early in the new reign in a painting by the Dutch artist Honthorst executed short-

The arts in the service of the Crown. The king's favourite, the Duke of Buckingham, presents the Muses to Charles I and Henrietta Maria in an allegory by Gerrit van Honthorst.

ly before the Duke of Buckingham's assassination in 1628. In it the duke appears as Mercury presenting the Liberal Arts to Charles and his French Catholic queen, Henrietta Maria, who, as Apollo and Diana, sun and moon, burst as radiances upon a night sky of ignorance. Figures representing satire and distraction are vanquished by this royal apparition in which the pair are presented as patrons of the arts and the focal point of the kingdom's intellectual activity. Time and again this interdependence of the arts and the Crown was to be reiterated through the 1630s, above all in the masques. These were inaugurated in 1631 in a new series covering the years of Charles's personal rule without summoning Parliament, annual rituals in which king and queen presented one to each other as an act of state. Both these opening spectacles were by Ben Jonson, and were to be the last he wrote, for his relationship with Inigo Jones finally broke down, ending with bitter recriminations by the poet against the architect. The arts figured in both. *Love's Triumph through Callipolis*, the king's, included a tableau in which a rock arose from the sea bearing the Muses, while the queen's, *Chloridia*, culminated with a springtime landscape encompassed by a rainbow, the emblem of peace:

> 'Here, out of the Earth, ariseth a Hill, and on the top of it, a globe, on which Fame is seene standing, with her trumpet in her hand; and on the Hill, are seated four Persons, presenting Poesie, History, Architecture, and Sculpture: who together with the Nymphs, Floods, and Mountaynes, make a full Quire; at which Fame begins to mount, and moving her wings, flyeth, singing up to Heaven.'

The court was thus staking a claim to everlasting fame through its patronage of the arts. By 1638 a masque could even take for its plot the Muses fleeing Greece to find refuge in Britain thanks 'to the divine minds of this incomparable pair.' In this way the decade and a half before the outbreak of civil war in 1642 witnessed an enmeshing of culture and political ideology on an unprecedented scale. The role of the arts in the eyes of the king was to set before his subjects noble ideals so as to strengthen the practice of virtue and direct human energy to praiseworthy ends. He and his queen, needless to say, were billed as living incarnations of these ideals.

Along with this came a particular interpretation of the history of the nation, one in which the present age was cast both as a restoration of ancient ideals and as the highest point of a new civilisation brought about by the rule of the Stuart dynasty. In the seventeenth century the new classical architecture in one aspect was not

Rubens's vision of the king's arcadia. Charles I as England's patron, St. George, vanquishes the dragon and rescues the princess, his queen, Henrietta Maria, ushering in a sunlit pastoral paradise of peace and plenty to the wonder of his onlooking subjects.

regarded as an alien Italianate importation but rather as a return to how the Romano-British built. Inigo Jones believed, in fact, that Stonehenge had been erected to teach the native Britons the principles of architecture as expounded by Vitruvius. Such a view fitted well with a ruling house which cast itself as an imperial dynasty ruling over a miniature empire. Charles I, far more than his father, was to set the visual style of his reign as being classical, Roman imperial, appearing attired as Augustus *redivivus* in the masques, having himself depicted in his portraits as an emperor riding beneath a classical triumphal arch and even daydreaming of constructing a vast new palace in the classical style. Nothing better summed up this association of art with what was to prove to be a fatal political philosophy than Thomas Carew's masque *Coelum Britannicum* (1634). In it the court witnessed on stage a progression across time from the ruins of Romano-British classicism through the barbarism of the intervening centuries closing with a final revelation of the present age epitomised in a scene of a Renaissance villa surrounded by an elegant garden. Such were seen to be the fruits of the king's policy of peace.

And indeed peace was to be a recurring *leitmotif* animating every courtly celebration. The old themes, which had held a country together under Gloriana, ones which were fiercely patriotic, militaristic and apocalyptic, fell into abeyance while painters, poets and playwrights united to hymn the blessings of the Stuart *pax*:

> Tournies, masques, Theaters better become
> Our Halcyon Days: what though the German Drum
> Bellow for freedom and revenge, the noise
> Concerns not us, nor shall divert our joys;
> Nor ought the thunder of their Carabins
> Drown the sweet Airs of our tun'd Violins;
> Believe me friend, if their prevailing powers
> Gain them a calm security like ours,
> They'll hang their arms upon the Olive Bough
> And dance, and revel then, as we do now.

Thus Carew again, this time drawing a comparison between the seemingly halcyon days of Charles I and Henrietta Maria and a continent rent by a bloody war which was waged on a scale not to be seen again before 1914. Four years before, in 1629, Rubens had encapsulated this mythology in paint in his great canvas *A Landscape with Saint George and the Dragon*. The saint is of course Charles I, a shimmering knight rescuing the princess, his queen. What we see is an allegory of his rule, a victory of regal reason and virtue over the passions and evil humours of his realm

pictured in the vanquished monster. A golden sun breaks through the clouds and touches a view of the lush and verdant English countryside from which grateful people look on in wonder and admiration.

But, alas, art can only be successful as propaganda if it at least bears some semblance to a political reality. Little in the culture fostered by the exclusive Caroline court ever did. The truth was that the kingdom was at peace for over a decade because the king could not afford war, nor did he wish to summon Parliament, which any conflict would certainly precipitate. The only means he had whereby to raise taxes was by the exertion of the royal prerogative which, in the form of the hated Ship Money, became ever more a source of popular grievance. But none of this was seen to impede what was from the outside one long royal triumph. Everything was to proclaim the benefits showered on the island by the union of this divine couple. And this emphasis on both king and queen again set Charles's reign apart from that of his father. His mother, Anne of Denmark, had been a covert Catholic, a patron of innovation in the arts, but she and James largely went their separate ways. In the case of Charles and Henrietta Maria they were as one, a union of the son of the peace-loving James I with the daughter of the warrior Henri IV of France. Thus Heroic Virtue was fused with Love and Beauty together making a force whose power was presented as irresistible in the State. Or so they believed.

As in the previous reign the masques were at the heart of the court's cultural life. Together in these annual epiphanies king and queen were seen to reform not only humanity but nature itself, even in one the heavens, so potent was their magic. To the inherited Jacobean cult of regal divinity was now added a new element, the role of the queen as a Platonic love goddess. Henrietta Maria introduced from the French court the manners and highly artificial language of adoration and service which was the height of fashion in the closed world of that court, in which women were deified as liv-

Charles I in the guise of an heroic prototype, the Emperor Albanactus, in the masque Albion's Triumph *(1632). Costume design by Inigo Jones.*

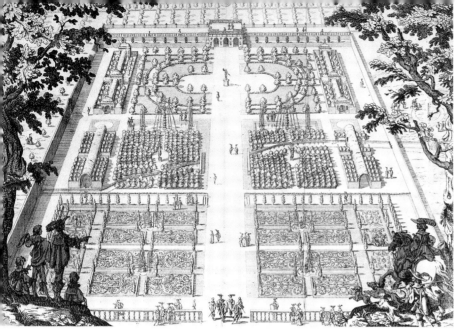

A new ideal. A view of the garden laid out for Philip, 4th Earl of Pembroke, at Wilton House, Wiltshire, during the 1630s by Isaac de Caus. De Caus was recommended to the earl by Inigo Jones to design both house and garden. The latter was revolutionary, transporting to England the villa garden style of Renaissance Italy.

ing abstractions of beauty and goodness. Such idealised love, above all that of the king for the queen, was seen also to be a cleansing action wiping away any stains left by the debauchery of the previous reign. Britain was now ruled by a monarch whose soul was a compound of the virtues and who aspired to philosophic enlightenment and the ascent of the soul to the divine mind. In this quest the queen played a role as his chaste assistant, a living embodiment of love and beauty. Through their amorous harmony Charles was able to make his heavenly ascent and thus bring untold benefits pouring down upon his obedient and admiring subjects.

The belief in the efficacy of spectacles such as the masques was profound. They were a form of white magic. The importance attached to their effect can be gauged by their cost, for each one would have equipped a small army. Add to that the prodigious amount of time given over to rehearsing them, even when political tensions were at their height. They remain monuments to an intense belief that to see is to believe, and that art has the power to draw down the benign influences of the heavens on the monarchy in the same way as an astrological talisman. After 1631 the masques were written by a succession of tame poets, but their concept remained firmly in the hands of Inigo Jones. The most eloquent was Thomas Carew's *Coelum Britannicum* (1634) which was staged when regal confidence was at its height. In this heaven itself was remodelled on the Caroline court. Only in the last of the masques do chinks appear in this endless self-congratulatory saga. *Salmacida Spolia* was staged in 1640 with a nation restless over what many regarded as arbitrary taxation, unhappy too over aspects of the royal religious policy, with Scotland in rebellion and a new parliament imminent. This time the secret wisdom of the divinely appointed Stuart king was seen as being unappreciated by an ungrateful people. Charles I, cast in the role

of Philogenes or Lover of his People, takes on long-suffering, Christ-like attributes. The masque opened with storms and furies raging, symbols of the ingrates over which the king ruled. Then followed a landscape such as Rubens painted for the king as Saint George, a prospect 'as might express a country in peace, rich and fruitful.' To this descended the Genius of Great Britain and Concord, bewailing the ingratitude of the populace and inciting them to pass their time not in opposing royal policies but in 'honest pleasures and recreations.' The king and his companions were indeed revealed triumphant beneath victors' palm trees and with bound captives at their feet, but their setting was the remote fastness of a mountainside. The queen came down in a cloud to join her husband in their time-honoured celebration of Love and Virtue, one to be mirrored in a final tableau, a city in the new classical style. On to this the heavens descend with a tableau of deities in what was a final royal incantation to avert disaster.

This is the defensive manifestation of a court turned in on itself, caught up in the fatal belief that what could be conjured up in the pasteboard world of the masque need only be staged to be true, when it patently was not. War lay only two years away and within nine the king's head was to fall on a scaffold erected outside the very palace in which the masques had been staged. Part of that breakdown can be attributed to the fact not that two opposing cultures had come to blows but rather that the one pursued by the king and his court had drifted dramatically away from having even the remotest roots in mass popular appeal. The king was seen overtly to have abdicated his role as the leader of Protestant Europe, so much so that by 1630 the bells in churches began to peal on Accession Day of Elizabeth I once more. For the unsophisticated average Protestant every aspect of court culture smacked of Rome. The king promoted a form of Anglicanism which restored ritual and images. He filled his palaces with works of art whose subject matter could not be construed in any other way than as being Catholic. He was even to accept gifts of works of art from that Antichrist, the pope. Worse, his queen was openly Catholic and her circle attracted fashionable converts. All of this created unease and an apprehension that the cultural road taken by the king led to Rome. And nothing was done to make anyone think otherwise.

Charles I's art collection was to outshine in terms of sheer scale and connoisseurship any other in the rest of Europe. His aesthetic sensibilities, inherited from his mother, were sharpened by his glimpse of the Habsburg imperial collections. Art collections were now a recognised index of regal grandeur. He was to return to England from Spain with Titian's *Venus del Pardo*, a Correggio as well as Giambologna's *Cain and Abel*. The same year he purchased the Raphael Cartoons which were used by

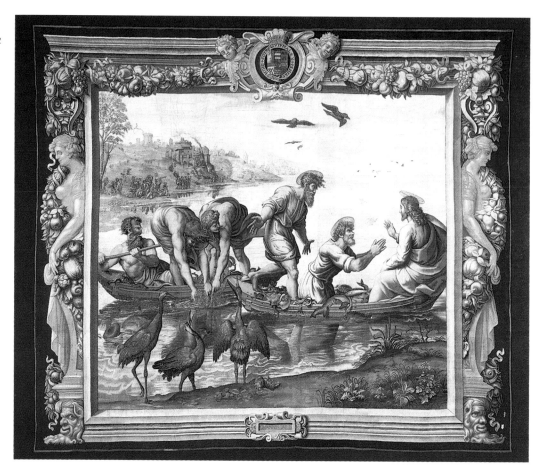

the royal tapestry workshops at Mortlake. But his great-est *coup* came in 1627 when he acquired one of the fin-est of all Renaissance princely collections, that of the Gonzaga, dukes of Mantua. This included splendid works by Mantegna, Perugino, Leonardo, Giorgione, Caravaggio and Giulio Romano. Two great series seemed especially apt in the context of Stuart imperial aspirations, Mantegna's *Triumphs of Caesar* and Titian's *Emperors*. Daniel Nys, the agent who clinched the deal, wrote: 'In short, so wonderful and glorious a collection that the like will never again be met with . . .' He was to go on and add to it the Mantuan collection of classical antiquities. This one *coup* at a stroke established the status of the Caroline court as the equal of any other in Europe. The king's agents, however, never ceased to seek further acquisitions. Those who sought royal favour also knew that a gift of a great work of art was one way whereby to achieve it. Within a few years there emerged a circle of informed connoisseurs, aristocrats like the Earls of Danby and Pembroke or gentlemen such as Endymion Porter or Sir Kenelm Digby.

The acquisition of the Raphael cartoons for the royal collection led to their use for the manufacture of tapestries in the workshop which was established at Mortlake late in the reign of James I.

At last, too, the king was able to secure the services of an artist who, if not the equal of Rubens, was certainly a great master, one whose vision and virtuosity with

the brush was to make his pictures the supreme apology for the reign. Anthony Van Dyck, Rubens's prime pupil, settled in England in 1633, establishing a studio which was to produce a long series of royal and aristocratic portraits which were to provide models for imitation and emulation by every generation of artists down to the reign of Queen Victoria. Van Dyck was able to put into paint the transient ideas of the masques, transforming the unprepossessing physical realities of the king and his consort by means of a series of dazzling canvases which show them as a union of true minds, elegant and gracious. Henrietta Maria is always the radiant love goddess whose presence virtually irradiates the picture space. Charles is the *imperator*, both hero and gentleman, riding through a classical triumphal arch or staying his horse beneath a mighty oak or lingering in a woodland glade, pensive with noble thoughts. No other painter has excelled in waving a wand over reality and lifting his sitters into another world so completely. The men and women of the court are depicted as assured yet relaxed, their aristocratic dignity borne with an air of casual ease and gentle restraint.

They are softly lit, posed often against massive pillars and a distant landscape. The skies above them are overcast with the light only filtering fitfully through to suggest complexity of psychological mood. Their exquisite sense of feeling and emotion is caught in their elongated hands, the fingers of which caress the silken fabrics, rest on sculpture or clasp a flower. Van Dyck's gentle baroque rhythms transmute his sitters into being a race apart, made up of superior persons invested with an aura of refinement which is almost spiritual. Nothing in these portraits could be more remote from the Elizabethan icons which had preceded them. For those who moved in the arcadia of the court, status is now seen to be inbred, natural and effortless, and no longer to be crudely asserted by overt opulence, hauteur or prowess. The change was total.

This sense of unreality was sustained by a court cult of rural simplicity. Henrietta Maria even acted in pastoral plays (much to the disgust of the Puritans) and courtiers could assume the guise of shepherds in their portraits. The nostalgia for what was left of the old pre-Reformation traditional culture was to reach its peak during these years, heightened by the steady erosion of it by Puritan Sabbatarianism. Increasingly in the royal eyes such things as May dances, midsummer watches and decking churches with greenery were viewed as innocent revelry and custom needful to the maintenance of a hierarchical, orderly church and state. English country life became its own version of classical arcady. The Caroline poets such as Thomas Carew and Richard Lovelace all celebrated such pastimes, but their supreme exponent was Robert Herrick. His poems, the *Hesperides*, were published in 1649 and opened with a verse

which would have been read at the time as one defiant to those who had executed the king that year:

> I sing of *Brookes*, of *Blossoms*, *Birds* and *Bowers*:
> Of *April*, *May*, or *June* and *July-Flowers*.
> I sing of *May-poles*, *Hock-carts*, *Wassails*, *Wakes*.
> Of *Bride-grooms*, *Brides* and their *Bridal-cakes*.
> I write of *Youth*, of *Love* and have Access
> By these to write of cleanly-*Wantonness*.

Increasingly the rural country estate began to take on the role of a man-made paradise in which the owner sought within his own domain to recapture a primordial paradise. The survival and indeed preservation of these age-old rituals was now seen as part of the arcadia of the royalist cause in which a beneficent lord of the manor was to play his part by maintaining ancient hospitality.

Poetry was one of the arts which made up the tableau at the close of the queen's masque of *Chloridia*. That too was to be subservient to the all-pervading diktat of the court. Poets indeed received posts in the royal entourage and then there were courtiers who turned poet. Suckling, Lovelace, Carew, Waller and Davenant, the Cavalier poets, all speak with one voice celebrating the king and queen as an heroic couple, demi-gods indeed, fit subjects for a poetry of vision and miracle. Both are written of almost in terms of religious veneration. Edmund Waller's poems are dedicated to Henrietta Maria as 'Queen of Britain, and the Queen of Love.' The elevated and hyperbolic purity attributed to her spills over and embraces a whole line of other poets' heroines including, for example, Waller's Sacharissa, subject of the poem 'Go, lovely rose.' Like Van Dyck's portraits this poetry is elegant and smooth but it can at the same time be artificial and devoid of depth. Drawing on the legacy of Jonson and Donne none yet manages to eclipse them. Significantly the only innovative poet of the age, John Milton, worked away from the court.

Inigo Jones's lavish interiors in the French style for Henrietta Maria at Somerset House during the 1630s established new criteria for elegance in interior decoration. This design for a vertical panel includes her cipher.

Courtly ideals of love and beauty are realised by Van Dyck in this portrait of Lady Mary Villiers with her cousin, the young Lord Arran, as Venus and Cupid. The portrait commemorates her marriage to Sir Charles Herbert, third son and heir of the Earl of Pembroke, in 1635.

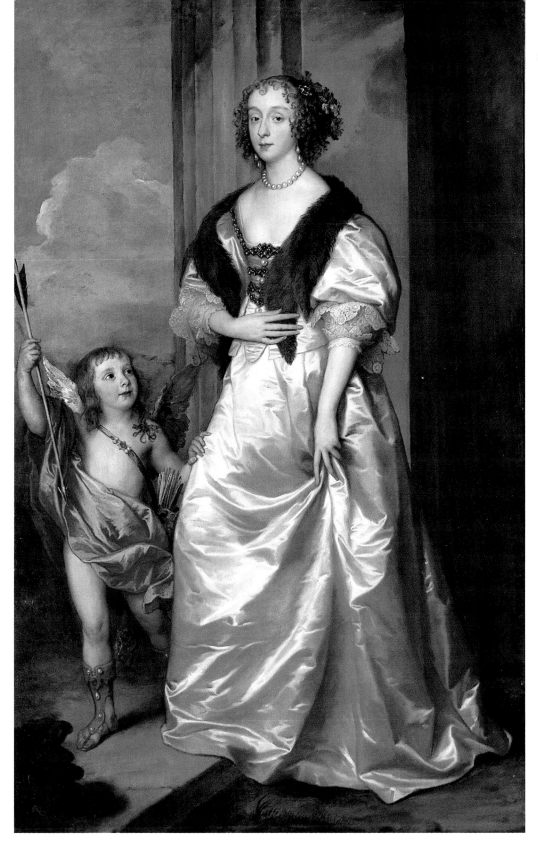

Under the aegis of Charles I London was to be transformed into an imperial city. This sketch by Inigo Jones from 1636 for a triumphal arch in the classical manner was for a royal entrance to the City, Temple Bar, and would have acted as a frontispiece to a route whose climax was St Paul's.

Architecture was also part of that tableau in *Chloridia*. Alas, Inigo Jones's architectural achievements were largely to be confined to masque scenery for the penury of the Crown meant that little moved beyond the drawing board. Most that did was incidental, elements like garden gates and fireplaces which added touches of modernity to old Tudor buildings. His masterpiece of interior decoration, Somerset House for the queen, was swept away in the eighteenth century. Nor does the Cockpit Theatre in Whitehall Palace, built as a miniature version of Palladio's *Teatro Olimpico* in Vicenza, survive. The plans for a gigantic new royal palace the size of the Escorial also remained a paper dream, as did plans for Temple Bar as a Roman triumphal arch marking the entry into the City from Westminster. But what these designs indicate is a regal vision of London as a cross between a new Jerusalem and a new Rome in which the two great axes were to be a new classical palace with a triumphal route via Temple Bar to a magnificent classical church, St. Paul's, rebuilt as a monument to the glory of the Church of England and the Stuart dynasty.

That too has gone but it was achieved at the time. St. Paul's had been in a parlous state at the opening of the century, its interior turned into a public arena and its exterior disfigured by arbitrary buildings tacked on to it. Its fabric urgently called for repair, and as early as 1608 there was the first of a series of efforts to raise money to create a church worthy of the empire of Great Britain and a Protestant faith which was now extending its sway into the New World. The drive was renewed in 1620, and

finally to effect in 1629. Four years later work actually began. Charles I himself had pledged £500 p.a. for a decade and the cathedral's most significant addition was his personal gift, a new portico, the greatest north of the Alps. The giant Corinthian order supported a pediment with an inscription recording the royal largesse topped by golden statues of the first two Stuart kings. This was Anglicanism's answer to St. Peter's.

All of this suggested Stuart London as the Rome of a new empire, a vision which was similarly reflected in the development of Covent Garden, an expansion of the City carried out in terms of an Italianate arcaded piazza, St. Paul's church, with its handsome Tuscan portico, as its anchor. Although developed under the aegis of the Earl of Bedford, who was inimical to royal policies, it was subject to royal control by way of the city building commission on which sat Inigo Jones and the Earl of Arundel. The piazza was the centrepiece of a larger development stretching from St. Martin's Lane into Drury Lane and north to Long Acre. Jones was its architect and we know that the king directly intervened and altered the design of what was London's first square. Such an urban scheme was a dramatic departure from the winding narrow streets and alleyways of the old medieval city. It was in fact the earliest application of the principles of Renaissance town planning which disposed of space in terms of squares and straight streets, orchestrating space according to the rules of perspective. Those perspective lines met their ideal centre, as in the masques when viewed by the monarch.

Such visionary dreams, most unexecuted, give us a glimpse into the aspirations of Charles I which included a noble capital in the classical style. This reflected the ever-rising importance of the metropolis in the nation's life. By the 1630s the court ceased

Inigo Jones's classical portico for St. Paul's Cathedral is one of the great lost pieces of architecture. It was on a scale unparalleled elsewhere in northern Europe.

to migrate beyond palaces in proximity to the City. More and more aristocracy and gentry closed their country houses for the winter and moved to London, hence the building boom. London was the home of learning, the centre of theological studies, whether Puritan or high church Anglican. It was out of the Inns of Court that new fashions in poetry and new intellectual trends came. Developments in coachbuilding made travel to London easier and once there the court, the luxury trades, the new indoor theatres and places of social resort, such as Hyde Park and Spring Garden, provided one unending round of pleasure.

The theatre indeed was to respond to this change of milieu. Plays now primarily provided amusement for an audience which could pay, and as a consequence the drama of the Caroline era was far different from that of the earlier heroic age. Here too the impact of the court was felt and conditioned the drama. Charles's father had plays which had clearly been written with him in mind, like *Macbeth*, but in the main he took what came from the playwrights. Now the latter began increasingly to pander to the isolated world of the court, putting on stage plays further and further removed from popular experience. Massinger, Shirley, Brome and D'Avenant were the chief purveyors of plays which concentrated on honour and duty set forth in the affected precious language cultivated by the court. They were filled with mannered encounters and elegant repartee, but their observation and wit were superficial. The result was a drama which four centuries later can no longer hold the stage.

That courtliness which neutered the drama and rendered so much of Caroline poetry stilted was not so inimical towards what was a golden age of sermons and religious verse. Sermons matched theatre in terms of being a public draw. This was an age of witty preaching and its chief adornments were Lancelot Andrewes and John Donne. But it was in the poetry of George Herbert that Caroline piety was to find its most profound and lasting expression. Sensitive and decorous, his verse is a monument to 'the beauty of holiness', that practice of the liturgy with good order and ritual which was the essence of the king's religious policy and the object of loathing by his Puritan opponents. Herbert began his life in the orbit of the court but turned his back on it and was ordained in 1630. His poetry was published posthumously three years later: *The Temple: Sacred Poems and Private Ejaculations*. They are the finest expression of seventeenth century high Anglican piety. Herbert celebrates all those things the Puritans wished to sweep away. He speaks of the beauty and significance of ritual, of the mystery of the sacraments offering praise to the angels, to the saints and the Virgin Mary. In them we move in a heaven which could only ever be Anglican, filled with a deep inner piety which spoke of the anguish of the heart in its search for God:

Love bade me welcome: yet my soul drew back,
Guiltie of dust and sinne.
But quick-ey'd Love, observing me grow slack
From my first entrance in,
Drew nearer to me, sweetly questioning,
If I lack'd anything.
'A guest,' I answer'd, 'worthy to be here:'
Love said, 'You shall be he.'
'I the unkinde, ungrateful? Ah my deare,
I cannot look on Thee.'
Love took my hand and smiling did reply,
'Who made the eyes but I?'
'Truth, Lord; but I have marr'd them: let my shame
Go where it doth deserve.'
'And know you not,' says Love, 'Who bore the blame?'
'My deare, then I will serve.'
'You must sit down,' says Love, 'and taste my meat.'
So I did sit and eat.

Poetry of this kind was evidence of a physical reality taking place as church buildings were put in order all over the country. By the 1620s churches had fallen into disrepair. Often they had become bowling alleys, chicken runs, places in which to loiter, even ale-houses. In the Puritan scheme of things there was no such thing as a holy place. But the Church of England with the advent of a new generation was giving expression to the ideals set forth in the work of its great apologist, Richard Hooker, in *The Laws of Ecclesiastical Politie* published at the close of Elizabeth's reign: 'The house of prayer is a Court beautified with the presence of celestial prayer; that there we stand, we pray, we sound forth hymns to God, having his Angels inter-mingled as our associates . . .' The saintly Bishop Andrewes set the pattern in his own chapel in which the liturgy was performed with due respect and dignity and the preservation of an atmosphere of holy reverence. In the 1620s and 1630s this new movement to observe 'the beauty of holiness' was adopted by the king and his Arch-bishop of Canterbury, William Laud. Order of a kind associated with Catholicism returned. The holy table was removed from the nave and set where the altar had been in the chancel, and covered with an embroidered carpet. On it stood two candle-sticks, even a crucifix, and it was railed off from the rest of the church. Sacred vessels, the use of incense and copes and, in time, images and stained glass made their appearance. The church resumed its status as a holy place again, leading to a huge

restoration and beautification programme in which painting and sculpture returned as aids to the liturgy. Alas, though to those who took this view these were things conducive to holiness, to the Puritans they were signs that England was drifting Romewards. The Puritans rejected the arts. Such a phenomenon as the new porch at St. Mary's, Oxford, with its twisted baroque pillars and statue of the Virgin holding the Christ Child, was anathema, the work of Antichrist.

All over England the Laudian clerics were reordering churches much to the abhorrence of the Puritans in their congregation. When the Long Parliament met in 1640 all was to be as dust. By then the civilisation which the court had created was under siege, its visions increasingly seen as pasteboard delusions which should be swept away. Both sides of the divide had viewed the monarchy as divinely appointed, but the approach to that divinity was very different. For the opposition, that was valid in the terms of the Crown occupying the position of Elizabeth I, an eschatological one of the kings of England as rulers of the Last Days preparing the way for Christ's Second Coming and the vanquishing of the Antichrist of Rome. For the king and his archbishop that divinity stemmed from an analogy of the monarchy to the cosmos, the king and queen as sun and moon raining down their blessings upon their subjects in terms of peace, justice and moral example. Both sides claimed that an imbalance had occurred. The royal view was that political order was the product of the king's power and Charles as an heroic ruler had brought order and civilisation to his people but now his power was threatened by erosion from the populace. The parliamentary view was that certain laws and liberties were derived from immemorial tradition as old and fundamental as the monarchy itself. Any king, they claimed, who attempted to violate them was dissolving the very foundations of society.

There was indeed a cultural dimension which contributed to the outbreak of civil war. It was not so much a polarity of two opposing cultures as that king and court had retreated into a self-perpetuating arcadia of their own. They beheld themselves as it were in an enchanted looking-glass. They ignored any warnings as to their isolation. There were, however, those who dared to hint at the bitter truth of things. D'Avenant's play *The Platonick Lovers* (1635) can be read as a critical burlesque on the court's Platonic love cult. So too can Richard Brome's *The Love-Sick Court* (1633-34) which opened with a warning of the impending rift:

> Th'unquiet Commons fill his head and breast
> With their impertinent discontents and strife.
> The peace that his good love has kept them in
> For many years, still feeding them with plenty,
> Hath, like o'er pampered steeds that throw their Masters,
> Set them at war with him. O misery of kings!

Perhaps the supreme monument to the turbulence ahead is Sir John Denham's 'Cooper's Hill' (1641-42). On the surface it is a topographical poem describing the river Thames as it wends its course from Windsor via

A rare survival of the reinstatement of the beauty of holiness, Nicholas Stone's extraordinary baroque portico to St. Mary's Church, Oxford, added in 1637.

Runnymede to London as viewed from a well-known hill. This is a poem haunted by foreboding. Denham re-echoes the eulogies of the masques but then his eye catches

a chapel in ruins, a victim of the upheaval of the Reformation. Unease now enters and Runnymede calls to mind earlier confrontations of king and Parliament. Denham, a royalist, sees the need to reassert royal authority in order to avert any further erosion of power:

> Thus Kings by grasping more than they can hold,
> First made their Subjects by oppression bold,
> And popular sway by forcing Kings to give
> More, than was fit for Subjects to receive,
> Ranne to the same extreame; and one excesse
> Made both, by stirring to be greater, lesse;
> Nor any way, but seeking to have more,
> Makes either lose, what each possest before.

In the coming upheaval a civilisation was swept away which was to leave a legend. Van Dyck was to die in 1641 but Inigo Jones lived on to 1652, everything he had stood for seemingly gone. No one could put the clock back to regal divinity again, nor its projection through the magic of the arts. But as the war bit deeper and the gloom of first the Republic and then the Protectorate spread its chill austerity through the land, the age of Charles I began to assume a retrospective golden glow. Writing in the 1650s Andrew Marvell, in his poem 'Upon Appleton House', frames a lament for a world that had gone:

> O thou, that dear and happy isle,
> The garden of the world erewhile,
> Thou Paradise of the four seas,
> Which heaven planted us to please,
> But to exclude the world did guard
> With watery if not flaming sword –
> What luckless apple did we taste,
> To make us mortal, and thee waste?

Chapter Twenty

THE MECHANISTIC UNIVERSE

I n the second book of his *Novum Organum* (1620) Francis Bacon, writer, philosopher and Lord Chancellor to James I, wrote as follows: 'For man by the Fall fell at the same time from his state of innocency, and from his dominion over creation. Both of these losses however can even in this life be in some part repaired; the former by religion and faith, the latter by arts and sciences.'

In these sentences Bacon encapsulates one of the driving forces behind seventeenth century science, the Utopian vision that man could return to the domination over the world of nature he had enjoyed in the Garden of Eden before the Fall. What that quotation also evokes is the profoundly religious atmosphere which surrounded all scientific endeavour, one which was just as strong at the close of the century in the work of that other scientific giant, Sir Isaac Newton.

That there was to be such an intense interest in science also owed something to the particular situation of England during the middle years of the century. The country was Protestant and a large part of it Puritan. All reformist theologians cast the Reformation of the previous century within an eschatological framework, as a milestone marking the imminence of the Second Coming of Christ and the Day of Judgment. No one demurred from the view that the world had entered its last phase, although equally no one agreed as to the exact date of its termination, although many speculated. The ordained span was six thousand years, a figure reached through biblical prophecy, and the world had already entered its final millennium. That was heralded by the series of events so vividly and graphically described in the Book of Revelation: the reign of Antichrist, identified with the pope, the forces of Catholicism and, for the Puritans, the established church, followed by the battle of Christ versus Antichrist leading to the victory of the saints and the return of the Earthly Paradise (man once more as he was before the Fall) followed by the finale of the Day of Judgment.

Such a view of time as nearing its end was inevitably heightened to an extreme degree in England, not only on account of the fact that everyone was brought up on Foxe's *Actes and Monuments*, which outlined a scenario casting England as inheriting

the mantle of Israel, but by the cataclysmic events of the Civil War which witnessed the monarchy and the state church swept away. These dramatic events produced an acute sense of urgency and acted as a huge incentive to the legitimisation of experimental science, the aim of which was to re-establish man's supremacy over the natural world. In this way the Scientific Revolution had as its backdrop all the fervour of Protestant prophecy. Indeed the two are inextricably intertwined. In the case of the rise and spread of the science of mathematics it was as much with the idea in mind that any advance would offer further clues to the reading of biblical numerology as it was for any practical purpose, an idea still true for Newton in 1700.

The English Revolution was to contribute substantially towards making a backward island into part of the mainstream of scientific innovation. That sudden leap took place during the decades 1640 to 1660, reaching its climax in the gaunt figure of Newton. In the sixteenth century the country was on the fringes of Renaissance science. That had brought to light a mass of forgotten classical literature, above all the works of the Pythagoreans. Their explanation of the universe in terms of numbers, together with a renewed fervour for Plato, pushed people more and more towards mathematics, seen increasingly to be the clue to navigation, exploration, geography, aesthetics and military science. By 1600 mathematics was regarded as offering the key for the understanding of the nature of things, nature itself being viewed as inherently mathematical.

Although the works of Plato were to give the first impulse to the study of the natural world a second came from the *Corpus Hermeticum*, a series of writings which arrived in fifteenth century Florence and were believed (until well into the seventeenth century) to be coeval in date with Moses and hence embodying a separate tradition, an ancient theology as it were stemming from distant antiquity but compatible with the Bible. On to this body of literature the two great Florentine philosophers, Marsilio Ficino and Pico della Mirandola, grafted magic from the Jewish Cabbala. Out of this synthesis came a new position of man cast in the role of *magus*, someone who by using magic and Cabbala to act on the world could control his own destiny through science. Man was exalted as the supreme operative, the unique link binding the celestial and terrestrial worlds. Such a recasting of humanity gave birth to the sixteenth century being the great age of exploration, not only in the form of setting sail and discovering whole new continents but also by observing every aspect of the physical universe accurately for the first time, phenomena like plants and animals as well as the heavens. As a result huge advances were made in the

The title page of Francis Bacon's Instauratio Magna (1620). The ship is depicted sailing through the Pillars of Hercules, the boundaries of the ancient world. In the same way Bacon saw himself crossing new intellectual boundaries.

FRANCISCI
DE VERULAMIO,
Summi Angliæ
CANCELARIJ,
Instauratio
magna.

Multi pertransibunt & augebitur scientia.

Sim. Pass. sculp.

Anno.

LONDINI
Apud Joannem Billium
Typographum
Regium.

1620.

fields of architecture, hydraulics, military engineering, metallurgy, agriculture and mining. Nature was examined in order to harness it by way of what was magic, natural magic, and that in its turn was to lead on to scientific empiricism.

In this way magic enjoyed a renaissance every bit as significant as that in the arts or the world of letters. Science and magic were to remain entwined, for although as the seventeenth century progressed magic in the sense of the performance of certain rituals, like the court masques, slowly went into abeyance, the conceptual infrastructure remained in place for a far longer period. Astrology, for instance, entered a heyday during the Civil War, the Republic and the Restoration, with astrologers like William Lilly accurately predicting both the Great Fire of London and the Plague of 1665 and 1666. What the hermetic tradition held out was the possibility that once man had recaptured this tradition he would become a powerful *magus*. Platonism and the cult of the hermetic tradition were to flourish in the university of Cambridge during the 1640s and 1650s and beyond, and to retain their vigour in the face of the emergence of the mechanistic philosophy, which argued that the universe was essentially a machine. As that spread the defence of the world of the spirit was to become a major preoccupation of many theologians and scientists. Natural magic, however, was equally able also to be an apostle of experimental science. By acute observation of the heavens, for example, the *magus* believed that the forces of the celestial world might be brought to bear on the terrestrial in order to achieve some natural task. But such observation would in the long run lead on to the new astronomy.

Although Copernicus's discovery of a sun-centred universe was published in 1543 the old world picture remained effectively in place until the following century. Nothing was to sound the death knell until the great Italian astronomer Galileo applied the telescope to the heavens. In 1632 his *Dialogue on the Two Chief Systems of the World*, in favour of the Copernican system, gave this system for the first time philosophical being and physical substance. A decade earlier Copernicus had been put on the list of forbidden books, the *Index*, by the pope. Effectively this silenced Galileo, and Copernicanism in Italy did not resurface until the eighteenth century. But the pope's very condemnation was to act as a spur to astronomical research. Copernicanism presented no problem for Protestant English scientists who held that the exercise of reason and research properly conducted could never produce a result which would conflict with religious dogma. Any discrepancy which occurred was explained by a failure of human apprehension.

If Galileo was an intellectual giant who re-created the bond between mathematics and motion thus laying the conceptual foundation of the mechanical philosophy, it

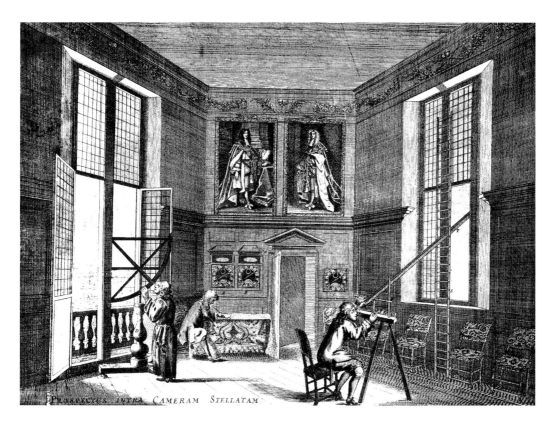

Prospectus intra Cameram Stellatam.

was the Frenchman René Descartes who, in his *Discourse on Method* (1637), was to establish the new mechanistic philosophy of the universe as an alternative to the old Renaissance world of qualities, magic and mysticism. This concept of the universe as a machine was not without its roots in classical antiquity, in the writings of the

The Royal Observatory, Greenwich, founded in 1675 'in order to the finding out of the longitude of places and for perfecting navigation and astronomy'. The building, designed by Sir Christopher Wren, epitomises the period's dedication to scientific observation.

Greek philosophers Epicurus and Lucretius, but they had been atheists. What Descartes did was to reconcile such a world picture with the premise that all knowledge of truth was implanted by God. Such truths could be detected by man exercising reason and thus discovering the mechanisms created by God in natural phenomena.

What happened in England has to be set against this wider European perspective born of a period in which science moved out of the universities into the towns and thence to the courts, and also began to be explored less in the study than in the laboratory. More, it increasingly ceased to be a solitary journey but one to be made collectively, resulting in the emergence first of informal groups and then societies and academies. Such advances were brought about by men who believed in a real, ordered, natural creation, independent of man but rationally understood by him. This

is a progression from philosophic to scientific rationality thanks to the slow, but in the long run unstoppable, spread and acceptance of mathematical method as being the key to understanding the universe.

The roots of the scientific explosion which took off in England after 1640 lay in the Elizabethan age. Its central figure was a colourful one, the *magus* John Dee, consultant to the queen and to the court and also to all those involved in maritime endeavour. Deeply committed to the hermetic and occult tradition it was nonetheless Dee who set the style of English science whose preoccupation was to be utilitarian, practical and experimental. In 1570 he wrote a preface to an edition of Euclid in the vernacular designed to encourage 'common artificers' 'to find out and devise new works, strange engines and instruments for sundry purposes in the commonwealth.' Dee in no way looked to the universities but instead to the merchants and craftsmen of Elizabethan London, speaking to them indeed in their own language. Their interest was certainly not in the abstractions of the schoolroom but in the practicalities engendered by the workshop floor.

That tradition, well in train by the close of the century, was to find institutional form in the mighty bequest by Queen Elizabeth's financier Sir Thomas Gresham in 1597. He left his own house to be set up as a college, with lectureships in divinity, rhetoric, music, physic, geometry and astronomy. The subjects were ones either not available in, or neglected by, Oxford and Cambridge, and more, the lectures were to be in English. As a consequence the opening decades of Gresham College read like one long roll-call of scientific achievement. Its professors included men such as William Gilbert whose book *De Magnete* (1600) declared the earth to be a magnet, and Edward Wright whose *Certaine Errours in Navigation* (1598) set the seal on England's supremacy in the theory and practice of navigation.

Under Henry Briggs, its first professor of geometry, the college was to become a centre of adult education and advanced science. Oxford and Cambridge would not begin to catch up until after 1619 when the Savilian chairs in geometry and astronomy were established, plus the Sedleian chair in natural philosophy and a lectureship in anatomy. But neither university was to make any impact until the 1640s and 1650s.

Medicine was also to make strides, again being London-based, but much was impeded by the medical monopoly of the great societies and companies, the College of Physicians, the Barber Surgeons Company and the Society of Apothecaries. In 1606 the great French doctor Theodore Turquet de Mayerne came to England and contributed greatly to the modernisation of English medicine. His work came out of the magical tradition expounded in the sphere of medicine in the previous century by Paracelsus, one which began to use chemistry as a handmaid to medicine, explor-

ing the world of chemical processes and phenomena. To evade the monopolists, men like William Harvey went abroad, particularly to the University of Padua, to study medicine. On his return in 1607 Harvey was elected to the College of Physicians and was appointed lecturer in anatomy to that conservative institution eight years later. His great discovery was the circulation of the blood. By reordering the known but misunderstood facts and observations Harvey published in 1628 his *On the Motion of the Heart and Blood in Animals*. In it he compared the heart to a 'prince in a kingdom', a view taken up by Descartes and extended across the natural world in the form of the mechanical philosophy. But Harvey's work came firmly out of the general framework of his Aristotelian background and education at Padua. He himself did not see the circulation of the blood in mechanical terms at all.

None of this quite explains the extraordinary scientific resurgence of the 1640s and 1650s. For that we have to turn to the writings of Francis Bacon which were to have enormous influence. Although he belonged to the tradition of the Renaissance *magus* Bacon emancipated natural magic by emphasising the need for systematic and exhaustive enquiry. Only by doing that would magic be restored to its ancient place of dignity in the scheme of things. His was a programme for the reform of natural magic, one which was taken up above all during the period of the Commonwealth and so becoming the driving force for organised scientific activity in England.

Bacon foresaw the eminence of natural science and was to be viewed as the founder of inductive philosophy. Indeed those who later founded the Royal Society looked to him as a supporter of the mechanistic view of the universe which was certainly not true. Baconian man was no longer passive man but a man whose mission was to explore nature and, having discovered its secrets, exploit them. Experiment, he realised, could move things on even accidentally and he believed that if experiment was backed it could change everything. Experiment, however, must combine with theory. In the *Novum Organum* Bacon wrote: 'The men of experiment are like the ant; they only collect and use; the reasoners resemble spiders, who make cobwebs out of their own substance. But the bee takes a middle course; it gathers its material from the flowers of the garden and of the field, but transforms it by a power of its own.'

Bacon also established that scientific investigation did not conflict with divinity, indeed it would in fact return man to his state before the Fall. In this way Bacon through his writings brought together the thinker in his study with the artisan in his workshop. Suddenly the old scholastic approach was seen to be sterile and unproductive and experimental science was seen as the way to true knowledge. For Bacon science was a collective endeavour which also had a social purpose, to improve the intellectual and material conditions of the human race.

Bacon may have been less original than he thought himself and was certainly looked back upon as the founding father and source of inspiration for many things in which he showed little interest. It has been argued that his approach made him the master of the Puritan bourgeoisie, technicians and merchants who despised the 'abstract' as useless along with aristocratic education and the ideals of English humanists. The Elizabethan age had been dominated by words. For Bacon a new age was imminent in which the traditional cult of learning in his scheme of things must be replaced by the cult of nature. He rehabilitated the mechanical arts, basing his new philosophy upon a humble and exact analysis of technical procedures. He was a man who had no time for the secrets of the *illuminati,* seeing advance depend on collaborative effort, a pooling of experiences and observation. The new age, he held, could be superior to that of the ancients. Strangely, he had little place for the use of mathematics as the supreme instrument, for in the long run modern science was to owe more to Galileo's mathematical theories based on quantitative and mechanical analyses than it would ever owe to Bacon's empirical experimentation. Nonetheless there is no doubt that Bacon's real importance lay precisely in the fact that he popularised across the social spectrum the notion of experiment.

Bacon's legacy was to be particularly influential during the years of the Commonwealth. The twenty years following the outbreak of the Civil War in 1642 witnessed an explosion of ideas prompted by Puritan eschatology and the utilitarian inheritance of Bacon. Education was seen as one of the prime battlegrounds for through it the Kingdom of God came within reach of man. Already between 1580 and 1640 there had been an unprecedented educational drive. By 1640 2.5% of the male population went to a university, a figure not to be exceeded until the 1930s. Education was seen as crucial so that a man could fulfil his religious calling and defend his liberties. Bacon, in his *Advancement of Learning* (1605), had dwelt on the weaknesses of the humanist system with its worship of the linguistic arts and its neglect of the more profitable sciences. As a result during the 1640s and 1650s reformers looked towards creating a new network of schools, academies and colleges in which science and technology would take precedence over humanist linguistic projects. There was a passionate belief in the need for well-educated and articulate craftsmen and labourers with vocational training in schools of husbandry or mechanics. There were projects, too, for universities at York, Durham, Norwich, Manchester and Wales. All of this was to be relegated to Utopia at the Restoration, only to resurface in the Victorian age.

For many, the New Jerusalem was conceived not only in religious terms but, exactly as Bacon had foreseen, in those of social amelioration and intellectual renewal.

During those two decades a whole stream of Utopian thinkers came to England. The Puritans purged the universities, introducing into them the experimental sciences. As a result Oxford and Cambridge became the focal points for the first time since the fourteenth century of developments in science, medicine, mathematics and philosophy.

A major figure in the midst of all this ferment was Samuel Hartlib, a Protestant German refugee and social philosopher, who produced some sixty publications aimed at the public good. He and his colleagues of the Commonwealth period poured out such works on practical improvement, books like Ralph Austen's *A Treatise of Fruit-Trees* (1653), advocating their planting, a publication which was to lead later to John Evelyn's work encouraging the reafforestation of the country. Things like universal suffrage and education for women were adumbrated in an atmosphere in which it seemed that dreams might indeed find their fulfilment. Books on science and medicine in the vernacular flowed from the presses all through the 1650s, opening these subjects up and away from a narrow educated élite. Chemistry emerged as an exact and empirical science with new applications in fields as various as mining and metallurgy as well as in the eternal quest for the Philosopher's Stone.

Natural history was cast as a science with a practical end, as it could lead to economic development and the solution to poverty. Later this was to bear fruit in a whole series of county natural histories like those by Robert Plot on Oxfordshire (1677) and North Staffordshire (1686) which explored the 'hidden treasures of our land.' Plants, animals and minerals all called for exploration and codification. The Puritan interest in agriculture, industry, trade and social analysis was to lead to post-Restoration *virtuosi* like the diarist John Evelyn, describing the techniques of etching, painting and enamelling.

When the Puritan cause collapsed in 1660 Baconianism faltered. It survived, but in order to do so the social aspirations of the Commonwealth era had to be jettisoned. Bacon was still looked to, but what had happened during the previous two decades in his name was ignored and written out. Samuel Hartlib and other members of his group, all committed Puritans and social innovators, went under. The Puritans were purged from the universities and their educational projects were wound up, although what they stood for continued in the dissenting academies where the natural sciences, experimental philosophy and Cartesianism continued to be taught. What was salvaged from the wreckage was to be enshrined in a new body, the Royal Society.

The Royal Society was of course anxious to distance itself from the era of the Republic but in fact came out of meetings held in 1645. 'We did,' wrote the mathematician, John Wallis, 'by agreement, divers of us, meet weekly in London on a certain

day and hour, under a certain penalty, and a weekly contribution for the charge of the experiment . . .'. Their base was Gresham College and fifteen years later on 28 November 1660 they were to meet in the rooms of Laurence Rooke, professor of geometry at the college, after a lecture by Christopher Wren, then professor of astronomy, and make a formal resolution to inaugurate 'a more regular way of debating things, and according to the way of other countries, where there were voluntary associations of men in academies, for the advancement of various parts of learning.' The Society received its first royal charter in July 1662 and its second in the April of the following year, sanctioning under royal aegis a society dedicated to the advancement of natural things and useful arts by experiment. The foreign academies they had in mind must have included the informal groups in Paris which preceded the establishment of the *Académie des Sciences* by Louis XIV in 1666. Charles II never put a penny into the Royal Society and regarded it as little more than a joke. He did build a Royal Observatory at Greenwich but the first Astronomer Royal, John Flamsteed, had to provide his own equipment and take a clerical living in order to support himself. French state funding was to make Paris the scientific centre of Western Europe.

The setting up of the Royal Society marked a parting of the ways. Those committed to science within the earlier millenary vision, like Milton or John Ray, retired from public life. Others, like Thomas Hobbes, found their way to membership of it blocked. The membership was in fact numerous, half of it from the aristocratic and gentry classes, 40% from the professions and the remainder made up of merchants and foreigners. This body was radically different from the dedicated enthusiasts of the years of the Republic. Few members earned a living from science and many were not even interested in the subject. But they did share a common belief that the knowledge such corporate enquiry might engender would be useful. Above all, for the first time science was actually institutionalised. The Society's *Philosophical Transactions*, which appeared monthly from 1665 onwards, were read throughout Europe. Nonetheless formalisation brought its own problems, ones of how to get the results of experiments in print, how to sustain any momentum of research and, more and more, how to attract popular support and interest.

The Royal Society was also a landmark in the acceptance of the mechanistic tradition in England. Some of its most distinguished founder members were adherents of this view of the structure of the universe, among them Robert Boyle, Robert Hooke and Henry Oldenburg. Boyle, who came from an aristocratic family, devoted his life to discovering the workings of the mechanical philosophy in the world of chemistry. His observations showed that air was behaving according to mechanical principles and his experiments sought to discover a similar mechanical explanation for chem-

ical changes. Devoutly Protestant, Boyle was crucial to the mechanistic philosophy being accepted in the changed political and social order of Restoration England.

Hooke, a late manifestation of the universal man of the Renaissance, was the Society's first Curator of Experiments. Trained as a painter he was a talented musician and a highly successful architect besides having a genius for mechanical invention, from the air-pump he devised for Boyle to the barometer. Today his fame rests more on his appreciation of the potential of the microscope, that invention which was the quintessence of the Baconian determination to explore the uncharted world of nature.

The Baconian imperative drove the sciences relentlessly forward towards solving the problems of the nomenclature, identification and classification of the phenomena of the natural world. John Ray was to lay the foundation of modern descriptive

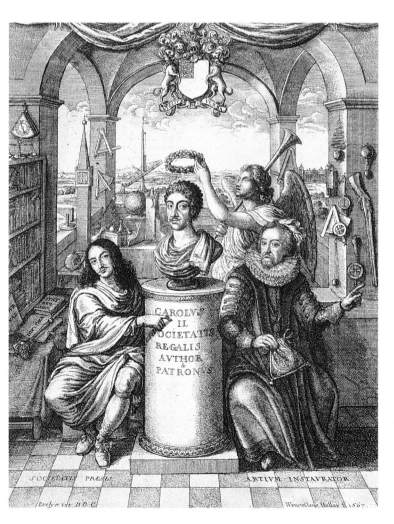

The frontispiece to Thomas Sprat's History of the Royal Society *(1667) shows Francis Bacon and the first President of the Royal Society, Viscount Brouncker, flanking a bust of Charles II crowned by Fame. Science is thus represented as an ally of the restored monarchy.*

The Hon. Robert Boyle, youngest son of the Earl of Cork and the 'father of English chemistry'.

THE
HONOURABLE
ROBERT BOYLE
Esq.ʳ

F. Kerseboom p. G. Vertue Sculp. 1738.

and systematic biology in a great series of volumes dealing with plants (1686-1704), birds (1676), fish (1686) and insects (1710). His was the best and the most important survey of living nature ever undertaken, a gigantic taxonomic effort which also pioneered comparative anatomy. These were studies of organic parts of Descartes' divine machine and others followed. Nehemiah Grew deduced that plants reproduced sexually in his *Philosophical History of Plants* (1672) and later Stephen Hales was to provide the groundwork for plant physiology in his *Vegetable Statistics* (1727), aimed at fruit growers and gardeners.

All of this was evidence of the continuing influence of the programme advanced by Bacon earlier in the century. One man, however, never even owned a single work by him: Isaac Newton. In the achievements of this dour individual we witness the

climax of the Scientific Revolution, the mathematical structure of nature being seen to be fully justified and the mechanical principles proved to be sufficient. That that became so was due to a new level of accuracy and detail of investigation. Experiments were repeated and repeated so that any theory Newton enunciated was not just beyond criticism but unassailable. The irony was he was reluctant to commit himself to a mechanistic view of the cosmos. Newton's discoveries were proof conclusive that it was so but he insisted that it was not completely. God for him was not the remote great engineer tending a mighty machine but part of the very nature of things.

Newton dominates science into the third decade of the eighteenth century with a reputation which was European. His theory of light proved that all the colours of the spectrum were equally primary. Using a prism, he discovered that colour was not only a qualitative but a mathematical property of light. In 1668 he constructed a tiny reflector having an aperture of only an inch with mirrors of white bronze. Through it he established the doctrine of the homogeneity of the seven coloured spectral rays and consequently the heterogeneity of the white light formed by their collective addition. Not only was this a revolutionary discovery but its verity was founded on new experimental evidence which could not be challenged. Abroad recognition came slowly and it was not until 1727 that Newton's *Optics*, published in England in 1704, appeared in French.

Of equal importance was his *Principia* (1687) which presented proof absolute of the Copernican system and in which he formulated the law of gravity, that the mutual attraction of two masses varies inversely with the square of the distance between them. Before Newton no known phenomenon or principle required the Earth itself to be in motion. He showed how the earth and the sun must rotate round their common centre, and that because the planets exhibit a centripetal acceleration towards the sun they must be in absolute motion around it. With this framework in place a man like Edmund Halley could go on and prove that comets, always regarded with fear as portents of cataclysm, could be brought within the laws of the mechanical universe. For the first time it was realised that the same comet could come round again.

Newton's *Principia* was the culmination of English scientific endeavour. In his work the mathematical and experimental methods were united and the mechanistic and magical traditions brought together. He still dwelt, however, in the world of the magical universe, devouring alchemical literature, believing in the ancient theology of the hermetic tradition and producing a torrent of religious writings. For Newton and his contemporaries the Scientific Revolution meant that the new knowledge gained would in the end unlock the mysteries of the Bible's prophetic books. Despite

adherence to mechanism in one sense Newton always drew back from a fully mechanistic explanation of the universe: 'This most beautiful system of sun, planets and comets could only proceed from the counsel and dominion of an intelligent and powerful Being.' God may not have exactly still been in his heaven any more but He was on the way to becoming the detached Deity of the eighteenth century.

By 1700 astrology, alchemy and magic were progressively becoming subcultures. The hermetic and magical view of the universe was virtually discounted as one which was mathematical and mechanistic took over. By the middle of the eighteenth century the English contribution to science, at first looked upon as idiosyncratic, was realised to be the truth. Suddenly an off-shore island was seen to irradiate the whole of Europe with its learning. English philosophy, science and even social and political customs began to be admired by those who in any way considered themselves to be part of what we know as the Age of the Enlightenment.

Sir Isaac Newton with his hand on one of his most famous works, a copy of the third edition of his Principia *(1726). On the table there is also a closed folio inscribed 'Optics'.*

Chapter Twenty-One

APOCALYPSE NOW

Sometime during the late 1640s a Welsh gentleman called Henry Vaughan put pen to paper in a poem entitled 'The Dawning'.

Ah! what time wilt thou come?
The Bridegroome's coming! fill the sky?
Shall it in the Evening run
When our words and work are done?
Or will thy all-surprising light
Break at midnight?
When either sleep, or some dark pleasure
Possesseth mad man without measure;
Or shall those early, fragrant hours
Unlock thy bowres?
And with thy blush of light descry
Thy locks crown'd with eternitie . . .

The coming of which he writes with such passion is the Second Coming when Christ will descend in glory, the great judgement follow, and then the thousand year reign of the saints begin in a reborn earthly paradise. Such were the musings of a defeated royalist as he looked around at the landscape of his native Breconshire conscious that his king had gone, executed by regicides, and so also had his church. In Vaughan's poems we walk in a visionary world where the divine is always imminent. And in his dwelling in and on transcendence he was not to be alone.

What sets the 1640s and 1650s apart is this all-pervading sense that mankind was living in the last age of the world. The apocalyptic atmosphere which was unleashed by the Civil War in 1642 cut right across society and was to ebb and flow in intensity for two decades according to the turn of events and then, in 1660, with the return of the monarchy, plunge underground. There was nothing novel in the ideas themselves, but what was new was that men and women actually believed that they were

Cupid arms the cavalier. Henry Mordaunt, 2nd Earl of Peterborough, in a portrait dated 1642 by William Dobson captures the spirit of chivalrous romance, typical of the Caroline court poets, which was lived out in the Civil War.

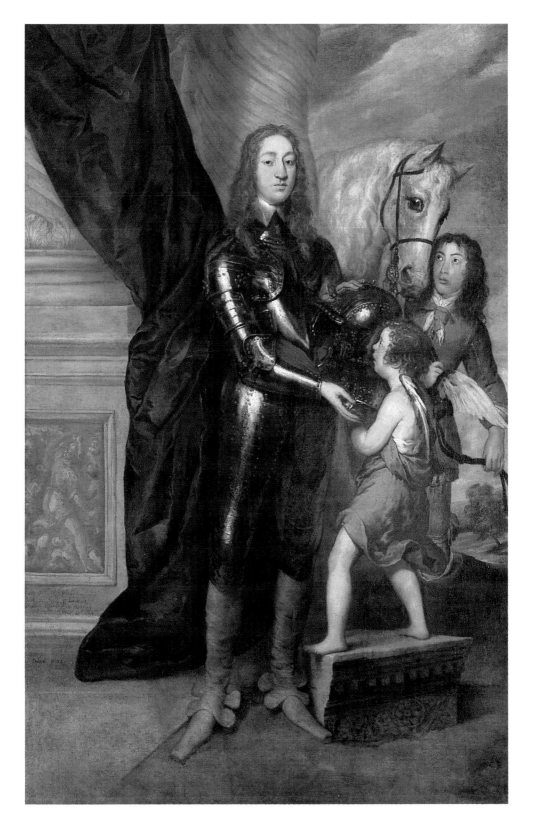

living out the prophecies of Daniel and Isaiah in the Old Testament, and also those of St John in the Book of Revelation. John Foxe's influential book *Actes and Monuments* had for decades instilled into the populace the idea that the English were God's chosen people, the successors to the Israelites, that here on this island God's truth had first been restored in the reformed Protestant faith, and that here too would take place the final battle between Christ and Antichrist. Moreover, God had chosen the English for a special role in this struggle. Antichrist was, of course, identified with Rome, Catholicism and Anglicanism of the kind promoted by Archbishop Laud. Chronologists had long since predicted that the fall of Antichrist would occur in the seventeenth century; as the Civil War progressed and the king and established church were swept away divines naturally saw these events as portents of the Second Coming. Everywhere one looks during these two tumultuous decades one is aware of a keen expectancy, that something cosmic could happen at any time. As a consequence, everything was cast into apocalyptic terms as the forces of light fought against those of darkness and the protagonists witnessed what they believed to be God's providence unfold.

On 10 February 1642 Charles I and his family left Whitehall and headed for Oxford. Ten days earlier the painter Van Dyck had died, a symbol of an era gone. For four years a court of sorts was maintained in the colleges of Oxford, one bravely recorded in the canvases of William Dobson. Here are the handsome heroic Cavaliers of romance, caught with all their bravado in buff jerkin or shimmering breastplate. In the distance rises the smoke of the field of battle curling up towards a turbulent sky while in the foreground usually stands an attribute recalling earlier days, symbolic classical sculpture of a kind which one would have seen in the gardens at Arundel House. These are figures from a masque not of the king's peace but of his war.

That sense that the past would never return is captured also in the onrush of publications by the Cavalier poets. The collapse of censorship in 1640 led them to print what they had written earlier, realising that they ought to get it into book form while they could. The poems of Thomas Carew, Edmund Waller, Sir John Suckling, James Shirley, Robert Herrick and Richard Lovelace were all printed in the 1640s. Poems from the past many indeed were, but by no means all. Lovelace catches the lovelorn Cavalier at war, still celebrating the beauties of his graceful heroine but against a very different background, caught in titles like 'To Lucasta, going to the Wars' or 'To Althea from Prison':

Stone walls do not a prison make,
Nor iron bars a cage;

Minds innocent and quiet take
That for an hermitage;
If I have freedom in my love,
And in my soul am free,
Angels alone, that soar above
Enjoy such liberty.

The young Abraham Cowley began an epic on the war but abandoned it when his friend, Lord Falkland, fell at the battle of Newbury in 1643. He was a Cavalier poet too late, as was Andrew Marvell, whose poem 'To his Coy Mistress' is a last gesture to the past for into his world irrupts violence. The peaceful arcady of Caroline courtly love is suddenly shot through with betrayal, loss and sudden death:

The wanton troopers riding by
Have shot my Faun and it will die.

'The Nymph complaining for the death of her Faun' encapsulates the bewilderment felt by so many at seeing innocence destroyed. Such a poem reflects a reality, for the war had split the country and divided families.

Until 1640 censorship had kept a firm lid on everything published. With the meeting of the Long Parliament in 1640 the old regime collapsed. A torrent of literature followed which was anti-clerical, anti-church, and radical. The views of a large submerged section of the population were heard for the first time, revealing a cacophony of conflicting ideas. At the same time, Sabbatarianism began to be enforced. The *Book of Sports*, which sanctioned traditional pastimes, was done away with, finally leading to the demise of what survived of the old pre-Reformation festive year. In 1644 there was legislation on Sunday observance and the following year all saint's days and holy days, including Christmas, were abolished. This was reiterated in 1647 when Christmas, Easter and Whitsun were suppressed. Christmas presented the Puritan authorities with the greatest problem. By the 1650s the churches were closed on Christmas Day but festivities still occurred and the soldiery was sent in to stop them.

That was one form of cultural erosion. Others began to be more significant. On 2 September 1642 Parliament passed an order forbidding stage plays on the grounds that they were inappropriate in time of war. Five years later this was followed by a far more chilling edict which opened with the statement that stage plays were not to be tolerated among those who professed the Christian religion. In Puritan eyes a boy masquerading as a woman on stage was as blasphemous as a priest assuming the role of Christ at the altar. Shakespeare's Globe was pulled down in 1642 and in the after-

math of the execution of the king in 1649 Parliamentary soldiers dismantled the Salisbury Court, the Cockpit and the Fortune theatres. Theatre had always been tarnished as an arm of monarchy and now it was finally abolished.

These were but harbingers of the tide of destruction which was to engulf the country as the Puritan war on the forces of Antichrist took its terrifying course. The war itself brought a terrible toll as towns and villages were burnt or pillaged. Up to two hundred houses and castles scattered across the country were destroyed, including major losses like the Marquis of Winchester's Basing House (where soldiery stripped Inigo Jones naked) and Sir Baptist Hickes's great house at Chipping Campden. The former was put to the sack, the latter was fired.

At the same time Parliament embarked on dismantling the Church of England. In December 1640 there was a petition to the House of Commons listing ceremonial abuses and expressing a distaste for the Laudian revival of religious art, '. . . the frequent venting of crucifixes and Popish pictures.' The following year commissioners were appointed 'to demolish and remove out of churches and chapels all images, altars, or tables turned altar-wise, crucifixes, superstitious pictures, and monuments and relics of idolatry.' In 1643 these directives began to be enforced. Their impact depended on the strength of loyalty felt by a particular area to Parliament. Some embarked on an iconoclastic spree while others took precautions by, for example, burying the stained glass windows. The most brutal record of destruction to survive is the diary of one William Dowsing as he made his progress through a hundred and fifty of Suffolk's five hundred churches. A typical entry, that for Gorleston, reads:

> 'In the chancel, as it is called, we took up twenty brazen inscriptions, *Ora pro nobis*, &c; brake twelve apostles, carved in wood, and cherubims, and a lamb with a cross . . . broke in pieces the [altar] rails, and brake down twenty-two Popish pictures of angels and saints. We did deface the font . . . ordered eighteen angels off the roof, and cherubims to be taken down, and nineteen pictures on the windows . . .'

What had not gone in the earlier tides of iconoclasm went now. Of the twelve Eleanor Crosses, erected by Edward I as a memorial to his queen, only three survive today.

The churches at least found a new role as meeting houses. The fate of the cathedrals was to be far worse. With the abolition of the episcopacy in the Root and Branch Bill of 1642 they became redundant. As in the case of the churches where Puritanism was strong, in the south and east, the devastation was untold. Canterbury had been a flagship of Laudian splendour. That year the nave became a barracks and

the soldiers stripped the lead from the roof. In 1643 its priceless thirteenth century stained glass windows were smashed. Only five out of the forty-nine single light windows in the clerestory are left and all fourteen large windows in the side aisles went, as indeed did five in the apse. At Peterborough the reredos was torn down, the tombs were mutilated and the Lady Chapel, cloister, bishop's hall and chapter house demolished. The Puritans of Yarmouth petitioned for the demolition of Norwich, the

A contemporary view of Canterbury Cathedral looking towards where the high altar, already demolished by the Puritans, would have stood. A Parliamentary Committee seated at a table in the nave is apparently supervising the destruction of what was viewed as popery. To the left men hatchet away at the choir stalls while to the right the stained glass windows are smashed.

contents of which were dragged to the marketplace and burnt. In the north, Carlisle and Durham suffered appalling depredations at the hands of the Presbyterian Scots. Most of Carlisle was demolished and Durham was gutted. St. Paul's in London, the shining symbol of Caroline Anglicanism, became a barracks and the king's gift, the great portico by Inigo Jones, was infilled with shops and the statues of the first two Stuart rulers destroyed. Mercifully the proposal to the House of Commons in 1651

that 'all cathedral churches . . . be surveyed . . . pulled down, and sold' was not carried.

After the king's execution the visual infrastructure of the monarchy began to be dismembered. Already six years earlier a Puritan mob had sacked the queen's Catholic chapel at Somerset House. The same year the royal chapels had been purged, many decorated and painted surfaces being subjected to the carpenter's plane. On 1 February 1649 a special committee was set up to 'take care' of all the royal goods which had been confiscated the previous year. In March an inventory was ordered and then the sales began, dispersing the legendary contents of the Tudor and Stuart royal palaces, including the king's picture collection, the greatest ever assembled by an English monarch. To take one artist alone, of the twenty-one pictures by, or assigned to, Titian, only three are now in the royal collection, four are in the Louvre, three in the Prado, one in Vienna, one in Antwerp and two in private collections. More than £118,000 was raised in this way and used to discharge public debts, settling the arrears in pay to the now unemployed court officials and meeting the needs of a state in economic crisis. Certain items had particular attention paid to them, the most important being the royal regalia, the accoutrements of magical monarchy. At the Restoration Sir Edward Walker, Garter King of Arms, wrote that 'all the Royal Ornaments and Regalia heretofore preserved from age to age in the Treasury of the Church of Westminster, were taken away, sold and destroyed . . .' In the autumn of 1649 the trustees of Parliament had broken into the jewel-house and seized the royal crowns and sceptres ordering them to be 'totallie broken and defaced.' The object was to prevent any artefact that might remotely be venerated as a regal relic from surviving.

Then there were the royal palaces. All but a handful of these were sold or demolished. Oatlands was demolished for the value of its materials, Eltham and Woodstock were left to fall to ruin. No buyer could be found for Greenwich so the Queen's House was given to a Parliamentarian, Bulstrode Whitelocke, while the palace became a prison. In 1660 it was a wreck. Wimbledon, one of Henrietta Maria's houses, was sold, so too was Holdenby, Northants, one of the greatest of all Elizabethan houses built by Elizabeth's favourite, Sir Christopher Hatton. The purchaser destroyed it. The same fate was meted out to that other great Elizabethan mansion, Lord Burghley's Theobalds, which James I had acquired. As a result of this holocaust little remains today to evoke the magnificence of Tudor and Stuart regal splendour.

The abolition of the monarchy finally sealed the fate of patronage. With the war the Royal Works, in the vanguard of taste and a crucial training ground for craftsmen, ceased, as did building work throughout the country. All the links with the new tides of taste coming from the Catholic baroque courts of the continental mainland came to a standstill. Culture depended on the court for setting style and fashion and for

employing all the most avant-garde practitioners. Now it had gone. A small army of musicians, for example, had either to join the royalist forces or flee abroad. The Chapel Royal disappeared and, with the abolition of the episcopacy, that lifeblood of English music, the cathedral organist and choir, vanished.

And yet the Puritans were not wholly inimical to the arts. Rather they saw that what the arts had come to represent was a far different cultural tradition from the one upon which they had been nurtured. That was a line of descent back to the apotheosised age of Gloriana who had played her role as the scourge of Antichrist beating down the Beast of the Apocalypse. Charles I in sharp contrast had had an agent of the pope resident at court. The literature Puritans looked to was stoutly Protestant and fiercely patriotic, the poetry and prose of Philip Sidney and Edmund Spenser. What Charles I favoured was sub-Catholic ceremonialism and peace with that arm of Antichrist, Spain.

This was an extraordinary period, a time when, for virtually everyone in society, everything which had been taken for granted for centuries was under attack or destroyed. For those who believed themselves of the elect it signalled the dawn of a new age. Christ indeed would come soon. For the defeated, Christ's coming was also looked forward to with equal fervour, but in their case as a release from an overwhelming sense of woe and despair. Men began to create their own hidden worlds as a solace, trying in their isolation to come to terms with the cataclysm which had overtaken them and shattered the world they had known. On both sides of the ideological divide this was to evoke a spiritual outpouring which still holds and moves us three centuries later. These are voices which haunt the mind in their anguish. These are souls in torment reaching out a hand amidst the encircling darkness, groping to find some hidden light.

The Anglicans had lost their church. The externals of their religion had been taken from them. Theirs is the tragic voice to be heard in the 1640s and 1650s, their faith covertly kept alive by the Book of Common Prayer and the devotional works of George Herbert. Herbert's collection of poems entitled *The Temple* went through four editions during that period. For Henry Vaughan, Herbert was 'a most glorious true saint of the British church.' Vaughan's poem *Silex Scintillans*, written in the late 1640s, captures a man who has passed through a profound spiritual crisis. His church has gone and he now seeks God by transmuting the landscape of Breconshire into that of the Old Testament, one that is suffused with divine immanence, where God is in the world of nature, the trees and groves, and in which visions can enrapture the faithful heart in its loneliness and misery:

> I sawe Eternity the other night
> Like a great ring of pure and endless light,
> All calm, as it was bright,
> And round beneath it, Time in hours, days, years
> Driv'n by the spheres
> Like a vast shadow mov'd . . .

Another defeated royalist, Thomas Traherne, was rector of a small parish just outside Hereford and became a member of a pious circle centring on a lady called Mrs Susanna Hopton. For her he wrote one of the great spiritual classics, unknown till its discovery in the twentieth century, the *Centuries of Meditation*. This is a work by someone who from childhood onwards seems to have been bathed in a perpetual transcendence. Like Vaughan, Traherne turns to the natural world around him and he too senses Christ's imminent coming. Unlike Vaughan, however, he already glimpses the earthly paradise in the world he sees about him. His poetry is bathed in a radiant joy and innocence:

> These little Limmes,
> These Eys and Hands which here I find,
> These rosie Cheeks wherewith my Life begins,
> Where have ye been? Behind
> What Curtain were ye from me hid so long!
> Where was? in what Abyss, my Speaking Tongue?
> When silent I,
> So many thousand years,
> Beneath the Dust did in Chaos lie,
> How could I Smiles or Tears,
> Or Lips or Hands or Eys or Ear perceiv?
> Welcome ye Treasures which I now receiv.

The hand of God ignites the stony heart of the poet Henry Vaughan on the title page of his Silex Scintillans, *(1650).*

Such mystic visions by Vaughan and Traherne look forward to William Blake just as the ecstasies of Richard Crashaw anticipate the Oxford Movement of the Victorian age. Crashaw's *Steps to the Temple* (1646) transmits the legacy of the Laudian movement which had attempted to restore to Anglicanism an aestheticism and an emotional response to religion which had been hitherto excluded. Crashaw finds no

difficulty in taking into the Anglican tradition the agony and ecstasy of Counter-Reformation piety with poems hymning the Virgin, the Holy Blood and the saints. No one else could have such an extraordinary response in verse to the Book of Common Prayer:

> Delicious deaths, soft exhalations
> Of soule, desire, and divine annihilations,
> A thousand unknown rites
> Of joyes and rarified delights.

So the forties and fifties gave birth to a quite astonishing renaissance of religious poetry. It also witnessed the creation of private worlds of another kind as the aristocracy and gentry, either defeated or in political exile, sought solace in their estates. A man like the diarist John Evelyn turned to gardening, the garden itself being an image of the earthly paradise everyone awaited. He laid out an elaborate garden at Sayes Court at Deptford in the 1650s. 'We will endeavour to show,' he wrote to Sir Thomas Browne in 1657, 'how the aire and genius of Gardens operate upon human spirits towards virtue and sanctitie.' He lists garden elements like grottoes which 'do contribute to contemplative and philosophical Enthusiasm . . . for those expedients do influence the soule and spirits of man and prepare them for converse with good Angells . . .'. Evelyn in this is not so far from either Vaughan or Traherne.

Thomas, Lord Fairfax, leader of the Parliamentary armies, also retreated to his Yorkshire estates, resigning his post after the execution of the king. There he practised husbandry, read books, wrote poetry, studied antiquities and cultivated his garden. Fairfax employed the young Andrew Marvell as a tutor for one of his daughters. Marvell, in his poem 'Upon Appleton House', used the estate and its history as a vehicle to review the recent past, looking back to the 1630s and forward to the impending Apocalypse as darkness falls and the poem reaches its close:

> Tis not, what once it was, the World;
> But a rude heap together hurl'd;
> All negligently overthrown,
> Gulfes, Deserts, Precipices, Stone.

Marvell is nothing if not a covert writer, reticent and ambivalent as to his true stance but yet he was to go on to celebrate Oliver Cromwell as the agent of God's providence, 'the angry force of Heaven's flame', whose role was to prepare the way for the last age of the world. By then Marvell was drawn close to republican circles, being a tutor to one of Cromwell's wards. Cromwell became Lord Protector in 1653 and in

Marvell's *The First Anniversary of the Government under His Highness the Lord Protector* we catch the millenary fervour at its height. Cromwell is cast as the man who will lead the elect nation and his government will prepare for Christ's coming and the rule of the saints:

> Sure the mysterious Work, where none withstand,
> Would forthwith finish under such a Hand:
> Fore-shortened Time its useless Course would stay,
> And soon precipitate the latest Day.
> But a thick Cloud about that Morning lyes,
> And intercepts the Beams of Mortal eyes,
> That 'tis the most which we determine can,
> If these be the Times, then this must be the Man.

That sense of apocalypse was to continue to cast a shadow, albeit a receding one, throughout the 1650s. Peace of a kind came. The Protectorate saw the re-establishment of a court of sorts at Whitehall and Hampton Court. The disposal of what was left of the royal goods was stopped while choice was made of tapestries, furniture and pictures to grace the Lord Protector's residences. His two most significant choices were Raphael's cartoons, *The Acts of the Apostles*, and Mantegna's *The Triumph of Caesar*. Ceremony and a degree of revelry returned, though modestly, for the protectoral court could only boast seven musicians. The Puritan objection to music had only ever extended to its use in the public theatre and to over-elaborate settings in church. Nor were the visual arts wholly neglected for any ruler needed to project his image as the somewhat wooden canvases of Robert Walker testify. Fortunately Cromwell also sat to the great miniaturist Samuel Cooper who depicted him as he wished, 'warts and all'.

All through the 1650s the arts bestir themselves again, even if only timorously. Roger North was to write of that period in respect of music: 'When most other good arts languished Musick held up her head, not at Court nor in profane Theatres, but in private society, for many chose to fiddle at home, than goe out and be knockt on the head abroad.' The abolition of censorship meant that music could be printed in abundance but it was music which had been composed earlier. Composers, like Thomas Tomkins who saw his posts at the Chapel Royal and at Winchester Cathedral vanish, shrewdly turned their attention to keyboard music which could be played in private. For anything resembling theatre or masque to return it had to be dressed up in a highly moral guise. One such was James Shirley's masque *Cupid and Death* which was performed at Whitehall by official command in March 1653. It had scenery and

the music was by Christopher Gibbons and Matthew Locke. Inevitably unambitious and tentative it tells how the arrows of Cupid and Death were exchanged, leading to fatal consequences for the lovers who, although restored to each other, are glimpsed at the end enthroned in the Elysian Fields. Perhaps in this allegory we see the ghosts of the Caroline world and the terrible war that had destroyed it laid to rest.

Cupid and Death was sung in recitative, in effect it was an opera. Performances of that kind, what were called 'moral representations', were in fact to bring back the stage. Sir William D'Avenant had worked with Inigo Jones on five of the court masques and in 1656 cautiously inaugurated just such a revival. *The First Day's Entertainment at Rutland House*, his own residence, presented in 1656, was a private entertainment with 'Musicke and Declamations after the Manner of the Ancients.' D'Avenant was astute enough to include in it a eulogy of the Lord Protector. Later that year he staged what was the first English opera, *The Siege of Rhodes*, with scenery by Inigo Jones's nephew and pupil John Webb, and music by the masque composer Henry Lawes. In this piece not only did women appear upon the stage but the roles of singer and actor were for the first time wholly conflated, for the piece was sung entirely in recitative. Two years later D'Avenant went public and opened the refurbished Cockpit Theatre in Drury Lane staging *The Siege of Rhodes*. After Cromwell's death he went on to present *The History of Sir Francis Drake* and *The Second Part of the Siege of Rhodes*. Where such 'moral representations' would have led had the Restoration not occurred it is interesting to speculate.

After the king's execution and with the return of stability, building began again. Philip Herbert, 4th Earl of Pembroke, had fought on the side of Parliament but during the 1630s he had Inigo Jones advise him on the rebuilding of Wilton House. Isaac de Caus, a Huguenot architect and garden designer, was to carry out the rebuilding of the south front and the laying out of the

Two of John Webb's designs for The Siege of Rhodes *(1656). The proscenium and the rocky side wings remained in place throughout while the shutters at the back changed.*

stupendous garden, the greatest Renaissance garden in England before 1642 with grottoes, fountains, statuary and embroidered parterres. But the south front was gutted by fire in 1647 and so Pembroke turned to John Webb to create the incredible set of state rooms, the most magnificent to survive from the era, the Cube and Double Cube rooms. They are the swan song of Caroline style, looking back to the interiors Inigo Jones had created for Henrietta Maria at Somerset House. But Webb was to go on to design nearby Amesbury House for Lord Hertford. A whole clutch of houses was built for members of the new political establishment; the most important of these was Thorpe Hall (c.1653), Northants, by Peter Mills, for Oliver St. John, the lawyer who had defended John Hampden in the famous Ship Money case. This was the earliest and most important example of what was called a 'double-pile' house, almost square but with a classical dressing which proclaimed its descent from Scamozzi by way of Inigo Jones's Prince's Lodging at Newmarket.

And then, quite suddenly, it was all over. Richard Cromwell succeeded his father as Lord Protector in 1658 and the regime began to disintegrate. And then, in 1660, Charles II returned and what had happened during the previous two decades was to be blotted out of memory. The new Restoration regime was initially a tolerant one but within two years it became repressive, as the old Cavalier gentry reasserted their hold on power. Censorship returned, and the reconstituted Church of England excluded all those who would not subscribe to the Book of Common Prayer. The

The Italianate tradition of Caroline court architecture was continued by Inigo Jones's nephew, John Webb, through the Commonwealth period. Amesbury House, Wiltshire, was under way at about the time of the Restoration in 1660.

The splendour of Inigo Jones's interiors for the royal palaces in the 1630s was transferred to the provinces by John Webb in the state rooms at Wilton House, Wiltshire, for the Earl of Pembroke in the 1650s.

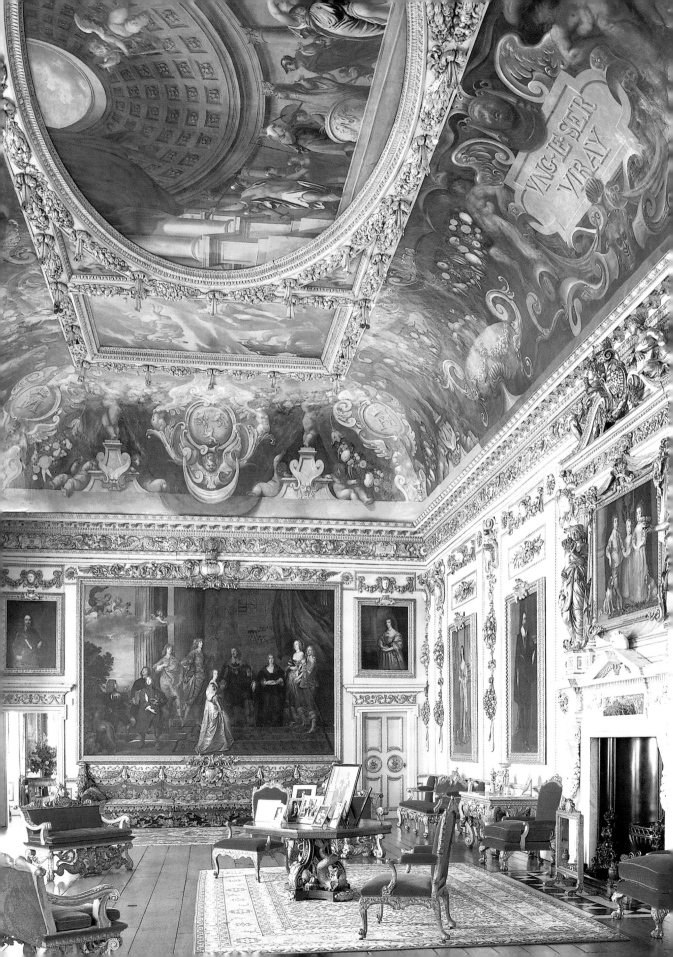

result was dissent and the emergence of an underground culture of the losers. They spent their time wondering why Christ had not come, why the English, God's chosen people, had failed, what had they done wrong that they had forfeited God's favour? It was a bitter cup from which to drink.

John Bunyan was one such. The son of a tinsmith, he had fought for Parliament. After 1660 he was to spend much of his time in prison as a dissenter, his conscience forbidding him to obey the civil law. He still believed that God would not forsake his people: 'In time of oppression the Saints can think of triumph.' So he believed in 1665, the year of the Great Plague, with 1666 in mind, a mystical number, which saw the Great Fire of London. His work reaches its climax in an enduring classic, *The Pilgrim's Progress* (1678), which opens with the simple question: 'What shall I do to be saved?' Bunyan's protagonist, Christian, then seeks the pathway to heaven, one littered with temptations and false turnings. What sets this book apart is its use of ordinary everyday speech and the fact that the action takes place in a recognisable panorama of contemporary society.

For John Milton the events of 1660 were to haunt him for the rest of his days. The greatest poet of the century was also a great revolutionary, and for him to see not Christ but Charles II return in glory was a betrayal of everything which his life had stood for. But without this traumatic event *Paradise Lost* (1667) might never have been written in its present form. The irony was that the greatest literary works of the age were to be written by those who were rejected by the new establishment. But by the time *Paradise Lost* appeared it must have seemed out of date, a voice from an era the memory of which had to be erased. For Milton his epic was a vehicle for coming to terms with the enormity of what had happened.

Milton, the son of a scrivener, was brought up in a firmly Protestant household. When he was at Cambridge he was anti-episcopal, an adherent of hermeticism and a follower of Francis Bacon. But his early apprentice work, written during the 1630s, is masque-like in feeling, sympathetic, at least on the surface, to ceremonial and pastoral. The masque *Comus* (1634) celebrates the virtue of chastity in an allegorical adventure of chivalry in direct descent from episodes in *The Faerie Queene*. From the first

John Bunyan's dream. In the background Christian sets off on his journey. Frontispiece to The Pilgrim's Progress, *(1678).*

Milton was ambitious to be a great poet but when the war came he took to pamphleteering for Parliament, contributing to the ferment of the 1640s by arguing for religious toleration (except, of course, for Roman Catholics), divorce, and an élite academy on Baconian principles. In the aftermath of the king's execution he was a stout defender of regicide. In *Eikonoklastes* (1649) he tears apart the props of monarchy in a violent attack on what everyone believed to be a book of meditations written by the king himself, the *Eikon Basilike*. The frontispiece of that depicts the king like Christ undergoing the Agony in the Garden, clasping the crown of thorns. For Milton this was but 'a masking scene', a compilation of 'devices begged from the old pageantry of some Twelfth-Night's entertainment at Whitehall.'

Milton in these years was Secretary for Foreign Tongues to the Commonwealth and had reached the summit of his public career, but blindness was to impinge on his ability to fulfil his duties. As the Protectorate staggered towards its collapse disillusion set in, but to the bitter end he defended the republican cause, even in the weeks before the king landed. He scorned a king who 'must be adored like a demigod.' The price he paid was arrest and imprisonment. Three of his books were publicly burnt and the rest of his life was passed in retirement. It was then that he returned to poetry, casting himself as a blind prophetic poet and seer, England's Homer. Poetry too, in an era of censorship, could convey covertly much which could no longer be printed in factual prose.

Milton's *Paradise Lost* is an epic story which embraces the whole of human experience, including that gathered from the myths of classical antiquity. The subject matter is the Fall of Man, Adam and Eve in the Garden of Eden and the events which led to their expulsion. The generally accepted date for its composition is between 1658 and 1663 with the first six books written before 1660. The Fall is a vehicle for pondering on why God had withdrawn his favour from England, why had the revolution failed and what was the way forward after the event? Like Spenser's *Faerie Queene* its aim was to instruct; not, as in Spenser's case, 'a gentleman or noble person', but Everyman. Paradise, Milton believed, must now be sought by a co-operation with God's purposes through inner spiritual regeneration. The Fall explained the need for the State, which evolved because of man's greed and avarice leading to rich and poor, master and servant, and the need to protect life and property by some form of authority. *Paradise Lost* is a gigantic concept belonging firmly within the old encyclopaedic tradition, written by a man who clung to the old cosmology with no gesture to the mechanistic universe. Christ would still come. It was a tract for those who found themselves in a new dark age coming to terms with waiting.

Paradise Regained (1671) is a bleakly simple epic of Christ undergoing the temp-

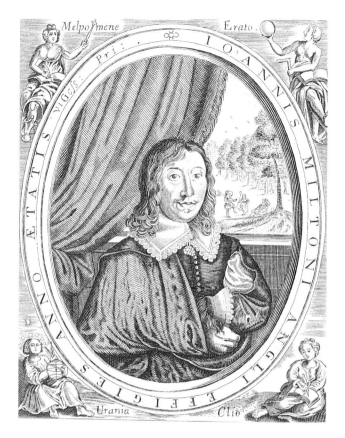

Frontispiece to Milton's Poems *of 1645.*

tations but in the same year Milton published *Samson Agonistes*, which takes up the message of his masterpiece. Samson is the faithful servant of God who has been cast down not only by events but also by his own weakness. In the poem he undergoes a spiritual regeneration which gives him the strength to destroy the enemy and triumph in death. The Philistines perhaps reflect the debauched excesses of Restoration society and their downfall signals that, in spite of all, God's purposes in the end will prevail.

Milton never loses faith in the millenary vision. Christ will come, and with him the earthly paradise, that image which embodied the deepest aspirations of seventeenth century man. In *Paradise Lost* Satan surveys the yearnings of an age:

A Heaven on Earth: for blissful Paradise
Of God the Garden was, by him in the East
Of Eden planted . . .
. . . in this pleasant soile
His farr more pleasant Garden God ordained;
Out of the fertil ground he caus'd to grow

All Trees of noblest kind for sight, smell, taste;
And all amid them stood the Tree of Life,
High eminent, blooming Ambrosial Fruit
Of vegetable Gold . . .
. . . the crisped Brooks,
Rowling on Orient Pearl and sands of Gold,
With mazie error under pendant shades
Ran Nectar, visiting each plant, and fed
Flours worthy of Paradise which not nice Art
In Beds and curious Knots, but Nature born
Poured forth profuse on Hill and Dale and Plaine,
Both where the morning Sun first warmly smote
The green field, and where the unpierc'd shade
Imbround the noontide Bowrs: Thus was this place,
A happy rural seat of various view . . .

Milton died in November 1674, the exact day is not known, and, it is recorded, 'with so little pain and emotion that the time of his expiring was not perceived by those in the room.'

Chapter Twenty-Two

POMP AND CIRCUMSTANCE

On 22 April, 1661, John Evelyn, diarist and virtuoso, recorded the state entry into London of Charles II almost a year on from his Restoration. The splendour of it quite overwhelmed him:

> 'This magnificent Traine on horseback, as rich as *Embroidery, velvet, Cloth of Gold & Silk* & Jewels could make them & their pransing horses, proceeded through the streets strew'd with flowers, houses hung with rich *Tapistry*, Windos & *Balconies* full of Ladies, The London Militia lining the ways, & the severall Companies with their Barriers & Loud musique ranked in their orders: The Fountaines runing wine, bells ringing, with Speeches made at the severall Triumphal Arches . . .'

There had been no spectacle filling the London streets on this scale since the entry of the king's grandfather, James I, nearly sixty years before. By casting the city as Rome, the Thames as the Tiber and the king as the Emperor Augustus the pageantry took up themes perennial in Stuart eulogy, those of empire, taking the story up as it were from where it had left off in 1642. The streets were punctuated by four gigantic arches. Up to a hundred feet in height they were covered with painted decoration, each housing also a dramatic interlude which involved costumed actors, singers and musicians. As Charles approached, the first of these arches, 'Britain's Monarchy', put to flight Rebellion and Confusion. A scene on the structure depicted Charles on horseback banishing into an awaiting hell-mouth two harpies and a hydra, one of whose heads was 'like CROMWELL'S.' In this way the arts of architecture, painting, music and drama combined to present to the onlooking crowd the new king as conqueror, saviour and peace-maker. Love and Truth burst into song:

> Comes not here the King of Peace,
> Who, the Stars so long fore-told,

Charles II as ruler of the seas in a swirling regal apotheosis by the court painter Antonio Verrio. In this quintessentially baroque vision of monarchy Envy is struck down by putti bearing the attributes of Peace and Love and dominion of the seas is ceded to Britain as the king sails in triumph through the waters in a chariot driven by Neptune.

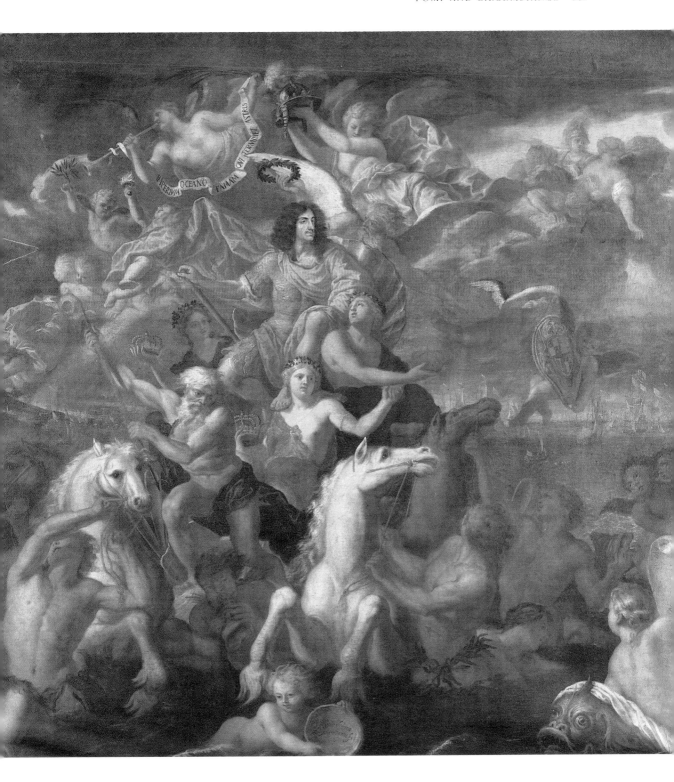

From all Woes should us release,
Turning Iron-times to Gold!

Here the theme of apocalypse, so potent through the previous decades, was turned to hail a royal epiphany endowing the young monarch with the attributes of Christ entering Jerusalem.

In sharp contrast to the closed world of the Caroline court masque, the arts were now to be deployed publicly to restore the mystery and magnificence of the Crown. Their style was to be epitomised in one word: baroque. That manifestation of the late Renaissance had only so far been glimpsed in England in Rubens's mighty canvases on the ceiling of the Whitehall Banqueting House, and in the stage pictures of Inigo Jones. Now, after almost twenty years of stylistic stagnation, the baroque was to burst across the scene, framing the visual presentation of the court to the populace.

Ironically, the baroque was to prove to be the ideal style to reflect what was a deeply fissured society, one which was to remain in political and religious turbulence until the second decade of the eighteenth century. The baroque always portrayed precisely such a scenario, forces in conflict, opposites and extremes confronting each other, but at the same time, contrary to surface appearances, seen to be manifestations of an ordered whole. Its key role was to purvey to the viewer the incorruptible truths of the sphere of heaven, ones which were fixed, immovable and permanent. That was the role assigned to the arts:

The first of the four great triumphal arches erected for Charles II's state entry into London in 1661 prior to his coronation in which Monarchy was again triumphant and the regicides vanquished.

> '. . .the celestial beauties above the moon being incorruptible, and not subject to change, remained for ever fair and in perpetual order. On the contrary, all things which are sublunary are subject to change, to deformity, and to decay . . . For which reason the artful painter and the sculptor, imitating the Divine Maker, form themselves, as well as they are able, a model of the superior beauties . . .'

Thus the Poet Laureate, John Dryden, in his translation of the Italian art theorist Bellori.

So it is that the art of the baroque is concerned with flux and paradox, illusion

and seeming, searching through a shifting and spiralling phantasmagoria of imagery to catch a vision of the eternal truths. The baroque was always all-embracing, drawing in every art. Its most natural forms were the palace and its surrounding domain, or whole cities, or a dramatic form such as opera or ballet which called for contributions across the aesthetic spectrum. The baroque began as the vehicle for the new and intensely emotional piety of Counter-Reformation Catholicism and moved on from there to be adopted as the ideal vehicle to express absolute monarchy. Its principal exponent was the ruler Charles II most admired, Louis XIV, whose palace at Versailles summed up everything to which the English king aspired.

The Civil War and then the Interregnum had delayed the arrival of the baroque and that in itself presented problems, for craftsmen accustomed to working in this new idiom had to be recruited from abroad, men like the illusionist painters Antonio Verrio and Louis Laguerre, or the 'stuccatori' Giuseppe Artari and Giovanni Bagutti. Only in the field of wood carving did a native exponent emerge in the figure of Grinling Gibbons, whose naturalistic garlands and trophies defy the medium and still amaze, but he was born and trained abroad. In architecture it was not to be until the 1690s that England was to produce its own outstanding baroque architects in Nicholas Hawksmoor, William Talman and Sir John Vanbrugh. Baroque was also a hugely expensive style and although its role was to bestow an aura of divinity and autocracy on Charles II, nothing could conceal the fact that he was maintained in power by the will of Parliament and an unwritten constitution. Money therefore had to be voted by Parliament and although what the king was able to spend steadily rose through his reign, not one of his major projects was ever finished.

And, as in the case of earlier waves from the Continent, the criterion of selectivity was maintained. Indeed the king was to recognise that fact in his greatest baroque creation, the state rooms at Windsor Castle, astonishing essays in illusion in which every ceiling opened to a sky from which descended benevolent deities, but the whole solidly encased within the ancient walls of a Plantagenet fourteenth century castle. Windsor also typified two other insular characteristics, the liking for restraint without and richness within, and a continuing reverence for the monuments of times past. Sir Christopher Wren, the great architect, argued for what he called 'Customary Beauty', which 'is begotten by the Use of our senses to those Objects which are visually pleasing to us for other Causes, as Familiarity or particular Inclination breeds a Love to Things not in themselves Lovely . . .' So it was that Sir John Vanbrugh outfaced the termagant Duchess of Marlborough, refusing to demolish the ancient royal palace of Woodstock which she regarded as an eyesore to Blenheim. That feeling for

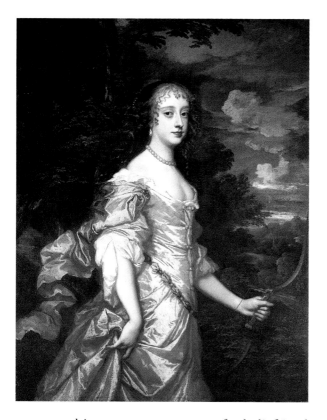

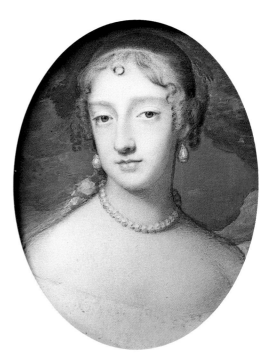

Two renderings of a beauty, Frances Stuart, Duchess of Richmond. To the left a portrait by Sir Peter Lely from his series depicting the great beauties of the court, the sitter being presented, bow in hand, as a nymph of the goddess Diana. To the right the great miniaturist Samuel Cooper in contrast records her with the meticulous observation typical of the scientific age.

things past sprang out of a belief in the role of what was called Fancy, a principle which was to be at the heart of English baroque civilisation. The latter has suffered because it had no literary spokesman at the time, for when retribution came in the form of the Palladian movement no words of censure were too vehement to be applied to what was then cast as a foreign importation and an aberration promoted by a tyrannous dynasty. The truth was very different. The English baroque is as astounding in its achievements as any in the rest of Europe and it owed much of this to the indigenous defence of Fancy. It was Thomas Hobbes, author of *Leviathan* (1651), who argued that Fancy was as important as Reason and Judgement. Fancy was the capacity to observe likeness in things of different natures. Only by playing on the spectators' emotions and imagination, he wrote, could the artist create his work of art. Dryden subscribed to this view in respect of poetry: 'Tis fancy that gives us the life-touches, and the secret graces to it.' Architecture called for Reason but also Experience and Fancy, the latter enabling the baroque eye to appreciate and even draw on elements of the medieval Gothic. These exponents of English baroque civilisation

were firmly Baconian Moderns having no time, as Wren wrote, for those who reduce the Ancients 'to strict and pedantic rules' when any dispassionate examination of their work would prove that not to be so.

With the Restoration, art became once again part of public life and a cultural programme viewed as integral to the enhancement of the monarchy. The personal role of the king during his twenty-five year reign can never be over-estimated. Although always constrained by lack of money and the constitution, no aspect of the cultural life of the country went untouched by him. Architecture, music, painting, theatre and gardens were all directly affected by a man who had travelled and resided for long periods abroad both in France and the Netherlands. And, unlike his father and grandfather, he and his court were part of the public domain and thus exerted even more influence on the direction of taste. He realised that baroque art's chief attribute was to control through its ability to both amaze and stupefy.

Charles II never got his Versailles but from the moment he returned his reign was littered with successive attempts in that direction. For twenty-five years a series of grandiose schemes ebbed and flowed. Almost all of them began by introducing what was a revolution in garden design, the reshaping of the landscape around the palace into a series of rectangular grids with formal vistas arranged in perspective radiating outwards from the palace façade, forming what was designed to act as an alfresco theatre of the court. That style had evolved in France under the aegis of the Mollet family, one of whose members, André, had worked for Henrietta Maria before the Civil War. In the autumn of 1660 St. James's Park was re-cast in this manner in anticipation of a new Whitehall Palace designed by Inigo Jones's nephew, John Webb. That never came but its garden façade would have looked down on to a long rectangular canal flanked by avenues of trees with further radiating avenues at its termination. The following winter the formula was repeated at Hampton Court, when a spectacular mile long canal, the Long Water, was dug, running from the east front. Both were copies of what the king had seen at Fontainebleau, evidence from the outset of his reign that the dominant cultural influence was to be France. In terms of garden design that style was to reach its apogee in the work of André Le Nôtre, creator of the vast gardens of Versailles, and it was to him that Charles was to turn for his next great project.

John Webb was called upon to design a new Greenwich Palace and one block of this began to arise during the 1660s. Louis XIV agreed to Le Nôtre laying out the gardens although there is no evidence that he came, but he certainly produced the designs for the great radiating avenues which we see today. The parterre, with its fountains, grotto and cascade, was never constructed, for work on the palace ceased in

1669 as part of the financial retrenchment which followed the Great Fire of London. This particular palace project was finally abandoned five years later.

The year before Greenwich came to its final halt the king turned his attention to Windsor Castle, seat of the Order of the Garter of which much was made during the Restoration period. The architect Hugh May was put in charge of restructuring its interior in line with that of a great baroque palace. Demolished in the 1820s it incorporated what were recognised to be two magnificent and ingenious staircases with illusionistic wall paintings by Verrio, leading to a series of state rooms decorated in the same manner and with virtuoso wood carvings by Gibbons. This was one long apotheosis of the dynasty which had its climax in St. George's Hall and the chapel. The castle's hilltop siting did not lend itself to baroque garden design which demanded a level terrain but the up and coming George London planted the three mile Long Walk, ensuring the submission of the landscape to the castle. London, with his partner Henry Wise, was to take the baroque style later to the great houses.

It was the king who spotted the architectural genius of Christopher Wren, who had begun his career as an astronomer. He was appointed to the Royal Works and sent to France to study the great palace projects of Louis XIV, Bernini's contribution to the Louvre, and Mansart's Versailles. The appointment of Wren was an inspired one for when he finally succeeded John Webb and became surveyor-general of the King's Works in 1669 he transformed the Works into what became a powerhouse and training ground for the baroque architects who were to dominate the 1690s.

The Great Fire of London in 1666 meant that palace building went into abeyance until the 1680s while energies centred on reconstructing the devastated City. Such a scheme would have been an ideal vehicle for the baroque and indeed as initially conceived London would have been built with splendid avenues and piazzas along continental lines. That was what both the king and Wren wanted, and if only Charles had been absolute it could have been achieved. But what little control that there was over the rebuilding had to be secured by way of Parliament and a commission. The result was that when the City rose again it followed for the most part the old medieval street patterns.

As it is, the most enduring legacy of the rebuilding was to be the City churches, designed by a variety of architects including Wren. They added to the skyline by the close of the century a unique application of the principles of the baroque to an indigenous format, the steeple. The fire forced the re-established Church of England to think about what kind of architecture was appropriate to its liturgy. It called for

Palace building lay at the heart of Charles II's artistic policies. None reached fruition, but the great baroque ensemble at Greenwich remains a testament to his aspirations with its manipulation of perspective and axes to enhance the grandeur of the Crown.

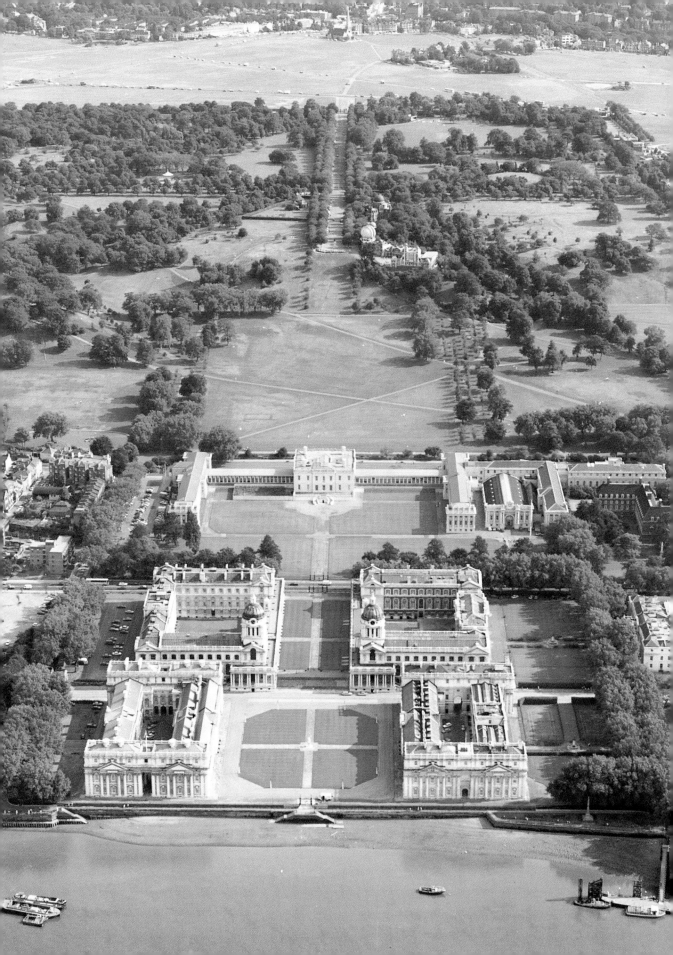

an interior which gave equal emphasis to the altar, the reading desk and the pulpit, with large windows to allow in light by which to read. Anglicanism by nature was both auditory and participatory and in essence was a religion of restraint, even more so after the excesses of the years before 1660. That is caught in the tentative use of

Wren's steeples for the rebuilt City churches are a uniquely insular contribution to the repertory of baroque architecture. Left to right: St Mary-le-Bow, Cheapside, St Bride, Fleet Street and St Vedast, Foster Lane.

any form of decoration in the interiors, confined to Moses and Aaron flanking the Ten Commandments, the Creed and Lord's Prayer, garlands of naturalistic fruit and flowers, plus the intrusion of the occasional cherub's head and rays of celestial glory.

A second commission was set up to discuss the rebuilding of St. Paul's Cathedral. Once again it was to be the result of compromise, for the Anglican clergy rejected the architect's initial design as departing too far from the traditional Latin cross ground-plan of English medieval cathedrals. This was a building saga which was to stretch into the third decade of the eighteenth century. As a monument it speaks of a mind grounded in the abstractions of mathematics. In its lack of any appeal to the emotions it is totally unbaroque, a cool Anglican riposte as it were to the tidal wave of passion exuded by any continental Catholic church. This was to be England's St. Peter's, neither unadorned nor overdecked but visually striking by the very force of its silhouette, its grey exterior carefully modelled, grooved, textured and enlivened

with carving of a kind Wren had seen in France. Unlike France, however, St. Paul's was not an expression of regal patronage but of patronage by the State. And that shift heralded what was to come.

Sir Christopher Wren's 1675 design for the south elevation of St. Paul's Cathedral.

In contradiction to that, everything in the last few years of Charles's reign suggested that some kind of absolute rule may have been within reach. The Crown had emerged triumphant from the political turmoil of the late 1670s precipitated by the Popish Plot and the Exclusion Crisis, when efforts had been made to block the succession of the king's Catholic brother James, Duke of York, to the throne. That new confidence found expression in the royal foundation of Chelsea Hospital in 1682. Again in emulation of Louis XIV who had founded a parallel institution for soldiers, Les Invalides, it was funded partly out of the royal Privy Purse. Its giant Doric columns reflected Wren's increasingly baroque style, which was also to be caught in the king's final palace project at Winchester on which Wren worked simultaneously. Here the disposition of the main façade directly echoed Versailles. Winchester went up with amazing speed and was almost finished when the king died. Work was never resumed.

The fact that virtually all the king's palace schemes foundered should not detract from the cultural clue they provide to the reign. The palace was central to monarchy

in the baroque age as a display of secular might, power, prestige and glory. It was not only in itself a work of art, it was also the setting for other arts which gave lustre to the Crown. Music was one which gave a palace animation, and on music Charles II had definite views. In 1660 few of the pre-1642 musicians survived and the Chapel Royal, with its need for twelve boy choristers, thirty-two gentlemen, and three organists, had to scour the realm in order to reconstitute itself. For eighteen years there had been no church music and no cathedral choirs but the recruits were to include the next generation of composers including Henry Purcell, Pelham Humfrey and Thomas Tudway. By July 1660 Samuel Pepys, the diarist, was to record that he went to the Chapel Royal at Whitehall and 'heard very good Musique', adding, 'the first time that I remember ever to have heard the Organs and singing-men in Surplices in my life.' By November he reported going to Westminster Abbey, 'the first time that I ever heard the organs in a Cathedrall.' What he captures was that in terms of English music this was a new beginning.

Not only had the Chapel Royal to be reinstated but also what was known as the Private and Public Music. The king liked music which he could beat time to, and he hated the old form of consort music with chamber organ, violin and viols, establishing instead what his cousin Louis XIV had, the Twenty-Four Violins. They were a musical revolution and quickly rendered any other form of ensemble obsolete. Soon they were making their appearance in the Chapel Royal. The Restoration musical renaissance owed its existence to a monarch who, in the words of Thomas Tudway, was 'tyr'd with the Grave and Solemn way, And Order'd the Composers of his Chappell, to add Symphonyes &c. with Instruments to their Anthems.' The resulting symphony anthem was to be the most glamorous musical vehicle of the epoch, great set pieces utilising rearranged biblical texts slanted towards regal apotheosis, deploying several groups of performers both vocal and instrumental. Pelham Humfrey was sent to France by the king to study such music in his role as Master of the Chapel. When he died in 1674 he was succeeded by John Blow, who, over thirty-five years, was to write about one hundred anthems using strings, then oboes and baroque recorders, and eventually the trumpet.

English vocal music changed rapidly not only on account of the influence of French court practice but also because of the arrival of Italian singers who brought with them a new style of singing. Through their example and teaching they changed the indigenous singing style, resulting in English male singers developing a distinctive alto-range of solo singing. The Italians introduced the bent-side spinet in the 1660s which within twenty years replaced the virginals as the standard musical instrument in the home for the next century.

The symphony anthems were parent to a burgeoning efflorescence of musical tributes to the Crown which multiplied as the reign progressed, taking the form of what were called royal odes. These began with one for the king's birthday, 29 May, instituted as a national feast day in commemoration of the Restoration, probably in quite a modest way within the palace. Gradually others came, marking New Year's Day and, from about the 1680s onwards, the return of the king from the country to Whitehall. The verses were by the Poet Laureate, John Dryden, and the music by Matthew Locke, Purcell, Pelham Humfrey and Henry Cooke. These were spectacular musical events when all the resources of the royal household were brought into play and which were likely, as they developed, to have included choreographed dance sequences.

Henry Purcell was the musical genius of what was to be the last flowering of the Chapel Royal as the focal point of the kingdom's music-making. Trained in the Chapel he was sworn in as composer for the Twenty-Four

A group portrait now believed to depict the King's Private Music, c.1661-63, with the German born violin virtuoso Thomas Baltzar seated to the left and the composer John Banister seated right.

Violins in 1677 and became organist at Westminster Abbey three years later. Purcell was fastidious, virile and wholly individual, pouring his energy into a vast sequence of some seventy anthems which he wrote between about 1675 and the Revolution of 1688. Here was a composer with a deep reverence for the country's pre-1642 musical inheritance and yet responsive to influences from the continent such as the Italian sonata which arrived in the 1670s. He wrote his first royal ode in 1680 and three years later inaugurated the annual St. Cecilia's Day celebrations in the City which again called for an ode. And yet the royal musicians always lived under threat. Their pay was constantly in arrears, so much so that in the 1670s the master of the Twenty-Four Violins began to give public concerts in his own house and run a school. In addition there was the king's desire to import a foreign opera company. Purcell was one of the first English composers to respond to that threat with his opera *Dido and Aeneas*. This is now believed to have been written for performance at court during the brief and disastrous reign of James II. On stage James in the guise of Aeneas, the founder of Rome, is warned not to be duped by the English Catholics, the witches, into aban-

The first collected edition of Henry Purcell's songs in Orpheus Britannicus *(1698).*

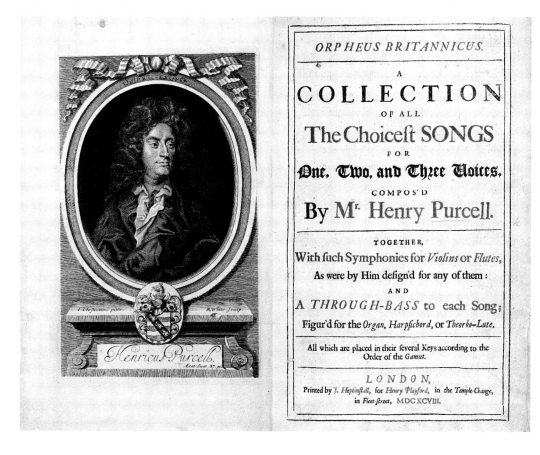

doning England figured in the person of the Carthage queen, Dido. The message was ignored.

Every cultural manifestation of the Restoration era had a politico-religious context. Control by the Crown was total as censorship returned and the repressive regime initiated by the Cavalier Parliament took effect. Theatre was to be a creature of royal whim. When it returned, after a gap of almost two decades, it came back as a State-controlled monopoly. On 21 August 1660 a patent was issued to Thomas Killigrew and Sir William D'Avenant to form two companies under the patronage of the king and the Duke of York. Both started off initially in the old Cockpit Theatre, moving shortly after to two converted tennis courts in Lincoln's Inn Fields. In 1663 the King's Men opened in Bridge Street, Covent Garden, in a theatre which was burnt down in 1672, reopening in the ancestor of the present Theatre Royal, Drury Lane. In 1671 the Duke of York's company moved to a lavishly equipped theatre at Dorset Garden, near Charing Cross. Each theatre had its own orbit. Dorset Garden was geared for elaborate scenic spectacle of the kind called for by the new semi-operas while Drury Lane was basically for plays.

The actual structure of these theatres was very different from the old public playhouses of Elizabethan and Jacobean London. Killigrew once boasted to Pepys that '. . . the stage is now by his pains a thousand times better and more glorious than ever heretofore', being lit by candles with 'no rudeness anywhere', with a large orchestra and 'all civil people' in the audience. The auditorium was now divided into pit, boxes and gallery. An orchestra pit was added for opera while above the proscenium arch there was a music gallery. Music was played before any performance and during the intervals as well as being introduced to accompany dances and ritual on stage. The acting stage itself was an area some twenty feet before the proscenium opening with entrances both sides for the actors. There the majority of the action took place, lit by candles in the same way as the auditorium, thus emphasising a close relationship between the two, far closer than that between the actors and what framed them behind, the great novelty of moveable scenery of a kind once the preserve of the court masques. This consisted of sliding shutters and side wings which changed in front of the audience and which did not always relate to what was going on on stage. Indeed the same side wings could remain in place for the duration of the action. The taste for visual spectacle however fed an increasing appetite. There was one other striking novelty: actresses.

Charles II was to dominate the drama for the opening decade. The two theatres were run by his personal friends and many of the best and most influential plays were written by people who had access to him. The king was also not averse to suggesting

plots for plays himself. This was a drama written for and about a closed circle, the victorious Cavaliers who returned to power in 1660. The citizens of London, looked upon as covert supporters of Parliament, generally did not go: some index as to how narrow the patronage of drama was can be gauged by the fact that when the era of political turmoil arrived in the 1670s the companies failed to attract enough people to fill the two theatres, and were forced to merge in 1682. The plays were written with an aristocratic and gentry audience in mind, which sat in the boxes and the pit. Censorship of what was put on stage was achieved through the office of the Lord Chamberlain and the Master of the Revels. Their views were permissive in the case of sex but repressive in that of politics.

Looking back, John Dennis wrote: '. . . in the reign of King Charles the Second, a considerable part of an Audience had such an Education as qualified them to judge of Comedy. That Reign was a Reign of Pleasure . . . Poetry and Eloquence were their Studies, and that human, gay, and sprightly Philosophy, which qualify'd them to relish the only reasonable pleasure which man can have in the World, and those are Conversation and Dramatick Poetry . . .' The truth of the matter was that the king had granted a monopoly to the two men who would give him what he wanted, a court theatre without having to pay for it. A large number of courtiers wrote plays including the Earl of Rochester and Sir Robert Howard. Playwrights like John Dryden and Sir George Etherege put on stage the kind of dazzling conversational brilliance that members of the onlooking court aspired to.

Restoration comedy was a drama for the entertainment of the king and his cronies. It was in no way conceived as an accurate reflection of contemporary life, putting on stage instead a highly selective version of it, with an emphasis on the licentious and the bawdy which the king, with his known sexual prowess and string of mistresses, liked. So the preoccupations of these plays are the ones of this small group with all their prejudices and social values. Brilliant comedies of manners they may be, embodying a new refinement in terms of language and ease of conversation, but their central concern remains one of rank and status in a world in which the old landed gentry were seen to be losing ground in the face of the commercial *nouveaux riches* and the new professional classes. Nor do the plays present to the audience any resolution to this constant clash of classes. The situation at the close of any play remains much as it started, a perfect mirror in its own way of the many fissures in late Stuart society. The cast is always gentry, servants being mere ciphers, and the settings are always

A scene from The Empress of Marocco *at the Duke of York's Theatre in Dorset Garden, 1673. Above the proscenium there is a gallery for musicians. The scenery, set behind the arch, remained a background against which the actors performed on a forestage a section of which is visible together with part only of two of the side entrance arches.*

elegant rooms or the pleasure grounds of the genteel. No one works, but instead ener-gies are expended on matters of love, wit and intrigue by means of plot, assignation, letter and deception. And virtually every human decency is sacrificed for an epigram.

John Dryden's *Marriage à la Mode* (1671) marks the advent of the fully fledged Restoration comedy with its arguments in favour of extra-marital sex. As a genre it contained such fine examples as Sir George Etherege's greatest play *The Man of Mode* (1676), which held up a mirror to the court as a group of self-obsessed people, and William Wycherley's *The Country Wife* (1675). Wycherley was a master dramatist whose plays work from an exposé of the hypocrisy of a society which encouraged people to a show of virtue but not to its practice. *The Country Wife* centres on a rake called Horner who announces his impotence with the hope that feminine responses will lead him to those who are seeking sex. This is an essay in an all-pervasive hypocrisy involving everyone, and emerging from a conflict of natural desires versus established social behaviour. And as in all Restoration comedy no one really changes. Instead the characters are choreographed around a series of set locations and encoun-ters bound together solely by the exercise of wit.

The actress 'Nell' Gwynn in a portrait living up to the view of her profession held by many.

That play represented a kind of zenith after which political unrest was to lead to a demand for farce, intrigue plays and the tragi-comedies of the female dramatist Aphra Behn, which dealt with broken or loveless marriages and the distress caused by arranged ones. Much of what she wrote belonged to the second stream of Restoration theatre, the heroic play, another taste which was initiated by the king who had seen such plays in exile. The greatest exponent was the French dramatist Corneille whose work was translated and performed in England to great applause. Such plays, modelled on the poetic epic and spoken in rhyming couplets, were regarded as the apex of classical literary form, dealing as they did with high-flown conflicts between the public role and private life of the prince. They debated moral issues and extolled heroic virtue. Set without exception in distant lands in remote times they represented a means of discussing contemporary events at a remove. The earliest was *The Indian Queen* (1664) by Sir Robert Howard and Dryden, after which the latter was to write a whole series culminating in *The Conquest of Granada* (1670). But the most famous and enduring of them all was Thomas Otway's *Venice Preserved* (1682) staged in the aftermath of the Popish Plot and directly topical to it. The play deals with a plot to overthrow the republic of Venice, arguing for the necessity for political conservatism and stability even at the price of licence and corruption in government.

This was an era when for the first time critical theory began to impinge through the writing of the French theorists of the drama. In that scheme of things the ideal truth of poetry was seen as superior to the particularised truth of history. The consequence of this was to be a reworking of much inherited drama. Thomas Rymer's *The Tragedies of the Last Age Consider'd and Examin'd by the Practice of the Ancients, and by the Common Sense of All Ages* (1677) did precisely that. It worked from the premise of rules, of the application of universal criteria on the basis that all men in all places think alike. Within the drama, therefore, there must be no departure from the ideal world order. Each character, the classical principle of classic decorum demanded, should be a type representative of a certain social rank, occupation and age and certainly not an idiosyncratic human being. Such a view of the nature of drama was profoundly to affect the theatre for a century. It led to the tidying-up of the plays of Shakespeare where it was seen that the canons of classical taste were offended. Thus Dryden in his adaptation of *Troilus and Cressida* (1679) removed 'that heap of rubbish under which many excellent thoughts lay wholly buried. Accordingly, I new-modelled the plot, threw out many unnecessary persons, improved those characters which were begun and left unfinished . . .' By 1681 Nahum Tate could even recast *King Lear* to accord with the demands of poetic justice.

Public taste drifted more and more in the direction of visual spectacle. For Charles

ll the quest was always to establish an Italian or French opera company such as existed at other European courts. His attempts came to nothing leading only to English composers attempting to write an equivalent. One such was John Blow's *Venus and Adonis* which was probably performed at court in 1683 with the king's current mistress, Moll Davis, in the title role. Everything in this, as in Italian opera with its use of continuo, was sung. The English tradition, however, which stemmed down from the court masque, was very different having a preference for a mixture of speech, music and song accompanied by scenic splendour. Dorset Garden was equipped for just such spectacles and Thomas Betterton, the actor and manager of the company, visited France where he saw the *comédie-ballet Psyche* which involved actors, singers and dancing. On return he commissioned an English version with music by Matthew Locke, libretto by Thomas Shadwell, choreography by Joseph Priest and scenery and costumes by John Webb. While they were preparing this he put on a version of Shakespeare's *The Tempest* (1674), on to which he had grafted two self-contained masques as well as songs, dances and orchestral numbers. It was a resounding success reflecting accurately the native enthusiasm for this insular hybrid, the semi-opera. *Psyche* was at last staged in 1675 in answer to the visit of a French opera company. Nothing, however, seemed to dislodge the king's desire for a foreign company and Betterton was sent to France to engage one. He failed, bringing back only a French composer, Louis Grabar, who wrote the opera *Albion and Albanius* to a libretto by Dryden. Designed in true baroque spirit as an apotheosis of Charles II, the king died before it was staged. Adapted for his successor, James II, it had its opening performance in May 1685 coinciding with the Duke of Monmouth's rebellion in the south-west. The opera was inevitably a disaster and nothing more in the way of opera was to reach the stage for another five years. Combining poetry and melody with painting, architecture and the dance, opera was the perfect baroque idiom for princely triumphs, fully explaining Charles II's perennial obsession with it.

Wherever one looks this was a culture concerned with the projection and exercise of power, not in the closed hermetic manner of the king's father's court but in a way that was overt and deliberately aimed at controlling the populace. That was writ large in the political work of one of the king's advisers, Thomas Hobbes, in his *Leviathan* (1651): 'In the first place, I put for a general inclination of all mankind a perpetual and restless desire of power after power, that ceaseth only in death.' Power is the driving force behind the arts of Restoration England even in the case of its poetry which takes the form of celebrations in the way of odes, eclogues and panegyrics to the king and the great, destruction of power by means of satire, and finally power of another kind, that exerted by love in human relations. All the writers of the age,

Abraham Cowley, Andrew Marvell, John Dryden, Samuel Butler and the Earl of Rochester, were infected by this quest.

Power of destruction animates Butler's *Hudibras* (1663), a mock-heroic poem used as a vehicle for an attack on the self-righteous, windy and rambling Puritans. The power of satire could equally take the form of self-destruction in the work of someone like Rochester, a wicked master of witty invective. All the cynicism of that prodigal decadent is caught in a few lines of his 'To a Postboy':

The poet-courtier John Wilmot, 2nd Earl of Rochester, crowning a monkey in a composition expressing the popular view that 'Art is the ape of nature'.

> Son of a whore, God damn thee, canst thou tell
> A peerless peer the readiest way to Hell
> . . . Ne'er stir.
> The readiest way, my lord, 's by Rochester.

The rising status of women provoked bitter satiric misogyny:

> If any vain, lewd, loose-writ thing you see
> You may be sure the author is a she.

Thus Robert Gould. But the greatest poet of the age was Dryden who covered the full range of poetic expression, pouring out poems, translations, odes, epistles, satires, prologues and epilogues to plays. Perhaps his finest poem is *Absalom and Achitophel* (1681) evoked by the Exclusion Crisis which had been led by the Earl of Shaftesbury. The poem tells in allegorical guise the attempts of Achitophel (Shaftesbury) to persuade Absalom (the king's illegitimate son, the Duke of Monmouth) to rebel against David (Charles II). It begins and ends with the king undergoing a second rebirth:

> . . . The Almighty, nodding, gave consent,
> And peals of thunder shook the firmament.
> Henceforth a series of new time began:
> The mighty years in long procession ran;
> Once more Godlike David was restored
> And willing nations knew their lawful Lord.

Dryden's poetry belongs firmly to the great tradition of Jonson believing in its public role in the State, its duty to express concern for settled and peaceful government, calling for conservatism as conducive to political stability and warning of the perils of extremes.

With an attitude such as this in mind Dryden was led to write *Threnodia Augustalis* (1685), celebrating the heroic qualities not only in Charles II but those of the brother who was to succeed him in the year in which he wrote it. Within three years, the illusion that baroque art had been harnessed to create around the restored Stuart monarchy was to lie in tatters. James II had no interest in the arts beyond their application to the cause of the triumph of Catholicism. The Catholic chapel which he erected in Whitehall Palace was in the full-blown baroque style with illusionistic painting by Verrio of the Assumption of the Virgin and a huge marble altarpiece designed by Wren with the Salutation of the Virgin flanked by statues of saints. John Evelyn wrote amazed at the 'world of mysterious ceremony' he saw, and that he

'could not have believ'd I should ever have lived to see such things in the K. of England's palace.' In that chapel baroque art met baroque Catholic religious liturgical spectacle of a kind profoundly alien to the Protestant English. James's commitment to that cause, aided by his political ineptitude, brought any attempt to make a bid for absolute power tumbling down. As in 1660 the governing élite of the country united in opposition and reasserted its control. In 1660 that had been exercised to bring back a king. Now it was exerted to remove one. In the revolution of 1688 James II fled and the crown was offered jointly to his daughter, Mary, and her husband, the Stadholder of the Low Countries, William of Orange. It was described at the time as 'the unexpected revolution.' Indeed it was to be unexpected in more ways than one, for its impact on the cultural direction of the country was to be as profound as that on its political and religious one. The curtain was finally to descend on the Stuart dynasty's alliance of art and monarchical power and to arise again on the long reign of the aristocracy.

Chapter Twenty-Three

THE CROWN ECLIPSED

Chatsworth is set commandingly at the eastern foot of a great basin of hills on the left bank of the river Derwent. It looks out over extensive gardens towards parkland and to the savage moorlands beyond, dominating the Derbyshire landscape. A palace rather than a country house, its equivalent on the mainland of Europe would be one of the residences of the ruler of a German principality. In a sense not only the whole political direction of the country but also its cultural one, after the Revolution of 1688, is summed up in this one building.

William Cavendish, 4th Earl of Devonshire, to be created a duke in 1694, was an ardent Protestant and an opponent of Stuart autocracy. During the reign of James II he had withdrawn to his estates and was one of the key members of the aristocracy to issue the invitation to William III to invade the country. Gifted and handsome, if also from time to time capricious, he was a man of exceptional taste. The transformation of the old Elizabethan house at Chatsworth under his aegis was to be a monument to that, but it was also to be one to a far more significant shift, as power, both cultural and political, moved sharply away from the monarchy. This is the aristocrat as prince and it comes as no surprise that the style of the new house looked back via Wren's Winchester Palace to Mansart's Versailles and Bernini's additions to the Louvre. The architect of Chatsworth's revolutionary south front was one of the new generation of English architects fully conversant with the baroque, William Talman. He swept away the customary hipped roof and attics in favour of a monumental two-storey block standing on a rusticated basement and topped by balustrading. This was patrician magnificence on the grand scale, a style which was to sweep on through the interior in a series of sumptuous state rooms in the full-blown baroque manner whose source was regal, the rooms carried out by Hugh May and Antonio Verrio for Charles II at Windsor.

The landscape outside, under the auspices of the two leading garden designers of the era, Henry Wise and George London, began to be laid out in a series of immense geometrical box parterres in swirling baroque patterns. The gardens, along with the state rooms, were

The State Drawing Room at Chatsworth, Derbyshire, in which the splendours of royal palace decoration of the Restoration period are utilised to glorify the post-Revolution aristocracy, in this instance William Cavendish, 4th Earl and 1st Duke of Devonshire.

to be a source of amazement to every visitor with their astonishing fountains culminating, in 1704, with a temple built on a distant summit as the source for a spectacular water staircase which descended to the main gardens. The temple was designed by the last great English architect to work in the baroque idiom, Thomas Archer.

The 1690s were to form the years of the great cultural divide even if it was not fully realised at the time. After 1688 the Crown was firmly under the rule of law and more and more the monarchy and the State became two separate entities, the State in the long term being the more significant in terms of cultural initiatives. That was increased by the new king's involvement of England in the war against France, an event which led to the rapid expansion of government and the civil service. In order to finance the war the Crown was forced to make more concessions to Parliament, although its powers of patronage were to remain considerable until the reign of Victoria. The war against France, which was to ebb and flow for over a century until the final defeat of Napoleon at the battle of Waterloo in 1815, also engendered an increasingly anti-French cultural bias and an emphasis on those things which set the island apart from Europe, rather than those which linked it.

That slippage by the Crown was not immediately apparent for the aristocracy subscribed to the monarchy as the apex of their hierarchy. On the surface there was indeed a sudden resurgence of royal activity, for William III, who suffered from asthma, could not abide the air pollution of London. As a consequence the court refocused first around a new palace, modest in scale, at Kensington and more particularly at Hampton Court, which Wren was entrusted to transform into an English Versailles with all speed. A block arose around the Fountain Court with its south front facing on to a new privy garden while the east front looked over a vast parterre with no less than thirteen fountains, which was designed by the French Huguenot, Daniel Marot, who was responsible also for much of the interior decoration. William and his queen, Mary II, both shared a passion for gardening which was to trigger the laying-out of vast formal schemes of this kind all over the country. Dutch influences percolated too, leading to the construction of canals and a fashion for huge displays of the blue and white china known as delftware. But in reality both palaces represented a retreat, for to be the hub of civilisation the monarchy needed to be in the metropolis. Much that was central to English culture had occurred within one building for a century and a half. That was Whitehall Palace and in 1698 it was burnt to the ground. Although elaborate schemes were drawn up for its rebuilding, that never happened. At one blow the Crown lost its cultural mecca and was reduced to the modest confines of St. James's Palace.

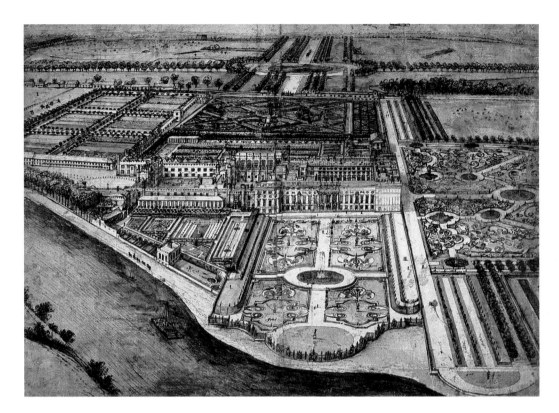

To compensate for the loss of Whitehall, building began again at Hampton Court but ceased abruptly on William's death in 1702 and was never resumed by his successor, his sister-in-law, the philistine Queen Anne. Mary II was the last Stuart to demonstrate any commit-

Sir Christopher Wren's rebuilding of Hampton Court recorded about 1702, the year of William III's death. This was the monarchy's last attempt to create a great ensemble in emulation of Versailles.

ment to the arts with a taste in architecture, interior decoration, gardening and the theatre. When she died in 1694 the withering of the arts in service to the Crown became a sharp reality.

The shift can be caught in that public acts in the arts were less and less gestures of munificence by the wearer of the crown than by Parliament, who voted the money on behalf of the nation. The transformation of the abortive Stuart royal palace of Greenwich into a hospital for sailors, although carried out under royal aegis, was in effect an act of government. Wren succeeded triumphantly in pulling together the various discrepant entities that he found on the site which included Inigo Jones's Queen's House and John Webb's block for Charles II. The result is the grandest baroque ensemble in England, but it cannot conceal the fact that what had started as an assertion of absolutism ended as one expressing constitutional kingship. On the

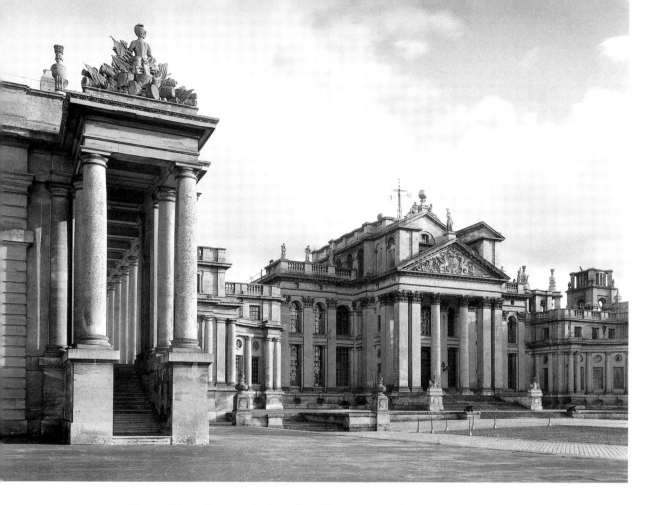

ceiling of the glorious Painted Hall the artist Sir James Thornhill depicted the Triumph of Peace and Liberty. In it William presides, vanquishing underfoot Arbitrary Power and proffering the cap of Liberty. At first glance this would seem a baroque regal apotheosis but the symbolic cap neatly keeps the wearer of the crown in his place.

The only palace to arise in the Stuart period was not for a monarch but for a subject. Sir John Vanbrugh's Blenheim Palace for the first Duke of Marlborough epitomises the eclipse of the Crown, and was the gift of a grateful nation after Marlborough's defeat of the French at the battle of Blenheim in 1704.

In exactly the same way, in 1705, when Queen Anne signified her intention of honouring the victorious soldier, John Churchill, Duke of Marlborough, with the gift of the royal manor of Woodstock, it was ratified by Parliament and Blenheim Palace was to arise out of Exchequer funds. The New Church Act five years later, although personally dear to the queen's heart, was again patronage not by her but by the State expressed through Parliament. As a result fifty churches were to arise in London and its suburbs, each handsomely sited and built. These were to serve its ever expanding population as well as providing visual beacons of Anglicanism.

After 1688 the energy was to lie with the aristocracy which reached the summit of its authority, which was to last until the wider extension of the franchise at the close of the nineteenth century. The French wars were in fact to make the members of that aristocracy far richer, for they benefited from the other revolution of the era, the Commercial Revolution, in which the country's business potential was unleashed, overtaking on the seas the supremacy of the Dutch, and allowing London to emerge as the nation's financial heartland. The great aristocrats gained not only from this but from the perks of office-holding and rents from urban property. It was the old Tory squires who began to go under, crippled and often ruined by the punitive Land Tax which paid for the war. As a consequence their estates came on to the market and were purchased by the grandees whose domains became ever larger, a fact reflected in the creation of no less than nine dukedoms between 1688 and 1714.

Chatsworth set off an aristocratic building boom. What is so ironic is that the style of these buildings erected for a nobility which had displaced a monarch was precisely that promoted by the Stuarts after 1660 as an expression of their bid for absolute power. Indeed the aristocracy was to employ most of the people who had worked on the royal palaces, including the illusionistic painters Antonio Verrio and Louis Laguerre, and the woodcarver Grinling Gibbons. The architects they employed were even more responsive to the baroque style, as for the most part they had been trained in the Royal Works under Wren. The presiding architectural genius was Nicholas Hawksmoor who from 1699 had an official partnership with the soldier, playwright and self-taught architect, Sir John Vanbrugh. If Vanbrugh provided the at times wayward imagination which is the essence of these extraordinary buildings, their reality in terms of draughtsmanship, practicality and administration fell to Hawksmoor.

A steady series of lavish and large country houses began to arise whose main purpose was show, externally to impress, internally to overwhelm. Comfort or convenience are words utterly foreign to these amazing piles which were conceived as monuments upon the landscape. The two greatest were Blenheim Palace and Castle Howard. Blenheim was the nation's tribute to its greatest military hero. It was begun in 1705 and Marlborough's widow was to continue work on it until her death in 1744, almost thirty years on from when Vanbrugh, reeling from the utterly 'intolerable treatment' meted out to him by her, had resigned. Sprawling over some three acres it remains a masterly essay in the handling of complex baroque rhythms. Castle Howard was built for the Whig grandee, Charles Howard, 3rd Earl of Carlisle. Some idea of its pretensions can be measured by the

The Heaven Room at Burghley House, Northamptonshire, one of the state rooms decorated by Antonio Verrio for the Earl of Exeter during the 1690s. Here the baroque idiom dissolves the architecture opening up vistas to earth, sea and heaven and allowing the gods to invade the room itself.

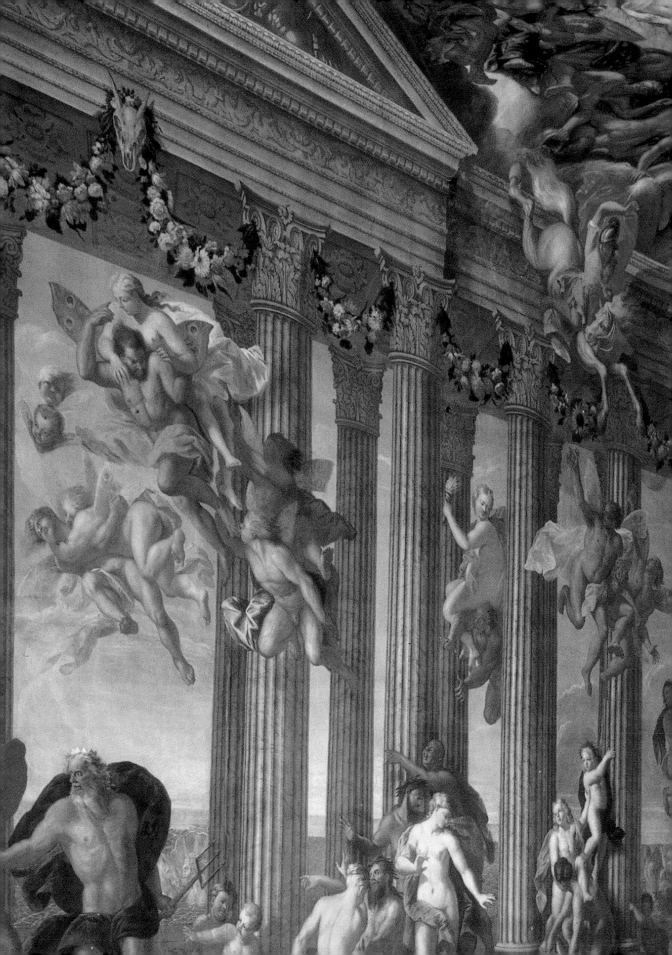

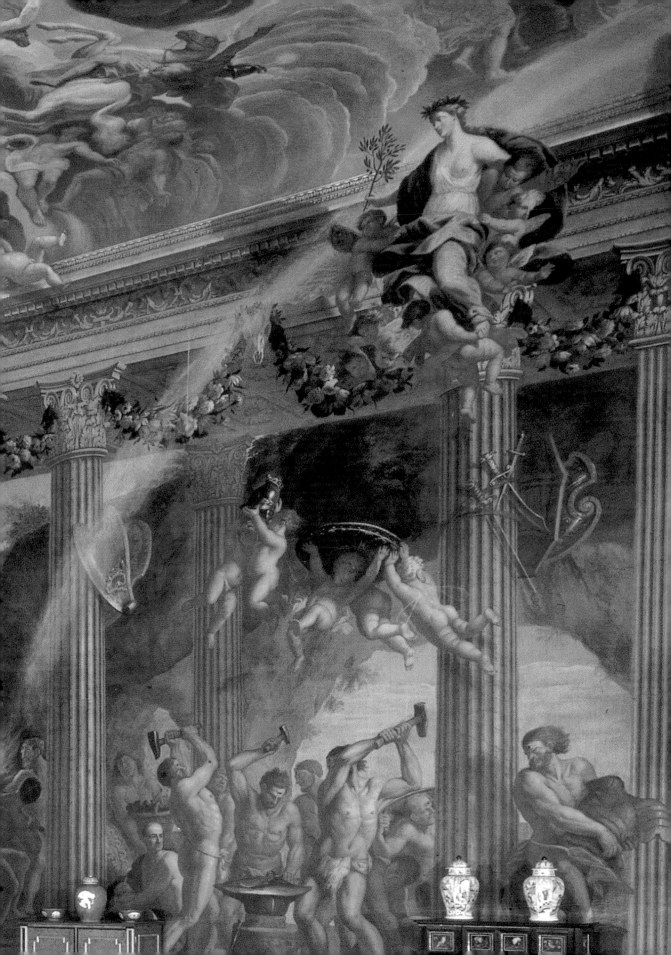

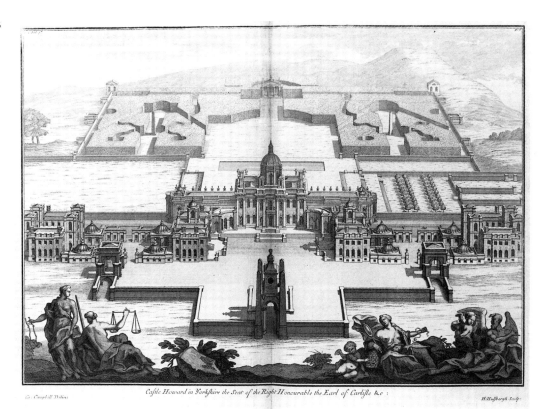

Castle Howard in Yorkshire the Seat of the Right Honourable the Earl of Carlisle &c :

intended length of its frontage, over six hundred feet. At its centre rose a dome as though it was a secular riposte to St. Paul's and indeed the hall beneath resembles that of a great cathedral crossing. Both houses within are of a breathtaking grandeur, calling for a living style which could only be magnificent and ceremonious. And yet

Vanbrugh's baroque palace for a Whig grandee; Castle Howard, Yorkshire, built for Charles Howard, 3rd Earl of Carlisle. Work began in 1699. The engraving shows the original ambitious design giving a frontage 667 feet long, but the extremities were never built.

both these buildings and others in this series of great houses like Seaton Delaval, Northumberland, or Grimsthorpe Castle, Lincolnshire, in spite of all their seeming modernity betray equally an obsession with the past to which Vanbrugh was especially susceptible. 'There is perhaps no one thing,' he wrote, 'which the most polite part of mankind have more universally agreed in; than in the value they have ever set upon the remains of distant times . . . some for their magnificence, or curious workmanship; and others; as they move more lively and pleasing reflections . . .' No wonder that as he grew older he was drawn more and more towards the Middle Ages building castles with Gothic and Tudor elements meshed into their baroque classical vocabulary.

The building boom was matched by a similar one in gardens as across England stupendous gardens were laid out in the formal baroque manner by the team of

George London and Henry Wise. Blenheim was to be one of the greatest, the site covering over two thousand acres, the garden proper, laid out on the plan of a fortress in tribute to Marlborough, stretching to seventy-seven acres and including a large parterre, formal walks and enclosures with fountains. At Longleat in Wiltshire Lord Weymouth was to spend £30,000 on his gardens by 1700. Two thousand five hundred flower pots alone lined the terrace on the east front and there were parterres, canals, fountains, orchards, avenues and a summerhouse for lemon trees. This was gardening on a gargantuan scale, calling for armies of workmen. Nature was to be subjugated to man and even the landscape beyond was to be laid low as radiating avenues of trees stretched outwards towards the horizon from the mansion house. The reaction against this complex ostentation when it came was to be a dramatic one.

What both houses and gardens reflected was a change in attitude to the countryside itself. If the Civil War had cast it into the role of a place to retire to in time of political turbulence, after 1688 it was increasingly to be viewed as somewhere actually to live. Such houses were, of course, demonstrations of power but this desire to live in the country signalled a new attitude to Nature, which was no longer studied in search of mysterious cabalistic signs or as a means of mystic communion with God but as an aspect of the glorious machine of the universe of His making. At the same time poetry also began to join the chorus hymning Nature as evidence of God's bounty and intelligence in ordering such plenitude for the benefit of man. As the principles of the mechanistic universe took root within the educated mind, the themes of power, hedonism and pleasure which had been such a feature of Restoration verse gave way to ones which sought to locate man within God's dispensation. These celebrated an innate fellow-feeling common to all humanity, were an index of a new morality, and also dwelt on patriotic glories reflecting a new feeling of nationhood in response to the war.

The new morality, which included a reformation of manners, was to affect the theatre, putting an end to the comedy of wit, refined and polished but at the same time wholly unemotional. But that tradition, which began with the Restoration comedy, was to have a final efflorescence in the work of three playwrights whose plays can still hold the stage, Sir John Vanbrugh, William Congreve and George Farquhar. All of Congreve's plays were written before he was thirty, a series which culminated in *The Way of the World* (1700), a play which deals with values achieved through the exercise of discipline traced in Mirabell and Millamant's quest for a marriage based on mutual respect. Serious and at the same time dazzlingly witty, it was written for an audience whose mood had a moral stance of a kind absent thirty years earlier. In spite of that the play was not a success at the time. Vanbrugh equally produced a

series of brilliantly witty plays including *The Provok'd Wife* (1697) and *The Relapse: or Virtue in Danger* (1696), the story of a young rake, Lord Foppington, in pursuit of the first woman he encountered. Farquhar's *The Beaux' Stratagem* (1707) and *The Recruiting Officer* (1706) took this kind of comedy out of the city drawing-room and into the countryside. But it was a doomed genre.

The tide was against them. In 1698 a cleric, Jeremy Collier, produced his *Short View of the Immorality and Profaneness of the English Stage*, an indictment of Restoration comedy as well as that of his own time for its profane language, bawdy scenes and abuse of the clergy. Congreve, Vanbrugh and even Dryden were all moved to reply but they were on the losing side, for the 1690s witnessed a widespread movement for moral reform with societies formed to tackle drunkenness, vice and Sabbath-breaking. The theatre by then no longer had either the support or active participation of the Crown. Dryden, in his epilogue to *The Pilgrim* (1700), looks back to 1660 and encapsulates in verse the rise and fall of a whole era in the history of the theatre:

> . . . a banisht Court, with Lewdness fraught,
> The seeds of open Vice returning brought.
> Thus Lodg'd, (as Vice by great example thrives)
> It first debauch'd the Daughters and the Wives.
> London, a fruitful Soil, yet never bore
> So plentiful a Crop of Horns before.
> The *Poets*, who must live by Courts or starve,
> Were proud, so good a Government to serve;
> Admixing with Buffoons and Pimps profain,
> Tainted the Stage, for some small snip of Gain.

After 1688 moreover to attack the immorality of the stage was no longer equated with being a crypto-republican. The theatres, devoid of the overt support of the Crown, increasingly relied on the City and the rich business community for their audiences and their attitudes inevitably began to change the subject matter and nature of the drama. People previously held up for ridicule, like the old or honest citizens, now began to be portrayed with sympathy. Social problems were aired and the stage was increasingly seen to be a vehicle whereby to present to the public models for emulation in terms of good behaviour and humane feeling. The shift is caught in the work of a new dramatist Richard Steele, who wrote *The Christian Hero* (1701) casting

Hampton Court, Herefordshire, was transformed by the architect William Talman and the garden designer George London for the Whig, Thomas, Lord Coningsby, during the 1690s. Central to the concept of these compositions was the subjection to art of the countryside around, with a clear distinction drawn between the geometric ordered garden and the unkempt nature beyond its confines.

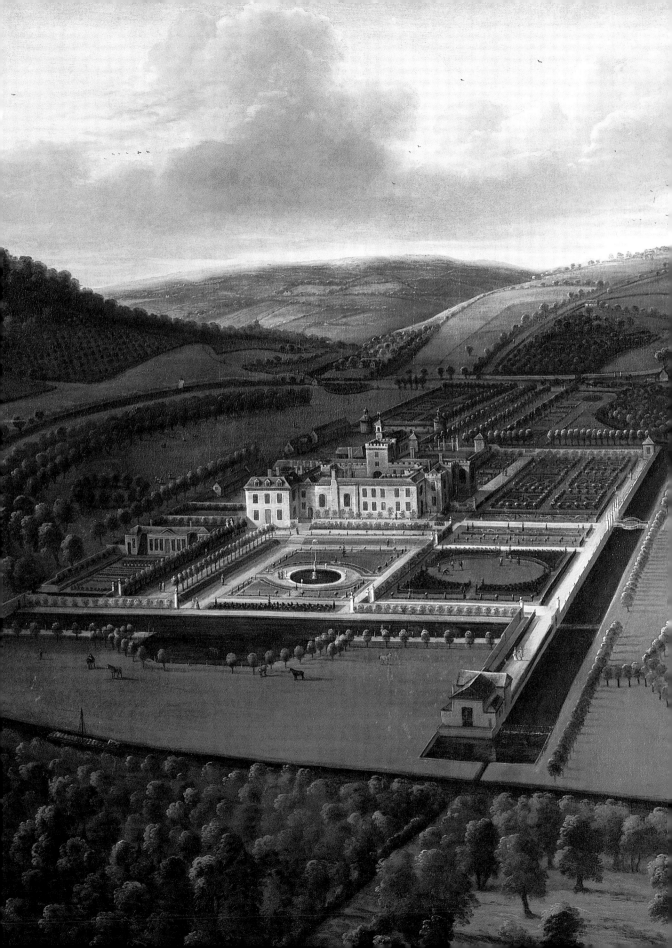

comedy still within the vein of wit but avoiding satire, seeing its role as the recommendation of the practice of the virtues. Steele's influence on the change in direction of the drama was to be huge as the opening decades of the new century unfolded. Sentimentalism also began to creep in, anticipating what was to be a major feature of the most important literary genre of the coming century, the novel. Sentimentalism was one indication of a fundamental change in the interpretation of human behaviour. That had always worked from the old view of man's essential depravity whereas the new drama's point of departure was an assumption of human benevolence. Such a shift led to an emphasis on scenes which expressed intensity of emotion, investigating the causes for such inner responses. Tragedy, which like Restoration comedy owed much of its existence to the tastes of the monarch, likewise, by 1700, went abruptly out of fashion as theatres responded to an audience which wanted instead comedy, pantomime and opera.

This contraction of regal involvement also radically affected music. Although William and Mary kept the court tradition of Private Music it was cut back. By 1690 its musicians had already come to view employment at court as only sporadic for ceremonial occasions. The queen had a taste for music but when she died in 1694 there was only her philistine husband left. Government was totally uninterested in the fate of music at court and within the Chapel Royal. The results in the case of church music were to be catastrophic. In 1689 instruments were banished from the Chapel and in 1691 William III went even further and instigated 'solemn music like a collegiate church'. In effect it was the death knell of the Chapel Royal being the musical powerhouse of the nation. Immediately it meant the end of the symphony anthems, but in the longer term it established a division of ecclesiastical from secular music which was deeply deleterious to the former. Cathedrals stuck to the stolid virtues of organ and choir singing sober and undramatic anthems, avoiding at all costs anything which would bring a charge of theatricality. The symphony anthem had one final fling of glory in Purcell's *Te Deum* and *Jubilate* for the opening of St. Paul's Cathedral. Of this Thomas Tudway was to write: 'There is in this Te Deum, such a glorious representation, of the Heavenly Choirs, of Cherubins, & Seraphims, falling down before the Throne & singing Holy, Holy, Holy &c. As hath not been Equall'd by any Foreigner or Other . . .'

To hear music it was now no longer necessary to go to court but to the concerts and operas staged in the City. The collapse of royal patronage meant that Purcell was forced to look to the stage for employment, developing that particularly English hybrid, the semi-opera. This began in 1690 with *The Prophetess; or, The History of Diocletian*, a landmark in being the first work for the theatre by an Englishman to be

Grinling Gibbons was the virtuoso master carver of the age, his supreme skill caught in this trophy of musical instruments in the Carved Room at Petworth House, Sussex, part of the elaborate decoration from the 1690s for Charles Seymour, 6th Duke of Somerset.

published in the full score. Then followed another equally as spectacular, *King Arthur* (1691) with a libretto by Dryden in which William III was equated with the hero-king and the perfidious Oswald with the deposed James II. The work was to remain in the repertory until 1840. Next came *The Fairy Queen* (1692) mounted at vast cost and based on *A Midsummer-Night's Dream*, the expense being so crippling that the company was forced to take a cut in wages. As a consequence its successor was a play with music, *The Indian Queen*, from the play written in 1664 by Dryden and his brother-in-law Sir Robert Howard and staged probably in 1695, the year of Purcell's death.

Although the royal odes continued, in effect the energy they once represented had migrated to the St. Cecilia's Day celebrations, in which the symphony anthems of Purcell reached their peak in *The Yorkshire Song* (1690) and *Hail, bright Cecilia* (1692). Nor did Purcell's outpouring of songs cease, all of which retained what was characteristic of English baroque art, the ability to sustain a delicate balance between symmetry and asymmetry, unity and diversity, simplicity of form with complex pat-

terning, elegance of expression along with passion of emotion. When Purcell died there was to be no native successor of such stature until the Victorian age.

By the turn of the century the ideas upon which English baroque civilisation depended were under attack. Baroque sensibility was at its best in its ability to create an acceptable heaven through the exercise of the human imagination, to make manifest to ordinary mortals the seemingly incomprehensible. The new mechanistic view of the universe was completely at variance with the system upon which this was based, an ancient hierarchical one of correspondences. The incoming philosophy no longer stressed hidden mysteries but the existence in Nature of order and rationality, the universe being viewed as governed by the rules of a rational God. As the role of art was to imitate Nature therefore its role in this new scheme of things was to stress the order and symmetry of God's creation. Art was no longer a vehicle whereby man expressed his emotional needs and in this way was able to unite himself with the eternal, immutable truths. Instead its role was to be far more mundane, being to enable him to lead a rational life.

The new rational Christianity of the Cambridge Platonists, a group of philosophic-religious thinkers, had no time either for any form of religious devotion which was based on the senses, or on sensual impressions activating the imagination. Such inner revelations could be revealed, in their view, in the symmetry and proportion of man, the universe and Nature, and the means of discovering that was no longer by exercising the imagination but through Reason.

The baroque's central pivot had been the resolution it offered to conflict and tension. When that was achieved in the cult of Reason, it removed at one blow the *raison d'être* for baroque. This is caught vividly in the writings of Anthony Ashley Cooper, 3rd Earl of Shaftesbury. His main work, *Characteristics of Men, Manners, Opinions, Times* (1711), was to set the agenda for the opening decades of the eighteenth century. As one of the few major commentators on the aesthetics of the age he viewed art as a product of economical, social, climatic and political forces. Each nation, he believed, had its own distinctive culture, or 'Genius' or 'Spirit' as he called it. Shaftesbury had a passionate belief in the 'English Spirit of Liberty', viewing the country in its post-revolutionary phase as the reincarnation of the virtues of republican Rome. As a consequence he abhorred the baroque as a style which glorified naked power and hence led to tyranny. Any society whose moving spirit was a search for liberty and truth was one in which good government, true religion and good morals and taste would be found. He wrote: 'Nothing is so improving, nothing so natural, so congenial to the Liberal Arts, as that reigning Liberty and high spirit of a People, which from the Habit of judging in the highest Matters for themselves, makes

them freely judge other Subjects, and enter thoroughly into the Characters as well as *Men* and *Manners,* as of the *Products* or *Works* of Man, in Art and Science.'

The baroque was cast into being an emblem of Stuart autocracy and the arts were seen henceforth to flower when walking hand-in-hand not with the ruler but with Liberty. To achieve this renaissance there was an urgent need for new patrons to rescue and revive native English culture: 'Well it would be indeed, and much to the Honour of our *Nobles* and *Princes* would they freely help in this Affair and by judicious Application of their bounty, facilitate this happy Birth.' And this is precisely what they were to do.

All kinds of currents converged in the second decade of the new century to render baroque culture obsolete. Baroque by then was considered Tory and, by inference, Jacobite, with hidden loyalties to the exiled Stuart dynasty. Then its prodigality and ostentation bred a sharply contrary reaction in favour of restraint and economy. Two events in the year 1715 embody what is the crossing of a divide into a new era, the Palladian. The first was the publication of the Scottish architect Colen Campbell's *Vitruvius Britannicus.* This collection of engravings of British architecture presented a mixture of styles but stressed above all the importance not of the continent but of an insular tradition which stretched back via Inigo Jones to Andrea Palladio. The great Italian baroque masters like Bernini, Fontana and Borromini were lambasted as being 'affected and licentious'. The very title of the book announces that it was published in the aftermath of the union with Scotland in 1707 and was evidence of a quest for a new national style. That style, the Palladian, was to become a test of Whig political orthodoxy and, in 1715, one year into the reign of the new Hanoverian dynasty, the Whigs came to political dominance. With the arrival of George I we enter the long decades of Whig rule, years which effectively ensured the victory of the Palladian movement. That was embodied in the curt dismissal in 1717 of the elderly Sir Christopher Wren as Surveyor of the Royal Works to be replaced by Colen Campbell. In the same way that William III's actions precipitated the end of the great court musical tradition, so the arrival of Campbell neutered the Royal Works and rendered it mediocre. The baroque lingered on into the fourth decade in the work of Thomas Archer, but even he was forced to make compromises. A great age had reached its end. The coming one was to be very different, dominated not only by the rule of the goddess Reason but also by a totally new phenomenon, the consumer.

THE RULE OF TASTE: RICHARD BOYLE, 3RD EARL OF BURLINGTON

In 1731 the greatest poet of the age, Alexander Pope, published his tribute to its greatest patron, Richard Boyle, 3rd Earl of Burlington, in the form of one of his celebrated epistles:

> You show us, Rome was glorious, not profuse,
> And pompous buildings once were things of Use.
> Yet shall (my Lord) your just, your noble rules
> Fill half the land with Imitating Fools . . .
> . . . make falling Arts your care,
> Erect new wonders, and the old repair;
> Jones and Palladio to themselves restore,
> And be whate'er Vitruvius was before . . .

Pope depicts the earl as the restorer of an architectural tradition which looked back not only to classical antiquity but also to how that tradition was recreated in the late sixteenth century by the Italian architect, Andrea Palladio, and to that style as it was first introduced to England in the following century by Inigo Jones. Elsewhere in the poem Pope castigates baroque magnificence, holding up to ridicule such gaudy illusory splendour:

> On painted ceiling you devoutly stare,
> Where sprawl the Saints of Verrio or Laguerre,
> On gilded clouds in fair expansion lie,
> And bring all Paradise before your eye.

These verses encapsulate what was billed by Pope as an aesthetic revolution achieved by Lord Burlington going backwards in time to the court of Charles I, the king regarded by those loyal to the Stuart dynasty as a saint.

Jonathan Richardson's portrait of Richard Boyle, 3rd Earl of Burlington, with, behind him, his earliest work, a classical pavilion in the grounds of Chiswick House known as the Bagnio.

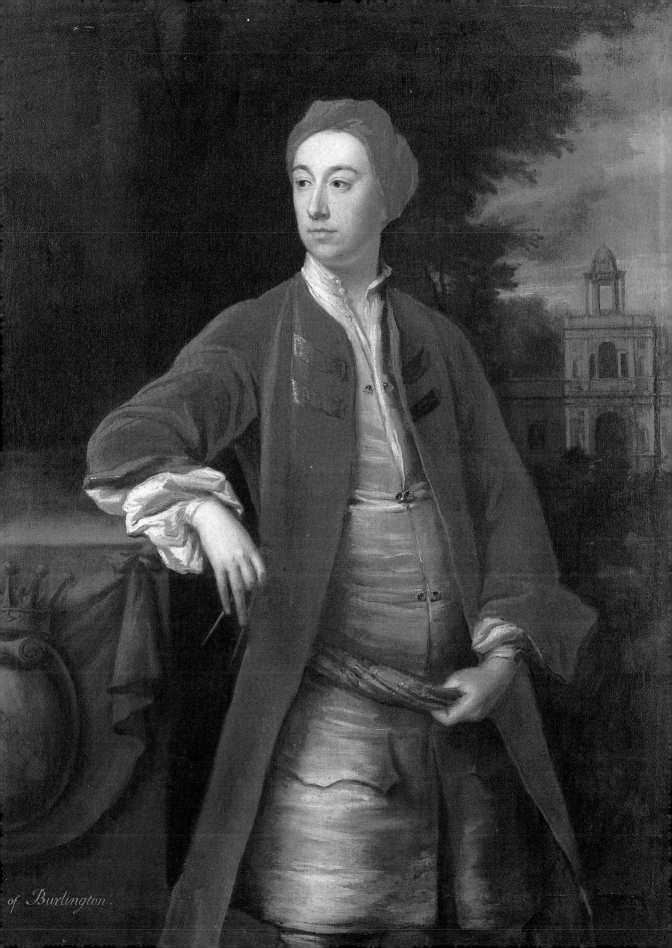

of Burlington

This Burlington did in order to promote a style which has since become synonymous with the triumph of the Whig party and the succession of the House of Hanover in 1714. From the outset, therefore, we are confronted with what seems like an ideological contradiction. And this is not the only one which bedevils any attempt to penetrate the mind of this extraordinary man.

No one at the time or since has challenged the earl's incalculable influence on eighteenth century culture. Indeed Pope's tribute is less flattery than a rehearsal of fact. George Vertue, who was to chronicle the arts of the early Georgian age, refers to Burlington as 'The noble Maecenas of the Arts' and, later in the century, that other notable trendsetter, Horace Walpole, was likewise to eulogise him: 'Never was protection and great wealth more generously and more judiciously diffused than by this great person, who had every quality of a genius and artist, except envy.' It would seem that in this single figure we have the fulfilment of the 3rd Earl of Shaftesbury's call for 'Princes and Great Men' to lead people in the arts and sciences towards a new national culture. And as Burlington's tutor Lord Somers was familiar with Shaftesbury he could almost be said to have been reared with this role in view.

Nonetheless Burlington emerges as one of the most enigmatic and mysterious figures in the history of British civilisation. This was a man with a keen and perceptive mind and eyes, endowed also with remarkable taste and a relentless sense of direction. And yet he was cold, austere, ascetic, in short a loner who reveals little about himself. His letters are few, almost one senses deliberately, for he might give something away in putting pen to paper. And yet he was to be the pivotal figure in a revolution in the arts, which was to leave a mighty legacy affecting not only this country but Europe and the United States.

Burlington came from an old royalist family, succeeding his father at the age of ten in 1704 as third earl. His inheritance was a substantial one with estates in Ireland, Yorkshire (centred on the family seat at Londesborough), a magnificent town house in Piccadilly and a country villa at Chiswick along the Thames. The London estate was a particularly valuable one in an age when the city was rapidly expanding and much could be exploited by aristocratic developers. His mother was musical and music was to be his own earliest overriding passion; his first appearance in terms of the arts is as the dedicatee of the libretto for Handel's opera *Teseo* first performed on 10 January 1713 at the Queen's Theatre. Burlington was then nineteen. A year later he was to leave the family house in Piccadilly with two coaches and an immense retinue of outriders and liveried servants bound for the continent, seemingly on that quintessential element of any great aristocrat's education, the Grand Tour.

The earl travelled in the company of two painters, Charles Jervas and a French-

man, Louis Goupy. The tour was far from the normal length, indeed it was almost cursory. Two months were spent visiting towns in Belgium and the Netherlands before the party headed south down through Germany and Switzerland reaching Rome on 31 September, having crossed the Alps via Chambéry and Modane. Burlington was then it appears unwell until Christmas, although he was already indulging in the purchase of pictures for his collection. On 5 February he left Rome travelling north to Venice and home via Paris, arriving in England on 2 May. Far from architecture being the prime purpose of the trip he arrived back with the cellist and composer, Filippo Amedei, and the violinist, Pietro Castrucci. Music still clearly dominated his thoughts, although while in Rome he met the person who was to be a major figure in his life, William Kent.

On his return nothing on the surface dispelled the illusion that here was a member of the prevailing Whig ascendancy, indeed he was referred to as such by his contemporaries. The new king expressed confidence by making him a Privy Councillor and Lord Treasurer of Ireland the year after his accession. Four years later Burlington made a second journey to Italy, this time in the company of Kent who wrote that his lordship was 'going towards Vicenza and Venice to get Architects to draw all the fine buildings of Palladio . . .', the purpose being to introduce into England a 'better gusto [i.e. taste] than the damn'd gusto that's been for this sixty years past.' So the aim of this expedition was clearly stated, to study the works of Palladio in order to inaugurate an architectural revolution in England. But, one should add, music was again to the fore. In 1719 a company had been established to introduce Italian opera to England and Burlington was one of the three major aristocratic sponsors who put up £1,000. And it was to be on this second Italian journey that the earl was to negotiate for the services of the famous composer, Giovanni Bononcini, who arrived in London the following year.

Shortly after his return Burlington married Lady Dorothy Savile, daughter of the 2nd Marquess of Halifax, by whom he was to have three daughters, one alone surviving as sole heiress. Lady Burlington shared her husband's taste for music and theatre and also for the visual arts. Kent gave her drawing lessons. On the accession of George II the couple continued to enjoy royal favour and Burlington was made a Knight of the Garter in 1730 and Captain of the Gentlemen Pensioners the year after. His wife became a lady-in-waiting to the queen. Then, in 1733, their relationship with the court collapsed. That seems to have related to the king's failure to appoint Burlington to the next vacant high office, but could also have been influenced by the fact that he joined a number of other aristocrats in opposing the Excise Bill, a customs tax on wine and tobacco. After this fissure little is heard of them, although the earl began to

run into serious debt problems. He died on 3 December 1753 and was buried in the family vault at Londesborough on his Yorkshire estate.

Ostensibly Burlington was a Whig, albeit an independent one, a man seemingly at the heart of the new political establishment ushered in by George I and his chief minister, Sir Robert Walpole. But recent research has questioned that assumption, so much so that it has produced to replace it a man whose lifetime was in fact spent covertly working for a second Stuart Restoration. What this startling reinterpretation does emphasise is that the upper echelons of society remained as sharply divided after 1714 as they had been before. The Jacobite rebellions of 1715 and 1745, let alone other plots in the intervening years, were far more dangerous to the political status quo than it would seem. The Stuarts had returned in 1660 and many people continued to believe that there was no reason why this should not happen again. Burlington it seems was one of these, a clandestine Jacobite whose true loyalty was to James III across the water, but someone who at the same time always took good care to distance himself from anyone too transparently linked to the cause. The secret Jacobite cipher for Burlington was 'Mr. Buck' and his journeys abroad can also be explained as making more sense in connection with Stuart intrigues than as campaigns for the arts. The composition of the Burlington circle was riddled with Jacobite sympathisers with, for instance, a sister married into one of the oldest of recusant Roman Catholic families, the Bedingfields. In the aftermath of the 1715 rebellion, when attacks were made on Catholics, it was Burlington who took into his house Alexander Pope and his family. The earl's first architectural commission for the dormitory of Westminster School also came from the official leader of the Jacobites in England, Francis Atterbury, Bishop of Rochester and Dean of Westminster. Then there were the earl's debts amounting by 1737 to £167,000, indicating perhaps that money was slipping across the Channel.

So we are confronted by a mystery man, a kind of double agent. To that we can add his role as a freemason, belonging to a line of descent of secret societies going back to the Rosicrucians at the beginning of the previous century. These societies were inextricably linked with the Stuart cause and in the post-Restoration period a new higher degree of membership emerged, the Royal Arch, to which it seems Burlington belonged. But in the mid-1720s Jacobite freemasonry went underground, adding to the mystery.

So what light do these revelations shed on one of the great revolutions in taste in the country's history, one for which Burlington was the self-appointed leader? The Palladian revival now emerges as being less the symbol of a political triumph than as an expression of a period of continuing religious and political debate. Those who

rejected or criticised the new regime, of whom there were many, expressed their scorn for its shortcomings by a cult of Ancient Virtue, that is by a celebration of the moral example set by the Romans in antiquity. The revival of ancient architecture for them carried with it a wider ethical critique of a revival also of ancient virtue. For Burlington that may have included the restoration of the Stuarts whose martyr king, Charles I, had been a great patron of Inigo Jones, whose work the earl set about deliberately reviving, restoring, imitating and publishing.

No one in 1714, when the Hanoverians succeeded, could have foreseen that the late sixteenth century architect, Andrea Palladio, and his English disciple, Inigo Jones, were to be the dominant influences on building through the century. That turning back to the Caroline court of the 1630s had already been underway earlier in Tory Oxford, as evidenced in the Peckwater Quadrangle of Christ Church dating from 1706. In fact the influence of Palladio and Jones can be traced through the work of the great baroque architects, but neither Burlington nor Kent would admit to it as it would have detracted from their 'revolution'. The need for change was also signalled by Pope's *Essay on Criticism* (1711) calling for a national reformation in taste and ideas and by Lord Shaftesbury's *Letter Concerning the Art and Science of Design* dedicated to Burlington's tutor, Lord Somers. So the way was already prepared for Burlington to assume the mantle in 1715 when Colen Campbell published *Vitruvius Britannicus*, as a manifesto launching a new style of 'the antique simplicity', and in the same year Nicholas Dubois published a translation into English of Palladio's *Four Books of Architecture*.

What set Burlington apart was both his position as an aristocrat and his unique understanding of both architects, for he realised that their work was deeply rooted in the architecture of classical antiquity. As a nobleman he could not be seen to soil his hands with any of the practicalities of the profession, although he belonged to a long and still flourishing line of gentlemen amateur practitioners. Not only did he comprehend the tradition that he was reviving, in a sense he almost owned it. In 1720 he purchased virtually the entire architectural drawings of Inigo Jones, those of his nephew and successor, John Webb (whose work was misattributed to Jones by then) and of Palladio himself. To these he added Palladio's drawings of Roman baths which were to have a seminal influence. In this way he assembled a paper museum which he was to use as a quarry in his role as an architect. But everything had to be achieved at a lordly remove in order to preserve caste, so he was to make use of various amanuenses to draw up his designs or to see through certain publications such as William Kent's *The Designs of Inigo Jones with some Additional Designs* (1727), which made available the architect's work. Nor did his cult of Jones stop there, for he

paid for the restoration of St. Paul's, Covent Garden, and rescued the architect's gateway for Beaufort House, re-erecting it in the grounds of Chiswick.

Burlington's campaign for a reformed architectural style was at its height in the decades between 1720 and 1750. Vertue bracketed him with Lord Pembroke as not only 'great and true judges of those sciences [geometry and architecture], but real practitioners of it in a fine degree and taste, equal and above the professions . . .'. The earl's earliest work was at his villa in Chiswick, the Bagnio, an elegant classical pavilion which closed a vista. But he went on to revive the architecture of Caroline England as typified by Wilton in Tottenham Park for his brother-in-law, Lord Bruce. He advised Thomas Coke on his vast house at Holkham, and in 1730-36 the extraordinary Assembly Rooms at York went up. As a result the style was to spread and we can see evidence of it everywhere in the use of Palladian Venetian windows, coffered vaults and semi-domes, of vaulted spaces and niches. Underlying it all was a strong feeling for Roman antique severity without concealing the gilded splendour within.

Under Burlington's aegis Palladianism was to become a national style, triumphing over the insular baroque of Wren and Hawksmoor. It was, it should be added, just as insular, but it was also unique, for it was a forerunner of the neo-classical style which was only to seize the rest of Europe much later in the century. Although Burlington was obsessed by Palladio and Jones he was even more obsessed by antiquity and any study of his buildings reveals this. That he was able single-handed to achieve this revolution, in which he established by the time he died what was in effect a national vernacular still admired today, was thanks to his ability to place his own nominees in the office of the Royal Works. It also owed much to his prestigious social position with influence over a wide circle of like-minded aristocrats and gentry, and to his own example in both Burlington House and his villa at Chiswick. But Burlington also profoundly realised that to achieve a Palladian revival called for moving beyond mere imitation and pastiche to originality of invention. In that lay his genius.

It was in his own houses that he set the pace. In 1717 he brought in Colen Campbell to remodel Burlington House, transforming it into a *palazzo* lifted

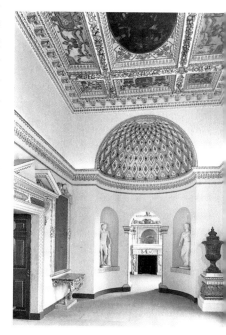

The Gallery at Chiswick House. William Kent's sumptuous interiors made use of contrasting room shapes and ceiling treatments, the latter here looking back to Inigo Jones's Whitehall Banqueting House. They were to be hugely influential.

from Palladio's Vicenza. Its most striking feature was the graceful Doric colonnade which linked its courtyard. But it was to be Chiswick which was to be the most admired, visited and emulated. Here he inherited an old Jacobean family house which he only transformed after a fire in 1725 led him to build a small villa close to it, ultimately to be linked back to the old house by a corridor.

Nothing quite like Chiswick had ever been seen before. Lord Hervey, the memoir writer, remarked that 'the house was too small to inhabit, and too large to hang on one's watch.' It is only seventy feet square with each front conceived in isolation from the other (an English trait). Its inspiration was one of Palladio's villas along the Brenta, the Villa Rotonda, but transmuted into something quite other by dint of raiding his paper museum. So it is a unique synthesis of both antique and modern precedents, the first house whose actual ground-plan is based on Roman antiquity. But its most daring feature was its deployment of interior space, a combination of room shapes, square, circular, octagonal, as well as an abundant use of niches and apses, columns and screening. This was to be the villa's most influential legacy. And for those who could read its emblematics this was a shrine to the exiled imperial Stuart dynasty. The visitor entered under an archway topped by a bust of the Emperor Augustus to be confronted by that archetypal icon of loyalty, a copy of Van Dyck's vast canvas depicting Charles I with his family.

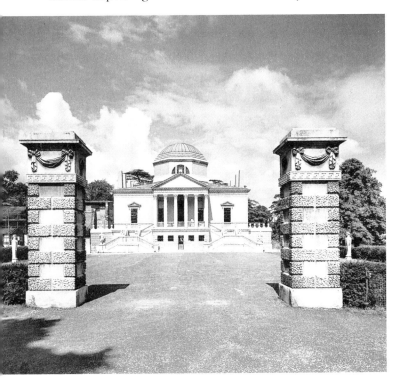

In Chiswick House Inigo Jones's translation of the villa style of Palladio along the Brenta to England is revived.

But a villa as it existed in classical antiquity was not only the building but even more the land around it. As early as the summer of 1716 the earl's friend, Alexander Pope, could write: 'His Gardens flourish, his Structures rise, his Pictures arrive.' For at Chiswick we are at the fount of another cultural revolution, this time a horticultural one. The new ideal was to create a domain modelled on that described by Pliny the Younger in his letters about his villas outside Rome and in Tuscany. In those there was an interplay between cultivated areas and ones which were left seemingly in a state of nature as meadow or woods. Even before Chiswick there had already been some breaking-down of the old formal style which stemmed from Versailles in the work of Charles Bridgeman, who introduced the ha-ha as a link between garden and landscape as well as deploying meandering serpentine walks. Alexander Pope's garden at nearby Twickenham, which Burlington certainly knew, developed this even further, the garden being conceived as a landscape painting, the terrain and its planting arranged in perspective, making calculated use of light and shade.

Pope was to be a major influence on the Chiswick garden. So too was William Kent. Work began in 1716 with three avenues converging on a single point, each one terminated by a different building. For over twenty years Burlington and Kent were to expand and develop this initial statement with additions drawn from what was known of Pliny's villas, like the exedra and a hippodrome and the placing of antique statuary. In this way Burlington presented a new aristocratic ideal, a garden which was a series of pictures made up of terrain, plants, water, architecture and sculpture arranged in emulation of Ancient Rome.

But what of William Kent, for the two are inextricably linked? Indeed the latter lived in Burlington House and it is difficult at times to disentangle where Burlington ended and Kent began. Like the earl Kent had his roots in Yorkshire. Just under a decade younger than his patron, Kent, a boy with talent from a poor background, was sponsored to go to Italy to be trained as a painter. In spite of that training he was never to be a particularly good one, but his apprenticeship in Rome brought him into contact with members of the English upper classes making the Grand Tour as well as giving him a grounding in Italian art and classical antiquities. The attraction between Kent and Burlington, one of opposites, seems to have been instant, for in contrast to the austere froideur of the earl Kent was an extrovert, ebullient character, easy-going, charming and in love with the good life. In the Burlington household he seems to have occupied the status at times of being almost a jester being affectionately referred to as the 'Signor.'

Burlington was to launch Kent on his career as a painter by influencing the king to commission him, instead of the august official painter Sir James Thornhill, to dec-

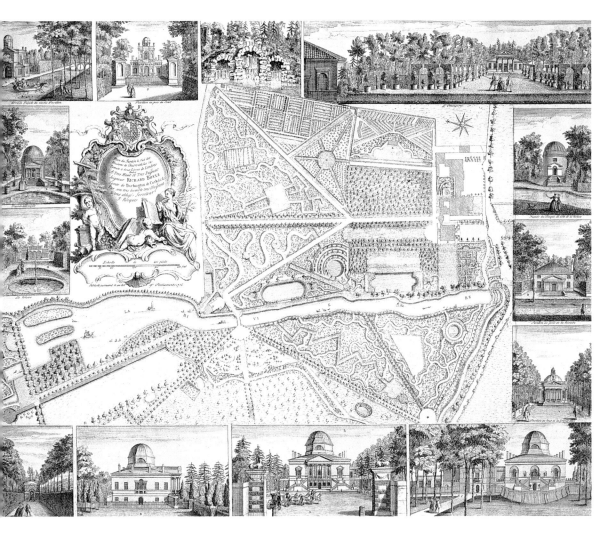

orate Kensington Palace. This commission was to establish that Kent's talent lay less in painting than in interior decoration, and Kensington Palace was to be the first of a series of interiors, including suites of rooms in major houses such as Holkham and Houghton, in which his taste for antiquity was to give birth to a totally original style of domestic interior. In this scheme of things walls either functioned as a backdrop for paintings or they were treated as receptacles for sculpture and therefore to be articulated in three dimensions with aedicules, semi-circular niches and scroll brackets. Walls in cool colours set off carving and plasterwork lavishly gilded, which

John Rocque's plan, along with inset vignettes of the house and garden at Chiswick, encapsulate every aspect of the architectural and garden revolution promoted by Burlington via his amanuensis, William Kent. The ground plan provides a stark contrast to the rigid geometry of the previous baroque garden style in a quest to re-create a villa garden of classical antiquity.

alternated with rooms hung thick with pictures in gilt frames set against rich fabrics in deep glowing colours. Above they were topped by gilded coffered ceilings or grotesque work looking down on his furniture which, although architectural in a classical idiom, owed much of its splendour to the fact that it drew on prototypes which were Italian baroque.

Kent was a man who was able to temper what could all too easily have become sterile Palladian orthodoxy with imagination. He revealed himself to be an interior decorator of genius and progressed from that to architecture. In 1726 he was appointed Master Carpenter and nine years later became Master Mason and Deputy Surveyor of the Royal Works. Through this Palladianism entered the official mainstream even if at times it seemed that Kent did nothing other than design buildings which remained on the drawing board, like his schemes for a new Houses of Parliament and for a new royal palace at Richmond. Those which actually arose,

A sketch, probably by Lady Burlington, of the talented William Kent, known to the family as the 'signor'.

like the old Treasury Buildings and Horseguards, were marked by a strong individuality which set his work firmly apart from that of his patron, Burlington. More even than his interior decoration and architecture Kent has been associated with the revolution in garden style. Pope's friend, Joseph Spence, was to write: 'Mr. Pope and Kent were the first that practised painting in gardening . . .'. As in the case of architecture change was, as we have seen, already in the air. That strong feeling for reviving antiquity in garden making was to be summed up in a book sponsored by Burlington, Robert Castell's *Villas of the Ancients* (1728) in which he actually attempted to reconstruct Pliny the Younger's villas. The dramatic shift underway in these decades is caught in Pope's epistle to Burlington in which he satirises the still prevailing symmetrical, stiff, French style, exhorting the earl:

> To build, to plant, whatever you intend,
> To rear the column, or the arch to bend,
> To swell the terrace, or to sink the grot;
> In all let Nature never be forgot . . .
> Consult the genius of the place in all;
> That tells the waters or to rise or fall.

In December 1734 Sir Thomas Robinson wrote a letter describing the new style as he had seen it in the garden of George II's son, Frederick Prince of Wales, at Carlton House, as it was laid out by Kent: 'There is a new taste in gardening just arisen . . . that a general alteration of some of the most considerable gardens in the Kingdom is begun, after Mr. Kent's notion of gardening, viz., to lay them out, and without level or line . . . this method of gardening is the most agreeable, as when finished it has the appearance of beautiful nature . . .'.

What Kent introduced was something quite new, transforming the land around country houses into a series of perspective landscape views. Kent's aim was to naturalise into England what people at the time believed the gardens of antiquity had been like, as well as those which had been re-created as such during the Renaissance in Italy. Antique statuary, monuments and temples were dotted through gardens composed as a sequence of pictures, each with a particular meaning which called for an informed response by the visitor.

In his gardens Kent's roles as a painter, book illustrator, interior decorator, architect and designer for the stage were all echoed. Their two key elements were surprise and variety, achieved by arranging contrasting scenes in succes-

A view or design by William Kent for the exedra at Chiswick with its display of antique statuary held in by a low clipped hedge amidst what is otherwise a loose naturalistic planting of trees.

A proposal by Kent for a cascade at Chatsworth, Derbyshire, transforming it into a vision evoking classical antiquity, drawing on what he had seen in Italy – *buildings like the temple of Vesta at Tivoli and cascades at the Villa Aldobrandini.*

sion. Each called for a different and skilful manipulation of light and shade designed to create visual recession and also to evoke psychological moods which could range from the elegiac to the poetic as well as, from time to time, being laced with sharp political or philosophical statements by the owner (as in the case of his work for Lord Cobham at his vast garden at Stowe, Buckinghamshire). Rousham, Oxfordshire, which Kent laid out for General Dormer in the late 1730s, remains his acknowledged masterpiece. Horace Walpole saw it as an English equivalent of an antique garden: 'The whole is elegant and antique as if the emperor Julian had selected the most pleasing solitude about Daphne to enjoy philosophical retirement.' In it Kent juxtaposed the natural and the artificial, the foreign and the English, ancient and modern, classical and Gothic. The eye was directed out of these pictures to eyecatchers beyond, like a triumphal arch set on a distant hill. To reach these the vision had to travel across agricultural landscape, peasants toiling in the fields below cast as actors in a tableau signalling that Arcadia was no longer in Greece but relocated just outside Oxford.

That naturalisation of the world of classical antiquity into England provides a vital pointer uniting all the arts in early Georgian England. Time and again the country was cast as the heir to the civilisations of both Greece and Rome in a stately migration across the mainland. But that by no means meant an abandonment of Britain's own heroic past. Indeed the two were to be inextricably interwoven. The owners who cast themselves as toga-clad exponents of revived ancient virtue also donned the mantle of the Middle Ages as descendants of the barons who had fought to guard ancient British liberties from encroachment by the Crown in times past. This explains why a man like Kent found nothing contradictory in deploying the Gothic as well as the classical styles. At Rousham, for example, he added Gothic details to the exterior of the house. In other gardens he designed Gothic buildings using a repertory of ogee arches, battlements and quatrefoils to evoke the baronial Middle Ages. The message is a clear one. For Georgian England the world of Virgil's *Eclogues* and that of Spenser's *Faerie Queene* are one and the same. As the century progressed this was to develop into a quest for a coherent identity expressed by means of a single national culture.

Chapter Twenty-Five

BABYLON

In *A Tour of the Whole Island of Britain* (1724-26) Daniel Defoe expresses his astonishment at the rapid expansion of what was to be the cultural mecca of the Augustan age, London: 'New squares, and new streets rising up every day to such a prodigy of buildings that nothing in the world does, or ever did equal it, except old Rome in Trajan's time.' The equation of the capital with the Rome of the emperors was not a new one, but it neatly pinpoints a mental association which, during an age in which the literate classes were nurtured on the Latin classics, moved naturally from the one to the other. By 1750 the population of London had reached some 675,000, 11% of the entire country, and that figure excluded those who were drawn to it from every region on account of sitting in Parliament, transacting business, or enjoying the delights of the capital's increasingly important social season.

No urban development on this scale had been seen before in Western Europe. London literally sprawled out in every direction and the approach to it, initially by way of villages and market gardens, quickly gave way to new streets and squares which were to continue to encroach across open land for the rest of the century. The main expansion was to the west and the north as the great urban landowners, like Lord Burlington, Edward Harley, 2nd Earl of Oxford, and Sir Richard Grosvenor, set in train Cavendish and Grosvenor Squares, Clifford Street and Savile Row. These, with their wide streets, pavements, and elegant symmetrical architecture were where the rich and fashionable resided on account of the cleaner air. To the east lay the rebuilt old city, its narrow streets huddled around the soaring splendour of Wren's St. Paul's, and the once smart Covent Garden area which was now given over to sleazy brothels, bagnios and gaming dens. Soho, St. Martin's Lane and the Strand acted as a bridge linking the old part of London with the new. Here congregated a teeming population of artisans, craftsmen and retailers, for London was the home of the luxury trades and the fount of every kind of conspicuous consumption.

Never before had there existed such a kaleidoscope of streets, houses, squares, churches, gardens, parks, theatres and markets, such a concentration of humanity thrown pell-mell together, rich and poor, idle and industrious, young and old, virtuous and depraved, grand and humble. For the first time there had come into exis-

tence a whole society whose entire life could be nothing other than urban, for whom the world of nature and the cycle of the seasons was something only dimly apprehended as they struggled to live amidst the appalling pollution caused by the burning of coal fires, the filth

A scene from a series painted by Joseph Highmore of incidents in Samuel Richardson's bestselling novel Pamela *(1740). Here the rake, Mr B., reveals his true colours in an unsuccessful attempt on the heroine's virtue.*

which filled both the streets and the river Thames, not to mention the deafening noise caused by the creaking of the carriages, the clatter of horses' hooves and the shrill voices of the street criers plying their wares.

Early eighteenth century culture was about and for London and Londoners. The city was ten times larger than any other in the country and although it was awash with the impoverished it also had an unparalleled concentration of those with an increasing amount of disposable income, the aristocracy and gentry and the ever-expanding professional classes. Everywhere one looks London recurs as the *leitmotif* of the age. John Gay's *The Beggar's Opera* is set in Newgate prison, Green Park was to provide the

setting for Handel's mighty *Music for the Royal Fireworks* while Henry Fielding's novel *Tom Jones* is the story of a young man who makes that classical progress from the country to seek his fortune in London. It is at the Bell Inn in Cheapside that William Hogarth's harlot begins her progress, while his rake is arrested where St. James's Street meets Piccadilly. Hardly surprising that visitors from abroad were stunned into wonder at the phenomenon. For them London was *the* city of the Enlightenment. Here uniquely freedom of the press, freedom of political debate, and freedom of religious observance reigned. Proud, Protestant and ever more prosperous, London was the lodestar of the age.

That prosperity stemmed from the city's heart, no longer its cathedral church of St. Paul's but the Royal Exchange and the burgeoning stock market. The wars with Louis XIV had brought huge commercial and colonial gains and London replaced Amsterdam as Europe's financial capital. The arrival of the House of Hanover in 1714 signalled an alliance of the Crown and the Whig party under the aegis of Sir Robert Walpole which was to last forty years. Its network of patronage endured even longer, until the accession of George III in 1760. Walpole's government presided over a period of unusual stability and prosperity, even though there were two Jacobite invasions in 1715 and 1745. For the opposition Tories and those with Jacobite sympathies Walpole embodied squalid mercantilism and materialism, the dethronement of the old landed aristocracy and gentry to whom power should naturally belong. To writers of their side of the political spectrum, like Jonathan Swift and Alexander Pope, Walpole was the incarnation of the worst kind of corruption. The waters of Augustan England were far from tranquil ones, for this remained a society still deeply divided, not only in terms of wealth and opportunity but also in those of religious belief and party loyalty. Nonetheless not even these factors could conceal what was a new and overriding feeling of confidence and possibility.

The bulk of the population remained as it always had been, in want and poverty eking out a rural existence, lacking opportunity and often the victim of a callous system of justice. The gap between the haves and have-nots continued to widen giving birth to feelings of guilt in those more fortunate, leading to acts of benevolence. For the first time there was non-landed wealth on a huge scale, the result of the Commercial Revolution. Fortunes were made (and lost, as in the notorious South Sea Bubble) through the stock market, whose operations were now essential to the working of government. Society remained hierarchical, peppered with infinite gradations between the titled and the merely rich, but the way from the latter to the former was always open. City daughters married into the aristocracy and aristocratic younger sons entered the professions, the army, the church and the law. The cultural efflorescence

of the era is directly linked with this remarkable economic and financial boom whose effect filtered quite far down the social scale. Ordinary people were better off than in any other European country.

The monarchy had passed into cultural eclipse with Queen Anne whose only real sympathy lay with music, being a strong supporter of composers like John Blow, Jeremiah Clarke and the young George Frederick Handel. George I continued to patronise Handel, had indeed a taste for opera, but his son George II was a dedicated philistine. The traditional court ceremonial survived but was now rarely enacted, the Hanoverians retreating into a closed domestic existence. The old baroque alliance of art and power had gone for ever, and if the arts figured at all as part of the monarchical pantheon it was for their role as being commercially beneficial and morally uplifting for the nation. The Crown in fact was devoid of the resources whereby to play a dominant role even if it had wished to do so. In order, for example, to put on the great firework display in Green Park for the Peace of Aix-la-Chapelle in 1749 Jonathan Tyers, the man who ran the pleasure gardens at Vauxhall, had to be brought in. He exacted in recompense for his services a public rehearsal of Handel's music at Vauxhall which drew twelve thousand people and made him a small fortune. The actual royal event was a flop.

With the monarchy no longer the leader of taste and the fount of patronage, where did men look? Aristocratic patrons still existed. The writer and satirist John Gay had a whole series of them from the Duchess of Monmouth to the Duke and Duchess of Queensberry. So too did the poet Matthew Prior who was rescued by a group of his noble friends when he fell on hard times. But Prior had only sunk into poverty after the Tories fell from power in 1715, when he lost office and was sent to the Tower for two years. Up until then he had occupied a series of government posts. Such sinecures came of course at a price. Joseph Addison was enrolled for the Whig cause for a pension of £300 p.a. and became Secretary of State in 1717 with an income of £10,000 and payments from the secret service funds. Writers were literally bought and sold. Daniel Defoe changed political sides more than once merely to survive. In spite of this there emerged for the first time the professional writer, someone whose whole living was made by the pen. At the lower end of the scale came the hacks of Grub Street while at the upper presided the formidable figure of Alexander Pope, who was the first person successfully to make a career entirely out of writing with no other means of financial support.

That he could do so was because there was an audience for what he wrote as never before. In today's terms it was still narrow, reaching even by the 1780s no more than a quarter of the population. Culture did not come cheap. What a novel cost would

have fed a cottager's family for a week or a fortnight. The vast bulk of the new audience was made up of what was referred to at the time as the 'middling sort', the merchant and professional classes. The truth of that is captured in the shift in attitude towards them. Writers like Defoe began deliberately to cultivate the commercial classes while Joseph Addison bestowed on them the accolade of his contributions to the *Tatler*. By 1710 the sanctity of trade and the virtue of the merchant was an established fact.

The majority of this new cultural activity depended on paper. And it could never have happened without the role played by printers, publishers, engravers and print-sellers. The turning point which produced this proliferation was the lapse of the Licensing Act in 1695. Although the laws against blasphemy, seditious libel and obscenity remained in place censorship effectively ceased and the Stationers' Company lost its monopoly. The effect of this was that a publishing industry, which had previously been confined to St. Paul's Churchyard and Pater Noster Row, had, by the middle of the 1720s, over seventy printing presses scattered through the city. The provincial press also expanded with twenty-six printers in towns outside the metropolis by the same period. It was these events which made possible the emergence of magazines like the *Tatler* (1709-11) and the *Spectator* (1711-12 and 1714), foundation stones of early Georgian cultural attitudes. In the 1730s they were followed by the *Gentleman's Magazine* and the *Monthly Magazine* and, in 1747, the *Universal Magazine*. By then journals like the *Connoisseur* and the *Critical Review* had also sprung into existence, catering for specialised sections of the reading public. Everywhere newspapers came into being. In 1724 London had sixteen, covering every shade of political opinion. As a result of the lapse of the Licensing Act copyright came under threat as unscrupulous booksellers cornered the market. In 1709 their power was to an extent curtailed by a Copyright Act, which conferred a period of twenty-one years on existing titles and fourteen on new ones.

A paper culture was not only about words but images. The publishing explosion released an extraordinary flood of prints, trade cards, and illustrated books. To them we must add the huge numbers of imported prints, particularly after works of art. As a consequence more and more people had seen a place or a work of art than ever before, even if their experience was at a remove. By the 1730s it was even possible for a minor artist like Arthur Pond to execute some seventy prints after Old Master drawings. Paper was the essential element which gave this emergent bourgeois culture its means of expression, one which was for the first time outside the constraints of the court.

The intellectual substructure upon which this new culture was built came directly

out of the Scientific Revolution of the previous century. Newton's *Principia* was accepted as its model, one which could explain the complex phenomena of the earth and sky in terms of a single, ordered mathematical system. Alexander Pope's *Essay on Man* (1733-34) states 'Order is Heaven's first law':

> The gen'ral Order, since the Whole began,
> Is kept in Nature, and is kept in Man . . .

Such order validated an hierarchical society in which all creatures had their proper sphere, a scheme in which mankind, endowed with superior faculties, exercised legitimate control over Nature's lower orders. The old Aristotelian and occult traditions gave way to the Newtonian mechanistic one, thus setting the tone for the century, which was in general one of hope, energy, creativity and optimism for mankind.

Newton's belief in the immutable laws of science went hand-in-hand with the philosophy of John Locke, whose *Essay Concerning Human Understanding* (1690) was to change the direction of European thought. For him the ways in which we perceive the world depended on our sensory experience of it, and he was to fit the new physics into a less theological, more sense-based and naturalistic theory of knowledge. Locke's optimistic attitude to human nature led him to believe in mankind's essentially benign disposition. His view of the world was to be the century's credo, one of moderation, flexibility, reasonableness and toleration. In such a scheme of things the arts were destined to play a healing and uniting role in the new culture of what was called 'politeness'.

The agenda was set by the two magazines previously mentioned, Richard Steele's *Tatler* and Joseph Addison and Steele's *Spectator*. These publications were a mélange of short pieces, letters, essays and poems commenting on contemporary manners, morals and events. Their general thrust was that the religious bigotry and division of the previous century should be put aside and replaced by mutual tolerance and understanding. That new balance in society was to be achieved through a commitment to a new way of life, which aimed at understanding oneself and the world. Such a way of life could no longer focus on the venues which had embodied division, like the court, the church and the universities, but on new ones like the coffee house, the club, the theatre and the tavern, where this new interplay based on mutual conviviality could take place. The *Spectator* was to shape the views of men and women for its era and also those for the next generation. Its articles provided a short cut to 'polite' opinions and the world of taste. Its tone was comic, Whiggish and sceptical but its pages exuded an urban security. The subjects it dealt with cut across educated society, aristocracy, gentry, trade and the professions, thus producing a shifting

accord between them as they were gradually welded into 'polite society', albeit access to that world depended on birth, connection, money, patronage and talent. What might be described as the aesthetic side of politeness demanded a new physical grace and elegance of personal presentation in terms of movement and dress, as well as ease of social manner and wit and polish in conversation. Politeness was above all an art which should be exercised in company.

The role assigned to the arts in this new ideal was the one inherited from the theorists of the previous century. Art was seen to have a persuasive power which could

set a person on the path to virtue. To understand oneself not only called for self-examination as demanded by the tenets of Christianity but for exercising what Steele categorised as 'The Commerce of Discourse'. Literature and the arts regulated and refined the passions thus fashioning a polite identity, one of whose prime purposes was to exercise these attributes. The result of this was an ever-proliferating raft of etiquette manuals as well as teachers of the 'polite' arts, dancing, music and

Delight in domestic conviviality and social encounter typical of the codes of the new polite society is reflected in the vogue for conversation pictures in which groups, such as this family, engage in conversation and dalliance. William Hogarth catches such an animated scene in a painting of c.1735 in which tea is taken and a young lady is at her embroidery frame.

drawing. Knowledge and some skill in such spheres fitted a young lady or gentleman to make an entrance on to the new stage of polite society.

Taste in the arts became an essential sign of refinement and cultivation. It was an indispensable attribute of the new 'sociable man' as he was delineated by Steele and Addison. Taste came through the exercise of the senses but not of course the sensual or carnal ones. The senses called upon were passive and intellectual, the exercise of higher perceptions. Such a way of life assumed both the time and the financial resources. It called for buying works of art and antiquities, books and musical instruments, let alone attendance at performances in the theatre and concert hall. For those who could lead such a privileged existence it was the fulfilment of a Newtonian ordered ideal, which brought with it other lauded virtues, those of unity, harmony, balance, correctness and rationality and, therefore, beauty. Society, it was argued, should not only be humane, acts of philanthropy reflecting man's inborn benevolence, but also more cultured, taste revealing his true judgement. The programme of the *Spectator* and the *Tatler* was designed to bring about precisely such a union of art and morality. On launching the former, Steele and Addison had told Lord Somers that its aim was to endeavour 'to Cultivate and Polish Human Life, by promoting Virtue and Knowledge, and by recommending whatsoever may be either Useful or Ornamental to Society.' In their eyes the pursuit of what they categorised as 'The Pleasures of the Imagination' contributed to a person's moral obligation to lead a virtuous life.

One of the effects of this sudden elevation of cultural activity was to hive off what we now call the Fine Arts, painting, music, poetry, literature, sculpture and the dance, later described by Edmund Burke as the 'works of the imagination and the elegant arts.' Such arts were regarded as appealing to the imagination and the aim of their creators was seen to be that of producing emotions of taste in their audience. These were the arts which stimulated refined sensations away from the social and sexual pleasures of the passions. The rest were deemed the necessary or mechanical arts and relegated to a lower sphere.

This was a fundamental turning point in the definition of what constituted cultural activity. Like most things in the eighteenth century it came out of the Scientific Revolution which for the first time divided the arts from the sciences. But as the century progressed a further striking division of another kind took place and this one was social. The consequence of the hiving off of the Fine Arts by the upper sections of society was to demote the old popular culture of seasonal festivities, folk songs and tales to the margins. Indeed it increasingly began to be dismissed as vulgar, particularly as the polite classes built up and explored their new cultural domain. By the

end of the century popular lower class culture had become so far removed that it began to be viewed as the survival of some earlier, more primitive phase in man's development, and as such worthy of study. But for those in the vanguard of polite society the sun shone and the new cultural dispensation was increasingly seen as something heaven bestowed on the island, along with its liberty and economic prosperity.

Whatever vicarious delights such pursuits brought they remained ones whose ostensible aim was to morally edify. And anywhere in which morality and social responsibility was part of the scheme of things involved sooner or later the State. Britain being a secular state had a role to play as the guardian of social values through the organ of a State church. The new polite arts were not only seen as an indictment of the licence and lewdness of their predecessors in Restoration England but their moral mission was viewed as an exaltation of the State. Not that this new cultural world was devoid of its detractors, clerics and others, who took the time-honoured view that such pursuits were vehicles for indulgence in vanity and lust, leading to a neglect of both work and duty. They were, however, to be on the losing side during an age which witnessed an unprecedented expansion in sociability.

The polite arts needed to be practised within society. In order to cater for this demand old venues were recast and new ones created. London had some two thousand taverns and coffee houses. The *Spectator* assigned to these the role of being centres for polite conversation. Rank was laid aside on entering and once inside newspapers could be read or letters written and received. Many attracted particular groups of people. Men of letters went to Will's and the Bedford coffee houses in Covent Garden, actors flocked to Wright's hard by, while Old Slaughter's Coffee House in St. Martin's Lane drew members of the artistic fraternity including Hogarth, Jonathan Richardson and Francis Hayman.

Then there were the clubs of which the most pre-eminent was the Kit-Kat Club which took its name from Christopher Cat, the keeper of the Cat and Fiddle tavern and later of the Fountain, where the club met. The club flourished between 1696 and 1720 with a membership of fifty-five including ten dukes but also the men of talent who fashioned the new polite world, Addison and Steele. Its politics were Whig but it also had a cultural agenda to shape the arts by creating a sympathetic climate of opinion for the writers it supported. To its members was owed the first theatre to move westwards, the Queen's (soon to be the King's) which opened in the Haymarket in 1705. The Kit-Kat Club helped publishers like Jacob Tonson, the most powerful bookseller of the day, the publisher of Milton, Dryden and Pope, as well as being the cradle and forcing house for the introduction of Italian opera to the coun-

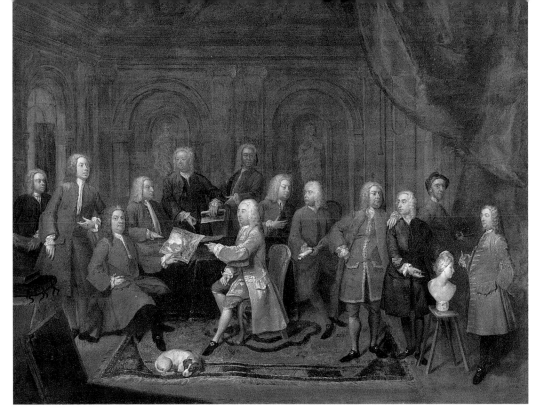

try. The Tories had their club too, the Brothers, founded in 1711 to which belonged Bolingbroke, Swift, Gay and Pope. Specialising in pamphlets and political squibs it evolved into the Scriblerus Club whose focus was wholly literary.

Clubs were exclusive, but other venues, such as the theatres, were accessible to any member of society who could pay the price of the entrance ticket. There were two concert halls in London in 1700, Hickford's Rooms in Panton Street and York Buildings off the Strand. In the 1720s and 30s Hickford's Rooms were enlarged to meet the demand for their subscription concerts. Later, in 1771, came the Pantheon in Oxford Street and four years later the Hanover Room which could accommodate nine hundred. Even more crucial for the city's musical life were to be the pleasure gardens. These had existed in the previous century but their nature changed in 1728 when Jonathan Tyers reopened Vauxhall as a place in which citizens could play the urban pastoral. Undesirable elements were purged and society was offered

Clubs were another aspect of the desire for social intercourse. This artists' club met at the King's Arms and included the architect James Gibbs, the landscape gardener Charles Bridgeman, the sculptor Michael Rysbrack, the architect and designer William Kent and the painter John Wootton. Painting by Gavin Hamilton, c.1734-35.

Pleasure gardens brought people together to share each other's company as well as social delights. The great Venetian painter Antonio Canaletto catches Vauxhall Gardens in their heyday, about 1750, recording the view first encountered on entry. Vauxhall was a vehicle for the latest rococo style, a setting for everything which was considered avant-garde in the arts.

genteel entertainment with elaborate décor and lighting. Music was an essential ingredient and there was a raised orchestra building and an organ. In 1738 the sculptor Roubiliac's famous statue of Handel in the guise of a latter day Apollo or Orpheus (now in the Victoria & Albert Museum) was installed as if to emphasise Vauxhall's musical commitment. Four years later the even more exclusive Ranelagh opened with its vast indoor rotunda, fifty-two supper boxes, orchestra and organist.

And so the stage was set, one, it should not be forgotten, which also embraced the home, where books and musical instruments, prints and pictures, began to proliferate. Polite culture calls for a certain kind of architecture and an elaboration of living space. Georgian houses not only had space for entertaining but increasing privacy achieved through more rooms, which in addition had doors with locks. The increase in letter writing indicated not only the time to indulge in such an activity but also the desire to develop personal relationships, which in a vast urban setting like London demanded private space. This was the age of the closet and the study to which a lady or a gentleman might retire in order to read and write. In 1714 probably 45% of the male population could read. That had risen to 60% by 1760. The corresponding figures for women were 25% and 40%. To be able to read did not necessarily bring with it the ability to write. Nonetheless this was a substantial section of the population and reading was by far the century's most important leisure activity.

This expansion in literacy explains the escalating demand for reading matter which resulted in the advent of magazines and newspapers and a growth in the numbers of full-time professional authors (aristocrats and gentry who wrote distanced themselves from the fact, as writing for money was viewed as tainted). Books were not only sold but could be borrowed for a fee. In 1742 the first subscription library opened and by 1800 there were some thousand of them. At the same time a library became an essential feature of any country house. There were many books published, more than ever before and on a far wider range of subjects, religious and theological, poetry and classics (often in translation) as well as imported books in French, a language universally read and spoken by the educated classes. Books had previously been few, usually the Bible and a handful of pious works, which were studied intensely. Now there were many, enabling reading to be far more extensive. Works on religion, especially sermons, were the most widely read of all. Books, like radio and television later, bound a family together in a shared intellectual and pleasurable experience offering both entertainment and instruction.

The Scientific Revolution also left its mark on how people wrote. The new mechanistic culture resulted in a dramatic change in prose style which now sought the virtues of concision and clarity of the kind found in the writings of John Locke.

The old traditional sources of language and imagery were invalidated and the analogy of the new literary style was seen to be mathematics. The former complexity of language typical of the wits and scholars of the Restoration gave way to the more factual prose characteristic of a society whose focus was on business transactions. The result was the simple positive style of the Augustan age, an exact reflection of the new scientific and rational outlook of the Enlightenment.

This is the period usually given the blanket label of Augustan. Although recent research has lifted the curtain revealing its raffish and deprived underworld the term still pertains, accurately describing certain of its identifying motifs. This was a vernacular literature whose roots lay in the schoolroom to which more people than ever before went. And these establishments were stocked with the same Greek and Roman authors, Virgil, Ovid, Horace, Lucretius, Cicero, Martial, Homer, Pindar, Aesop, Juvenal and Persius. Along with them there were the classical historians like Tacitus, Plutarch and Livy. As a consequence of spreading education and through translations, more people than ever had a mind furnished with a classical frame of reference. Georgian writing works from that premise and much of it is an exercise in translating into the vernacular one or other classical precedent. Just as Lord Burlington's architectural programme transported Ancient Rome to Augustan Britain or Kent's new landscape gardens evoked classical arcady, so a poem like James Thomson's *The Seasons* recast the Latin pastoral idyll for those who lived in northern climes.

In the new scheme of things satire as a literary genre fitted in with Addison's wider objective of trying to avoid the extremes of either Puritan enthusiasm or Restoration libertinism. Satire could contribute to fashioning a new national temperament by using laughter as the prime vehicle against fanaticism and vice. In the view of the authors of the *Spectator* any satire which made use of personal or political invective or contributed to what was known as 'the spirit of party' was by definition 'impolite'. Politeness called for the satirist to use his weapons not against individuals as such but against vice in general. In practice this was largely ignored. For Addison that middle way was epitomised by the satires of Horace and Juvenal which were now reworked into the vernacular and transposed from Rome to London. Satire by its very nature was based on the events and personalities of the moment. Parody was central to its working and the satirist was to develop a whole battery of new devices for setting off one thing against the other: contrasting ideas, values, principles, attitudes, style and identities. Its vehicles were the mock-panegyric and the mock-heroic, the burlesque and travesty as well as simple imitation.

Jonathan Swift, who by turning Tory was to lead most of his life in exile as Dean of St. Patrick's in Dublin, wrote the greatest of the satires, *Gulliver's Travels* (1726).

Cast in the fashionable guise of a travel book it recounts four journeys by a ship's surgeon to fantastic locations like the island of Lilliput where human beings are little bigger than ants. In it the rational Swift subjects the power of reason to merciless criticism. The result is a book in which moderation is equated with impotence and where the sane observer turns out by the end to be far madder than anyone else. Beneath what is a sober, placid text there lurks a desperation as human relations are revealed to be brutal and oppressive and men's institutions manipulable and corrupt. *The Battle of the Books* (1704) mimics the style of excitable journalism in a debate on the relative merits of the ancients as against the moderns in literature, while in *A Tale of a Tub* (1704) Swift personates a madman in the most alarming of all eighteenth century visits to Bedlam used for a satire on 'corruption in religion and learning'.

Alexander Pope was at heart a satirist, producing two great mock-heroic poems, a brilliant series of Horatian imitations and four verse epistles on moral themes. The greatest without doubt is *The Rape of the Lock* (1712 and 1714), a poem based on a piece of real-life gossip, the snipping off of a lock of a young girl's hair. This he used for a mock-epic in which so much waffle is apotheosised by him into high art but with a disturbing subtext lurking beneath its surface steely glitter. Strange areas of the subconscious are touched upon in this poem of magical transformations. Pope also parades a whole range of allusions to both the great writers of the classical heritage and also those, like Milton, within the native tradition. The *Aeneid* above all is parodied in this account of the severance of Arabella Fermor's hair by a young aristocrat:

> He takes the Gift with rev'rence, and extends
> The little Engine on his Fingers' Ends,
> This just behind *Belinda*'s Neck he spread,
> As o'er the fragrant Streams she bends her Head:
> Swift to the Lock a thousand Sprights repair,
> A thousand Wings, by turns, blow back the Hair,
> And thrice they twitch'd the Diamond in her Ear,
> Thrice she look'd back, and thrice the Foe drew near.
> The Peer now spreads the glitt'ring *Forfex* wide,
> T'inclose the Lock; now joins it, to divide.
> Ev'n then, before the fatal Engine clos'd,
> A Wretched *Sylph* too fondly interpos'd;
> Fate urg'd the Sheers, and cut the *Sylph* in twain,
> (But Airy Substance soon unites again)
> The meeting Points the sacred Hair dissever
> From the fair Head, for ever and for ever!

The Rape of the Lock remains Pope's most perfect achievement.

The Dunciad (1728 and 1743) is also a mock-heroic, this time a savage attack on hacks and booksellers, told in the form of a celebration of the progress of an empire, that of Dullness. Again this is a Virgilian epic, this time set in eighteenth century literary London with swipes at the Hanoverians, the corruption of Walpole's government and what Pope saw as the cultural malaise of the era. It remains vivid still with its misapplied lyricism and coruscating wit. No one could equal Pope's parody of Milton's *Paradise Lost* in presenting his arch-villain, the Poet Laureate, Colley Cibber:

> High on a gorgeous sea, that far out-shone
> Henley's gilt tub, or Fleckno's Irish throne . . .
> Great Cibber sate: the proud Parnassian sneer,
> The conscious simper, and the jealous leer,
> Mix on his look . . .
> Lift up your gates, ye Princes, see him come!
> Sound, sound ye Viols, be the Cat-call dumb!

Pope's *Epistles* form a sharp contrast. Addressed in the main to friends they delineate a world of men and events, telling stories, cracking jokes and pointing morals. That 'To a Lady', his life-long friend Martha Blount, has a brilliance which is at once relaxed and easy, witty and conversational.

Pope, however, took no part in what was to be the major literary innovation of the period, the novel. This emerges for the first time as a recognisable genre, albeit still at the fringes of literature. A quite exceptional convergence of circumstances gave birth to it. Like much else the novel could never have happened without John Locke. A novel works from the Lockeian view that truth can only be discovered by the individual through his own senses. For Locke the pursuit of truth is a matter for

William Kent's witty evocation of Alexander Pope in his mysterious grotto, c.1725-30.

the individual independent of past thought. A novel's prime criterion is truth to a single person's experience, recognising the fact that each individual's experience is unique. Plots were no longer derived from previous literature, from history or classical mythology, but from that unique individual experience. Locke also defined human personal identity as an identity of consciousness through time. And the means whereby an individual remained in touch with his own identity was through

memory. Time as the agent of change was seen as the force shaping man's individual and collective history, which is in essence the substance of the novel.

The novel also comes out of an aspect of the Scientific Revolution with its emphasis on the role of individual human effort. It also owed much to the Puritan tradition with its preoccupation with self-scrutiny leading on to self-analysis. In addition the Puritan conception of the dignity of ordinary human labour led directly to the novelist's general belief that daily life was of sufficient interest to be worth writing about at all. The result was a unique form that brought life as lived through time and art together. But this could not have occurred without certain changes in society, which made it worth reading about the experiences of a single human being. That could only have come about in a milieu which was highly secularised, for the action of a novel depends not on divine intervention but on the exercise of choice by ordinary human beings. Personal relationships, which are integral to the form, could only move centre stage in a society which had enough time and security in which to indulge them.

Early eighteenth century England witnessed just such social change. Under the aegis of the Puritan ethic courtly love, which within the medieval and Renaissance tradition had always been adulterous, was transferred to marriage. For the first time women began to be able to exert a small degree of choice in their partner. Once married a new and separate family unit was created. All of this needed to be in place before a genre could develop which took as its pivot courtship leading to marriage. Female chastity which ended in a virtuous marriage, in which both a financial and property settlement were involved, was central to the Protestant ethic. It was to be the *leitmotif* of every novel into the twentieth century. But that is not to say that such sagas of virtue were not also a means whereby the sexual imagination could freely range in a way denied by the etiquette of life. And the novel had the advantage of exploring matter which could never be put on stage.

The earliest creators of the novel had all the exhilaration of starting with a clean slate. What is astonishing is that its three greatest exponents, Daniel Defoe, Samuel Richardson and Henry Fielding, between them established every element of the genre within a few decades. Daniel Defoe created in *Robinson Crusoe* (1719), the story of a man cut adrift from civilisation, a masterpiece. In Crusoe he fashioned a new heroic archetype, one who could be read and re-read in many ways. Rugged economic individualism and the record of an inner life animate a secular and spiritual fable in which providence ensures both deliverance and survival. Survival is indeed the key theme which binds other Defoe novels together: *Moll Flanders* (1722), as Moll spirals both up and down driven by a desire for money and the maintenance of her genteel

status, and *A Journal of the Plague Year* (1722), which graphically reconstructs the terrible events of 1665.

Defoe was a journalist. Samuel Richardson was a successful bookseller. *Pamela: or Virtue Rewarded* (1740) transformed the role of women in fiction. Richardson not only got inside the heads of his characters but into their houses too. In *Pamela* he used the form of the letter in which to recount the tale of a maidservant whose defence of her sexual virtue was rewarded by a genteel marriage. In England the book ran into five editions and it also swept through the mainland of Europe. Richardson created a female prototype, the pale and delicate heroine who wilts at the least sign of a sexual advance and whose descendants in Victorian fiction pass out at even the hint of an indiscretion. *Clarissa* (1747-48), his greater masterpiece, has the dubious distinction of being the longest novel in the English language. This is the story of an innocent country girl who is corrupted by the city and ultimately dies a saintly death. If *Pamela* might be said to have represented one aspiration of the social scene, the ability for a woman to marry up, *Clarissa* opened out on its pages what passed through the subconscious mind, touching deep into the moral and social preoccupations of the age. Richardson's attempts to do the same for a virtuous hero in *Sir Charles Grandison* (1753-54) ended in failure, but his work overall had set in place the two directions which could be taken by future novelists, the first the exploration of an individual's psychological and moral awareness, the second to purvey vicarious sexual experience and thus fulfil adolescent fantasies.

Henry Fielding was a feckless spendthrift who started out as a brilliant writer of satirical plays until his stage career was cut short by Walpole's clamp-down on the theatre. As a result he turned to the novel and in doing so opened the highway to comedy, establishing thereby a pattern for the comic novel which was to lead directly to Dickens. Of his three novels, *Joseph Andrews* (1742), *Tom Jones* (1749) and *Amelia* (1751), it is the second which is regarded as his most enduring masterpiece. Divided into three parts it traces the eponymous hero's life from a childhood and youth spent in Somerset through an unstable period on the road, peopled by a motley cast of characters, ending in London. Fielding brought to his novels a vivid narrative technique and a wide knowledge of the ways of the world. As a consequence of this he paints a sweeping panorama of mid-Georgian society in what he conceived as an epic within the classical tradition.

These were the heroic decades of the novel to which Laurence Sterne was to make a very individual contribution. *A Sentimental Journey* (1768) is a fictionalised account of Sterne's travels in Italy and France but *Tristram Shandy* (1713-68) is something else, a gloriously chaotic yet great comic work with a mastery of the realistic presentation

of fleeting thoughts, feelings and gestures, and a flexible handling of time which prefigures the break with the tyranny of chronology which came in the twentieth century. In this way, within virtually a single generation, the novel had made an incredible journey from being a narrative of adventure to one exploring man's inner life.

It is important to remember that the novel lay on the fringes of literature. At its heart lay poetry. No successors of the stature of Dryden were to emerge before the second decade. The only poet of significance before that date was Matthew Prior, an impressive practitioner of a variety of verse forms and the author of two major poems: *Solomon on the Vanity of the World* (1718), an elevated Augustan exercise on a moral theme, and *Alma: or The Progress of the Mind* (1718), a mock treatise on the seat of the soul. But the century was to be dominated by the work of two other writers, James Thomson and Alexander Pope. Thomson's *The Seasons*, which came out in stages between 1728 and 1730, captures the way Newtonian optics led poets to appreciate colour within the universe. The poetry of the eighteenth century is indeed suffused with this emphasis on the varied hues of nature. *The Seasons* is at once scientific and descriptive, partly too an imitation of a Miltonic epic with Nature in the role of hero. This is a British countryside attuned to the ideals of a new urban bourgeoisie, patriotic, pastoral, classical and sentimental. In this way the post-Newtonian universe was incorporated into the poetic mode.

No single writer could, however, measure up to Pope. Pope is the first really successful writer who made a fortune from his powers and created and retained a reading public to support him. Only four feet five inches tall and suffering from tuberculosis of the spine, Pope was undoubtedly a genius. He was endowed with quite extraordinary powers of observation and he was hugely ambitious. He was, in addition, an outsider, a Catholic, whose faith excluded him from a university education as well as public office. As a consequence he was self-taught and self-created. This was a man with an agenda. The age was Augustan and he cast himself as its Virgil. His overriding aim was to introduce a new 'correctness' to English poetry. In his *Imitations of Horace* (1735) he places himself exactly:

> . . . Britain to soft refinements less a foe,
> Wit grew polite, and Numbers learn'd to flow.
> Waller was smooth; but Dryden taught to join
> The varying verse, the full resounding line,
> The long majestic march, and energy divine.
> Tho' still some traces of our rustic vein
> And splay-foot verse, remain'd, and will remain.
> Late, very late, correctness grew our care . . .

status, and *A Journal of the Plague Year* (1722), which graphically reconstructs the terrible events of 1665.

Defoe was a journalist. Samuel Richardson was a successful bookseller. *Pamela: or Virtue Rewarded* (1740) transformed the role of women in fiction. Richardson not only got inside the heads of his characters but into their houses too. In *Pamela* he used the form of the letter in which to recount the tale of a maidservant whose defence of her sexual virtue was rewarded by a genteel marriage. In England the book ran into five editions and it also swept through the mainland of Europe. Richardson created a female prototype, the pale and delicate heroine who wilts at the least sign of a sexual advance and whose descendants in Victorian fiction pass out at even the hint of an indiscretion. *Clarissa* (1747-48), his greater masterpiece, has the dubious distinction of being the longest novel in the English language. This is the story of an innocent country girl who is corrupted by the city and ultimately dies a saintly death. If *Pamela* might be said to have represented one aspiration of the social scene, the ability for a woman to marry up, *Clarissa* opened out on its pages what passed through the subconscious mind, touching deep into the moral and social preoccupations of the age. Richardson's attempts to do the same for a virtuous hero in *Sir Charles Grandison* (1753-54) ended in failure, but his work overall had set in place the two directions which could be taken by future novelists, the first the exploration of an individual's psychological and moral awareness, the second to purvey vicarious sexual experience and thus fulfil adolescent fantasies.

Henry Fielding was a feckless spendthrift who started out as a brilliant writer of satirical plays until his stage career was cut short by Walpole's clamp-down on the theatre. As a result he turned to the novel and in doing so opened the highway to comedy, establishing thereby a pattern for the comic novel which was to lead directly to Dickens. Of his three novels, *Joseph Andrews* (1742), *Tom Jones* (1749) and *Amelia* (1751), it is the second which is regarded as his most enduring masterpiece. Divided into three parts it traces the eponymous hero's life from a childhood and youth spent in Somerset through an unstable period on the road, peopled by a motley cast of characters, ending in London. Fielding brought to his novels a vivid narrative technique and a wide knowledge of the ways of the world. As a consequence of this he paints a sweeping panorama of mid-Georgian society in what he conceived as an epic within the classical tradition.

These were the heroic decades of the novel to which Laurence Sterne was to make a very individual contribution. *A Sentimental Journey* (1768) is a fictionalised account of Sterne's travels in Italy and France but *Tristram Shandy* (1713-68) is something else, a gloriously chaotic yet great comic work with a mastery of the realistic presentation

of fleeting thoughts, feelings and gestures, and a flexible handling of time which prefigures the break with the tyranny of chronology which came in the twentieth century. In this way, within virtually a single generation, the novel had made an incredible journey from being a narrative of adventure to one exploring man's inner life.

It is important to remember that the novel lay on the fringes of literature. At its heart lay poetry. No successors of the stature of Dryden were to emerge before the second decade. The only poet of significance before that date was Matthew Prior, an impressive practitioner of a variety of verse forms and the author of two major poems: *Solomon on the Vanity of the World* (1718), an elevated Augustan exercise on a moral theme, and *Alma: or The Progress of the Mind* (1718), a mock treatise on the seat of the soul. But the century was to be dominated by the work of two other writers, James Thomson and Alexander Pope. Thomson's *The Seasons*, which came out in stages between 1728 and 1730, captures the way Newtonian optics led poets to appreciate colour within the universe. The poetry of the eighteenth century is indeed suffused with this emphasis on the varied hues of nature. *The Seasons* is at once scientific and descriptive, partly too an imitation of a Miltonic epic with Nature in the role of hero. This is a British countryside attuned to the ideals of a new urban bourgeoisie, patriotic, pastoral, classical and sentimental. In this way the post-Newtonian universe was incorporated into the poetic mode.

No single writer could, however, measure up to Pope. Pope is the first really successful writer who made a fortune from his powers and created and retained a reading public to support him. Only four feet five inches tall and suffering from tuberculosis of the spine, Pope was undoubtedly a genius. He was endowed with quite extraordinary powers of observation and he was hugely ambitious. He was, in addition, an outsider, a Catholic, whose faith excluded him from a university education as well as public office. As a consequence he was self-taught and self-created. This was a man with an agenda. The age was Augustan and he cast himself as its Virgil. His overriding aim was to introduce a new 'correctness' to English poetry. In his *Imitations of Horace* (1735) he places himself exactly:

> . . . Britain to soft refinements less a foe,
> Wit grew polite, and Numbers learn'd to flow.
> Waller was smooth; but Dryden taught to join
> The varying verse, the full resounding line,
> The long majestic march, and energy divine.
> Tho' still some traces of our rustic vein
> And splay-foot verse, remain'd, and will remain.
> Late, very late, correctness grew our care . . .

Pope's summons was for a revolution casting off the country's literary insularity. For him that new ease, order and correctness was enshrined in his adoption of the heroic couplet. Symmetrical, stately, ordered and yet lyrical it worked for every poetic form and was an ideal machine for thinking in, being logical, sequential, clear as well as polite. Pope became the master of the heroic couplet which far from being an easy option called rather for immense skill in order to achieve a subtle and carefully modulated rhythm.

He made his living through translations. The *Iliad* (1720) was undertaken 'purely for want of money' but it was a translation done in the full Augustan spirit of transmitting a foundation stone of the western poetic tradition to this island. The *Odyssey* (1725-26), which he did in collaboration, was to fall short. These were his breadwinners which brought him not only fame but a fortune, enabling him to set himself up as a country gentleman on a mini-estate at Twickenham and create one of the first gardens in the new landscape style. Pope was an astute businessman and also a master of publicity maintained through endless portraits of himself and through his letters, in which he cast himself as a latter day Pliny or Cicero. Ironically his prosperity depended on what he most despised, the new mercantilism and urban culture. Pope may have been both Catholic and Tory but paradoxically for him his mind was urban.

Through exploring the Greek, Roman and English classics (he edited Shakespeare to conform to Augustan ideals) he discovered both himself and his poetry. His output in the form of satire, already touched upon, was prolific. Pope was a prodigy who produced his first poems, the *Pastorals* (1709), before he was twenty and whose first collected works were already issued at twenty-nine. *The Rape of the Lock* and his *Essay on Criticism* (1711) established him overnight as a major figure with a total mastery of versification and form, a familiarity with tradition and an awareness of new combinations. *An Essay on Man* (1733-34), now looked upon as shallow, was at the time his most influential work. No other writer in the century made such an indelible impression on the age, his writings so perfectly crystallising its ideals, so much so that his works make up a complete archive of its culture, one so monumental that it had to be repudiated by the Romantics before poets could once again move on. Pope's achievement lay in harnessing the new rationality to the powers of the creative poetic imagination and in applying the perspective of Greek and Roman literature to modern manners. He stands unchallenged as *the* man of letters of the age.

Whereas in the case of literature the lapsing of the Licensing Act precipitated a renaissance, the passing of the Stage Licensing Act in 1737 was to stultify theatrical invention for a generation and more. Theatre entered the new century with all the

traditional legacies which made government and the city authorities chary of it. For them the stage was always a potential threat to public order, both what was acted on it and the often riotous behaviour of audiences, not to mention its ancient alliance with prostitution. It was, however, an age of great actors: Thomas Betterton, James Quin, Peg Woffington, Colley Cibber and Elizabeth Barry. Initially theatres multiplied. Betterton, gaining a temporary royal licence, set up in Lincoln's Inn Fields and the King's Theatre opened in the Haymarket. Richard Steele's attack on the decadent drama of the Stuarts reached its climax in his sentimental comedy *The Conscious Lovers* (1722), but by then the theatres were already suffering from the aristocratic mania for Italian opera. Theatre managers hit back with the pantomime, an afterpiece combining dance and mime, music and spectacle with the added attraction of the greatest harlequin of the century, John Rich. And then in the very year that Italian opera foundered, 1728, came John Gay's *The Beggar's Opera*. This broke every record in theatrical history by running sixty-two nights at the Lincoln's Inn Fields theatre, then managed by John Rich. Nothing like it had ever been staged before and its appeal cut right across the social spectrum. It took satire on to the stage with an unparalleled brilliance attacking the depravity of the Walpole government, the absurdity of Italian opera, and the general venality of early Georgian society. The actors dressed in the mock finery of their rival, the opera, replaced its arias with parodies of Handel and Bononcini, intermingled with lyrics set to popular ballads and folksongs. The story of Macheath the highwayman's passion for Polly Peachum set in Newgate prison had zest, guts, sex and sentiment. The discrepancy between its words, which depicted the Whig oligarchy and the commercial classes as rogues, and the music came as delight to audiences who were utterly seduced by its charm. The production has gone down in history in the phrase that it made 'Gay rich and Rich gay.'

The effect of this was to unleash a decade of theatrical expansion culminating in a whole series of scathing political satires by Henry Fielding at the Little Theatre in the Haymarket. The old patent theatres responded too, with drama that was also politically charged. The result was that in 1737 Walpole got the Stage Licensing Act through Parliament whereby all plays had to be submitted to the Lord Chamberlain fourteen days before performance. The impact on the theatre was devastating. Drama was henceforth confined to the two historic patent theatres only. Worse, the Lord Chamberlain reserved the right even to ban a play which he had passed should he so wish. The spoken drama was to be the only art form subject to such rigorous government control, one which was not to be relinquished until the 1960s.

Fielding turned to the novel and he was not the only playwright to abandon the stage. As for the theatres themselves there was no choice but to opt either for bland

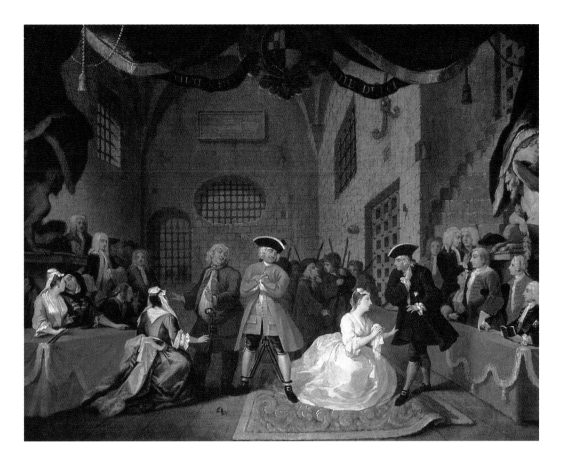

new plays which eschewed politics or to rummage through the inherited repertory of the past. One of the direct consequences of the Act was to be the cult of Shakespeare. But the damage to the spoken drama was to be immense and long lasting.

William Hogarth's rendering of the last act of John Gay's The Beggar's Opera *(1728) in which Lucy Lockit and Polly Peachum entreat their fathers, the gaoler and the informer, for the life of the highwayman, Macheath, whom each supposes to be her husband. Hogarth's painting includes a send-up of what he regarded as the pomposity of Italian opera.*

What was unaffected was the contribution theatre continued to make to musical life. In 1715 J.C. Pepusch, who had arranged the music for *The Beggar's Opera*, was appointed music director at Drury Lane, thus inaugurating a new era of musical spectacle. He revived the masque, and in the 1720s came the pantomime which contained airs, recitatives, ensembles and choruses interspersed with small orchestral pieces. A huge quantity of music was produced by William Boyce, Maurice Greene and Thomas Arne including the latter's setting for Milton's masque of *Comus* (1738). Arne was indeed the most wide-ranging and important composer of theatre music, but he was not to achieve his greatest successes until later, *Thomas and Sally* (1760),

an entertainment which combined the traditions of *opera buffa* with the English ballad opera, the first true English *opera seria*, *Artaxerxes* (1761) and a new form, the ballad opera, *Love in a Village* (1762), which mingled music from Italian opera with folk tunes and specially composed pieces.

The abundance of theatre music by English composers is some indication that they were able to hold their own in this genre, but they equally held it in the composition of odes, songs and cantatas, concerti grossi and trio sonatas. There was a burgeoning as music-making moved away from the court and new societies were founded, festivals inaugurated and concert rooms and pleasure gardens opened. In 1710 the Academy of Ancient Music was set up at the Crown and Anchor tavern in the Strand with its aim 'the study and practice of vocal and instrumental harmony.' The Academy was devoted to the performance of the works of composers such as Byrd, Palestrina, Tallis and Purcell. In 1726 an Academy of Vocal Music followed, to perpetuate the tradition of English church music. Subscription concerts began at Hickford's Room in 1729 and ten years later they moved to Brewer Street where concerts were to continue for the next four decades. Such performances included orchestral pieces, vocal music and instrumental solos. From 1739 Vauxhall became a major centre for every kind of musical event and Ranelagh followed not long after. To these must be added St. Paul's Cathedral and Westminster Abbey with their choirs as well as the music heard in other churches and in private houses, not to mention that sung and played in the streets. Everything was in place for London to become the musical capital of Europe, a position signalled by the arrival of the composer who was to dominate music in the same way that Pope dominated literature, George Frederick Handel.

Handel was born in Halle in Germany on 25 February 1685, in the same year as Bach. A musical prodigy virtually from birth, his first opera was staged in Hamburg in 1705 when he was just twenty. From there, under the patronage of a Medici, he went to Italy, seminal not only for opera but every aspect of musical education, being the home of all the various baroque forms both vocal and instrumental. There he learnt the art of opera and his first Italian opera *Rodrigo* was staged in Florence in 1709, followed a year later by the resounding success of *Agrippina* in Venice. Handel was offered a post at the Hanoverian court, with the freedom to travel, and in 1710, he arrived in a London hungry for opera and, what was more important, with the wealth to pay for it. In 1711 *Rinaldo* was performed to acclaim and he attracted the patronage of Queen Anne who gave him a pension and commissioned him to write the *Te Deum* on the occasion of the Peace of Utrecht (1713).

Handel settled permanently in England in 1712 and took out citizenship in 1726. He was to remain court composer for his entire life contributing, for example, music

for the coronation of George II in 1737 which is still used at coronations today. But the bulk of his work lay away from the court, for the theatre and the concert halls of London in the form of operas, instrumental music and oratorios. He began with the patronage of Lord Burlington followed by that of the Duke of Chandos (for whom he composed the *Chandos Anthems*), then came his appointment as composer for the Royal Academy of Music. By that date he had already achieved an unassailable position on the musical scene, one which continued to grow until, by the middle of the century, he took on the guise of a national monument. He died aged seventy-four on 14 April 1759, and was buried in Westminster Abbey.

Handel was an overwhelming personality, an impatient and excitable man, and there was to be no sphere of music-making into which he did not breathe new life. His orchestral music included the *Water Music* (1717), the *Music for the Royal Fireworks* (1749), and two sets of *Concerti Grossi*. They all remain as vivid today as at their first performance. The sense of occasion which any new work by Handel brought is beautifully caught in a contemporary account of the first performance of the famous *Water Music* on a July evening in 1717 when George I and the court went by water from Whitehall to Chelsea:

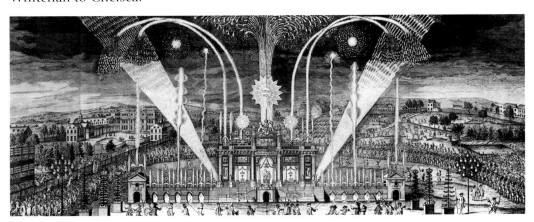

'Many other Barges with Persons of Quality attended, and so great a Number of Boats, that the whole River in a manner was cover'd; a City Company's Barge was employ'd for the Musick, where were 50 Instruments of all Sorts, who play'd

'A View of the Public Fire Works' to celebrate the Treaty of Aix-la-Chapelle staged in Green Park on 27 April 1749, for which Handel wrote one of his grandest scores.

all the Way . . . the finest symphonies, compos'd express for this Occasion, by Mr Hendel; which his Majesty liked so well, that he caus'd it to be plaid over three times in going and returning.'

But his impact on the arrival of Italian opera was to be far greater. That was an

importation of an art form which had evolved in Italy during the previous century, one which had been seen by members of the English aristocracy on the Grand Tour. Italian baroque opera was largely a vehicle for beautiful melody and ravishing singing. The action was described in the recitatives while long *da capo* arias conveyed the general mood and emotions. Italian singers were of an unrivalled virtuosity, both those with a soprano voice and the famous *castrati,* men who had been castrated in childhood in order to prevent their voices from breaking. The result was an extraordinary quality of high voice which was deployed for emotional utterances in the masculine roles. This was what was known as *opera seria.* The plots dealt with the conflicting demands of love and duty among the aristocracy, utilising stories from classical mythology, history and medieval romance. Great singing was central to the experience but it was set within visual spectacles on the grand scale with elaborate transformation scenes and magical ascents and descents. It was very, very expensive.

The earliest attempt to import Italian opera to England was made by Thomas Clayton who returned from Italy with a libretto and songs for an opera entitled *Arsinoe, Queen of Cyprus* (1705): 'An opera, after the Italian manner: All sung.' A period followed with bilingual opera and then in 1710, Italian opera won with Francesco Mancini's *Idaspe* in which sang the great *castrato* Nicolini. Fashionable society was entranced, the Purcellian tradition of semi-opera promptly collapsed and London became the mecca for hundreds of immigrant sin-

Design for 'A Room of State' by Sir James Thornhill for the earliest opera in the Italian style, Arsinoe, Queen of Cyprus, *to be staged in England in 1705.*

gers and musicians. The 1712-13 opera season included Handel's *Teseo* which inaugurated the composer's long relationship with John James Heidegger who took care of the management side of the operation, an arrangement which was to last thirty years.

The Royal Academy of Music, set up in 1719, was a joint-stock company to back the opera company financially in the absence of a court. Three of the leading singers of the day were recruited, Senesino, the celebrated *castrato*, Francesca Cuzzoni, one of the most splendid sopranos of the century, and, in 1726, Faustina Bordoni, another great singer but one whose attractions led to her exchanging blows on stage with her rival, contributing to the collapse of the Academy. The cost was huge: Senesino commanded a fee of 3,000 guineas for his first season. Besides Handel there were two other composers recruited, Giovanni Bononcini and Attilio Ariosti. The Academy opened at the Haymarket in April 1720 with Handel's *Radamisto*, the first of a long series of successes culminating in *Giulio Cesare* (1724), *Tamerlano* (1724) and *Rodelinda* (1725).

When the Academy collapsed in 1728, Handel and Heidegger leased the King's Theatre for five years and staged a whole new series of operas including *Ariodante* (1735) and *Alcina* (1735). Meanwhile the aristocracy, with whom Handel had fallen out, forced him out of the Haymarket to make way for their own new company, the Opera of the Nobility. Handel and Heidegger went to Covent Garden but London had simply not the resources to support two major opera companies and eventually both of them failed. It was not the end of Italian opera in England but opera never effectively recovered until the 1760s.

All of this led to Handel finally abandoning opera in 1741 for oratorio. The shift had begun earlier with a highly successful revival of an early work, *Esther*, at the Crown and Anchor tavern in the Strand in 1732. The

Caricatures of Italian opera singers, above, the soprano Faustina Bordoni with the castrato Senesino; below, the soprano Francesca Cuzzoni and the castrato Farinelli with, in the background, the impresario, Joseph Heidegger.

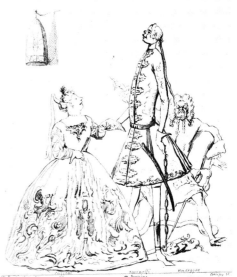

decision was taken to re-stage it in the King's Theatre. As the Dean of Westminster refused to allow the Abbey choristers to wear stage costume the performance took the form of a concert. Unlike his operas, which remained resolutely Italianate, in the case of the oratorio Handel evolved a musical format which was strikingly different from its European counterparts, so much so that it took on a character which remains resolutely insular. Such oratorios were usually staged during Lent, combining as they did both piety and entertainment. The subject matter made use of religious and patriotic themes from the Bible and the works of Spenser, Milton and Dryden. Appealing equally to both Anglicans and dissenters they crossed the religious divide. What they represented was a fusion of the drama of opera, the oratorios similarly being divided into three acts, with the native choral tradition. The role of the chorus in *opera seria* was minimal but in the oratorios Handel was able to develop its full potential. In addition, between the acts the orchestra played a concerto, Handel eventually composing special organ concertos which he performed himself.

Handel's oratorios, like *Saul* (1739), were as dramatic as his operas. But it was to be his *Messiah* (1742) which was to place him at the heart of the British musical inheritance. Its initial performance in Dublin was not auspicious and its ascent into cult status only began in the 1750s when it began to be staged annually for the benefit of the new Foundling Hospital. Written in twenty-four days it managed to be both theatrically colourful and also deeply conducive to spiritual meditation. But *Messiah* was only one of a whole series of oratorios which the composer wrote during the 1740s all of which were vivid, powerful, original and resourceful. Boyce, Greene and Arne all followed but never emulated him. His achievement was neatly summed up by his early biographer, Mainwaring: 'His Oratorios . . . being in our own language, have chiefly endeared him to the nation.'

That turn of phrase catches a mood which was increasingly to permeate the cultural scene by the middle of the century, patriotism. The Jacobite invasions of 1715 and 1745 fed it, so did the wars with France. In addition it was played upon by opposition parties to the long hegemony of the Walpole regime. English history was recast as a struggle of liberty against faction (Walpole), the former finding heroes in the Ancient Britons and the freemen of Saxon England. It was no coincidence that Thomas Arne's 'Rule Britannia', with words by the poet James Thomson, was first heard in the *Masque of Alfred* performed before the Prince of Wales in 1740. Augustan Rome began to lose ground to Elizabethan England as the yardstick whereby to measure the triumphs of contemporary culture. In no sphere of activity was that pull more powerfully registered than in the visual arts where for the first time there was a deliberate effort to create a British school of painting to rival the Italian and French schools.

Ever since the Reformation, outside of the court the visual arts had never quite lost the stigma of popery. That fear is caught in the extremely restricted range of subject matter open to artists; virtually all were portraits, of people, their houses, their estates and their animals. Art in the Great Tradition, that is art which took as its subject matter heroic, historical and mythological themes, was viewed as something foreign. In England that kind of painting was the province of immigrants to the country or something which could be purchased in what was the beginning of a market in old master paintings. By 1700 there was already in existence a network of highly professional dealers who organised the import of over a thousand pictures annually into England. As in the case of publishing this had meant sweeping away a monopoly, in this instance that of the Painter Stainers Company who had made it illegal to import foreign art. By the opening years of the eighteenth century all of this had been dismantled and by 1750 five to ten major picture sales were held each year in London. This was to be the collecting century.

In one sense this only aggravated the situation as far as it concerned native artists, who were not only up against foreign competition but also the increasing cult of old masters. Aristocrats who had been on the Grand Tour naturally looked down on English painters as somehow inferior, being neither genteel nor in possession of a classical training. The problem was how to raise the status of native artists and their work. The general consensus was that this had to be achieved by the artists essaying works within the Great Tradition. Shaftesbury had cast art, reflective as it was of the order, proportion and harmony of God's universe, into the role of being a pathway to virtue. The subjects which artists chose should be those which would instil thoughts of civic virtue into the onlooker, scenes of classical history and mythology, stirring patriotic moments and mythological allegories. In this he subscribed to what the continental academies recognised as the hierarchy of genres, in which history painting as it was designated was recognised as the summit of artistic achievement. Everything else occupied a lower niche. British artists therefore needed to graft their work on to the Great Tradition as enshrined in the works of the masters of the Renaissance and of classical antiquity, a theme which the *Spectator* echoed in its papers on 'The Pleasures of the Imagination'. It was a view also popularized by the writings of the influential theorist Jonathan Richardson who joined the chorus calling for an elevated native art in the Great Tradition. This did not depict what was actually seen but rather '. . . a painter must raise his eyes beyond what he sees, and form a model of perfection in his own mind which is not to be found in reality.' In a series of essays (1715-19) Richardson produced the standard works on art criticism which were to set the agenda for the century, leading to the triumph of those who advocated the adoption

of the Great Tradition and to the founding of the Royal Academy.

Inspired by Richardson one group of painters, headed by Arthur Pond, came together and started the Roman Club to discuss and promote Italian art. Members of the club went to Italy in 1725 and that voyage henceforth was seen more and more to be indispensable for any painter with aspirations. Not everyone went along with this viewpoint and one painter in particular, William Hogarth, was to spend his entire career attacking everything he considered smacked of abroad. The Palladian style, the Italian opera and the worship of the old masters were all anathema to him. He was, of course, as any analysis of his work reveals, keenly aware of the heritage of the past, but his chief pride lay in being resolutely British. He drew around himself a contrary group of painters who met at Old Slaughter's Coffee House in St. Martin's Lane forming an imbalanced, anarchic, anti-academic off-beat group. Hogarth's programme for the future of British art was a very different one and he summed it up in *The Analysis of Beauty* (1753), in which he attacked the tyranny of academic rules and advocated a British school that did not look either to antiquity or Italy. Instead he directed the artist to look at what he saw in the streets of London. In this he was a pure disciple of John Locke, basing his arguments not on the authority of the past but on personal observation and on rational enquiry into the working of the human mind. Beauty for Hogarth was founded not on ideal but empirical principles, its perception part of the Lockeian realm of sensation. Sadly Hogarth compromised his dismissal of the world of academe by substituting for it a rule of his own, 'the serpentine line', something which was to make the young Joshua Reynolds's attack on Hogarth in *The Idler* (1759) all the easier. Later Reynolds dismissed the painter's work as not even worthy of a place in the academic hierarchy of genres since Hogarth was an artist, in his opinion, who had expended his powers 'on low and confined subjects.'

Hogarth is the great maverick of the age, radical and pugnacious, a man who had fought his way up from poverty and the social exclusion of dissent. In that sense he had much in common with the other native giant, Pope, with whom he also shared a hunger for status, money, the high life and social acceptance. Most of it he got, although not on Pope's exalted level, for Hogarth was touchy, envious and angry and most of his work was aimed at tearing into shreds the official vision of Augustan England. Beneath the patina of frothing lace, stiff brocade and rustling silks his eye spied not only the dirty linen but worse. His was an acutely literary turn of mind which revelled in meanings and double-meanings making him fit more naturally into the gallery of the novelists than in that of the painters of the day.

Hogarth was the son of an impoverished classics teacher. Brought up in the Smithfield area of London he was familiar from childhood with the popular culture

of the streets and with the seamier side of urban life. When he was seventeen he was apprenticed to an engraver and decided that his way up would be by learning copperplate engraving so that he could respond to the boom in prints. In 1720, when he was twenty-three, he joined the new artists' academy in St. Martin's Lane (the only place where artists could draw from the nude model and receive instruction) where he learned to draw and paint. His first major print appeared in 1724, *Masquerades and Operas* or *The Taste of the Town*, a scathing attack on the vogue for Italian opera, the fashion for fancy dress masquerades and pantomimes, as well as a swipe at William Kent and Lord

A country dance, a plate from William Hogarth's The Analysis of Beauty *(1753), the painter's treatise in which he argues in favour of the serpentine Line of Grace as the formal basis of aesthetic theory.*

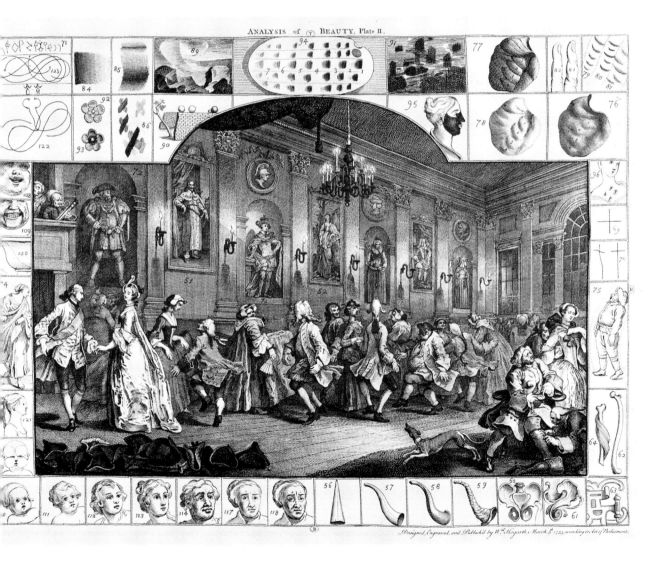

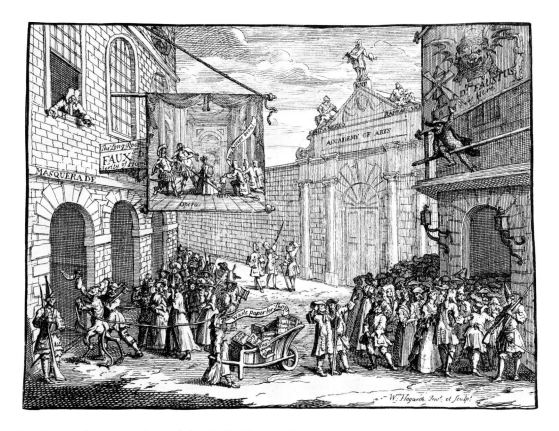

Burlington's promotion of the Palladian style. His next eruption on to the scene came as the painter of no less than five versions of *The Beggar's Opera* which brought together everything which obsessed him most, from low life to another tilt at Lord Burlington.

The mainstream of his work during this period, however, was conversation pictures, a new form of group portrait which had its origins on the Continent but which mirrored exactly the new conviviality of polite society. Hogarth had a natural skill for catching a likeness but in the end he was to view these pictures as 'a kind of drudgery'. By that time he had hit upon the format which was to ensure him immortality. He decided, in his own words, 'to turn my thoughts to a still more new way of proceeding, viz painting and Engraving modern moral Subjects, a Field unbroke up in any Country or any age . . .' 'My picture,' he wrote, 'was my stage and men and women were my actors . . .'

A Harlot's Progress (1730) appeared in engraved form in 1732. It had attracted over

Hogarth's satire Masquerades and Operas *(1724) attacks fashionable fads for both. To the left the opera impresario Heidegger leans out of a window welcoming those who flock to the Italian opera, a scene from which is on the billboard, while, to the right, another crowd presses to get into a masquerade while someone trundles away the works of Shakespeare and other playwrights as so much rubbish. In the background atop a Palladian arch Michelangelo and Raphael 'worship' another of Hogarth's bêtes noires,* William Kent.

twelve hundred subscribers and made the artist a small fortune. Hogarth was an astute businessman, executing and marketing the engravings himself, cutting out the middlemen. The idea of a series of pictures on a moral theme as a story sequence was absolutely innovative and in them Hogarth revealed himself to be both a storyteller and a satirist in the great tradition. He also had the rare judgement to be able to indulge in narrative social comedy of a kind which could also be enjoyed by its victims. And *A Harlot's Progress*, which told the story of a country girl's arrival in London and downward spiral into prostitution, had plenty of recognisable people in it. Resembling in a way a medieval morality play recast for Georgian London, these were ambivalent images which could be read many ways by the viewer. In them Hogarth was able to indulge in displays which were prurient but set within a framework which was unanswerably edifying.

A Rake's Progress (c.1733) repeats the formula. Hogarth's Tom Rakewell is a bourgeois who is seduced into a way of life he cannot possibly afford. Beneath it all he retains a sensibility so that in the end his mind snaps and he ends in the madhouse. With *Marriage à la Mode* (c.1743) these sequences reach their highest point in the story of the consequences of an arranged match between an alderman's daughter and the syphilitic son of a bankrupt earl. Others followed, but only in the form of engravings aimed at reforming the apprentice classes, among them *Industry and Idleness* (1747) and *The Four Stages of Cruelty* (1751). By that date Hogarth had become a survivor from an earlier age.

Hogarth was a mass of contradictions but he remains a genius, a great humanitarian, a man who cared about the fate of his fellow artists, of foundlings left on the London streets, and animals. It was Hogarth who was instrumental in persuading Jonathan Tyers to commission canvases by contemporary British painters for Vauxhall and who offered his services free to St. Bartholomew's Hospital to decorate its staircase, rather than see the commission go to an Italian. Although a failure as a history painter himself, he executed works as gifts for the new Foundling Hospital and set in motion its role of bringing together works by British painters in a venue which was visited and patronised by everyone of note of the day. His portrait of the hospital's founder, Thomas Coram, depicts a warm-hearted merchant endowed with the trappings of a baroque prince. It was Hogarth, too, who fought for a copyright act for artists which he got in 1735. Like Shakespeare his name has become an adjective evoking at once a whole world, one of telling details, from a cosmeticised face to a cat climbing up the back of a chair. Nothing escaped his unerring eye for the follies of this world and the sad reality of human weakness. From him was to stem the mighty stream of British caricature and cartoon but in the case of painting he was to

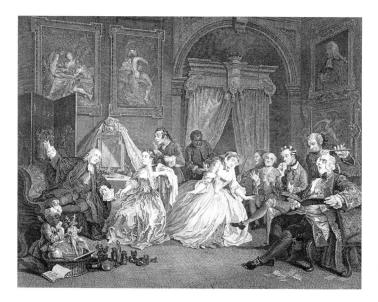

A scene from one of Hogarth's modern moralities, Marriage à la Mode *(c.1743), a series which attacks property marriages, a daughter of a wealthy businessman being sacrificed for a title. Here, the new countess is depicted at her toilette, with her lover suggesting a visit to a masquerade of the kind depicted on the screen. To the left an Italian castrato sings.*

be on the losing side against those who advocated the Great Tradition.

The opening decades of the eighteenth century make up some of the most complex and exhilarating in the country's cultural history. Everywhere one looks there is an extraordinary energy and drive, a feeling as to the possibility of things. At the same time the temptation to view the era solely through the eyes of hindsight has to be resisted. At its most misleading it presents a picture of a calm, united and triumphant Augustan age, the consequence of the Revolution of 1688 and the Hanoverian succession of 1714. The reality was that the country in the half century after 1688 was not only politically but culturally divided. Large swathes of the population would have welcomed a Stuart restoration which remained a possibility until the defeat of the Young Pretender in 1745. Up until then and beyond, above all in Scotland, there existed a vigorous Jacobite sub-culture expressed in a coming together of elements of Stuart high culture with folk elements such as songs and ballads.

In the case of the former we can trace Jacobitism in a range of symbols and references from Virgil's Aeneas, the exiled, wandering prince of the *Aeneid*, to allusions to that old Elizabethan myth of the return of Astraea and the golden age. Scholars argue as to how widespread that sentiment was, for it calls for an ability to read between the lines. Early Georgian government kept a firm lid on political dissent, so that those who opposed learned how to write in such a way as to be seemingly inoffensive and yet for those who recognised the signs and signals the meaning would be far different. In the higher cultural reaches Lord Burlington was not alone (there are other instances of 'Jacobite architecture'), for in the case of writers' works as diverse as Thomas

Otway's *Venice Preserved* and, later, Thomas Gray's 'The Bard' have been argued to be crypto-Jacobite. Pope's affinity, through his Catholicism, with the Stuart cause is at times only thinly concealed. In the case of England much of this must remain conjectural; in that of Scotland, Scottish nationalism and a cult of the Stuarts became inextricably linked.

In spite of this, as the decades of Hanoverian rule progressed there were accelerating moves towards creating a culture which was British, increasingly so after the Act of Union of 1707 which united England and Scotland. That consciousness was slow to develop but in 1750 the pace was beginning to quicken. Until the third quarter of the eighteenth century the cultural primacy of France was unchallenged. The court, the aristocracy and upper classes all read and spoke French as the *lingua franca* of European polite society. A period in France learning the language and a visit to Versailles were as important as a sojourn in Italy for those who made the Grand Tour. Figures of the stature of Voltaire and Rousseau enjoyed a European fame as representatives of the culture of the country which was the acknowledged home of the Enlightenment. In England it was only the middle classes who saw the French as the enemy and, worse, Roman Catholic, and who fostered a suspicion of all things foreign. Only with the outbreak of the French Revolution in 1789 were all the various elements to come together to create a coherent national cultural tradition, one to which all members of the educated classes could subscribe. Until then all cultural roads led first to Paris and then onwards to Rome.

Hogarth's own engraved trade card.

THE GRAND TOUR AND AFTER

In 1711 John Talman, the virtuoso son of the architect William Talman, suggested to Lord Cornbury, then in Rome on the Grand Tour, that he should commission a picture. The subject matter was to be as follows: 'Learning and Arts as the Chief accomplishments of a Nobleman in order to render himself an ornament to his Country, showing Queen Anne receiving a group of Grand Tourists returning from Italy, surrounded by works of art and led by Minerva.' In this way Talman was depicting in allegorical terms what was to be a recurring theme of eighteenth century English culture, the transference of the classical tradition from the seat of its Latin origins, Italy, to the island of Britain. The great Whig aristocracy, who were in the political ascendant for the first half of the century, saw themselves as grave Roman senators. Indeed, often in their portraits and on their tombs they chose to be depicted thus, clad in toga, cuirass and sandals, although still bewigged. It was Ancient Rome that they identified with, both republican and early imperial. In the case of the former it was as representatives of a free democratic system as against the absolutism which prevailed on the Continent; in that of the latter it was the reign of the Emperor Augustus, a cultural golden age of patronage and creativity. And just as the Romans then had voyaged to Greece to seek inspiration for their own cultural renaissance so now it was the turn of the British to travel to Italy to accomplish the same end for their own country. Britain was seen not only as inheriting this cultural mantle but also the one of empire, as her victories spread her colonies and her commercial dominance across the globe. This was an age which had a deep-seated belief in the role of individual creative genius, in man's ability to scale the heights through academic study, industry and rational discourse. As a consequence, for the first time, the classical world was there not only as a source of inspiration but to be emulated and hopefully surpassed.

'After the manner of the Ancients' is a phrase which reverberates through the era. Up until the eighteenth

The Italian artist Pompeo Batoni painted virtually everyone of note who made the Grand Tour. Colonel William Gordon of Fyvie was a younger son of the Earl of Aberdeen. He sat in Rome in 1766 for this portrait in which Batoni arranged the tartan drapery as though it were a toga, surrounding the sitter as usual with items to evoke antiquity, a seated figure of Roma and a panorama of the Colosseum.

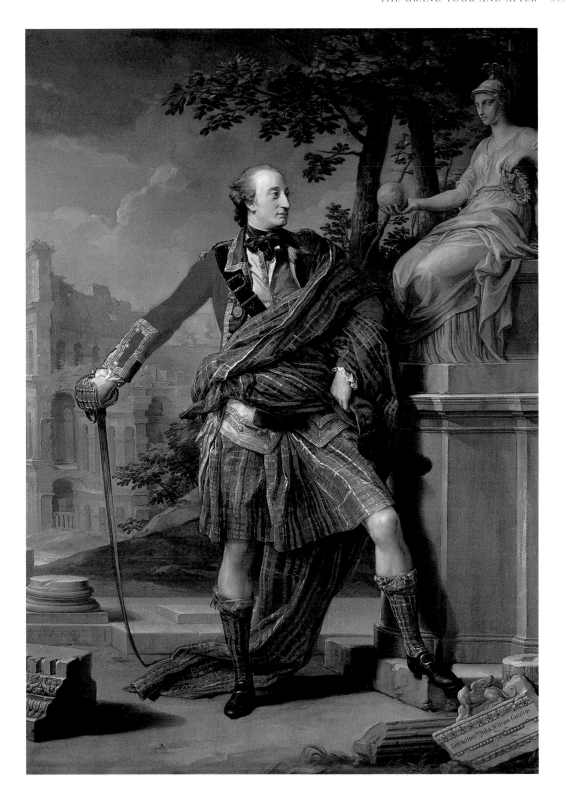

century knowledge of the classical world was sparse, confined in the main to what could be garnered from texts and illustrated books. Those, like the great Earl of Arundel and John Evelyn, who had actually seen the ruined reality of Ancient Rome through travel were few. Now all of that was to change as continental travel became one aspect of the consumer revolution which swept through not only the social élite but also extended more and more to those designated 'the middling sort', men of the new professional classes. As a result what was called the Grand Tour became a common experience shared by a vast swathe of the British ruling classes, so much so that those who had not experienced it, like the painter William Hogarth, were to be bitterly resentful of those who had, and of what they imported and represented.

But what was the Grand Tour? It was an acknowledgement of what Dr. Johnson was to put so eloquently: 'All our religion, all our arts, almost all that sets us above savages, has come from the shores of the Mediterranean.' Travelling abroad to view foreign countries in order to study their politics and customs was established as far back as the Elizabethan era. Indeed Francis Bacon in his essay *Of Travel* (1615) regarded it as an essential part of the education of any ambitious young man. But those who actually went were few because of wars, and more especially because of the theological divide which virtually closed Italy to Englishmen. The actual expression 'Grand Tour' was first used in the French translation of the *Voyage or Compleat Journey through Italy* written by a Catholic, Richard Lassels, published in 1670.

After the long wars against Louis XIV peace came at last, and although the first half of the century was not devoid of conflict travel became easier than ever before, and Enlightenment attitudes to religious belief began to thaw the religious divide. The golden decades were those following the Treaty of Paris in 1763. In that year Johann Winckelmann, the great German classical scholar, recorded that there were three hundred Englishmen in Rome simultaneously. This was the period when Britain became the richest country, with an ever-expanding empire opening up new commercial opportunities around the globe. There was money to spend on an unprecedented scale, one which, in the past, had rarely passed beyond royalty or the richest members of the aristocracy. As a consequence over six hundred country houses were built between 1760 and 1800, virtually all of them in the classical style and the majority during the two decades after 1760. Britain's cultural status also began to ride high, lifted internationally by the unparalleled prestige of Newton within the intellectual circles of the European Enlightenment. The idyll was only shattered by the loss of the American colonies and the French Revolution. The latter effectively put an end to the Grand Tour.

Peace having come, the British set out to cross the Channel and view the home of

the classical heritage which, through their education, they had come to cherish. That they did so was also prompted by the poor education offered at both Oxford and Cambridge, then in a state of decline. After Eton or Westminster the universities were replaced or supplemented by a sojourn of up to five years on the Continent. In the case of Thomas Coke, 1st Earl of Leicester, it lasted as long as six. No other country matched Britain in the sheer numbers of people who went on the Grand Tour, so much so that it became in essence a British phenomenon. It also covered a remarkably wide spectrum of society including both aristocrats and commoners, patrons and collectors, artists and designers, and, in addition, many women. Taken together those who went made up what has been described as a 'virtual' or 'invisible' academy.

The serious side involved learning foreign languages, studying the history, politics and laws of each country. That also embraced looking at architecture, art and antiquities. A young man was expected to return endowed with all the attributes that would enable him to move with assurance in international courtly aristocratic society, being fluent in at least French, graceful in his deportment and polished in his manners. Such a young person did not of course embark on the tour ill-equipped, for he would have been reared on classical texts and could even have read the works of writers such as Dante, Boccaccio and Tasso. He would also have been familiar with Italian music and opera. Such young men travelled either singly or in groups, under the supervision of what was called a bear-leader. For great aristocrats who travelled alone there was a governor. In either instance, these people tended to be antiquarians, often fussy incompetent clergymen, pedagogues or place-seekers; they had great difficulty in controlling their charges who were not only their social superiors but more often than not were far more bent on savouring the women of a town than visiting its distinguished buildings.

The route that was taken became a more or less fixed one. Over the Channel to Calais it began in the Low Countries and France, passing south to cross into Italy either by mountain pass, over Mont Cenis, to Turin or by sea from Marseilles to Genoa or Livorno. Then followed the *giro d'Italia*: Florence, Rome, Naples, back to Rome and up over the Apennines to Venice. Then Vicenza, Verona, Milan and thence to Switzerland, Germany and back to Calais and home. Travelling was not easy and contemporary accounts, of which there are many, form an unending hymn of complaints about bad roads, poor inns, coaches devoid of springs, fear of plague, awful food and venal customs officials. French being the *lingua franca*, some months were usually passed at an academy in the Loire area learning the language as well as being instructed in social graces like dancing and fencing. To appear in Paris a man had to re-dress himself from head to toe. Visits to the great buildings, libraries and art col-

lections there were *de rigueur* but no one seemed to have much time for the city which was regarded as filthy. Versailles, the seat of the French court, was also deemed an essential experience but liked even less, pronounced by Smollett to be 'a dismal habitation' and by Horace Walpole a 'lumber of littleness.'

Italy, however, was something quite different. It was Parnassus, the Elysian Fields and the Garden of the Hesperides all wrapped into one. Travellers arrived with a preconceived notion of the country, a nexus of ideas, often vague and inaccurate, which, to the generation which came of age in the unique liberal political regime which emerged after 1688, made Italy a kind of paradise. But only in retrospect, for the country was now visited with minds and eyes firmly fixed on the past, on Ancient Rome and the Renaissance. The Italy of that time, a series of self-contained weakly governed states, was looked upon with a withering condescension. In vain will one look for references to many of the great living artists, an architect like Juvarra or a painter like Tiepolo. Nonetheless, as Joseph Addison wrote in his *Remarks on Several Parts of Italy* (1750): 'There is certainly no place in the World where a Man may Travel with greater Pleasure and Advantage than in Italy.' That pleasurable vision was largely formulated by pictures, the harmonious classical landscapes of Claude with their idyllic calm and diffused golden sunlight or the soul-stirring grandeur of the sublime scenes of Salvator Rosa with their sinister mountains, jagged rocks and shattered trees. To that they were to add the architectural fantasies of the artists Pannini and Piranesi and the perpetual pageant of Venice as caught by Canaletto and Bellotto. And at the heart of it all lay the lure of actually seeing the reality of classical antiquity, known about virtually only from literary texts.

The time of the year to reach Italy was autumn, the visitor heading south for warmth during the winter months. Movement was also conditioned by the need to catch certain great festivities and spectacles, carnival in Rome, Venice or Naples, Holy Week in Rome and Ascension Day in Venice. Four cities were critical to every traveller: Florence, Rome, Naples and Venice. Even more than in the previous century Italy was seen to be the fount of art, literature, philosophy and music. This was therefore the Grand Tourist's cultural mecca.

These tours were greatly facilitated by diplomatic representatives and other British residents in Italy. Such people were able to open doors, arrange for licences to visit and excavate archaeological sites, and also introduce travellers to dealers in old master paintings and antiquities. Horace Mann, for example, was resident in Florence for half a century entertaining everyone who passed through the city to view its fabulous art collections, both old master paintings and legendary classical statues such as the 'Venus de'Medici', 'The Dancing Faun' and 'The Wrestlers.' This experience of the

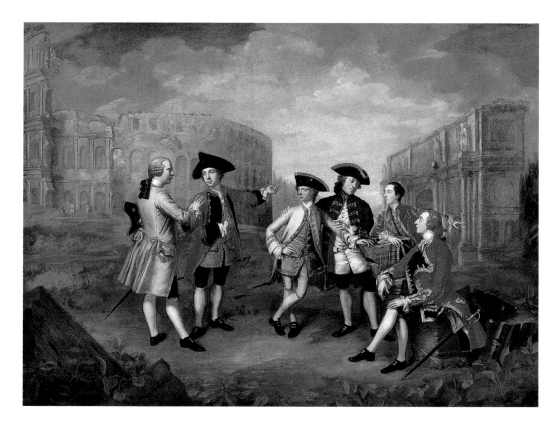

classical world would reach its climax in Rome which was one long series of visits to historic sites as well as tours of the great sculpture collections in the Capitoline Museum and the Museo Pio-Clementino. Then there

British connoisseurs in Rome, c.1750, responding with animation to the relics of classical antiquity, the Colosseum and the Arch of Constantine.

were excursions to Tivoli to view Hadrian's Villa and along the Appian Way to inspect the tombs of the Roman nobility as well as to Lakes Nemi and Albano. Direct contact with the Jacobite court had to be avoided and also with the papal court, although its art treasures, headed by the greatest works of Michelangelo and Raphael, had to be seen as the summit of painterly achievement. And of course many sat for their portraits, for it was cheap. Some two hundred sat for Pompeo Batoni, giving us a unique gallery of these young men endowed by his brush with a sensuous high glamour as they posed nonchalantly amidst the ruins of imperial Rome.

Travelling south the visitor entered the Kingdom of the Two Sicilies with its capital Naples. Naples at that date was the third most populous city in Western Europe. With its miraculous climate and its breathtaking bay, not to mention the threatening backcloth of Mount Vesuvius, Naples offered the traveller astonishing contrasts. And, in 1768, Sir William Hamilton arrived as ambassador. He was to remain for almost

thirty years, a presence rendered legendary by his liaison with Emma Hart whom he married in 1791. To him this stunningly beautiful young girl was a maiden from classical antiquity returned to earth, a living art object parallel to items in his fabled collection of antique vases. His first collection he sold to the British Museum in 1772 with the object of informing not only antiquaries but also artists. The great potter, Josiah Wedgwood, and his partner, Thomas Bentley, were to make a fortune manufacturing reproductions of them. For the serious visitor Naples was the home of the poet Virgil and it was possible to visit what was thought to be his tomb and grotto at Posillipo. They were also able to see the Temple of the Cumaean Sybil and Lake Avernus where Aeneas, the hero of the *Aeneid*, had made his descent to Hades. Later in the century they pushed further south to inspect the temples at Paestum. Earlier they had all the excitement of the excavations at Herculaneum (1731) and Pompeii (1748), seeing more of classical life than had ever been seen before. And there was always the terrifying ascent of Vesuvius to be made when soles of shoes were scorched by the heat of the lava.

Venice had maintained continuous relations with England for over a century. The republic was admired for its political stability and seeming prosperity. There the consul, John Smith, and others acted as dealers and brokers for works of a school of painting for which the English had long had a passion. In the great public buildings and churches they could drink their fill of Titian, Tintoretto and Veronese. Along the Brenta were dotted the villas of Palladio and in Vicenza they could savour the major concentration of his work including the Teatro Olimpico. Venice must always have been an extraordinary revelation, contradicting as it did everything that epitomised English upper class life, for there were no country houses as such, no horses and no outdoor field sports.

Italy was shopping. In spite of the consignments of old master paintings, works in *pietra dura* and *scagliola*, bales of rich textiles and Venetian glass, the greatest prize of all was the acquisition of classical antiquities: sculpture, vases, cameos, gems, coins and medals. Gavin Hamilton, the Scottish painter and dealer, wrote to the collector, Charles Townley, in 1779: 'Never forget that the most valuable acquisition a man of refined taste can make is a piece of fine Greek sculpture.' The purchase of antiquities obsessed the British. In Rome it was in the control of two men, Thomas Jenkins and James Byres, who saw to it that the flow, for example, of antique cameos never quite dried up nor that of antique busts and statues which were 'restored.' The papacy moreover was anxious, in the aftermath of the collapse of the Jacobite cause, to restore relations with Britain and so granted licences to excavate, always with the proviso that the pick of what was found went into the papal collections.

As a result the British took a leading part in what was a renaissance in archaeological scholarship. A whole series of grand publications appeared which provided measured drawings and views of what had been discovered. The consequence was to change people's perception of the classical past. Suddenly antiquity ceased to be part of a single stream flowing down to the present. It became instead another country as periods began to be compartmentalised one from the other: Antiquity, the Dark Ages, the Middle Ages and the Renaissance. Books which came out from the 1750s onwards were to fuel a dramatic change in visual style, one which we associate with the word neo-classical. The earliest was Robert Wood's *Ruins of Palmyra* (1753) followed four years later by his *The Ruins of Baalbeck*. James 'Athenian' Stuart and Nicholas Revett went to Greece and in 1762 produced the first volume of their *The Antiquities of Athens*. Two years later followed Robert Adam's *Ruins of the Palace of the Emperor Diocletian at Spalatro* [Split] in

Classical antiquity transported. Charles Townley's house in Westminster was open to those who wished to inspect his collection of antiquities. It contributed greatly to the emergence of the neo-classical style.

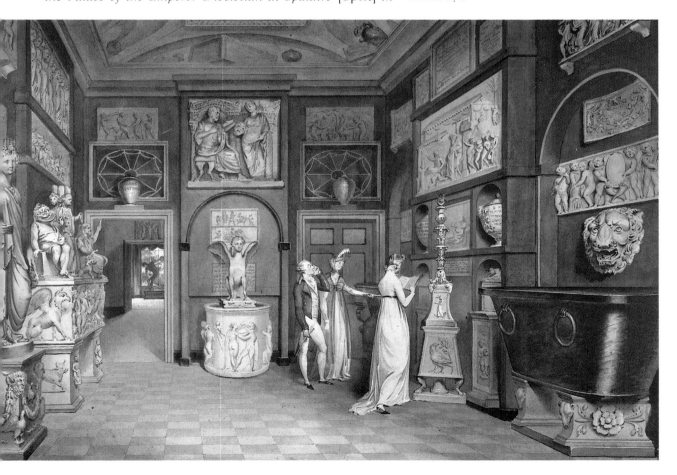

Dalmatia. These and others by both English and foreign writers recorded not only the Roman world as it had manifested itself in places hitherto unrecorded but began to push back in time and begin the rediscovery of Greek civilisation.

Such a ferment could only have major repercussions at home. Many of course may have returned from the Grand Tour with only confused memories and a sigh of relief or, as Lady Mary Wortley Montagu tartly put it: 'The boys only remember where they met with the best Wine and the prettyest Women.' But a minority responded, returning with their minds enriched, bringing to English culture a cosmopolitan influence, a refinement of manner and an intellectual curiosity which in fact brought about a lasting change in English art, architecture, music and manners.

Although the greatest age of collecting had yet to come, the Grand Tour began to fill the country and town houses of Georgian Britain with works of art. In houses like Saltram (Devon), Corsham Court (Wiltshire), and Felbrigg Hall (Norfolk), special cabinet rooms were built to accommodate what their owners had brought back. An aristocrat like the 2nd Marquess of Annandale returned in 1720 with over three hundred pictures for his great house at Hopetoun. These often included copies of some of the most famous Italian works by Raphael, Titian, Guido Reni and Correggio which were far more valued than originals by lesser artists. Then there were the sculpture collections. Here interest focused less on fragments, whatever their quality, than on complete pieces. To purchasers the subject matter of a piece of classical sculpture

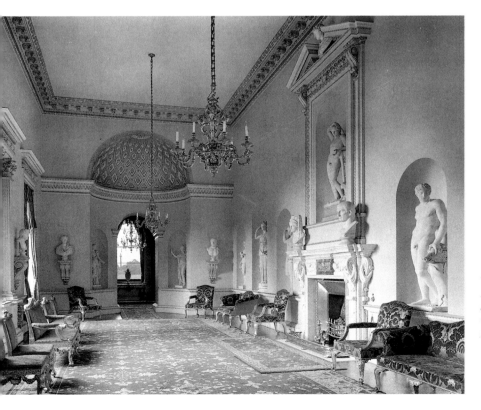

The Statue Gallery at Holkham Hall, Norfolk, built during the 1750s was designed to display the collection of Greek and Roman sculpture acquired by Thomas Coke, 1st Earl of Leicester.

was of far more importance than any claim to its authenticity. Restoration and general fakery in response to demand was rife. But now the sculpture galleries of Arundel and Burlington were to spawn their progeny in houses like Holkham (Norfolk), Petworth (Sussex), Chatsworth (Derbyshire), Woburn (Bedfordshire) and Newby Hall (Lincolnshire). In these cases special galleries were built for their display. In most houses the gesture made was to relegate the family portraits to back passages and transform the entrance hall into a classical pantheon.

Such collections were evidence of something else, the evolution of the virtuoso into the connoisseur. The virtuoso of the previous century had filled his cabinet with curiosities which could range from medals and gems to minerals and shells. A collection was viewed as assembling a compendium of God's miraculous creation of the natural world and its transmutation at the hands of art. The connoisseur in the eighteenth century was someone far different. His eye was able to differentiate the work of the master from the hand of his assistant or studio in the case, for instance, of a painter. Collections now became assemblies of the new fine arts, painting, sculpture, drawings, classical antiquities, prints, gems and medals. The prize exhibits of the virtuoso's cabinet, items like a unicorn's horn, were relegated, evidence of the old world picture which the Enlightenment had banished. To be a connoisseur moreover proclaimed that one had been on the Grand Tour, for only through that could such pronouncements of the discerning eye be cultivated.

In no area was that vision of Britain as Ancient Rome reborn more evident than in architecture and interior decoration. This was the classical century as houses were either built or rebuilt by owners who had been on the tour. Everywhere one looks the same neo-classical vocabulary occurs of anthemion and patera, winged griffin and tripod urn. The classical style and repertory of decoration swept its way through interior design embracing every artefact from door furniture to carpets, from plaster ceiling to the plates on the dinner table. Once taken up it was to change the living style of members of the 'middling class' who would never even have the chance of foreign travel.

Rome in the 1750s was full of young British architects studying the remains of antiquity, among them the two men who were to dominate the architectural scene during the decades following the 1760s, Sir William Chambers and Robert Adam. Both were exponents of the emerging neo-classical style which had been initially pioneered by French and Italian architects in a quest to peel away the later accretions of the Renaissance and baroque periods in a search for first principles. The new attitude to the past brought about through the recent archaeological discoveries meant that architectural style ceased to be part of an historical continuum but instead

became a choice from one of a series of period compartments. Both Chambers and Adam in their separate ways were to wrestle with the consequences of this in their respective careers. Both were fundamentally classicists and their work, symptomatic of a vast array of new building which went on all over the country in the classical manner, seemed to stem from the assumption that a nation which was the focus of an empire exceeding in scale that of Ancient Rome called for a style which spoke of imperial grandeur.

Chambers studied in both Paris and Italy, where he spent five years. In 1755 he returned to England gaining an introduction to the future George III, thus securing royal favour. Throughout the 1760s and 1770s Chambers was responsible for a whole series of town and country houses, but he was unique in having the opportunity to design the only major public building of the century, Somerset House. That its predecessor was Greenwich Palace, begun in the 1660s, is some indication of the absence of royal initiatives. Elsewhere in absolutist Europe the palace was still the major vehicle. In Britain that role had been passed to the aristocratic country house. The Hanoverians never built a great palace, failed even to rehouse Parliament, although the schemes were many. In 1775, however, the idea of putting various government departments under a single roof was mooted. Old Somerset House was razed to the ground and the present building arose, magnificent in parts, monumental in scale but always somehow falling short. Perhaps the very multiplicity of functions that it was meant to fulfil (including housing the Royal Academy of Arts in its early stages) eroded its focus. It is nonetheless Chambers's masterpiece, thoughtful, sensitive, yet episodic. Its courtyard has been likened rightly to that of a Georgian town square.

Chambers ended a knight of the realm and that reflected the shift in status which was affecting the professions. In the past, in the case of architects, they had either been carpenters or masons or they had been gentlemen, like Lord Burlington, who practised architecture at a remove. But with the new polish and learning acquired by the Grand Tour the architect was seen gradually to take on the status of gentleman in his own right. On the tour these young hopefuls would have mingled with and met their future patrons on virtually equal terms. That the divide was only gradually eroded can be learnt from a letter written by Robert Adam while he was still studying: 'If I am known in Rome to be an Architect, if I am seen drawing or with a pencil in my hand, I cannot enter into genteel company . . .' Adam was to be one of the men who was to change all of that.

Adam has given his name to a style which conjures up a whole epoch. It is one which is instantly recognisable, a unique synthesis uniting columns and carpets,

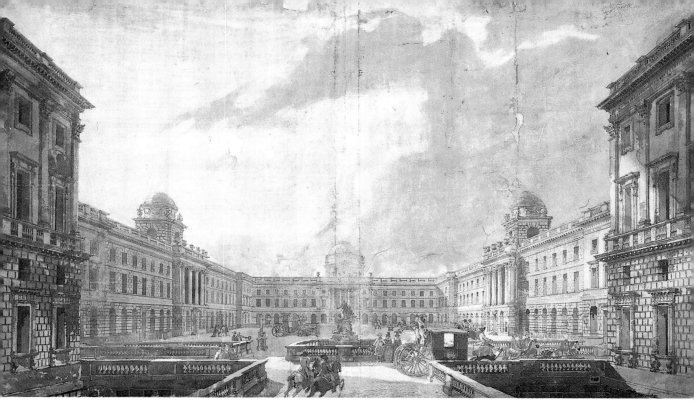

pedestals and porticos in a single visual evocation of the world of Greece and Rome. Adam, the son of a landed Scottish architect, had only one ambition in life, to dominate the architecture of his age. He embarked on his

career with the advantages of a good education and of foreign travel and study in Italy. Even while in Rome in the 1750s he knew that his only possible rival was Chambers, categorised at that date as a 'formidable foe.'

Adam arrived in London in 1758 setting himself up jointly with his brother James in the grand manner as the social equal of his clients. His publicity machine knew no bounds, he himself proclaiming: '. . . to have brought about in this country, a kind of revolution in the whole system of this useful and elegant art.' His was a vision of a new architecture based on his own response to the public and domestic building of imperial Rome as revealed through the new archaeology. There was no lack of wealthy patrons to whose demands he responded by providing a living style which now called for contrasting enclosures for specific social purposes, dining, playing cards, conversation or dancing. His style was to work from the fundamental idea that the Romans did not adhere to rules but that such rules as they had were elastic, to be adapted as the architect thought fit. Drawing on a wide mélange of sources Adam formed a style unique for its richness of variety and its sense of movement. The roll call of great houses from the 1760s alone is breathtaking: Harewood House (York-

shire), Croome Court (Worcestershire), Kedleston (Derbyshire), Bowood (Wilt-shire), Syon and Kenwood (Middlesex). Then, in the 1770s, followed a series of splendid town houses of which his surviving masterpiece is Home House, Portman Square. Such houses responded to the elaboration in entertaining as hostesses out-vied each other in the ostentation and elegance of their interiors. In addition he embarked on a series of property developments, including the Adelphi, which was to prove a disaster and nearly bankrupted him.

The war with the American colonies and the French Revolution brought an end to the boom. Also, taste changed, and Adam became the target of criticism as taste-makers like Horace Walpole began to label him as a purveyor of 'gingerbread' and 'sippets of embroidery.' Money was tighter too, so Adam looked northwards to Scotland. In his later years he worked on Charlotte Square in Edinburgh, and, surpris-ingly, on a series of Scottish castles. Culzean for the Earl of Cassilis remains his mas-terpiece in that seemingly puzzling genre. Within, its rooms are neo-classical but outside, at first glance, it would seem to have little connection with what had gone before. But in Adam's view of history castle architecture was a direct descendant of the architecture which the Romans had brought to Britain. In his squaring of the medieval castle into the classical tradition he is in fact touching something central to the age, the desire to reconcile the two as twin aspects of a single civilisation.

The significance of Adam was to be far wider than any other architect of the period because he gave birth to what we know as the 'Adam Style', one still recognisable at a glance and one also which crossed not only this country but Europe and the United States, where it is known as the 'Federal Style'. The reason that this was so is because Adam's work coincided with the building boom of the 1760s and 1770s. His influence was huge because he provided a synthesis of the latest fashions, drawing on old and new, which could be applied to all manner of buildings, both public and private as well as large and small. His *Works in Architecture* (1773) gave everyone access to the ingredients of the style in which ponderous Palladianism was banished as well as the fripperies of the Frenchified rococo which had enjoyed some success in the 1740s and 1750s. Adam was the first architect to devise an overall integrated look to a house which ran through everything in it, from its façade to the silver on the table. The gospel of neo-classicism stemming from the British archaeologists and turned into a reality for the present by Adam was copied by countless imitators.

Although the Adelphi terraces had been a near disas-ter for the architect they set new standards in urban housing, for it was the first development in which

All the magnificence of imperial Rome was evoked by Robert Adam for this ante-room at Syon Park, Middlesex, for the 1st Duke of Northumberland. The twelve Ionic columns veneered with verd-antique scagliola *were purchased in Rome in 1765 by Robert's brother, James.*

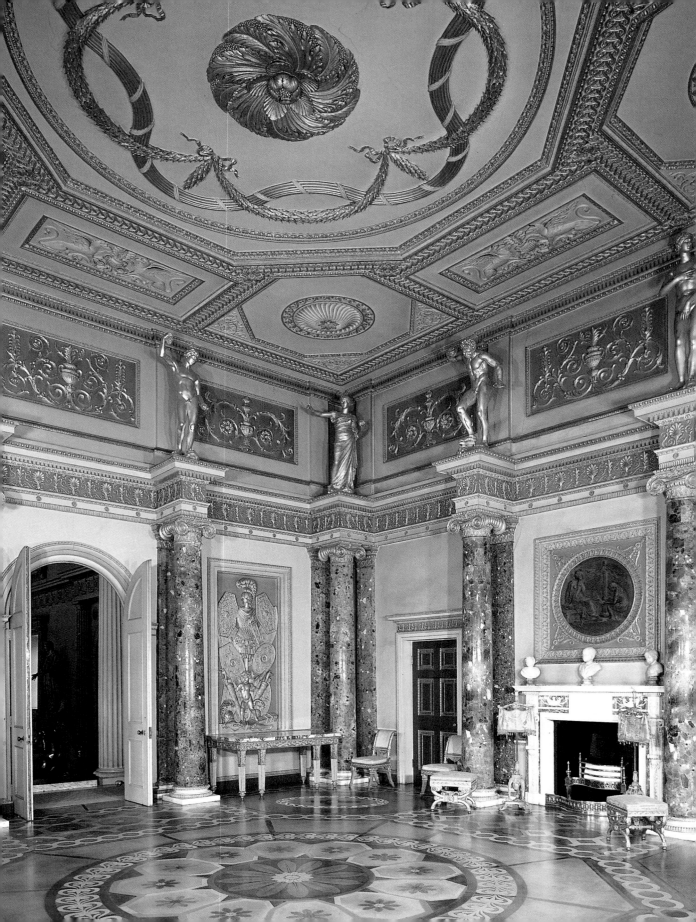

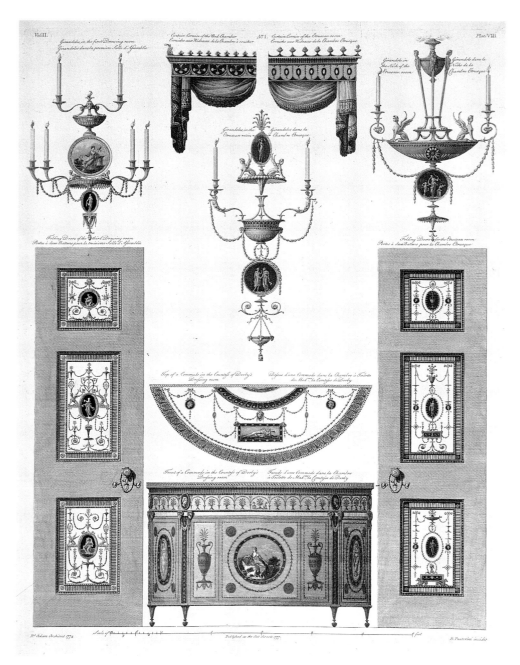

Designs for decorations for interiors from Robert Adam's Works in Architecture (1773-78). Strong architectural forms are set off by delicacy of line combined with the use of a repertory of neo-classical motifs such as vases and griffins. Such a publication was a public relations exercise and spread the highly adaptable style.

The Royal Crescent, Bath, by John Wood the Younger, 1767-75, showing how vertical town houses were united to form a single sweeping classical composition which became the model for the next half century.

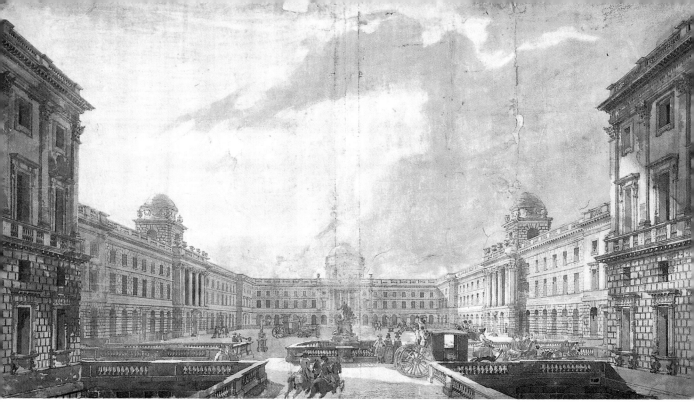

The courtyard of Sir William Chambers's masterpiece, Somerset House in the Strand, built from 1775 onwards, epitomises the triumph of neo-classicism.

pedestals and porticos in a single visual evocation of the world of Greece and Rome. Adam, the son of a landed Scottish architect, had only one ambition in life, to dominate the architecture of his age. He embarked on his career with the advantages of a good education and of foreign travel and study in Italy. Even while in Rome in the 1750s he knew that his only possible rival was Chambers, categorised at that date as a 'formidable foe.'

Adam arrived in London in 1758 setting himself up jointly with his brother James in the grand manner as the social equal of his clients. His publicity machine knew no bounds, he himself proclaiming: '. . . to have brought about in this country, a kind of revolution in the whole system of this useful and elegant art.' His was a vision of a new architecture based on his own response to the public and domestic building of imperial Rome as revealed through the new archaeology. There was no lack of wealthy patrons to whose demands he responded by providing a living style which now called for contrasting enclosures for specific social purposes, dining, playing cards, conversation or dancing. His style was to work from the fundamental idea that the Romans did not adhere to rules but that such rules as they had were elastic, to be adapted as the architect thought fit. Drawing on a wide mélange of sources Adam formed a style unique for its richness of variety and its sense of movement. The roll call of great houses from the 1760s alone is breathtaking: Harewood House (York-

shire), Croome Court (Worcestershire), Kedleston (Derbyshire), Bowood (Wiltshire), Syon and Kenwood (Middlesex). Then, in the 1770s, followed a series of splendid town houses of which his surviving masterpiece is Home House, Portman Square. Such houses responded to the elaboration in entertaining as hostesses outvied each other in the ostentation and elegance of their interiors. In addition he embarked on a series of property developments, including the Adelphi, which was to prove a disaster and nearly bankrupted him.

The war with the American colonies and the French Revolution brought an end to the boom. Also, taste changed, and Adam became the target of criticism as tastemakers like Horace Walpole began to label him as a purveyor of 'gingerbread' and 'sippets of embroidery.' Money was tighter too, so Adam looked northwards to Scotland. In his later years he worked on Charlotte Square in Edinburgh, and, surprisingly, on a series of Scottish castles. Culzean for the Earl of Cassilis remains his masterpiece in that seemingly puzzling genre. Within, its rooms are neo-classical but outside, at first glance, it would seem to have little connection with what had gone before. But in Adam's view of history castle architecture was a direct descendant of the architecture which the Romans had brought to Britain. In his squaring of the medieval castle into the classical tradition he is in fact touching something central to the age, the desire to reconcile the two as twin aspects of a single civilisation.

The significance of Adam was to be far wider than any other architect of the period because he gave birth to what we know as the 'Adam Style', one still recognisable at a glance and one also which crossed not only this country but Europe and the United States, where it is known as the 'Federal Style'. The reason that this was so is because Adam's work coincided with the building boom of the 1760s and 1770s. His influence was huge because he provided a synthesis of the latest fashions, drawing on old and new, which could be applied to all manner of buildings, both public and private as well as large and small. His *Works in Architecture* (1773) gave everyone access to the ingredients of the style in which ponderous Palladianism was banished as well as the fripperies of the Frenchified rococo which had enjoyed some success in the 1740s and 1750s. Adam was the first architect to devise an overall integrated look to a house which ran through everything in it, from its façade to the silver on the table. The gospel of neo-classicism stemming from the British archaeologists and turned into a reality for the present by Adam was copied by countless imitators.

Although the Adelphi terraces had been a near disaster for the architect they set new standards in urban housing, for it was the first development in which

All the magnificence of imperial Rome was evoked by Robert Adam for this ante-room at Syon Park, Middlesex, for the 1st Duke of Northumberland. The twelve Ionic columns veneered with verd-antique scagliola were purchased in Rome in 1765 by Robert's brother, James.

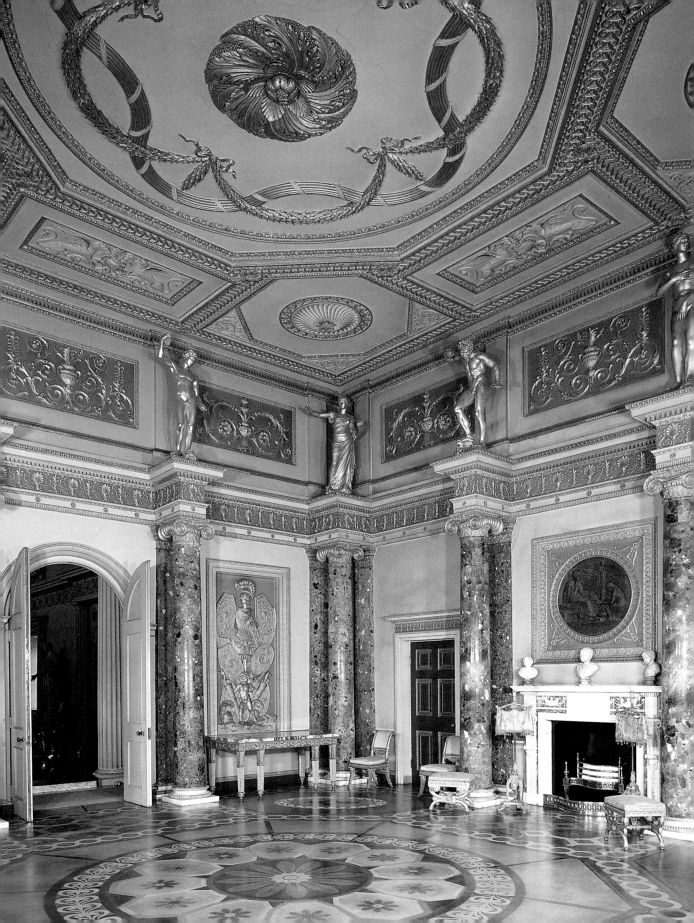

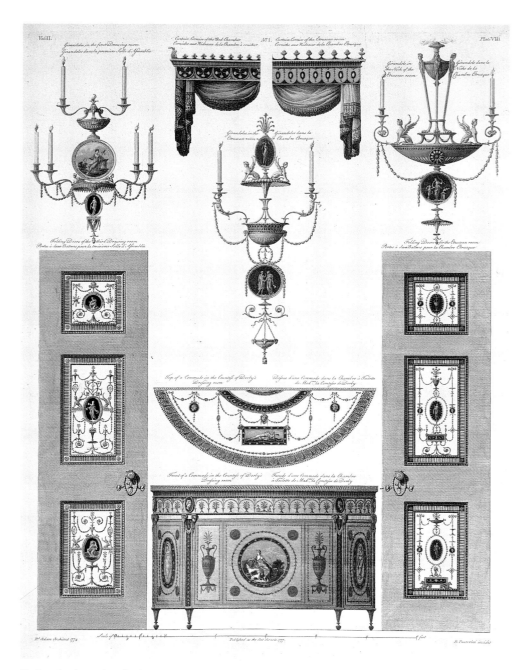

Designs for decorations for interiors from Robert Adam's Works in Architecture (1773-78). Strong architectural forms are set off by delicacy of line combined with the use of a repertory of neo-classical motifs such as vases and griffins. Such a publication was a public relations exercise and spread the highly adaptable style.

The Royal Crescent, Bath, by John Wood the Younger, 1767-75, showing how vertical town houses were united to form a single sweeping classical composition which became the model for the next half century.

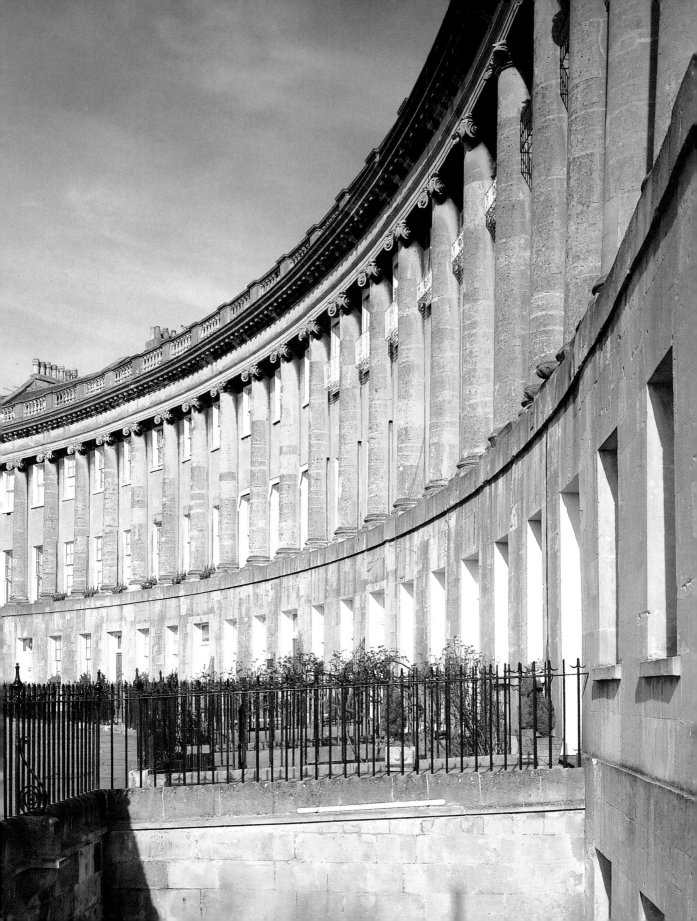

houses were conceived as a single architectural composition, striking the eye at first glance from afar as a single Italian palazzo rather than a separate series of houses. All over Britain squares, crescents and terraces arose in the new neo-classical manner, designed by far lesser architects or just put up by jobbing property speculators from pattern books which spread the style across country and down the social scale. In the 1760s Edinburgh New Town arose, and in the fashionable spa resort of Bath the earlier speculative building by John Wood of Queen Square and the Circus (begun 1754) reached a climax in Royal Crescent (1767-1775). With its monumental sweeping curve this became the model for every grandiose housing project for over half-a-century. In London Bedford Square (completed 1783) scaled new heights of elegance as each side of the square assumed the mantle of a palace façade. What set these town houses apart from their European counterparts was that they were vertical and that however modest the façades, orders and other items from the repertory of the Adam style of decoration were used in order to give both emphasis and a sense of movement. The result was a style of house unequivocally British.

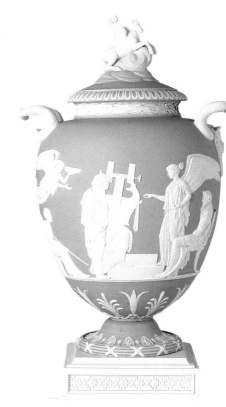

The Adam style was to be linked with two other great names, Thomas Chippendale and Josiah Wedgwood. Chippendale, like Adam, was an adept publicist. Born in Yorkshire he set up shop in London in 1753. Although he produced the first edition of his famous *Gentleman and Cabinet-Maker's Director* in 1754 it was to be the third edition in 1762 which promoted the neoclassical style. For thirty years Chippendale ran a team of some fifty craftsmen producing pieces from these designs in a range of styles which also included the rococo and chinoiserie, ones which were also copied by a host of minor workshops. His influence was to be European and stretched also into America. Chippendale furnished some of Adam's finest interiors and remained true to the neo-classical ideal.

Just as Chippendale fused the increasing demand for furniture to match the new neo-classical taste so the Staffordshire potter Josiah Wedgwood met the demand for ceramics in the same manner. With Thomas Bentley he opened his new works at Etruria in 1769. This was

Ceramics in the neo-classical style. Josiah Wedgwood's 'Homer Vase'. Such pieces were factory produced taking the new style into more homes than ever before.

factory production in a village specially built for the workmen. Wedgwood was to be the first ceramicist to harness the new simplicity and purity of the neo-classical style to everyday china. Through that and mass production what had hitherto been regarded as unattainable luxuries became generally accessible. What is so striking about the Adam Style is that it became the first to be taken up by the increasingly prosperous middle classes. It was one which could be adapted for the most modest of domestic interiors and as a consequence it has retained its hold to the present day.

Architects were not the only British artists studying in Rome in the 1750s. Painters and sculptors were too, and the impact of direct contact with the art of classical antiquity and of the 16th and 17th centuries was to be as profound on them also. Sculpture in England had been dominated by foreign artists, in the first half of the century by Michael Rysbrack and Louis François Roubiliac, the former an exponent of the baroque and the latter of a far more rococo style. Both had responded to the Augustan demand for works in the antique manner, particularly portrait busts. Joseph Wilton who had been in Rome in the 1750s returned to England with a zeal like Robert Adam's to raise the status of the artist. Wilton signals the advent for the first time of a native school of sculptors. Its greatest exponent was yet to come, the effect of contact with Italy being far less immediate than in the case of painting. That man was to be John Flaxman. He was a rare phenomenon, a British sculptor who enjoyed European fame, being praised by the great German writer Goethe, and the French neo-classical painter Ingres. Although he was not to get to Italy until he was nearly forty, Flaxman saturated himself in antiquity from youth onwards, devouring all the great archaeological volumes and studying the Greek vases from the Hamilton collection in the British Museum. The result of this was his extremely refined and elegant linear style of drawing, which eschewed the use of any shadow, and which he used for his illustrations to Homer's *Iliad* and *Odyssey*, published in 1793. These were known and acclaimed all over Europe and were re-issued many times. The same style was used by him for the many commissions which he received from the Wedgwood

The neo-classical style in graphics. A plate from the sculptor John Flaxman's hugely influential Outline Drawings to Homer *(1793).*

pottery during the 1770s and 1780s. In Italy he deliberately set out to emulate antiquity in a series of works including *The Fury of Athamas* (1790) which was commissioned by the Earl Bishop of Bristol (almost a permanent Grand Tourist and the man after whom all the hotels are named) for his house at Ickworth, Suffolk where it remains. Back in England Flaxman embarked on a series of monumental tombs in the neo-classical manner taking the style through into the 1820s.

The effect of the Grand Tour on painting was to be accomplished with remarkable rapidity in the figure of one man, Joshua Reynolds, who arrived in Rome in 1750. He also, like Adam, was bent on lifting the status of his profession, inspired by the writings of Richardson and therefore wishing to see painting as a liberal art, recognised as the visual equivalent of tragic or epic poetry. The son of a Devon cleric, Reynolds had learnt his trade, for such it then was largely viewed, in the studio of the fashionable portrait painter, Thomas Hudson. Reynolds, however, knew that he could not succeed in his mission unless he had studied antique sculpture and the great works of the Renaissance. He remained in Italy for two years and arrived in London in 1753.

His earliest portrait, painted on his return as a demonstration piece, was designed to exhibit his revolutionary powers. Nothing quite like it had ever been seen before. He depicted the naval commander, Admiral Keppel, in a pose based on the famous 'Apollo Belvedere' striding, windswept, along a stormy foreshore, the whole rendered with a rich dark chiaroscuro effect derived from studying the work of Titian and Tintoretto. From that moment on Reynolds's career was one long triumph. Up to a hundred and fifty sitters came to him in any one year and his success was such by 1760 that he moved to a large house in Leicester Square with liveried servants. But his ultimate ascent to establishment fame was to come with the creation of an academy along the lines of those usual in other European countries.

An informal academy of some kind had existed in Rome among British artists who aspired to painting history and mythology in what was called the Grand Style, that is a style modelled both on a study of antiquity and

Sir Joshua Reynolds's advertisement for his talents: the naval commander, Augustus Keppel, strides along the seashore in the pose of the famous classical statue, the Apollo Belvedere.

of the great masters of the past. But it had languished. That the idea was revived was owed to an influential gentlemen's dining club, the Society of Dilettanti, which had been founded in 1734 for men who had been on the Grand Tour and which was to be responsible for some of the major publications devoted to the new archaeological discoveries. In 1755 the notion of an academy resurfaced leading to a tortuous history involving two rival groups of artists, the Free Society of Artists and the Incorporated Society of Artists, of which Reynolds was a leading light. The latter was granted a royal charter in 1765; three years later a group seceded from it and, with the aid of Sir William Chambers, gained the patronage of George III. The Royal Academy of Arts was the result and Reynolds was elected its first President with the accolade of knighthood bestowed the following year. Not only did the Academy guarantee an annual exhibition of its members' works but it set out to provide 'well-regulated schools of

design' with a cast collection, a library, life classes, prizes and lectures. Reynolds became a leading member of a new cultural establishment, moving with ease in society and including among his closest friends Dr Johnson and Oliver Goldsmith. When he died in 1792 he had achieved what he had set out to do, elevate the insular and empirical tradition of British art to a more universal realm through becoming a living reincarnation of the old masters he worshipped. He was also to leave in his *Discourses on Art*, lectures delivered at the Academy to students and to 'people of fashion and dilettanti', a coherent body of practice so distinguished in thought and prose style that they were to earn a major place in the history of aesthetics.

That elevation should have come as the result of painting what was universally recognised as the only true form of high art worthy of the Grand Style, historical scenes and allegories. Reynolds, it is true, occasionally painted such pictures but today we view them almost as travesties of the old masters they sought to emulate. The quest to paint this kind of picture was to haunt British painters into the twentieth century. The problem resided in the lack of demand and the uniquely British obsession with portraiture, which came out of an élite culture whose focus was no longer the royal

Reynolds's portrait of Lady Sarah Bunbury sacrificing to the Graces, painted probably in 1763, epitomises aristocratic taste for the antique.

palace but the great private house. British sitters were depicted with almost unrivalled princely splendour in a way that continually astonished foreigners. Reynolds's solution to practising the Grand Style therefore was to elevate his portraits by casting his sitters into impressive roles, transforming them, whatever the reality, into heroic and poetic personages. Solemn rich colour and dramatic lighting effects enhanced sitters presented with a relaxed grandeur. The men command authority in their heavy ceremonial robes, the women exude good breeding, intelligence and sensibility. Time and again poses and effects derived from the antique and the old masters are used to glamorise them, although nothing is permitted which might erode an aura of high seriousness. In the case of female portraits contemporary dress was modified into 'something with the general air of the antique for the sake of dignity.'

Reynolds's greatest masterpiece, the family group of the 4th Duke of Marlborough, sums up in one magisterial image the fruits of this new classical civilisation born of the Grand Tour. In it the younger members of the family group romp and engage the spectators' attention, providing a foil to the reticent and dignified bearing of the parents and their eldest son and daughter. The duke's heir carries to him cases containing items from the fabled ducal collection of antique gems while the duke himself holds a magnificent cameo of the Emperor Augustus. The game the children play is indeed derived from an antique gem and a final classical gesture is bestowed in the figure presiding over the scene proffering a winged Victory. Here in one outstanding image Reynolds has gathered together the ideals of an age, combining the transference of the classical inheritance from Italy to Britain with a tribute to the splendour and taste of her ruling classes. It is a picture which speaks of the domestic virtues and of humour alongside powerful reminders of the duties incumbent upon those with a great heritage.

This classical high point with its resonances of the Grand Tour is also caught potently in the work of another artist, Richard Wilson. There again are the same impulses to lift not only himself socially but also the art of landscape painting which he practised to another sphere. He too studied the antique and the works of the old masters, in his case those of Claude Lorraine and Gaspard Dughet, in order to formulate a Grand Style. Returning from Italy in the middle of the 1750s he found, like Reynolds, little demand for mythology and history but a ready market first for views of Roman ruins and also for landscapes of his own country rendered in terms of the classical tradition. Wilton House, for instance, is glimpsed as a Romanised

Eighteenth century aspirations distilled in one image. Reynolds's group portrait of George, 4th Duke of Marlborough and his family, painted during the 1770s, records aristocratic classical culture at its most assured. The statue of Victory and the cameo of the Emperor Augustus brought to the duke by his son are just two motifs that draw on antiquity in a composition of monumental grandeur.

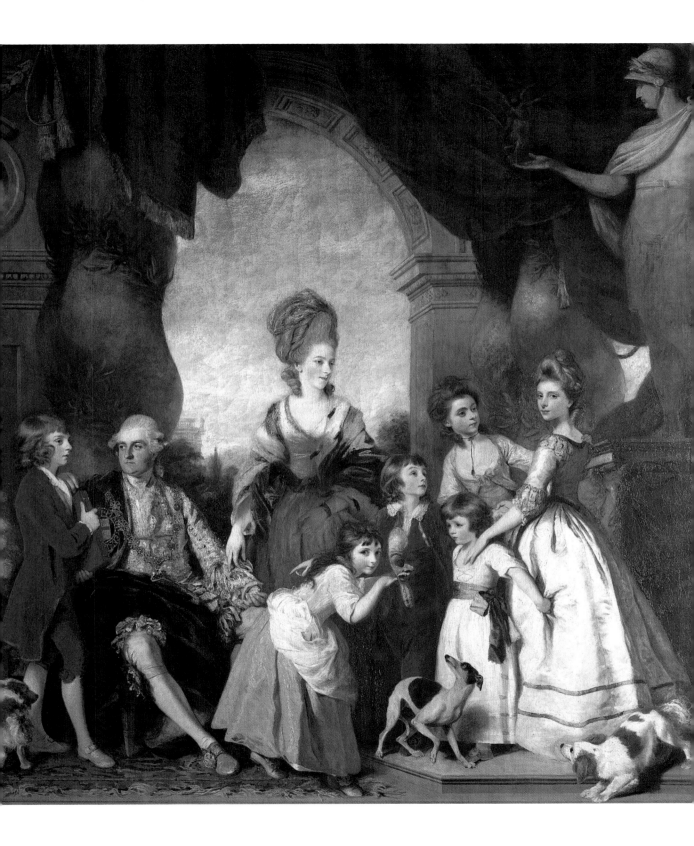

rural ideal, a vision in paint parallel to what the Augustan poets depicted in words. This is the island recast as a classical arcady caught in an unfading and effulgent

Richard Wilson's painting transforms Wilton House into a classical villa set amidst a landscape evocative of the Roman campagna, c.1758-60.

golden light. The great house looms almost incandescent as the seat of this new classical civilisation. Pliny's Tuscan villa has been transported to Britain.

In the decades after 1760 one sees evidence everywhere of the consequences of the British obsession with classical antiquity, the result of the Grand Tour. It was carried out in the spirit of a transference of both a political and cultural empire to the island of Great Britain. At the same time the island's own ancient cultural traditions were being rediscovered. The progressive urgency was to create out of these two streams a single British culture, one that could simultaneously look back to Greece and Rome but equally to the Anglo-Saxons, the barons of the Middle Ages and the heroes of Gloriana's England. And it is to that quest that we must now turn our attention.

Chapter Twenty-Seven

FORGING A CULTURE

Stowe is the largest, grandest and most important landscape garden in England. Situated on a south-facing hillside in mild, undulating country to the north of the town of Buckingham, it stretches over some four hundred acres. Its owners were the Grenville-Temples, one of the most powerful of Whig families, a network of connection which was to remain a dominant political force for over a century during which its owners ascended in rank from baronet to viscount, from viscount to marquis and, finally, from marquis to duke. Every phase of landscape garden style is encapsulated at Stowe, from the early formality of the turn of the century, with its stately walks and avenues, clipped evergreens and geometric ponds, to the sweeping informality of the genius Lancelot 'Capability' Brown (who became head gardener here in 1741), in which it seems that the native British countryside has been ordered by the artist's brush to accord to a perfection of pastoral paradise.

But Stowe is much more than a monument to garden style, for it catches vividly a particular moment in time when the notion of a common national culture began to take on substance. That it did so here came out of the politics of the 1730s as they affected one man, Richard Temple, Viscount Cobham. Cobham had been one of Marlborough's officers, married to a rich heiress, who had honours heaped upon him by the new Hanoverian dynasty. But in 1733 he fell out with Sir Robert Walpole over the Excise Bill and went into opposition, leading a coalition loosely known as the Patriots. That event was to precipitate the creation of a new scenic landscape at Stowe, the Elysian Fields, based, it seems, on an article written by Joseph Addison:

> 'The great road lay in a direct line, and was terminated by the temple of Virtue . . . The persons who travelled up this great path were such whose thoughts were bent upon doing eminent services to mankind, or promoting the good of their country . . . The edifices at the extremity of the walk were so construed, that we could not see the temple of Honour, by reason of the temple of Virtue, which stood before it . . .
>
> Having seen all that happened to this band of adventurers, I repaired to another pile of building, that stood within view of the temple of Honour . . .

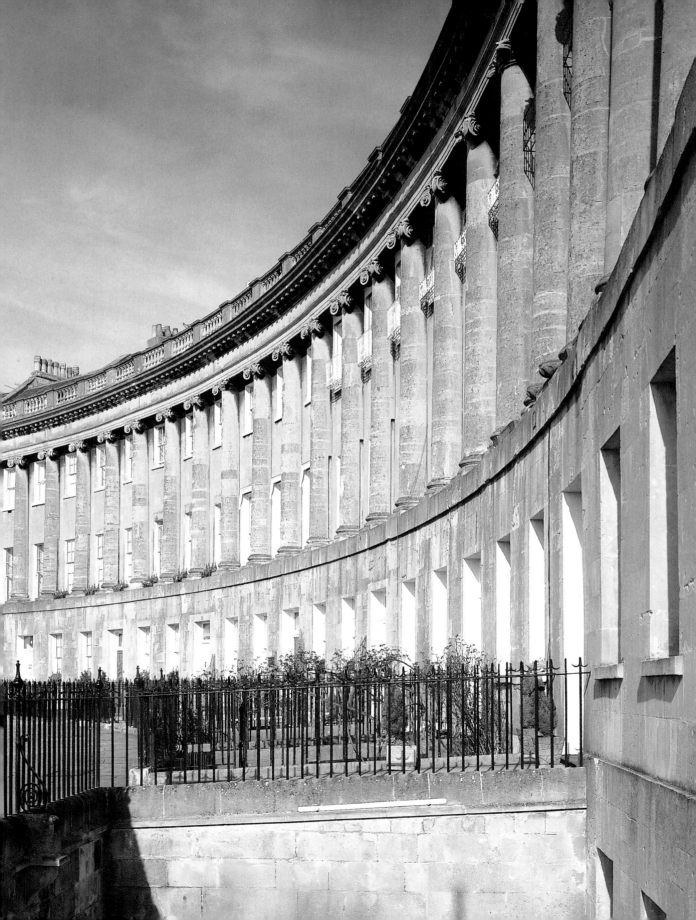

houses were conceived as a single architectural composition, striking the eye at first glance from afar as a single Italian palazzo rather than a separate series of houses. All over Britain squares, crescents and terraces arose in the new neo-classical manner, designed by far lesser architects or just put up by jobbing property speculators from pattern books which spread the style across country and down the social scale. In the 1760s Edinburgh New Town arose, and in the fashionable spa resort of Bath the earlier speculative building by John Wood of Queen Square and the Circus (begun 1754) reached a climax in Royal Crescent (1767-1775). With its monumental sweeping curve this became the model for every grandiose housing project for over half-a-century. In London Bedford Square (completed 1783) scaled new heights of elegance as each side of the square assumed the mantle of a palace façade. What set these town houses apart from their European counterparts was that they were vertical and that however modest the façades, orders and other items from the repertory of the Adam style of decoration were used in order to give both emphasis and a sense of movement. The result was a style of house unequivocally British.

The Adam style was to be linked with two other great names, Thomas Chippendale and Josiah Wedgwood. Chippendale, like Adam, was an adept publicist. Born in Yorkshire he set up shop in London in 1753. Although he produced the first edition of his famous *Gentleman and Cabinet-Maker's Director* in 1754 it was to be the third edition in 1762 which promoted the neo-classical style. For thirty years Chippendale ran a team of some fifty craftsmen producing pieces from these designs in a range of styles which also included the rococo and chinoiserie, ones which were also copied by a host of minor workshops. His influence was to be European and stretched also into America. Chippendale furnished some of Adam's finest interiors and remained true to the neo-classical ideal.

Just as Chippendale fused the increasing demand for furniture to match the new neo-classical taste so the Staffordshire potter Josiah Wedgwood met the demand for ceramics in the same manner. With Thomas Bentley he opened his new works at Etruria in 1769. This was

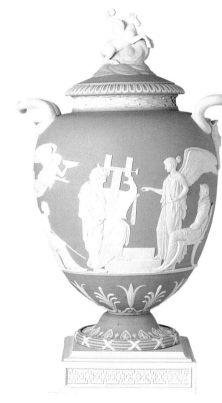

Ceramics in the neo-classical style. Josiah Wedgwood's 'Homer Vase'. Such pieces were factory produced taking the new style into more homes than ever before.

factory production in a village specially built for the workmen. Wedgwood was to be the first ceramicist to harness the new simplicity and purity of the neo-classical style to everyday china. Through that and mass production what had hitherto been regarded as unattainable luxuries became generally accessible. What is so striking about the Adam Style is that it became the first to be taken up by the increasingly prosperous middle classes. It was one which could be adapted for the most modest of domestic interiors and as a consequence it has retained its hold to the present day.

Architects were not the only British artists studying in Rome in the 1750s. Painters and sculptors were too, and the impact of direct contact with the art of classical antiquity and of the 16th and 17th centuries was to be as profound on them also. Sculpture in England had been dominated by foreign artists, in the first half of the century by Michael Rysbrack and Louis François Roubiliac, the former an exponent of the baroque and the latter of a far more rococo style. Both had responded to the Augustan demand for works in the antique manner, particularly portrait busts. Joseph Wilton who had been in Rome in the 1750s returned to England with a zeal like Robert Adam's to raise the status of the artist. Wilton signals the advent for the first time of a native school of sculptors. Its greatest exponent was yet to come, the effect of contact with Italy being far less immediate than in the case of painting. That man was to be John Flaxman. He was a rare phenomenon, a British sculptor who enjoyed European fame, being praised by the great German writer Goethe, and the French neo-classical painter Ingres. Although he was not to get to Italy until he was nearly forty, Flaxman saturated himself in antiquity from youth onwards, devouring all the great archaeological volumes and studying the Greek vases from the Hamilton collection in the British Museum. The result of this was his extremely refined and elegant linear style of drawing, which eschewed the use of any shadow, and which he used for his illustrations to Homer's *Iliad* and *Odyssey*, published in 1793. These were known and acclaimed all over Europe and were re-issued many times. The same style was used by him for the many commissions which he received from the Wedgwood

The neo-classical style in graphics. A plate from the sculptor John Flaxman's hugely influential Outline Drawings to Homer *(1793).*

pottery during the 1770s and 1780s. In Italy he deliberately set out to emulate antiquity in a series of works including *The Fury of Athamas* (1790) which was commissioned by the Earl Bishop of Bristol (almost a permanent Grand Tourist and the man after whom all the hotels are named) for his house at Ickworth, Suffolk where it remains. Back in England Flaxman embarked on a series of monumental tombs in the neo-classical manner taking the style through into the 1820s.

The effect of the Grand Tour on painting was to be accomplished with remarkable rapidity in the figure of one man, Joshua Reynolds, who arrived in Rome in 1750. He also, like Adam, was bent on lifting the status of his profession, inspired by the writings of Richardson and therefore wishing to see painting as a liberal art, recognised as the visual equivalent of tragic or epic poetry. The son of a Devon cleric, Reynolds had learnt his trade, for such it then was largely viewed, in the studio of the fashion-able portrait painter, Thomas Hudson. Reynolds, how-ever, knew that he could not succeed in his mission unless he had studied antique sculpture and the great works of the Renaissance. He remained in Italy for two years and arrived in London in 1753.

His earliest portrait, painted on his return as a dem-onstration piece, was designed to exhibit his revolution-ary powers. Nothing quite like it had ever been seen before. He depicted the naval commander, Admiral Keppel, in a pose based on the famous 'Apollo Belve-dere' striding, windswept, along a stormy foreshore, the whole rendered with a rich dark chiaroscuro effect de-rived from studying the work of Titian and Tintoretto. From that moment on Reynolds's career was one long triumph. Up to a hundred and fifty sitters came to him in any one year and his success was such by 1760 that he moved to a large house in Leicester Square with liver-ied servants. But his ultimate ascent to establishment fame was to come with the creation of an academy along the lines of those usual in other European coun-tries.

Sir Joshua Reynolds's advertisement for his talents: the naval commander, Augustus Keppel, strides along the seashore in the pose of the famous classical statue, the Apollo Belvedere.

An informal academy of some kind had existed in Rome among British artists who aspired to painting his-tory and mythology in what was called the Grand Style, that is a style modelled both on a study of antiquity and

of the great masters of the past. But it had languished. That the idea was revived was owed to an influential gentlemen's dining club, the Society of Dilettanti, which had been founded in 1734 for men who had been on the Grand Tour and which was to be responsible for some of the major publications devoted to the new archaeological discoveries. In 1755 the notion of an academy resurfaced leading to a tortuous history involving two rival groups of artists, the Free Society of Artists and the Incorporated Society of Artists, of which Reynolds was a leading light. The latter was granted a royal charter in 1765; three years later a group seceded from it and, with the aid of Sir William Chambers, gained the patronage of George III. The Royal Academy of Arts was the result and Reynolds was elected its first President with the accolade of knighthood bestowed the following year. Not only did the Academy guarantee an annual exhibition of its members' works but it set out to provide 'well-regulated schools of design' with a cast collection, a library, life classes, prizes and lectures. Reynolds became a leading member of a new cultural establishment, moving with ease in society and including among his closest friends Dr Johnson and Oliver Goldsmith. When he died in 1792 he had achieved what he had set out to do, elevate the insular and empirical tradition of British art to a more universal realm through becoming a living reincarnation of the old masters he worshipped. He was also to leave in his *Discourses on Art*, lectures delivered at the Academy to students and to 'people of fashion and dilettanti', a coherent body of practice so distinguished in thought and prose style that they were to earn a major place in the history of aesthetics.

Reynolds's portrait of Lady Sarah Bunbury sacrificing to the Graces, painted probably in 1763, epitomises aristocratic taste for the antique.

That elevation should have come as the result of painting what was universally recognised as the only true form of high art worthy of the Grand Style, historical scenes and allegories. Reynolds, it is true, occasionally painted such pictures but today we view them almost as travesties of the old masters they sought to emulate. The quest to paint this kind of picture was to haunt British painters into the twentieth century. The problem resided in the lack of demand and the uniquely British obsession with portraiture, which came out of an élite culture whose focus was no longer the royal

palace but the great private house. British sitters were depicted with almost unrivalled princely splendour in a way that continually astonished foreigners. Reynolds's solution to practising the Grand Style therefore was to elevate his portraits by casting his sitters into impressive roles, transforming them, whatever the reality, into heroic and poetic personages. Solemn rich colour and dramatic lighting effects enhanced sitters presented with a relaxed grandeur. The men command authority in their heavy ceremonial robes, the women exude good breeding, intelligence and sensibility. Time and again poses and effects derived from the antique and the old masters are used to glamorise them, although nothing is permitted which might erode an aura of high seriousness. In the case of female portraits contemporary dress was modified into 'something with the general air of the antique for the sake of dignity.'

Reynolds's greatest masterpiece, the family group of the 4th Duke of Marlborough, sums up in one magisterial image the fruits of this new classical civilisation born of the Grand Tour. In it the younger members of the family group romp and engage the spectators' attention, providing a foil to the reticent and dignified bearing of the parents and their eldest son and daughter. The duke's heir carries to him cases containing items from the fabled ducal collection of antique gems while the duke himself holds a magnificent cameo of the Emperor Augustus. The game the children play is indeed derived from an antique gem and a final classical gesture is bestowed in the figure presiding over the scene proffering a winged Victory. Here in one outstanding image Reynolds has gathered together the ideals of an age, combining the transference of the classical inheritance from Italy to Britain with a tribute to the splendour and taste of her ruling classes. It is a picture which speaks of the domestic virtues and of humour alongside powerful reminders of the duties incumbent upon those with a great heritage.

This classical high point with its resonances of the Grand Tour is also caught potently in the work of another artist, Richard Wilson. There again are the same impulses to lift not only himself socially but also the art of landscape painting which he practised to another sphere. He too studied the antique and the works of the old masters, in his case those of Claude Lorraine and Gaspard Dughet, in order to formulate a Grand Style. Returning from Italy in the middle of the 1750s he found, like Reynolds, little demand for mythology and history but a ready market first for views of Roman ruins and also for landscapes of his own country rendered in terms of the classical tradition. Wilton House, for instance, is glimpsed as a Romanised

Eighteenth century aspirations distilled in one image. Reynolds's group portrait of George, 4th Duke of Marlborough and his family, painted during the 1770s, records aristocratic classical culture at its most assured. The statue of Victory and the cameo of the Emperor Augustus brought to the duke by his son are just two motifs that draw on antiquity in a composition of monumental grandeur.

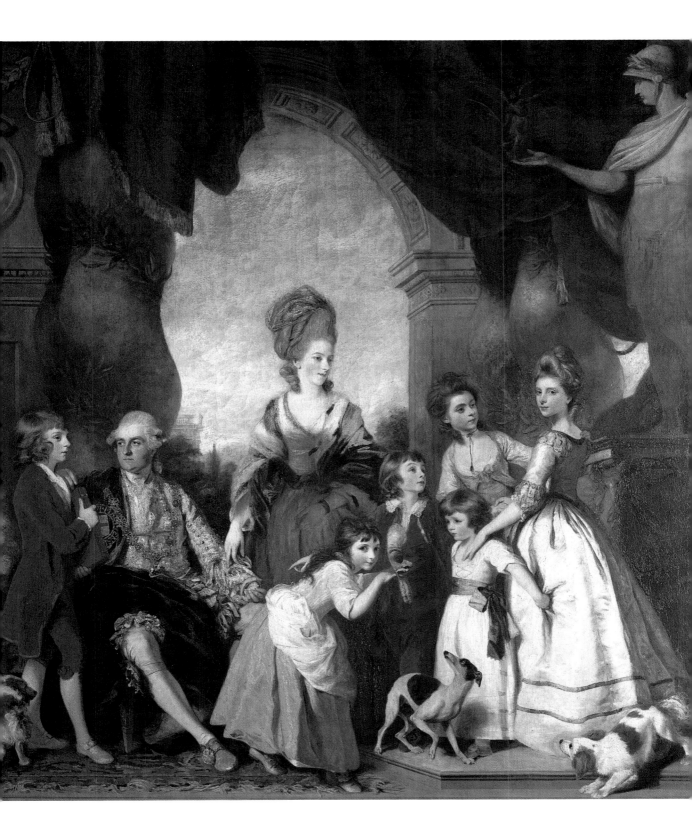

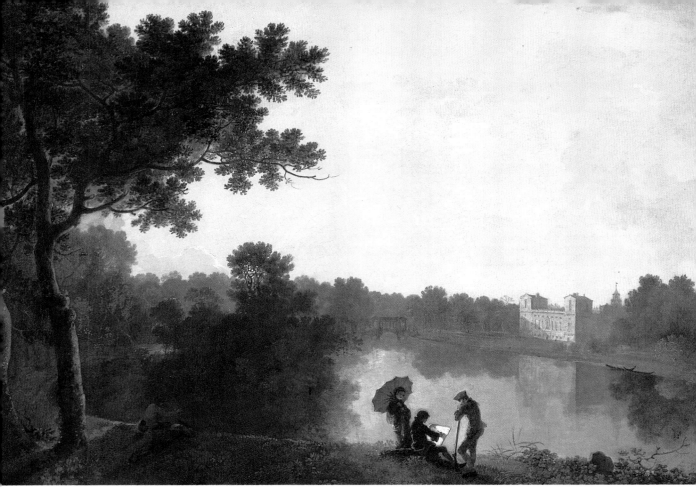

rural ideal, a vision in paint parallel to what the Augus-
tan poets depicted in words. This is the island recast as
a classical arcady caught in an unfading and effulgent
*Richard Wilson's painting transforms
Wilton House into a classical villa set
amidst a landscape evocative of the
Roman campagna, c.1758-60.*
golden light. The great house looms almost incandescent as the seat of this new
classical civilisation. Pliny's Tuscan villa has been transported to Britain.

In the decades after 1760 one sees evidence everywhere of the consequences of
the British obsession with classical antiquity, the result of the Grand Tour. It was
carried out in the spirit of a transference of both a political and cultural empire to the
island of Great Britain. At the same time the island's own ancient cultural traditions
were being rediscovered. The progressive urgency was to create out of these two
streams a single British culture, one that could simultaneously look back to Greece
and Rome but equally to the Anglo-Saxons, the barons of the Middle Ages and the
heroes of Gloriana's England. And it is to that quest that we must now turn our
attention.

Chapter Twenty-Seven

FORGING A CULTURE

Stowe is the largest, grandest and most important landscape garden in England. Situated on a south-facing hillside in mild, undulating country to the north of the town of Buckingham, it stretches over some four hundred acres. Its owners were the Grenville-Temples, one of the most powerful of Whig families, a network of connection which was to remain a dominant political force for over a century during which its owners ascended in rank from baronet to viscount, from viscount to marquis and, finally, from marquis to duke. Every phase of landscape garden style is encapsulated at Stowe, from the early formality of the turn of the century, with its stately walks and avenues, clipped evergreens and geometric ponds, to the sweeping informality of the genius Lancelot 'Capability' Brown (who became head gardener here in 1741), in which it seems that the native British countryside has been ordered by the artist's brush to accord to a perfection of pastoral paradise.

But Stowe is much more than a monument to garden style, for it catches vividly a particular moment in time when the notion of a common national culture began to take on substance. That it did so here came out of the politics of the 1730s as they affected one man, Richard Temple, Viscount Cobham. Cobham had been one of Marlborough's officers, married to a rich heiress, who had honours heaped upon him by the new Hanoverian dynasty. But in 1733 he fell out with Sir Robert Walpole over the Excise Bill and went into opposition, leading a coalition loosely known as the Patriots. That event was to precipitate the creation of a new scenic landscape at Stowe, the Elysian Fields, based, it seems, on an article written by Joseph Addison:

'The great road lay in a direct line, and was terminated by the temple of Virtue . . . The persons who travelled up this great path were such whose thoughts were bent upon doing eminent services to mankind, or promoting the good of their country . . . The edifices at the extremity of the walk were so construed, that we could not see the temple of Honour, by reason of the temple of Virtue, which stood before it . . .

Having seen all that happened to this band of adventurers, I repaired to another pile of building, that stood within view of the temple of Honour . . .

I found that the stones were laid together without mortar, and that the whole fabric stood upon so weak a foundation, that it shook with every wind that blew. This was called the temple of Vanity . . . [and] was filled with hypocrites, pedants, free-thinkers, and prating politicians . . .'

This is in fact exactly what we still see today. The Temple of Virtue contained statues of Greek heroes, role-models for the Whig politicians, while that of Vanity, which lay in ruins, had within it a headless statue which some said was Walpole. The Temple of Honour, or the Temple of British Worthies, contained a series of portrait busts of those 'members of the British nation thought worthy of being set in such exalted company.' These were in two groups, representing the classical division of human life into the active as against the contemplative. Those embodying the *vita activa* included figures such as Alfred the Great, Elizabeth I and Sir Francis Drake. Those who represented the *vita contemplativa* were Inigo Jones, Shakespeare, Milton, Francis Bacon, John Locke, Sir Thomas Gresham (a gesture towards mercantilism), and, from among the living, Alexander Pope. Cobham was to go on and erect other buildings which filled out this initial message of his political principles. These included one of the earliest in the revived Gothic style, the Temple of Liberty, which was decorated with Saxon heraldry and scenes celebrating the freedoms and ancient British liberties which Walpole, by inference, had violated.

This was a tableau designed to inspire those who saw it and many did, for Stowe's gardens enjoyed a European fame and were the most visited of all the great landscape ensembles. In them the visitor was confronted with what was in effect a representation in three dimensions of a theme which was to dominate the century, the creation of a British national cultural tradition, equal to if not surpassing that of Greece and Rome. What is striking about the Temple of British Worthies is that it was an expression not of the court, nor of the government of the day, but of the opposition. Secondly, that, apart from Pope, its heroes were all located firmly in the past and, although it was three decades on from the Act of Union there was no Scot. This pantheon was firmly English in spite of its British label.

That such a cultural configuration could be staged at all stemmed directly from the Scientific Revolution of the previous century, which had demonstrated the superiority of the Moderns as against the Ancients in proving that what had been accepted as immutable truths for centuries were, in fact, not so. This celebration of the achievement of later ages explains the presence of Bacon, Newton and Locke but not at first glance that of the poets. It was, however, inevitable that once this emulation of the distant by

A pantheon of national heroes. William Kent's Temple of British Worthies in the garden at Stowe, Buckinghamshire, constructed in the 1730s, includes in its gallery cultural figures such as Shakespeare, Milton and Inigo Jones.

the more recent past had been established in the scientific sphere it should equally affect the cultural. So Shakespeare, Milton and Inigo Jones are made to take their place in this new starry firmament, one invoked on behalf of a political opposition claiming that it was the true guardian of ancient virtue.

But it was not only the political opponents of Walpole who were to stimulate this drive towards a national cultural identity: it was also a deep desire to establish the country's cultural credentials against France. This was a period during which Britain was at war on and off with France, culminating in the decades of the Napoleonic wars at the close of the century. It was indeed the defeat of France in the Seven Years War, which came to an end in 1763, that prefaced what can only be described as an unprecedented efflorescence reflecting what was a new-found confidence in the country's cultural potential. The war had also seen for the first time Scottish and English troops fighting side by side in what was a common British cause. The division of Scotland and England did not so easily vanish. The old Stuart concept of the multi-kingdoms lingered on, fuelled by the Jacobite cause which was not finally laid to rest until after 1745. In the second half of the century Scotland was both politically and socially drawn more and more into the network of England, a development which in the long run was also to have a cultural dimension. That was to be found, as it had been in the case of England, by looking backwards towards an antiquity which could be shared north and south of the border.

What emerges as the century progresses is the firm belief that the strength of British culture lay not in a monolithic uniformity but in its very diversity. A people of mixed descent governed by a mixed constitution was seen to call for a culture which drew on elements from each part of its historic generic make up. Ancient British, Celtic, Roman, Anglo-Saxon, Norman, Huguenot, Jewish and Flemish antecedents could bring a cornucopia of cultural gifts embracing such attributes as the elegance of Latinity, the sense of liberty which fuelled the Germanic races, French grace and the sublimity of the Celtic bards. All of these strands were held together not only by the geographical confines of the island but by a common Christian tradition, predominantly Protestant and firmly based on the Old Testament. A vision which had long equated England with Israel was now extended to embrace the whole of Britain. All of this coincided too with a recognition of the racial origins of the country. In the past it had been accepted that Britain was founded by Brutus, the grandson of Aeneas, the founder of Rome. By 1700 that myth had given way to the reality that its roots lay in a variety of peoples who had crossed the Channel and settled here, or as Daniel Defoe, in his *True Born Englishman* (1701), neatly put it:

. . . a Race uncertain and unev'n,
 Deriv'd from all the Nations under Heav'n.

As a result at the same time that it seemed that all roads led to Rome, others were firmly thrusting back in time into the island's past, questioning whether a classically based culture was indeed the ideal one for a modern nation. This concern was heightened as Britain moved to imperial greatness. The British Empire was billed as a very different phenomenon from its Roman predecessor, basing itself firmly on trade and not on brutality. The new *Pax Britannica* was cast not as an aggressor but as a liberator and guardian of peace, bringing to its subject peoples friendship and commerce, practical science and the benefits of Christianity. The false values of the Roman Empire were contrasted with the benevolent mercantile virtues of the British. The poet William Cowper in his poem 'Charity' catches the ethos:

. . . the band of commerce was design'd
 T'associate all branches of mankind;
 And, if a boundless plenty be the robe,
 Trade is the golden girdle of the globe.

Those who wished further confirmation that the British Empire was an act of divine providence, a belief which was fervently held, need only turn to Edward Gibbon's *Decline and Fall of the Roman Empire* (1776-81). In this, the greatest historical work of the age born of a Grand Tour visit, could be discerned the fate of an empire which had based itself on the false values of brutality and degradation as well as untold vice and violence.

Parallel, therefore, to the all-pervasive cult of politeness as a bridge crossing the previous century's religious and political divide, came this exploration of the nation's cultural past seeking further common cultural ground. It was to be found in one supreme figure, William Shakespeare, whose ultimate apotheosis was to be one of the most astonishing phenomena of the Georgian age. Shakespeare's plays had, of course, never ceased being performed from the moment that the theatres reopened after the Restoration, and indeed after the Licensing Act of 1737 were even more in evidence, establishing what was a nascent canon of national dramatic classics. That Shakespeare was able to take on this role as the supreme artistic hero of a nation was due to his ability to be a cultural chameleon. His plays were cheerfully altered and rewritten as both dramatic taste and the political scene changed. As a consequence they could be made to coincide with the views of whoever happened to be in power or, for that matter, out of power. In addition what was added or omitted enabled the

plays to conform to every shift in taste and fashion. To Alexander Pope's generation Shakespeare's low comedy characters were an offence against classical decorum, so Pope in his edition of the plays blamed their appearance on 'the ignorance of the Players' and relegated whole passages to the footnotes. But during the 1740s and 1750s the comedies enjoyed huge popularity as a result of having been cut and rewritten to be monuments to patriotism, celebrating both trade and national glory. In this way Shakespeare became an icon of middle class mercantilism, a poet who gave voice to the heroic age of Elizabeth I. The virtues Shakespeare was seen to extol were those now billed as the essence of any true-born Englishman, ones diametrically opposed to those cultivated by decadent French aristocrats subject to an absolute monarch.

In 1734, the year before William Kent's Temple of British Worthies at Stowe, a campaign was launched to commemorate Shakespeare in Westminster Abbey. That too was an anti-Walpole project by those anxious to establish a shrine to one now presented as the quintessential embodiment of the nation's values. Nothing initially came of this until, in 1737, a supporter of the government subscribed to the erection of a bust of John Milton in Poets' Corner. Then the campaign for a monument to

Shakespeare was revived by the opposition Patriots with Lord Burlington as a leading proponent and Kent as the designer. In 1741 Peter Scheemakers's elegant rococo statue of the playwright was unveiled, which almost instantly supplanted in the popular imagination every previous image of the poet. Here was Shakespeare, the man of letters, the British Worthy, who had immortalised a nation's golden age when true liberty had reigned. A national icon had been successfully launched.

This was Shakespeare sanctified within a church when, in reality, it was to the theatre that he belonged. He was not to wait long for his recapture. In 1741, the same year that the Scheemakers statue was revealed, a young actor, David Garrick, made his debut on the London stage. For almost forty years Garrick was to dominate the theatre as the greatest actor of the age (a subject to which we will return), a position he occupied as a man with a mission, to elevate his profession and along with it that of the drama within society. To do this he cast himself as the guardian of a sacred inheritance, that

Peter Scheemakers' monument to Shakespeare in Westminster Abbey, 1740, launched what was to become a major cult of the bard as a national political and cultural symbol.

of Shakespeare, claiming to have restored his true words to the stage. In fact he did what his predecessors had done, re-edited them to accord with current taste. In 1755 Garrick signalled his arrival as an establishment figure by purchasing a villa on the Thames at Hampton and erecting in its grounds a temple to the glory of Shakespeare or rather to Garrick as Shakespeare, for he posed for the statue himself to the sculptor Roubiliac. Garrick's Shakespeare is a very different one from the sinuous figure in Poets' Corner. Here the playwright takes on the role of the presiding deity of bourgeois morality, one whose plays, tidied up, were beginning to take their place on the shelves of virtually anyone who claimed to belong to the educated classes.

Then came the canonisation. Garrick's Shakespeare Jubilee, staged in Stratford-upon-Avon in 1769, is remarkable amongst other things for the fact that not one line of the poet's works was uttered. Amidst a barrage of publicity the actor presented a statue of Shakespeare, along with a portrait of himself with a bust of him, to the town. There were balls, a masquerade, a horse race, not to mention the Grand Procession of Shakespeare's Characters which had to be cancelled due to torrential rain. No matter, for the disastrous Jubilee was restaged at Drury

The great actor David Garrick joins the man he idealised. Shakespeare, attended by Tragedy and Comedy, awaits to welcome Garrick as he is borne heavenwards. Seventeen actors, each in a Shakespearean role, bid him farewell in this picture painted three years after his death in 1779.

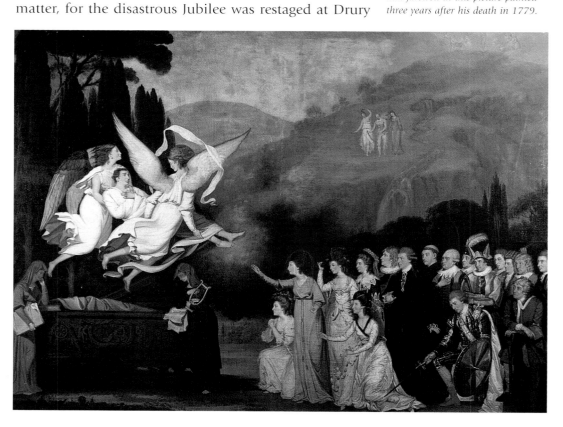

Lane and became one of the greatest theatrical hits of the century. At Stratford, however, the climactic moment was Garrick's unveiling of the bard's statue. He had arranged for an actor in the role of a Grand Tour aristocrat to spring up from the audience and protest at the apotheosis of this low-born provincial. Garrick then stepped on stage banishing such ignorance and delivered an ode to full orchestral and choral accompaniment with music specially composed by Thomas Arne. In Garrick's ultimate lines we witness the birth of bardolatry:

'Tis he! 'tis he! – that demi-god!
Who Avon's flow'ry margin trod,
While sportive *Fancy* round him flew,
Where *Nature* led him by the hand,
Instructed him in all she knew
And gave him absolute command!
'Tis he! 'Tis he!
The god of our idolatry!'

This is Shakespeare cast as the universal man inspired by Nature to voice the truths of humanity enshrined as a national cultural deity.

Shakespeare, however, was not to be alone for long. In 1757 the poet Thomas Gray, in his *The Progress of Poesy*, had charted the progress of poetry from Greece to Rome and thence to Britain, enshrined not only in the works of immortal Shakespeare but in those of Milton and Dryden. Until the 1770s the transmission of that literary heritage was in the hands of the booksellers who controlled the copyrights. The Tonson family owned, amongst others, those of Spenser, Milton, Waller, Dryden and Congreve. Admittedly in 1709 Tonson's great series of critical editions began to appear, but the widespread reading of that heritage could not take off until the booksellers' control was challenged in the courts. That happened in the 1760s resulting in a flood of cheap editions in response to what was a spreading literacy. The effect of this on booksellers was to make them turn publisher and for a new type of bookseller to emerge, one epitomised by Hatchards in Piccadilly, which opened in 1797.

The putting together of the literary heritage was a piecemeal affair. In the Temple of British Worthies there was Shakespeare, Milton and Pope. By the middle of the century Chaucer had joined them as a paternal ancestor, a rough but natural British voice. Edmund Spenser was re-cast as a master of a quasi-Gothic, allegorical epic which was now viewed as a pure expression of the native moral and religious imagination. The political aspects of Milton were quietly forgotten about as he was remoulded into the blind seer who wrote a sublime modern epic. Alexander Pope

and James Thomson were designated as the present-day inheritors of this mighty mantle. So by the third quarter of the century side-by-side with the classical pantheon filled with the likes of Homer, Virgil and Ovid there emerged a parallel one in which figured Shakespeare, Spenser, Milton and Dryden. In order to achieve that called for abandoning long held classical criteria of judgement and replacing them instead with criteria judging the works on their own merits. So, for example, Spenser's imaginative vigour was seen as being more important than his failure to observe classical form. In the case of Shakespeare, being Nature's darling and the model of genius, the classical canons were simply abrogated. This movement was summed up in the magisterial editions of Samuel Johnson, *Prefaces Biographical and Critical to the Works of the English Poets* (1779-81), the introductions to which were printed separately as *Lives of the Poets*. This was a milestone in literary history placing the poets into the political and social context of their age and attempting to relate their private lives to their work.

What had begun as an antiquarian quest into early literature was to have major implications for contemporary writing, in effect loosening and finally demolishing the Augustan canon. By the middle of the century the fascination with earlier native literature had taken a strong hold. In 1754 Thomas Warton published his *Observations on the Faerie Queene of Spenser* and a decade later Thomas Percy produced his *Reliques of Ancient English Poetry* (1765). So far the literary heritage was firmly English but to be British it needed to pull in the Celtic fringes. That necessity was recognised by Thomas Gray in his ode 'The Bard' (1757) which tells the story of Edward I's attempts to kill all the Welsh bards after the conquest of Wales and how that free-born native poetic tradition was to survive and be reborn in Tudor England. That was written a decade on from 1745, memories of which had to fade before the Celtic fringe could finally be brought into the cultural fold. And that was to be achieved by the publication of the works of Ossian (1760-65) under the aegis of James Macpherson.

Macpherson claimed to have translated the works of an early Celtic bard, Ossian. The result is a mixture of orally transmitted Gaelic originals held together by bridging passages by Macpherson. In it some genuine pieces of Highland poetry were refashioned to meet the growing interest in early primitive poetry. The result was quite unlike anything else at the time and Ossian naturally took on the dimension of a literary sensation. A passage from the opening book of *Temora* is sufficient to capture how different it was:

> ' . . . There Moriath stood with darkened face. Hidalla's long hair sighs in the wind. Red-haired Cormar bends on his spear, and rolls his side-looking eyes.

Wild is the look of Malthos from beneath two shaggy brows. Foldath stands, like an oozy rock, that covers his dark sides with foam. His spear is like Simora's fir, that meets the wind of heaven. His shield is marked with the strokes of battle. His red eye despises danger. These and a thousand other chiefs surrounded the king of Erin, when the scout of ocean came . . .'

The public was suddenly presented with an epic set in a distant and heroic past of a totally different kind from that offered by either Homer or Virgil. Its heroes were noble, not brutal, champions of truth and justice. Its womenfolk were sentimental and virtuous. The impact of Ossian was to be European in extent, being translated into German, French and Italian. Through it a door was opened into an unknown mythic Celtic past and its effect was hypnotic. Ossian painted a picture of a Scotland which was proud and independent but, as it was set in the misty past, there was no problem in accommodating it within the new British cultural pantheon. It also appeared at a moment when, as culture became more and more metropolitan, a nostalgia set in for a past which had either gone or was going. That glance over the shoulder across the centuries enshrined in Ossian was to prove a liberating force on poetry itself, driving it towards the romantic age.

If the creation of a national literary culture was summed up in the Shakespeare Jubilee of 1769, the establishment of a musical one was to be epitomised in the Handel Commemoration in Westminster Abbey in 1784. As in the case of literature that heritage also came out of an exploration of the past. But the story in respect of music was to be a rather different one from that of either plays or poetry which remained in print to be read or performed. In sharp contrast there was no tradition or ostensible reason for continuing to play old music. Up until the eighteenth century music was occasional, written for a specific event and then discarded. The idea of a canon of classics did not exist and England was the first country in Western Europe where such a notion was to emerge. By the close of the eighteenth century there was no other country where such a diversity of old music could be heard or where it had assumed such a major role as part of the ritual of national culture.

As in the case of literature it was to be the quite unique political circumstances which were to bring this about. The role of the Chapel Royal and of the musical network which stretched out from it across country to the cathedrals was to be crucial. The Chapel musicians cherished their musical heritage from Byrd and Tallis down to Purcell because it was one the Puritans had almost succeeded in destroying. Church music had been wiped out for two decades during the previous century. So, after the Restoration in 1660, the Chapel Royal acted as guardian of a precious musical tradit-

ion which now symbolised also the Stuart monarchy and loyalty to the Church of England. By 1700 that body of music was known as 'ancient music' and, with the advent of the House of Hanover in 1714, it was to assume an even greater ideological potency. Just as in the Elizabethan age, when much of the music by the Chapel Royal's composers was a cryptic lament for the loss of pre-Reformation Catholicism, so the music composed for the Tudors and Stuarts was cultivated by a broad spectrum of the opposition, Tories, High Anglicans and Jacobite sympathisers. This movement, which originated in Oxford, was to find institutional form in the antiquarian Academy of Ancient Music (1710).

Other developments were to assist this drift towards the performance of 'ancient music'. One was the abdication by the court as the focal point of musical innovation. As it provided few splendid occasions for the composition of music the inevitable result was to play what already existed. And, also as a consequence of the court's abdication, the greatest annual musical event ceased to be a royal but a City one, the service held in St. Paul's Cathedral to raise funds for the charity, the Sons of the Clergy. This had begun in the aftermath of the Restoration to provide for children of clergy who had suffered during the Interregnum but it gradually escalated into a magnificent musical occasion to which all the musicians of the Chapel Royal contributed, and where a full orchestra provided accompaniment. Each year its focal point was the performance of Purcell's *Te Deum* and *Jubilate.*

Such an event, as it crossed into the Georgian age, took on political overtones for it was seen as a celebration of the Church of England and its clergy within a framework of music composed in the Stuart era. The Three Choirs Festival, alternating between Gloucester, Hereford and Worcester, was a provincial imitation of this event, a fund-raising and again basically Tory celebration where the music of Purcell dominated.

That indeed was the problem, because for any truly national canon to emerge called for a composer who was not so doctrinally and politically committed, one whose work, like Shakespeare's, could be read in more ways than one, according to changing times and circumstances. This role was to be more than amply fulfilled in the figure of Handel. His political affiliations were never very definite and the fact that his oratorios were given concert performances in theatres and not in churches meant that he bridged the divide between the Church of England and dissent. The libretti, however much they may have had a special context on their first performance, were like Shakespeare's plays, adaptable to every situation. Their subject matter in the main dealt with the triumphs and deliverances of the Hebrew nation which by long tradition was equated with the English and by extension the British.

By the 1750s, as the Jacobite cause faded, the Three Choirs Festival and others which proliferated across the country began increasingly to stage oratorios by Handel. At the same time these events began to spill over to several days and the local aristocracy and gentry not only attended but took on particular roles. In this way 'ancient music', primarily that of Purcell and increasingly that of Handel, became the means whereby the English fashioned a musical ritual which stood outside the liturgy and conflicting church traditions. The performance of old music gradually became part of an upper class ritual expressive of a new-found cultural unity.

The association of aristocracy with what were viewed as the virtues of antiquity was a long one. It formed part of the argument for maintaining the hierarchical status quo. However, in the third quarter of the century, that came under threat not only from ideas of equality seeping into England from the thinkers of the French Enlightenment but, more particularly, from demands from below for parliamentary reform and an extension of the franchise. At the same time the defeat of Britain in the American War of Independence severely dented establishment confidence, engendering a drawing together of the aristocratic classes. Cultural solidarity was to be one manifestation of the reassertion of aristocratic status and music was where it found its earliest concrete expression. In 1776, the year of the Declaration of Independence, John Montagu, 4th Earl of Sandwich, was the moving force behind the foundation of the Concert of Ancient Music. This man, unpleasant in so many aspects, was yet not only the most distinguished amateur musician of his day but also a powerful innovator. At these concerts 'ancient music' was finally defined as that which was more than twenty years old and that alone was to be played before an audience which was a display of caste. In 1785 the entire court attended, and admittance to concerts was reserved virtually exclusively to those of aristocratic descent. As a result of this time embargo a canon of classics was for the first time established in Europe. Old music and the *ancien régime* were interlocked together in an annual musical ritual which was also viewed as having a role in the moral regeneration of the upper orders, for many who came were committed evangelicals. The Concert of Ancient Music in effect created Britain's musical establishment, one which was to hold on to its dominance until the 1840s.

The Handel Commemoration of 1784, organised by the Concert of Ancient Music, was the composer's canonisation. The event followed the end of the disastrous American war which lost the colonies, and the aftermath of a general election which was a royalist triumph and in which the younger Pitt came to power. The Royal Family and

Handel apotheosised as a national symbol. The Handel Commemoration of 1784 was without precedent in the nation's musical history. The painter, Edward Edwards, records the scene in Westminster Abbey as it would have been viewed by the king.

the entire establishment, regardless almost of political stance, came together in West-minster Abbey to listen to Handel's sacred music. Music for his operas was staged at the Pantheon, but it was the Abbey gathering which was the significant one, a national musical ritual in which all could join. George III was himself deeply involved in the whole affair which cast the monarchy into a role of being protector of the civic virtues. The commemoration was a huge success and went on being repeated for a few years until it was finally abandoned. By then, however, the notion of the performance of a canon of old music, classics, as an expression of civic order had been firmly put in place. It is still going strong today, as the building of a concert hall at the heart of any urban configuration and the maintenance of an orchestra bears testimony.

All of this went hand-in-hand with something else which was to be a *leitmotif* of Britishness, the landscape. Indeed the link between national identity and the British landscape first became fixed in the eighteenth century, a vision brought about by literature and art rather than direct perception. As in the case of literature there was a move away from looking towards classical antiquity turning instead towards an appreciation of native beauties. The landscape gardens of William Kent early in the century had transformed nature into a series of pictures inspired by Ancient Rome. That still pertained in the 1740s when, for instance, William Hoare laid out his grounds at Stourhead in Wiltshire. He cast its central lake as Avernus, the lake across which Aeneas in the *Aeneid* had passed to Hades, and the scenes Hoare constructed around its perimeter were designed to recall events in Virgil's epic poem. But that approach was to change dramatically after the middle of the century. If a landscape garden was to be a series of pictures it presupposed a role for Nature as a painter. The result of that equation was for people to look increasingly at the untouched countryside in pictorial terms, as examples of Nature's pencil at work. The other change was that just as the first landscape gardens had appealed through the intellect to the imagination now that appeal was to be transferred to the passions.

Edmund Burke's *A Philosophical Inquiry into the Origin of Our Ideas on the Sublime and the Beautiful* (1756) was to be hugely influential and innovative, contributing to this new perception of things which stressed the primacy of psychology in artistic response. A new valuation was given to emotions such as awe and terror which gave status for the first time to negative qualities like darkness and solitude, silence and immensity of scale. This was a radical shift from Augustan ideals of harmony and proportion. In the case of landscape it opened the way to an appreciation, for example, of mountains and all kinds of other wild terrain hitherto regarded as horrendous aberrations.

The change in the aesthetic perception of Nature coincided with the Agricultural

Revolution which in effect created the English landscape of today. That entailed massive enclosure and the creation of our present field system with hedges and clumps of trees. Common land vanished and, as a result, an underclass of agricultural labourers emerged. But the enclosure movement meant that estates could be arranged on an even more gigantic scale to accord with the emotional response now called for from landscape. That immensity of vision was to be met in the work of Lancelot 'Capability' Brown who set up his own practice in 1751. In the 1750s he was to remodel the huge parkland areas of Burghley, Northamptonshire, Longleat, Wiltshire and Wrest, Bedfordshire. In the 1760s he moved on to places like Blenheim, Oxfordshire, where some two thousand acres were rearranged to his diktats. During his thirty-five years of professional practice he improved up to a hundred estates of the aristocracy and gentry, leaving thereby an indelible mark on the landscape. And he had, of course, many imitators.

No more was England rearranged as though it were the Roman *campagna* imported. Instead it was a proudly British terrain of a kind which could stir the passions of a man of feeling, a Nature perfected with flowing hills capped by irregular groves of trees and watered by serpentine rivers exuding a gentle timeless serenity. For the aristocratic classes who could afford such magnificent private elysiums they were British liberty in landscape form. It was an image of the nation as gentle and pastoral, peopled by contented rural workers happy with their lot. The reality was far different but gazing through their rose-tinted quizzing glasses the aristocracy saw what it wanted to see, a vision which accorded perfectly with the presentation of the country's imperial might as essentially peace-giving and benevolent.

Such a reassessment of the rural landscape led to what is known as the 'discovery of Britain.' Faster horses, better coaches, proper signposting, not to mention an ever-expanding network of turnpike roads, made travel easier than it ever had been. The new emotional aesthetic responses outlined by Burke could be found by touring through Britain's countryside along the dramatic scenery of the Wye Valley or in the Lakes of Cumberland and Westmorland or, even further afield, in the Scottish Highlands. Guidebooks, which began to appear during the 1770s, told travellers not only *what* to look at, but *how* to look at it. Highlights were picked out, attracting the words 'romantic', 'sublime' or 'picturesque'. Those who voyaged often took with them what was called a Claude glass, a slightly convex mirror about four inches in diameter which could capture any picturesque view in the palm of the hand. This experience was the reverse of that at the beginning of the century. Then Nature had been recast to look like a painting. Now Nature was investigated to see where she had painted her own pictures unassisted.

Such a view in the long term was to tell against the manipulations of 'Capability' Brown, whose work could not survive the onslaught of the new picturesque aesthetic as expounded by William Gilpin in his *Observations on the Wye and South Wales* (1782), in which he demonstrated the picturesque nature of that terrain reflected in its natural wildness and ruined abbeys and castles, scenes unpolluted by the hand of the improver. By the 1780s and 1790s increasing urbanisation, together with the tidying up of the countryside due to the Agricultural Revolution, rendered that which had not been so, more and more alluring. These early tourists came in search of a lost primitive world, a journey back in time. In doing so they simultaneously eroded what they had come to experience.

By about 1790 a British culture had been forged. This is caught in a roll-call of books which traced the history and celebrated the achievements of the native tradition: Horace Walpole's *Anecdotes of Painting in England* (1762), Thomas Warton's *History of English Poetry* (1774-78), Samuel Johnson's *Works of the English Poets* (1779-81), Sir John Hawkins's *A General View of the Science and Practice of Music* (1776) and Charles Burney's *A General History of Music from the Earliest Ages to the Present Period* (1776-89). A cultural identity was firmly in place to meet the challenge of the French Revolution and the decades of war with France. The British State and all it represented was to find itself under siege from without as never before. Edmund Burke's *Reflections on the French Revolution* (1790) was a powerful attack on what had happened across the Channel arguing against sudden innovation and for organic evolution. It was to be the foundation stone of British conservatism. The cultural unity which had been fabricated during the previous decades now acquired a new urgency as one aspect of a programme which would pull people together to stave off the ideology of revolutionary France and the threat of radicalism from below. The success of this young national culture, which was in essence élite and aristocratic, would depend on how long its various partners would acquiesce in the dominance of England. But its ability to hold was to lie in the acknowledgement from its inception that its strength lay in unity in diversity.

A British landscape. The grounds of Longleat House, Wiltshire, were transformed by 'Capability' Brown from 1757 onwards with his characteristic mixture of undulating hills, clumps of trees and serpentine lake.

Chapter Twenty-Eight

SENSIBILITY

The *Morning Walk*, a portrait of a handsome young couple, Mr and Mrs William Hallett strolling in the countryside was painted in the autumn of 1785. It is one work among the many which proclaimed that the art of painting had come of age, and is recognised as one of Thomas Gainsborough's masterpieces. The paint is thin, in places almost transparent, in order to capture the gauzes, rustling silks and nodding ostrich plumes of the couple as well as the landscape which enfolds them, its feathery trees shimmering in the morning light. The blissful marital pair are presented as ideals, his a young and serious face, hers, in contrast, modest, with eyes slightly downcast, averted from the onlooker. The gravity of their affection is dispelled by the white dog which bounces up at them adoringly. Gainsborough's control of his chosen palette range is total, a symphony of blues and greens and whites with only a few touches of creamy gold. As a consequence the couple virtually dissolve into the landscape around, Nature as it were taking them in her embrace. Husband and wife, elemental man and woman, are as one in a paradisal vision. In one radiant image the artist has transmuted into paint the ethic of an age, that of sensibility.

By the middle of the eighteenth century sensibility was used to describe the expression of heightened, intense human feelings, ones which embodied a new kind of refinement of response by the educated classes. This attribute was to establish the credentials of a different type of human being, the man or woman of 'feeling'. The nervous heroines of Richardson's novels, above all *Clarissa*, portray exactly this new feminine ideal. In Laurence Sterne's *A Sentimental Journey* (1768) sensibility is a badge of moral and aesthetic refinement. Such a return to emotion could only happen once the extremes of religious enthusiasm, which had been such a marked feature of the previous century, had become a distant memory. This made it possible for refined persons to be judged by their emotional responses to both art and nature, a reaction which was to find support not only in Burke's exposition of the sublime and the beautiful but also in an earlier work, David Hume's *An Enquiry Concerning Human Understanding* (1739), in which he demonstrated that the mind oper-

At one with the world of Nature. Gainsborough's famous portrait of a young couple known as 'The Morning Walk', painted in 1785, captures exactly the mood of unpretentious relaxed sensibility adopted by the leisured classes during the decades preceding the French Revolution.

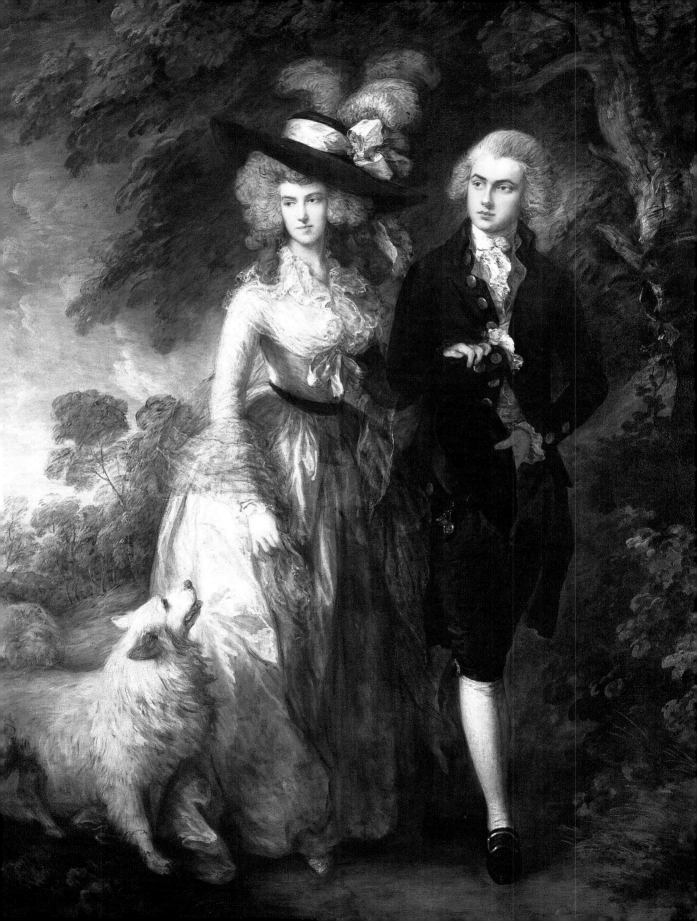

ated from patterns of association and juxtaposition rather than from Reason. To-gether Burke and Hume contributed to a conception of mankind which showed that man was ruled not by Reason but by feelings and by the passions.

This shift in ideals was to have a profound effect on the cultural ethos of the generation which preceded the French Revolution. The 'man of feeling' was a person in whom courage and good nature mingled, whose tender heart and benevolence was overt. Sensibility was above all a spontaneous characteristic and, at first glance, quite contrary to the etiquette of politeness. The irony is that both were found to be compatible. Sensibility released eighteenth century man to give rein to a whole range of emotions such as grief and pity, joy and love. This perception of natural and moral beauty was held to be divinely implanted by God in the soul, expressly in order that it might give man happiness and evoke his most noble passions.

These internal currents were reinforced by ones from abroad. The great French philosopher of the Enlightenment, Jean-Jacques Rousseau, was widely read in Eng-land. Rousseau argued that mankind had been corrupted by civilisation. In his philo-

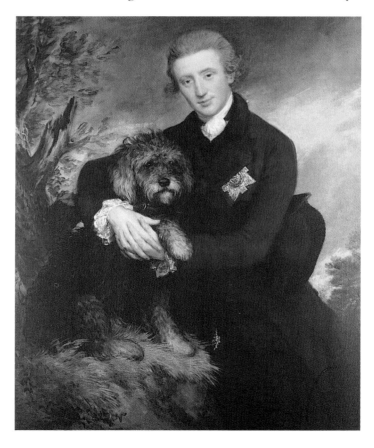

Robes of state and coronet are put aside in favour of being depicted as a country gentleman hugging his dog. Gainsborough's portrait of Henry, 3rd Duke of Buccleuch, painted in 1770, shows him to be a 'man of feeling'.

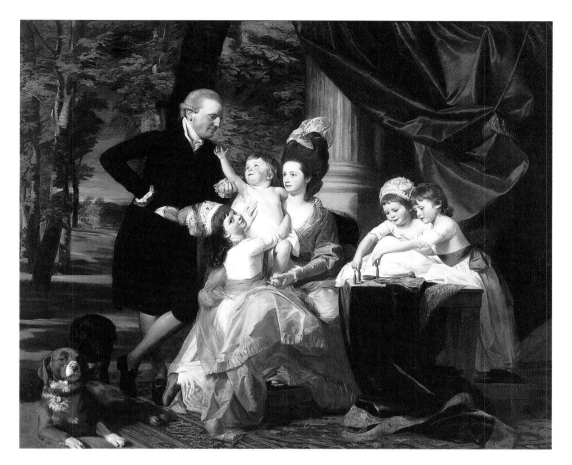

sophy the passions and affections could be improved by an education which was founded on contact more with things than words. Priority should be accorded to the expression of natural feelings and emotions above any official code of morality. In his novel *Émile* (1762), which was translated into English in 1763, Rousseau

Men and women 'of feeling' took joy in family life, childhood for the first time being seen as a separate phase. The American painter John Singleton Copley's group portrait of Sir William Pepperell and his family was exhibited at the Royal Academy in 1778.

believed that children should be nurtured naturally, just as one might cultivate a tree. The effect was a revolution in child-rearing among the upper classes where children ceased to be regarded as miniature adults. Instead childhood was recognised as a distinct segment of life which demanded, for example, different, loose-fitting clothes and the freedom to roam. Nothing was to disturb Rousseau's influence in England until 1789. He was seen as the epitome of the French Enlightenment, a man opposed to decadent French absolutism.

These ideas gained acceptance simultaneously with the coming to maturity of two

dazzling generations of British painters, Reynolds, Gainsborough, Francis Cotes, George Stubbs, Joseph Wright of Derby, John Opie, George Romney and Thomas Lawrence. Although many of them were openly to curse the British obsession with the genre, their livelihood lay in portraiture however much their aspirations were to scale the heights of history. That frustration was not, however, to be a negative force, for the consequence of it was an age of quite outstandingly innovative portrait painting, one which was unparalleled anywhere else in Europe. Gradually the inherited French-inspired conventions were displaced by compositions designed to reflect the unique nature of British society.

The portraits by these artists trace the emergence of informality. Men of social rank were no longer posed in an assertive manner but depicted wearing country attire, often with gun and dog, in what was seen as the antithesis of French court dress and therefore viewed as expressive of British liberty. Gainsborough, who began his life in Suffolk followed by Bath and who finally settled in London in 1774, gives supreme expression to this changing ideal. His sitters almost conceal their social rank. Even the Order of the Garter star, which it was obligatory to wear at all times, could virtually be hidden beneath a coat lapel. His male sitters' faces are depicted open, often smiling, a visual testament to a recognition that nobility was no longer only a matter of birth but a principle of virtue. In the case of women rank is also discarded, choosing rather to be presented as monuments to the female virtues which extolled not only purity but domesticity. Time and again Rousseau's new concept of motherhood and childhood is celebrated as infants fondle, play and tumble across aristocratic canvases. These are 'women of feeling' and feelings, according to Burke, become more acutely excited as the scenery becomes wilder and more remote. So often the grandest of ladies is discovered attired in a simple dress seated, pensive, her dog at her side, amidst nature untamed.

Joseph Wright of Derby, who passed his life in the regions, is another artist who responded fully to the cult of sensibility. His famous portrait of Sir Brooke Boothby (1781) shows an elegantly dressed young man who does not hesitate to embrace Nature to the full, casting himself on the ground and clutching a volume of Rousseau in one hand. In his portraits Wright captures this new philosophical and sentimental enjoyment of the countryside, as well as recording what is clearly pride in ownership by the sitter. But Wright also recorded something else which was more disturbing about the cult of sensibility, that it was not unifying but in a sense divisive. In his group portraits, like that depicting the progress of an experiment with an air-pump, the reactions of those gathered around are not the same but different, each face registering separate aspects of private emotion and sensation. Like Gainsborough,

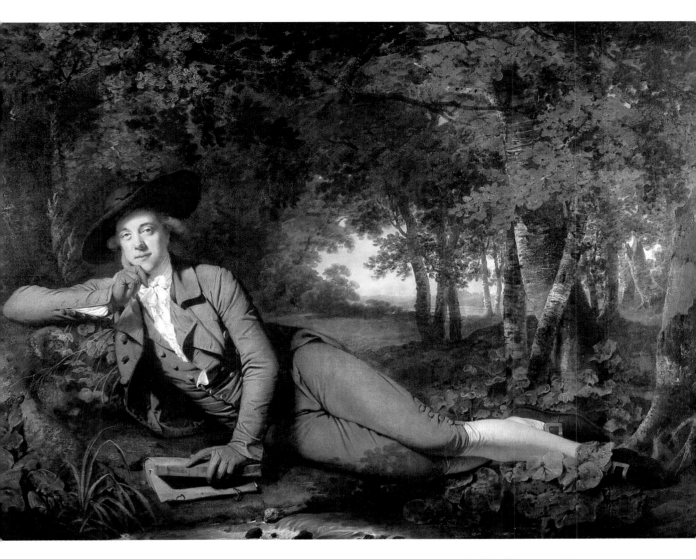

Wright was able to respond to the discovery of the British landscape, moving away from painting views of Italy to ones of Matlock and Dovedale.

Stubbs is another painter whose subject matter could only have come about through the uniqueness of English society with its passion for the open air, for field sports and racing. The love of animals, along with the realm of Nature, was one aspect of sensibility as the ever attendant horse and dog testify, but in Stubbs's case

Joseph Wright of Derby's portrait of Brooke Boothby commemorates his friendship with the French philosopher Jean-Jacques Rousseau, a volume of whose works lies by his side. He epitomises in his casual elegance the new ideal of the gentleman with references not only to contemporary sensibility but to a long tradition of the thinking man seeking the shade of the greenwood tree.

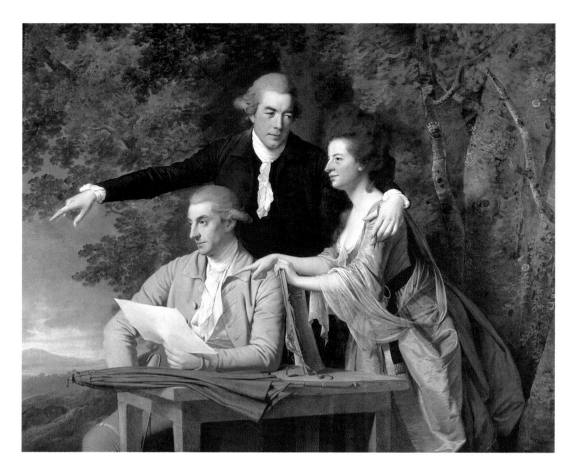

these creature assume an importance of their own, demanding separate canvases. The pictures in which these adored animals are celebrated by their owners form a sharp contrast to the painter's unerring delineation of the lower classes who wait upon them. His observation confirms the suspicion that sensibility was as much as anything the attribute of an élite.

Wright of Derby's portrait masterpiece depicting the Rev. D'Ewes Coke, his wife Hannah and his cousin Daniel Parker Coke was painted about 1781-82. In it we see sensibility in action as an affectionate family group respond to the landscape as they consider what may be either a design for altering the park or a drawing of the view by Mrs. Coke.

The cult of sensibility undoubtedly liberated painters. Its effect on writers was to be less dramatic. All the time there is a sense that they were being constrained by the sheer weight of the classical inheritance. The result is a kind of frustration because the existing forms of poetic expression were inadequate for what the poets increasingly wanted to say. Thomas Gray's famous *Elegy Written in a Country Churchyard* (1751), inspired by the one at Stoke Poges, draws together the attitudes of an era. This is a poem permeated with a sense of isolation and a withdrawal into the inner self, the

poet indeed as that 'man of feeling' meditating on obscurity and death, time and history, fame and passion. At its close he imagines his own epitaph:

> Fair Science frowned not on his humble birth,
> And Melancholy marked him for her own.
> Large was his bounty, and his soul sincere,
> Heaven did a recompense as largely send:
> He gave to Misery all he had, a tear,
> He gained from Heaven ('twas all he wished) a friend.

Other poets like William Shenstone, William Collins, William Cowper and Christopher Smart articulate the new sincerity but not without stress. Collins had a mental breakdown and both Cowper and Smart had periods of insanity. Together they represent a movement away from the public themes which dominated the Augustan age towards a poetry which was more domestic and personal. Although banality too often creeps in, such lyrics can even now be delicately moving, like Cowper's 'Friendship' which reads almost as a handbook to the new masculine ideals:

George Stubbs's picture of Captain Samuel Sharpe Pocklington with his wife Pleasance and his sister, painted in 1769, offers another microcosm of people of feeling at one with the landscape which they own, sensitive and sincere not only to each other but equally to the horse.

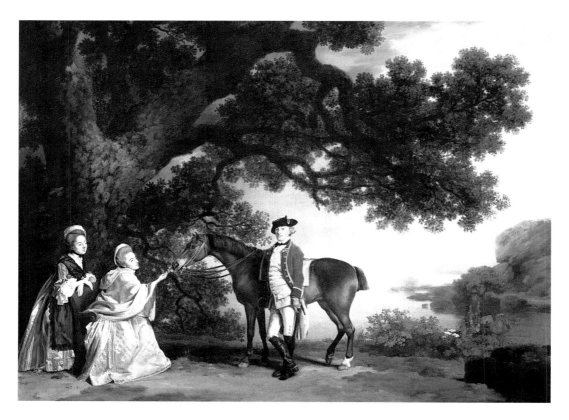

> Who seeks a friend, should come disposed
> To exhibit in full blood disclosed
> The graces and the beauties,
> That from the character he seeks,
> For 'tis an union that bespeaks
> Reciprocated duties.
> Mutual attention is implied,
> And equal faith on either side,
> And constantly supported . . .

Christopher Smart, like Cowper, was a man of deep religious sensibility who began his life as a Cambridge classicist and then moved to London, where he was overtaken by several bouts of madness from which he finally recovered in 1763. The impact of that on his work led him to break the Augustan mould, first in *Song to David* (1763) and secondly in the even more radical *Jubilate Agno* which, although written in 1760, was considered unpublishable until the twentieth century. This is less poetry than prose run berserk but it includes passages of quite startling originality, like the one on his cat, Jeoffry. What the poem appears to be is a series of antiphonal prayers whose exact meaning is quite opaque but whose general drift is a hymn to the Almighty from a universe in which the cat too finds his place:

> For he is of the Lord's poor and so indeed is he
> called by benevolence perpetually – poor Jeoffry!
> poor Jeoffry! the rat has bit thy throat.
> For I bless the name of the Lord Jesus that Jeoffry is better.
> For the divine spirit comes about his body to sustain it in compleat cat.

These are poets besieged by melancholy, anguish and affliction. Their plight is caught in the tragedy of Thomas Chatterton whom poverty drove to suicide at the age of eighteen. His fame was to rest on what was eventually unmasked to be a forgery, a series of fifteenth century poems written in the Chaucerian style supposedly by a Bristol monk which were published in 1777. Many were taken in by them, but for the Romantic generation that followed Chatterton was cast as the youthful poetic genius in the making whose life was cut short by the indifference of the world around him. What he also represented, however, was poetic liberation of a different kind kindled not by madness, like Smart, but through going back in time and responding to the rediscovery of medieval and Renaissance poetry.

One figure towers above every other and that is the awkward bulk of Dr. Samuel Johnson. He was the supreme literary lion of the age and he too was a man of sensib-

ility, for feeling in his case ultimately counted more than abstract reasoning. Even more than Alexander Pope, whom he defended, Johnson was a man of letters in his own right, able to retain a gentlemanly status and respectability in spite of being paid for his labours. As in the case of Garrick and Reynolds this arose from the acknowledgement of his genius. In the long run his achievement was to help free the writer from the burden of patronage. Johnson's energy was such that he contributed to every form of literature: drama, poetry, moral essays, travel, satire and the novel. He arrived in London from Lichfield with David Garrick but fame only came his way from the essays he wrote in the *Rambler* (1750-52). It was cemented by his monumental *Dictionary* (1755) which he undertook virtually single-handed and which was the earliest critical account of the English language as a means of thought and communication. Three years later came his edition of Shakespeare, one of the great pieces of

Dr Johnson in his travelling dress as described by Boswell in his Journey to the Western Isles of Scotland *(1775).*

criticism which challenged contemporary views on plays like *Antony and Cleopatra*, which went unperformed because it defied the classical unities. Johnson was universally looked upon as a quite extraordinary figure, farouche, lonely, sympathetic to the afflicted and attuned to the young. He was supremely a humanitarian whose humanity radiates across the centuries as it was fortunately caught by his friend James Boswell in his *Life of Samuel Johnson* (1791), regarded at the time of its publication as scandalous, but now seen as uniquely capturing Johnson's personality and brilliant flow of conversation. That was given a forum all of its own in the Literary Club which was formed in 1764 precisely for that purpose and in which came together the worlds of art, literature and politics including Reynolds, Garrick, Gibbon, Burney, Burke and Sheridan. Johnson's *Journey to the Western Islands of Scotland* (1775), which he made with Boswell, is a great work, fascinating for delineating a meeting between a representative of a highly sophisticated metropolitan culture and members of one regarded as a primitive survival.

Oliver Goldsmith, like Johnson, was a polymathic writer of prose, plays, history, poetry, biography and novels, of which the most notable was *The Vicar of Wakefield* (1768). He again was an exercise in tender sensibilities lamenting, in *The Deserted Village* (1770), the social and economic woes inflicted on the countryside by the enclosure movement. The creators of the great landscape ensembles were viewed not as improvers but destroyers of a time-honoured way of life, the death knell of a society. The fate of 'Sweety Auburn! loveliest village of the plain' is a dismal one:

> Thy sports are fled, and all thy charms withdrawn;
> Amidst thy bow'rs the tyrant's hand is seen,
> And desolation saddens all thy green . . .
> While, scour'd by famine, from the smiling land
> The mournful peasant leads his humble band;
> And while he sinks, without one arm to serve,
> The country blooms – a garden and a grave.

Goldsmith also wrote one of the great comedies of the century, *She Stoops to Conquer* (1773), where the debt to Shakespeare is amply evident and in which he parodies in the lovers the extremes of sensibility.

Sensibility too was to pervade the theatre during the long reign of David Garrick, who had taken the London stage by storm in 1741 in the role of Richard III. Six years later he teamed up with James Lacy as joint proprietor-managers of Drury Lane. For twenty-nine seasons Garrick was to dominate the theatre, retiring finally in 1776 and dying three years later. He stood unchallenged as the greatest actor of his age. En-

dowed with strong expressive features and a bone structure which responded to artificial lighting, his eyes were large and dark, his voice flexible and his movements both graceful and powerful. These physical attributes were brought into play in achieving a revolution in acting style. That in its own way was a response to sensibility, for his approach to any role was a psychological one, replacing the heavy and slow delivery of the older generation of actors with one in which the words he uttered matched as closely as possible to what looked like natural movement and emotional reaction. Here was an actor who pointed his lines and used his face, as any of his numerous portraits in character reveal.

Garrick was always a man with a mission. Through his alliance with Shakespeare he set out to create a dramatic inheritance divorced from politics and religion. This he achieved by means of a blaze of publicity, making himself a thespian archetype who was to be emulated down to Laurence Olivier, an actor-manager who was also a public figure. Garrick posed as a gentleman of taste and saw that his repertory complied with contemporary sensibilities with plays that extolled the domestic virtues and patriotism. As a result the theatre began to be viewed less as a threat to social order, becoming instead part of a new establishment culture which crossed the political and religious divide. Garrick believed that plays only truly existed in performance, and both press and public were gradually educated to appreciate individual qualities of acting, especially in the great Shakespearean roles.

Garrick's contribution did not end there for he initiated significant practical reforms, banishing spectators from the stage and taking away the hooped chandeliers which had lit the acting forestage. To compensate for their loss he increased the number of footlights and introduced batteries of lights on poles in the wings. Although the auditorium continued to be lit during the performance, the cumulative effect was a move towards the peepshow. By bringing in the painter Philip de Loutherbourg stage scenery gave the audience all the emotional experiences sensibility extolled. Garrick may have failed in lifting the status of his profession overall but he certainly lifted himself. Edmund Burke was to declare that Garrick had 'raised the character of his profession to the rank of a liberal art.' But for the most part those on stage were regarded as the incarnation of what the audience had come to see, wit and beauty but also lasciviousness.

Garrick's acting style called for a degree of intimacy but as the market for the theatre expanded the two licensed playhouses were rebuilt on a vastly extended scale. By the 1790s Covent Garden held some three thousand people and Drury Lane three thousand five hundred. The result was the end of the theatre of the Enlightenment as these vast spaces demanded an acting style full of grand gesture which could be seen

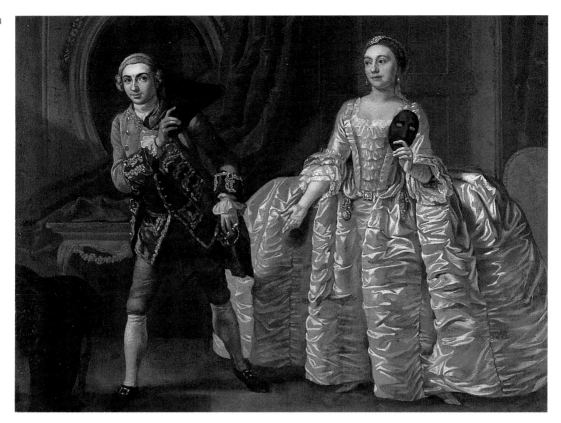

from afar. Spectacle took over as the theatre of the word went into abeyance for virtually a century. Richard Brinsley Sheridan's updatings of Restoration comedy, *The Rivals* (1775), *The School for Scandal* (1777) (which included a parody of sensibility in the relationship of the two Surface brothers) and *The Critic* (1779) lowered

David Garrick in one of his favourite roles, the rake in Benjamin Hoadly's The Suspicious Husband *first produced in 1747. The actress is Mrs. Pritchard who began by playing comedy moving later to tragedy. Painting by Francis Hayman, c.1747.*

a curtain in the history of the drama which was not to rise again until Oscar Wilde.

London continued to maintain its place as the musical capital of Western Europe, concerts taking over from opera in offering the most *avant garde* musical experiences. In 1765 Johann Christian Bach, known as the London Bach, together with Carl Friedrich Abel began the long series of subscription concerts at Carlisle House in Soho Square, importing dazzling foreign virtuoso performers like the young Mozart. There they introduced to the London public the latest music in the new lighter 'galant' style. A decade later they built a new concert room in Hanover Square. In the 1770s the Pantheon opened in Oxford Street, a magnificent venue for balls, masquerades and music-making. Joseph Haydn's concerts there during the 1790s caused a sensation. In music too the attributes of sensibility also manifested themselves. The audiences

which had previously moved around and chatted during concerts now sat responding in rapt silence.

But by 1790 London was no longer alone in having the monopoly of an élite culture. The second half of the century witnessed a huge surge of urbanisation caused by the stirrings of the first phases of the Industrial Revolution. Liverpool, Manchester, Newcastle, Birmingham, Nottingham, Bath and Brighton were boom towns, each sustaining a cultural life dominated by the local gentry and professional classes. This they modelled closely on that in the metropolis to which they were linked by easy means of communication. Gradually each acquired its own assembly rooms, theatre, concert hall, lending library and pleasure gardens. Bath had led the way earlier in the century where Richard Nash had introduced a code of behaviour based on politeness in which the nobility, gentry and middle classes could mingle freely. By the 1780s even the wearing of swords had vanished.

Such a significant shift in the pattern of urban life was reflected in architectural change, in elegant streets, squares and crescents in the new classical style as well as places of public assembly. Each town developed its own season of cultural activities and engendered its own clubs and associations which covered the wide variety of topics typical of the Enlightenment. In Birmingham it was the Lunar Society, in Manchester the Literary and Philosophical Society and in Edinburgh the Dilettanti. These emphasised yet again that refinement no longer came from birth but through knowledge and wisdom. They also crystallised the faith of the age in collective endeavour, the belief that those who held varying views could come together united by a creed committed to moral, technical and cultural improvement. Culture, science and philosophy harnessed by Reason and disseminated in print, it was believed, would lead the nation to enlightenment.

Not all of this was by any means to be lost in the turbulent decades ahead, but the French Revolution spelt the end of sensibility. It was seen as linked to politically dangerous ideas of social levelling and equality. In the 1790s it was condemned as being self-indulgent, anti-social, effeminate, vicious and, worst of all, foreign. But it did not vanish. Jane Austen could still censure it in the character of Marianne Dashwood in *Sense and Sensibility*, published in 1811.

Chapter Twenty-Nine

'A LITTLE GOTHIC CASTLE': HORACE WALPOLE

On 10 January 1750 Horace Walpole wrote to Horace Mann, British minister in Florence, about his building plans. 'I am going to build a little Gothic Castle,' he announced, to which Mann, somewhat taken aback, replied: 'Why will you make it Gothic? I know it is the taste at present, but I am really sorry for it.' For Mann, who spent his life introducing upper class young men, amongst them Walpole, to the glories of classical and Italian Renaissance civilisation, such a decision was a betrayal of aristocratic ideals. But Walpole remained wholly undeterred by such a reaction, returning indeed to the topic three years later when he wrote again to Mann: 'As my castle is so diminutive, I give myself a Burlington-air, and say, that as Chiswick is a model of Grecian architecture, Strawberry Hill is to be so of Gothic.'

What this correspondence reveals is Walpole's conscious wilfulness in setting up Strawberry Hill, his house at Twickenham, as an architectural fount on a par with Lord Burlington's Chiswick. And in this he was to be proved right. But he cannot have been happy to have been reminded by Mann that what he was doing was in fact not original at all but 'the taste at present.' Originality was in the end to come to Strawberry Hill, however, as it evolved over almost three decades, ensuring its enduring position as one of the seminal buildings in the history of the country's domestic architecture.

There is something vaguely unpleasant about Horace Walpole. Ambitious, arrogant, tetchy, snobbish, malicious, jealous and small-minded are adjectives generally applied to him. How much these characteristics were heightened by being an outsider, a homosexual, within a conformist society it is difficult to say. His irritability must certainly have been made worse by gout, but one senses that much must have stemmed from a long and solitary life as an effeminate aristocratic bachelor whose code of class ruled out any form of permanent relationship. His passion for the handsome bisexual Henry Fiennes-Clinton, 9th Earl of Lincoln, was to

Horace Walpole seated in his library at Strawberry Hill, a drawing from the 1750s by one of the contributors to his extraordinary house, J. H. Muntz.

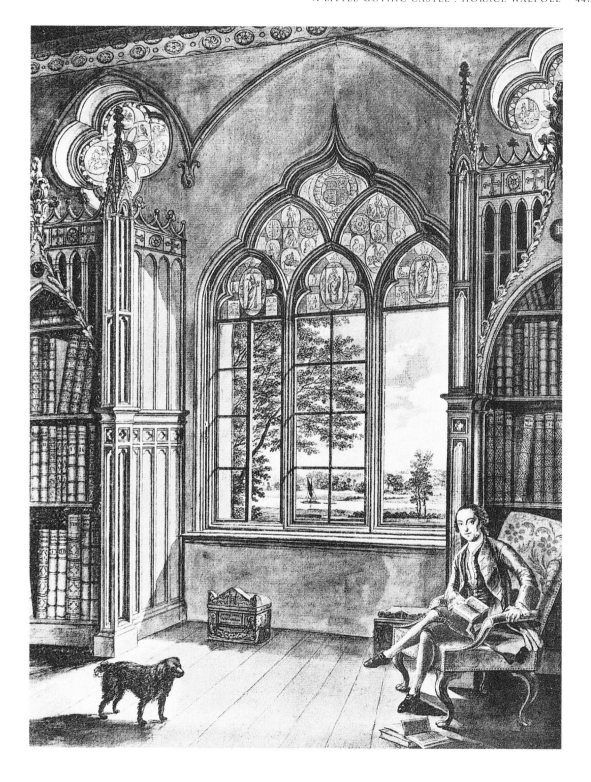

lead nowhere and that felt for him by the poet Thomas Gray was to be rebuffed as from a social inferior. Small of stature, with large lustrous eyes set within a narrow face, and exhibiting a peculiar mincing gait, Walpole was always destined to be odd man out. And yet he was to be one of the century's great trend-setters, operating with an almost perverse sense of defiance of the established norms of taste and style.

Walpole's position from birth was one of privilege being the youngest son of the most influential politician of the century, Sir Robert Walpole, a father who in many ways embodied the antithesis of his son's aspirations. The parents, however, lived apart and Walpole, who was physically a frail child, was brought up by his mother whose memory he was later to celebrate in the Tribune at Strawberry Hill. His was a conventional upbringing, passing by way of tutors to Eton where he fell in with many of the people who were to form his life's inner circle, including Lincoln and Gray. Cambridge followed and then the conventional Grand Tour which he set out on in the company of Gray in 1739, initially it seems only with France in mind in order to perfect his French. Soon the tour was extended to include Italy with the usual scenario of Turin, Florence, Rome and Naples. In Italy his latent passion for raven-haired Lincoln was reawakened; they met at Reggio and then moved on together to Venice. No aspect of Walpole's life was as opaque as this relationship, if such it was, for he either destroyed or edited any evidence which would provide a clue as to its exact nature.

Lincoln's influence was far from benign, for he introduced Walpole to a dubious loose-living circle which included the homosexual John Chute, theatrical and flaunting, but someone who was to stay the course as the one constant member of what Walpole called his Committee of Taste advising on Strawberry Hill. Lincoln in fact married in 1744 and eventually he was to inherit the Pelham dukedom as 2nd Duke of Newcastle. No amount of venom was too great to be heaped upon any member of that family as far as Walpole was concerned. By the late 1740s he had already settled into what was to be the pattern of the rest of his life. And that consisted of a London season while Parliament was sitting (for he became an MP), first in a house in Arlington Street and later in Berkeley Square, and late spring and summer at his house in Twickenham. Little occurred to alter this except his retirement as an MP in 1767 and his rediscovery of France later in life. As a result he visited Paris a number of times, the last being in 1775. In his dotage Walpole was to inherit the title of Earl of Orford but too late to make it worth his while taking his seat in the Lords. He died on 2 March 1797, writing about that event two months before in the following terms: 'I shall be quite content with a sprig of rosemary thrown after me, when the parson of the parish commits my dust to dust.'

Nothing was further from the truth than this statement for obscurity was not his aim in life. Far from it, for Walpole had long before determined otherwise when, only in his second year at Cambridge, he had decided to be the social chronicler of his age. More than four thousand letters by Walpole exist, an almost inexhaustible mine of anecdote and gossip covering four decades of Georgian England. In addition he wrote memoirs of the reigns of George II and George III. These he left in a locked box to be opened only in the next century to what he must have known would be devastating effect. Walpole is an irresistible writer who knew how to wield his pen to deadly purpose. Unlike the diarists Pepys and Evelyn, Walpole wrote both his letters and the memoirs with posterity very firmly in view. The result has been to see the age through his eyes and with all his prejudices. Only in recent times has it been at all possible to discount his at times appalling distortion of both people and events. But that should not detract from the fact that Walpole's powers of narrative description and delineation of character are brilliant and his work remains a *tour de force*.

His fame as a writer was to be posthumous but he was to enjoy fame of another kind during his own lifetime, in the main through the building of his Thameside villa, Strawberry Hill. In May 1747 Walpole took a lease on five acres of fields and 'Chopp'd Straw Hall', Twickenham. This was an area where aristocrats, gentry and members of the merchant classes had their country retreats built in every imaginable style. The site was a delightful one, with meadows stretching down to the water's edge from the house and vistas to the wooded slopes of Richmond Hill. From the outset he had determined that the house should not only be Gothic in style but asymmetrical in plan.

Walpole never actually articulated what had first enticed him about Gothic, but he was certainly haunted by the pinnacles and spires of Eton College and by the turrets of Windsor Castle which soared above it. Indeed the year before he took Strawberry Hill he had leased a house in the lower ward of the castle. In Paris too he had been drawn to one of the capital's least imposing Gothic edifices, the Chartreux, because of its rambling and melancholic qualities. And this had inspired him to visit the Grande Chartreuse, high in the mountains of Savoy, which, although the building itself turned out to be a disappointment, left him enraptured by the wild Alpine scenery.

What Horace Walpole was to achieve through Strawberry Hill was to sell Gothic to high society as a fashionable living style. The house was built to be noticed and every addition he made to it was trumpeted abroad. At the outset there was nothing particularly novel about the project. Gothic as an architectural style had meandered on through the seventeenth century as one to be used for churches and college

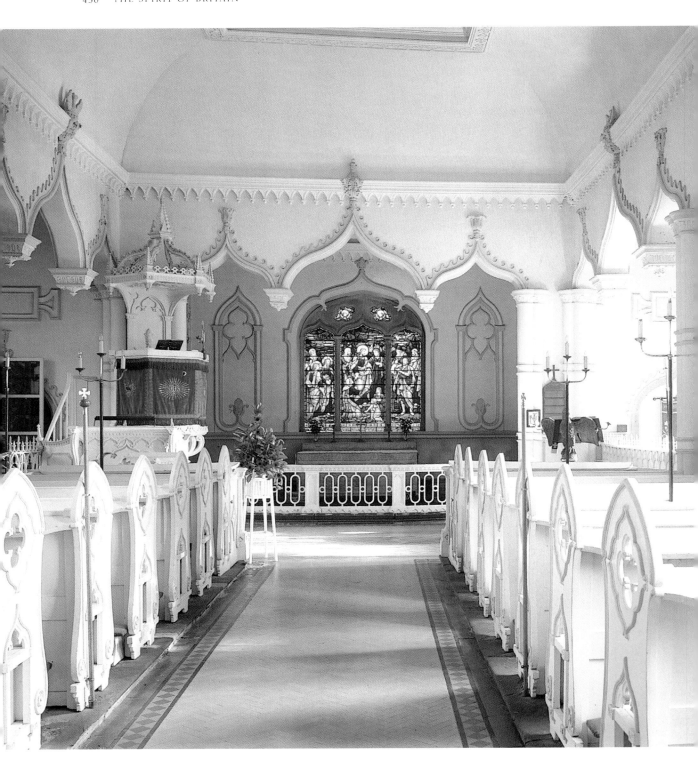

buildings. In the early eighteenth it had gained a political connotation as symbolic of the ideals of the ruling Whig oligarchy and ancient British liberties. Compared with the classical style, however, it was still but a trickle. Its potential to become a flood was there, as the dichotomy faced by aristocrats and gentry looking two ways at once gradually impinged, back to Ancient Rome and, at the same time, back also to the national medieval past. The result was an unhappy tension between simultaneously maintaining a respect for the classical heritage and, side by side, a devotion to the national heritage of the Gothic style.

The latter proliferated hugely during the 1730s and 1740s, thanks to a whole series of pattern books, particularly those by Batty Langley. These worked from the premise that Gothic was a corrupt version of Roman architecture which only called for squaring with the works of Vitruvius. All over the country Gothic garden buildings, entrance gates, towers, pavilions, steeples and mock ruins were erected by architects such as Sanderson Miller and Richard Bentley. The atmosphere of this rebuilding of the English medieval past is caught in lines by Thomas Gray, himself also an antiquarian and lover of Gothic, on some mock ruins put up by Lord Holland in Kent:

Richard Bentley's gothic headpiece to Thomas Gray's Elegy Written in a Country Churchyard (1751). Walpole was the publisher of Gray's works and Bentley worked on Strawberry Hill.

> Here mouldering fanes and battlements arise,
> Turrets and arches nodding to their fall,
> Unpeopled monasteries delude our eyes,
> And mimic desolation covers all.

That style was to take off even more in the 1750s because it was fully compatible with the new ideals of the Sublime as articulated by Edmund Burke. On to that later in the century Uvedale Price and Richard Payne Knight were to graft the aesthetic of the picturesque, which rested between the Sublime and the Beautiful but which gave theoretical sanction for the application of irregularity to buildings and sites which could not lay claim to the qualities demanded by the Sublime. Most of that lay in the future when Walpole began working on Strawberry Hill in the late 1740s but it was in fact to provide the vital thread which was to lead from Gothic

An early phase of the revival of the Gothic style, the church of St. John the Evangelist at Shobdon, Herefordshire, 1746, by William Kent.

to Gothic Revival, a principal nineteenth century style which was to cross the globe.

Walpole's contribution was to be crucial on two points. At Strawberry Hill for the first time there was an insistence on archaeologically correct Gothic, a criterion which Walpole disseminated to his wide circle of acquaintance. Secondly he introduced asymmetry into domestic architecture as any study of the ground-plan of Strawberry Hill amply demonstrates. 'I am as fond,' he once wrote, 'of the . . . Chinese lack of symmetry in buildings as in grounds or gardens.' Asymmetry was to be part of Strawberry Hill from the start. Walpole was in fact applying to a building what William Kent, whose gardens if not his rendering of the Gothic style he admired, had first applied to garden design earlier in the century. Strawberry Hill had a variety of volumes and an indeterminacy of outline which together were to form the central characteristic of villa architecture thereafter.

Walpole's so-called Committee of Taste rambled on as the house was built over the years but only one person was to survive the whole course, John Chute. He was a younger son also, although later in life he inherited The Vyne (Hampshire) which he partly Gothicised. Walpole considered him 'an exquisite architect, of the finest taste, both in the Grecian and Gothic styles . . .' Chute seems to have goaded Walpole on to new excesses. The third member of the team was Richard Bentley, a pasticheur in the rococo Gothic manner who was to begin to fall from grace during the 1750s and who finally went in 1760. By then Walpole had turned against him as the purveyor of inauthentic Gothic. Bentley was only one of a procession of contributors which included William Robinson, Johann Heinrich Muntz, Thomas Pitt, James Essex and Robert Adam. But the truth of the matter was that the vision was Walpole's and these were his amanuenses. When those people worked for any other client the result was far more conventional and, in particular, the houses were always symmetrical.

Gothic whimsy became the fashion in the 1740s and 1750s fed by pattern books such as Paul Decker's Gothic Architecture Decorated . . ., *1759, in which this unlikely garden ornament figures.*

The construction of Strawberry Hill went in two phases, the first a Gothicising of what was already there, the second the addition of what was in effect a second house tacked on to the existing one, a showplace in which Walpole's ever-expanding collections could be displayed and, increasingly, to which the public might be admitted to admire. The initial phase opened with superimposing a Gothic skin, inspired by Kent's Esher

The front of Strawberry Hill from Horace Walpole's A Description of Strawberry Hill (1784).

Place nearby, on to the east front towards the river. Like most of the exterior it lacked character in the detail and, although Walpole was to denounce Batty Langley's Gothic, it was very much in his manner. Far more important was the involvement of Bentley in designing a new entrance hall to act as a dramatic centrepiece for the house. With its complex use of attenuated Early English columns and dim shadowy light filtered through coloured glass (he bulk-bought old stained glass from Flanders) its effect on visitors was immediate. At the same time the south, or garden, front began to be remodelled and, in 1755, the Great Parlour was finished, allowing Walpole to entertain.

He had begun to fall out with Bentley and what might be categorised as the rococo Gothic phase drew to an end, to be replaced by a keenly historicist one in which every feature in the interior was to have its known source. By the autumn of 1758 Walpole had set his mind on 'a gallery, a round tower, a larger cloister, and a cabinet.' These formed in effect the display area and went up piecemeal; the Gallery was completed in 1763 and the Beauclerck Tower, at the extreme end of the development, was finished in 1776. Walpole, writing of the tower, summed up what was the visual impression of the whole: 'It has an exceedingly pretty effect, breaking the long line of the house picturesquely and looking very ancient.'

The impact of Strawberry Hill was to depend less on its exterior than on its interior decoration and on the disposition of its actual rooms, which were all shapes and

sizes. Walpole was an interior decorator of genius, in essence making living with antiques fashionable for the first time. In that he was a pioneer of what was to become widespread after 1830 and ubiquitous by the close of the twentieth century. But in the second half of the eighteenth century it was a novelty. The usual treatment of the interiors of grand houses was for the furnishings and fittings to be designed in a single coherent style by the architect or by an upholsterer. By 1750 that could be in any of a number of styles, neo-classical, rococo, Chinese or, indeed, Gothic, but the central point was that everything was new, even if somehow old family things were incorporated. Much was of course designed and specially made for Strawberry Hill but these items were integrated into a décor which prided itself on being based on historic sources and in deploying real objects, ones which were treasured for their lineage, having belonged often to this or that famous historical personage. Although rooms were themed there was also an unprecedented mingling of periods and styles of artefact in a way which anticipated the cacophony of the Victorian era.

This was the key feature of the display rooms, for the private part of the house was far less eccentric, in fact the breakfast-room and bedroom were not Gothic at all. But it was what the public saw that mattered and it has been estimated that at least ten thousand members of the élite classes passed through the public rooms. By 1754 a trickle had begun and nine years later Walpole semi-officially opened the place, opining to a friend: 'My house is full of people, and has been so from the instant I breakfasted, and more are coming in; in short, I keep an inn; the sign, "The Gothic Castle". Since my Gallery was finished I have not been in it a quarter of an hour together; my whole time is passed in giving tickets to see it . . .' By 1776 he had published his first guidebook for visitors.

It is difficult to think that Walpole had not deliberately calculated the impact of his creations as being novel. The route followed was a set one: in through the entrance hall, up the stairs to the Armoury, the Library, the Star Chamber, the Holbein Chamber, the Tribune (formerly the Chapel), the Great North Bedchamber, the Gallery and down the backstairs and out along the Great Cloister which ran beneath the Gallery. What would have struck the visitors would have been the authenticity of the Gothic. In the Library the bookcases were based on a screen in Old St. Paul's and the chimney was inspired by the tomb of John of Eltham. In the Holbein Chamber the screen was modelled on that on Archbishop Warham's tomb in Canterbury Cathedral. The ceiling in the Tribune was derived from the vaulting in the chapter house at York while that in the Gallery was fan vaulting in papier mâché, copied from one of the side aisles of Henry VII's Chapel in Westminster Abbey. Every room was filled with objects and pictures, Tudor and Elizabethan ones in the Holbein Chamber,

including items like Cardinal Wolsey's hat hanging from the back of a chair made for one of the last abbots of Glastonbury. In the Tribune, in emulation of the grand-ducal one in the Uffizi, Walpole assembled all his greatest treasures in a setting deliberately ecclesiastical.

The Gallery at Strawberry Hill, an almost vulgar riot of crimson and gilt, mirror glass and papier mâché with a display of historical portraits. One of the house's show rooms as recorded in 1781.

A four-apsed square was lit with a golden gloom from coloured glass and there was an altar with candlesticks, sconces and ivory vases. 'I like Popery as well as you,' he wrote to a clerical friend, 'and I have shown I do. I like it as I do chivalry and romance. They all furnish me with ideas and visions . . .'

That it supplied just such for its visitors is undoubted. Walpole had transformed his house into a secular treasury of British and family history. Rooms like the Gallery with its crimson damask walls, niches lined with mirror glass and spider's web of gilded Gothic filigree work crammed with old portraits and old masters, paraded a glittering vulgarity which proved to be deeply seductive to the next generation. One other thing was also evident. This was a bachelor's house with little thought given to household practicalities and much instead applied to what at times barely arose above a series of tawdry stage sets.

But Strawberry Hill made its point. If offered above all to middle income people a possible style which was both manageable and distinctive. Asymmetry was henceforth to be of prime importance in domestic architecture. Also Walpole's deep concern with authenticity (in which he was not alone in his generation) led to a dramatic change of fortune for surviving medieval buildings. They began for the first time not to be used as handy quarries for building stone but instead to be prized. The ruins of Fountains Abbey, for example, were incorporated into the landscape gardens of Studley Royal (Yorkshire). It led also to the earliest rescues of historic monuments. In 1765 the Bristol High Cross was saved and re-erected as a feature in the garden at Stourhead (Wiltshire). All of this led on in turn to the first serious restoration of cathedrals and churches, albeit that such work could precipitate damage. But that price was worth paying for what was a pioneer recognition of an architectural heritage which called for preservation.

Side by side with that Strawberry Hill gave an impetus to antiquarian studies which were revived earlier in the century with the founding in 1707 of the Society of Antiquaries. From 1773 onwards Francis Grose's volumes *Antiquities of England and Wales* began to appear, and also John Carter's works, including *Specimens of Sculpture and Painting* (1786), which was dedicated to Walpole, and his *Views of Ancient Buildings* (1786-93). Those fuelled the publication of Gothic architectural details, a movement which was to reach a climax in A. C. Pugin's *Specimens of Gothic Architecture* (1821-23) and L. N. Cottingham's *Working Drawings for Gothic Ornaments* (1823).

The full impact of Strawberry Hill on architecture lay in the future in 1797 when Walpole died. So too did his impact on the literary world which included not only his letters and memoirs but items which he produced from his own press which he had set up in 1757. Amongst these were the first defence of Richard III (1768), a subject which was to sire a progeny two centuries on, and *Anecdotes of Painting in England* (1762). The latter was based on the notes of the antiquary George Vertue which he had acquired in 1758 from Vertue's widow. The resulting book remains the foundation stone of English art history. But it is upon neither of these that his principal fame was to rest but rather on a novella, what he billed as a translation from an old manuscript, of which he published five hundred copies in 1765. It was entitled *The Castle of Otranto.*

That book, it has recently been argued, was written in a few weeks in the aftermath of the author's sexuality being cited in a contemporary pamphlet. What is striking is that *The Castle of Otranto* has never been out of print. It is recognised as the fount of a new literary genre, the Gothic novel, huge quantities of which were written until the close of the first quarter of the nineteenth century. In addition it was to be

a major source engendering enthusiasm for the Middle Ages and also for what were the trappings of the Romantic movement. As in the case of Strawberry Hill *The Castle of Otranto* was not without precedent, for it had predecessors in France in the 1730s and 1740s and it needs also to be placed into its native context. The poems of Ossian were being published at the time and the year in which Walpole's novella appeared Bishop Percy published his *Reliques of Ancient English Poetry.*

The Castle of Otranto tells the story of a castle ripped apart by a monstrous ghost. It contains all the inner dynamics which were to be utilised by almost all the Gothic novels which followed in its wake. These focused on a crime committed in the past which had not yet been avenged. The criminal was usually a murderer or a usurper and the real heir was generally lurking under a false identity unaware of his own destiny. The plots traced the persecution of that heir by the criminal until he was unmasked and the heir was able to take possession of his patrimony.

Two of Bertie Greathead's almost surreal illustrations to the 1791 edition of Walpole's The Castle of Otranto.

The book, however, could never have been written without Edmund Burke's reappraisal of the Sublime: 'When danger or pain press too nearly, they are incapable of giving any delight and are simply terrible; but at certain distances, and with certain modifications, they may be, and they are delightful, as we every day experience'. Pain and terror, he argues, 'are capable of producing delight, a sort of delightful horror, a seat of tranquillity tinged with terror.'

The plot of *The Castle of Otranto* opens with a gigantic helmet falling from the sky into the courtyard of the castle, killing the Prince's heir on his wedding day. 'Terror,' Walpole wrote, 'the author's principal engine, prevents the story ever languishing . . .' And in this the supernatural was to play a major part:

> The door was ajar: the evening gloomy and overcast. Pushing open the door gently, he saw a person kneeling before the altar. As he approached nearer, it seemed not a woman, but one in a long woollen weed . . . "Reverend Father, I sought the lady Hippolita." "Hippolita!" replied a hollow voice. "Camest thou to this castle to see Hippolita?" – and then the figure, turning slowly round, discovered to Frederic the fleshless jaws and empty sockets of a skeleton, wrapt in a hermit's cowl.

It took a generation for the Gothic novel to take off. In 1777 Clara Reeve wrote *The Old English Baron*, acknowledging it to be 'an offspring of *The Castle of Otranto*.' But it was not until the 1790s that such novels began to appear in quantity, ones

which included a repertory of castles, convents, fleeing females, trapdoors, ghosts, torture, terror, dungeons, dreams, prophecies, shock and sudden death. In short everything that was the antithesis of the Enlightenment. In the novels of Ann Radcliffe, Matthew 'Monk' Lewis and Charles Maturin the genre ran its course, the interest shifting more and more towards the villain of the piece. By 1820 the Gothic novel had petered out but the influence of *The Castle of Otranto* was not yet spent for it was to affect the emergence of the historical novel and later the development of the novel of crime and detection.

In 1788 Horace Walpole wrote to Thomas Barrett: 'My house is a sketch for beginners.' In fact Walpole was a prophet of much that was to come in reaction against the rule of Reason. Barrett was busy building his own version of Strawberry Hill in Kent, Lee Priory, for which the architect was James Wyatt. Wyatt was the first architect to focus on the Gothic Revival style with a fidelity to the letter and spirit of the original antique prototypes. This he had learned through long years of being involved in cathedral restorations. Walpole recognised in Wyatt the torchbearer of his own Gothic style and he realised the importance of Lee Priory as a prototype for the glut of Gothic houses to come. Dying three years before the turn of the century Horace Walpole had by then lived on into what was already a different world.

In his life and work we cross a bridge leading us from the era of the Enlightenment into the Romantic age.

The influence of Strawberry Hill spreads: James Wyatt's Lee Priory, Kent, 1782-90.

Chapter Thirty

LIGHT NORTH OF THE BORDER

On 25 March 1707 the last session of Scotland's Parliament was held in Edinburgh. The occasion was the passing of the Act of Union dissolving the separate kingdoms of England and Scotland and creating from them a single kingdom of Great Britain. The Duke of Queensberry, who had been one of those instrumental in bringing this about, addressed the assembled members saying that the Act would 'promote an universal Desire in this Kingdom to become one in Hearts and Affections, as we are inseparably joyn'd in Interest with our Neighbour Nation.' In this the duke glossed over fact with fiction, for Scottish public opinion was against the Union and its enactment was signalled not by rejoicing but, in places, by riots.

The Act of Union was an economic deal whereby the acceptance by Scotland of the Hanoverian succession, which followed seven years later, would facilitate the opening up of English markets abroad to the Scots. Scotland was allowed to keep her own church, which was Presbyterian, and also her own legal system, but otherwise the kingdom was to be incorporated into a single unitary British state to be governed from Westminster. The Union's beneficial effects were not immediately apparent, for the opening years of the eighteenth century in Scotland were ones of failed harvests and famine. Nor did the peoples of the two kingdoms change overnight their traditional view of each other. To the English the Scots were proud, impoverished and politically dangerous. To the Scots the English were also proud, but in their case rich and, in addition, obstructive to Scottish aspirations. The Act of Union, a seemingly political and economic document, also had cultural implications of the first magnitude. Suddenly after hundreds of years an identity was wiped out. The consequences of that decision remain with us today.

The cultural history of Scotland is very different from that of England, but nothing can erode the fact that it is the story of a gradual but inevitable anglicisation. The country had two languages, Gaelic, spoken in the Highlands and islands and which was a vehicle

The frontispiece to the third edition of the Encyclopaedia Britannica *(1788), published in Edinburgh, exemplifies all the ideals and aspirations of the Scottish Enlightenment with its prime concern with practicalities but still cast in a classical setting.*

for a rich oral culture, and Scots, a version of north country English, which was spoken in the Lowlands and which produced a distinctive literature which, in the main, responded to literary developments south of the Border. Lowland culture centred on a court, that of the Stuart kings, a civilisation which reached its apogee in the late fifteenth and early sixteenth centuries during the reigns of James IV and James V. During the reign of the former flourished the 'Makars', a group of poets which included Robert Henryson, William Dunbar and Gavin Douglas, whose work in general took up that of Chaucer. The result was a poetic flowering far in excess of anything at the early Tudor court, one which was brought to an abrupt end when James IV was killed at the battle of Flodden in 1513.

That efflorescence was followed by a second, this time firmly francophile, for his son James V not only visited France twice but had two French brides. Moreover his daughter, Mary Queen of Scots, was brought up at the French court and was, for a brief period, queen of France. Both monarchs introduced into their rugged and impoverished northern kingdom some of the elegances and sophistication of Valois civilisation. James V's palaces at Falkland and Stirling display a classicism, albeit crude in execution, far in advance of anything being built in England at the time. The court poet Sir David Lyndsay's *Ane pleasant Satyre of the Thrie Estaitis*, performed at court in 1540, can still hold the stage, embodying an idiosyncratic Scots satirical tradition. But, as in the case of England, all of this was to change violently with the advent of the Reformation in 1560.

The Reformation, under the formidable leadership of John Knox, not only despoiled a Catholic culture as savagely as it had in England and Wales but inaugurated a long period of religious and political turbulence which contrasted starkly with the stability of the Elizabethan age. Inevitably Scotland now became anti-Catholic and anti-French. A Scots culture of a kind was still maintained at the court of the young James VI although the advent of Protestantism furthered the process of anglicisation. North of the Border the type of Protestantism opted for was Calvinism, a form in general strongly inimical to arts such as the theatre, although not to education. Already by the close of the fifteenth century Scotland had three universities, providing for a country whose population was only a tenth that of England. John Knox's *First Book of Discipline* extended that with the provision that every church in a town of any size was to have a schoolmaster teaching arts and languages attached to it. This educational system was to be hugely influenced by the great Scottish humanist scholar and writer, George Buchanan, who had been tutor to the young king, establishing the classical tradition as being at its very heart.

If the Reformation had been one blow, the departure of the court in 1603, when

James VI became James I of England, was an even worse one. The matrix for the development of any indigenous Scottish culture vanished and the language fragmented into a series of regional dialects. Where there had been court poetry and songs there was now only the music and poetry of the popular tradition. Not that the perpetual ebb and flow of religious and political turmoil leading up to and through the Civil War and after allowed for the civilising arts to flourish. Only with the Restoration in 1660 could some kind of cultural activity begin once again. During the Exclusion Crisis of 1680-81 the future James II took up residence in Edinburgh. For a brief period there was a court in the palace of Holyrood House. James revived the Order of the Thistle, extended the mission of the university, instituted the Advocates Library (now the National Library of Scotland) and established the Royal College of Physicians. The obverse side of this renaissance was that it was accompanied by outrage, for James flaunted his Catholicism. In 1681 the extreme Calvinist Covenanters rejected all 'Pipings, Sportings, Dancings, Laughings, singing profane and lustfull songs and ballads' as well as forbidding all 'story-books . . . Romances and Pamphlets, comedy-Books, Cards and Dice.' Nonetheless, James's sojourn had transformed Edinburgh into an Episcopalian royal capital, thereby laying the foundation stone of what was to lead to the Scottish Enlightenment. The form that was to take was indeed fashioned by the Calvinism which by its very nature curtailed so many aspects of artistic expression. The consequence of this was that creative energies had to be channelled into areas which were not subject to religious censorship and debate, ones like mathematics, the physical and biological sciences and medicine.

The Act of Union of 1707 brought to a conclusion the process which had been begun in 1603 and was taken further in 1688, for William III treated Scotland as a province and not a kingdom. The Scots were left with the church and the law as the sole vehicles for maintaining some kind of separate cultural identity. The church could never occupy that role, leaving the law. This was made up of a small highly educated professional class, the members of which were to be the driving force in adopting the new polite culture of early Georgian England, the world of clubs, newspapers and periodicals. Lawyers were also expected to be literary, to be people who indulged in gentlemanly pursuits and the exercise of the liberal mind.

The reaction to 1707 in Scotland was to be twofold. One group of Scottish intellectuals rushed headlong to cultivate the new Britishness while a second group, disoriented and capable of looking more ways than one, began to probe backwards to recapture the culture and identity which had been lost. In the case of the former there were all those who headed south to gain fame and fortune, men like the poet James Thomson, the architects James Gibbs and Robert Adam, the historian David Hume,

the political economist Adam Smith and the novelist Tobias Smollett. Once south of the Border, the Scots unashamedly networked and as the century progressed many of them attained government office. In the case of some professions, like medicine, the Scots began to dominate. Already in 1750 they were well established in the London medical world with Dr William Smellie as the leading obstetrician of the day. When the Lanarkshire-born John Hunter died in 1793 he was loaded with honours. Twelve years before his brother William, also a doctor, had died, leaving in their joint names the collections which now form the Hunterian Museum to the University of Glasgow. And moving south was not such a clean break as in earlier times, for many Scots went to and fro, thanks to the increasing ease of travel. By 1786 two coaches a day left London bound for Edinburgh, a journey which took just sixty hours.

But all of this was fame and fortune at a price, for after 1707 Scots ceased to be a literary language, declining to being a spoken vernacular. The *literati* indeed strove hard to eliminate Scots from their written work and as the subjects were ones of the intellect, philosophy, law, history and the sciences, they encountered no problems.

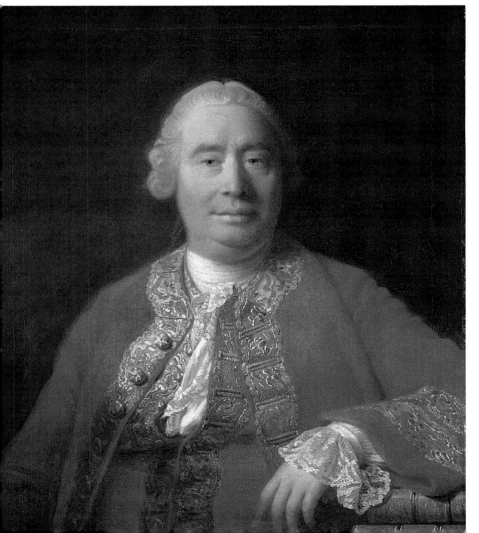

The philosopher David Hume by the Scottish painter Allan Ramsay (son of the poet), a portrait painted in London in 1766.

Indeed by doing this the leaders of the Scottish Enlightenment ensured their place at the summit of the Georgian intellectual Parnassus. The cost was their failure to produce an imaginative literature of the heart for the very reason that they talked and felt in Scots but wrote in English. Those who cultivated Britishness cut themselves off from the sources of literary strength in their own past. Nonetheless their achievement within a generation was signal. It was neatly summed up in a letter by David Hume to Gilbert Elliot of Minto in July 1757: 'Is it not strange that, at a time when we have lost our Prince, our Parliaments, our independent Government, even the presence of our Chief Nobility, are unhappy in our accent & Pronunciation, speak a very Corrupt Dialect of the Tongue which we make use of; is it not strange, I say, that, in these Circumstances, we should be the People most distinguish'd for literature in Europe.' In such a context it should come as no surprise that the author of 'Rule Britannia' was a Scot, James Thomson.

The other side of the coin were those disoriented by 1707. The Stuarts, until then regarded as a dynasty which had abandoned the kingdom, were now recast, particularly after 1714, as symbols of a once proud and independent nation. After the final defeat of the Jacobites in 1746 such sentiments were to continue to find expression in an unsophisticated folk emotion expressed in song. That was one aspect of what was a cultural cleavage, also precipitated by the Union, between those who took up a version of southern genteel culture and those who continued to live within the confines of the old indigenous folk one. There was, for instance, genuine Gaelic literature being written but the *literati* showed no interest in it, preferring instead the fabrications attributed to the bard Ossian. In much the same way it was to be the Edinburgh *literati* who were to urge Robert Burns to drop his use of the Scots dialect and adopt the idiom of the south.

The shock of 1707 was to generate a cultural antiquarianism piecing together for the first time the Scottish literary heritage. James Watson, who had been a Jacobite, published his *Choice Collection of Scottish Poems* (1706-11), a mixed bag but representing what was then available for reconstructing some kind of Scottish poetic. Allan Ramsay's *The Tea-Table Miscellany* (1724-32) put together a collection of Scottish song, albeit gentilified, and his *Evergreen* (1724) reprinted the poetry of the 'Makars', including Henryson and Dunbar. But Ramsay, who was a self-made bookseller as well as being a poet, was one of those torn two ways. His best known work, *The Gentle Shepherd* (1725), was in somewhat anglicised Scots and the lure to imitate Alexander Pope could not be resisted. In fact those who did not emulate the Augustans and who lacked a patron were doomed to failure. One such was Robert Fergusson who died at twenty-four in a bedlam of drink, trauma and depression. His life had been one of

unremitting drudgery quill-pushing. He had no time for the Union:

> Black be the day that e're to England's ground
> Scotland was eikkit by the Union's bond.

He, like Ramsay, attempted indifferent verses in the Augustan manner but his poetic guts wrote Scots. His masterpiece, *Auld Reekie* (1773), traces the passage of a day in Edinburgh:

> . . . morn, with bonny purpie-smiles,
> Kisses the air-cock o'St. Giles;
> Rakin their een, the servant lasses
> Early begin their lies and clashes . . .

That Robert Burns was able to take the Edinburgh *literati* by storm was by dint of him being cast by one of its leaders, Henry Mackenzie, as some kind of Scottish version of the noble savage, '. . . the unlettered ploughman.' Burns was in fact far from being unlettered. He could write English as well as any of the *literati*, was educated and widely read, drawing equally on the 'Makars', Ramsay and Fergusson as well as on Shakespeare, Milton and the Augustans. Within the context of his period his poetry appears as some kind of extraordinary aberration, fusing as it did high culture and the folk tradition in such a way that it was to create a vision of national identity which succeeded in being both proletarian and universal.

Burns was the son of an Ayrshire tenant farmer. His early life was one of hard physical toil of a kind which shortened his life. He died in 1796 at thirty-seven of rheumatic heart disease. He achieved immediate fame in 1786 with his *Poems, Chiefly in the Scottish Dialect* and, although he was lionised for a period by the Edinburgh establishment, he was to end his days as an excise officer in Dumfries. With a string of love affairs and a brood of illegitimate children as evidence Burns was to be one of the greatest of all love poets, producing a steady stream of the most tender and sensuous love-songs ever written. Poems like 'A Red, Red Rose' and 'John Anderson, My Jo' are etched into the nation's consciousness in a way only rivalled by Shakespeare, and 'Auld Lang Syne' is as well known as the national anthem. In his poetry tender sentiment and robust realism combine as a reflection of his large humanity and innate exuberance. And even though he was to recant his radicalism, such poems as 'A Man's a Man for a' That' echo to the word the thoughts of Thomas Paine's *The Rights of Man* (1791). Burns bursts out of traditional Scottish Calvinistic repression not only to celebrate life's joys but also to satirise those who deliberately set out to kill them off, among whom none figured more prominently than religious hypo-

crites. No innovator, he used traditional poetic formats but transformed them by the sheer force of his genius, utilising homely proverbs and a conversational quality to articulate what was a uniquely Scots response to sensibility:

'To a Mouse, On Turning Her Up on Her Nest With the Plough, November 1785'

Wee sleekit, cowrin' tim'rous beastie,
O, what a panic's in thy breastie,
Thou needna start awa' sae hasty,
Wi' bickerin brattle!
I wad be laith to rin an' chase thee,
Wi' murdering pattle!

Burns's work has been translated into as many languages as Shakespeare. He was to leave a mighty poetic legacy but, alas, it was to have no progeny.

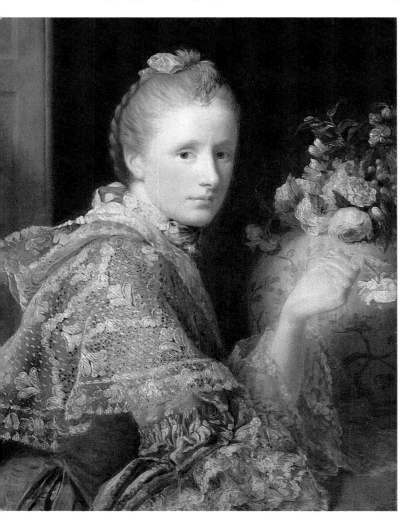

Ramsay's masterpiece, the portrait of his wife, c.1758-60, showing her in the everyday act of arranging a vase of flowers.

The heart of the Scottish Enlightenment was never to lie in creative literature but in a quite extraordinary outpouring of analytical, speculative and historical work. It was a movement which, within a single generation, was able to decisively shed some of the most basic orientations of previous periods. Out of collective Scottish endeavours came the beginnings of many of the social sciences, in particular economics, sociology, politics and anthropology. The Scottish Enlightenment was also to embrace the beginnings of modern geology and make significant contributions in philosophy, chemistry, architecture and medicine.

Although it had its exponents in Glasgow and Aberdeen, this work was essentially Edinburgh-based. No collective statement of purpose was ever made and the term Scottish Enlightenment was only attached to it posthumously. But overall there is no doubt as to its general thrust. The Scottish Enlightenment was concerned with the improvement of man's understanding of himself, both body and mind, both the individual and the social self. It also reached out beyond to include man's understanding of the natural world around him. Communication was central to its message, not only physical but intellectual and social. It was also deeply practical. In no way did it remain an exercise confined to the desk in the study or to polite chatter in the drawing-room, but was designed to improve the actual environment in which men lived and worked.

That it could happen at all depended on its firm roots in the Scots educational system and on the new prosperity which the Union brought to the country. But it was also rendered possible by finding an accommodation over religion. Calvinism held back the imaginative arts. Even when John Home's play *Douglas* was successfully staged in Edinburgh in 1756 there was a huge outcry of protest from those horrified by the idea of a minister writing for the stage. The endless wranglings over religion were laid to rest by the cult of Moderatism. This stressed benevolence and morality and placed faith in human progress and deliberately avoided all theological issues which could lead to dissension.

Much was also owed to the renaissance within the Scottish universities. Unlike their English and continental counterparts, which were in contraction and decline, they were buoyant, filled with a deep desire, it seems, to resuscitate what was a fading cultural tradition. The fees were low and the subjects cultivated, like medicine and law, were in increasing demand. The printing of books, newspapers and periodicals as well as the proliferation of clubs, all played their part. Starting with the *Courant* in 1705 there was a steady stream of periodical literature. Edinburgh by 1790 could boast sixteen printers including the Foulis brothers who produced distinguished editions of the classics. In 1725 Allan Ramsay opened the first circulating library in

the city and then there were the clubs: starting with the Easy Club in 1712 there were to be clubs to cover every aspect of human knowledge and the arts.

Medicine was to be in the forefront. Between 1685 and 1807 no less than eleven medical chairs were established in the university of Edinburgh. The turning point came in 1720 when Alexander Munro was appointed Professor of Anatomy. The town council gave him an anatomical theatre and, in 1738, access to the city's infirmary for teaching purposes. In the forty years following his arrival some thirteen thousand students were to pass through the school of medicine. Glasgow followed by the middle of the century. There the principal figure was Dr. William Cullen. In 1747 the university fitted out for him a chemical laboratory and he began to teach *materia medica* and botany. By the close of the century Glasgow Royal Infirmary had opened and classes in medical and clinical surgery were given there.

The expansion of medicine came out of the concentration on subjects outside of religious debate. History and sociology, where the developments were just as spectacular, owed their renaissance to the shock of 1707 and, in addition, to the preoccupation of Enlightenment thinkers with improvement. The latter by its very nature recognised the need for change and change was traced through the study of history, because history charted man's progress from barbarism to cultural refinement. That interest in history was now intensified by the Scottish loss of their own national identity. The two greatest historians of the Scottish Enlightenment were William Robertson and David Hume. Robertson, a Moderate divine, produced a two-volume *History of Scotland* (1759), dealing with the reigns of Mary Queen of Scots and James VI, the last resident Scottish sovereign. He went on to write a *History of the Reign of Charles V* (1769) and a *History of America* (1777). They were universally acclaimed and translated into more than one European language. His work, together with that of Hume, saw the emergence of historical scholarship based on narrative structure and the scrupulous citation of sources.

David Hume began his career as a lawyer but abandoned it and went to France where he encountered the Enlightenment thinkers of the day. The result was *A Treatise of Human Nature* (1738-40), in which Hume argued that 'reason is, and ought only to be, the slave of the passions.' In that pronouncement he was sounding what was to be the death knell of the movement of which he was part. It was his *History of England* (1754-62), however, which gained him classic status. It was to run through a hundred and fifty editions in a century. History was central to Hume's thinking for it was a record of how people behaved. It called for impartiality and balance in the telling but its accumulation of data offered unrivalled material for the student of the 'science of man.' For Hume the only way to understand the present and plan for the future was

through understanding how and why things had changed in the past.

Hume was a rigorous thinker, but at the same time an intensely sociable and affable man. He detested his Calvinistic upbringing which made him almost violently anti-religious, dismissing all miracles and religion as so much superstition. For a period in the 1760s he was *chargé d'affaires* at the British embassy in Paris and was much fêted by the French *philosophes*. His status was international and he was the first Scots philosopher to publish all his works in English.

Sociology is also about change, and economic activity was seen as going hand-in-hand with the spread of taste and the refinement of manners. Much of the argument of Adam Smith's epoch-making *An Inquiry into the Nature and Causes of the Wealth of Nations* (1776) drew on that fact as revealed through the study of history. Even more than his friend Hume, Smith enjoyed a quite remarkable status within society, the Prime Minister, William Pitt, once letting the writer be seated first at dinner, saying: 'We are all your scholars.' *The Wealth of Nations* was recognised at once as a landmark. Edward Gibbon was to sum it up when he wrote that it was '. . . an extensive science in a single book, and the most profound ideas in the most perspicuous language.'

Smith's career, like Hume's, was a brilliant one, attaining the Chair of Moral Philosophy at Glasgow university by the age of twenty-eight in 1751. Thirteen years later he was to resign that in order to accompany the 3rd Duke of Buccleuch on the Grand Tour, taking the opportunity to learn much, particularly from the French physiocrats, and benefiting from the handsome life-time pension bestowed on him by the duke. Although he produced *The Theory of Moral Sentiments* in 1759, in which he based his philosophic stance on the idea of sympathy, it was never to eclipse in importance *The Wealth of Nations*. That book, misread as it was to be by nineteenth and twentieth century liberals and bankers, remains still the most seminally influential work ever written on political economy. In it Smith pulled together much that had already been written into a single coherent related system, illustrating it at every stage by a wealth of empirical evidence. In contrast to the Rev. Thomas Malthus, who believed that the engine of economic growth was rapid population expansion, Smith held that it was mechanization, by which he meant the rational division and organisation of labour. Its theme was a plea for enlightened self-interest and for the abolition of unnecessary and unprofitable restraints on trade.

The Scottish Enlightenment was to leave one visible legacy as an expression of its profoundest ideals, Edinburgh New Town. This was indeed the heavenly city of the *literati* realised, expressing the application of rational principles to the parameters of an urban existence. It was to be the supreme statement of Edinburgh's arrival as one of the intellectual capitals of Western Europe. In 1767 the architect James Craig was

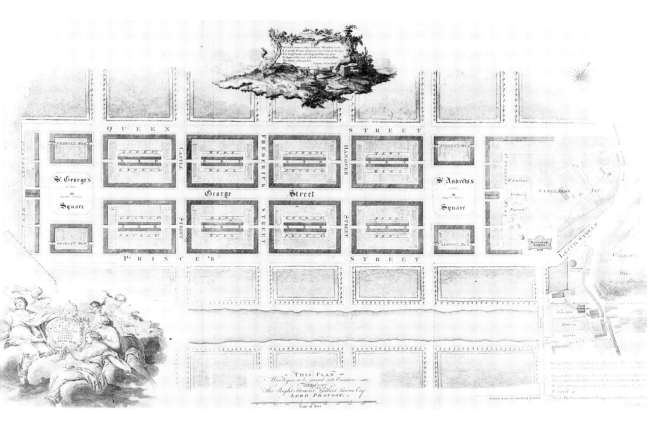

James Craig's 'Plan', 1767, for the original lay-out of Edinburgh New Town.

chosen to design Edinburgh New Town. He was the nephew of the poet James Thomson and the plan he submitted for the new development had inscribed on it lines from his uncle's poem on 'Liberty'. They were words spoken by the goddess herself:

> August, around, what Public Works I see!
> Lo! stately Streets, lo! Squares that court the breeze!
> See long Canals and deepened Rivers join
> Each part with each, and with the circling Main
> The whole enlivened Isle.

Although Craig's initial scheme was never fully realised the New Town remains a perfect embodiment of the ideas of the Scottish Enlightenment, laid out with rationality, elegance and symmetry. This was a monument, not to the old pre-1707 Scotland, but to the new Britain of the Union, its streets named in honour of members of the house of Hanover. Here we see Scottishness sublimated into a comprehensive Britishness.

The Scottish Enlightenment was an extraordinary phenomenon but it was by no means an inclusive one. As its historians viewed human history in terms of progress to some elevated present-day refinement, earlier periods were cast as less sophisticated forebears of their own age. The Scots, through their identity loss, were earlier than many in probing back into their own past, gathering old poetry along with folksongs and ballads which were in essence oral. Gaelic was gradually seen by the *literati* to occupy the role of a culture of another age surviving into the present. By the 1780s interest in the Highlands and the islands began to increase. In 1741 a *Galick and English Vocabulary* was published and fifteen years later a Gaelic New Testament. It was not long before the educated urbanites of the Lowlands were making expeditions northwards to explore this lost world.

By then there were abundant signs of cracks in the smooth optimistic surface of what had been the Enlightenment. Fragmentation began to set in as subjects became more and more complex, gradually eliminating the age-old assumption that any educated mind could move with ease from one to the other. Added to that there was Hume's prophetic advocacy of the passions. These, he held, were what primarily motivated man's actions and not the calm judgement reached through the exercise of Reason. When, on 14 July 1789, a Parisian mob stormed the ancient royal prison of the Bastille as a symbol of a hated and decadent regime, a passionate turbulence was unleashed which was not only to sweep away a society but to engulf the whole of Europe in decades of war. Nothing after it was ever to be quite the same again. In the face of such dramatic threats from without, the newly created civilisation of Britain now had to prove itself strong enough to hold a people together.

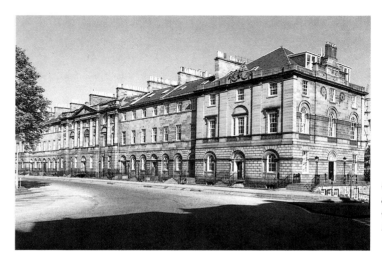

Charlotte Square, Edinburgh, classical elegance of the type associated with Georgian London or Bath, transported North of the Border.

Chapter Thirty-One

REVOLUTION, REACTION AND ROMANCE

The young William Wordsworth encapsulated the feelings of many of his generation when he wrote of the outbreak of the French Revolution:

Bliss was it in that dawn to be alive,
But to be young was very heaven!

Although written in retrospect in his autobiographical poem *The Prelude* (1805, published 1850), Wordsworth captures exactly the huge surge of optimism which swept through society in response to this dramatic event. His friend Samuel Taylor Coleridge felt in exactly the same way, saluting the fall of the Bastille with an ode. To many who had grown up during the decades of sensibility the sweeping away of the *ancien régime* across the Channel was the summation of their ideals. The opening phases filled people with a sense of hope that new dawn had broken for humankind. The tragedy was that this vision was so soon seen to be an illusion, for the Revolution went on to attempt to wipe out a whole class, the aristocracy, to execute the king and queen, and to indulge in scenes of mob violence. The cumulative effect in Britain was to send the initial enthusiastic reactions into complete reverse, for the established classes were quick to realise that what had occurred in France could also happen to them.

No single event in modern history, not even the Russian Revolution of 1917, has had such a profound effect. The French Revolution was to haunt the whole of the nineteenth century. In the first place it was an event so cataclysmic that everyone had to react to it. After untold centuries in which change unfolded slowly people saw that unexpected, total and rapid change was a possibility, albeit at an appalling price. Inevitably this triggered a debate about the whole nature of society, the basis of civil government, the

Byron joined Milton, Shakespeare and Ossian in providing subject matter for Romantic painting. This scene by John Martin is of Byron's hero, Manfred, contemplating suicide: 'Ye toppling crags of ice! / Ye avalanches, whom a breath draws down / In mountainous o'erwhelming, come and crush me!'

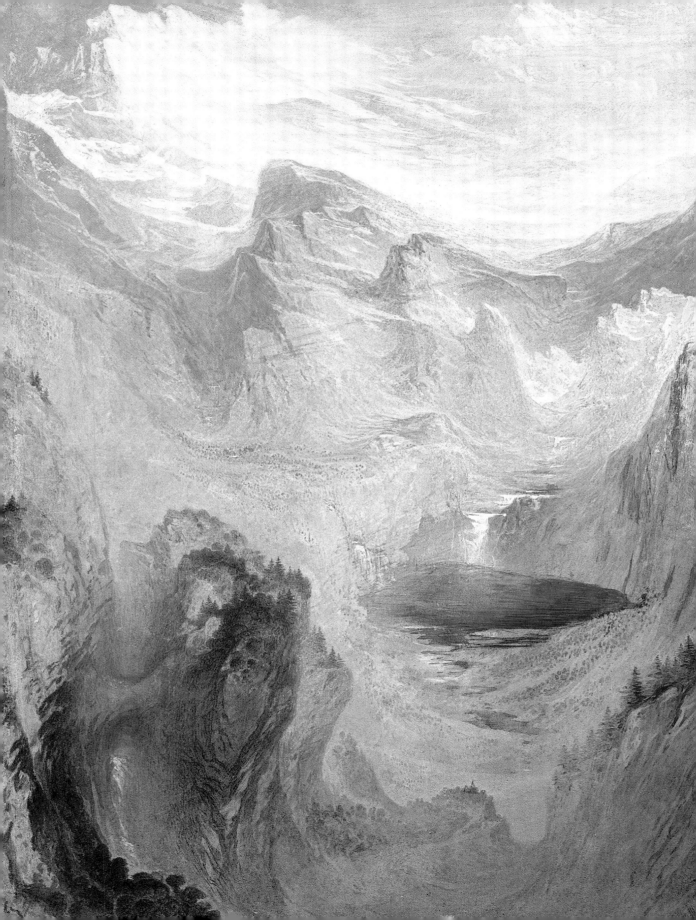

doctrine of 'rights' for individuals, the notion of political justice and the roles and relationship of the sexes. Suddenly the boundaries did not exist any more, explaining, for instance, why the poet Robert Southey could write that the Revolution opened up a 'visionary world.' For some writers and artists, like William Blake, it went even further than that to clothe these years with the vesture of apocalyptic expectation.

Without doubt this is one of the most extraordinary periods in British history, four turbulent decades, of which twenty-two years were dominated by what was the first global war, fought no longer only by a standing army and mercenaries but also by a citizen army, and thus involving the whole nation. At the same time, while a social revolution was averted, an industrial and an agrarian one actually happened. As if the dislocation caused by those and the war was not enough, simultaneously the Enlightenment view of the world gave way to the values of a modern industrialised society and, by the opening of the 1830s, the entrenched landed classes capitulated to pressure and welcomed in the new commercial and industrial interest.

It was also a period of extreme confusion combined with quite extraordinary innovation. Everywhere one turns there is conflict, stress and tumult. The key to it all is the word change. The French Revolution unleashed an era of unprecedented change of a kind which was to embrace every aspect of society including the arts. And change could fuel the mind in two contrary directions, one carrying it forward into new realms of possibility, the other pulling it backward, mourning what had been lost. The sense of perpetual flux was to lead those in the arts to explore every form of impermanence and yet also to peer cautiously for the first time into the inner recesses of the psyche, exploring dreams, memory, desire, and the indescribable which lurks within the inner recesses of the subconscious. The consequences of this in literature alone were some of the most brilliant, unforgettable and radiant images ever created.

But this efflorescence was uneven. In some areas it produced no heady release of creativity at all. Music and the theatre, both on the Continent to leave great masterpieces from the Romantic period like the symphonies of Beethoven or the plays of Schiller, lay virtually fallow. In the case of music the two visits of Haydn in 1791 and 1794 left an all-pervasive influence and the establishment in 1813 of the Royal Philharmonic Society ensured the vigour of the orchestral tradition, but in the rest of Europe the view began to gain currency that the British were not really musical. As things stood the London scene was dominated anyway by foreigners, either resident or visiting singers and virtuosi. The theatre was much the same. Here the size of the auditorium meant that spectacle took over, well suited to a largely uneducated audience hungry not for domestic drama or comedy but for heroic action, par-

ticularly anything patriotic during the war period. These vast theatres called for a new acting style, one which eschewed naturalism in favour of a high-flown neo-classical world of lofty sentiment and extravagant attitudinising. In John Philip Kemble and his sister Sarah Siddons the style found its two greatest exponents. Kemble literally choreographed his every step, gesture and pose and his sister did much the same, her performance in tragedy leaving behind a legend. But not even that can make up for the fact that from this period there is hardly a single piece of music by a British composer worth performing or a play which can hold the stage, even though poets like Shelley attempted to write them. But, apart from those absences, few eras in the history of the arts in Britain have produced such a cornucopia of innovation.

Change was already well underway in England before 1789. The 1760s had witnessed the creation of a second British Empire, the Industrial and Agrarian Revolutions had already taken root and, as a consequence of new wealth, the middle classes had hugely expanded. But this boom also reinforced the hegemony of the landed classes, for they were among the first to explore any possible commercial or industrial advantage which might come their way and equally were to be in the vanguard in enclosing their land in the interests of greater profitability, thus creating a landless subclass of wage-earning labourers. The harsh realities of the Agrarian Revolution had a beneficial side, for it achieved the feeding of a population which, during the century 1730 to 1830, had doubled from seven to fourteen million. In 1760, for instance, Norwich was the second largest city in the country. A century later it was little more than an insignificant provincial town. Birmingham had already passed it in terms of population by 1800, with Liverpool and Bristol not far behind. A whole way of life changed as the old cottage industries vanished and factories opened up, calling for rigid hours by their employees to keep the machinery rolling. Within these industrial cities and towns there emerged a new urban proletariat which, it was soon realised, could erupt into mob violence. Nor was that unrest confined only to the towns for the introduction of machines was to lead to riots in the countryside. It was little wonder that a fear of social revolution pervaded the established classes.

These were years of remarkable technical and scientific progress leading to the development of steam power and its use in industry, for the new railways and also for ships. The same period saw the founding of the organic sciences together with a long series of astronomical discoveries, including the planets Neptune and Uranus. The earliest experiments in photography were also undertaken, not to mention the introduction of gas street lighting, the use of chloroform and the invention of telegraphy and Portland cement. Improved transportation meant that the country was shrinking. The great engineer Thomas Telford constructed, over a period of eighteen years,

a thousand miles of road and a thousand bridges in Scotland alone. In 1825 the first railway was opened, running between Stockton and Darlington. Such scientific and technological advance aroused not only admiration but fear. For workers it meant the loss of employment, leading in some places to the smashing of factory machinery by the Luddites, a protest group initiated originally by mill workers opposed to wage cuts as well as to the new technology. For the educated classes it engendered fear of another kind, that science was getting out of hand, thus opening an on-going debate as to how human beings would be able to control objects they had made when those objects proved too complex and revolutionary. In retrospect it can be seen that all these new discoveries far from diminishing man's control over his own environment actually increased it.

During the two decades before the French Revolution social criticism was widespread among the upper classes, ideas which if taken to their logical conclusion could destroy precisely the class which had so freely discussed them. Readers were called upon, for example, in novels like Henry Mackenzie's much acclaimed *Man of Feeling* (1771), to feel sympathy for life's victims. As the Revolution embarked on its more gruesome phase such feelings began to be sharply dismissed as a threat to established hierarchy and order. Reaction took hold and a counter-revolution was set in motion.

The fear of revolution. James Gillray's savage cartoon (1793) on the horrors of the French Revolution, which swept away a society in a bloodbath, sums up what was to fuel a conservative reaction in Britain.

No one, however, could ignore the fact that the French Revolution had encouraged radicalism and that it was rife throughout the middle classes and, during the 1790s, spread down the social scale to embrace the working classes. This was a decade during which some of the foundation stones of modern radical thought were laid. Thomas Paine's treatise *The Rights of Man* (1792) set working class radicalism ablaze, no less than two hundred thousand copies of the book being sold during its first two years of publication. William Godwin, philosopher and atheist, wrote in a stream of books and pamphlets of the iniquities of the social system, and how it had corrupted the spirit of citizens. And in his novel *Caleb Williams* (1794) he dealt with the destructiveness perpetrated by a system of honour which set up official distinctions between men and urged them to seek power. Godwin's wife, Mary Wollstonecraft, produced the earliest feminist landmark, *A Vindication of the Rights of Woman* (1792). What upset people most about this radical literature was that it was deliberately written to be read by those outside the liberal élite. Freedom and equality could as it were be discussed but not in the presence of the servants.

The irony was that the French Revolution was in fact to set the radical cause back. Paine had written *The Rights of Man* in reply to what was to become the bible of conservatism, Edmund Burke's *Reflections on the French Revolution* (1790). What was to Burke horrendous about that event was precisely that it left nothing unchanged. Burke cast the French Revolution as the destroyer of ancient chivalry and age-old institutions. He argued instead for the virtues of organic growth and the maintenance of the status quo in terms of customary law and social hierarchy. The impact of the book was not immediate, but by the time that the nineties reached their close its principles had been firmly embraced by its middle-of-the-road and political audience. In the years immediately preceding 1800 government carried through a series of repressive acts driving radicalism firmly underground, not to resurface until after the war with France.

That war, which broke out in 1793, was likewise to have a profound effect. It shattered what had earlier been an ideological alliance between patriotism and radical ideas. Henceforth anyone who called for reform was deemed a traitor to the country. As a result a new alliance emerged between the State and those of the middle classes who rallied to its aid to fight a war which was quite unlike any of its predecessors. For the first time men were conscripted into the forces and every effort was made by the State to unite as broad a spectrum of society as possible against the common enemy, the French. That alliance was intensified when, in 1804, Napoleon crowned himself emperor. The war became a people's war during which the cartoonists and caricaturists, exemplified by the genius of James Gillray, invented nat-

ional archetypes like John Bull and Jolly Jack Tar. It inevitably recruited the arts onto its ideological bandwagon. Exhibitions were filled with pictures on naval and military themes. Competitions were held to commemorate the new heroes like Nelson and Wellington. Such a policy stimulated the belief that the State had a role to play in the patronage of art for which, in return, artists would glorify the State by adopting suitable patriotic subject matter.

Art in the service of patriotism. The long war with France was the first citizens' war calling for heroic exemplars for the populace like Nelson. In Benjamin Haydon's apotheosis of 1807 the dead victor of Trafalgar, transmuted into a Greek god, is borne heavenward towards the embrace of Britannia.

Beleaguered by threats from without, which included invasion, and by those within in the form of mob violence, a hard reaction took place. Sensibility and individualism were abandoned in favour of an identification with a time-honoured status quo and a common cause, to defeat the enemy. The family was cast as the bedrock of a new loyalism to the State and parenthood and domestic life were extolled for their virtues. Any hint of women's rights was beyond the pale, so too was any sympathy for those whom the war hit hardest, the members of the lowest classes who fought it or bore the brunt of the deprivation caused by the cycles of recession it engendered.

Nevertheless the war did produce this overall sense of collective mission which as it came to its close in 1815 was seen to have been highly successful. The country was

bathed in glory, cast seemingly into some divine role as the arbiter of Europe. The euphoria was to be short-lived, for victory ushered in a huge economic slump aggravated by the demobilisation of four hundred thousand troops. Peace having returned, radical ideas resurfaced, inaugurating a renewed period of internal turbulence culminating in the passing of the 1832 Reform Act. That brought further prominence to the middle classes and ensured the continuance of the status quo for several decades to come. It still, of course, left out of this nascent national consensus the majority of the population, but on the whole tradition was seen to have been victorious over innovation.

This is the essential background to what the twentieth century has labelled the Romantic Age. It is a deeply misleading label covering up any number of contradictions, and it is that which sets it apart. Unlike previous cultural waves, such as the Renaissance, Romanticism by its very nature is diverse. But that is not to say that certain common threads do not run through it. When pulled together, those threads put in place for the first time a cultural framework of a kind which still pertains today. At the head of this comes the change in the status of the artist. In the eighteenth century his prime duty of extolling formal order in society was taken as a revered assumption. The artist was public man. In sharp contrast the Romantic artist, in particular the writer, is a monument to self-absorption. This is a totally different role for him to occupy, one which focused on him laying bare his own soul, his dilemmas and uncertainties, his deeply personal way of observing the world around him. And in doing that he was to go beyond what accommodates man's rational faculties to explore the whole soul.

Such inwardness reflected what was a profound philosophical shift. The great German philosopher, Immanuel Kant, questioned the Enlightenment belief that knowledge came only through experience. For him it is the mind which is the creative force imposing its own pattern on our existence. Such a stance led directly to the idea of the artist as the defiant creator of his own world and an egotism which was exactly the reverse of the eighteenth century. In the Romantic view of things the power of the artist's imaginative vision was such that it could actually transform the world. Such a belief accounts for the poet Shelley's startling assertion that poets in their role as creators of new knowledge through the imagination were 'the unacknowledged legislators of the world'. Nearly all Romantic writers accepted this centrality of the imagination (Byron was a rare exception). What that represented was a gigantic contraction of perspective based on the argument that what the inward eye perceives is more important than what the outward eye observes of reality. It also reflected a general reaction against Newtonian science which had stripped mystery and the divine from

the world of Nature. The poet John Keats, for example, dismisses Newtonian optics in his poem *Lamia* (1817). In this way Romanticism began that restoration of spirituality which was to lead to the religious revival of the 1830s.

The French Revolution and its aftermath had another important impact. It made people realise that they were living through history. That, together with the pace of change and the patriotism of the war, accelerated interest in the past. This interest had been steadily growing through the century, reaching into history and folklore in an attempt to quarry out a national past and through it forge a new collective identity. The eighteenth century's explorations of the country's collective roots had found in ancient Scots and Welsh culture the world of the druids and Ossian, material to feed their objection to the domination of the metropolis. By the close of the century both of these were accommodated in a new State mythology. History always pulls two ways. It can either be a lament for what has gone or give testimony as to just how far society has advanced. As industrialisation and urbanisation spread and speeded up, what was only yesterday seemed suddenly very far away. The present began to take on an aura of uniform dullness giving rise to a yearning for heroes, for extraordinary and extravagant figures, villains, even, of a kind which could only exist in an *ancien régime* society. Literature responded with a whole gallery of heroes and villains, from Shelley's Prometheus to his wife Mary's Frankenstein. This craving was met in reality by such figures as George Brummell, the Regency dandy, as much as by the craze for virtuoso performers. Lord Byron had no hesitation in promptly casting himself from the outset into just such a role in his poem *Childe Harold* (1818):

> But I have lived, and have not lived in vain:
> My mind may lose its force, my blood its fire,
> And my frame even in conquering pain;
> But there is that within me which shall tire
> Torture and Time, and breathe while I expire . . .

Rebellious and passionate by nature, Byron created the archetypal stereotype of the Romantic poet to be followed in more muted guise by the consumptive Keats and the tragic Shelley. This is the poet as hero, a man who through his inner creative imagination roams unfettered through the realms of thought.

Patriotism, history and heroes in all kinds of permutations pervade these decades during which so many of our seminal national myths came into being. To these we must add one more: country. That word, of course, can mean two things, the nation and the countryside. Landscape had already donned patriotic colours in the era of Pope and Gay, laying the foundation for a new historic identity by framing it with a

past which no longer depended on kings and mythical founders but instead was deep-rooted in earlier peoples and their relationship with the land. The use of the native landscape as emblematic of Britain was brilliantly deployed by James Thomson in *The Seasons,* in which he depicted the labours not only of the middle classes but of the common people. The famous view of the Thames from Richmond Hill was taken by the poet to exemplify Happy Britannia.

The cult of the countryside had also imperial overtones, for landscape in the eighteenth century would have been seen through the eyes of a text known by every educated person, Virgil's *Georgics.* The Roman poet had advocated the harmonious establishment of a rural society ordered on a socially moral basis. Such a society would engender civic order and material wealth, thus augmenting the glory of Rome and her mighty empire. The transference of these thoughts across to Britain and her empire was common. So a scenario was put together in which labour tended the fields producing the crops which fed those in the expanding industrial towns, their collective endeavours in this way generating thriving commerce and arts as part of a new imperial vision. The twin virtues of industry and honesty were seen as essential elements in this cycle.

That potent image of the British countryside was to be intensified by the Industrial Revolution during which the land was depopulated, leading to poetic laments. But just as the war turned middle class radicals into loyal patriots so it turned the rural imagery (which had previously been used to express opposition by the disenfranchised to Crown and bureaucracy) into a powerful image supportive of the State. Any tableau depicting the countryside now had infused within it profound feelings of idealism, emotion and patriotism. Deep down, however, there lurked an ambiguity. To conservatives the country came to represent old values and a social hierarchy under threat which must be preserved. For radicals the country had a very different meaning, symbolising a lost freedom which needed to be reinstated. Add to that the fact that by its very nature countryside was contradictory for its moods could range from arcadian to the tempest-tossed. With all this in mind it is understandable why the countryside as it appears in novels, poetry and pictures lies at the very heart of the Romantic Age.

No other area catches more vividly all these complex thoughts than Romantic literature. On the surface so much of the poetry and prose projects to the reader an imaginative plane which transcends present day actualities. Any connection with the tide of historic events and social reality would seem at first glance remote. But in fact the reverse is true, for the literature of few other periods is so deeply entwined with the narrative of the age. Writers during these decades occupied a position of almost

unparalleled influence for the French Revolution and the spread of literacy gave them unheard-of power. That Revolution, it was believed, had been achieved through the circulation of ideas in words, thus confirming to Romantic authors that language actually had the power to change things. When it became clear that this was not wholly true, their quest for revolution was internalised into apocalyptic and Utopian visions of their own.

That these writers found such a ready audience was because the bulk of their readers was made up of precisely those who were excluded before 1832 from political power, disenfranchised men and women. Whereas in the past this would have formed quite a narrow constituency by 1830 it was very large, for it not only represented new wealth but new-found literacy. That was another of the many revolutions. In the eighteenth century literacy was regarded as a prerogative of the élite, but in spite of that fact, between 1730 and 1830 the adult readership figures rose steadily, and by the latter date some three-quarters of the working class had access to some kind of literacy. Fear of its proliferation remained, but it was too late. The tide was not to be turned, even though many of the élite took the line that literacy should not be made available to those classes devoid in their view of reliable social, moral and political allegiances because it would only result in further radicalism. But spread literacy did, so much so that by the 1820s mechanics' institutes with libraries were making books available to members of the working classes bent on self-improvement.

There were other factors which combined to make this a golden age of reading. Not only did books become progressively cheaper but circulating libraries increased their availability. Even the aristocracy, unable to indulge in foreign travel because of the war, discovered the delights of reading. And this again is evidence of the extraordinary bewilderment which is so characteristic of the age, triggered by change on all sides. Such constant fluctuation produced in people a new sense of urgency to learn and an almost insatiable desire for knowledge. The result was a wholly new audience ready to devour what was to be a quite astonishing outpouring of imaginative literature.

There were not only more books to read but more of everything else. Most of today's major newspapers started up during these years: *The Observer* (1791), *The Manchester Guardian* (1821), *The Sunday Times* (1822) and the *Evening Standard* (1827). In 1800 there were over two hundred and fifty newspapers in England and in 1814 a further landmark occurred when *The Times* introduced steam-driven machinery. The war must also have contributed to the hunger for news and more and more reading matter. Periodicals multiplied, reflecting not only the new literacy but the increasing compartmentalisation of knowledge. Shared reading engendered shared

viewpoints and there was a parallel roll-call of new periodicals: the *Edinburgh Magazine* (1802), the *Quarterly Review* (1809) and *Blackwood's Magazine* (1817). Book reviews, which had first emerged during the 1760s, now became a major feature and were keenly followed by the reading public. William Cobbett's radical *Political Register* (1816) became Britain's best-known cheap national periodical, articulating for those who would otherwise have no public voice. Its circulation was enormous.

Novel writing became a major literary industry. With the spread of literacy it took on a prime role as the means whereby one section of society found out how another section lived. Its readership was overwhelmingly female. The Gothic novel, descendant of Walpole's *Otranto*, flourished through the 1790s and made a return to fashion after the war, but during the war such

A golden age of reading. The isolation of the war, the spread of literacy, the proliferation of lending libraries and ever cheaper printing resulted in more books being read than ever. Here in a drawing of 1820 a mother and her son read by a window.

books, which often depended on obsessives describing the disintegration of leading characters and the subversion of normal civic order, were looked upon with dis-

favour. When the format was revived it was with a vengeance: Mary Shelley's *Frankenstein* (1818) embodied every contemporary fear about advances in science in a novel in which Frankenstein usurps the place of God by creating an artificial human being, a monster which in the end destroys him. In this book, as is the case of so much writing by the Romantics, an archetype was created which spawned a progeny which is still going strong today.

Women readers wanted romantic fiction and this constant demand was met by the Minerva Press, which was set up in 1790 and continued for over three decades to produce novels to a set formula to satisfy its readers. That formula centred on the preparation of a young woman for marriage. Domestic fiction celebrating family life and exulting home and hearth was fully in tune with the all-pervasive loyalism of the war years. In the 1790s its leading exponents were Fanny Burney, Maria Edgeworth and Jane Austen. Fanny Burney's *Camilla: or A Picture of Youth* (1796), which traced the fortunes of a family over two decades, was a hugely influential bestseller. The sentimental novel continued to appear in spite of its being viewed with suspicion. Indeed Jane Austen was to satirise it. Only after the war was the format to revive in the high artifice of the novels of Thomas Love Peacock. Then there were the oriental tales, an exotic genre which began to be seriously exploited by William Beckford in his novel *Vathek* (1786). In the 1820s came a new type of romantic novel, one which was set in the upper reaches of society and therefore deliberately designed to be devoured by those immediately below hungry for glimpses and a foot within the door. These included two from prominent statesmen who were also novelists: Benjamin Disraeli's *Vivian Gray* (1826), and Edward Bulwer-Lytton's *Pelham* or *The Adventures of a Gentleman* (1828). The latter was so phenomenally successful that it affected the way men dressed, leading to the universal adoption of dark suiting. What is striking is the sheer variety and the overwhelming quantity that was produced compared with before 1790.

But two major novelists dominate the age, Jane Austen and Sir Walter Scott. Jane Austen, the precocious daughter of a country cleric, belonged to the gentry with connections which stretched socially upwards. She began her writing during a period when the propertied classes were at the summit of their power and when the suppression of radicalism was at its height during the years 1796 to 1798. Jane Austen was to remain a woman of the Enlightenment, both in the clarity of her prose style and in her rationality. Liberty presented her with no problems in the sense that her class understood it, but she had no place for either equality or fraternity. In her mastery of language and in her wit she also looks backwards, to the age of Pope and Gay. No writer has been a greater apologist for the status quo, her novels unconsciously

idealising a way of life which remains hypnotic even today. It is a circumscribed but irresistible world which she conjures up, always being careful never to let her rose-tinted spectacles glance in a direction which might prick the social conscience. Three out of her six novels, *Sense and Sensibility, Pride and Prejudice* and *Northanger Abbey* were all drafted during these years of the Counter-Revolution. In the first, sensibility, once the brave badge of upper class concern for those less fortunate, was cast as a selfish attribute. It is not wholly dismissed, but it cannot contend with the primacy of sense. Her novels accord with the format of the romantic fiction of her age, in which a heroine, usually of the Cinderella kind, finds the man best suited to her. In her later novels such as *Mansfield Park* (begun 1811), *Emma* (1816) and *Persuasion* (1818) the classes are more stratified, catching the triumph of hierarchy as the war drew to its close, and the aristocratic opulence of the Regency of the future George IV.

In comparison with Jane Austen's circumscribed cameos of élitist life, Sir Walter Scott's range can only be described as protean. He changed the direction of the novel which, up until he began writing in 1814, had always centred on the preparation of women for marriage. And Scott was responsible for creating a wide range of genres still with us today. Amongst the prolific work of this Scottish writer we find the nautical tale, the tale of terror, the ancestor of the 'Western', the saga of London low-life as well as the first multi-volume novel. Scott wrote as a representative of the country which had lost its political separateness but still retained a cultural identity. As in the case of Jane Austen he wrote from the status quo but in a very different way. Scott virtually invented the historical novel in which he placed human beings into the web of history. In every instance the periods in which he locates his novels are ones of intrigue, rebellion, revolution and change. He traces the impact of such events upon the characters but draws his novels to an end with an act of reconciliation. Scott always searches for what unites society and not for what divides it. He looks for what heals divisions and resolution is almost always found in the form of a hero who opts for being a private citizen willing to settle into a tolerant middle class world of peace and commerce. Social mobility is recognised as characters rise and fall but the hierarchy remains intact as people accept a present which has been fashioned by the hand of history. From his very earliest great novel *Waverley* (1814) onwards, Scott's major preoccupation was to preach the gospel of social harmony across the class divides and this explains why his work was to have such an enduring popularity with the Victorian reading public.

The French Revolution may not have enhanced the role of the novelist within society but it certainly did that of the poet. Poetry in the Romantic age was viewed as the highest form of prophecy and, as many of its readers were also devoid of political

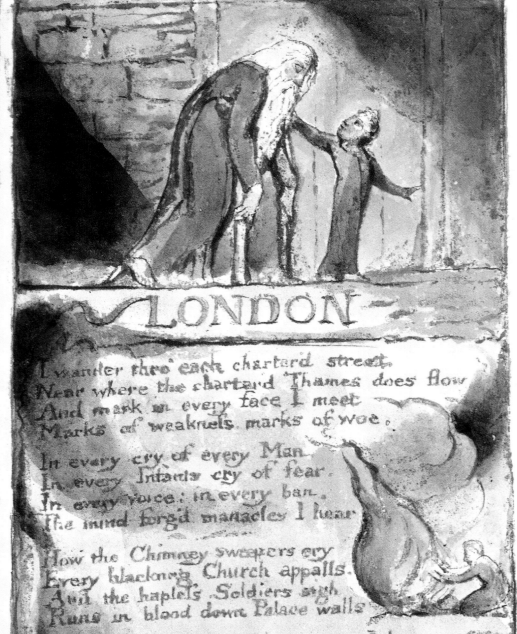

LONDON

I wander thro' each charterd street,
Near where the charterd Thames does flow
And mark in every face I meet
Marks of weakness, marks of woe.

In every cry of every Man,
In every Infants cry of fear,
In every voice: in every ban,
The mind forg'd manacles I hear

How the Chimney sweepers cry
Every blackning Church appalls,
And the hapless Soldiers sigh
Runs in blood down Palace walls

But most thro' midnight streets I hear
How the youthful Harlots curse
Blasts the new born Infants tear
And blights with plagues the Marriage hearse

rights, the poems most typical are those which take for their subject matter topics which were favourable to the excluded or hostile to established authority. Romanticism sought to achieve in poetry what revolution had in politics, innovation and transformation, the sweeping away of a centuries-old repertory of images in favour of new and visionary poetics. These are works written by men seized with the realisation of the power of ideas transmitted through words. Its poets cut right across the class divide and ranged from the aristocratic Lord Byron to the rural labourer John Clare. It also embraces two generations of writers, one born in the 1770s which included William Wordsworth, Samuel Taylor Coleridge and Robert Southey and another born in the 1790s whose leading exponents were Byron, Shelley and Keats.

Their forebear could be said to be William Blake, a working class engraver and radical who early on turned against the rule of Reason in favour of the 'vision' which was 'Determinate and Perfect'. Blake loathed the Newtonian mechanistic universe which far from giving him assurance left him in utter despair. For him it was not Reason but the imagination which purveyed exactitudes. This was the fount of both his writing and his art, such visions of the imagination calling, he believed, for the exploration of new pictorial techniques. Through the nineties Blake was a radical anticipating a millennium which never came. His *Songs of Innocence* (1789) and *Songs of Experience* (1794) superimpose an age of innocency over a world of corrupt laws and social inequality. His is a bitter view of things, a world in which human beings are shamelessly exploited by those in power. By 1800, his earlier hopes unrealised, he became a patriot. But his prophetic fervour never left him. His two great epics, *Milton* (1810) and *Jerusalem* (1820), cast the revolutionary wars in an apocalyptic light and look towards the revival of the ancient religion of the druids. Blake believed that somehow human beings must keep the flame of liberty alive within themselves. Along with several other Romantic poets revolution for him became internalised. In 'Auguries of Innocence' he wrote:

> To see a World in a Grain of Sand,
> And a Heaven in a Wild Flower,
> Hold Infinity in the palm of your hand,
> And Eternity in an hour.

Living by then in isolation, Blake was looked upon as cranky, his dreams long since betrayed and his thoughts firmly turned inwards. He was an untutored genius, a poor shopkeeper's son, devoid of the luggage of a classical education and thus able to write with a blinding

'London' from William Blake's Songs of Innocence and Experience. *Radicalism unleashed again visionary voices not heard since the 1650s, ones which could cry out against the cruel inequalities of contemporary society.*

visionary directness which is still unnerving.

At least Blake never betrayed his radicalism. Most other Romantics did. The three great writers of the first generation all ended their lives as conservatives. William Wordsworth came from a middle class Anglican background and became a radical at Cambridge, making his way to France to take part in the events of the Revolution and acquiring there a French mistress. Disillusion set in, and he returned to England forming a friendship with Coleridge and eventually, in 1805, he settled in the Lake District with his sister Dorothy. *Lyrical Ballads* (1798), with poems by both Wordsworth and Coleridge, was a major landmark in the development of English Romanticism. 'Poetry,' Wordsworth wrote, 'takes its origins from emotions recollected in tranquillity.' For him the imagination was paramount. Wordsworth was inspired by nature, casting the countryside as the repository of eternal verities. He presents humble people, as in 'The Old Cumberland Beggar', with a dignity and a tragic quality as unifying emblems of mankind, accepting their hard lot without protest. The ballads indeed preach an acceptance of things as they are. 'Tintern Abbey' is contemplated for its consolatory and harmonious qualities, a perfect picturesque composition used as a vehicle to celebrate his affection for his sister:

> If I should be where I no more can hear
> Thy voice, nor catch from thy wild eyes these gleams
> Of past existence – wilt thou then forget
> That on the banks of this delightful stream
> We stood together . . .

This is a poetry which takes hold of simple incidents and brings out the special significance of what were commonplace sentiments, celebrations of hearth and home, domesticity and service. *The Prelude* (1805), his profoundly introspective autobiographical poem, was not published until after his death in 1850. Along with Blake, Wordsworth found the mechanistic universe oppressive, putting his faith in the existence of a spirit of nature, a feeling which lifted poets above it into some new realm of apprehension.

If Wordsworth was an aesthete inspired by the reality of nature his friend and fellow author, Coleridge, was a metaphysician whose poetry seeks to penetrate, by the exercise of the imagination, the unseen world. Coleridge was a poet only for a few years, his later career spent brilliantly as a writer of political, scientific, critical and moral literature as well as enjoying a major status as a literary critic. After 1820 his work pursues religious themes, capturing a younger generation in the grip of spiritual renewal. But his poetry belongs to his youth in the nineties. During that period he

was a radical, planning a rural Utopia in the United States along with Robert Southey whose sister he so disastrously married. The scheme came to nothing and he retreated to the Lake District near Wordsworth. Once again the imagination is the key to his work, the means whereby, in his words, the poet 'dissolves, diffuses, dissipates in order to create.' Coleridge's poetry is strictly of the inner eye. Poems like 'The Ancient Mariner' (1798) are deep, sombre and arcane:

> Alone, alone, all, all alone
> Alone on a wide, wide sea!
> And never a saint took pity on
> My soul in agony.

All his greatest poems, like 'Christabel' and 'Kubla Khan' read like feverish and neurotic dreams in which the poet is discovering his inner self. He ended his life a Christian apologist, listened to with reverence by the conservative élite.

Coleridge's brother-in-law Southey was another turncoat radical, in his case becoming in 1813 Poet Laureate, hardly remembered today for his poetry but more for Byron's scathing dismissal of him: 'He had written much blank verse, and blanker prose / And more of both than anybody knows.' In George Gordon, Lord Byron we reach the fulfilment of everyone's dream image of the Roman-

The scandal of Byron's private life and the breakup of his marriage in 1816 was avidly followed and satirised. Here Byron, his arms around a Drury Lane actress, bids farewell to his wife attended by a nursemaid holding his daughter.

The Separation, a Sketch from the private Life of Lord IRON who Panegyrized his Wife, but Satirized her Confidante !!

tic poet: handsome and brooding, rich and extravagant, his life was littered with a string of women who found him irresistible, and he was to die at thirty-six in Greece fighting for its freedom. From the moment of the publication of his autobiographical epic *Childe Harold* (1812), Byron was acclaimed a genius. Although he was notorious in flouting authority, he was no radical. In fact quite the contrary, living a life the embodiment of aristocratic condescension. The public was fascinated by him until his behaviour just went too far even for Regency England, and he left to live abroad. Byron was different also in that he in no way subscribed to the sovereignty of the imagination, preferring instead to write on subjects he knew about, like himself. Few emerged from his cynical pen unbesmirched. His satirical masterpiece, *Don Juan* (1819-24), looks back to the satire of Pope and takes the form of an assault on institutional religion.

Percy Bysshe Shelley was aristocratic too, the grandson of a baronet. Unlike Byron he remained a diehard radical to the end of his days. His career opened with being expelled from Oxford for writing *The Necessity of Atheism* (1811). Eventually he fell in with the anarchist philosopher William Godwin, deserting his wife and making off with Godwin's daughter Mary to Switzerland. His was a life packed at every stage with high drama, ending at thirty when he was drowned at Lerici in Italy. Inevitably he was unpopular with the élite. Shelley managed to combine the attributes of a life-long revolutionary with those which gave him the ability to write some of the most intense and lyrical poetry in the language. But even a poem like 'Ode to the West Wind' (1819) is far from being simple, for beneath the surface it is a poem of prophecy against the reactionary Europe re-established in the aftermath of the defeat of Napoleon in 1815:

> Be through my lips to unawakened earth
> The trumpet of a prophecy! O Wind,
> If Winter comes, can Spring be far behind?

Shelley passionately adhered to the belief that the poet was the creator of new knowledge taking hold, for example, of classic tales, as in his *Prometheus Unbound* (1820), and using them as a means of purveying universal truths to mankind through allegory.

In this he was the antithesis of John Keats who, like Wordsworth, wrote poetry which was self-absorbed and private depicting a world ruled by Beauty. He died young, aged twenty-five, in his case of tuberculosis. The son of an ostler his origins led to his work being dis-

Keats wrote his Ode to a Nightingale *in the spring of 1819. It is recorded that 'One morning he took his chair from the breakfast-table to the grass plot under a plum tree where he sat for two or three hours' scribbling on some scraps of paper, one of which was this.*

Ode to the Nightingale

My Heart aches and a ~~drousy~~ drowsy numbness ~~falls~~ pains
My sense, as though of hemlock I had drunk
Or emptied some dull opiate to the drains
One minute ~~time~~ past, and Lethe-wards had sunk:
Tis not through envy of thy happy lot
But being too happy in thine happiness
That thou light-winged dryad of the trees
In some melodious plot
Of beechen green, and ~~shadows~~ numbuss
Singest of summer in full-throated ease.

O for a draught of vintage that has been
Cooling an ~~long~~ age in the deep-delved earth
Tasting of Flora, and the country green
~~Good~~ Dance, and provencal song and sunburnt mirth
O for a Beaker full of the warm South,
Full of the true and blushful Hippocrene
With clustered bubbles winking at the brim
And purple stained mouth
That I might drink and ~~leave~~ the world unseen
And with thee fade away into ~~the~~ forest dim —

Fade far away, dissolve and quite forget
What thou among the leaves hast never known
The weariness, the fever and the fret
Here, where Men sit and hear each other groan
When palsy shakes a few sad last grey hairs
Where ~~youth~~ grows pale and thin, and ~~old~~ dies

missed by critics, but his poetry gave the new middle classes the idealism which they pined for during the 1820s, paving the way for the Christian morality of mid-Victorian England. Keats's greatest poems were all written in four years beginning in the autumn of 1818. Few other poets of the nineteenth century continue to have the same power to move us, supremely in the great odes culminating in 'To Autumn' . . . 'Season of mists and mellow fruitfulness' (1819).

Except for the Elizabethan age no other period has produced such an explosion of poetic genius. And yet as a gallery it lacks the coherence of the earlier age. Each poet was his own man united only by their response, each different, to the tide of events, to the awareness of the possibility of change and to the release of a new creative potential. Each too was extraordinary in his own right, none more so than those, like William Blake, who came from areas of society not part of the established cultured élite. The Northamptonshire labourer John Clare was another who sprang seemingly from nowhere, writing poems of a touching lyricism crystallising a meticulous observation of the countryside around him and its customs. But like Blake he was not devoid of a political edge.

If the poets of the Romantic era puzzle and confuse by their contradictory variety so also do its great painters. In their case too the only strand which holds them together is their reaction to the successive political and social revolutions taking place around them. Artists, unlike the poets and novelists, had a recognisable institutional framework within which they operated, the Royal Academy. This gave them a showplace for their art and also a place where taste could be learned and the public instructed. As time went on it became progressively clearer that the Academy also embodied the triumph of a certain viewpoint as to the role of art in society and that it was under the control of an oligarchy.

Sir Joshua Reynolds's inheritance was the practice of the 'great style', which made the nation's inability to achieve a major school of painting all the more acute. That failure was blamed on the Reformation and the Civil War, not to mention the constant incursion of foreign artists. History painting was the supreme expression of such a school and to achieve that called for education and an exemplar. Education was found in the Royal Academy Schools and the model chosen was Italy. From the middle of the 1780s onwards comes that melancholy procession of projects designed to give this country the heroic masterpieces which were supposed to equal those by Michelangelo or Raphael. Alas, this was to be a delusory quest. It began with John Boydell's Shakespeare Gallery in 1786. Boydell, a wealthy printmaker, commissioned the major artists of the day to paint scenes from the plays, his expenditure being recouped by the sale of the prints. The gallery opened in 1789 and was initially a huge

success until killed off by the war in 1805. In 1788 another printmaker, Thomas Macklin, launched his Poets Gallery following it two years later with a series of commissions for an illustrated Bible. The Swiss painter Henry Fuseli's Milton Gallery followed in 1790 and Bowyer's Historic Gallery a year later.

The result of this gargantuan effort was a series of canvases which spend much of their time today in museum store-rooms. More successful were individual pictures which depicted contemporary events like the American artist John Singleton Copley's *Siege of Gibraltar* (1791). The tragedy of pursuing this chimera of history painting worthy of a great British School was that it led to painters like the manic Benjamin Robert Haydon wasting his life attempting unsuccessfully to meet the public's hunger for grandeur and heroism. His picture *Christ's Entry into Jerusalem* (1814-20), acclaimed at the time, cannot be looked upon as anything more than a wooden aberration.

As in other spheres of cultural creativity this was an era of shifting sands. The old apprenticeship system gave way to art school training, an open market for art devel-

oped in what was a consumer society, the number of artists escalated and the notion of 'private' art gained ground. Much in the end was dictated by the customer and he tended to be a member of the ever-expanding middle classes. None of the grand historical pictures was relevant, both on account of their size and their subject matter. Artists by 1830 were realising this and beginning to respond to the demands of the market-place, producing smaller pictures for smaller houses and recognising that their commercial future lay in a different kind of genre painting whose focus was domestic, and more often than not owed its subject matter to a scene from a play or a novel which the public would recognise. The moral content to what was depicted was retained.

Fuseli, anticipating the post-Reform Act world, said that in a privatised society painting could no longer be expected to transmit ideas, moral or otherwise. Richard Payne Knight, the theorist of the picturesque, wrote in his *Analytical Inquiry into the Principles of Taste* (4 editions, 1805-1808) that painting was 'colour, light and shade and all those harmonious and magical combinations of richness and splendour which form the charm and essence of art.' This statement was a very far cry from Reynolds's exalted role for the artist as the purveyor of 'intellectual pleasure and instruction by means of the senses' but Payne Knight's views began to take hold.

The market for art after 1800 crossed country at a remarkable speed. Societies of artists seemed to spring up everywhere: Norwich (1803), Edinburgh and Bath (1808), Leeds (1809) and Liverpool (1810). In 1804 the Society of Painters in Watercolour was formed and the following year a rival to the Academy opened. The British Institution, founded amidst the patriotic fervour of the year of Trafalgar, was designed specifically for the exhibition of works by native painters. It was a profound expression of the belief that a great nation is known through its cultural legacy. This task it set about by staging retrospective exhibitions of British painters, Reynolds in 1813 followed by Richard Wilson, William Hogarth and Thomas Gainsborough in 1814.

Conflict surrounded the very definition during these years as to who was qualified to pronounce on what constituted art. Did that lie with the connoisseurs, seen as allies of the private collector, or did it lie with the artists, seen as advocates of the general public? This reached its climax in the debate over the acquisition by the nation of the Elgin Marbles, brought to England from Athens by Lord Elgin. These were exhibited in 1809 resulting in a division as to whether they should be purchased for the British Museum or not. A Select Committee was set up to inquire into the matter and the debate was taken to Parliament. The Select Committee's Report came down in favour of the artists and the acquisition of the Marbles, as they would provide

students with 'the finest models, and the most exquisite monuments of antiquity.' By doing this the State had admitted that it had a role to play, a concept wholly foreign to the previous century but one which was henceforth never to go away. That notion of government somehow being involved in the provision of art for its citizens found equal expression in the foundation of the National Gallery in the year of the great Reform Act, 1832.

Our perception of the art of these decades from our own century is a distortion. Artists we regard as the summit of achievement, like Blake or Constable, were looked upon at the time as peripheral. Even Turner as he grew old was viewed as wilful and eccentric. The mainstream in the public's eyes still largely remained with the portrait painters during what was a golden age. Artists such as George Romney, Sir Thomas Lawrence and Sir Henry Raeburn endowed their sitters with a rarely equalled high glamour. But it was in landscape painting that an unparalleled contribution was to be made. Did contemporaries but realise it, it was in the canvases of Turner and Constable that the nation in fact achieved a British painterly pantheon equal to that of any other national school from the past. The irony lay in the fact that both of these artists saw themselves as history painters but, and this was their originality, set out to achieve their end by way of landscape. Taking into account all the many layers of meaning which could be read into representations of the native countryside during these years it is hardly surprising that it was landscape which dominated the visual arts.

Joseph Mallord William Turner, the self-educated son of a barber, set his sights high from the outset, determined to rival the Old Masters by following in the footsteps of Poussin and Claude, painters of idealised landscapes peopled with embodiments of moral qualities. His subjects were drawn from the Bible, mythology and classical history. He was a man of intense ambition and great skill; his productivity was daunting, almost obsessive, leaving behind him ten thousand sketches and five hundred oil paintings for a gallery only built in this century. His output included antiquarian watercolours, subject pictures and historical landscapes poured out with a never ceasing flow of invention, exploring the world of the individual imagination and, at the same time, registering the huge changes in society.

These are pictures which call for reading, like the novels or the poetry, with a sharp eye on the context of the times. *Snowstorm: Hannibal and his Army crossing the Alps* (1812) is a rumination on the fate of empires. Later pictures dwell on the fortunes of Carthage, Rome and Venice, pictures which delivered to the onlooker at the time a moral warning about Britain in the aftermath of war and the onset of an agricultural depression. A picture like *The Fighting Téméraire* (1839), a sailing ship tugged

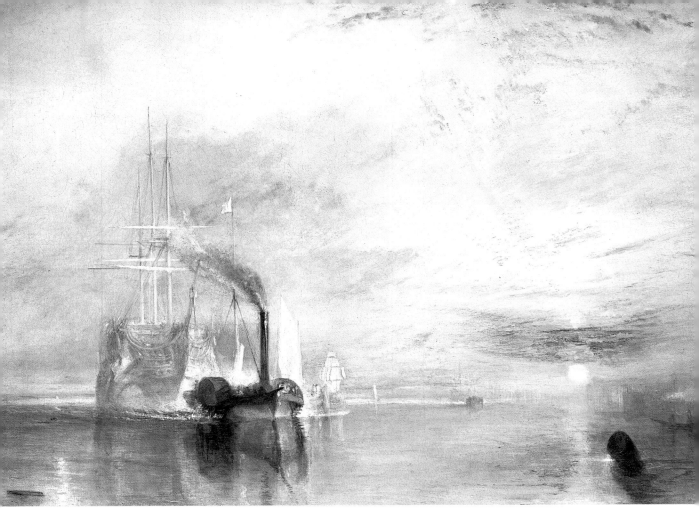

to her last berth to be broken up, spoke of the decline of a country in the throes of industrialisation. Turner superimposes both a public and a literary meaning on his landscapes which are seemingly on first encounter merely virtuoso essays in pure form and colour. His scenes range through every category of the sublime, the beautiful and the picturesque. On the one hand he paints avalanches and shipwrecks, on the other parties, festivals and love stories. His subjects usually encapsulate pivotal movements, a rise or fall, a victory or a defeat, a sunrise or a sunset, summer as against winter. All of them emphasise man's insignificance in the face of the powers of nature, caught often in a swirling vortex in which the figures are mere ciphers and in which the eye is forced to face the sun head on. The latter is painted with a heavy impasto, a dominant powerful disc, symbolic of warmth, energy and fruition but also at times redolent of passages in the Book of Revelation, the sun as the harbinger of blood-

Turner's The Fighting Téméraire, tugged to her last Berth to be broken up *(1839). An heroic warship from the Napoleonic war era is towed to its fate by an emblem of the new industrial age, an iron-clad steamer.*

baths. Turner's stature is one which time has progressively enhanced and whose work is now realised to capture more than any other the tempestuous revolutionary era through which he lived. In *Rain, Steam and Speed* (1844) he celebrates the advent of the railway age but cast in terms of a mystical apocalyptic vision of terrified horror.

Turner was elected a Royal Academician in his twenties but John Constable had to wait until he was fifty-three. Turner certainly had recognition in his own time but Constable, often neurotic and brittle, hardly did. He, like Turner, followed Reynolds and it has been said that we can understand one aspect of his art if we look at his canvases as though they were settings framing a grand heroic subject by an artist of the stature of Titian but with the figures removed leaving only the background. But Constable's work is far more complex than that for it centres on the ennoblement of an area of England in which his family owned land as his personal vision of Happy Britannia. Of the Stour Valley in Suffolk he wrote: 'The beauty of the surrounding scenery, the gentle declivities, the luxuriant meadow flats sprinkled with flocks and herds, and well cultivated uplands, the woods and rivers, the numerous scattered villages and churches, with farms and picturesque cottages, all impart to this particular spot an amenity and elegance hardly anywhere else to be found.'

Constable's Salisbury Cathedral from the Meadows, *painted in the early 1830s during the period of the passing of the Reform Bill, reflects the artist's deep commitment to the old order of things typified in what is an apotheosis of the Established Church seen as vulnerable and under threat.*

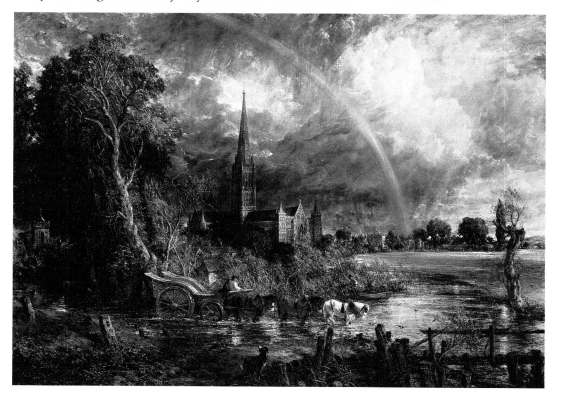

Constable elevates landscape but in contrast to Turner has no time for literary texts and historical subject matter. And yet his canvases are just as resonant with inner meaning. He was a man of the middling classes, a member of a family which owned and managed land in the Stour Valley. And he was a die-hard conservative, viewing the extension of the franchise in 1832 with horror as giving the 'government into the hands of the rabble and the dregs of the people.' He paints his landscapes as Georgic images of Britain, visions of thriving husbandry and industry, a microcosm of the nation. Views of Salisbury Cathedral, sometimes within the embrace of a rainbow, are symbolic representations, mnemonics of Church and State and hope. These are records of a landscape he sees as under threat from agrarian unrest and reform. They are also landscapes of self-identification in which the ever-changing sky is an index of the painter's own emotions, sun to rain, calm to storm. 'Painting,' Constable once wrote, 'is but another word for feeling.'

So much of the art of the age is about inner visions. Turner and Constable were not alone in this. John Martin's cataclysms capture a world seemingly engulfed in perpetual apocalypse. In the same way another artist, Samuel Palmer, echoing Blake, transmutes the landscape around Shoreham in Kent into a series of hallucinatory and haunting dreamscapes. The painters alone

Samuel Palmer's Ruth Returning from Gleaning *encapsulates the release of the Romantic imagination enabling artists to give full expression to their own inner vision.*

reinforce the fact that no previous period has had such a multiplicity of personal statements or such a seeming release into a freedom which allowed the artist to take off into almost any direction which he chose. In architecture it was to be same, albeit with the constraints of the client, and that was due to Britain's one major contribution to aesthetics, the picturesque.

This aesthetic was codified in Sir Uvedale Price's *Essay on the Picturesque as Compared with the Sublime and the Beautiful* (1794). The picturesque occupied a position midway between these two extremes. It was never a precise style for its aim was rather to create a building and a landscape which would form a picture enlivened by variety, movement and asymmetry. This was an aesthetic which could be applied to every situation. It was architecture deployed as stage scenery with an open ticket to voyage back to other ages and to other countries. So the classical norm of the eighteenth century, breached already by the Gothic, now gave way to become just one more possibility in a repertoire of styles which ranged from Greek revival to Chinese, from Tudor to Mogul. This stylistic pluralism meant that style was chosen according to the purpose and site of a building. It was also selected under the impact of the Romantic imagination to evoke an emotional response in the viewer, thus resulting in sober

pedantic Greek revival for the British Museum (1823–47), exotic Mogul for the Prince Regent's fairy seaside palace at Brighton (1815–21) or melodramatic gloomy Gothic for that megalomaniac William Beckford's folly, Fonthill Abbey (1795–1812).

The rapid urbanisation of the country demanded a range of styles for the new types of building which were the result of economic and social change: banks and offices, schools and hotels, shopping arcades and factories, as well as a multiplication of existing formats such as churches and chapels, theatres and bridges. Not only was there this wave of new building types but equally the advent of new materials with which to construct them, stucco, artificial stone and Portland cement, not to forget the most innovative of all, iron moulded and mass-produced. Appropriately during this era of fervent patriotism many of those public buildings today seen as the essence of the country's identity came into being: Buckingham Palace (1825–30), Marble Arch (1828), the National Gallery (1833–38), Regent Street and

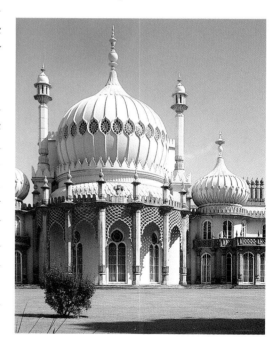

Picturesque pluralism I. John Nash's exotic pavilion for the Prince Regent in the Indian style.

Regent's Park (1811–30), the British Museum (1823–1847) and the Bank of England (1792–1833).

Regal prodigality, 1829. A horrified John Bull tots up the cost of Buckingham Palace. Nash, the architect, stands in the forecourt his foot extended towards Marble Arch, once the ceremonial entrance but later removed to Cumberland Gate.

This was a golden age of town planning. Architects took up from the elegance of Georgian Bath (1729–1771) as created by John Wood, who had laid out the town in a sequence of streets, squares, circuses and crescents each made up of separate dwelling houses but drawn together as single architectural compositions by imposing on them unified façades. The greatest of these schemes was that by John Nash for Regent's Park and Regent Street (1811–1830), the Park with its superb terraces, individual villas, its two villages, East and West, all set within a landscape park by the architect's unofficial partner, Humphry Repton. Together, these formed a perfect essay in the picturesque, blending grand classical architecture with the surrounding natural scenery to produce a composition of striking variety and dramatic contrast. From it a noble street with a colonnade curved its way boldly down to what is now the Duke of York's steps but was then the residence of the Prince Regent, Carlton House. This was the most comprehensive scheme in the capital's history, one which went on to include the formation of Trafalgar Square, the replanning of the Mall and St. James's Park and the building of the present Buckingham Palace. This was London envisioned as a great imperial city in the aftermath of a triumphant victory.

The formula was copied throughout the country in Brighton, Leamington Spa, Clifton, Tunbridge Wells, Newcastle and Cheltenham. Everywhere squares and terraces dominated the inner city areas giving way to elegant detached villas in the suburbs, together forming urban compositions unequalled for their panache and style. Cheltenham is perhaps the most complete surviving Regency town. In 1801 its population was three thousand; by 1826 it was twenty thousand. J. B. Papworth designed what was in essence the country's first garden city with formal avenues and squares and villas in the Tudor, Greek and Italian styles, so perfect that he made the semi-detached an acceptable type of residence.

In both the rapidly expanding industrial areas and in the fashionable spa towns there was a similar surge of building activity. Developments in local government called for shire halls to house everything from the law courts to the gaol, the barracks to the armoury. For these symbols of regional law and order the style almost invariably chosen was Greek revival with a massive, almost threatening, deployment of vast Doric columns. Chester Castle (1785–1822) was the first of a series which culminated in the stupendous St. George's Hall (1839–40) in Liverpool designed by Harvey Lonsdale with magnificent interiors by C. R. Cockerell. This, a combination of law court, assembly rooms and concert hall, takes its place as one of Europe's greatest neo-classical buildings.

The tremendous shift in population into the towns called for a massive church building programme. War

The Quadrant in Regent Street, since destroyed, once part of the massive ensemble Nash contributed to London in what was a superb exercise in town planning.

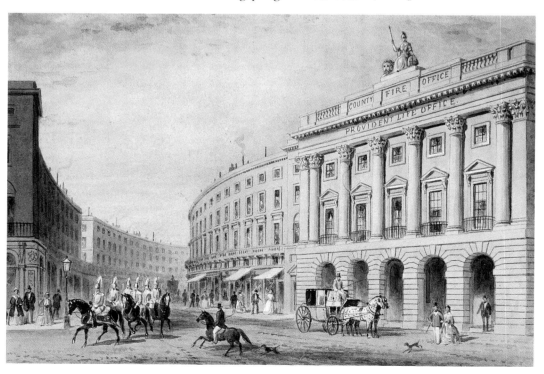

had accelerated urbanisation and churches were seen as beacons averting the spread of revolutionary ideas among the urban proletariat. The Church Building Act (1818) called for the construction of six hundred new churches. These arose during the following decades designed by the leading architects of the day, John Nash, Sir John Soane and Sir Robert Smirke. The styles ranged from the Greek revival of St. Pancras,

Picturesque pluralism II. Reproductions of the caryatid porch of the Erechtheion, Athens, incorporated into W. & H. W. Inwood's St. Pancras Church, Woburn Place, London, 1819-22.

Consumer boom. Ware's Royal Opera Arcade, Pall Mall, London, 1816-18.

Woburn Place (1819–22), to the Gothic of St. Luke's, Chelsea (1820–24). The high street bank arrived in the aftermath of the 1826 Bank Act which granted note-issuing facilities to corporations outside London and the establishment of branches of the Bank of England in the provinces. C. R. Cockerell in the 1830s and 1840s established the quintessential image of the bank, its security and stability writ large in severely Doric columns.

Increasing prosperity called for new shopping facilities and places of assembly. Shopping arcades capture the new consumer boom, Nash's Burlington Arcade and Samuel Ware's Royal Opera Arcade arose in the same year, 1816. The professions demanded buildings which would express their new-found status in society like George Dance's classical Royal College of Surgeons (1806–13). The gentleman's club as a meeting place

also came into being during the final years of the war bringing together the male élite grouped according to achievement, social distinction and political affiliation: the Travellers Club (1829–32), the United Services Club (1826–28), the Carlton Club (1826–27), the Athenaeum (1827–30), the Oxford and Cambridge Club (1835–38) and the Reform Club (1837–41).

What is so striking is this proliferation of public places of assembly fully reflecting the extension of the franchise in 1832 and the spread of involvement in politics across a far broader spectrum of society. The belief that such a public should have access to art as a uniting and civilising force across society is captured in the opening of museums to the public: Sir John Soane's Dulwich Gallery (1811–14), George Basevi's Fitzwilliam Museum, Cambridge (1834), Sir Robert Smirke's rebuilding of the British Museum (1823–47), C. R. Cockerell's Ashmolean Museum, Oxford (1839–45) and William Wilkins's National Gallery (1833–38). The demands of the aspiring classes equally affected education leading to the opening of new school buildings in what was solid Anglican Gothic, Rugby (1809–21) and Harrow (1819–20). In Scotland education was to retain its dour classical guise. Oxford and Cambridge, moribund throughout the previous century, also began to spring to life with a flurry of new building, in the main in Gothic.

The acquisition of an estate in the country and the erection of a house continued throughout the century to be the only way of achieving recognition as a member of the governing classes. The doctrine of the picturesque enabled the *nouveaux riches* to resort to the

Picturesque pluralism III. William Wilkins's revival of the Tudor style for Tregothnan, near Truro, Cornwall, 1816-18.

dressing-up box of past styles, while existing ancient families emphasised their superiority by embroidering false antiquity on to what already existed. There was unprecedented wealth available for houses in an almost bewildering array of styles. What united them was the multiplication of rooms each for a different activity, from breakfasting to music-making. The old stiff suites of formal reception rooms on the *piano nobile* gave way to rooms on the ground floor with French windows and verandahs giving access to the garden, part of the era's new-found cult of nature and flowers.

It is remarkable that the classical style held its own in spite of its adoption by both Revolutionary France and by Napoleon. It continued to remain safe in British eyes, untarnished for men who would have been classically educated at Eton or Winchester followed by Oxford and Cambridge. Inevitably it is the extraordinary houses in Gothic and Tudor which most catch the eye. Castles arose all over the country, evidence of the reassertion of social hierarchy as much as to the Romantic imagination. In Scotland William Atkinson revived the 'baronial' style of the sixteenth century endowing Sir Walter Scott with the fantasy of Abbotsford (1817–23). In England the castle mania reached its height in the remodelling of Belvoir Castle (1801–13) by James Wyatt for the Duke of Rutland and the architect's nephew's remodelling of Windsor Castle for George IV in the 1820s. Windsor as a result looks like a castle lifted out of a novel by Scott, a Romantic movement vision with picturesquely disposed towers and machicolations and yet within, true to picturesque principles, rooms in quite other styles, rococo and classical as well as Gothic. This was Britain in her hour of triumph, secure in her monarchy and in her culture, all of it expressed in a style which affirmed the nation's historic continuity and abhorrence of revolution.

Perhaps some of the most delightful architecture produced by the picturesque movement can be found in its cottages, small villas and lodges. A steady stream of pattern books opened to the public a wide range of possibilities giving people the option of indulging in some pretty, sentimental and nostalgic reverie of times past.

Picturesque pluralism IV. The peasant's humble cottage prettified. Lodge to Woolston House, Loddiswell, Devon, 1820s.

The picturesque caused the upper classes to view the dwellings of their estate workers with new eyes, making them rebuild and decorate them to form part of a picture worthy of viewing from a carriage. It was not long, however, before they began to build their own versions, the *cottage orné*, small dwelling houses in the cottage style replete with every luxury. Nash's Blaise Hamlet near Bristol (1810–11), an idyllic group of thatched almshouses set around a green, signals the arrival of the cult of the cottage as an ideal.

The perfect picturesque vision. Turner's watercolour of Belvoir Castle, Rutland, in 1816 invests its recent rebuilding in the medieval Gothic style with all the patina of venerable antiquity.

Architecture for the first time took on the dimension of a profession with the foundation of the Institute of British Architects in 1834. Architectural journals sprang into existence during exactly the same period. The galaxy of architectural talent was prodigious, dominated by its two greatest figures, John Nash and Sir John Soane. Nash is the lesser of the pair, adaptable, quick and slick. His career took off with

Downton Castle, Herefordshire (1774–78), which he rebuilt for one of the prime theoreticians of the picturesque, Sir Richard Payne Knight, a castle lifted as though out of a landscape by Claude. By 1796 Nash had formed a partnership with the man who had inherited the mantle of 'Capability' Brown, Humphry Repton. Together they made an almost unbeatable team, able to create a house and park as one breathtaking and seductive picture. Their emphasis was always on pictorial values, epitomised by Repton's famous Red Books in which he presented his clients with a series of watercolours of his proposed improvements. Each picture had flaps which, when lifted, revealed the possibilities of transformation by his magic wand.

Soane is by far the greater architect, a towering genius with an idiosyncrasy of style which can be experienced still by any visitor to his house in Lincolns Inn Fields. Soane was obsessed by 'the poetry of architecture' and was what one might describe as a Romantic neo-classicist. Trained in the Academy Schools and in Rome his austere, complex and brilliant buildings are masterpieces of restraint in terms of the disposition of space and the orchestration of light. The Bank of England (1792–1833), demolished between the wars, was his greatest work. Dulwich Art Gallery (1811–14), a combination of picture gallery and mausoleum, is testimony in its austerity and control to his supreme perfection of style. As an architect he deserves to stand alongside Inigo Jones and Wren as one of the country's greatest.

Harleston Park, a country house presented to its owner by Humphry Repton in a before and after version. The landscape designer's technique was to present his client with pictures which would enable them to visualise what their grounds would look like after his 'improvements'.

What was in the long run to be more important was the emergence of the engineer. In 1818 the Institute of Civil Engineers was founded. Fire-resistant iron, the product of the Industrial Revolution, was to change building construction radically as the century progressed. Engineers of the distinction of Thomas Telford and John Rennie were outside the architectural profession but in fact used the architectural language, tautened and refined, of the Greek revival. Road and bridge building throughout Britain were to figure amongst their greatest achievements. Iron was used for bridge building and the London to Holyhead road, constructed from 1815 onwards, was to culminate in Telford's most famous bridges, the Menai Bridge (1819–25) and the Conwy (1826). Nothing on this scale had ever been constructed before.

At this point it is perhaps necessary to pause and draw a breath. The forty years following 1790 take on at times an almost disorientating quality. Every phase of British culture up until these decades seems in contrast so contained, so controllable, so unified in statement. Suddenly one is faced with an explosion, with everything seemingly careering off in all directions. How, one wonders, could so much be achieved during what was a world war and in a society permeated by fear: fear of

scientific advance, fear of revolution from below, fear of new machinery, fear of the railway, fear of the hideous sprawl of the new industrial cities? At the same time one registers people's sense of liberation, which opened new

The architectural genius of Sir John Soane revealed in this design by him for the Consols Office in his Bank of England, tragically demolished in this century.

possibilities and new hopes for a far wider section of the population than ever before. What was clear is that the floodgates demanding change could not be closed. Although the upper classes had never been richer or in a way more self-assured they had the foresight to realise that their centuries-long reign could only be extended by drawing in a large section of those hitherto excluded. And this they did, thereby setting the scene for the cultural consensus of the Victorian age.

That feeling for consensus was on the *tapis* already from the end of the war in 1815. It is caught early on in the novels of Thomas Love Peacock like *Headlong Hall* (1816) and *Nightmare Abbey* (1818), where the reader is asked to laugh at himself. Similarly a brilliant era of cartoon and caricature asks Everyman to laugh at Everyman. Charles Lamb's *Essays of Elia*, which appeared in the *London Magazine* from

1820 onwards, speak gently of the enduring values of duty and affection. Scott's novels through the same period dwell on reconciliation. Keats's poetry reaches out to the heart. This dwelling on the nobler qualities of man was something which everyone could share in. Unifying attributes were needed in what was an acceleration of change. The Reform Bill was not the only act of government which reconfigured society. The repeal of the Test and Corporation Acts (1828), which excluded from office and the universities anyone who was not a member of the Church of England, meant that Dissenters and Roman Catholics would henceforth be part of a far more plural society. The Catholic Emancipation Act (1829) finally ended what had been nearly three centuries of exclusion.

Much generated during the war years could be built upon. Through it a national mythology rooted in a view of history and the countryside had sprung into being which was adopted by everyone. For the artist this was a wholly new world, a vast new constituency of consumption for his wares. The question arose, what exactly was his role to be in it? In the post-war period that had pulled two ways. One option was to re-assert his position as the radical, the critic, the opponent who voiced opposition to established authority. The other was to don the mantle of being a guardian of the nation's past, a keeper of the country's conscience and a champion of the status quo at its best. And so the scene was set for the plateau that was to be Victorian civilisation.

Picturesque pluralism V. Thomas Telford's iron suspension bridge at Conwy, 1821-26, a profound expression of the age to come but firmly endowed with the trappings of one long gone.

Chapter Thirty-Two

A NEW NATION

Alfred, Lord Tennyson's *In Memoriam A. H. H.* is a poem about the repressed passion of one man for another. Arthur Hallam, whom it commemorates and who died young, had been the poet's muse, and the work was published anonymously in 1850. Written over a period of seventeen years during two decades of momentous change, it reverberates with the hopes, fears and, in particular, the doubts besetting an age. It is a poem haunted by uncertainty:

> I falter where I firmly trod,
> And falling with my weight of cares
> Upon the world's great altar-stairs
> That slope through darkness up to God
>
> I stretch lame hands of faith, and grope,
> And gather dust and chaff, and call
> To what I feel is Lord of all
> And faintly trust the larger hope.

In Memoriam is recognised as the supreme representative poem of the early Victorian era. Within it the bell tolls for the passing of a certain social order, for the demise of a kind of Britishness and the realisation that henceforward the individual must come to terms with a world which seemingly no longer grants any appeal to an external moral authority. Tennyson wrote it in the hope that 'the whole human race would through, perhaps, ages of suffering, be at length purified and saved.' In this way he voiced the anxieties of an age in which the discoveries of science and geology had taken away the hand of the divine in shaping the universe:

> There rolls the deep where grew the tree.
> O earth, what changes thou hast seen!
> There where the long street roars, hath been
> The stillness of the central sea.

And taken away not only from the universe but from man too, a view to be dramatically reinforced nine years

Agony of an age: William Holman Hunt's The Awakening Conscience, *1853-54. A kept woman, surrounded by every novelty, suddenly starts up from her lover's arms realising her lost innocence symbolised by the paradisal glimpse through the open window.*

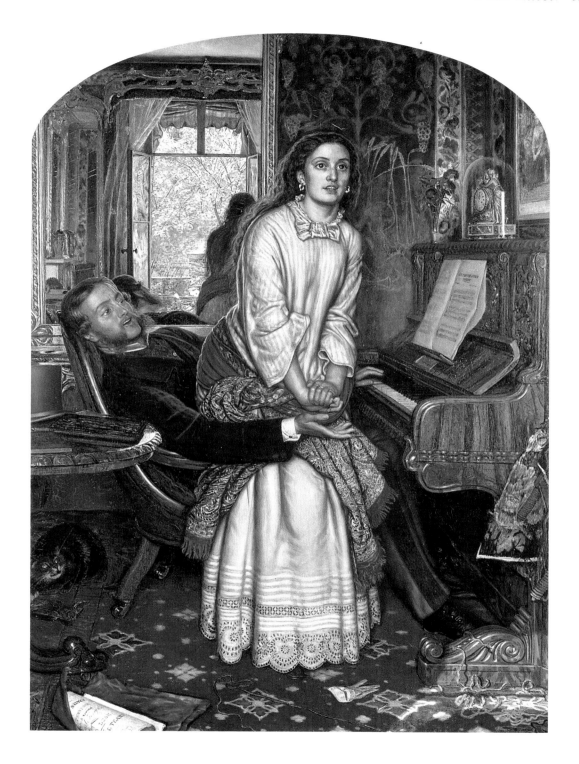

later with the publication of Charles Darwin's *Origin of Species* (1859).

The impact of these scientific discoveries can equally be traced in Victorian painting. William Dyce's haunting picture *Pegwell Bay* records a celestial phenomenon of the previous year. Its subtitle is 'A Recollection of October 5th 1858.' On a desolate seashore women and children apparently search for fossils beneath a sulky grey sky. They strike one as isolated, forlorn and vulnerable. Behind them arises a meticulously painted cliff face with fossils embedded within it. In the centre of the sky there is the faint streak of a comet, Donati's, seen at its brightest on that October day. The comet was sixty-two million light years away. In one disturbing image Dyce has depicted the disorientation of modern man in the face of the new realities posed by the discovery of geological and astronomical time. As if to emphasise his message, the setting Dyce chose was the bay where St. Augustine had landed, bringing the Christian faith from Rome.

The discovery of aeonic time and the subsequent development of evolutionary theory sent shock waves into every area of Victorian intellectual and creative life. Geology led the way with the publication of Sir Charles Lyell's *Principles of Geology* (1833). The planet was demonstrated to be no longer an instantaneous act of God's creation but a natural phenomenon that had evolved over millions of years. The identification of the fossilised remains of extinct species presented evidence which could not be squared with the Creation story as told in *Genesis*. The new timespan was equally irreconcilable. As a result the workings of the planet were now explained by the impersonal operation no longer of divine but of natural forces. As evidence from geologists, palaeontologists and biologists accumulated it was clear that some kind of development of species had taken place. By the 1840s the drift more and more was towards seeing man as part of the animal kingdom rather than some offshoot of the celestial world, an instant creation by the hand of God.

Not all this was to sink in at once. It was to percolate slowly throughout the century but its impact on any educated person was incalculable, far in excess of any of the social or political changes, penetrating deep as the accepted framework of Christianity and a God-centred universe could no longer be taken as a certainty. Mankind was put back into the world of nature and into an evolutionary time scale. As a consequence man's dignity was eroded.

Simultaneously, German theologians began to study the Bible as history in response to the archaeological discoveries which were progressively revealing complex ancient civilisations like Egypt and Babylon. The historical Jesus was presented for the first time in Friedrich Strauss's *Das Leben Jesu* (1835), which was translated into English by the novelist George Eliot. All through the century intellectual advances

later with the publication of Charles Darwin's *Origin of Species* (1859).

The impact of these scientific discoveries can equally be traced in Victorian painting. William Dyce's haunting picture *Pegwell Bay* records a celestial phenomenon of the previous year. Its subtitle is 'A Recollection of October 5th 1858.' On a desolate seashore women and children apparently search for fossils beneath a sulky grey sky. They strike one as isolated, forlorn and vulnerable. Behind them arises a meticulously painted cliff face with fossils embedded within it. In the centre of the sky there is the faint streak of a comet, Donati's, seen at its brightest on that October day. The comet was sixty-two million light years away. In one disturbing image Dyce has depicted the disorientation of modern man in the face of the new realities posed by the discovery of geological and astronomical time. As if to emphasise his message, the setting Dyce chose was the bay where St. Augustine had landed, bringing the Christian faith from Rome.

The discovery of aeonic time and the subsequent development of evolutionary theory sent shock waves into every area of Victorian intellectual and creative life. Geology led the way with the publication of Sir Charles Lyell's *Principles of Geology* (1833). The planet was demonstrated to be no longer an instantaneous act of God's creation but a natural phenomenon that had evolved over millions of years. The identification of the fossilised remains of extinct species presented evidence which could not be squared with the Creation story as told in *Genesis*. The new timespan was equally irreconcilable. As a result the workings of the planet were now explained by the impersonal operation no longer of divine but of natural forces. As evidence from geologists, palaeontologists and biologists accumulated it was clear that some kind of development of species had taken place. By the 1840s the drift more and more was towards seeing man as part of the animal kingdom rather than some offshoot of the celestial world, an instant creation by the hand of God.

Not all this was to sink in at once. It was to percolate slowly throughout the century but its impact on any educated person was incalculable, far in excess of any of the social or political changes, penetrating deep as the accepted framework of Christianity and a God-centred universe could no longer be taken as a certainty. Mankind was put back into the world of nature and into an evolutionary time scale. As a consequence man's dignity was eroded.

Simultaneously, German theologians began to study the Bible as history in response to the archaeological discoveries which were progressively revealing complex ancient civilisations like Egypt and Babylon. The historical Jesus was presented for the first time in Friedrich Strauss's *Das Leben Jesu* (1835), which was translated into English by the novelist George Eliot. All through the century intellectual advances

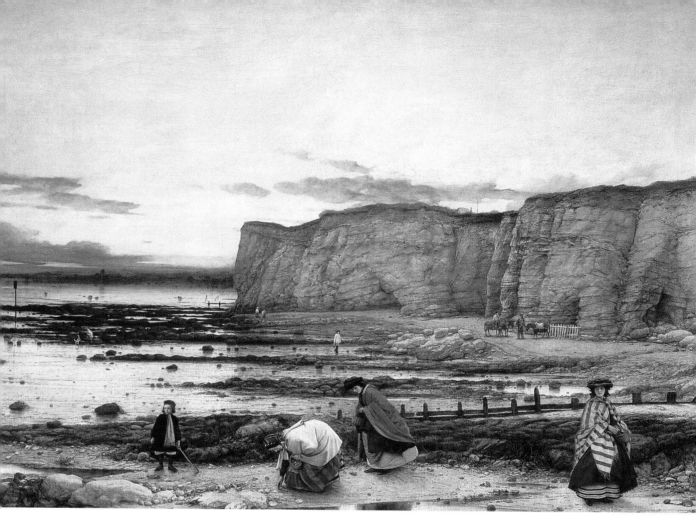

increasingly cast Christianity as an historical movement of belief parallel to many others: a century and a half later it has still not fully recovered from this battering by history and rationalism. Dissent, based as it was on biblical literalism, found this assault the most difficult to

William Dyce's sombre Pegwell Bay *is a tragic elegy on the human condition. The fossils in the cliff face and the comet just seen streaking through the heavens speak of the newly discovered dimensions in time.*

come to terms with. The Anglican Church began to do so only in the 1860s, accepting that the Bible was an historical text and that there was indeed room for doubt. Only Catholicism faced up fully to the implications. In his *An Essay on the Development of Christian Doctrine* (1845) John Henry Newman, who had crossed from the Church of England to Rome in 1845, worked from the premise of change, that doctrine, like the new discoveries about the natural world, could also evolve. In this he anticipated the showdown between Catholic truth and rationalism which was to be a major theme of the twentieth century.

Doubt was to lie at the heart of the Victorian age. The poet Arthur Hugh Clough, friend of Matthew Arnold, reflects the desolation felt by the generation of the 1840s in his poem 'Easter Day' (1849):

Eat, drink, and die, for we are souls bereaved:
Of all creatures under the broad sky
We are most helpless, that had hoped most high,
And most beliefless, that had most believed.

That unease was reinforced by what was a strong reaction against evangelical religion. Evangelicalism, fundamentalist and Scripture-based, had emerged as a reaction to the decadence of the Regency. It also came out of the need of the new burgeoning urban life for a fresh code of behaviour, one which emphasised seriousness of purpose and respectability. The Evangelicals, along with those who made up the spectrum of Dissent, were in the vanguard of a reform of society which embraced not only manners and morals but practicalities. They were to be one of the driving forces behind the sweeping legislation of the 1830s and 1840s. Theirs was a conversion experience which called for social action by women as well as men. Out of it came that quintessential archetype, the middle-class Victorian family with its cult of the exemplary domestic life, its worship of home and hearth and its belief in the gospel of hard work, self-help and fairness in business dealings. That often went hand-in-hand with a commitment to *laissez-faire* economics of a kind which in fact contributed to many of the social problems they attempted to ameliorate. Evangelicalism had other downsides. It easily slipped into a philistinism which was deeply distrustful of the arts, those like the theatre or the novel. It was responsible, too, for enforcing new government legislation on Sunday observance, acts which precipitated riots by those whose pleasures were suddenly curtailed. In addition their belief in the conversion experience and in predestination, that there were those destined to be saved and others, regardless of what they did, who were doomed to damnation, led to spiritual crises like those endured by George Eliot and Matthew Arnold, who could not believe in such a barbaric God and turned instead to a form of religion based on an elevation of human conscience and humanitarianism.

From the opposite end of the theological divide, at the same time, came a Catholic revival in the aftermath of emancipation in 1828. By the 1850s a new Catholic hierarchy was in place and the established church began to feel increasingly under threat. Under threat, too, from within its own ranks for in the wake of the Church's loss of its monopoly on education and office-holding came the Oxford Movement in 1833. Once the centuries-old equation of Church and State was dissolved, the former

had to re-establish its credentials and in order to achieve that had to demonstrate its role as being continuous with what had gone before, the Catholic Church of pre-Reformation England. That meant exulting the role of tradition in the Catholic sense and putting back the sacraments as the centre of the faith. Mystery thus came back to Anglicanism, along with ceremonial and images, the effect of which on architecture and the decorative arts was to be profound.

All the great minds of the Victorian era wrestled with some form of spiritual crisis. John Henry Newman, arguably the finest intellect of the age, at least never lost his Christian faith but in the end found the Oxford Movement's Catholicity untenable and left for Rome. This conversion had its cultural implications, for after years of the isolation caused by the Napoleonic Wars it signalled the reopening of a dialogue with other European cultures, the effect of which was to be greatly in evidence by 1900. Newman spoke of the alienation of his times when he wrote in his *Apologia pro vita sua* (1864): 'I look out of myself into the natural world of men, and there I see a sight which fills me with unspeakable distress.'

In the case of the historian Thomas Carlyle the search for new certainties was to be found in the cyclical working of 'the Eternal Powers' which presided over the course of human history. Opinionated and occasionally turgid, Carlyle nonetheless asked questions central to the new age, using language charged with all the emotional power of Evangelical Christianity. His response to the beleaguered Christian tradition was to pin his faith in the idea of the heroic, on a history dominated by Great Men and their deeds. In *Sartor Resartus* (1833–34) he addressed what he saw as the spiritual dilemma of his time by discovering an Eternal God in a religion devoid of theology.

At another intellectual pole stood John Stuart Mill, a civil servant in the India Office, who was brought up in utilitarianism. Mill had no time at all for intellectual abstractions, enunciating his celebrated principle of 'the greatest good for the greatest number', arguing in *On Liberty* (1859) for freedom of opinion and expression and contributing later in *The Subjection of Women* (1869) to the huge change in women's status which was to be a major feature of the final years of the century.

Such in outline is the intellectual backcloth against which must be set the four decades which followed the passing of the Reform Bill of 1832. Those years fall broadly into two sections, the first culminating in the Great Exhibition of 1851 (to which I will come in the next chapter), the second ending with the further extension of the franchise in 1867. The first two decades were the ones which in effect witnessed the emergence of a new nation in the aftermath of the demise of the Anglican-aristocratic state. Its heartlands lay no longer just in London but in the industrial areas of

the midlands, the north and Wales. The expansion of the new industrial towns was unprecedented, causing a breakdown in the old social patterns with a segregation of classes previously integrated. Although the old hierarchy remained in place the energy of the era came from groups hitherto excluded, Dissenters and Roman Catholics. Suddenly a society which had always been plural in religion and belief became officially so. These were years of social conflict amidst a tidal wave of reform. As the 1830s progressed it was realised more and more that a sharp break had occurred, that the world before 1790 was a different one, now extremely remote, and that England had rapidly passed from being a mainly rural and mercantile society to one which was predominantly urban and industrial.

All the arts engaged with how to respond and interpret these changes, how to find a new context for politics, one which would not jettison the past. The concern was always with practicalities, caught again and again in the work of the novelists who described the oppression, smoke, grime and misery of the new industrial England.

The new nation's commitment was to individualism, to a deep belief that men should be free, expressed in the doctrine of free trade and a deep dislike of any form of government intervention. In 1846 the Corn Laws were repealed, opening the doors to the import of cheap corn to feed the industrial masses. By 1850 not only had the country survived without a revolution of a kind which had happened in every other country in Western Europe in 1848, but the challenge of the Chartist movement, which demanded the vote for the working classes, had been warded off. The country entered a rare period of two decades of consensus during which prices, wages, rents and profits all rose simultaneously. Upward mobility for those below was possible and the textbook for that was Samuel Smiles's celebrated *Self-Help* (1859). Both the old aristocracy and the middle classes could also meet in a new ideal, the gentleman. The new public schools acted as induction courses for those who wished their children to move up the social scale and join the élite. These were years of buoyancy, balance and stability. Bearing in mind the continuing population explosion from nine million in 1801 to twenty-seven million in 1841 that achievement without a violent upheaval was remarkable.

But that population was assailed by change. The railways and the electric telegraph which went along with it ensured the intrusion of such change into the remotest areas of the island. That tide of communication was to be an irreversible one. Change on such a scale and with such speed, far from fuelling people's fascination with the new, accelerated instead an intense preoccupation with the past. That at least embodied certainty for it had already gone and, moreover, it could be rewritten to accord with every political, religious or cultural standpoint. History suffuses the Vic-

torian age as never before, its architecture, its literature and the visual arts. In history too was writ large the debates of the present. Everyone read Thomas Carlyle's great narrative *The French Revolution* (1837) in which a society was swept away, a text providing in the eyes of the new classes a salutary warning as to what might befall the aristocracy. It was a lesson the latter learned, enabling the existing hierarchical structure to live on. Thomas Babington Macaulay in his *History of England from the Accession of James II* (1849–51) dealt with the events of the Glorious Revolution of 1688 arguing that Britain had had its revolution in the 1640s. He provided the newly expanded electorate with an optimistic and progressive view of the past, one now labelled as the Whig interpretation of history, in which the new nation was seen as a lineal descendant of a series of heroic struggles against autocracy of different kinds across the centuries. The Reform Act was its culmination in the present, an act which once again brought Parliament and people into harmony.

Never before was so much known about the past, nor so much about its art. Traumatised by the present, it is hardly surprising that instead of boldly forging a new style the past was recycled, thereby disguising or ennobling what was new as old. Although the civil war period was to be colonised by factions as discrepant as the radicals and Chartists, as well as by exponents of the Oxford Movement, to justify their causes it was to remain essentially an arena for politics and religion and not culture. Cultural thought was hypnotised by one period only, the Middle Ages. Here was a native alternative to the foreign classical past which had been the essence of aristocratic Georgian civilisation. One of the greatest cycles of romance, the Arthurian legend, was indeed set in Britain so that for Victorian readers Arthur and his knights could be all too easily transposed into being the forebears of contemporary monarchy and knighthood. Until the final decades of the nineteenth century, when academic medieval studies blasted away the rose-tinted spectacles, it remained an infinitely vague period offering escape into an age of certainties of an adaptable kind. For Augustus Welby Pugin the Middle Ages were Christian, Catholic and Gothic, for Tennyson in his *Idylls of the King* (1859–85) they presented a mirror of present moral conflicts, while for a painter like Dante Gabriel Rossetti they offered a sensuous dreamworld of love and beauty.

Thanks to Scott's *Ivanhoe* (1819) the Middle Ages entered the Victorian age as an epoch when democratic liberties had been asserted against the yoke of Norman autocratic rule, making them an acceptable past to the newly enfranchised electorate. At the same time they could be used to justify aristocratic rule as was done during the 1830s and 1840s when they were seized upon as a prop for those who wished to preserve the old order of things. The architect Augustus Welby Pugin's *Contrasts, or a*

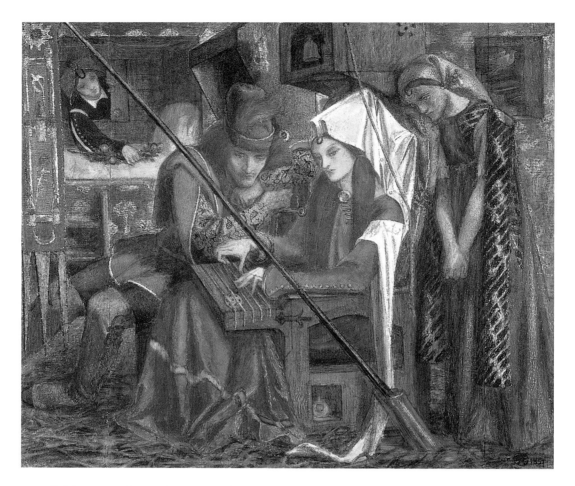

Parallel between the Architecture of the Fourteenth and Fifteenth Centuries and Similar Buildings of the Present Day (1836) was a passionate and biased indictment of the present, looking back to an idealised medieval world, devout, Catholic and caring. It was a view taken up both

Camelot revived. Dante Gabriel Rossetti's The Tune of the Seven Towers, *1857, captures a medieval dreamworld, one which was shared by both radical and conservative Victorians.*

by Tory radicals and by members of the Oxford Movement with their nostalgia for a pre-industrial, pre-Reformation aristocratic society which had been swept away. For a short period during the 1840s the young Benjamin Disraeli led a 'Young England' Tory group who sought just such a turning back of the clock. A revived updated medieval chivalry was cultivated by a group of Tory aristocrats as an answer to the new commercial, industrialised and mechanised nation. This aristocratic cult of the Middle Ages had its most picturesque manifestation in the famous Eglinton Tournament which the earl of the same name staged in 1839, when participants dressed in

armour and period dress to re-enact a medieval joust. It was not until 1850 that the Middle Ages began to be taken over by those who adhered to the opposite end of the political spectrum. Carlyle in his *Past and Present* (1843) stood the earlier view of the Middle Ages on its head and far from linking this period with a benign aristocracy connected it instead with democracy and individualism of a kind brought about by 1832. Gradually the never-never land of the Victorian medievalism began to shift ever leftwards, becoming by the close of the century a fiefdom of nascent socialism under the aegis of the designer William Morris in his *News from Nowhere* (1890).

This was the first age of mass culture, for it embraced all those who up until 1832 had been excluded and in that capacity had cultivated a kind of subculture of protest of their own against the establishment. As a consequence the 1830s and 40s witness a drive, aided by the advent of cheap printing, to popularise a common culture, one which could also draw in the skilled working classes. The cultural role of the aristocracy as leaders and patrons had largely gone, had indeed passed to the newly enriched and enfranchised classes. Nonetheless the thrust was always towards maintaining inclusiveness in a country which delighted in being seen as liberal and proud

Camelot re-lived. In 1839 a group of Tory aristocrats led by the Earl of Eglinton re-staged a medieval tournament. The portrait records the earl's appearance on the day.

of its non-revolutionary status. With such a vision in view the aim seems always to have been to achieve some middle way, some form of compromise, reconciling past and present, reform with tradition, belief in the face of doubt, and romance with the need for the preservation of domestic stability.

And this is where the past played such a vital role, for every class of society could be reunited in sharing common past glories. 'Olden Time' became a golden age, one depicted as the birth of a nation and a people, evidenced in highly dramatic historic events which were recreated in pictures on the walls of the Royal Academy and in illustrations in books and magazines. The Tudor and Stuart periods moved centre

stage, being eras of commercial endeavour when the merit of the self-made was rewarded. Places like the Tower of London and Hampton Court were opened to the public, allowing everyone to see the settings in which such heroic deeds had taken place. In this we are witnessing the birth of cultural tourism. Great houses

Olde England apotheosised. The heroic past re-created in the interests of a shared heritage. Yuletide in the great hall at Penshurst Place as depicted in John Nash's highly influential The Mansions of England in the Olden Time *(1839-49).*

like Knole and Penshurst, homes of heroes and men of letters, also opened their doors to the thousands who, thanks to cheap day railway excursions, could make the

pilgrimage. With this gesture of aristocratic generosity the new nation was brought into what was recast as a shared common cultural heritage.

And notwithstanding evangelical philistinism there was a vast extension in cultural activity. The recently enfranchised classes aspired to the higher culture. The result was more culture of a more varied kind than ever before. Vast numbers went to art exhibitions and to the newly established galleries and museums. One million alone visited the Art Treasures Exhibition in Manchester during its six month run in 1857. Bearing in mind its location and the size of the population it is an astounding attendance figure, eclipsing that of any twentieth century art exhibition.

One of the keys to this expansion was the spread of literacy which went hand-in-hand with a revolution in printing techniques and book and magazine production. The English language was perceived more and more to be the source of the nation's identity. In 1850 a Libraries Act empowered town councils to finance public libraries which would lend out books. Between 1840 and 1870 the annual output of books quadrupled. Even as early as 1820 the sixpenny novel was available and during the same decade a whole raft of popular annuals was launched. In 1832 the publishing entrepreneur Charles Knight launched his *Penny Magazine* which was to sustain a circulation of 200,000. As a result this was an age of words greedily devoured as periodicals kept everyone abreast of virtually everything that was happening across the whole field of human knowledge. Scientists remained committed to popularising and communicating their discoveries and, as a consequence, they had a great impact on figures like George Eliot, John Ruskin, Charles Dickens and Tennyson.

With the universal passion for reading, novel writing moved from being an indulgence to a career which could bring not only financial reward but also social prestige.

Art for all. Exhibitions of both new and old art attracted large audiences, so much so that a rail would have to be put up as here to protect a picture. In George Bernard O'Neill's painting of 1863 they must be looking at 'the picture of the year' at the Royal Academy.

Although the usual three-volumed format, read by way of the circulating libraries, remained the norm of distribution, serialisation for the first time became a highly profitable alternative. During the 1860s the monthly *Cornhill Magazine*, under the editorship of William Makepeace Thackeray, would serialise two novels simultaneously, selling a hundred thousand copies of each issue. Readers in this way were held as a captive audience for a period of up to two years. Nonetheless it was the circulating libraries, led by Mudie's (founded in 1842), which dominated the market place. Their virtual monopoly was only challenged in 1848 by W. H. Smith. It was the libraries which dictated the tone of the genre, casting themselves in the role of guardians of family values. What was written had to be suitable to read out aloud to a family audience. Sex was, of course, taboo, presenting writers with a substantial problem, but in general the range of subject matter was extensive, covering areas of human activity and exper-

The Warrington Mechanics' Institution Perambulating Library, 1860.

ience never before touched on. The old pre-Victorian format which had centred on courtship leading to marriage was retained but used as a vehicle to explore the condition of England: poverty, destitution, child exploitation, prostitution, industry and over-crowding. The novel became an essay in the education of the human heart, aimed at engendering in the reader an acute social and personal awareness. And in spite of the fact that readers demanded romance, escape and a happy ending, this in no way impinged on the novelists' attempts to use the format as a means of interpreting the changing world around them. Writers during these four decades were able to maintain an optimistic vision, one which was only finally to break down under the pessimistic insights of the 1880s.

The novel remains the supreme and enduring achievement of the age, during a period when great writers were writing in what was the heyday of a relatively new genre. In the 1830s the aristocratic, or so-called 'silver fork' novels, were still in the ascendant but, by the following decade, novels depicting upper class life gave way to ones concerned with ordinary life, as the novelists joined the reformers in an attempt to inform the middle classes and influence public opinion as to the social misery caused by the Industrial Revolution. Stories focused on accepted ethical norms and traced how people managed or failed to live up to them. The family was always pivotal, both relationships within it and across the generations, so much so that later

in the century fiction could take the form of multi-volume sagas tracing how one family responded to history and change. The framework into which characters were placed was one of absolute certainty, expressed in a multiplicity of detail about dress and appearance as well as geographical and historical location. Although the endings could sometimes be almost naive, what the reader was presented with was a quite unrivalled delineation of the complex processes governing family life and what formed human character. In that context Victorian novels are tales with a moral which hold up models of action and behaviour to be either emulated or abhorred.

Charles Dickens towers above every other writer, leaving a pageant of characters which have etched their way into the collective national consciousness. Uniquely he established a relationship with his audience that cut across all the social boundaries in a way only paralleled by the playwrights of the Elizabethan age. Dickens himself was a Victorian ideal, a self-made man, the son of a bankrupt, a victim himself of the new commercialised society who was put to work in his youth in a blacking factory. Scarred by that experience he went on to become the greatest and most popular author of the age.

Dickens made his debut in *Sketches by Boz* (1834) after which followed a steady stream of great novels running from *The Pickwick Papers* (1836–37) to the unfinished *The Mystery of Edwin Drood* (1870). Nine of them were serialised in monthly parts making him a master of suspense. The origins of his novels lie in the narratives of Fielding and Smollett of the previous century but re-dressed to deal with the social issues of his own day. He attacked the workhouse system in *Oliver Twist* (1837–39),

Mr Pickwick's skating party, one of Phiz's irresistible illustrations to the most popular of all Charles Dickens's novels, The Pickwick Papers.

the legal profession and the fate of orphans in *Bleak House* (1852–53), and in *The Old Curiosity Shop* (1840–41) the nightmare of the industrial city. None of the novels is devoid of sharp social comment, although Dickens was careful never to cross the taboos. Instead of sex he exploited pathos and sentiment, as well as the macabre and violent. The novels all deal with change, several of them, like *David Copperfield* (1849–50), deliberately being set back in time. They depend for their success on a strong narrative drive, on surprise, on plots and subplots which twist and turn; if they have a weakness, it is the all-too-frequent providential ending. But in those he reflected the needs and demands of the age, which yearned for reconciliation and harmony. In his portrayal of the development and actions prompted by the human heart he lays before his readers a religion which is one of humanity, made all the more moving because he retained the ability to see life through the innocent eyes of a child, never losing his sense of open-eyed wonder. He saw and recorded an extraordinary panorama of Victorian life, so much so that it is difficult to view the period in any other way. *Great Expectations* (1860–61), the story of Pip, an erratic progress full of ups and downs, contains perhaps Dickens's quintessential vision, in which the tragedies of the past are revisited with understanding and forgiveness. It is some index of his public that his most popular novel was *Pickwick Papers* with its portrayal of an idealised society, in which rich and poor, town and country, high and low, young and old are all seen to be at ease with each other. These are great novels of the human heart.

Dickens was not alone in exploring the changing social scene. Benjamin Disraeli, the statesman novelist, looked back in *Coningsby* (1844) to the aristocratic past in search of role models for his own era, so that the noble hero becomes a reformed man and appropriately marries the daughter of a rich industrialist. In *Sybil* (1845) Disraeli was again to explore the two emergent nations of rich and poor from a conservative standpoint. From the opposite end of the political spectrum came Charles Kingsley, rector of Eversley in Hampshire, who was later in life to become a Christian Socialist. In his novel *Yeast* (1848) he courageously took as his central character an agricultural labourer, and was to go on in *Alton Locke* (1850) to deal with Chartism and the struggle of the working classes for education. Mrs Gaskell was someone else who wrote from her own experience, in her case of relieving the urban poor in Manchester. In *Mary Barton* (1848) she faced up to the clashes between labour and capital, and described the appalling deprivations of the working classes. *North and South* (1855) contrasted the industrial north, a world of new wealth and mass poverty, with the rural south where poverty of another kind existed, this time in the countryside, but so also did the untold opulence of the fashionable world.

Passion and commitment are the hallmarks of these authors, features shared also by the extraordinary Brontë family. Emily, Charlotte and Anne, together with their brother Branwell, were brought up by their father in the remote parsonage house of Haworth on the Yorkshire moors. As in the case of Dickens it was to be their own experience which was to provide them with the substance of their novels, subjects such as the trauma of girls' schools, the humiliations endured by governesses or, in the case of Charlotte, the inner life a woman had to suppress in the interests of duty. In their inebriated brother Branwell they were provided with a pattern exemplifying male degradation. All of this was affected by their own wide reading which ranged through the Bible and the great classics of English literature, especially the Romantics. Their novels all came in the 1840s with two supreme masterpieces, Charlotte's *Jane Eyre* (1847) and Emily's *Wuthering Heights* (1847). *Jane Eyre* captures the tension which existed between the author's head and heart, tracing the spiritual and emotional progress of a plain but unconventional girl. This is a tale with a high moral seriousness of purpose with a hero, Mr Rochester, in the flamboyant, threatening Byronic mould. But Rochester comes nowhere near being as unconventional as Heathcliff, the hero of *Wuthering Heights*, a novel which, by implication, crosses the sexual taboos in a saga of pulsating violence and passion culminating in the heroine's unforgettable utterance: 'I am Heathcliff.' Emily Brontë was to die young and it is difficult to see how her writing could have progressed.

All of these writers had lives marked by trauma. This was equally true of George Eliot who revolted against her evangelical religion and, in 1854, left England for a stay in Europe with George Henry Lewes. Lewes was a married man, unable to get a divorce, and on their return to England they were to remain together until his death in 1878. George Eliot's life was one of spiritual and intellectual crisis, and this is vividly reflected in her novels which focus on the moral dilemmas and decisions of her heroes and heroines. Within her writing is embedded her own personal quest to come to terms with the changes and challenges of her own era, something which she achieved through adopting a new religion of humanity founded on the sympathy and feeling which existed between human beings. Thus her novels, like those of Dickens, offer hope, but of a kind only reached through anguish and tragedy. Of none is this more true than in what is arguably the greatest of all Victorian novels, *Middlemarch* (1870–72). This is set during the 1830s and charts the impact of social change on a series of interlinked characters in a small midland town. George Eliot's research was always meticulous, giving us a portrait of a society caught at a significant moment and evoking a myriad of feeling in response by its major characters. Her plots are multi-layered, to allow for precisely such investigations to be explored at

different levels of the class and professional structure. The great moments are always those of heroic renunciation leading to tragic moral grandeur.

Not every writer made the point by means of such overwhelming intensity. Others commented on the Victorian scene in a manner which continues to evoke a smile and a tear rather than a lump in the throat. One such was Robert Surtees, a north country Tory, who created, in 1838, the fox-hunting squire Jorrocks, deploying him in a series of hilarious novels picking up from the Smollett-Fielding tradition. Another was William Makepeace Thackeray, who in *Vanity Fair* (1848) provides a critique of the England of the Regency written as though through the eyes of a Rowlandson, satirising its snobbery and raffishness as the irresistible Becky Sharp pushes her way ever upwards. Thackeray's output was meagre compared with the prolific Anthony Trollope. Writing was to Trollope a business and there are forty-seven novels to prove it, including a series based around the cathedral city of Barchester running through the 1850s and 1860s and another centred on one family, the Pallisers, which appeared from the 1860s down to 1880. Trollope wrote with a moral end: 'The novelist, if he have a conscience, must preach his sermons with the same purpose as the clergyman and must have his own system of ethics.' His was a voice from the world before 1832, one in which birth, breeding, custom and inherited status were all-important. His plots revolve around business affairs, the church, love and marriage. His characters are always vivid and varied, although he could lurch towards caricature as in the case of Mrs Proudie in the Barchester series. Trollope has a style which fairly sweeps the reader along in stories which manage to cover life in the metropolis as well as the countryside. In *The Way We Live Now* (1875) he was to provide the most biting satire of the age, but his masterpiece is recognised to be *The Warden* (1855). Change as far as Trollope was concerned was unwelcome but his novels are shrewd and worldly-wise, almost cynical. In his view of things only those with cash can afford to have a conscience. Those without it have to fall into line.

Criticism of society could equally be incorporated into what was a new form of novel written deliberately to provide vicarious experiences for the respectable middle classes. It was Wilkie Collins who launched the genre known as sensation novels with *The Woman in White* (1859). This utilises an extravagant and melodramatic mystery story as a vehicle to raise questions about the status and treatment of women.

It is the novelists who were in the forefront of responding to the needs of the age. In sharp contrast poetry was never quite up to the challenge. The Romantic tradition continued but it was shorn of the prophetic voice which had given the early Romantics their visionary power. That mantle passed to the thinkers while the poets grappled with their own personal doubts and fears:

Alone, let us be true
To one another! for the world, which seems
To lie before us like a land of dreams,
So various, so beautiful, so new,
Hath really neither joy, nor love, nor light,
Nor certitude, nor peace, nor help for pain;
And we are here as on a darkling plain
Swept with confused alarms of struggle and flight,
Where ignorant armies clash by night.

Matthew Arnold's *Dover Beach* (published 1867) captures the despair and sense of alienation which pervades Victorian poetry, reflected in its greatest figure, Alfred, Lord Tennyson. Tennyson began writing at the age of five but it was when he was up at Cambridge that he fell in love with his poetic muse, Arthur Hallam, releasing the poet's imagination to give us such poems as *The Lady of Shalott* (1832). Tennyson

William Holman Hunt's illustration for The Lady of Shalott *for the 1842 edition of Tennyson's poem.*

made his public debut ten years later, inaugurating a life which was to be one long personal triumph culminating in his being made Poet Laureate in 1850 and a baron in 1864. The death of Hallam in 1833 is the key to his work, endowing it with the recurring twin shadows of grief and loss.

Matthew Arnold equally struggled with the problem of uncertainty and in his case he lost his faith. When that happened and he became Professor of Poetry at Oxford in 1857 he ceased to write poetry. All his poems belong to the previous decade including his masterpiece *The Scholar-Gipsy* (1852–53), recollections of under-graduate wanderings in Oxford and Berkshire. Thoughtful and serious-minded, Arnold's poetry is about loss, disenchantment and regret, catching his belief that he had been born in an '. . . iron time / Of doubts, disputes, destructions, fears.' In his view political power had passed to a philistine middle class unfit to govern. After 1857 his critical writings were to influence the closing decades, his most important book *Culture and Anarchy* (1869) calling for bourgeois philistinism to be tempered by the 'sweetness and light' of Hellenism. In other books he opted for the teachings of Christ without the luggage of church and dogma and, in his role as an inspector for schools, he campaigned for changes in education. With the creation of 'grammar' and 'county' schools in 1900 Arnold saw his life's work come to fruition in a system of education for the talented which had at its heart the old humanities.

Not even as robust a poet as Robert Browning could escape alienation. *Childe Roland to the Dark Tower Came* (1855) is an unnerving journey into uncertainty, a poem in which the darkest fears of the period are never far below the surface. But his chief contribution is his long series of dramatic monologues:

> That's my last Duchess painted on the wall,
> Looking as if she were alive. I call
> That a piece of wonder, now: Fra Pandolfo's hands
> Worked busily a day, and there she stands.

My Last Duchess (1842) is one in a gallery of complex and enigmatical characters ranging from licentious painters to indulgent clerics. These are portraits drawn in line, short and sharp. Through them Browning explores the many and often baffling facets of a single human being and also, by implication, those which exist within himself. At the time his wife, Elizabeth Barrett, with whom he eloped to Italy in 1845, was admired much more as a poet, but no longer.

Tennyson, Arnold and Browning stand as solitary figures, unconnected. In sharp contrast the poets associated with the Pre-Raphaelite Brotherhood of painters (to whom I shall shortly turn) make up a family linked by birth, friendship and dis-

cipleship. The circle rippled out from the strange, unstable figure of the painter Dante Gabriel Rossetti and included his sister Christina, the designer and social reformer William Morris, Algernon Swinburne, who met Rossetti at Oxford in 1857, as well as lesser figures like Edward Fitzgerald, Coventry Patmore and George Meredith. Their poetry went on far beyond the dissolution of the Brotherhood and indeed Rossetti was to be the vital link between writers of the middle years and those at the century's close. All were overt Romantics, Rossetti's own poetry narrow and intense, with poems like *The House of Life: A Sonnet Sequence*. Written over the years these sonnets sprang out of the highly unconventional relationship he had with a series of his models, one of whom, Elizabeth Siddal, he married but who later committed suicide. William Morris was to write escapist romances in a Chaucerian vein, the tone of which is captured in the opening lines to his *The Earthly Paradise* (1868–70):

> Forget six counties overhung with smoke,
> Forget the snorting steam and piston's stroke,
> Forget the spreading of the hideous town.

The odd fact is Morris did not forget any of these things, for he was to become a committed socialist. Algernon Swinburne, sado-masochist and chronic alcoholic, burnt himself out by the age of forty-two. Inheriting the mantle of the revolutionary Shelley, his was the work of a major lyrical poet who was bitter against the church and organised Christianity. His best poem, *Atalanta in Calydon* (1865) is a cry from the heart against religion:

> None hath beheld him, none . . .
> The lord of love and loathing and of strife
> Who gives a star and takes a sun away;
> Who shapes the soul, and makes her a barren wife
> To the earthly body . . .
> Who makes desire, and slays desire with shame . . .
> The supreme evil, God.

This is cynicism and blatant disbelief of a kind which set the scene for what was to follow after 1870.

Gloom and despair were pervasive but there were those who managed to cling on to belief in what was also an age of faith. Christina Rossetti was one who simultaneously faltered, yet never quite lost hope. Arguably the greatest woman poet before the twentieth century, her devotional poetry is of a rare quality that pulls us back to the golden age of George Herbert. A poem like *Remember* (1849, published 1862)

encapsulates keenly the ever more significant role assigned to memory in the new scheme of things:

> Remember me when I am gone away,
> Gone far away into the silent land;
> When you can no more hold me by the hand,
> Nor I half turn to go, yet turning stay.
> Remember me when no more day by day
> You tell me of our future that you planned:
> Only remember me; you understand
> It will be late to counsel then or pray.
> Yet if you should forget me for a while
> And afterwards remember, do not grieve:
> For if the darkness and corruption leave
> A vestige of the thoughts that once I had,
> Better by far you should forget and smile
> Than that you should remember and be sad.

So far we have had the novelists facing up to change, dismayed yet resilient, seeing their task to comment, contribute, and offer some beacon of light, and the poets, in contrast, their radiance dimmed to the glimmer of their soul's own anguish, turned inwards, perplexed and introverted. Unable to come to terms with the present they unlocked the doors of memory and that which led them to a dream of fair romance in a medieval fairyland. But how did all this soul searching affect the visual arts? Which way did they turn and why? Unlike either the novelists or the poets the world of artists and architects was dominated by the utterances of a single intellectual giant, John Ruskin. No figure before or since has occupied quite such an all-commanding position, one in which he was actually able to determine the direction in which the visual arts of the Victorian age should go.

Opinionated and prudish though he was, Ruskin was the greatest critic in the English language. His powers as a rhetorician told the emergent nation *what* to look at and *how* to look at it. In his case the response to the attacks of science and history on traditional Christianity and institutional religion was a Romantic one. Ruskin cast nature as a reflection of divine truth, asking people to look at the earth and the skies as manifestations of God. His *Modern Painters* (1843–60) set the aesthetic agenda for the period. He resurrected Turner's reputation, then undergoing an eclipse, on the grounds that here was the artist who was able more than any other to penetrate the inner forces of the world of nature and hence divine truth. At the same time science

was brought on board with a call for the meticulous ob-
servation of nature (of a kind verbally achieved by the
poets), a call which was to lead directly to the work of
the Pre-Raphaelite painters. This programme went hand-
in-hand with a commitment not to the cult of the Old
Masters but to the art of the day, thereby accelerating the
patronage and collecting of contemporary works by the

*John Everett Millais's portrait of John
Ruskin in the Highlands, 1853-54
records him in the role he cast
himself, as the art critic deeply
observant of natural phenomena.
The picture led to the break-up of
Ruskin's marriage as Millais became
infatuated with his wife, Effie.*

new middle classes. At the same time this was linked with a rejection of classicality: 'All classicality . . . is utterly vain and absurd, if we are to do anything great, good, awful, religious, it must be got out of our own little island, and out of these very times, railroads and all.'

As a consequence there emerged a stream of contemporary genre painting epitomised by the pictures of William Powell Frith.

But for all Ruskin's commitment to the new he never shed his predilection for the Middle Ages. A new nation called for a new style but Ruskin instead led it backwards, to revive Gothic not only in ecclesiastical architecture but also for secular buildings. In *The Stones of Venice* (1851–53) he went further, and laid the ground for adopting continental styles of Gothic which were by 1900 to spawn their progeny in a whole series of public and commercial buildings. By then his mind had moved on to social issues, his earlier views on art having crumbled in the face of the onslaught of Darwinism. In *Unto This Last* (1860) Ruskin pointed out the gulf between Christianity and the prevailing creed of *laissez-faire* economics. Art and morality for him were inextricably linked, so that he found himself living in a society in which the commercial classes had elevated a doctrine which opposed what he believed to be the first principles of religion. With this Ruskin was treading along a road which led to art and socialism.

In the second volume of *The Stones of Venice* he had already made a passionate attack on modern industrialised society which subjected man to the machine. That attack sowed the seeds for William Morris and the Arts and Crafts Movement later, but it was a backward-looking polemic, preparing the ground for the rejection by the coming generation of what had made Britain lead the world, an enthusiasm for the machine age. That was now to go into reverse. In the same volume Ruskin was to go on to encourage the revival of the Gothic style on social grounds as one of a moral and deeply religious age. The effect was to determine the architectural style of the Victorian era, for up until then there had been a battle of styles.

By 1830 the flood of material whereby to recreate the past had become a torrent. This happened simultaneously with the country moving into the new era, which threw up a whole range of hitherto unknown building types such as gas works, business offices, insurance companies, banks and factories. In retrospect the only people to respond with buildings to match the change were engineers and not architects. Isambard Brunel's glorious Clifton Suspension Bridge (1836–64) or his Great Western Railway Station at Bristol (1839–40) speak of their times as vividly as does his Paddington Station (1852–54) based on Joseph Pax-

Pugin's gilded Gothic tabernacle in the new House of Lords from which the monarch still formally opens Parliament epitomises the deep need by the Victorians to recreate the past.

ton's Crystal Palace (which will come in the following chapter). Add to them the early iron ships and we have all the elements of a new style fit for an industrialised and mechanised society. But it never happened. Instead such quintessentially modern features as gasworks were transformed into what could look from afar like a Norman castle.

National identity was a strong motive, driving the Gothic style relentlessly forwards. Pugin in his *Contrasts* had cast it as indigenous and one can see the logic of its adoption, a visual parallel to preserving the social hierarchy of an earlier age thereby giving a semblance of continuity and security amidst change. In 1834 the Palace of Westminster burnt down. Here was a chance to build in a style to reflect the advent of the newly enfranchised classes. The 1835 competition, won by Sir Charles Barry, stipulated from the outset that the new Houses of Parliament must be Gothic or Elizabethan, a mandate which was decisive in dressing-up the new in the robes of the past. Barry moreover was to bring in Pugin to work on the interiors of his monumental Gothic pile. The latter was never to let up in his crusade, producing a steady stream of publications proliferating the glories of the Gothic style and giving the architects of the day a deep practical understanding of its construction and ornament. In *An Apology for the Renewal of Christian Architecture in Britain* (1843) Pugin narrowed his taste still further, opting for the fourteenth century Decorated phase of Gothic, a decision which was to result in the building of literally hundreds of churches in the style. Pugin, being Roman Catholic, was naturally viewed with some suspicion by members of the Anglican Oxford Movement, whose churches adopted more often than not what was regarded as an even more insular manifestation of the Gothic, the Perpendicular. Pugin's own most famous church was St. Giles, Staffordshire, which was built at huge cost for the Earl of Shrewsbury.

Although Barry was to go on to build in the classical manner houses like Cliveden, Buckinghamshire (1850–51), the pronouncements of Ruskin tipped the balance the other way. Only a politician of the stature of Lord Palmerston could force George Gilbert Scott to change his winning Gothic design for a new Foreign Office (1856) into the Italian *palazzo* style. Nowhere else in Europe was there such an extraordinary revival, one in which a whole generation of architects suddenly abandoned the centuries-old classical repertory and embarked on rebuilding the Middle Ages. It was not to be devoid of its own idiosyncratic masterpieces. William Butterfield's All Saints, Margaret Street (1849–59), a phantasmagoria of coloured brick, mosaic, marble and polychrome tiles, is one. John Loughborough Pearson's St. Augustine's, Kilburn (1870–97) is another, a building in the French Gothic style with the highest spire in London. Butterfield was to build seventy churches, Pearson seventy-five,

and Scott a hundred and forty, excluding his restoration of sixteen cathedrals and three hundred other churches. Scott was to adapt his rejected Gothic Foreign Office scheme for St. Pancras Station (1868–74) and leave his unforgettable imprint on Kensington Gardens in the Albert Memorial (1864–71).

The return of images and ritual to religion. After Catholic Emancipation the Church of England set out to emphasise its continuity from its pre-Reformation forbear. William Butterfield's All Saints, Margaret Street, London, from the 1850s, exactly reflects such an aspiration.

At the same time secular Gothic blossomed in the industrial cities which outvied each other in the erection of magnificent town halls, art galleries and museums, and public offices. Alfred Waterhouse's Assize Courts (1859) and Town Hall (1867) for Manchester attired the good burghers of one of the greatest industrial cities of the north in the garb of medieval England revived. This was an architecture which was proudly insular, patriotic and romantic, monuments to the fact that one way to come to terms with the present was to go backwards and relive the past as though no great changes had ever occurred.

A new medieval city. Alfred Waterhouse's Manchester Assize Courts, 1859, is an essay in Gothic as the national style.

All the time one senses unprecedented situations demanding new solutions and new initiatives and that the way to deal with these was to reinforce links with the past rather than to sever them. That attitude was ultimately to lead on to the conservation movement later in the century. It was also to affect another great innovatory feature of the Victorian scene, the public park. These were direct responses to the widespread unease felt by urban authorities about the squalor and air of the cities. Green lungs were called for and in 1848 a Public Health Act enabled municipalities to finance what were called 'public walks'. In fact their purpose also became one of social engin-

eering, for in such parks all classes of society could mix and, it was hoped, middle class values would somehow rub off on to the working classes. Typically their prototype again emphasised continuity with the aristocratic past, for it was an adaptation of the eighteenth century private landscape park which was transported and laid out in the inner cities. The formula was that familiar in the work of 'Capability' Brown, a shelter belt of trees around the perimeter with a walk, an irregular Georgian lake and undulating terrain dotted with clumps of trees. On to that formula were superimposed elements familiar from another feature of the Georgian era, the urban pleasure garden: bandstands, pavilions, kiosks and ornamental bridges. Finally there was an overlay of contemporary horticultural taste in the form of conservatories for rare plants, an arboretum, displays of bedding-out plants or a rose garden. Paxton's Sydenham Park, created in 1854 to accommodate the Crystal Palace, offered a menagerie, a panorama, and concerts of classical music, not to mention its famous tableau of dinosaurs.

All over Britain parks began to be laid out in the main by totally anonymous municipal gardeners. They reinforced what was to become a uniquely British passion for the world of nature and horticulture, which was crystallised in the small front and back gardens which were to be one of the most dominant features of urban domestic dwellings. In the prolific writings of the energetic John Claudius Loudon gardening, once the prerogative of the aristocracy and gentry, was adapted for the burgeoning middle classes. *The Suburban Gardener and Villa Companion* (1838) was a major work devoted to small and medium-sized urban gardens. Loudon was also to found the first periodical to deal exclusively with gardening in 1826 and to be a key figure in reviving the formal style.

That gardening could become an aspect of the new mass culture owed much to the quite extraordinary developments in reproductive techniques. The invention of engraving in steel in 1822 meant that any number of clean impressions could be made from a single plate, as against the decline in quality from the old copper ones once the imprint had exceeded about five hundred. Five years later stereotyping meant that illustrations could be incorporated into the text. Then came lithography. The *Illustrated London News*, founded in 1842, was to be the first magazine to be picture-led, subordinating text to illustration. The earliest magazine devoted exclusively to art appeared in 1839. By the 1850s the *Art Journal* had a circulation of twenty thousand but it would have been read or looked at by triple or quadruple that number. These were responses to a mass public hungry for art on a scale never witnessed before. Exhibitions like the annual one at the Royal Academy attracted huge attendance figures, so great that in the case of certain pictures rails had to be erected to keep the

public at bay. After 1850 art was to break out of the Academy with the advent of dealers' galleries to cater for collectors of a new kind, men like John Sheepshanks, a Leeds manufacturer who had made a fortune in the Napoleonic wars, and who was to leave his collection to the nation. Sheepshanks represented the geographical shift in art patronage to the newly prosperous of the midlands and the north. Everywhere patronage moved away from the aristocracy to the classes of the new nation, to people who had not been educated in the tradition of the Old Masters and the cult of classical antiquity bred of the Grand Tour. Lady Eastlake, wife of Sir Charles Eastlake, Director of the National Gallery, captured that migration in 1870 when she wrote: ' . . . the patronage which had been almost exclusively the privilege of the nobility and higher gentry, was now shared . . . by a wealthy and intelligent class, chiefly enriched by commerce and trade . . . collections, entirely of modern and sometimes only of living artists began to be formed.'

Artists as a result had to come to terms with an entirely different kind of client, one who, later, under the influence of Ruskin, was to be encouraged to buy the new. Inevitably there was a dramatic change in subject matter. The Grand Style inaugurated by Reynolds abruptly went out of fashion after 1830. Smaller pictures were needed for smaller middle class homes, pictures whose content became increasingly anecdotal, familiar incidents painted with humour, embodying homespun philosophy and executed with an eye for detail. There was also a steady stream of scenes from British history presenting a heritage to be shared by all classes. Equally subject matter was found in plays, particularly Shakespeare, in literature, and in depictions of a mythological 'olden time' England.

The demand for new art was such that high prices could be paid for pictures or at least ones which could become subjects for major commercial exploitation. The dealer Flatow paid £4,500 for Frith's *The Railway Station* (1862) which twenty-one thousand people paid to see during its seven week exhibition. He then sold the picture and the copyright for over £16,000. The engraved reproductions of it brought a small fortune. And so artists could become rich, ascending a professional scale within the Royal Academy from Associate to Fellow to President. In the 1850s and 1860s Sir Edwin Landseer had an annual income of £6,000, a large sum. He was created a baronet, bestowing upon him a social status far in excess of that won by Reynolds in the previous century.

The new classes engendered an art which was essentially narrative and domestic with an emphasis on character and situation. Subject matter was of a kind to reinforce middle class morality, scenes which exemplified the virtues of kindness and care, the worship of home and hearth, the exercise of compassion and moral choice.

Although this could all too easily push art towards acting as a comforter to middle class values, it also satisfied the demand for a serious art in what was a privatised society. Victorian genre painting was, however, never wholly escapist for it covered either directly or indirectly a remarkable range of social issues: poverty, illicit love, illness and death, destitution, bereavement and prostitution. This was particularly the case after the 1850s when Ruskin's incitement to depict the present took hold. In a picture like Frith's *Derby Day* (1858) we are presented with a panorama of Victorian society at every level, interlocked into a series of relationships as complex as any of those in the great novels of the period. Painting similarly mirrors literature in its preoccupation with detail.

The 1830s witness what was in effect a democratisation of art. In the genre paintings of David Wilkie and Edwin Landseer there occurs a sharp move away from idealisation and grandeur, from the monumental and pompous, to pictures which engage the onlooker and ask him to draw his own explanation. The painter abdicates his old role of being a purveyor onto canvas of eternal verities and instead invites the viewer to participate by weaving his own interpretation of scenes which might as well be a still from a novel for which the chapters before and after have to be supplied. This reflected exactly an essential need for art to come to terms with the mechanical age, which demanded the recognition of ordinary daily life and its material artefacts.

Perhaps the archetypal painting of the period is Landseer's *Monarch of the Glen* (1851), a transmutation of the previous century's sensibility in respect of animals to an emotional involvement with their fate, which was to lead to the establishment of the Society for the Protection of Animals (1824) and an Act against cruelty in 1835. In one and the same seemingly banal image the onlooker is presented with a prototype of Christ, for the stag would be sacrificed, and also of man, for by the 1850s man was seen increasingly to be part of the animal kingdom himself.

All these tendencies were to find their fullest expression in what billed itself as a revolutionary movement, the Pre-Raphaelite Brotherhood founded in the autumn of 1848. The name itself is confusing beyond indicating an appeal to art before the academic movements of the Renaissance. What the Brotherhood did draw upon from early painting was its clarity of narrative technique and also its use of symbolic allusion. This was an indictment by the young of what was seen by them to be a sterile academic tradition. Of their seven members John Everett Millais was nineteen, William Holman Hunt and Dante Gabriel Rossetti both twenty. Together they preached a reversal of the previous century's aspiration to put on canvas nature idealised, seeking instead to apply the searching eye of the scientist and recording the minutest detail with unadorned honesty. By painting direct from nature rather than in the

studio and by applying the paint over a brilliant white ground they produced pictures of an almost startling reality of detail. This was art with a high seriousness of purpose, stories with morals in which the deepest thoughts were embedded in the multiplicity of things

Paintings to be read. Edwin Landseer's The Monarch of the Glen, *1851, calls on the viewer to contemplate and identify with the eventual fate of this magnificent animal.*

depicted across the picture's surface. In doing this they were responding to Ruskin's call in the first volume of *Modern Painters*: ' . . . go to Nature in all singleness of heart, and walk with her laboriously and trustingly, having no other thoughts but to penetrate her meaning, and remember her instruction; rejecting nothing, selecting nothing, and scorning nothing; believing all things to be right and good, and rejoicing always in the truth.'

The result is a series of quite astounding pictures in which every blade of grass,

leaf, pebble and flower can be counted. And not only counted, for each detail was meant to be read as an element contributing to compositions of a high moral intensity. Equally this was painting reflecting Ruskin's belief that through the world of nature man saw the divine. That was ultimately to founder in the face of Darwinism but by the time that happened the Brotherhood had already dispersed. But their stylistic impact remained throughout the century, influencing many other artists. Equally their impact on religious painting was to be a lasting one, for they took up the challenge represented by the new critical approach to the Bible. Pictures like Rossetti's *Ecce Ancilla Domini* (1850) in which the Virgin appears as a terrified young girl or Millais's *Christ in the House of His Parents* (1849–50) in which the young Christ is shown as a poor boy in a carpenter's workshop, came as a shock. The clock to the old ideal world was not to be put back. Holman Hunt's *The Finding of the Saviour in the Temple* (1856–60) is a clean break from the iconography of the past, the result of study and minute observation in the Holy Land. Christ is depicted in a setting which passionately tries to be authentically and historically correct, in a composition which also aimed at being fiercely Protestant, containing the artist's deepest convictions on Judaism and Christianity. This was an art movement springing directly out of the spiritual and religious currents of the 1840s.

This shock of attempting to present historical reality had repercussions also in pictures which dealt with

Art reinforcing the challenge to faith. The quest to invest the Bible narrative with the trappings of exact archaeological accuracy resulted in pictures as startling as William Holman Hunt's The Finding of the Saviour in the Temple, *1856-60.*

the present, revitalising genre painting. Ford Madox Brown's *Work* (1855) gathered into one canvas those who laboured with their minds as well as those who did so with their hands in one magisterial symbolic composition. Holman Hunt's *The Awakening Conscience* (1854) portrays a kept woman starting up from her lover's embrace as the memory of her virginal past flickers across her mind. She stands in a room filled with new furniture but its window opens out on to a landscape symbolic of her lost innocence. After the movement broke up at the close of the 1850s artists like Rossetti drifted off to paint a dreamworld of mysterious hallucinatory beauties. If divine truth was no longer attainable through scientific observation beauty was. Rossetti's influence on the up and coming generation of painters was to be considerable.

In all of this preoccupation with science by artists photography hardly figures, and yet here was a visual art more purely representative of the new age than any other. And, as in the case of so much else, every attempt was made by its practitioners to demonstrate that it embodied no clean break. Every effort was made to recast its possibilities in terms of existing pictorial traditions. It was Henry Fox Talbot who discovered the calotype in 1835, just three years on from the Reform Bill. The rapid technical development of photography was astounding, so much so that by 1900 it was possible to dispense with the long exposures demanded to take a picture and take a snapshot. Although the craze for the new art was in the 1850s to be led by the queen and Prince Albert, from the outset this was an art form for a mass culture. It gave to people what they most craved, images of memory in permanent form.

Photography was simultaneously a science and an art, a vehicle of factual record and also of painterly aspirations. Both approaches produced extraordinary results, so much so that they can claim to rank as the truest expressions of the era. There was no lack of masterpieces, whether the photographer was using his camera as a scientific instrument or as a means to paint without a brush. David Octavius Hill and Robert Adamson in Edinburgh during the 1840s were already exploring its potential, whether for portraits which look back to the tradition of Lawrence or for genre compositions of the fisherfolk of Newhaven. Roger Fenton in the following decade was to extend the camera's uses still further with portraits of the royal family, landscapes, still life, and architecture, as well as going to the Crimea as the first war photographer. These are stunning images, evidence that those who set out, like Henry Peach Robinson, to emulate High Art ended in producing high artifice. The formidable Julia Margaret Cameron trod that path but redeemed herself by the dazzling series of close-up portrait heads caught

After the dissolution of the Pre-Raphaelites Rossetti retreated into a sensuous world of love and beauty. Mona Vana, *1866, is one of a series of such decorative pictures.*

in dramatic chiaroscuro of some of the greatest figures of the age. They mesmerise the imagination in a way never achieved by any of the fashionable portrait painters.

The four decades after 1832 are ones during which those engaged in the arts sought for new anchors and found none. The Industrial Revolution had cut the Victorians adrift from their own recent past with the result that they constantly reached back for it. They reached back further still, making journeys into imaginary historical worlds again in search of timeless verities. They relentlessly conjured up past eras on canvas or in three dimensions on the landscape. They disguised the new as old, and even if the new was totally new, like photography, that too was quickly subsumed into a repertory which worked from the past. These were the generations which had had taken away from them what had inspired every creative person since the age of Shakespeare, the belief that man was above the beasts of the field, that he was a spark of the Divine Being, hovering just below the angels but soaring above the animal world. Within a generation that had been eroded leaving a gnawing sense of alien-

Three Victorian icons: Thomas Carlyle, Sir J. F. Herschel and Lord Tennyson. Julia Margaret Cameron's revolutionary close-ups, taken in the 1860s, arguably give us the greatest portraits of the period in the new medium of photography.

ation as man was reduced to recognising that he too was an animal who had also arrived at his present status by dint of a long evolutionary process of natural selection. What made that worse was that the world of nature too, whether in its old idealised form or in the new one of exact scientific observation, was also distanced from the hand of the Almighty. Belief was inevitably challenged and secularisation of thought hastened as a search began for some new guiding principles to which man might aspire. The engulfing mists of resignation, despair and a new stoicism of mood set in even harder after 1870. Hope fades. In 1869 the scientist Thomas Henry Huxley was to coin the word 'agnostic'. In doing so he had enunciated what was to become the dominant characteristic of the century to come.

Chapter Thirty-Three

ALBERTOPOLIS: THE PRINCE CONSORT

On 9 March 1876 Queen Victoria, in her customary widow's weeds, unveiled the most stupendous of all the many monuments in memory of her beloved Albert. Those present were confronted with a gigantic Gothic tabernacle of marble, mosaic and ironwork, topped by a small forest of symbolic statuary and pinnacles piercing the sky over Kensington Gardens. Within it sat Prince Albert, a gilded colossus, holding in his hands the catalogue of the exhibition which had been the summation of his life's work, that staged in the Crystal Palace in Hyde Park in the summer of 1851. His gaze is in the direction of the vast complex of public institutions sometimes referred to as Albertopolis, which today includes the Albert Hall, the Royal College of Music, Imperial College, the Victoria & Albert and Natural History Museums. The monument is surrounded by attendant sculptures by the leading practitioners of the day, each depicting a category of objects which had been part of the Great Exhibition: Agriculture, Manufacture, Commerce and Engineering. Four more groups personify the four continents, Europe, Asia, Africa and America, to which the exhibition's message was to be taken, one which was optimistic and progressive. Through the advances of science had come the benefits of material progress. These should now be spread to all the other peoples of the globe.

By the time that this ceremony took place Albert had been dead a decade and a half and the hope expressed in the monument was already passing into an eclipse. The prince's vision had been one of universal peace and harmony achieved through a world which was to be united by trade and commerce and redeemed through work. During his lifetime the monarchy was to be uniquely allied with some of the most progressive minds of the new industrial age. The irony was that Albert was never to be popular with either the great British public or indeed with the old aristocratic classes who viewed him as a parvenu prince from an impoverished minor German principality. In that they happened to be right.

The gilded image of the Prince Consort on Sir George Gilbert Scott's Albert Memorial in Kensington Gardens. He sits within an astonishing Gothic shrine presented as an object of veneration.

Saxe-Coburg was a tiny Thuringian state in the area of Germany to which the Hanoverian kings had always looked for suitably Protestant brides. At the turn of the century the Saxe-Coburg dynasty had entered on a winning streak. The intelligence and drive which typified this generation seems to have come from the future prince consort's grandmother, one of whose sons, Leopold, had pursued a highly successful military and diplomatic career during the Napoleonic wars. In 1816 this younger son of a minor prince had set his cap at Charlotte, only daughter of the Prince Regent (soon to become King George IV) and, in spite of her father's objections, married her. The match was hugely popular with the public and with Parliament, which had little time for the feckless and extravagant George and promptly voted an annual income of £50,000 to Leopold for life. Charlotte died the following year and George's surviving brothers were called upon to marry and produce an heir. One of them, the Duke of Kent, married Leopold's sister and fathered, in 1819, the future Queen Victoria. Almost from the moment of her birth Leopold, who later became King of the Belgians, had one idea in mind: that Victoria should marry his nephew Albert.

Albert was born on 26 August in the same year as his cousin. He was one of two children, the elder being his brother Ernest. His parents' marriage had been a disaster, both drifting off into indiscretions of a kind which, in the case of his mother, resulted in her exile in 1824. The upbringing of both the young princes was entrusted to a tutor, Christoph Florschütz, who set about their education during a childhood which was one of peregrination from one residence to another through the Coburg domains. The programme of studies included ancient and modern history, reading, writing, German grammar and composition, geography, religion, drawing and painting as well as attaining facility in three foreign languages, one of which was English. In 1837, the year Victoria came to the throne, both princes went for a period to the University of Bonn and in the same year Albert made his first visit to Italy, travelling back via Munich where he saw the new architecture and interior decoration under execution for the king of Bavaria which was later to be such an influence on him. That helped form his taste, as indeed also did a Grand Tour in the manner of the previous century undertaken the following year. Accompanied by Baron Stockmar, Leopold's adviser, Albert passed January and February in Florence, sightseeing and learning English, followed by visits to Rome and Naples. The tour left a deep impression, for, in contradiction to the stylistic drift to Gothic in Britain, Albert's taste remained firmly neo-classical. He also returned with a cult of Raphael which was to remain with him throughout his life.

Lt. Col. Francis Seymour was also one of the Grand Tour party and wrote of Albert at this period of his life as 'slight in figure and rather tall, his face singularly hand-

some and intelligent . . .' When, the following October, Albert arrived with his bro-
ther at Windsor with marriage in mind the young Victoria declared him 'beautiful'
and promptly fell in love with him the wrong side of idolatry. Albert and Victoria
were married on 10 February 1840. The prince's role was not only to be the dynastic
stud producing an overflowing nursery of princes and princesses but also the queen's
cultural mentor and political secretary. Albert in effect educated his wife. By nature
he was a workaholic, beginning each day at 7 a.m. by dealing with mounds of govern-
ment papers and drafting memoranda. The workload which he carried ever escalated,
effectually being the real cause of his early death. It was not helped by the fact that
he was unable to delegate. But for twenty years he acted as a man with a mission, and
that mission was to reform the monarchy by removing it from politics and making it
the epitome of domestic respectability. In both endeavours he was successful.

In the sphere of public affairs Albert was fully in tune with the reforming tide of
the era, taking a keen interest in health, working class housing and education. But
even this never endeared him to the British public, to whom he remained stiff and
Germanic. Parliament only granted him an allowance of £30,000 p.a. and he was
given no constitutional position, his title of Prince Consort being bestowed on him
by his wife in 1857. What Albert did have was an ability to talk on his own terms with
members of the new professional classes, to architects, builders, artists and engineers.
Apart from a commitment to the arts, embracing architecture, painting, collecting
and music, he was deeply interested in the sciences and in practicalities.

To Albert we owe much of the visual infrastructure of the monarchy. In 1845 the
estate of Osborne on the Isle of Wight was purchased as a summer retreat for the royal
family. No architect was employed. Instead Albert made use of the services of the
highly efficient builder, Thomas Cubitt, who had built most of Belgravia. Together,
for Cubitt was in effect the prince's amanuensis, they erected an Italianate classical
villa of brick surfaced with stucco. In the case of Buckingham Palace, left unfinished
in 1837, the architect Edward Blore was brought in to erect a new wing with a façade
looking on to the Mall. At Balmoral, purchased as another retreat in the fastnesses of
the Highlands in landscape reminiscent of Thuringia, a local Aberdeen architect,
William Smith, worked with Albert. Although each was not devoid of a certain charm
or magnificence, architecturally all three places were dull, and at Buckingham Palace
the new wing was so badly built that the façade crumbled and had to be replaced after
Victoria's death.

When it came to the visual arts Albert's taste was in the main conventional, fav-
ouring genre pictures by artists such as Sir Edwin Landseer. With the Old Masters he
was far more adventurous, collecting both Italian and German primitives, works by

Duccio, Fra Angelico and Cranach, under the direction of his 'adviser' on art, Ludwig Grüner, who came from Coburg. Grüner had arrived in England in 1841 and occupied his advisory role from 1843 working with the prince on schemes for the interior decoration of Buckingham Palace and Osborne, as well as on a project to form a Raphael archive at Windsor of engravings and photographs of the painter's works. In this way the prince was associated with what was in effect the birth pangs of a new discipline, art history. It fully explains the role of Albert as one of the driving forces behind the earliest grand scale art exhibition ever held, the Manchester Art Treasures Exhibition of 1857. The prince wrote to the Earl of Ellesmere, one of the leading lights in the project: 'If the collection you propose to form were made to illustrate the history of art in a chronological and systematic arrangement, it would speak powerfully to the public mind, and enable in a practical way, the most uneducated eye to gather the lessons which ages of thought and scientific research have attempted to abstract . . . ' This exhibition was a landmark, for it was the first time that artists and historians of art could actually compare works by various masters side by side.

In his commitment to the Manchester exhibition Albert was fully in tune with views articulated strongly from the 1820s onwards by the middle and upper classes that exhibiting works of art would unconsciously improve the taste of the masses. This had led to the foundation of the National Gallery in 1838 and it was an attitude which would find its greatest expression in the South Kensington museum complex after his death. What he embodied, which was also typical of the new society emerging from 1830 onwards, was the practice of art. This was not an attribute particularly widespread during the previous century. The change came about and was encouraged by the development of water-colour as a medium by 1800. Virtually anyone could embark on painting in a way which was easy to handle and enabled the exponent to execute rapidly an instinctive visual response to what he saw. By the 1840s paper was cheap and firms like Winsor and Newton produced inexpensive water-colour boxes with the colours in metal tubes. The practice of art suddenly became accessible to large numbers of people and amateur water-colour painting was taken up by the upper and middle classes headed by the queen, the prince, and the royal children.

The belief in art as an educating force on the public equally lay behind the first act of government patronage in the history of the country. Four years before Albert married Victoria a Select Committee on the Arts and Manufactures had called for a revival of fresco painting. In 1841 a second commission was set in motion for 'the promotion of the fine arts' in relation to Barry's new Houses of Parliament. In order to achieve that a Fine

Prince Albert in 1860. A page from one of the Royal Albums at Windsor Castle. Both the queen and prince were passionate advocates of photography.

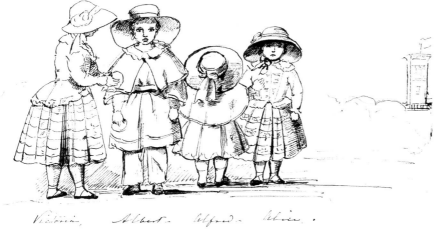

A drawing by the queen of her four eldest children in July 1846 with the flag tower of Osborne House in the distance.

Arts Commission was created which, at the suggestion of the prime minister, Sir Robert Peel, Prince Albert was to chair. The only known prototype for such an ambitious scheme of decoration was the Residenz at Munich with its huge wall paintings depicting heroic mythological and historic events glorifying the new kingdom of Bavaria. In April of the following year a competition was announced for cartoon drawings 'illustrating subjects from British History or from the works of Spenser, Shakespeare or Milton.' Allegory was firmly rejected, pinpointing neatly the radical shift from the Grand Style and the commitment to subject-matter seen as uniting the new electorate in a common vision of the historic past and a common cultural heritage.

The prince threw himself into the project by experimenting with fresco in a garden pavilion constructed in the grounds of Buckingham Palace. The most important room was adorned with subjects from Milton's *Comus* with contributions from pain-

Design by Prince Albert for an estate cottage. Thanks to his interest the tenants on the royal estates were well housed.

ters including William Dyce and Edwin Landseer. An exhibition of the cartoons took place in July 1843, a hundred and forty in all, vast compositions hung edge to edge, floor to roof timbers, in Westminster Hall. Three prizes were awarded, the first to Edward Armitage's *Caesar's Invasion of Britain*, the second to G. F. Watts's *Caractacus Led in Triumph through the Streets of Rome* and the third to C. W. Cope's *The First Trial by Jury*. Then followed a competition to test the technical competence of the artists and, at last, in 1845 the first major commission, Dyce's *The Baptism of Ethelbert*.

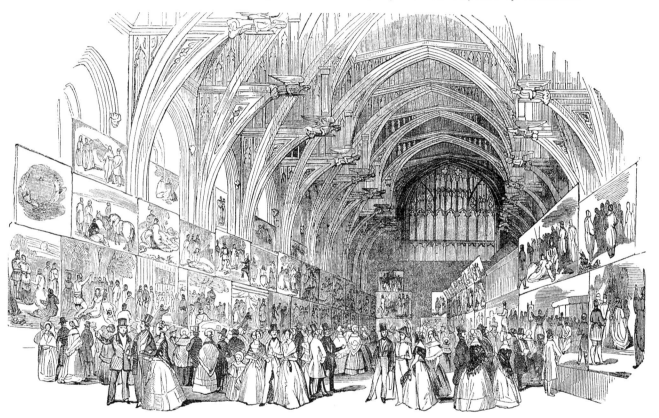

Others followed, but by 1850 the impetus had gone for the frescoes had rapidly deteriorated in climatic conditions so very different from those in southern Europe.

The exhibition of the cartoon drawings of scenes from British history in Westminster Hall in July 1843.

The whole exercise was in many ways a disaster, for the public failed even to recognise the subject-matter when it was exhibited. In all it was a throw-back to the Boydell Gallery and its successors in the previous century.

What was to be of far more importance in the long term was Prince Albert's contribution to the Victorian obsession with the relationship of 'art' to 'manufacture'.

Up until the 1880s industrialisation and mechanisation, along with the division of labour as advocated by Adam Smith, were viewed as creative, beneficial and progressive movements. Charles Babbage's *On the Economy of Machinery and Manufactures* (1832) was one long panegyric to the 'science of calculation', pleading for an ever more scientific and rational approach to factory production. The more perfect the machines the more perfect, it was argued, their products would be in terms of uniformity and precision. Three years later Andrew Ure was to take this transformation of the factory worker into automaton even further in *The Philosophy of Manufactures*. It was in an atmosphere which embraced the recent industrialisation with enthusiasm that the initial stages of the debate about the role of art in manufacture took place. What never occurred to anyone at the time was that this polarity could have been solved by dissolving the one into the other or that the reduction of the worker to an automaton could have been exacerbated by the exaltation of collective endeavour.

In 1835 a Parliamentary Select Committee was set up 'to inquire into the best means of extending a knowledge of the arts and principles of design among the people (especially the manufacturing population) of the country.' The result of this was the establishment of a Government School of Design in Somerset House, a milestone signalling a changed role for art in the life of the nation. Its initial phase was not a success but the event itself established that the State had a part to play in the education of what were the ancestors of today's designers of mass-produced goods. At this early stage that process was seen merely as providing patterns and drawings with no thought as yet of the craftsman being involved from the outset, working from the technical practicalities and possibilities of production. In 1840 other schools of design were opened in several major industrial cities. The driving force was not only concern with what was believed to be the low standard of British design compared with continental counterparts, but a strong belief that learning to draw had a beneficial effect on the working classes.

The institution which should have led the way was in fact moribund. The Royal Society of Arts was founded in 1754 'for the Encouragement of Arts, Manufactures and Commerce', offering prizes for inventions and improvements in the fields of design, architecture, industry and agriculture. In 1843 Prince Albert took on the presidency of the Society, declaring that henceforth the object of its existence would be 'the application of science and art to industrial purposes . . .' Within the Society there existed a group bent on achieving just those ends which included the artist Richard Redgrave, the chemist Dr Lyon Playfair and, in particular, the future Sir Henry Cole. Cole was a shambling caricature of a man behind whom always trotted a minute dog, but he had application and drive as well as an ability to upset people in the process

of getting his own way. He is remembered most today as the inventor of the Christmas card.

The initial move was to catch up with what had happened on the Continent where annual exhibitions of manufactures had been held as early as the end of the eighteenth century. In 1845 the RSA committee decided 'that the experience of foreign countries has proved that great national advantages have been derived from the stimulus given to industrial skill by bringing the manufactures of different establishments into competition with one another . . . ' A series of exhibitions was inaugurated which attracted large numbers of visitors, as many as 70,000 in 1848. By then it was clear that only to imitate what was already being done abroad was not enough. Somehow it had to be upstaged, so on 30 June 1849 a decision was reached to hold the first exhibition ever which was to be international. And it was Cole who came up with the idea of Hyde Park as the setting. But it was to be the prince who was to have the energy and application to push the project ever forward despite its most vociferous critics.

In January 1850 Albert became chairman of the commission set up to stage the exhibition. The money was raised by public subscription, acting as a guarantee against loss. In July Joseph Paxton produced his master design which arose in ten months, a gigantic greenhouse of glass and iron enclosing whole trees. Optically it looked like a cathedral of manufacture shimmering amidst the parkland. Inside were assembled some 100,000 exhibits chosen from items submitted by 14,000 exhibitors from around the world. On May Day 1851 the queen opened it. 'The tremendous cheering,' she wrote in her journal, 'the joy expressed in every face, the vastness of the building, with all its decoration and exhibits . . . and my beloved husband, the creator of this peace festival "uniting the art and industry of all nations of the earth", all this was moving and a day to live for ever.' The Great Exhibition was a triumph of organisation and invention. Six million people flocked from all over the country to see it.

The Crystal Palace as it was nicknamed was one of the marvels of the age, light and functional, daring in its conception, and in its construction a feat of technical virtuosity. The size alone must have astonished, being 1,848 feet long and 408 feet wide and three storeys high. In an age which witnessed the proliferation of the greenhouse this was the greatest greenhouse of them all. The building itself embodied what the exhibits represented, the fruits of mass production and prefabrication. So successful was it that the format was repeated in 1862 in South Kensington and this time five and a half million people went. Again the display was aimed at raising the standards of design and art, but as the prince died during its inception the exhibition lacked focus.

The 1851 exhibition was unique in actually making a profit. The surplus of £180,000 was doubled by the government to found 'an Establishment in which by the application of Science and Art to industrial pursuits the Industry of all nations may be raised . . . ' By 1853 twenty acres of South Kensington had been acquired in the Brompton area under the aegis of Albert with Cole acting as his agent. A garden was laid out by the Horticultural Society and the prince tried to persuade the National Gallery to move to the present site of the Albert Hall. In the south-east corner a group of buildings began to arise for the 'application of Science and Art to industrial pursuits.' That conglomeration was to be the fountainhead of the present Victoria & Albert Museum, the Royal College of Art, the Science Museum and Imperial College.

The initial moves were made by the prince's crony, Sir Henry Cole, who, in 1852, was appointed secretary of the newly formed Department of Practical Art which incorporated the old Government School of Design along with a network of other schools throughout the country. The new Department began its life in Marlborough House where Cole assembled a collection of pieces from the Great Exhibition to be used for teaching purposes, along with items which were 'Examples of False Principles of Decoration.' Five years later the move was made to South Kensington to which Cole had attracted the polymathic German designer Gottfried Semper. He by no means rejected Cole's belief in teaching design through museum objects, but in addition was a strong advocate of teaching rooted in practicalities and in apprenticeships in workshops. This was put into effect in the schools, establishing the basis for what was the training of a designer for industry. Semper left in 1855 but he produced one great pupil, Christopher Dresser, a botanist whose preoccupation with fitness of form based on natural structures produced machine-made objects which anticipated the Modernist Movement. Dresser was also influenced by Owen Jones whose *Grammar of Ornament* (1856) came out under the aegis of Cole and the Department of Practical Art and immediately established itself as a repertory of international importance. Its effect, however, was to encourage the equation of design with the application of pattern and decoration to artefacts and not their overall concept.

Albert's death, ostensibly of typhoid fever, on 14 December 1861 removed the luminary who could perhaps have kept the initial South Kensington vision on the rails. Alas, that was not to be so and it quickly degenerated into squabbles and what became a piecemeal development of the site. This pragmatic approach produced the Royal College of Art in 1897, the Science Museum and what was to be called

The Great Exhibition on the occasion of its opening on 1 May 1851. The vista across the transept from south to north is dressed with potted plants and two Yeomen of the Guard flank the gate awaiting the arrival of the royal procession.

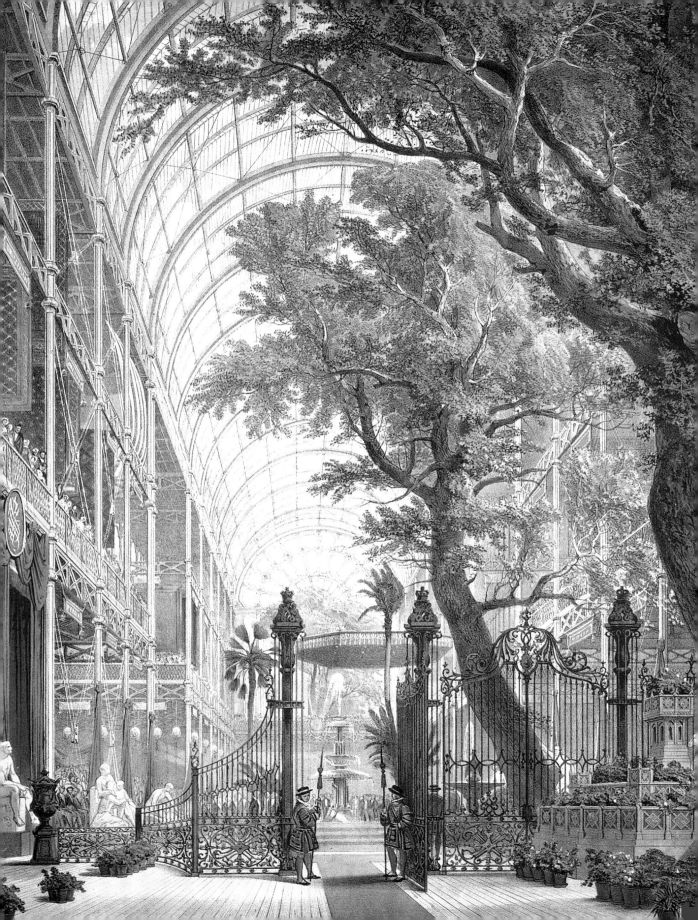

the Victoria & Albert in 1899 and, finally, Imperial College in 1907. Albert's contribution had been crucial, for he was committed to the new age achieving what was in effect the beginnings of a shift by the establishment away from the old Whig aristocratic culture based on the Latin classics and the Grand Tour. But it was not destined to last. Already in the 1820s and 1830s writers had begun to make appealing the concept of an idealised pre-industrialised England unsullied by the pollution of the new factories and towns, in which the rural craftsman in his cottage took pride in his work. 'Men are grown mechanical in head and heart, as well as in hand,' wrote Carlyle. Ruskin was to be even more damning about the machine age. In 'On the Nature of Gothic' in *The Stones of Venice* (1853) he attacked the division of labour, equating it with the division of men 'broken into small fragments and crumbs of life . . . ' Everything the Great Exhibition had stood for was dismissed as an obliteration of time-honoured 'experience and skill'. The division of labour was spurned as the destroyer of society and individual endeavour, as in time past, was exalted over the collective achievements of the machine era. Out of this debate came a turning against industrialisation, a yearning to put the clock back to some lost domain. It was unfortunately a vision which could be shared by both radical and Tory alike. The Albertian alternative of mechanisation marching hand-in-hand with progress for the benefit of all humanity was condemned as mass degradation.

The prince consort was laid to rest in the great (and appropriately dull) mausoleum at Frogmore in Windsor Great Park. Modelled on the one at Coburg it was designed by his adviser Grüner together with A. J. Humbert. It takes the form of a Roman cross with arms extended to form three chapels and an entrance portal. Built of stone and granite, the interior is of marble and decorated with compositions based on works by his favourite painter Raphael. Above the effigies of Albert and Victoria there is an azure dome powdered with golden stars. It is difficult to reconcile the mausoleum's ponderous neo-classical gloom with the man responsible for the epoch-making Crystal Palace. And yet in this he was true to his age in wanting to go backwards and forwards simultaneously, attempting to marry past and present and thereby achieve a resolution masking dramatic change.

Chapter Thirty-Four

LAND OF HOPE AND GLORY

Sir Edward Elgar's *Pomp and Circumstance Marches Nos. 1 and 2* had their first London performance at a Promenade Concert on 23 October 1901. They were conducted by the future Sir Henry Wood who wrote of the occasion as follows:'I shall never forget the scene at the close of the first of them – the one in D major. The people simply rose and yelled. I had to play it again – with the same result; in fact they refused to let me get on with the programme . . . Merely to restore order, I played the march a third time.'

What the audience had just heard in the trio section of that first *March* was one of the greatest melodies in the history of English music, one which the King Emperor Edward VII, who had come to the throne that year, suggested should have words added so that it could be sung. Elgar was to insert this new arrangement, made by royal command, into his *Coronation Ode* which was eventually performed at Sheffield in the October of the following year. Ever since, 'Land of Hope and Glory' has assumed the mantle of a second national anthem. The tune is hymn-like in its solemnity, and the verses extol British glories, celebrating the island's dominion over land and sea in what, by then, had become an empire eclipsing that of ancient Rome, embracing a fifth of the world's land mass and some four hundred million people. Neither two catastrophic world wars, nor the loss of that empire, nor a saga of almost continuous decline in the fortunes of the country, has done anything to dislodge the popularity of that anthem. Almost a century later it is still sung with fervour and much waving of Union Jacks on every last night of the Promenade Concerts at the Albert Hall.

And yet in reality this music was composed and first performed at the very moment when the glory, if not the hope, was already fading fast. The forty years from 1870 to 1910 are decades to which one attaches the word transition. On the surface they were years of triumph, optimism and seeming certainty. But beneath the surface pageantry and splendour lurked something rather different, a malignant and eroding cancer containing forces which were irrevocably to change the entire structure of British society, and along with it the arts. After 1870 the great Victorian boom years were

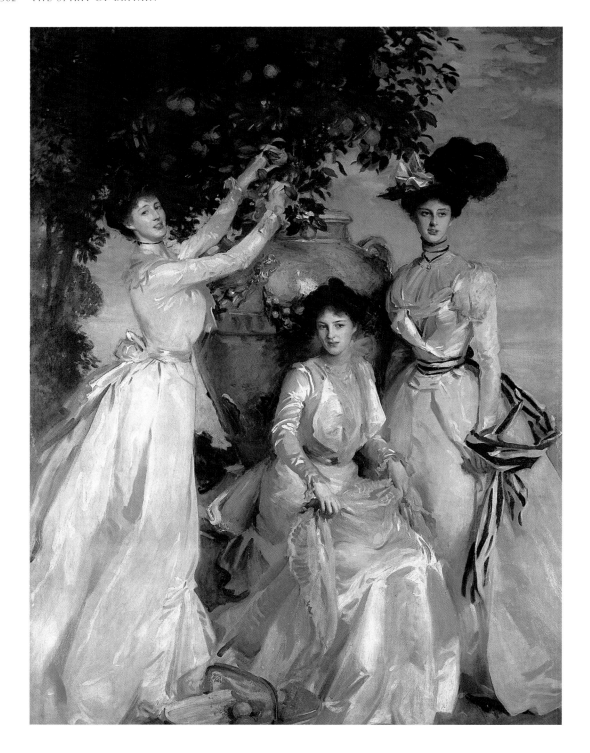

over and interests which up until then had held people together began to diverge. Agriculture went into sharp depression, and foreign competition in the field of manufacture became a progressive reality. The Franco-Prussian war revealed the military might of the newly-formed German Empire, whose navy was equally to challenge British supremacy on the seas. At home militant trade unions began to assert their stranglehold, engendering fear in the middle classes of revolution from below. In 1890 the first Trades Union Congress was held and the struggle of labour against capital became increasingly bitter, culminating in the years of industrial turmoil either side of 1910. Socialist ideas began to permeate areas of the educated middle classes and by the turn of the century there was an active Labour Party. Women, too, were on the move, demanding a new status in society and, in 1903, the suffragette movement entered its militant phase.

If there was turbulence below, above, the centuries-old political and social powers of the aristocracy were to be dramatically eroded, not only by the economic disaster of the agricultural depression but by a further extension of the franchise in 1884–85 which finally severed the connection between the vote and property owning. The vote was now given to the male working class. Even more catastrophic was the advent of a new system of death duties in 1894. The deleterious effects of this were exacerbated in 1909 when income tax rose to one shilling and ninepence in the pound and a supertax was imposed on those with an annual income in excess of £3,000 p.a. Finally, in 1910–11, came the passing of the Parliament Act which curtailed the right of veto on legislation of the House of Lords. This signalled the final demise of aristocratic political power after centuries; and with it went centuries of patronage of the arts.

Already by the 1880s great country houses began to be closed or let to save money, giving rise to a series of sales dispersing their contents. Ostensibly these years remain fixed in the imagination as decades which witnessed a final efflorescence of aristocratic culture, resembling in retrospect a rose whose petals are about to fall. That efflorescence was to pinpoint something else which was to be a unique feature of British twentieth century cultural life, the survival and transmission of the appreciation of that aristocratic tradition, so much so that by the 1980s it had become part of a classless heritage cult. Unlike the rest of Europe there was to be no sweeping revolution rendering anything aristocratic suspect. In fact the very acquiescence of the aristocracy in their declining political and social role in society progressively ennobled their lifestyle as an ideal. That path towards the apotheosis of country house culture, in which the very building itself was to be cast as a potent emblem of

The finale of the grand manner. John Singer Sargent's flamboyant portrait of the three daughters of the 4th Earl of Gosford, 1902, catches the final flowering of aristocratic culture in a composition which deliberately looks back to the eighteenth century.

all that was best in the country's identity, had already begun to be formulated as early as 1910 in E. M. Forster's novel *Howards End*.

This is a period of quite extraordinary complexity during which the infrastructure of the old order was still firmly in place but at the same time the forces which were to change it were everywhere in evidence. Both strands deeply affected the arts which were also in transition, for the paths were already being forged which led to the final explosion of modernism (to which I will come in the following chapter) in all its varied forms onto the scene in the years immediately after 1910. That movement had its roots back in the 1880s with the consequence that virtually every art form by the turn of the century was to have its obverse and reverse, the world of the establishment and that of the forces setting out to challenge and transform it. The success or otherwise of that challenge, either to overthrow the existing scheme of things or to be accommodated within it, set a pattern which was to be a dominant one in the arts for the rest of the century. But in the decades down to 1910 and the Great War in 1914 other topics were to affect the arts even more immediately.

One of these was the Empire itself. By the year of Edward VII's coronation a small island had seemingly been transformed into a world-wide state on a scale matching the German and Russian Empires and the U.S.A. The Golden and Diamond Jubilees of Queen Victoria in 1887 and 1897 fed the newly enfranchised populace with images of cavalcades through the London streets of the Empire's many peoples come to pay homage to the Queen Empress. The Empire's success was rooted in a belief in individual effort, sobriety and high moral probity. In its heyday those involved exuded both a sense of security and confidence in the superiority of the British as a race, and of their way of life and culture as something worthy to be exported around the globe. The results are still there for us to see from India to Australia, from South Africa to New Zealand. The Empire reinforced the old hierarchy and its cult of the civic virtues at the very moment when they were under attack from socialism and suffragettes. Imperialism suffused the arts, whether in the form of the triumphal music of Elgar or the light-hearted operettas of Gilbert and Sullivan, whether in the visions of life in imperial Rome painted by Sir Lawrence Alma-Tadema or in the swagger portraits of aristocrat or *nouveau riche* by John Singer Sargent, whether in the literary works of Rudyard Kipling or in Sir Aston Webb's great set-pieces of ceremonial architecture. It was during the decades before 1910 that the grand imperial tableau of Admiralty Arch, the Mall, the Victoria Memorial and the new façade of Buckingham Palace, with its balcony for regal epiphanies, was put in place. Splendid it may be and indeed still is, but it is difficult not to concede that what so much art of this period is about is style without substance, a style achieved not by looking forwards but by digging ever

deeper into the dressing-up box of the past. But the continuing potency of the theme of Empire should never be underestimated. It was not to be a spent force for decades and indeed was to run its course into the 1940s, a rallying cry to which all classes of society could equally respond. In addition, for the establishment, loyalty to the Empire was one means whereby to keep at bay the forces of socialism.

One effect of the cult of Empire was to reinforce British cultural isolationism. Instead of the Grand Tour travellers voyaged to outposts of Empire, taking their insular culture along with them. Increasingly the Continent, and especially France, was viewed with suspicion and contempt. The result of this was that Britain became intellectually isolated from major new movements in the arts like the new realism permeating French fiction in the works of authors such as Zola and Balzac, or the achievements of the great Russian novelists Tolstoy and Dostoevsky, the new dramas of Ibsen and the works of the French Impressionist painters. In England the establishment regarded the novels of Zola as poison, the Lord Chamberlain kept Ibsen off the stage and the Royal Academy exercised a stranglehold on the visual arts of a kind amounting to censorship. Such attitudes to innovation from abroad were only confirmed when those who did respond, like the writer and playwright Oscar Wilde or the graphic artist Aubrey Beardsley, were seen as the living embodiments of depravity.

Forces of disruption. Decadence and incipient depravity stalk in Aubrey Beardsley's The Toilet of Salome, *1894, an illustration for Wilde's text. On the lower shelves of the dressing table appear 'forbidden' books, de Sade's* Fêtes galantes *and Zola's* Nana.

Now that the working classes had the vote the middle classes pursued with even greater vigour their aim of framing them in their own image. That was to be an ongoing saga through the century. Instead of being excluded, the proletariat was to be drawn into the existing structure of things, including the arts. The creation of museums and galleries is an index of this mission: Birmingham (1867), Liverpool (1877), Leicester (1885) and Leeds (1888). In 1871 the Albert Hall opened and a year later Penny Subscription Concerts began 'to enable all classes to enjoy music'. The working week contracted to five and a half days, with the half-day being a Saturday, and one or two weeks of holiday also became a norm. The middle classes never viewed art as solely the prerogative of the élite but rather as a potential cement to the newly emerging social structure. Their sense of social responsibility resulted not only in the provision of museums but libraries, theatres and concert halls, and went on to embrace innovative architectural projects for better working class housing such as the garden city. At the same time the urban working classes began to take on a more complex profile in terms of their own cultural activities which embraced the brass band, the choral society, the dance hall and by 1910 the cinema.

Education was seen as one way of averting working class anarchy in the aftermath

Art for the masses reaches the regions. The first floor landing of the Harris Museum and Art Gallery, Preston, in the 1890s.

of the first major franchise extension of 1867, a view signalled in Matthew Arnold's book *Culture and Anarchy* (1869). The 1870 Education Act, which laid down the provision of elementary education for everyone, was aimed at achieving precisely that, plus a work-force which would be able to respond to what was clearly an era of accelerated change in working practices. Universal literacy opened the floodgates of the popular press and in 1896 Alfred Harmsworth, later Lord Northcliffe, founded the *Daily Mail*. At the same time popular magazines like *Tit-Bits* (1881), which achieved a circulation of 800,000, were launched. For the educated classes new reproduction processes resulted in a similar mushrooming of magazines, this time profusely illustrated, thanks to the invention of the half-tone block. All the time the communications revolution was moving at an ever-increasing pace with the invention of the phonograph in the 1870s, to be followed by the telephone and the car. The latter, during these decades an élite symbol, was to herald the invasion of the countryside in a manner that could never be matched by the railway. The town was now able to make its presence felt in the remotest hamlet.

In Britain, unlike the rest of Europe, the Industrial Revolution had been carried through with the active participation of the aristocracy. That meant the existing structure of society remained in place, indeed, via the public school system, it was able to filter its values to the newly emergent classes. The result was that the up and coming generation began increasingly to look down on industry, trade, science and the world of business, opting rather for an aristocratic-gentry life-style with the attributes of country house, garden and park, the cultivation of style, the pursuit of leisure and political service rather than overt sordid money-making and entrepreneurship.

That distaste for industry and the city had found its initial aesthetic voice in Ruskin, and accounts for the fact that a quintessentially urban age produced so little art mirroring the fact. What Ruskin could not have foreseen was that his hatred for what industrialisation had done would be taken over and attached to a growing social and political force, the working class. In this the designer, poet and writer William Morris was to be the pivotal figure, moving to a viewpoint which cast the middle classes as 'irredeemable' and that 'the cause of Art is the cause of the people'. Art and political ideology were for the first time yoked with consequences which have reverberated through to the present. Morris's achievements within the arts and crafts were to range over book design, weaving, furniture, stained glass, gardens, architecture and painting. What set his contribution apart was his linking of it to the cause of socialism. In 1883, having studied the writings of Karl Marx, Morris joined the Socialist Democratic Federation, leaving it a year later to set up the Socialist League. Morris was a political radical attacking the existing industrial and commercial system, arguing that

Walter Crane's sketch of William Morris speaking at a May Day Rally in Hyde Park in the 1890s.

factory production was not only ruining the environment but debasing men and their products. The irony was that his solution lay not in reforming that system but by putting the clock back, creating what was in effect an élitist cottage craft movement whose inspiration lay in the countryside and the vernacular artefacts of its past. This turning against the city and industry therefore permeated both the top and bottom of the social and political spectrum.

If this fixation with the country heralded one direction for the arts, the Aesthetic Movement heralded another. In this, the gaping void left by the absence of God in the aftermath of Darwinism was to be filled by a cult of art and life. The source was France and the first enunciation of the phrase 'Art for Art's sake' occurred in an article by the poet Swinburne on Baudelaire. The Aesthetic Movement's greatest exponent was Walter Pater, and its textbook was to be his *The Renaissance* (1873), in which the human mind was cast as 'a solitary prisoner of its own dream of a world', Leonardo da Vinci's *Mona Lisa* was presented as symbolic of a contemporary consciousness which is weighed down by a multiplicity of knowledge ('She is older than the rocks among which she sits . . .'), and where the notorious concluding passage seemed to encourage every reader to hedonism and indulgence in every experience, however

transitory. Inevitably it was an aesthetic programme deeply appealing to a new generation reacting strongly against the commercialism of their parents. Pater's work gave them their credo, one which was distrustful of systems and theories and stressed instead the importance of sensation and impression of a kind above all sublimated in the worship of Art and Beauty. It had another attraction, for just as Ruskin had firmly bonded art to morality, Pater, equally as firmly, dissolved it. The resulting figure was the aesthete, typified by the dandified Oscar Wilde with his green carnation and W. S. Gilbert's satirical Bunthorne in *Patience* (1881).

The Aesthetic Movement had a predecessor of a kind in the Pre-Raphaelites but the notion of effecting artistic change by way of initiating some new group of people

The affectations of the Aesthetic Movement offered ready copy for one of the great cartoonists of the age, George du Maurier. This one comes from Punch, *14 June 1879.*

REFINEMENTS OF MODERN SPEECH.

SCENE—*A Drawing-room in " Passionate Brompton."*

Fair Æsthetic (suddenly, and in deepest tones, to Smith, who has just been introduced to take her in to Dinner). " ARE YOU INTENSE?"

animated by a set of common principles was to result in the bewildering succession of movements and groups which was to run through the twentieth century. But such phenomena had another aspect to them. With the advent of democracy they provided a vehicle for those who wished to preserve caste of some form. Social hierarchy was gradually to be dissolved and replaced by one which was far more intangible, that of style and taste.

That was one way of preserving caste. Another was to turn to the past. More and more its artefacts came to be viewed as evidence of an earlier age which had better values. The obsession with antiques, caught in its infancy in Horace Walpole's Strawberry Hill, now intensified. Evidence for that is found in three major events, whose purpose was the preservation of the past, which took place during the last three decades of the nineteenth century: the formation, under the aegis of William Morris, of the Society for the Protection of Ancient Buildings (1877), the Ancient Monuments Act (1882), and the setting up of the National Trust (1895). Less and less was written about change and progress and more and more about old manor houses, churches, villages and towns which were billed as the quintessence of 'Old England'.

One way to meet the threat posed by the advent of the newly literate classes was to look back and regenerate what was now cast as a traditional culture which had been obliterated by the triumph of capitalist industrialisation. The lost true English culture, it was argued, needed to be recaptured in order to revitalise the nation. As the urban scene and its brutalised masses were viewed as a ghastly blight, country folk and their customs, earlier condemned as immoral, profane and often outright cruel, were extolled. The fact that the rural ideal, which was patriarchal, hierarchical and condescending to women, was a retrogressive one was bypassed. In the 1890s folklore emerged as a subject for serious study with, in 1898, the formation of the Folk Song Society which was to have significant implications for the future of music.

This was the middle classes reinventing Merry England. From either side of the political divide the rural ideal worked. For socialists it brought back an idealised rural way of life destroyed by Victorian capitalism; for those on the right it apotheosised what had been an aristocratic society. What all this ensured was that the fundamental vision of England was to remain a pastoral arcadian one which it had been since the Elizabethan age, albeit with different glosses put upon it. Englishness was seen to reside in her green and pleasant land dotted with villages and manor houses. Two world wars, far from eroding the myth, only strengthened it. It is still there.

This, of course, explains the conservatism of so much British art from the vernacular of the Arts and Crafts Movement of the 1880s to today's mock Tudor suburban houses. The English way of life was no longer to be seen as a monument to perpetual

change and innovation, happy to embrace every techno-
logical discovery, but, rather, to reside in an unchanging
stability, a preoccupation with the maintenance of the

*Norman Shaw's seminal re-creation of
the vernacular of Tudor and Stuart
England. Leys Wood, Kent, 1868.*

status quo and a deep reverence for the past. In this way ruralism was created as a
compensating image for city dwellers. The countryside was presented through all the
resources available to early twentieth century media as a timeless vision, a paradise
regained.

Virtually throughout the arts there was this yearning for the past. Not, one might
add, a grand aristocratic past but, rather, gentry and yeoman. Nowhere is this more
evident than in architecture. Architects recreated the past as a world of pre-industrial
simplicity, 'quaint' and 'old-fashioned', whose point of reference was the small man-
or house, farmhouse or cottage of Tudor and early Stuart England. Houses were no
longer built to look new but old, being irregular, discreet and tucked away into the
folds of a landscape which they no longer sought to dominate. Existing dilapidated
or ruined old buildings suddenly became deeply desirable. Instead, as in the past, of
demolishing them and building from scratch, they were restored, enlarged and mod-
ernised, but in a way which avoided any loss to their aura of venerable antiquity. Both
these houses and the new ones built for the recently affluent professional classes fuel-
led what was recognised as a revolution in domestic architecture in terms of comfort

and living style. By the first decade of the twentieth century the English house was hailed as the island's unique contribution to contemporary architecture. Hermann Muthesius, technical attaché to the German Embassy in London, wrote in his book on *The English House* (1897): 'There is nothing as unique and outstanding in English architecture as the development of the house . . .'

The architect Richard Norman Shaw was to dominate this revival between 1870 and his death in 1912. He began his practice in the 1860s, developing an 'Old English' country house style, typified by Cragside, Northumberland (1869–85), a rambling, picturesque mélange full of incident, with massive tiled roofs and soaring chimney stacks. During the 1870s Shaw was to become the exponent of warm red-brick 'Queen Anne'; in the following decade he moved on to Georgian. In a stunning series of houses, above all Leys Wood, Kent (1868), he gave the emerging classes a setting for their new way of life, houses which exuded old world charm, romance and wit. Within, ceilings could be both high and low, rooms could be of contrasting sizes,

both grand and intimate, there were changes of level and a plethora of handsome leaded windows allowed the light to stream in.

Simultaneously, William Morris's friend Philip Webb also turned to the English vernacular, starting his career

'Sweetness and Light'. Norman Shaw's designs for houses for Bedford Park, 1877, established a vernacular suburban style.

The House Beautiful I.
The main living room of the Orchard,
Chorley Wood, Hertfordshire by
C. F. A. Voysey, 1899.

with Morris's famous Red House, Bexley Heath (1860), a setting for the artist's friends to decorate. His masterpiece was Clouds, Wiltshire (1881–86, rebuilt after a fire 1889-91), in which Victorian gloom and clutter was banished in favour of a more relaxed informality, the interior mainly white or of unstained wood, colour being only in the form of superb Morris textiles. Clouds was to be one of the most influential houses of the age.

This was a golden era of house-building with a long list of eminent contributors including W. R. Lethaby and C. R. Ashbee, who both started their careers under Shaw, C. F. A. Voysey, Ernest Newton and Reginald Blomfield. In ecclesiastical architecture there was also a return to Englishness, to that sturdy insular style called Perpendicular. North of the Border, too, there was a parallel vernacular revival in the work of Robert Lorimer, an admirer of Morris, who looked back to Scottish castle architecture. Lorimer was committed to the Arts and Crafts Movement as was Charles Rennie Mackintosh who combined his vernacular enthusiasm with a rare response to

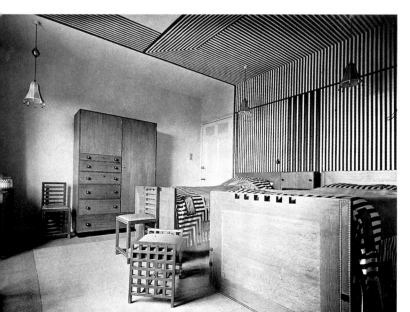

The House Beautiful II.
The guest bedroom at 78 Derngate,
Northampton by Charles Rennie
Mackintosh, 1916.

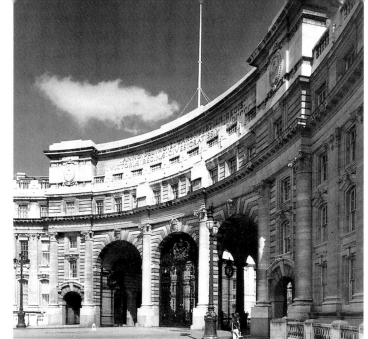

*Triumphalism: Aston Webb's
Admiralty Arch, Westminster, 1906-11.*

continental Art Nouveau and *japonaiserie*. His Glasgow School of Art (1897–1909) was to be unique. Mackintosh was to leave no native followers but his influence on the continental mainland was to be major.

The imperial theme could not go unadorned and in the Edwardian decade it made its presence felt in a return to monumental classicism in commissions like Sir Aston Webb's new façade for Buckingham Palace (1913), the Victoria Memorial (1913) and Admiralty Arch (1911). E. W. Mountford's Old Bailey (1907) assembled a mixture of influences resulting in an inflated Palladian style which was to spread through the country in the form of banks, offices and other institutions. This feeling of overblown splendour was to tip over even into ecclesiastical architecture in Sir Giles Gilbert Scott's Anglican cathedral in Liverpool, nominally Gothic but in spirit baroque, which was begun in 1904 and only finished, albeit in truncated form, in 1976.

But if one had to choose Elgar's equivalent in architecture it would have to be Sir Edwin Lutyens who was to remain in practice until his death in 1944. In the years before the outbreak of war in 1914 Lutyens was to build the last great wave of country houses, ones which married modern order and convenience with a reassuring 'ancient' style drawing on a mélange of historical periods. Unassertive and relaxed and perfectly controlled, no-one has surpassed them for the architect's attention to every detail, or his eye for telling incident and delicacy of texture, often making use of old bricks and

Sir Edwin Lutyens's Deanery Garden, Sonning, Berkshire for the editor of the new magazine Country Life, *1899-1902. The garden was by Gertrude Jekyll and together they created one of their most famous compositions, marrying house and garden in a paradisal vision which was to retain its hold throughout the century as an English ideal.*

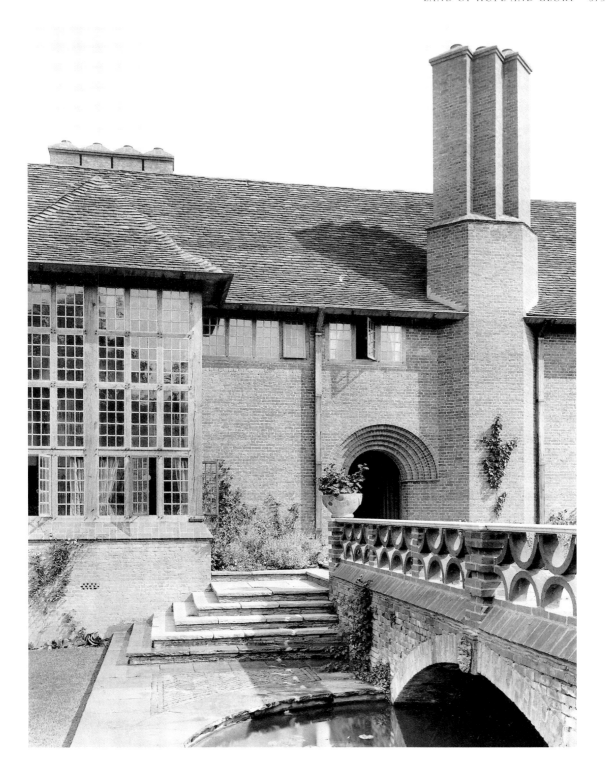

weathered timber. Houses like The Deanery, Sonning (1899–1902) are works of art, often enhanced by Lutyens's unique alliance with the great plantswoman and garden designer, Gertrude Jekyll. Lutyens provided her with the architectural setting in the form of pergolas, paths, flights of steps and terracing which stretched to form a series of rooms flowing outwards from the house. This built structure Jekyll would soften with planting of a rare sophistication made with a painter's eye. Again, as in the case of architecture, the impulse was to go backwards, the plants being those regarded as 'Old English' cottage ones and the style as Tudor or Stuart. Lutyens and Jekyll to a degree defined garden style for the century. Just before 1914 Lutyens was commissioned to lay out the new imperial capital of Delhi including the viceroy's house. When that was finished Lutyens stood revealed as one of the greatest classical architects in the country's history. Alas, it was too late, for he had been trained to build for a world which vanished in the Great War. In 1908 Asquith was to be the first prime minister without a country house, a benchmark of the end of a civilisation. Lutyens, like Elgar but more so, was tragically to outlive his age.

This deep yearning for a mythical past Englishness pervaded music with a parallel sense of longing. 'Public opinion must be raised,' George Bernard Shaw, in his role as music critic, wrote in 1919, 'to the need for providing in England the conditions in which it will be possible for Englishmen after a lapse of two centuries, once more to express themselves in genuinely British music . . . ' These decades witness a conscious search for just such a new music which would be recognisably English. In that quest literature, both past and present, the landscape and the rediscovery of earlier music were all to play their part. It was accepted that as the essential nature of English culture was literary, therefore any renaissance had to be rooted in the language. The search for a lost rural England beats as strongly in music as in any of the other arts. The editing and publication of the rich heritage of Tudor, Elizabethan and Stuart music as well as the recovery of folk-song were also to have a profound effect. Composers were aware that they had almost to start from scratch.

Up until the 1870s English music had been dominated by imports, both the music and the musicians, by Rossini, Weber and Mendelssohn. But it was during these very decades that the foundation-stones were to be laid for the renaissance of the 1870s. In 1852 the Crystal Palace was re-erected at Sydenham and George Grove, engineer and musical enthusiast, was put in charge. Three years later an orchestra was formed and the Saturday concerts (to which Elgar went) began pioneering the appreciation of Beethoven, Schubert, Brahms, Liszt and Dvořák. In 1858 the St. James's Hall opened between Piccadilly and Regent Street, seating two thousand and occupying the position taken over by the Albert Hall in 1871. In 1895 the Promenade Con-

certs began under the aegis of Sir Henry Wood at the Queen's Hall, which had opened in 1893.

During the same period orchestras burgeoned. Manchester in 1858 appointed a German pianist, Charles Hallé, as conductor and a decade later he formed an orchestra. But in London as late as 1900 only the Queen's Hall Orchestra under Henry Wood had any homogeneity for the others were wrecked by a system which allowed any member to send a deputy as a replacement if he received an offer of better employment elsewhere. The foundation of the London Symphony Orchestra in 1904 was to be a milestone in the elimination of this practice.

For English music to re-establish itself composers who were native born had to attain social status. Two of them, Sir Charles Villiers Stanford and Sir Hubert Parry, achieved precisely that, both being knighted and both occupying prestigious positions within the late Victorian establishment, Stanford as Professor of Music at Cambridge and Parry as Director of the Royal College. Musicologists generally date the renaissance from 1880 and Parry's setting of *Scenes from Shelley's Prometheus Unbound*, although as a composer Parry survives today largely on account of his setting of Milton's *Blest Pair of Sirens* (1887) and even more of Blake's *Jerusalem* (1916) which has taken its place, alongside Elgar's 'Land of Hope and Glory', as one of the sacred totems of the last night of the Promenade Concerts. Stanford poured forth choral works, turning in the end to church music, incidental music and music for festivals in order to make a living. Not much of a living could as yet be made from music, the third Victorian musical knight, William Sterndale Bennett, having to earn his by giving no less than 1,650 music lessons a year.

There were other conditions which contributed to this revival. One was the spread of musical literacy, thanks to cheap music printing. Another was the place of the piano in the average Victorian and Edwardian home. Music education improved. Although the Royal College of Music was founded as long ago as 1823, it was not until it was reconstituted under George Grove, who was also author of the celebrated *Dictionary of Music and Musicians* (1879–80), that it revived. The Corporation of London was to found the Guildhall School of Music (1880) and, in 1893, Sir Charles Hallé became the first principal of the new Royal Manchester College of Music. The colleges, however, were conservative. Modern informed musical criticism took off in the brilliant figure of George Bernard Shaw. Equally it was modern communications which enabled major musical figures to perform the length and breadth of the country. Dvořák loved English audiences so much that he came from Czechoslovakia no less than nine times: it could no longer be argued, as had been the case, that the British had no ear for music. Indeed there was to be a renewed emphasis upon it in the

aftermath of the extension of the franchise because music was seen not only as classless and undivisive but as offering some kind of quasi-religious or mystical experience in what was fast becoming an agnostic age.

The revival of music was also aided by theatre becoming acceptable once again to polite society. Without that, the celebrated alliance between W. S. Gilbert and Sir Arthur Sullivan could never have happened, for their operettas work from the premise of an intelligent and informed audience. Sullivan, as was the case with many late Victorian composers, received his musical education in Leipzig, establishing his reputation in the 1860s with a range of compositions from oratorios to hymns like 'Onward Christian Soldiers'. But it was his collaboration with Gilbert, which began with *Trial by Jury* (1875), for which he is most remembered. For over two decades the operettas, which ranged from a satire on the House of Lords, *Iolanthe* (1882), to sending-up the aesthetic cult of *japonaiserie* in *The Mikado* (1885), delighted late Victorian audiences. In spite of their caution and conservatism they brought political satire back to the stage in a series of productions which were as tuneful and memorable as they were insular. Although Sullivan's opera *Ivanhoe* (1891) was to run for a hundred and fifty performances it, together with what he regarded as his serious compositions, never achieved the fame or popularity of his work with Gilbert. The result was to sour and in the end dissolve the partnership.

Insular indeed British composers were to remain until the music of Sir Edward Elgar was to place the country firmly back on the international map. Elgar was born near Worcester, the son of an organist and music dealer and a farm labourer's daughter. He was also Roman Catholic. These were the attributes of an outsider, but his passion was to be a composer and he had one surpassing asset. He was a genius. These humble origins explain much about his music which resembles his character in oscillating between pools of light and caves of darkness, reflecting moods which could run from depression and paranoia to generosity and affection. His eventual success was to owe a supreme debt to the woman who married him. Eight years his senior and from a superior social rank, being a general's daughter, Alice Elgar recognised her husband's quite extraordinary abilities.

Entirely self-taught the young Elgar had to make his way up from the bottom. By the 1890s his career had begun to progress and in 1899, when he was forty-two, he composed his first great landmark, *The Enigma Variations*, a rich orchestral panorama celebrating his friends. The work, when it was first played at the St. James's Hall in London, was acclaimed at once to be a masterpiece of fantasy and ingenuity. Elgar exactly reflects all the aspirations to Englishness for which composers were then striving. His music breathes the air of landscape. 'This is what I hear all day,' he wrote to

Sir Edward Elgar with his first bicycle, 1910.

his friend Jaeger, ' – the trees are singing my music – or have I sung theirs?' Writing in a late romantic idiom whose source was the German school, once, when asked what it was he composed, he replied that it was English folk music.

Thereafter the masterpieces flowed: the oratorio *The Dream of Gerontius* (1900), based on Cardinal Newman's poem and a work of passionate intensity drawing on Wagner and Verdi as well as plainsong, his two great symphonies (1909 and 1911), his violin concerto (1910), his tone poem *Falstaff* (1913), and his 'cello concerto (1919). Elgar was an eclectic, his creative vitality giving his music an overwhelming power and distinctive voice, one wrapped in introspection and deep emotion. His music coincided with the nation's imperial zenith and much as it seems to celebrate that, it seems simultaneously to be its requiem. His subject-matter, which looks back to the world before the Industrial Revolution, is chivalrous and romantic making him the embodiment in musical terms of England. The war of 1914 finished him and his music which was not to be resurrected until his centenary in 1957. Its reputation since has never waned.

Being Christian and deeply patriotic Elgar seems to stand poles apart from Frederick Delius, a man caustic, ascetic and firmly anti-religious. Although Sir Thomas Beecham was to be his greatest advocate and the composer was to ask to be buried in England, his creative life was passed abroad. He always saw himself as a European. His music, however, which aimed to move the emotions, had a deep poetic appeal for the English who never really regarded him in any other way except as one of them-

selves, contributing to the contradiction. Elgar can only ever be read in one way but Delius can be embraced both as the high tide of Edwardianism and as part of the incipient modernist movement which was to disrupt it.

Like Elgar, Delius was largely self-taught, coming from a German commercial family which had settled in Bradford. In common with others of his generation he reacted strongly against the world of industry. In 1884 he left England never really to return, settling eventually in France and contracting an illness which was to leave him virtually paralysed. Although the Norwegian composer Grieg was to be the greatest influence on his work, the circles in which he moved abroad read like a roll-call for the modernist revolution: Strindberg, Gauguin, Mucha and Edvard Munch. Of his operas only *A Village Romeo and Juliet* (1900–1901) can still hold the stage but his greatest work is *A Mass of Life* (1909), eleven soliloquies based on prose poems by the philosopher Nietzsche, which, as it calls for a huge orchestra and choir, is rarely performed.

Delius, therefore, stands as a somewhat questionable figure within the British musical tradition and its search for an English style. The same does not apply to the sudden proliferation of native composers who crowd the opening decades of the new century including Samuel Coleridge-Taylor, Rutland Boughton, Granville Bantock, Havergal Brian, Arnold Bax, Walford Davies and Ethel Smyth. Most produced works which were acclaimed in their day but few have survived the passing of time. One which has is Coleridge-Taylor's *Song of Hiawatha* (1900) which is still occasionally to be heard. The same cannot be said of the slightly cranky Boughton's *The Immortal Hour* (1914) which enjoys the dubious eminence of being the most successful English opera of the century. Of the eccentric Ethel Smyth all that can be said is that she pioneered the role of women in music. Objectively by far the most important of these composers was Walford Davies in his capacity as the man who set out to popularise classical music for the masses in the 1920s via the new medium of radio.

Theatre was to undergo a somewhat similar renaissance. Although hugely popular throughout the nineteenth century it had been shunned by the polite classes who patronised the opera. Theatre was given over to sensation and spectacle to lighten the lives of the working classes. With the departure of the upper classes the sophistication of Georgian drama was rendered obsolete, as an urban working class craved escape in the form of exotic melodramas and scenic spectacle. As a consequence the technical side of theatre developed, with the addition of fly galleries, trapdoors and gaslight. At the same time acting became stylised and broad of gesture, producing a succession of actors in the grand heroic manner: John Philip Kemble and his brother Charles, Edmund Kean and William Charles Macready. The ever-adaptable Shakes-

peare was transformed into a vehicle for pageantry as the quest to recreate accurately the historic past conquered the stage. Theatres multiplied when the old licensed system broke down in the 1830s and 1840s. What appeared on stage was now conditioned by a new Censorship Act (1843), giving the Lord Chamberlain absolute powers over the theatre. The result was that anything remotely sensitive in the way of religion, politics or sex was kept firmly off the stage.

And then, as was the case with music, the atmosphere changed in the 1870s. Although it was to take a generation, the upper classes were slowly wooed back to the stage, essentially by a new kind of theatrical figure, the actor-manager. That movement was begun by Squire and Marie Bancroft at the Prince of Wales Theatre in the 1860s. As the rougher elements in the audience were drawn off to the newly emergent music halls, polite society was attracted by a seating hierarchy of stalls and dress circle, and by a series of plays by Tom Robertson acted within minutely observed drawing-room box sets. Gradually the multiple bills inherited from the eighteenth century gave way to the presentation of a single play on at hours in accord with the demands of polite society. In 1880 the Bancrofts moved to the Theatre Royal, Haymarket, which epitomised this new sophisticated elegance of milieu. By then auditoriums had shrunk in size in response to a new type of drama, the well-made play.

Another actor-manager, George Alexander, was to undertake a similar exercise at St. James's Theatre, finding in Arthur Wing Pinero and Oscar Wilde writers who could both portray and attract society. Between 1891 and 1914 St. James's, under Alexander's management, became the most fashionable theatre in London, staging plays which called for a new and more naturalistic style of acting which gradually rendered the mid-Victorian histrionics crude by comparison.

In this way the scene was set for the two decades up to 1910 becoming the golden age of society drama. It was a renaissance which shared with other arts a backwards look, this time to the theatre of the Restoration era which similarly housed a drama aimed at only a small select circle of the king and his cronies. In the case of Edwardian drama that circle was admittedly larger, consisting of the ten thousand or so who made up what was deemed as society. The plays indeed worked from that premise, one in which the audience sat looking at itself on stage. The theme of these plays was society, how to get into it and, once in it, how to stay there or avoid exclusion. It was accepted and generally expected that everything on stage would uphold the established consensus in respect of religion and morals, the established social structure and imperial supremacy. In this sense such plays became a kind of social ritual in which the audience saw the status quo affirmed. Nonetheless what was demanded of theatre was to an extent very different from what was asked of a

novel. The prime consideration was always that any audience should feel entertained.

As theatre became an arm of the establishment those who had achieved this were suitably honoured, both Squire Bancroft and George Alexander being knighted in the 1890s. The theatre thus became respectable and indeed acting became a career which it was now possible for a gentleman to consider. It not only became a career but a profession for the first time, one which demanded formal training. In 1904 the Royal Academy of Dramatic Art was founded followed, five years later, by the Central School of Speech and Drama. To become a playwright equally attained a new status and in addition became profitable. The 1887 Berne Convention on copyright and the 1891 American Copyright Act ended the piracy of plays and meant that they could be safely published. As royalties began to flow, writing plays became once more an attractive proposition to the world of letters.

Wilde and Pinero established a new kind of adult drama in the 1890s. Wilde's *Lady Windermere's Fan* (1892) was billed as a 'New and original play of modern life' and inaugurated a series by him which revived the theatre of wit for the first time since the age of Congreve. Most of his plays are about women with a past, distressed wives and distraught husbands. The plots creak, turning on things like a misplaced letter or a fan, but Wilde used them as a vehicle for his epigrams. As a result the really interesting characters are the peripheral ones. In *The Importance of Being Earnest* (1895) he created one of the greatest masterpieces of comedy in what was an inversion of the values of normal society drama.

Unlike Wilde, Arthur Wing Pinero learned his craft the hard way, emerging to prominence in the 1880s with a series of farces, including *The Magistrate* (1885), taking up again the kind of mad world of Ben Jonson. Gradually Pinero found it possible within the confines of censorship to evolve a new kind of play, one which responded as far as was possible to the challenge of Ibsen, 'a drama based wholly on observation and experience . . . [which] . . . illustrates faithfully modern social life.' *The Second Mrs Tanqueray* (1893) crossed new boundaries, putting on stage the dilemma of a man of the world who had married a woman with a past who in the end commits suicide. The effect on the audience was electric. Later Pinero was to move on to tragedy in *Iris* (1901) and *Mid-Channel* (1909). In *Trelawny of the 'Wells'* (1898) he was to pay poignant tribute to the world of the theatre of his youth which his own work had replaced. Dying in 1934, like Elgar and Lutyens he was to outlive his era.

If the well-made society drama reassured its audience that all was well with their world, so too did the pageantry of a great Shakespeare production or a romantic melodrama under the aegis of Sir Henry Irving. Irving was the late Victorian equivalent of Garrick, turning the Lyceum Theatre, which he took over in 1878, into a temple of

Society drama. Mrs Patrick Campbell as Paula Tanqueray with George Alexander in The Second Mrs Tanqueray, *1893.*

Thespis. Irving brought glamour and a sense of occasion to every production, fine-tuning them so that they attracted both a select and a popular audience. His sensational success in *The Bells* (1871) made him overnight the leading actor of the age, noted for his bold effects. In Ellen Terry he discovered an actress whose interpretation of Shakespeare's heroines has never been equalled. In contrast to the box-set plays of Wilde and Pinero this was pictorial theatre on the grand scale, dense, realistic and mysterious, in which the heroic past unfolded itself before the audience's eyes in every detail.

This tradition was to be continued down to the outbreak of the Great War in the productions of Sir Herbert Beerbohm Tree. He built Her Majesty's Theatre (1891) and from 1905 offered an annual Shakespeare season in

Theatrical pictorialism on the grand scale. The forum scene in Herbert Beerbohm Tree's production of Shakespeare's Julius Caesar, *1911.*

which romantic realism was carried to new heights of illusion with aberrations like live rabbits on stage in *A Midsummer-Night's Dream*.

These were the official faces of late Victorian and Edwardian theatre but, far more than was the case with either architecture or music, there was pressure for change. Increasingly the educated and socially conscious classes wanted a form of drama which fully responded to Ibsen and explored social issues of a kind vetoed by the Lord Chamberlain's Office. The only means whereby this could be done was by way of the club, for such stagings could be deemed private, therefore falling outside his jurisdiction. In 1891 the Independent Theatre Club was founded to stage plays of literary and artistic worth. On 13 March Ibsen's *Ghosts* was performed. The leading critic of the day voiced the view of the establishment in condemning the play as an 'open drain'.

It was George Bernard Shaw who was the first playwright to begin to explore these new horizons. Before 1914 only two of his plays ever reached the public stage, the others being performed for the Independent Theatre Club and latterly for another club at the Royal Court Theatre where no less than eleven of his plays were put on between 1904 and 1911. The earliest, *Widowers' Houses* (1892), sent shock waves but not nearly as many as did *Mrs Warren's Profession* (1898), which dealt with the unmentionable subject of profits from prostitution. A whole spate of plays followed, including *Candida* (1898), *Man and Superman* (1903) and *Pygmalion* (1912). All of them explored the relationship of the sexes in what was a rapidly changing society by means of a revival of the elegance and wit of Restoration comedy. In these plays Shaw utilises the formula of the well-made society play to his own end, adapting it to satirise and attack conventional middle class ideas. Many of the plays can still hold the stage today thanks to their comic effect, but his characters remain unreal, not flesh and blood but ideas in human form. Once Shaw abandoned his comic talent for sermonising and political writing that hold slipped. Although he was to live until 1950, and was awarded the Nobel Prize for literature in 1925, he was a spent force in the theatre after *Heartbreak House* (1919) and *Saint Joan* (1923).

Shaw was not alone. Others followed him in the exit from the drawing-room, daring to tackle forbidden themes. John Galsworthy's plays like *Strife* (1909) explored the factory, the office and the prison cell: Harley Granville-Barker's, among them *The Voysey Inheritance* (1909), exposed the rottenness which so often lay concealed beneath the shallow façade of established respectability. The early plays of Somerset Maugham crossed the same barriers, as the wicked were seen no longer to be punished by the time the curtain fell, and doubts over religion began to be openly expressed by characters on stage.

The sense of attack on the established theatre by the new drama set off a move in

the opposite direction towards escapism. J. M. Barrie purveyed whimsy to his public whether it was *Quality Street* (1912), a slight Regency costume drama, or *Peter Pan* (1904) whose subtext in retrospect is now viewed as disturbing. The enthusiasts for the new drama in fact belonged to a narrow educated middle class élite. The mainstream of Edwardian theatre depended on spectacle, on the continuing popularity of romantic melodrama, and also on a new genre, the musical comedy. George Edwardes at the Gaiety Theatre from the 1870s onwards was to transform this rudimentary form into the acme of elegant froth, leisurely, lavish and ingenuous.

Harley Granville-Barker was not only a dramatist of distinction but the first man to be a new kind of figure in the theatre, the producer-director, the man who coordinated every part of a production from its design to the delivery of the lines, movement on stage and lighting. At exactly the same time that Irving and Tree were dazzling audiences with untold visions of Old England an alternative approach to Shakespeare production was also underway, a movement in which Granville-Barker played a major part. It was one which restored primacy to the text and was pioneered by William Poel who formed the Elizabethan Stage Society in 1894. He supervised performances of Shakespeare, reconstructing the type of stage that the plays would originally have been performed upon. Though in one sense this can be seen as a modernist impulse, it was also a quest for Old England,

A theatrical revolution. A scene from Harley Granville-Barker's stylised production of Twelfth Night *at The Savoy, 1912.*

fuelled by developments in the academic study of Shakespeare's age. The productions by Harley Granville-Barker at the Savoy in 1912 and 1914 rendered the tradition of Irving and Tree redundant overnight. Realistic sets were jettisoned in favour of stylised ones, and the resulting simplicity of staging not only speeded up the action but also the speech delivery. Such an approach to staging was also to be crystallised in Edward Gordon Craig's *The Art of Theatre* (1905). His contribution to theatre design, which was ignored at the time, aimed at simple monumental effects, light-years away from Edwardian pictorialism. What Craig's book heralded was precisely director's theatre, a form of theatre which was classified firmly as art. By 1910 therefore the division of the world of theatre into two camps, commercial and art, was already securely in place.

These stirrings, which spelt the death knell of established theatre, were not confined only to the metropolis. The opening decade of the new century saw a revival of regional theatre in direct response to the demands of the educated middle classes in the larger urban conurbations. In 1907 Annie Elizabeth Horniman founded the Gaiety Theatre in Manchester. This was to be a repertory company and others followed: Glasgow (1909), Liverpool (1911) and Birmingham (1913). All reflected the credo of the new drama. The task of these companies was to stage new writing, both local and foreign, making use of their own group of actors and not depending on imported stars. Only in Manchester did local writing talent emerge in William Stanley Houghton. It was in Dublin, where Miss Horniman sponsored the Abbey Theatre to be run under the aegis of Lady Gregory, that the repertory movement achieved its greatest triumph in the plays of W. B. Yeats.

Establishment art was to run in tandem with establishment theatre, offering what was the visual equivalent of the well-made play, painting and sculpture of a kind which would not ruffle the existing scheme of things. In 1869 the Royal Academy moved to Burlington House and entered its apogee, a zenith which was to go virtually unassailed before 1900. Its walls were banked with nostalgia, fancy pictures of children, evocations of pre-industrial Regency England, scenes of everyday life in Ancient Rome or arcadian landscape. Art was fashionable and during the 1880s some three hundred and fifty thousand visitors thronged the Academy's galleries during the run of the Summer Exhibition.

This popularity equally reflected a new confidence in what was now proudly billed as the British School of Art. Earlier in the century Allan Cunningham in *The Lives of the Most Eminent British Painters, Sculptors and Architects* (1829–33) had rewritten the British contribution to the European tradition. Turning the ideals of the previous century on their head he argued that foreign study had only led English artists astray,

losing 'their island originality in gazing upon the splendid works of Michelangelo and Raphael; they come home bringing with them all that is weak and leaving all that is strong.' So the British School began to be defined as having its own especial genius, expressive of native wit and humour, non-academic and idiosyncratic. The definition worked from insular nationalism, passing over those periods dominated by foreigners like Holbein and Van Dyck and locating the birth of the true British School in the eighteenth century with Hogarth, Gainsborough, Reynolds and Wilson as its founding fathers. Such a view of things was endorsed further by Samuel Redgrave's influential *A Century of British Painters* (1866). Public awareness that the island actually had a school of painting of which it could be proud was further fuelled by two stupendous art exhibitions, one at Manchester in 1857 and a second, held in the South Kensington Museum in 1862, when over six thousand works of art were brought together and the British contribution was presented on a par with that of the other major European schools. These exhibitions were the direct precursors of the spate of regional museums and galleries which began to spring up from the 1870s onwards. Founded in the aftermath of the Education Act they were designed to present British art past and present as a common national achievement crossing every class barrier. And the keystone of their representation of contemporary art was of course the Royal Academy, for it was here that the local authorities did their annual shopping so that those in the regions could see the latest triumphs of the British School. The vast holdings throughout the country of late Victorian and early twentieth century academic art remains a lasting monument to that period of confidence, one that was to find national expression with the opening of the Tate Gallery of British Art on Millbank in 1897.

The Academy was, however, able to accommodate on its walls the products of many of the artists of the Aesthetic Movement, who rejected the mimetic and didactic role of art, placing a supreme emphasis instead on the formal values of line, colour, tone and pattern. Narrative, anecdote and moralising, which had been the essence of Victorian art, were discarded. The only religion to which these artists subscribed was that of beauty, often reflected in scenes of the classical world, not heroic ones as in times past but ones which reflected the new interest in psychology, capturing fleeting moments and sensations.

Those who responded within the established framework included the ageing Rossetti with a gallery of beautiful if unhappy and cruel women whose full lips and soulful eyes spelt doomed ecstasy. Albert Moore and Lord Leighton celebrated such art and beauty, the latter's *Flaming June* (1895), a subjectless picture of a woman in a diaphanous orange gown, catches this exactly. For Moore the artist's only obligation

now was towards 'form, colour, and the contrasts of light and shade.' Sir Lawrence Alma-Tadema, along with Sir Edward Poynter, enlivened the Academy's walls with archaeologically exact and highly tactile re-creations of life in ancient Rome, presenting the public with a parallel imperial society, a mirror across the centuries of their own. In portraiture the brush of the American John Singer Sargent bestowed on aristocracy and gentry alike a glamour of a kind unseen since the days of Gainsborough and Reynolds. Nor was social conscience wholly absent. Scenes recording the deprivations of the working classes made their appearance: Luke Fildes's *Applicants for Admission to a Casual Ward* caused a stir in the 1874 Academy.

But one artist's fame eclipsed all others, George Frederick Watts. Artist and sage, he dedicated his life to filling vast canvases with high-minded allegories on life, death and the origins of the cosmos. For these he was hailed as England's Michelangelo. Believing in a God but not in organised religion, Watts struggled to create a new pictorial language. First acclaimed in the Academy of 1881 he went on to paint what remains his best-known work *Hope* (1886) and the vast allegorical series, *The House of Life*. Venerated as a living Old Master his reputation collapsed on his death, never to recover.

As far as the Royal Academy was concerned it *was* British art. In that role it supervised the purchases to form a national collection from the immense bequest by Sir Francis Chantrey. That in fact allowed for the acquisition of works by foreign artists if they had been executed whilst resident in Britain. Between 1876 and 1904 over a hundred purchases were made but among them there was not one picture by any of those whom we would now regard as the major painters of the age. When the new Tate Gallery opened its doors in 1897 the public became aware for the first time of the grip of the Academy on the definition of what was art.

By that date the Academy's supremacy had begun to be undermined. In the first instance this was by way of the emergence of a major alternative exhibition venue, the Grosvenor Gallery, which opened in 1877. It was there that the Aesthetic Movement was launched in the form of its two major painters, Edward Burne-Jones and the American, James McNeill Whistler. Burne-Jones, who was a prolific designer for William Morris for the decorative arts, re-emerged as a painter in 1878. His pictures reflect a rejection of late Victorian materialism, presenting a dreamworld in his words 'of something that never was, never will be.' Whistler was to be a far more disturbing figure invoking the ire of Ruskin. The painter's response to Aestheticism was to be much more extreme than Burne-Jones's, throwing out any ethical, social or spiritual context for art at all, casting it as something out-

Painting as music. James McNeill Whistler's Symphony in White No. 1 *which he originally called* The White Girl, *1861-62.*

side the conventions of society and pursuing Pater's dictum: 'All art constantly aspires towards the condition of music.' In pictures like *Symphony in White No. 3* (1867) and *Arrangement in Grey and Black No. 1* (1872) the painter shocked. All that mattered, he argued, was 'the amazing invention that shall have put form and colour into such perfect harmony.' Already these pictures by implication were strides towards abstraction with their monochromatic colour, simplified shapes, and their interest in pure form and calculated painterly effects.

Whistler had studied in France where the Impressionist movement was entering its heyday. In the 1880s that growing resentment of the Academy and the country's dogged insularity began to spread. More and more painters began to go to France and, as a consequence, started to respond to the work of artists such as Millet and Corot. From the middle of the 1880s it was the French painter Bastien-Lepage who was to assume the status of a cult figure for the up and coming generation. His pictures of peasant life in Normandy make use of a trellis of rectangular brush strokes which emphasised the picture's surface flatness and ton-al values at the expense of colour. This technique was widely copied by a group of English artists, headed by

The search for a new reality I. Stanhope Forbes's A Fish Sale on a Cornish Beach, *1884-85.*

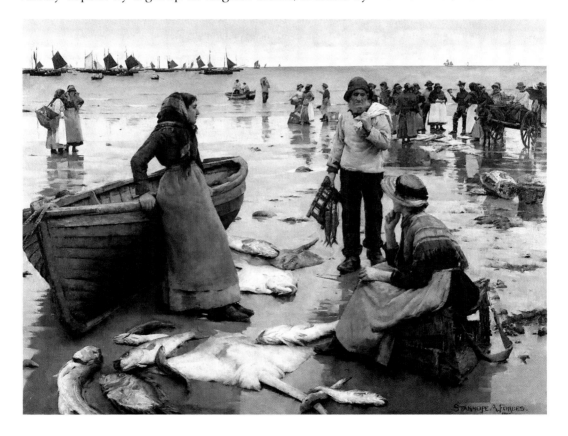

Stanhope Forbes, who returned and set up an artists' colony at Newlyn in Cornwall to paint the life of the fishing village in emulation of their French counterparts.

It was Whistler who was to introduce the young Walter Sickert to Degas and Manet. The Impressionists had often used as their material scenes from contemporary life and Sickert followed, exploring subject-matter such as the working class haunt of the music hall. In 1886

The search for a new reality II. Walter Sickert's The Gallery of the Old Bedford, 1894-95. The painting's original title was that of a popular music hall song, 'The Boy I Love is Up in the Gallery.'

he and a number of other English artists, including Philip Wilson Steer, formed the New English Art Club as an institutional challenge to the Academy. Their aim, proclaimed in their first exhibition, was to 'render the magic and the poetry which they daily see around them.' North of the border a similar group was formed, the Glasgow Boys, which included amongst their number the future Sir John Lavery. What these dissident groups signalled was that painters could exist outside the Academy's seeming monopoly.

Sculpture was affected by parallel shifts moving away from the anecdotal and mythic in favour of deploying textures and form to express spiritual truth. Sculpture had been in the doldrums for decades, reduced to tomb sculpture and busts, and then, in 1877, Lord Leighton, who was also a sculptor, regalvanised a younger generation by his *Athlete Struggling with a Python*. Amongst those who responded was Alfred Gilbert who founded the New Sculpture movement. Gilbert had mastered the 'lost wax' technique of casting in bronze which gave his work a quite unique finish and texture. Although his memorial to the great Lord Shaftesbury, *Eros* in Piccadilly Circus (1893), is his best known work,

A rare English response to Art Nouveau: *The figure of St. Michael on Alfred Gilbert's tomb for the Duke of Clarence in St. George's Chapel, Windsor Castle.*

his masterpiece is his tomb for the Duke of Clarence at Windsor (begun 1892). The project bankrupted him and, in 1901, he left England only returning in 1926.

Many of the artists involved in the new movements were tinged with, or committed to, socialism, a factor which was to become of great significance as the new century developed. There began to emerge a seeming alliance, however ill-defined, between the avant-garde and reformist politics. Up until now what those who practised within the arts believed politically was of no consequence but as the franchise became ever more inclusive the arts would inevitably in the long run be drawn into the political arena. So far they survived from day to day solely in terms of nineteenth century *laissez-faire* economics, sinking or swimming in the market-place. A man like Sir Herbert Beerbohm Tree was running what was in effect a nascent National Theatre without subsidy. The cost was crippling, but it was still an age of cheap labour. The idea of state involvement had hardly surfaced. Although in 1868 the State had made the unprecedented gesture of an annual grant of £500 to the Royal College of Music,

when, later, Sir Henry Tate offered his art collection to the National Gallery the negotiations became so protracted that after a Liberal government offered him a site on Millbank he went on to build the gallery himself. But the atmosphere was changing. In 1879 when the Shakespeare Memorial Theatre opened in Stratford-upon-Avon the idea that a national theatre should be built began to be aired. It was to take until 1976 to materialise, but all these small incidents were signs that change was in the air and that in a new century of mass democracy art, government and politics were to become inextricably intertwined.

The origins of that intertwining were inexorably bound up with the revolt against industrialism embodied in the Arts and Crafts Movement. William Morris's attack on factory production set in motion a huge nostalgia for a revised or re-invented vernacular. For Morris this meant not only a recovery of vanishing skills wiped out by the factory, but also the reassertion of social and humanitarian values. So what was a stylistic movement carried as part of its baggage an implied commitment to a reorganisation of society, one in which capitalist values would be expunged and an inherent vision of beauty accessible to Everyman stand revealed. Morris clothed this essentially secular Utopian vision with language which re-echoes the mood of prophecy of the 1650s. In an address on *The Beauty of Life* (1880) he spoke of 'the victorious days when millions of those who now sit in darkness will be enlightened by an art made by the people and for the people, a joy to the maker and the user.'

A deep moral earnestness was therefore always to lie behind all the design movements in Britain during the twentieth century and that we owe to Morris. And it was not only on this that Morris set the agenda, for the pre-industrial vernacular he extolled was that of the farmhouse, the cottage and the barn. These were cast as uncorrupted and pure, peasant art unsullied by either the aristocracy or the middle classes. They were also seen as quintessentially English and in this Morris and his followers were, as we have seen, at one with those at the other end of the political spectrum who also saw Englishness as residing in the countryside. What is so fascinating is the difference of application of Morris's ideals on the continent as against in his own country. Abroad, his fundamental tenets of truth to materials, utility and beauty were immediately applied to mass manufacture. Here, in sharp contrast, they set in motion a revival of handcrafted artefacts. More, they were to ensure that any attempts to raise standards of design in factory production were always to start from a craft basis.

What he also left as a legacy was that all design movements should be collective. That started with Morris in the 1860s when Philip Webb built the Red House, the interior of which his friends filled with furniture, textiles, embroideries, stained glass, ceramics and painted effects. That initial essay in interior decoration transformed

itself into corporate form with the firm of Morris, Marshall, Faulkner & Co. in 1861. Twenty-six years later it moved to Oxford Street offering furniture, fabrics and wallpapers designed to give any house a look for what was seen as the dawn of a new and more artistic age. The decade of the 1880s saw the principles which were to dominate design in the new century put in place, those which set store by functional efficiency and fitness-for-purpose. Design indeed took on all the attributes of a moral crusade preached with almost evangelical fervour. Democracy and beauty for all were billed as allies and simplicity and practicality seen as a birthright.

During the 1880s the Arts and Crafts Movement mushroomed like some new religious sect. In 1884 a group of young men in Norman Shaw's office set up the

The Kelmscott Chaucer, issued June 1896. The crowning achievement of William Morris's collaboration with Sir Edward Burne-Jones.

A new aesthetic in interior decoration. A London drawing-room of the 1870s with wallpaper by William Morris, a display of china and pottery in an ebonised cabinet and a Japanese screen. The room is that of the author, Robert Edis, of the influential Decoration and Furniture of Town Houses, *1881.*

Art Workers' Guild, thus institutionalising the new craft ideal. Its aim was to bring craftsmen and architects together. Four years later an annual Arts and Crafts Exhibition Society was established with the brilliant designer for the decorative arts, Walter Crane, as its first president. In the same year, 1888, C. R. Ashbee formed the Guild of Handicraft, whose members were to produce some of the Movement's most outstanding furniture, silver and jewellery. This was an organisation strongly committed to the new socialism and, in 1902, in order to fulfil this mission, over a hundred of its members moved to Chipping Campden in the Cotswolds to form some kind of ideal community. The experiment proved a disaster and folded six years later. So it is that the two decades 1890 to 1910 mark the high tide of the Arts and Crafts Movement, one which equally spread to the regions. In 1890 the Birmingham Guild of Handicraft was created. Finally the Movement's message was taken into the art educational system. In 1896 the Central School of Arts and Crafts opened, providing what was the most progressive education and training in design in Europe. At the Royal College of Art W. R. Lethaby was appointed first Professor of Design, thus reinforcing the notion that handicraft was its basis.

The Movement effected what was a revolution in living style by a whole swathe of the educated middle classes. That revolution had already begun under the impulse of aestheticism in the 1870s. The home was now apotheosised as the house beautiful, a temple to art. These interiors were filled with artefacts in the vernacular, Old England recreated. Throwing out their grandparents' clutter, such people embraced what was seen to be a new form of classless simple life, filling their rooms instead with honest oak furniture, craft pottery and embroidery, as well as fabrics and wallpapers covered with formalised patterns based on the flowers and leaves of Old England. Understatement and reticence were married to what was a quintessentially insular quirkiness and fantasy to produce a quite unique style.

A wall hanging designed for Morris & Co. by John Henry Dearle, c.1895. Such items were purchased as kits and reflect the high standard of amateur needlework.

The Movement, with all its socialist zeal, was seen in the end by one of its fervent advocates to have been an illusion. C. R. Ashbee wrote in the aftermath: 'We have

made of a great social movement, a narrow and tiresome little aristocracy working with great skill for the very rich.' What the Movement also failed to answer was the fact that what the factories produced, which they condemned, sold. Out of that was to spring another never-ending twentieth century refrain, the education of the masses in what was regarded by a minority as good taste. More important than all of this was W. R. Lethaby's realisation that a totally new direction was urgently called for. In 1910 he wrote: 'We have passed into a scientific age, and the old practical arts, produced instinctively, belong to an entirely different era.' Lethaby firmly believed that a machine-made object should look precisely that. This was a step forward in recognising the realities of the new century, but the crafts were to remain firmly on the agenda.

The Arts and Crafts Movement posed no seeming threat to the established scheme of things. Literature was another matter. By 1910 it was suffering seriously from the constraints imposed by the taboos still in place in the Obscene Publications Act of 1857. If anything that sense of constraint was to be exacerbated by the National Vigilance Association (1885) and the trial and imprisonment of Oscar Wilde for homosexual offences a decade later. As a result what was to be modern literature endured a prolonged, twisted and stunted birth. Writers had to be cautious in responding to the new realism of the great French writers. At the same time they felt under increasing pressure to give voice to the major concerns of the age, loss of faith, the demands of socialism and women's rights. In 1900 Sigmund Freud published *The Interpretation of Dreams* and the year after *The Psychopathology of Everyday Life*. At about the same time quantum theory began to be adumbrated. Those facts alone emphasise the insularity of the English world of letters.

With the advent of universal elementary education in 1870 readership changed, producing a situation akin to theatre where the divide between art and commerce began to open wide, with only some writers able to straddle both. Increasingly there was a demand for 'mass' popular reading, one which was met by authors such as Robert Louis Stevenson who cultivated the hugely expanded children's market with books like *Treasure Island* (1883) and *Kidnapped* (1886). This was in fact to be a golden age of children's writing with the Alice books of Lewis Carroll and those by Beatrix Potter and Kenneth Grahame. But in the case of adult readership there was a divide between what was written for a mass audience and what in retrospect we would deem literature.

From the 1870s onwards novelists responded to the all-pervading gloom of post-Darwinism, none more so than Thomas Hardy whose novels take on the great scientist's grimmer side, delineating characters who struggle in the battle for survival and

who fail. For over twenty years Hardy was to produce a steady stream of remarkable novels including *Under the Greenwood Tree* (1872), *The Mayor of Casterbridge* (1886), *Tess of the D'Urbervilles* (1891) and *Jude the Obscure* (1895). Hardy, the son of a country builder, casts his native Dorset as Wessex, a landscape in which the lives of ordinary people are dominated by the immemorial rhythm of the seasons and presided over by eternal spirits who manipulate events. This is a vision of Old England, of a people who are living survivors of a vanished pre-industrial age, people who fear the coming of the machine. In an essentially tragic view of the human condition he deals with sharply contemporary topics like education, the plight of the unmarried mother and women's rights.

After 1895 Hardy was never to write another novel, turning instead to writing poetry which looks back to Victorian romanticism and forward to modernism. In his verse he makes use of a unique vocabulary derived from his knowledge of the Bible, of English poetry and the vernacular of his native county. These angst-ridden lyrics crystallise the uncertainty of the age. *The Darkling Thrush*, originally entitled 'The Century's Deathbed', was written as the old century gave place to the new. It is a secular ode bringing no cause for any rejoicing apart from the reassurance of the eternal cycle of the seasons:

> An aged thrush, frail, gaunt, and small,
> In blast-beruffled plume,
> Had chosen thus to fling his soul
> Upon the growing gloom.
> So little cause for carollings
> Of such ecstatic sound
> Was written on terrestrial things
> Afar or nigh around,
> That I could think there trembled through
> His happy good-night air
> Some blessèd Hope, whereof he knew
> And I was unaware.

Thomas Hardy in bicycling dress.

If Hardy's characters reflect man as the victim of the fight for survival and the powers of fate, Henry James traces their internal response to events whose consequences only reveal themselves gradually. In his novels he explores the moral life of the consciousness, fascinated by encounters of innocence with depravity, brin-

ging in his writing a unique depth and fullness to the understanding of human motivation. James was an American, cosmopolitan, but who chose in the end to settle in England where society offered him material made for the subtlety of his pen, one which was by the turn of the century more opulent, less industrious and simultaneously both exquisite and coarsened. Being American he could explore the impact of the New World on the Old. In his masterpiece, *Portrait of a Lady* (1881) he depicts the fate of an American girl who comes to Europe in order to enlarge her experience but finds herself trapped into a loveless marriage to which, in the end, she adheres out of duty. Later, in *The Ambassadors* (1903) he paints another portrait of the New World invading the Old, this time identifying strongly with the central character of the narrative in a way whereby author and reader move forward together, in a voyage of exploration of a kind which was to anticipate a pattern for future novelists.

Henry James saw the novel as a work of art which is reflected in the precision and delicacy of his writing style. The prime end for him was self-discovery. That view was shared by another writer from abroad, Joseph Conrad. Never popular in his own lifetime, although admired by colleagues like James, Conrad believed that ' . . . fiction is history, human history, or it is nothing.' He saw his work as dedicated to truth and also as art: 'My task . . . is by the power of the written word to make you hear, to make you feel – it is above all to make you see.' An expatriate from Poland Conrad, who became a British subject, spent two decades at sea before settling in Kent in the late 1890s. For someone whose first language was not English his mastery of it is nothing short of astonishing. But the worlds he conjures up are far removed from the taste of the reading public during these insular decades. His travels across the globe made him keenly aware of other cultures and how they could be corrupted by the commercial pressures of Europe. *Heart of Darkness* (1902) is a devastating portrait of such an impact on the Congo. His greatest work, *Nostromo* (1904), deals with the same theme but the setting is South America. Again it is an indictment of imperialism or rather what transpired when it passed into the hands of the wrong sort of people and how, when that happened, things could slip badly out of control.

If James and Conrad saw the novel as art allied to self-discovery, H. G. Wells regarded it as a vehicle for public enlightenment. Conrad may have dealt with the evils of contemporary imperialism but Wells was alone in awakening the public to the potential consequences of ever-escalating technological innovation. Like Edward Elgar he was an outsider, a shopkeeper's son, an ambience he captured in *The History of Mr Polly* (1910). But it is his science fiction novels like *The War of the Worlds* (1898) which so graphically paint some of the prospects before humanity, seeing that the

struggle ahead for society was going to reside in coming to terms with the full implications of technology.

Other writers tackled other aspects of the contemporary scene. Gloom and failure are ever-recurrent themes. George Meredith urged man to quell his Darwinian instincts and achieve harmony by the exercise of common sense. George Gissing etched in the demoralising effects of poverty on everyone in his finest, strongly autobiographical novel, *New Grub Street* (1891). Samuel Butler similarly was to produce one masterpiece, *The Way of All Flesh* (1903, not published until after his death but written over the previous thirty years). This again was autobiographical, a bitter cry from the heart against everything Victorian society had foisted on people.

But in the golden Edwardian decade such outcries against the system would have been dismissed by what seemed an all-triumphant establishment. Far more to their taste was Rudyard Kipling, the most widely read and celebrated writer of the age. Here was the literary spokesman of the British imperial idea, a man who cast Britain as a new but more just and humane version of the Roman Empire. Although Kipling left India in 1889 that country was to remain central to a steady stream of books like *Kim* (1901) and the *Just So Stories* (1902). Later he was to move on and embrace that other icon, Old England, in hugely influential patriotic children's books, *Puck of Pook's Hill* (1906) and *Rewards and Fairies* (1910), in which he dealt with England and the moulding of English character through history.

Poetry was equally struggling to come to terms with the world of material science, attempting to restore some kind of meaning by utilising the musical suggestiveness of language. In this the poets were responding both to Impressionism and to the work of the French Symbolists, although English poets found it impossible to quite shake off the insular inheritance of the romantic tradition. A. E. Housman's *A Shropshire Lad* (1896) and Walter de la Mare's *The Listeners* (1912) mix the all-pervasive ruralism with manliness and patriotism of a kind taught by the public schools. Perhaps the most significant forward-looking event was the publication in 1918, the year in which the Great War ended, of the poems of Gerard Manley Hopkins. Written some of them as long ago as the 1870s, these have often been hailed as the harbinger of twentieth century poetry. Hopkins, unhappy and repressed, converted to Roman Catholicism and became a Jesuit. It was a sad life for someone endowed with such extraordinary poetic gifts. In one way his poems belong firmly to their own time, late Victorian romance stemming down from Keats via the Pre-Raphaelites. In another, thanks to his interest in philology, his poems read as precursors of much which we associate with modernism. A poet within the romantic tradition, his quest was to find the innermost, unique nature of whatever he studied. This he called the 'inscape'. In

these hymns to the beauties of the natural world there is also buried the tortured anguish of an age which had lost its faith, although in his case he strove to cling on to it:

> Glory be to God for dappled things . . .
> For skies of couple-colour as a brinded cow;
> For rose-moles all in stipple upon trout that swim;
> Fresh-firecoal chestnut-falls; finches' wings;
> Landscape plotted and pieced – fold, fallow, and plough;
> And all trades, their gear and tackle and trim . . .

One can easily understand how those who first read these poems in 1918, when modernism had already blazed its path, would have been astonished to realise that this poem was written as long ago as 1877.

These indeed are decades of contradiction. One is left wondering what would have happened if war had not come in 1914. Would the new directions which, as we shall see, accelerated so dramatically after 1910, have been accommodated within the existing scheme of things? It is an intriguing question. It is, however, undeniable that by the close of the first decade of the new century much of that old order had become ossified, a code and ritual gone through which at its heart was hollow. In the arts the realities of an ever-pressing new agenda were never being wholly confronted. Dramatic social change was already underway with the coming to office of the Liberals in 1906. The years that followed witnessed the final demise of aristocratic political power against a backcloth of industrial turmoil. The King Emperor Edward VII, the pleasure-loving embodiment of his own opulent age, died on 6 May 1910. Towards the end of that year the novelist Virginia Woolf noted in her diary: 'In or about December 1910 human character changed.' It is to a consideration of that change that we must now turn.

Chapter Thirty-Five

FRAGMENTATION

On 8 November 1910 the first exhibition of Post-Impressionist art opened in London. The pictures had been selected by the art critic Roger Fry. As a gesture to the style's forebear, Impressionism, it included eight canvases by Manet, but the main body of the work exhibited included twenty-one pictures by Cézanne, twenty-two by Van Gogh, thirty-six by Gauguin, not to mention others by the young Picasso and Matisse. Sensing that the audience's reaction might be less than welcoming Fry had prepared the ground carefully by enlisting a suitably impressive array of establishment names as an Honorary Committee, including members of the aristocracy and the then Director of the National Gallery. All of this, however, was to prove of no avail as the world of fashion flocked not to admire but to mock. The effect of the pictures was either to evoke laughter or rage, and not just from philistines but also from those who regarded themselves as visually sophisticated. The poet and diplomat Wilfrid Blunt wrote in his diary:

> '15th Nov. – To the Grafton Gallery to look at what are called Post-Impressionist pictures sent over from Paris. The exhibition is either an extremely bad joke or a swindle . . . The drawing is on the level of an untaught child of seven or eight years old, the sense of colour that of a tea-tray painter, the method that of a schoolboy who wipes his fingers on a slate after spitting on them . . . In all the 300 or 400 pictures there was not one worthy of attention even by its singularity, or appealing to any feeling but of disgust . . .'

Nothing could better sum up the cultural isolation into which England had drifted by the opening decade of the twentieth century. Anything foreign was viewed with a mixture of suspicion and contempt.

What sets the preceding four decades before the Great War apart is this quite extraordinarily arrogant cultural isolationism. While the empire progressively straddled the globe, Britain withdrew from political and cultural contact with other nations, the result being intellectual ossification as the nineteenth century drew to its close.

The trauma of the Great War captured in a single image: Stanley Spencer's The Resurrection of the Soldiers, *1928-29, in the Oratory of All Souls, Sandham Memorial Chapel, Burghclere, Berkshire.*

Elsewhere in Europe the foundations of twentieth century art and thought were being laid, but in this country Ibsen was banned by the censor, French literature of the kind written by Zola and Balzac was seen as depraved, the great Russian novelists remained untranslated, and no Impressionist paintings could be seen. All of this was to come under siege sharply in the years immediately preceding the outbreak of the Great War in 1914 as the full force of the movement known as modernism began to erupt on to the cultural scene.

Modernism was the greatest revolution in the arts since Romanticism. In its simplest terms it ushered in atonal music, free verse in poetry, and painting which no longer worked from the notion that a picture was a window. It was a sea change within European civilisation on the scale of the Renaissance or the mechanistic universe. It was also far more perplexing and even today scholars have not finally agreed as to its full significance. The further we move into the twentieth century, the more difficult it inevitably becomes not only to assess the significance of this or that movement in the arts but equally that of its exponents. In short, the jury is still out. From now onwards all that can be presented to the reader is a structure in which to move and place things, and even that becomes progressively more and more difficult to discern the closer we approach to the present day.

The four decades 1870 to 1910 which form the setting for the advent of modernism were ones of unparalleled change. The whole structure of the universe was questioned with the discovery in 1900 of the quantum theory of energy. In 1905 Einstein published his *Special Theory of Relativity*. Even more fundamental for the arts was the work of Sigmund Freud, *The Interpretation of Dreams* (1900) and *The Psychopathology of Everyday Life* (1901). The discovery that the mind had hidden layers which exerted an enormous impact on human conduct and that sleep and dreams enabled people to deal with unwelcome impulses when the rational powers were in abeyance had an untold effect on literature. In the case of Surrealism it resulted in a whole movement in art. During this period also genetics established itself as a field of study, radioactivity and X-rays were discovered and, in 1911, came the atom. Simultaneously all those things we now take for granted as essential to modern living came into being, or became more widely available in an era of burgeoning consumerism: the telephone, cars, typewriters, aeroplanes, synthetics, the modern office and, a little later, radio. What no one could have foreseen prior to 1914 was that this explosion in technological advance would radically change the nature of warfare from being a distant event fought by a regular army into a killing machine, which was to wipe out the educated men of the middle and upper classes who were conscripted to serve in it.

At the same time the supremacy of scientific method came under fire and there

was a renewed interest in the occult, the irrational, and other cultures and religions. By 1900 there was anyway an urgent need for a new mythological repertory to replace or amplify the centuries-old classical and Christian ones. That was provided for partly by Freud's revelations about the human subconscious but partly also by anthropology. The twelve volumes of J. G. Frazer's *The Golden Bough* (1890–1915) were to provide the creative with a coherent mythic core to what at first glance seemed only a morass of disparate material from many primitive cultures and religions.

The result of all this was that human nature was now seen to be indeterminate, elusive, contradictory and multiple. Whereas in the nineteenth century society at large was the custodian of universally recognised human values, primacy now shifted to the individual. Human nature being recast as many-faceted, there was no longer any such thing as absolute truth or universal norms for society as a whole. This was a dramatic shift from collective to individual values. Artists, poets and writers did not see the world as their predecessors had done as a series of recognisable laws and abstract universal principles which it was their duty to share, but saw it as a complex of relationships individual to them and of which their own perception was the co-ordinator. The consequence for the arts was a bewildering diversity of treatment and theme on a scale unimaginable before.

In this sense modernism set the artist free, but the outcome was aesthetic turbulence, disruption, and a belief that western civilisation was in the throes of some kind of apocalypse, a view only strengthened by the horror of the Great War during which some of modernism's most revolutionary works were produced. The creed of modernism worked from a repudiation of the past which was at best regarded with irreverence. It revelled in challenges, being punctuated by a never-ending series of manifestos demanding social, political and artistic revolution. This ferment of ideas did indeed throw up a dazzling series of movements: Impressionism, Post-Impressionism, Fauvism, Cubism, Futurism, Vorticism, Dadaism, Expressionism and Surrealism. All of them came and went, their innovations often quickly a spent force, matching in a way the obsolescence of twentieth century consumer products as one year's model gives place to the next.

This was a revolution in human consciousness which also affected both social behaviour and attitude. Under the influence of the German philosopher Nietzsche, the era was cast as one in which all human values had also to be rethought and traditional morality of the kind rooted in Christianity was to be jettisoned. What makes it so difficult to comprehend even now is the fact that this wholesale demolition of the past and passion for everything new produced nothing coherent to replace it. We enter a century dedicated to Babel and fragmentation. The only discernible factor that

all the new movements share in common is that work was no longer ordered in sequence of time or history or even evolution. Instead it was conceived spatially or as moving through layers of consciousness towards a logic of metaphor or form.

In the case of England the reception of this eruption was to range from ambiguous to hostile. London, a world city, with its six and a half million inhabitants and its cosmopolitanism, should have been modernism's natural forcing-ground for what was essentially an urban movement, but that never really happened. In its initial phases the climate was hospitable, but this was gradually to shift. Those involved in the arts were only too acutely aware of the break. Virginia Woolf had placed it in 1910. Five years later the novelist D. H. Lawrence was to write: 'It was in 1915 the old world ended.' Writing still later in 1933 the art critic Herbert Read saw the movement with an absolute clarity: 'It is not so much a revolution, which implies a turning over, even a turning back, but rather a break-up, a devolution – some would say a dissolution. Its character is catastrophic.' What is so striking in the case of England is how many of modernism's pioneers and exponents were not indigenous but exiles, American, French, Danish, Russian and Polish, from Henry James to Joseph Conrad, from T. S. Eliot to Wyndham Lewis, from Jacob Epstein to Henri Gaudier-Brzeska, from Serge Chermayeff to Ove Arup. It is hardly surprising therefore that one always senses an underlying unease about modernism as though it posed a threat from without to what had come together as an established and immutable native culture.

That attitude was exacerbated by two world wars with Germany running from 1914 to 1918 and again from 1939 to 1945. Both fuelled insularity and distrust of foreign culture. The years between the wars saw an equally determined attempt to politically disengage until the rise of fascism in the thirties forced a reversal. Of the two wars the impact of the first was to far exceed that of the second. In the instance of the former a country whose civilisation seemed divinely guided was suddenly shattered, and a century of peace and prosperity was violently and abruptly brought to an end. Few people in 1914 could even remember war and, worse, it was of a kind that had no precedent, a factory for killing. In effect it wiped out a generation, including those who might have flowered in the arts. The sense of apocalypse that it engendered made it one of history's great

Max Beerbohm's caricature of two pillars of Bloomsbury, Roger Fry and Clive Bell, entitled Significant Form.

was a renewed interest in the occult, the irrational, and other cultures and religions. By 1900 there was anyway an urgent need for a new mythological repertory to replace or amplify the centuries-old classical and Christian ones. That was provided for partly by Freud's revelations about the human subconscious but partly also by anthropology. The twelve volumes of J. G. Frazer's *The Golden Bough* (1890–1915) were to provide the creative with a coherent mythic core to what at first glance seemed only a morass of disparate material from many primitive cultures and religions.

The result of all this was that human nature was now seen to be indeterminate, elusive, contradictory and multiple. Whereas in the nineteenth century society at large was the custodian of universally recognised human values, primacy now shifted to the individual. Human nature being recast as many-faceted, there was no longer any such thing as absolute truth or universal norms for society as a whole. This was a dramatic shift from collective to individual values. Artists, poets and writers did not see the world as their predecessors had done as a series of recognisable laws and abstract universal principles which it was their duty to share, but saw it as a complex of relationships individual to them and of which their own perception was the co-ordinator. The consequence for the arts was a bewildering diversity of treatment and theme on a scale unimaginable before.

In this sense modernism set the artist free, but the outcome was aesthetic turbulence, disruption, and a belief that western civilisation was in the throes of some kind of apocalypse, a view only strengthened by the horror of the Great War during which some of modernism's most revolutionary works were produced. The creed of modernism worked from a repudiation of the past which was at best regarded with irreverence. It revelled in challenges, being punctuated by a never-ending series of manifestos demanding social, political and artistic revolution. This ferment of ideas did indeed throw up a dazzling series of movements: Impressionism, Post-Impressionism, Fauvism, Cubism, Futurism, Vorticism, Dadaism, Expressionism and Surrealism. All of them came and went, their innovations often quickly a spent force, matching in a way the obsolescence of twentieth century consumer products as one year's model gives place to the next.

This was a revolution in human consciousness which also affected both social behaviour and attitude. Under the influence of the German philosopher Nietzsche, the era was cast as one in which all human values had also to be rethought and traditional morality of the kind rooted in Christianity was to be jettisoned. What makes it so difficult to comprehend even now is the fact that this wholesale demolition of the past and passion for everything new produced nothing coherent to replace it. We enter a century dedicated to Babel and fragmentation. The only discernible factor that

all the new movements share in common is that work was no longer ordered in sequence of time or history or even evolution. Instead it was conceived spatially or as moving through layers of consciousness towards a logic of metaphor or form.

In the case of England the reception of this eruption was to range from ambiguous to hostile. London, a world city, with its six and a half million inhabitants and its cosmopolitanism, should have been modernism's natural forcing-ground for what was essentially an urban movement, but that never really happened. In its initial phases the climate was hospitable, but this was gradually to shift. Those involved in the arts were only too acutely aware of the break. Virginia Woolf had placed it in 1910. Five years later the novelist D. H. Lawrence was to write: 'It was in 1915 the old world ended.' Writing still later in 1933 the art critic Herbert Read saw the movement with an absolute clarity: 'It is not so much a revolution, which implies a turning over, even a turning back, but rather a break-up, a devolution – some would say a dissolution. Its character is catastrophic.' What is so striking in the case of England is how many of modernism's pioneers and exponents were not indigenous but exiles, American, French, Danish, Russian and Polish, from Henry James to Joseph Conrad, from T. S. Eliot to Wyndham Lewis, from Jacob Epstein to Henri Gaudier-Brzeska, from Serge Chermayeff to Ove Arup. It is hardly surprising therefore that one always senses an underlying unease about modernism as though it posed a threat from without to what had come together as an established and immutable native culture.

That attitude was exacerbated by two world wars with Germany running from 1914 to 1918 and again from 1939 to 1945. Both fuelled insularity and distrust of foreign culture. The years between the wars saw an equally determined attempt to politically disengage until the rise of fascism in the thirties forced a reversal. Of the two wars the impact of the first was to far exceed that of the second. In the instance of the former a country whose civilisation seemed divinely guided was suddenly shattered, and a century of peace and prosperity was violently and abruptly brought to an end. Few people in 1914 could even remember war and, worse, it was of a kind that had no precedent, a factory for killing. In effect it wiped out a generation, including those who might have flowered in the arts. The sense of apocalypse that it engendered made it one of history's great

Max Beerbohm's caricature of two pillars of Bloomsbury, Roger Fry and Clive Bell, entitled Significant Form.

divides. Nothing was the same after it, and the initial reaction was to deride the world that had gone before as a sham and a failure.

The three decades following 1910 are ones of industrial turmoil and class confrontation on such a scale that it is surprising that revolution did not actually take place. After 1918 it was clear that further concessions to democracy would have to be made, the vote being given to men at twenty-one and women at thirty. Secondary education for everyone until the age of fourteen was introduced, with some limited provision for access to higher education for the brightest by way of scholarships. However no sooner was the war over than depression set in and wages began to spiral downwards. The defeat of the General Strike in 1926, hard though it was for the working classes, meant that parliamentary democracy survived. Elsewhere in Europe it began to go under.

The twenties were years of doubt and anxiety, with a keen sense of an order in dissolution. For the first time the governing classes lost their nerve and failed to lead. The power of the old landed classes was finally extinguished and the long sale and demolition of country houses began its ever-upward curve until it reached a climax in the 1950s. Those who prospered were the *nouveaux riches* and what continued to be an expanding white collar middle class. Less attractive was the cynical gaiety and wit of the fast set bent on pleasure and the abandonment of sexual taboos, ignoring the poverty and ever-rising unemployment around them.

The thirties were as uneasy. The Wall Street stock market crash in 1929 ushered in worse depression, and by 1931 there were three and half million unemployed. In Europe fascism reared its head and grew stronger as Hitler came to power in Germany, Mussolini in Italy and Franco in Spain. The impact of the depression on the arts was disastrous, leaving, for example, architects devoid of work. Fascism and unemployment drove the artistic community ever leftwards as they saw what they believed to be an ideal society emerge in communist Russia. New left wing journals like *The Left Review* and the *New Statesman* sprang up, and artists and writers departed for Spain to join the struggle against fascism. Dictatorship spelt death for modernism. In Germany the Expressionism of the Weimar Republic was destroyed. In Russia Stalin obliterated the aesthetic innovation of the twenties and inaugurated a reign of realism.

Modernist exiles found refuge in England as the storm clouds gathered but what they found was a political rather than an aesthetic haven. The cult of pre-industrial pastoral England, already an *idée fixe* before 1910, was only to be accelerated by the Great War which spread it across the social classes. After the war it became a leitmotif of national identity, the Conservative prime minister Stanley Baldwin declaring: 'England is the country and the country is England.' The crisis of 1940 reinforced yet again the ruralism which marked the between-the-wars decades in the form of a steady stream of books devoted to every aspect of it, from old villages and towns to castles and cathedrals. What was more Old England could now be reached by an ever-expanding public transport system and private ownership of cars.

The foundations of the emergence of a heritage cult which was to reach an apogee in the seventies and eighties were firmly being laid. One index of this was the shift in attitude to the country house, seen in the twenties as expendable but by the thirties as a precious heritage which had to be preserved. Once symbols of grinding social inequality, as soon as they ceased to be powerhouses they were released to take on their role as almost mystical emblems of the nation's cultural achievement. By 1945 the novelist Evelyn Waugh could define them in *Brideshead Revisited* as 'our chief national artistic achievement . . .'

This transmutation was to become typical of the century as the artefacts of the nation's artistic past began in people's minds to replace the repertory of religion. Unlike the Reformation this was not a violent rupture of the past but a slow and progressive erosion. The decline in religious attendance was steady in the twenties, more rapid during the following decade and only catastrophic after 1960. The long-term effect was inevitably to erase from the population's minds the context which had framed a large majority of what had been created over the centuries, not only in terms of buildings and works of art but also literature. At the same time a firm grounding in the classics ceased to be the norm in education so that knowledge of the classical tradition was simultaneously being eroded. In this we see the breakdown of the cultural core of the nation as it had been put together during the late sixteenth and seventeenth centuries, embodied in a humanist programme of education and certain works in the vernacular like Spenser's *Faerie Queene*, Milton's *Paradise Lost*, the plays of Shakespeare, and, above all, the Authorised Version of the Bible and the Book of Common Prayer. These had all been seen as essential icons of a common culture shared across the social spectrum, but as the century wore on some were to be dethroned, all radically marginalised.

Everywhere during these decades there was fragmentation as the classes which in the past had led taste were no longer in a financial position to do so. The State as yet saw no role for itself in the arts. As a result there was no consensus, no coming to terms with modernism, which was either ignored or ridiculed. Its case was not aided by what was seen to be an absence of any sense of social responsibility, which the arts of the Victorian period had certainly not lacked. Only towards the close of the thirties was there a shift as modernism and socialism drew together in what was to prove to be an influential alliance aimed at ushering in the new Utopia.

The reaction of those actually within the arts was variable. Some embraced modernism with fervour in an attempt to deconstruct the old world. Others looked back, trying to do the exact opposite and reconstruct the past as a means of reviving liberal values. Yet a third group drifted towards escape and withdrawal, creating for themselves private worlds. The leaders of the first group, the modernists, were two Americans, Ezra Pound and T. S. Eliot. Pound in the end left England but Eliot stayed. Their attitude was summed up by Pound in his *Hugh Selwyn Mauberley* (1920):

There died a myriad,
And of the best, among them,
For an old bitch gone in the teeth,
For a botched civilisation.

Charm, smiling at the good mouth,
Quick eyes gone under the earth's lid,

For two gross of broken statues,
For a few thousand books.

In the case of those who withdrew, escape could take many forms, varying from the triviality of the unchanging rectories and country houses of Agatha Christie's crime stories to the decadent exotic fantasies of Ronald Firbank or the weird inward family feuds delineated by Ivy Compton-Burnett. Painters pursued parallel paths of private reverie.

This was an era also of collectives, like the Neo-Pagans who included amongst their number the handsome poet Rupert Brooke, or that which centred on D. H. Lawrence in Nottinghamshire. Then there was the Sitwell family clan of Osbert, Edith and Sacheverell who deliberately set out to shock in the twenties but who essentially belonged to the vanished aristocratic world before 1914. All such groups were devoted to the cause of literature and art and equally to a new-found freedom in sexual relationships. And each in its own way is evidence of this fragmentation of culture which rendered it in the old pre-1914 sense impossible to maintain. Of all these groups, however, that which eclipsed the rest was composed of those whose adherence found its identity after a particular area of north London, Bloomsbury.

The Bloomsbury Group had its roots in Cambridge at the turn of the century in a group of brilliant young men: Lytton Strachey, Leonard Woolf, Clive Bell and Thoby, the son of Sir Leslie Stephen, whose house and daughters, Virginia and Vanessa, were in Bloomsbury. They were middle class and belonged to a generation which still sought to cling on to the moral framework of Christianity but discarded its doctrine, dogma and ritual. The Cambridge philosopher G. E. Moore's rejection of what he categorised as the old-fashioned virtues of self-sacrifice and personal heroism in favour of the contemplation of beauty, truth and love was to become central to their thinking. In such an intellectual framework conventional attitudes and morals had no place, nor did traditional wisdom. Within the Group women were given an equal footing with men and homosexuality was openly accepted. With the adoption of such a credo it is hardly surprising that members of the Bloomsbury Group were viewed at the time as socially beyond the pale and since have attained the status of sacred totems of late twentieth century feminism and sexual liberation.

The Group was gradually to widen its membership. Leonard Woolf married Virginia Stephen and Clive Bell her sister Vanessa. By the 1920s it had expanded to form a closed intellectual and artistic network drawing in Roger Fry, Desmond MacCarthy,

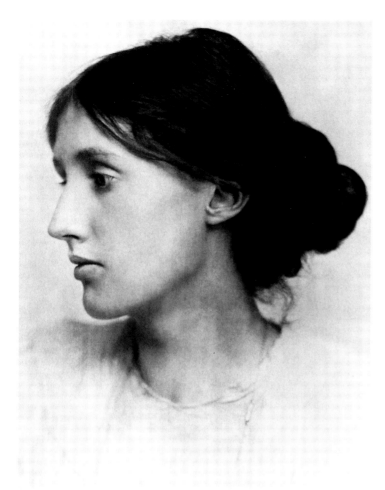

Bloomsbury icon: Virginia Woolf, 1907.

Duncan Grant and E. M. Forster. Together they deliberately set out to demolish Victorian culture, a campaign achieved in virtually one book, Lytton Strachey's notorious *Eminent Victorians* (1918). Hard-headed, critical and dispassionate, Bloomsbury was in a way a return to the élite sceptical circles of the Enlightenment. They fervently believed that it was their role to lead, albeit propped up by servants, and that those below should support their artistic and intellectual endeavours. They were inevitably widely disliked not only by the establishment but more surprisingly by many other intellectuals, for whom the novelist D. H. Lawrence might be said to speak when he wrote: 'There is never, for one second, any outgoing of feeling, and no reverence, not a crumb.' Although the Group's overt pacifism could be contained within the context of the First World War it was unsustainable in the face of the rise of fascism, so that by 1939 the Bloomsbury Group was a spent force, although it has continued to exert a fascination ever since.

Privileged and financially independent, this rarefied clique was poles away from the opposite end of the cultural spectrum, for it was during these decades that a mass culture emerged. For the most part this was consumer-led, appealing to the lowest common denominator. The war had killed off any nascent British film industry and Hollywood took over. The music hall withered as the working classes succumbed to the products of the dream machine, first silent and then talking. Popular music, including the introduction of jazz, in the main was also an American import. In the home the piano was gradually replaced by the gramophone and the radio. The latter was the first medium, apart from printed matter, capable of reaching everyone. From the outset in 1922 the British Broadcasting Corporation (BBC) posed a moral dilemma for government which

The advent of radio. Ekco radio cabinet in bakelite designed by Wells Coates, 1932.

granted it a charter in 1927 and which took the view that this State-sponsored organisation should set out to educate. In a situation where the public is largely given what those in control think is good for it there are no winners as the subsequent history of the BBC has proved. Already in 1925 there were two million licence holders. Much of the air time initially was given over to dance music, but there were the beginnings of radio drama and the impact in the field of classical music was to be remarkable. No one could argue any more that great music and theatre were accessible only to the élite. But they could argue that the arts, which in previous centuries had been the peculiar expression of a narrow group in society, were somehow being imposed from on high as part of a new popular mass culture. The BBC, with its dissemination of what was later to be labelled high culture, anticipated what was to happen after the Second World War with the creation of the Arts Council. What cannot be denied is that from the start it set high standards and aimed to lift public taste.

So these are confusing and contradictory decades in the history of the arts in Britain. Nonetheless there are a few threads which if clung to act as guides through the maze. One is the advent of full democracy by 1928 and the seeds of the belief by the governing classes that what had hitherto been the preserve of the few should now be made available to the many. The irony is that democracy coincided with an era in the arts of an inaccessibility paralleled only by the most arcane expressions of the Renaissance. Modernism might proclaim from the rooftops its desire to respond to a technological and democratic age but its art remained firmly incomprehensible to

the masses it set out to release. In virtually every field the same story is re-enacted, a revulsion from the new and the continuing deep appeal of the traditional, fuelled in England by insularity and pastoralism.

In the case of poetry the arrival of modernism was akin to the end of the Ancient World or the advent of Romanticism. Up until the present century poetry had largely been either drama or heroic narrative. It was first and foremost seen as a shared public experience, the collective expression of a single culture, a nation or a ruling class. All that began to change in the nineteenth century when the novel took over heroic narrative. This left the poet free to develop the lyric as his archetype, a restricted and exquisite form which could as equally be an intimate communication or non-communication. T. S. Eliot was to define the lyric as the voice of the poet speaking to himself or nobody. To that we can add the need felt by poets for a new language, one which could adequately reflect the new technological century. The results of this quest still retain the power to shock and bewilder the reader.

In this thought context the very process of writing was to become the object of poetry, a triumph of form over content, so that words could be chosen, for example, just because they happened to form a pattern on the page. The problem was that this revolt against Victorian versification led to a breakdown in the old poetic consciousness and also in linguistic coherence. In 1954 T. S. Eliot, viewing what had happened in retrospect, wrote: 'I do not see how anyone can doubt that modern poetry is a greater novelty than any other "new poetry" but new in a new way, almost in a new dimension.'

The change was already under way before 1914 in the work of the American poet Ezra Pound who arrived here in 1908. Fiercely anti-bourgeois and anti-establishment, his aim was to 'break the pentameter', to counter sloppy diction and emancipate verse from too much emotion: 'Objective – no slither; direct – no excessive use of adjectives; no metaphors that won't permit examination . . . straight as the Greek!' This was the free verse movement known as Imagism, the image being content conceived as form, concise, hard, drawing on the stridency of everyday speech. This is poetry based on the theory that less is more, as evidenced by Pound's two-line poem 'In a Station of the Metro'.

> The apparition of these faces in the crowd;
> Petals on a wet, bleak bough.

Pound was to leave England but his influence was enormous, particularly as the champion of T. S. Eliot and the editor of Eliot's poem *The Waste Land* (1922).

As a consequence of modernism poetry was to undergo a gigantic decline in pop-

ularity, since few readers could understand it. The transition can be caught in the flood of poetry engendered by the First World War. As the full apocalyptic horror of this unfolded the pastoral inheritance of the Georgians became more and more inadequate, as Keatsian images of sensuousness were utilised to depict mutilation or the conventions of romantic love poetry were transmitted into sacrificial eroticism:

> Are limbs so dear-achieved, are sides
> Full nerved – still warm – too hard to stir?
> Was it for this the clay grew tall?
> – O what made fatuous sunbeams toil
> To break earth's sleep at all?

Wilfred Owen's 'Futility' is evidence that Georgian poetry was still flexible and resilient enough to cope with the war but the sense of strain is there in his poetry and in that of other war poets such as Edward Thomas, Isaac Rosenberg, Siegfried Sassoon and David Jones.

After 1918 poetry was to be dominated by three great figures, W. B. Yeats, T. S. Eliot and W. H. Auden, although some would add a fourth, D. H. Lawrence. Auden was to leave England in the middle of the thirties and eventually take American citizenship, Yeats was Irish and Eliot American. These are all signs that English literature (Ireland was to gain its independence in the twenties) was fast transforming itself into literature in English, the boundaries of the island becoming increasingly irrelevant as what had been a literary language indigenous to it was taken over to serve other nations and cultures, often those which had once been part of its empire. This explosion of the English language across the globe was to be both a gain and a loss, a gain in the sense that Britain's great literary inheritance was to become more global than that of any other European language, a loss in the sense that the island was to lose its hold on its own vernacular.

W. B. Yeats was in England during the 1890s when he was a leading member of the Rhymers' Club whose members responded to the work of the French Symbolists. Dedicated to the cause of Irish nationalism he left a vast corpus of work revealing an intense interest in the occult. Like Eliot he was keenly aware that the reception of modernism (he met and was affected by Pound) bore with it a responsibility not to jettison the inherited poetic tradition. His greatest poems like *The Wild Swans at Coole* (1919) and *The Tower* (1920) lie at the heart of what was an attempt to create an Irish literary tradition. Perhaps no other poet in English captures so vividly the modernist preoccupation with crisis and apocalypse. *The Second Coming* (1919) was written one year after the conclusion of the war:

Surely some revelation is at hand;
Surely the Second Coming is at hand.
The Second Coming! Hardly are those words out
When a vast image out of *Spiritus Mundi*
Troubles my sight: somewhere in the sands of the desert
A shape with lion body and the head of a man,
A gaze blank and pitiless as the sun,
Is moving its slow thighs, while all about it
Reel shadows of the indignant desert birds.

T. S. Eliot was born in St. Louis in 1888 of an old American family. He came to Oxford via Paris in 1914. His early poetry too was influenced by the French Symbolists but also by the Jacobean metaphysical poets and dramatists. His landmark is *The Waste Land* (1922), which is universally acclaimed as the central poem of the entire twentieth century, an arrangement of images, whose meaning is often obscure and whose references are worldwide and multicultural, owing much to Frazer's *The Golden Bough*. Its resonances and complexities are such that it is difficult to extrapolate even a few lines:

April is the cruellest month, breeding
Lilacs out of the dead land, mixing
Memory and desire, stirring
Dull roots with spring rain.

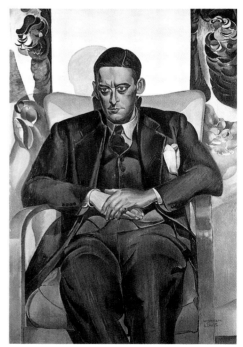

These almost casual opening lines to *The Burial of the Dead* give little hint as to the intricate ramifications that permeate his text. Eliot's poetry is one of modernist aesthetic impersonality: 'Poetry is not the turning loose of emotion, but an escape from emotion; it is not the expression of personality, but an escape from personality.'

Eliot was to become an Anglo-Catholic and be naturalised in 1927. He edited an influential right wing journal throughout the twenties and thirties, reviving, during the latter decade, drama in verse, writing a series of plays of which the most memorable was *Murder in the Cathedral* (1935). During the same period and into the opening years of the Second World War he wrote his great sequence of poems, *The Four Quartets* (1935–42),

Wyndham Lewis's portrait of T. S. Eliot, 1938.

which are haunted by a sense of loss and renewal and by a search for intimations of the infinite and the eternal. Perhaps Eliot summed himself up best in 1938: 'Classicist in literature, royalist in politics, and Anglo-Catholic in religion.'

The thirties were very different years for poets, the drift of political events pulling them back from the pursuit of obscurity to a mode of writing more easily understood. This is the era of writers who were deeply politically committed, men of the left, W. H. Auden, Stephen Spender and Louis MacNeice. Auden emigrated to the USA in 1934, returning only spasmodically to Britain when he was elected professor of poetry at Oxford in 1956. His early poems shocked and at the same time domesticated modernism. His contempt was bitter for the establishment and for the parochialism of the island as heads were hidden in the sand rather than face the approaching conflict. *A Summer Night* 1933 describes the ascent of the moon in a garden:

> To gravity attentive, she
> Can notice nothing here, though we
> Whom hunger does not move,
> Keep gardens where we feel secure
> Look up and with a sigh endure
> The tyrannies of love:
> And gentle, do not care to know
> Where Poland draws her eastern bow,
> What violence is done
> Nor ask what doubtful act allows
> Our freedom in this English house,
> Our picnics in the sun.

In sharp contrast to the poets, modernism was not to be such a dislocation to the novel, nor did it precipitate such a dramatic fall in readership, although it did emphasise the increasing divide between the medium in its high art as against its middle-brow popular form. Those who took up modernism consciously committed themselves to literature as an expression of high art dedicated to experiment and innovation. Their quest was summed up by Virginia Woolf '. . . There is no limit to the horizon, and . . . nothing – "no methods", no experiment, even of the wildest – is forbidden, but only falsity and pretence. "The proper stuff of fiction" does

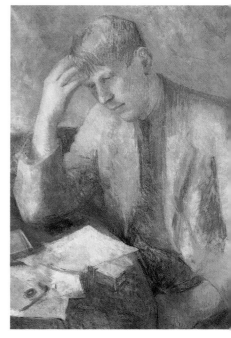

William Coldstream's portrait of W. H. Auden, c. 1938.

not exist; everything is the proper stuff of fiction, every feeling, every thought; every quality of brain and spirit is drawn upon; no perception comes amiss.'

The result of this was that modern writing was suddenly able to open up layers never before exposed. Narrative art was released from the burden of plot to explore inward states of consciousness, the nihilistic disorder behind what was the ordered surface of life. That change was already well under way in the work of Henry James and Joseph Conrad who recast the author or narrator's role as one of perceiving events through their own consciousness. By 1912 Freud's work began to be known in England and that gave novelists a whole new uncharted realm so that henceforth a novel's action could take place as much in someone's mind and imagination as it could through any outward physical act. The narrator too could turn out to be unreliable, chronology could be abandoned and incidents could be presented from a multiple viewpoint like a Cubist painting. Typecast characters, typical of the Victorian novel, gave way to ones who were contradictory and lacked coherence. Writers were equally released from maintaining or propagating any collective social ideals so that they could pursue instead whatever obsessed them. In the long run it was to lead to plotless novels and plays in which seemingly nothing at all would happen.

It is arguable whether the Irishman James Joyce should figure in a history of the arts in Britain or not as he never lived here and left his native Dublin for a life on the continent. What cannot be challenged is a place parallel to that of Eliot in poetry, for his novel *Ulysses* (1922) is accepted as the most prestigious fictional text in any modern language. Along with *The Waste Land* it is one of the classics of experimental modernism, an epic in which the events of a single day in the life of three characters in Dublin are cast into the mythic terms of the *Odyssey*. Joyce sets out to colonise hitherto unclaimed and often squalid parts of the human psyche, probing into the depths of his hero's thoughts, sensations and behaviour, recording everything and explaining nothing. In what is an unending stream of consciousness, projection and perception jostle side by side with the forces of memory and external stimulus. *Ulysses*, along with Joyce's other works, has earned him a place as a saint of modernism and a major influence not only on his contemporaries but on all those who followed.

D. H. Lawrence belongs to an earlier phase of modernism, avoiding as he did experiments with time and presentation. The son of a Nottinghamshire miner, Lawrence made his way up from a working class base, explaining his life-long commitment to the notion of meritocracy and also his ability to depict accurately a wide spectrum of English society including its lower reaches. It has been argued that his poetry should rank alongside that of Yeats and Eliot, but it is upon his innovatory novels that his fame rests, in particular *The Rainbow* (1915) and its sequel *Women in*

Love (1921), in which he found a new way of treating human personality. Crossing the social divide himself, Lawrence was fascinated by the interface between the classes, depicting a secure middle class world with its set values and code of behaviour and the conflicts caused by the incursion into it of types like gypsies, miners and gamekeepers, who made no effort to suppress their primal instincts.

Clashes of disparate worlds dominate the novels of E. M. Forster, albeit of a different kind. *Howards End* (1910) traces the confrontation between the sphere of business and that of refined culture and emotion, a parable for its age, the representatives of either strand in the end marrying and inheriting a country house symbolic of the continuity of English life. *A Passage to India* (1924) widens the panorama in a great novel which sets out to depict what happens when two cultures face each other.

Virginia Woolf's novels follow those of Joyce in exploring human consciousness: 'Life is a luminous halo, a semi-transparent envelope surrounding us from the beginning of consciousness to the end.' Masterpieces like *Mrs Dalloway* (1925) and *The Waves* (1931) take apart the ordinary perceptions of reality in prose which is an amalgam of speech and thought. Her novels move like a film camera through close-up and tracking shots to sudden cuts and flashbacks, exterior events forever triggering off the inner life. Her advocacy of the feminist cause and the fact that she drowned herself in 1941 have turned her into a late twentieth century icon.

The Great War certainly emerges in literary terms as the breaking point which somehow released a torrent of innovatory writing. It ranges from the tragi-comic satires of Aldous Huxley and Evelyn Waugh, in which society is seen as absurd and meaningless, to the more socially committed authors of the thirties like Christopher Isherwood and George Orwell, the latter setting out to capture life among the down-and-out and moving on to his indictments of dictatorships, *Animal Farm* (1945) and *Nineteen Eighty-Four* (1949).

It was an era too in which gentlemen publishers held sway over eponymous publishing houses such as Jonathan Cape, Victor Gollancz and Hamish Hamilton. But one publisher was to effect a sea change in the reading habits of the British public, Allen Lane, who issued at sixpence each the first ten paperback Penguin Books in July 1935. Previous attempts to publish cheap reprints had concentrated mainly on the classics but Lane included the works of popular modern writers as well, thus paving the way for the paperback explosion of the future.

If modernism in literature produced a crop of landmarks, in the case of theatre the result was utter failure. The war precipitated not masterpieces of drama but a demand for light entertainment and escapism. The effect of the war on theatre itself was as cataclysmic as the closing of the theatres had been in 1642. The great revival

of drama which had been such a feature of the years before 1914 ceased. In addition, apart from Birmingham and Liverpool, the repertory companies folded. Worse, the actor-managers went under, leaving the impoverished Old Vic, under the aegis of the redoubtable Lilian Baylis, alone continuing to mount productions of Shakespeare. After the war the situation was no better. The theatre was dominated by commercial managements whose sole objective was to extract maximum profits from the theatres under their control. Cinema had killed off the stage spectacular and took away also any popular audience. What was left was a smaller and more sophisticated one which, as in the 1880s and 90s, saw themselves on stage, albeit endowed with glamour and wit, in the plays of Noël Coward and Terence Rattigan. Theatre owners wanted plays with one box set if possible and a few lowly paid actors to prop up a star who would draw an audience. As a result, theatre saw the confrontation of staff and management along the lines of that affecting industry, and both actors and stage workers became unionised in 1919.

All of this has to be placed into the context of the rest of Europe where a revolution was taking place in theatre, particularly in Germany and Russia. Scenery in the Expressionist, Surrealist or Constructivist manner was unheard of in England. What percolated through of modernism was a mere trickle and even that took place at the smaller theatres like the one at Barnes where, in 1926, the great Russian director Komisarjevsky directed Chekhov and Gogol, or Nigel Playfair's productions at the Lyric, Hammersmith, such as *The Beggar's Opera* (1920) with its elegant, sparse designs by Claud Lovat Fraser.

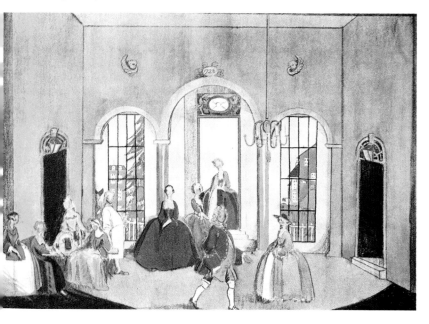

The advent of the permanent set. Design by Claud Lovat Fraser for Gay's The Beggar's Opera *at the Lyric, Hammersmith, 1920.*

This was a dead era for the stage although change was beginning to be in the air in the thirties when a dazzling younger generation of actors came of age and were to dominate the profession for the rest of the century: John Gielgud, Laurence Olivier, Ralph Richardson, Edith Evans and Peggy Ashcroft. The first two epitomised opposing acting roles, Gielgud lyrical and sensitive and a master of verse speaking, Olivier urgent and virile with heroic delivery. Ensemble playing was pioneered by Tyrone Guthrie at the Old Vic and by Gielgud too in his role as director in a whole series of famous productions including *Hamlet* (1934 and 1939) and *The Importance of Being Earnest* (1939). South of the river Lilian Baylis continued not only to keep Shakespeare on the stage but also to lay the foundations of what, after 1945, were to become English National Opera and the Royal Ballet.

It was the visits of the Diaghilev company that sparked off the rapid advance of ballet. These had begun in 1911 when the Russian company took London by storm with its legendary dancers and spectacular productions. The visits continued, culminating in Tchaikovsky and Petipa's *The Sleeping Princess* at the Alhambra in 1921. In 1931 Marie Rambert, who had worked with Diaghilev, founded the Ballet Club, the ancestor of Ballet Rambert. At the same time, Lilian Baylis entrusted another dancer who had worked with the impresario, Ninette de Valois, with the task of building a ballet company. Rambert and de Valois between them assembled a group with talent equal to that of the actors, but this time it was made up of dancers and choreographers: Frederick Ashton, Anton Dolin, Robert Helpmann and Margot Fonteyn. In their case full fruition was to come even more after 1945 but already there was the firm intent by those involved to establish what was a recognisably English style. De Valois's *Job* (1931) with its mysterious music by Vaughan Williams and Ashton's witty *Façade* (1931) using Walton's score meant that by 1939 that objective had been achieved.

Ballet had the great advantage of starting from a *tabula rasa*, a new branch springing from the mighty tree of the old Russian imperial ballet. Somehow it was able to fuse English pastoralism with modernism. Part of that effort to make an English tradition certainly influenced de Valois's decision to choreograph Ralph Vaughan Williams's *Job* as a 'masque for dancing'. With that composer, who was taught by Parry and Stanford, we witness the continuance of the quest for Englishness which was to be the essence of the musical renaissance. Vaughan Williams's music is deeply rooted in folk-song, which he believed 'for generations voiced the spiritual longings of our race,' and also the music of the Tudors, of Henry Purcell and the English Hymnal. The debt to early music is evident in his first great masterpiece, *A Fantasia on a theme by Thomas Tallis* (1910). Atonal modernism made no inroad on his work, his belief being

that a composer should be national first and international second. He was to be prolific, composing a whole series of symphonies and film music, including his *Symphony No 4 in F minor* (1935), heard now as a premonition of the terrible world war to come.

Where Vaughan Williams was visionary his friend Gustav Holst was mystic. Holst reacted to the incessant cry of the twenties for novelty and responded with his suite *The Planets* (composed 1914–16) and *The Hymn of Jesus* (performed 1920). The inspiration of folk music was also central to him, as indeed it was to a whole series of other composers of the period, such as John Ireland, Frank Bridge and Roger Quilter. The pastoral poems of Hardy and Housman provided another rich source of inspiration for these composers. Although Elgar fell from grace abruptly after 1918 it is surprising how his presence remained as a strong undercurrent. Arthur Bliss, who had gained a reputation for being an *enfant terrible* in the twenties, had returned by the following decade to the Elgarian manner. The same can equally be said of a far more important figure, William Walton.

Walton, the son of an organist, sprang from the lower middle classes. He won a choral scholarship to Oxford and was rescued, if that is the word, by Sacheverell Sitwell and adopted into his family as their secret musical weapon for challenging Elgar. There was no question, therefore, that their protégé should be exposed to the Royal Academy of Music for fear of being tainted. What they rightly perceived was that he was a genius and his debut, *Façade* (1923), engendered precisely the furore dear to the Sitwells. The music ran in tandem with a series of poems by Edith Sitwell and both she and the musicians were concealed behind a cloth with an aperture in it. Whatever the sensation at the time it has retained its place as a piece quintessentially capturing both the zany wit and melancholy of those years.

That was a transitory phase in Walton's career for by the thirties he had assumed the mantle of Elgar and gradually became the embodiment of musical patriotism. *Belshazzar's Feast* (1931), although greeted as a modernist milestone, in fact looks back to the oratorios of Handel. In 1937 Walton wrote the march for the

Portrait photograph of the young William Walton by Cecil Beaton.

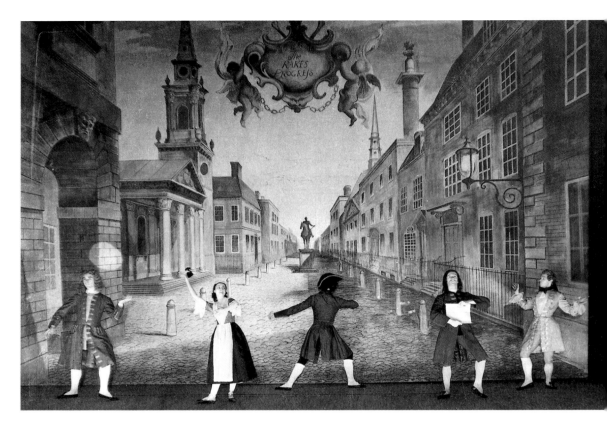

coronation of the new king and queen. His film music included Olivier's *Henry V* (1944), reflecting exactly what was the heroic phase of the war at that time, after which he was to go on to write his opera *Troilus and Cressida* (1954). By then he had opted to live in Italy which only

The birth of British ballet. A scene from The Rake's Progress *with book and music by Gavin Gordon, choreography by Ninette de Valois and sets and costumes by Rex Whistler after Hogarth, 1935.*

rendered his music even more unmistakably English with its aura of melancholy and the bitter-sweet. Like Vaughan Williams he was never to write atonal music.

If English composers had now firmly established themselves again, the First World War also led to the demise of the foreign domination of performance. A great succession of conductors emerged, Thomas Beecham, Adrian Boult, Malcolm Sargent and John Barbirolli. Soloists also flourished, like the pianists Clifford Curzon and Myra Hess, whose concerts in the National Gallery during the Second World War became a legend. London orchestral provision, which in the twenties had reached its lowest ebb, was reversed by the creation in 1930 of the BBC Symphony Orchestra which was to spur Beecham to set up the London Philharmonic. In 1934 came the BBC Northern Orchestra and the year after orchestras for Wales and Scotland.

BBC radio was to change the face of British music under the aegis of Sir Walford Davies. In 1927 the BBC took over the Promenade Concerts. Contemporary music was heard over the radio, that of Bartok, Stravinsky, Schoenberg and Janáček. In 1923 the first opera was broadcast from Covent Garden and twelve years later from Glyndebourne, the opera house built in the Sussex countryside by John Christie which opened in 1934. Although the taste for opera and serious music generally was growing it should not obscure the fact that in terms of the overall size of the population it was small.

Considerably larger was the 'middle-brow' audience which could admittedly accommodate some of the more popular classics like Beethoven's *Eroica* but whose repertoire was light music, either easily assimilated selections from the classics or pieces by composers such as Albert Ketelbey or Eric Coates whose compositions dominated restaurants and cinema intervals. Some indication of where the national musical taste had reached was the advent of the first classical record hit, Joan Hammond's recording (1941) of the aria 'O My Beloved Father' from Puccini's *Gianni Schicchi* which sold more than a million copies. None of this would qualify as high art but it was the true music of the newly emergent democracy.

Everywhere one looks during these years there is the emergence of the middle-brow, the taste of the ever expanding middle classes who found modernism quite beyond their comprehension. Nowhere is this more striking than in the visual arts where modernism established an immediate and lasting divide. Modernism eliminated the centuries-old distinction between form and content, form taking over as the content, which was the eventual consequence of the theory that all art was nothing more than sensation. This revolution in the visual arts was far more dramatic than the one which had occurred at the Renaissance. For hundreds of years any picture had been a recognisable reconstruction of nature. Now it was to become a construction of the artist who could conform to a fixed viewpoint, or not, as he chose. All the major forward developments in the visual arts happened not here but on the European mainland. The Impressionists released colour from its traditional role of defining solid objects. The Post-Impressionists took that further, although both movements adhered to a fixed viewpoint. Then came the impact of the art of other cultures, like Africa, which inspired the Cubists in their adoption of multiple viewpoints within a single canvas. As the influence of Freud and psychology took hold the world was seen to be largely as each single person saw it and no longer a shared collective experience.

The result of all this was a series of movements running into the 1930s, among them Cubism and Surrealism, whose arrival in England was often delayed and whose

reception was to be resisted by both the general public and by the establishment in the form of the Royal Academy. At best a kind of neutering took place. Modernist art was to make no headway with the educated classes until the 1950s and the tendency throughout was always towards realism. And, as in the case of all the other arts, no one gave a lead so that the result once again was fragmentation.

The Post-Impressionist exhibition of 1910 retains its position as a turning point, inaugurating an extraordinary frenzy of activity among artists which was to last until after the war as those in the vanguard, like the Bloomsbury Group painters Duncan Grant and Vanessa Bell, strove to catch up with everything that had happened abroad during the previous thirty years. In 1912 Roger Fry staged a second Post-Impressionist exhibition, this time including works by Russian and English painters, and there was also an exhibition of the work of the Italian Futurists. They insisted that art must reflect the speed and dynamism of the machine age. Clive Bell, the critic, wrote of the Post-Impressionist exhibition: 'The battle is won . . . we have ceased to ask, "What does this picture represent?" and ask instead, "What does it make us feel?" We expect a work of art to have more in common with a piece of music.'

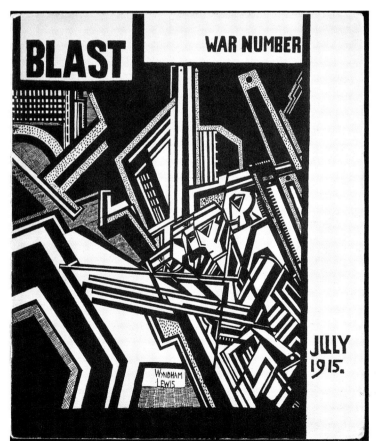

The polemic of Vorticism. Wyndham Lewis's cover for Blast *No. 2, 1915.*

Alas, the battle was far from being won. Nonetheless for a few heady years modernism ran its course as realism was thrown out by the *avant garde* in favour of line, shape, colour, space, rhythm and design, valued for their own sakes. It also produced one of the only art movements indigenous to Britain, Vorticism, the brainchild of that perennial trouble-maker Wyndham Lewis and the poet Ezra Pound. Around it gathered painters like Edward Wadsworth and William Roberts and the sculptors Henri Gaudier-Brzeska and Jacob Epstein. Their style overall was spare, architectonic, anti-humanist and violently anti-establishment. Vorticism issued its manifestos by way of the magazine *Blast* which only ran through two issues in 1914 and 1915, attacking the art establishment and calling for a revolutionary transformation of life to meet the new technological century. Aggressive and strident, its war cry called upon the British to turn their backs on wallowing in romance.

The war cut this short. Gaudier-Brzeska, the startlingly original sculptor, died in the trenches. Initially, however, modernism produced some quite extraordinary responses to the de-humanising effects of the war, but by its close the pendulum had swung firmly back to the representational and the twenties witnessed a re-

The modernist revolution in sculpture: Jacob Epstein's Rock Drill, 1915.

turn to order and the classical tradition. This return can be traced in the work, for instance, of Wyndham Lewis who turned to portraiture or that of David Bomberg who painted landscapes. In sculpture this transition is vividly caught in the American-born Jacob Epstein, who became a British subject. Here was an artist who had turned his back on the Hellenistic, Renaissance, and the entire European inheritance, looking instead towards African, Indian, Assyrian and Oceanic primitive art. When his sculptures commissioned for the British Medical Association (1908) were unveiled their overt sexuality caused a storm. Under the influence of the philosopher T. E. Hulme, who supported the Vorticists but who was to be killed in the war, Epstein sought for new forms of abstraction to catch the fleeting dynamism of the machine age. In *Rock Drill* (1915) he broke the boundaries with a white plaster figure straddling a secondhand American drill mounted on a tripod. This was revolution, but he

was later to revise the work, reducing it to a torso. The war had in fact given Epstein a nervous breakdown; the machine, far from being viewed as the herald of a new age, was now regarded as the relentless agent of death.

So Epstein through the twenties and thirties settled for a watered-down modernism, producing a brilliant series of portrait busts. His early urge to carve direct from the material, simultaneously associating himself with the status of a worker and releasing the image hidden within the stone, gave way to modelling and casting in bronze. These later works are a far cry from the man who once denounced what he called the 'sloppy dregs of the Renaissance.' The return to order was expressed equally by other sculptors like Frank Dobson and Eric Gill, who turned to the human figure as their main vehicle of aesthetic expression.

The twenties were a period of retrenchment and recovery, the depression leaving artists devoid of patronage and drifting politically sharply leftwards, seeing themselves as the victims of a grinding capitalist system. Painters tended to pass their time in worlds of their own making, Matthew Smith in one of sensuous serenity, Stanley Spencer into visionary dreamscapes in which the Thameside village of Cookham, where he lived, could become the setting for Christ's entry into Jerusalem or the Last Judgement. Haunted by sexual guilt, his was a childlike apparition in which sacred and profane, revelation and reality, merged in a deep desire to hallow the ordinary. Gwen John retreated into a world inhabited by erect women, silent, frozen in space, their stoicism occasionally tempered by the presence of a cat. Her brother, the flamboyant Augustus, took to the road to capture gypsy life before succumbing to mammon as a fashionable portrait painter for those who wanted tradition tempered by a gloss of the present.

Abstract art, although presented as the true reflection of the harmony and balance of the new democratic society, in fact made little headway with an uncomprehending public. The arrival of exiles like Naum Gabo and Piet Mondrian at the close of the thirties had little initial effect, although greater in the long term, as Henry Moore and Barbara Hepworth responded. The attempt in 1933 to launch a new movement, Unit One, dedicated to 'the expression of a truly contemporary spirit', was only to last two years. Instead of abstractionism the horrendous sprawl of suburbia raping the countryside spurred a return to representational landscape painting, with Christopher Wood in Cumbria, Edward Bawden and Eric Ravilious in Essex and Vanessa Bell and Duncan Grant in Sussex. To them can be added the somewhat surreal compositions of Paul Nash.

The same year Unit One was launched the Marxist Artists International Association was formed: 'Conservative in art and radical in politics.' Dedicated to revo-

lution and class war its work was propaganda for what its members viewed as an enslaved proletariat. In their dedication to the cause of realism they were oddly at one with the Royal Academy under Alfred Munnings. The AIA was not the only group moved by the depression and mass unemployment. The Euston Road School was another, made up of painters like Victor Pasmore, Claude Rogers and William Coldstream. The latter had written in 1937 that he was 'convinced that art ought to be directed to a wider public; whereas on all sides ideas which I had learned to regard as artistically revolutionary ran in the opposite direction. It seemed to me important that the broken communication between the artist and the public should be built up again and that this probably implied a movement towards realism.' The result was a series of pictures, urban certainly, but quintessentially English in their gentle lyricism.

If painting lacked any central thrust so equally did design. There was again no driving force, as there was in Germany with the Bauhaus or in France with the dominance of art deco. Instead there was the continuing saga of craft and its relationship with mass manufacture plus the ongoing dilemma that what was deemed good design was commercially unviable. This opened with a short-lived aberration, the Omega Workshops, the brainchild of Roger Fry, a gathering of artists who decorated normal, often machine-made household objects, living out Fry's contention that the greatest art had always been communal. The artists went in for strong colour and abstraction but soon found that what they had conceived to be an attack on capitalist goods ended up as a purveyor of items for the rich. By 1919 it had lost its momentum.

The post-war decades pulled in two contrary directions. One was a continuation of the tenets of Morris looking for inspiration to traditional art, this time finding it in the fairground, popular theatre and barge-painting as well as in items like corn dollies and inn signs. These were seen as sources unsullied by the bourgeoisie and fathered a steady stream of manufactures, ranging from Poole Pottery to textiles by Claud Lovat Fraser.

The other stream tried to take modernism on board, for both modernist architects and designers agreed in regarding abstract art as the ideal determinant of form. The source of this belief in the role of the abstract artist as the fount of a new design vision was continental and its propagator in England was the art critic Herbert Read in his *Art and Industry* (1934). Unfortunately, the apostles of modernism had little concern for practicalities, ignoring the realities of the marketplace, failing to take into account what people could afford or even machinery methods. Not until the war and utility furniture did the modernists face up to producing furnishings at a reasonable price for ordinary people. The problem was that the public still preferred neo-Tudor or Georgian.

The attempt to raise public taste was a sorry tale, government's interest being solely economic as Britain slid down the industrial league. The response from industry and business was never more than limited and even then the items produced by Ambrose Heal for his shop or Gordon Russell for his workshop in the Cotswolds remained craft-based, albeit utilising some machine-made elements. Where there were temples of new design they were places of transitory use like the Savoy and Strand Palace hotels (1930) or ocean liners such as the *Queen Mary* (1936) and the *Orion* (1935), in which the visitor could bask in a fusion of chic French-inspired art deco and Hollywood glamour. The other temples were sustained by the influence of vast corporations like London Transport or Shell, where executives encouraged the use of modern art in posters and advertising.

Efforts to raise standards produced a succession of new organisations beginning with the Design and Industries Association (1915), whose father figure was W. R. Lethaby and whose most prominent members were Ambrose Heal and the London Transport chief Frank Pick. The DIA began to respond to modernism in the

The glamour of art deco. Entrance foyer to the Strand Palace Hotel, London, by Oliver P. Bernard, 1930.

thirties and even then only in a muted way. The taste for it was promoted by a series of exhibitions but the organisation ran out of steam and was taken over by the Society of Industrial Artists (1930, later adding Designers) and the prestigious Royal Designers for Industry (1936), an élite, self-elected body covering the whole range of design from engineering to theatre. A recognisable design profession had emerged but industry saw no need for their services on the whole, as what they produced seemed to sell without it.

Any modern feeling which did penetrate tended to be Scandinavian inspired, viewed as a version of the style which was popular without being populist, graceful and natural and thus fully in accord with the Arts and Crafts tradition. As a result Scandinavia continued to be the prime channel for the modern style in Britain until the 1950s. The problem with design was that it was never able to shake off the Utopian social agenda with which Morris had endowed it. Design in people's minds was linked with socialism. Neither in the USA nor in Europe did that problem arise but in Britain design, along with architecture, was always latently a vehicle for social engineering. That this gained new energy at the close of the depressed thirties was due to the arrival of artistic and intellectual émigrés fleeing from fascist Europe, among them the art historian Nikolaus Pevsner. He picked up the moral and social message of Morris, writing in 1937: '. . . The question of design is a social question, it is an integral part of *the* social question of our time.' The purgation of 'shoddy design' was deemed by him a 'moral duty'.

That alliance of a style and social reform was to dog the arrival of modernism in architecture. As in the case of the other arts architectural modernism was a clean break, throwing out associationalism, imagery, metaphor and symbol, all of which were to be replaced by the god of function. So to adopt the new style was to go against most of the constants in the country's architectural history. Worse, for it turned English architecture from being a trendsetter, which it had been from the neo-classical period to the Arts and Crafts movement, into a follower. Those who introduced modernism to England almost all came from abroad, including Amyas Connell from New Zealand, Serge Chermayeff and Berthold Lubetkin from Russia, Ove Arup from Denmark, and Erich Mendelsohn, László Moholy-Nagy and Walter Gropius from Germany. Those who promoted it were unashamedly dogmatic, calling for the abolition of all other styles and eliminating any option of plurality, imposing instead flat roofs, balconies and whitewash as well as wiping out all ornament, context, and association as a matter of principle. Their Utopian and totalitarian gospel of functionalism equated fitness with beauty. What they failed to observe was that what they so assertively introduced was also a style. But along with the new architecture came the social

agenda so that although their headway was minimal before 1939 their influence on the up-and-coming generation of young architects in a depression which had seen mass unemployment was huge. Their reward was to be reaped after 1945.

That this social context became central is hardly surprising in an era which demanded better living conditions for the citizens of what was now a fully fledged democracy. The drive for that had its origins far earlier in the rise of the garden city. Ebenezer Howard's *Garden Cities of Tomorrow* (1902) was translated into French, German, Russian and Italian. It outlined self-contained, low density settlements which combined the best of town and country. In 1903 a company was formed to build the first garden city at Letchworth, Hertfordshire, and two years later followed Hampstead Garden Suburb. The concept was to counter developers' *laissez-faire*, offering instead tree-lined streets and individual gardens and homes to a far broader spectrum of society. The garden city style was to be Arts and Crafts vernacular; it is one which took hold and has dominated ordinary housing for a century. Port Sunlight had anticipated this type of leafy suburb in the 1880s; it was a new town on the Mersey

built by the soap manufacturer Lord Leverhulme for his workers, the vast majority of its houses being in the Queen Anne, neo-Georgian and Arts and Crafts styles, extending by 1916 to a hundred and forty acres. Liverpool Garden Suburb begun in 1910 incorporated, like its counterpart in Hampstead, a social programme which set out to mix classes and provide communal buildings. Welwyn Garden City in 1920 was the last of the line. All of them set a fatal formula in motion, the individual or semi-detached house in its own plot of land. That ideal, once fixed, has become immovable, resulting in the sacrifice of vast tracts of the countryside to suburbia.

Architecture was in fact dead in the twenties. There was no money and apart from the proliferation of art deco cinemas it was a bleak period, as public building virtually ceased. There was admittedly a trickle of small country houses still being built, low-ceilinged Tudor by Baillie Scott or neo-Georgian by Oliver Hill or Clough Williams-Ellis, but it was the tail end of a tradition. More and more, those with

Letchworth Garden City, begun 1904, by R. B. Parker, R. Unwin and others established a suburban format which has dominated this century. In it the vernacular and the picturesque were harnessed to provide mass housing for the new democratic age.

the financial resources opted to buy an old house or ruin and do it up; the classes that should have led new style chose rather to seek the security of the past.

The architecture that did go up fell into two streams, one presided over by Lutyens who fiercely resisted modernism, the other by those who took up a kind of muted modernity which looked to the Netherlands and Scandinavia. Twenties modernism was square-cut, vertical and devoid of decoration but it was a mere foray for what was to follow in the thirties with the arrival of modernism proper of the kind proselytised by Le Corbusier's book *Vers une architecture* (1923), with its famous definition of a house as 'a machine for living in'. The book was translated into English in 1927. The year before, the first modernist house was built in Northampton by Peter Behrens. The first Corbusian house came in 1929, Amyas Connell's 'High and Over', Amersham, Buckinghamshire. Verticalism went out and horizontalism came in. For those used to the vernacular such a building was a blot on the landscape.

In 1933 the modernists banded together to form the Modern Architectural Research Group (MARS). Some sixty followers of the Bauhaus and Le Corbusier came together with Wells Coates as its chairman. He had come to London from Canada and with Jack Pritchard formed, in 1929, Isokon, the firm which built a model block of flats four years later in Lawn Road, Hampstead. With built-in furniture, these flats were conceived as a modernist manifesto for the life-style to come and have since attained icon status. The public never warmed to them. In 1935 came the Kensal House flats, Kensington, by Maxwell Fry and Elizabeth Denby, modernist again and including a social slant embodied in the playground, school and club attached to the scheme. Berthold Lubetkin's Penguin Pool at the London Zoo (1935) and his luxury flats at Highpoint, Hampstead (1934–35) contribute to the list of barely a dozen modernist buildings worth looking at by 1939. But their time was still to come.

What is one to make overall of the arts in the decades following 1910? They resemble in their confusion the 1640s and 1650s, only instead of being the result of internal civil war, the war was without. But both share social turbulence and confrontation with a babel of viewpoints often before unheard, pulling the arts in contrary directions. There was no coherence, no leadership. Rather one feels that there was a dogged resentment for what seemed a threat to an established insular tradition rooted in ruralism and the past. In the nation's history as it slid into decline at least there lay a security which was certainly absent in the present. The Second World War was only to reinforce that feeling.

By the outbreak of war in 1939 artists had re-awoken to the cult of the country's past, rediscovering the work of Samuel Palmer, William Blake and Thomas Bewick, as well as the giants Constable and Turner. This romance of England was fuelled by

*A portent of modernism.
Wells Coates's uncompromising Lawn
Road flats, Hampstead, 1933-34.*

books on the country's landscape and architectural glories. It was in an atmosphere of a land under threat that the artists John Piper and Graham Sutherland recorded what they saw in the years leading up to 1939. In Sutherland's case it was the bold hills of Pembrokeshire endowed by his brush with a surreal sense of disquiet and foreboding. In that of Piper, he began to paint his long series recording churches and country houses, essays in bravura techniques but saturated with an aura of a great civilisation which could be swept away.

The war, with its bombing by the enemy, left a profound effect. The young Kenneth Clark, Director of the National Gallery, was appointed chairman of the War Artists Advisory Committee. Artists had to address the public in their hour of need, the sculptor Henry Moore choosing to record the recumbent figures of those sheltering in the Underground. Likewise Sutherland and Piper set about painting bombed houses and churches.

Civilian morale had to be lifted and the arts were seen by government as having a role to play. In 1939 the Council for the Encouragement of Music and Arts (CEMA) was set up with that end in view. Touring units were formed to bring theatre and music to the remotest areas of the country. The Vic-Wells companies took classical drama, ballet and opera in English to the factories, hospitals, service camps and air raid shelters. Under State auspices high culture was forced to reach out to new audiences in the crisis. It was admittedly a captive audience, but the seeds were sown. When Olivier and Richardson were released from the forces to play under the direction of Tyrone Guthrie at the New Theatre in 1944 subsidised theatre was born.

Everything produced during those years of the war speaks of a culture under siege, of fighting not just for a political cause but for a civilisation that embraced the literature of Shakespeare, Jane Austen and Dickens, the paintings of Gainsborough, Hogarth, Turner and Constable, the music of Purcell and Handel, the manor houses of Tudor and Stuart England as well as the elegancies of Georgian Bath and Regency Brighton. Its shared pantheon had no place for modernism but was firmly rooted in the pre-1914, even pre-1815, world.

T. S. Eliot's 'Little Gidding', one of *The Four Quartets*, was written at the darkest hour of the war in 1941. It is about the village where one Nicholas Farrar established a pious Anglican community in the reign of Charles I. No other poem catches that feeling of a nation's precious heritage violated. The pentecostal fire of the poem is an all-enveloping one, embracing in its flickering flames the country's past as well as its tortured present. In the mind's eye is conjured up that most potent of all wartime images, Wren's St. Paul's, symbol of Christian hope, soaring still upwards amidst the billowing carnage of smoke and flames:

> Water and fire succeed
> The town, the pasture and the weed.
> Water and fire deride
> The sacrifice that we denied.
> Water and fire shall rot
> The marred foundations we forgot,
> Of sanctuary and choir.
> > This is the death of water and fire.

Destruction of a heritage: St. Mary le Port, Bristol 1940. John Piper in his role as a war artist was instructed to record the destruction caused by German bombing.

Chapter Thirty-Six

CONSENSUS ARTS

The curtain rose at the Royal Opera House, Covent Garden, for the first time since the war on 20 February 1946. The production, *The Sleeping Princess*, with Tchaikovsky's marvellous music and Marius Petipa's dazzling choreography reinterpreted by Ninette de Valois and Frederick Ashton, was for Sadler's Wells Ballet in its new role as resident company. Ashton himself danced the mime part of the wicked fairy, Carabosse, while a new star shone out as the Princess Aurora, Margot Fonteyn, who was to become the country's first *prima ballerina assoluta*. The king and queen and the two young princesses were in the royal box, watching what was the transportation on to native soil of the high art of the imperial court of pre-revolutionary Russia. Oliver Messel's scenery conjured up a world of aristocratic courtliness, colonnaded palaces and arcadian vistas in washes of pale blue, grey and green. Against this moved the dancers in rich colours flecked with shimmering gold. As the evil Carabosse was vanquished and the handsome prince awakened the princess from her enchanted slumber it was not just an event on stage, but an action emblematic of a particular moment in the history of the arts in Britain. Here was high art, the ballet of the Romanov court, subsidised by the State, reborn in England. Enmeshed together in this single production were the essential features of the new culture of post-war democratic Britain: aristocratic, élite and intellectual, bent on keeping alive and making accessible what had become enshrined as monuments to the arts in previous non-egalitarian forms of society. This aspiration lay at the heart of a vision which was to last almost three decades until all it represented fell apart, the victim of shifts in cultural ideology and even more of inflation and consumerism.

Britain was bankrupt in 1945, saddled indeed with a mountain of war debt. Two years later what little fiscal power that was left vanished with the devaluation of the pound. This was an era of unheard-of grim austerity and controls, which was to last until well into the fifties. Nonetheless in the euphoria of having seemed to have won the war there was optimism as the Labour Party swept to power and the Welfare State was established, a comprehensive system based on maintaining full employment, providing free health care, child and unemploy-

High culture over the air. Eric Fraser's design celebrating the tenth anniversary of the BBC's Third Programme in 1956.

ment allowances, together with national insurance to ensure provision in old age. In addition the Education Act of 1944 afforded State aid for the talented to rise through the education system. In this way the foundation stone of the meritocracy to emerge in the 1960s

The Prologue from Sadler's Wells Ballet's production of The Sleeping Princess *which reopened the Royal Opera House, Covent Garden, in 1946.*

was put in place. The basis for all these changes was laid during the war in the Beveridge Report of 1942. Both sides of the political spectrum knew then that there must be no return to the polarities of the twenties and thirties, agreeing on a pragmatic reform which embraced a mixed economy, one in which transport, along with other major industries like steel and coal, was nationalised. Together this was to form a consensus from which neither political party was to depart until it finally broke down in the 1970s. But in 1945 the programme spelt Utopia for all.

The fatal flaw lay in the fact that an expensive welfare system had been put in place in what was progressively revealed to be an ailing economy unable to pay for it. Worse, Britain's world position continued to slip ever downwards as through the next two decades the Empire dissolved into the Commonwealth. The last imperial adventure, the Suez crisis (1956), only resulted in ignominy. The feeling of bitter disillusionment engendered by these events brought into derision the virtues of patriotism and heroism which had created the Empire and seen the country through two

wars. This sense that the old establishment governing classes had failed left an indelible impression on all those concerned with the arts, only exceeded by the revulsion felt when what had gone on under the Nazis became public knowledge, above all the degradation of the concentration camps where six million Jews and others had been deliberately liquidated. To that was added the horror of the atomic bomb dropped on Hiroshima with its consequences for any future global conflict. That too seemed ever imminent as Europe, split down the middle between Communist East and Capitalist West, entered the decades of the Cold War. Perhaps at no other time in the history of western civilisation was there such a sense of gloom, such a realisation that human life was virtually meaningless in the face of so many terrible happenings. Man emerged as a far from noble being, instead rather a Darwinian beast who would stoop to any form of cruelty to achieve his ends and who certainly had no claim to ethical superiority.

These were years of profound social change as the material well-being of the majority of the population improved in a way unknown before. As the western economies picked up in the sixties we enter the consumer age. Increased prosperity, especially for the working classes, triggered an uninhibited youth culture dedicated to fashion and pop music. After 1960 religion went into radical decline, church attendance becoming a marginal activity by a tiny minority of the population. Simultaneously there was an ever-increasing demand for the arts, postulating that in some way they occupied a place in people's lives once taken by religion.

Simultaneously there was a revolution in morality as the infrastructure which had held in place Victorian values was dismantled. That this happened was due to the predominant school of philosophy in the country after 1945, logical positivism, which declared moral absolutes of any kind to be meaningless. The groundwork was thus laid for the series of acts which also affected every aspect of the subject matter of the arts: the Obscene Publications Act (1959), the abolition of the death penalty (1965), easier abortion and homosexual law reform (1967), the abolition of stage censorship (1968), and a new divorce act (1969). Added to that the women's movement was well under way by 1970. As these values, the last vestiges of Victorian restraint, went they fed a desire not just for novelty but fuelled a never-ending quest by those in the arts to shock. Values, however, were not the only things to dissolve in the sixties, so also did the boundaries between the various arts.

Life became increasingly privatised. Arts activities, once only available communally, could now be had at the flick of a switch in an era less of radios than of television sets. By 1976 there were some eighteen million receivers. This was one aspect of an ever-widening accessibility to art forms which up until then had only been available

to a narrow section of the population. Education for all, and a major expansion in the form of new universities in the sixties, would seem to spell indeed an evermore growing constituency. Neither, however, was to work out in the long run quite as anticipated. Education was blighted by the introduction at the end of the sixties of new teaching methods. Instead of learning the basics of English grammar, pupils were given lessons in creative writing to encourage self-expression. The result was a shocking decline in literacy on a scale which was to reach crisis point in the 1990s.

Few eras in the history of the arts can be so neatly encapsulated as this one, for the arts too were part of the consensus package. As a full-blown democracy came on the agenda for the first time only properly after 1945 the problem arose as to what constituted the role of the arts in such a society. Labour, unlike the Conservatives, had culture in their political knapsack. Their view flowed down from the Fabians, whose stance was that it was the duty of those who were cultured gently to lead by the hand those who were not, guiding them towards the enlightened dawn. In that sense it was, like Bloomsbury, élitist, and a view not so far removed from those who regarded the advent of democracy as the barbarians at the gate. The dominant voices in that camp were the great literary critic F. R. Leavis and the poet T. S. Eliot, whose *Notes Towards a Definition of Culture* (1948) spelt out in no uncertain terms that the best was the prerogative of the few. As part of the post-war consensus, however, a network across the classes agreed that money should be spent on the provision of the arts on a much larger scale. But it was a concept of art of a kind defined by the intelligentsia, that of the existing intellectual establishment of Oxbridge and the metropolis.

That view of the arts embraced only what is now referred to as the high arts: opera, ballet, drama, literature, music, painting and sculpture. It did not include, for instance, architecture, film or photography. Art was seen as a sacred preserve whose guardians ensured that the preservation of excellence lay at its heart. This was the philosophy which prevailed, one in which those who were known collectively as 'the great and the good', establishment figures in the world of the intellect, radiated downwards to the masses all that was thought noble within the European and native traditions. But the fear was always there that this ivory tower would be assailed and vulgarised, which eventually it was.

Increasingly it came under fire from working class radicals like Richard Hoggart and Raymond Williams. They shared with their opponents a fear of Americanisation, but their focus was instead on those they cast as the disinherited masses. They had little if any time for the high arts, moving towards a far wider definition of culture which drew in such mass media as cinema, television, radio and advertising, things which were commercial and part of the ever-rising consumerism. Populism of this

kind was one ingredient which was to bring about the downfall of consensus culture. To that can be added the clash of metropolis versus the regions, the increasing politicisation of the arts and the assaults of the generation which produced the so-called 'Angry Young Men'. None of these proved as fatal as the link with consumption which was ultimately to drive everything into the marketplace. But that is to anticipate.

The keystone of consensus culture was the Arts Council. That had its origins in the wartime CEMA under the chairmanship of a member of the Bloomsbury Group, Maynard Keynes. From the outset therefore the Arts Council, of which he would have been first chairman had he not died, was stamped with Bloomsbury. Keynes believed fervently in the role of élite circles, in the supremacy of the metropolis, and in the maintenance of excellence. The arrival of the Council meant the State accepted for the first time that the contemporary and performing arts alongside national museums and galleries, which it already funded, were a responsibility of government. The Arts Council's duties were defined as 'to develop and improve the knowledge, understanding and practice of the arts' and 'to increase the accessibility of the arts'. It operated on what was called the 'arm's-length principle', that is, that money was provided by the State but government and politicians distanced themselves from how that money was spent, which was decided by the Council and its various panels. As government appointed the panel members it was not altogether true that it did not influence the Council's decisions. The issues became more and more contentious as the years went by and money became tighter and tighter, resulting in the pulling of the strings by whichever political party happened to be in power becoming more and more evident. At the outset in 1946 the Council's role was clearly to be conservative, resolutely British, and fiercely anti-American in the face of what was regarded as the cultural threat from Hollywood.

The beginnings were auspicious with the establishment of national opera and ballet companies at the Royal Opera House, Covent Garden. But the pro-active phase quickly subsided as the Arts Council retreated from the things which CEMA during the war had pursued, like direct management, a deep concern for the regions and a commitment to arts education. Under its secretary-general, W. E. Williams, the Council shifted from 'the Best for the Most' to 'Few but Roses', and it set about creating what others later would denounce as bourgeois cultural imperialism, trying to make the masses appreciate arts which had never been intended for them in the first place. And the winners, as in every other aspect of the Welfare State, were the ever-burgeoning and aspiring middle classes, who found to their delight arts activities for which in the past they would have had to pay dearly now came cheap.

The regions were to remain a source of grievance. Wales and Scotland were accor-

ded their own Arts Councils, branches of that in London, but the main Council's regional offices were wound up early on. The 1948 Local Government Act allowed local authorities to levy up to sixpence in the pound for the arts, a facility extended in 1963 to county councils. This remained discretionary and the results across country were patchy but on the whole the amount levied continued to rise, reflecting increases in disposable income as well as rising expectations.

These expectations found expression in important structural changes in the sixties. In 1964 a Labour government returned to power and the arts, hitherto directly answerable to the Treasury, had a minister attached to them, Jennie Lee, who presided over an Arts Office which was part of the Department of Education. That ministry was to take various forms until in the 1980s a full-blown Department of National Heritage was set up. What the arrival of a nascent ministry of culture signalled was the increasing dabbling of politicians into the realm of the arts. In 1965 the government produced its first-ever paper on arts funding, pointing out the need for more money and also the need for a fund to house the arts to meet what was an expanding audience, the consequence of increased access to higher education. Over a hundred arts building projects sprang up and Regional Arts Associations were created in what was an expansive era, coinciding with cultural and economic confidence.

So what was the nature of consensus culture? This was the reign of the intellectual aristocracy, in the main made up of those in the arts who had been alienated from government during the thirties along with the new pundits of expanded academe. Together they formed 'the great and the good' who served on all the boards of the national museums, the Arts Council, the British Council (which promoted British culture abroad) and the BBC. It was a network which lasted until the eighties. In general it stood for excellence against populism, for the metropolis as the showcase for the great national art institutions and was against commercialism, viewing the arts as a social activity which bore with them a moral as well as an aesthetic dimension in what was an increasingly agnostic age. The commitment was firmly to the middle ground with a distaste for extremes, perhaps summed up as a combination of native neo-Romanticism with neutered modernism.

The BBC was to form a central part of consensus culture. Its commitment was reflected in the launching of the Third Programme in September 1946, a totally élitist network to which only one per cent of the population ever listened but which during the twenty-four years of its existence offered a more culturally varied programme than anything else on radio or television. The transformation of the Third Programme into Radio 3 in 1970 marked the end of the corporation's commitment to high culture. That anyway had already been severely eroded. Although the first reg-

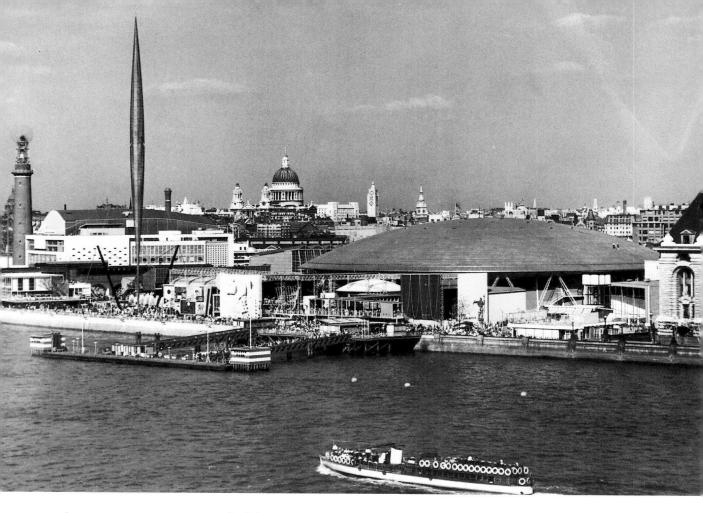

The Utopia of Socialism. Panorama from across the Thames towards the Festival of Britain with the Skylon and the Dome of Discovery, 1951. The Festival set municipal and bureaucratic style for the coming decades.

ular arts programme on television, *Monitor*, presented by Huw Wheldon, was launched in 1958, the same year saw the advent of commercial television. That marked a further erosion of élitism and lit the torch of consumerism, its revenue being derived from advertising. The creation of BBC 2 in 1964 and later in 1982 Channel 4, ostensibly for the more serious-minded, could not prevent what television became, a lower middle-brow medium of light entertainment in the home, made up of quizzes, comedy, pop music, soap operas and crime and hospital dramas. But television was watched by all classes of society and did bring a new audience to the arts, in particular to live theatre. In the case of drama the medium provided abundant work for playwrights, but any with aspirations migrated to the live theatre rather than work in an expendable transient medium.

One event crystallised the aspirations of these early post-war years, the 1951 Festival of Britain. On the surface of it commemorating the centenary of the Great

Exhibition this was the Socialist Utopia writ large in a *ville imaginaire* which sprang up on the South Bank of the Thames, designed to lift the gloom-laden spirits of a people who ached for spectacle and delight. The Festival spread out beyond that site to include Pleasure Gardens at Battersea, travelling exhibitions and events in the regions. It set out to be a celebration, asking the British to perk up and look towards a bright and dynamic future. It was run by well-meaning, do-gooding Fabian gentlemen. Ralph Tubbs's Dome of Discovery and J. H. Moya's phallic Skylon were the most memorable architectural features in what was a shrine to muted modernism of a kind which set a style which was to dominate the cities and towns of Britain for the next twenty years. Its essence was bright and cheerful colour, a use of new materials, laminates, plastics and synthetics, and the proliferation of stylistic *leitmotifs* like spindly metalwork chairs with splayed legs. In the picturesque pavilions of the Pleasure Gardens and in the deployment of ancient heraldry, modernism was tempered by a heady nostalgic romanticism. The Festival's only enduring legacy was a new venue for music making, the Festival Hall.

The Festival of Britain was a one-off but it heralded what was fast to become a tidal wave of arts festivals. In 1947 Edinburgh inaugurated its International Festival of Music and Drama, followed a year later by Bath and Aldeburgh. Within thirty years these were to multiply as festivals sprang up covering the country, ranging from all-round arts events to those specialising in music, poetry or literature.

As we move into a time span which is within living memory the evaluation as to what out of the vast torrent of creativity will be of lasting importance becomes far more difficult, if not impossible, to assess. Names and events which seem around the time of the millennium to be important will inevitably fall into oblivion as a true estimation of their worth becomes possible, aided by the perspective of time. Nonetheless, taken overall it is difficult not to conclude that the second half of the twentieth century has not been a golden age, particularly when set against the previous inheritance. Quantity has replaced quality, and the demands of a not over-educated public water down any attempts at esoteric endeavour. Consensus means committee-speak and compromise which spells the tame and the mediocre. More important even than that is the fact that for two centuries Britain had been the richest country in the world. The visual infrastructure of that, where it has not been demolished, is still there for us to see. That can only heighten the poverty of this later age and in no other art is this more evident than in architecture.

This was the age of State architecture. In 1948 forty per cent of all architects were in public service. Punitive redistributive taxation, rigid planning controls and the fear of expressing anything which might hint at social inequality, wiped out private dom-

estic architecture for the first time in the country's his-
tory. Architecture after the war was one thing only, State
housing, as governments set about replacing the half
million homes lost through bombing as well as rehous-

Planning and social engineering went hand-in-hand after 1945. Here such a group pore over a model of Kenilworth School, Borehamwood, Herts, 1952.

ing those who lived in slums. Already during the war a Ministry of Town and Country
Planning had been set up to lay plans for what should be done after the war. The sol-
ution was seen to be that which in fact happened, the introduction of high-rise slab
blocks of flats with lower buildings grouped around them, houses, shops, schools
and public facilities.

In this manner the ground was laid for the triumph of the pre-war MARS group,
architects like Maxwell Fry, Frederick Gibberd, the Russian Lubetkin and the Hungar-
ians Ernö Goldfinger and Marcel Breuer. Their god was Le Corbusier, a modernist
commitment which was only strengthened by the worship of the work of the Ger-
man-American Ludwig Mies van der Rohe. They and most of the architectural profes-
sion were left wing, often in fact communist sympathisers. The result was a marriage

of misplaced theories about working-class gregariousness and housing as a public monument, which led to disaster. This was architecture as social engineering and those involved were under no illusions about it. As Barbara Castle, a member of the Labour government, said on opening a new housing estate at Kirby in Northamptonshire: 'This is your chance to build a new Jerusalem.'

The flagship of this movement was London County Council's Roehampton Estate (1952–58) in the south-west of London, a Corbusian vision of high-rise concrete blocks of flats arising amidst a landscape which looked to the parks of 'Capability' Brown. Developments of this kind, but far inferior in quality, mushroomed all over the country even as late as the 1970s, by which time the full nature of the catastrophe was recognised. Vast enterprises like the Parkhill and Hyde Park estates in Sheffield (1955–65) bear witness to the triumph of Stalinist realism under the aegis of local Labour authorities. They shot up with an astonishing rapidity due to a massive use of prefabrication, giving almost instant low-cost housing. But by the sixties such developments had already been discovered to be unsuitable for families, subject to vandalism, and in need of high maintenance which they never got. When, in 1968, Ronan Point in south London experienced a gas explosion which destroyed several storeys the death knell of high-rise was sounded. By then a massive reaction had set in against social realist housing and architects began to rediscover Lutyens and the island's vernacular tradition in a wave of heritage inspired post-modernist architecture.

The architecture of Socialism I. Aerial photograph of the Roehampton Estate in 1958 designed by the Architects Department of London County Council.

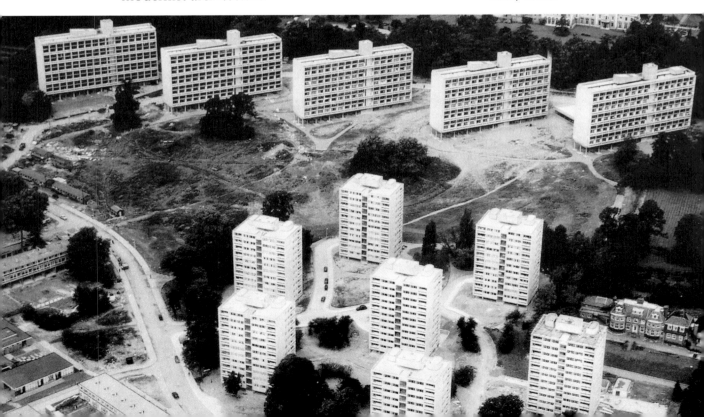

*The architecture of Socialism II.
Two views of the centre of Harlow
New Town begun in 1957 with
Frederick Gibberd as chief architect
and planner. Its dominating features
were its angularity, its emphasis on
the horizontal, its abundant use of
concrete and metal-framed windows
and its attempt to pedestrianise areas.*

The most significant monuments to the planning era were the New Towns. The New Towns Act (1946) set out to solve the problem of inner city slums by transporting their inhabitants to what were hoped to be elysiums inspired by and in direct descent from the Edwardian garden city. Indeed they were to be its last expression. Fourteen sites were chosen, eight to relieve London, and the last to be built was Milton Keynes in the seventies. Each town consisted of an industrial, civic and domestic area, the last of which was divided into neighbourhoods, each centring on a school or a church. Rooted in British anti-urbanism the towns were informal and picturesque in their lay-out, with low-rise, low-density housing which adopted some of

the stylistic tenets of international modernism. And as in the case of the housing estates they were architectural social engineering, this time on the grand scale, but again they failed. As there was no variation in the housing they became one class ghettos, and as the civic centres were the last parts of the towns to be built the result was a series of towns with a hole in the middle. Nor was the expansion of existing towns allowed by a 1952 Act to be any more successful, the result being a tidal wave of industrial and housing estates of a kind still being built, devoid of civic buildings and remote from the town's centre.

Old towns and cities were also to fare badly during the sixties, as developers, together with municipal authorities obsessed by the problem of the car, gutted their historic centres in the interests of roads, car-parks and shopping malls, altering for ever the urban configuration of the country. As in the case of the high-rise flats the reaction against what had been done by the 1970s was to be intense, fuelling what was to become a heritage cult. The last disastrous essay was the Barbican Centre in the City of London, the final architectural swan song of the Socialist Utopia.

These were the decades when the only public buildings to arise were those expressive of the Welfare State and its vast bureaucracy. Coventry Cathedral (1951–62) stands out as a solitary exception and the first major public building since 1939. It is the aesthetic ethos of the Festival of Britain made permanent. The architect Basil Spence incorporated the war-damaged ruin of the old medieval church to form a composition which is more neo-Romantic than modern. Inside and out the sculpture of Jacob Epstein, the stained glass of John Piper and the tapestry of Graham Sutherland speak of the art of the war years. But Coventry was a throw-back to a believing age which was swiftly going. Schools and universities were to be the over-riding architectural manifestations of consensus art. In schools new industrial techniques were pioneered using prefabricated metal-framed components. Much admired at the time their life was short, for they began to disintegrate. Perhaps the most forceful

The only major post-war public building: Basil Spence's Coventry Cathedral with its huge tapestry by Graham Sutherland of Christ in Majesty. The photograph is of a rehearsal of Benjamin Britten's War Requiem commissioned for the cathedral's inauguration in 1962.

statement of the new age in terms of its schools was Peter and Alison Smithson's grim brutalist building at Hunstanton, Norfolk (1954), constructed under the influence of Mies van der Rohe and Le Corbusier. The *leitmotiv* of brutalism was the use of unadulterated industrial materials and of concrete cast in unplaned wood shuttering.

The repertory of brutalism was well to the fore in the new universities, a whole series arising to provide the State with a better educated workforce. Sussex (1958 onwards) was designed by Basil Spence, East Anglia by Denys Lasdun, two out of several which set out to cope with the problem of how on a small budget to combine the needs of an industrial plant with those of a representational institution, and also with housing for students. Here too, Le Corbusier was the driving influence, Spence drawing on his use of shallow barrel vaults supported by concrete framing at Sussex and James Stirling and James Gowan looking to him, along with the work of the Russian Constructivists, for their menacing engineering block at Leicester (1964), and Stirling's Faculty of History at Cambridge (1968). The finale of the style was not to be a university but a theatre, Denys Lasdun's National Theatre on the South Bank (1969-76) and a library, Colin St. John Wilson's British Library (comp-

The new brutalism I: James Stirling and James Gowan's Engineering Building, University of Leicester.

The new brutalism II: panorama along the Thames to Denys Lasdun's National Theatre which opened in 1976.

leted 1998 but designed in the sixties), both of which came to symbolise in the eighties everything that had gone wrong with British architecture.

If consensus architecture was to spawn grassroots revolt by those for whom it was built, design tells a very similar story. Under the aegis of the State the Council of Industrial Design was set up in 1947 with a vision parallel to that of the Arts Council. In this case it was the sacred duty of its members to impart and raise the standard of taste of the masses. The stage was set by its director Gordon Russell, under whose aegis in war-time Utility furniture had been produced. The premise continued to be rural rather than urban, and craft rather than machine-based. Groups and workshops, like one headed by Robert Welch at Broadway in the Cotswolds or by David Mellor in Sheffield, continued to work in this manner in which hand and machine values merged. The Council saw design as a force for social betterment in a democracy, promoting a self-effacing style accessible to anyone, simple, unostentatious and direct. The adjectives most usually applied to the objects to which they gave awards for good design were 'practical', 'well-organised', 'agreeable', 'pleasing' and 'plain but handsome'. The truth of the matter was they propagated an austere aesthetic for which the public had no taste. By the sixties their efforts to promote some kind of elevated democratic style lay in tatters as consumerism took over.

Of far greater significance was a craft revival on a scale unseen since the golden age of Morris. Thanks to its modesty it was able to escape the tentacles of the State until 1971 when the Crafts Advisory Committee (later Crafts Council) was set up. This revival owed most to the potter Bernard Leach who re-created the idea of the craftsman in his *A Potter's Book* (1940) in which he also divorced the craftsman's role from the burden of Morris's socialism, replacing it with an aesthetic derived from the fine arts and from Japan, one based on the 'intuitive and humanistic' nature of craftwork as aspiring 'to be of a higher, more personal order of beauty.' Leach formulated all this between the wars when the going was hard, grafting on to the native slipware tradition Japanese brushwork and sensitivity to ceramic shape.

Leach's real success only came in the fifties by which time the art schools were crammed with students who did not want to opt for either the fine arts or industrial design but chose rather the path of the crafts. Their gospel came in 1970, David Pye's *The Nature and Art of Workmanship*. In sharp reaction to Leach's ruralism this articulated on behalf of a wave of craft endeavour which was unashamedly urban and which rejected traditionalism, casting the crafts among the fine arts. The result has been an unrivalled outpouring of work in wood, textiles, leather, ceramics and metal equal in terms of technique and originality to anything made in previous centuries.

What happened in the crafts formed a quite extraordinary contrast to what oc-

curred in the case of the visual arts. During the war mus-
eums and galleries had been shut and artists pursued an
indigenous neo-Romanticism which was taken up by a
younger generation who continued to look to land-
scape and natural form for their inspiration. That style
found its two greatest exponents in Graham Sutherland

*The legacy of war. Graham
Sutherland's* Thorn Cross, 1954,
*catches the shadow which war-time
brutality cast over the creative
imagination long after the event.*

and Henry Moore who reached their public apogee in the 1950s. Sutherland's style was firmly rooted in the European and insular tradition, inspired in his early years in particular by the strange visionary world of Samuel Palmer. After the war the brutality of what had happened affected his work, so that his studies of thorn bushes become crucifixions and his later portraiture never hesitates to be brutal in its delineation of humankind. Indeed his monumental canvas of the war hero Winston Churchill offended the sitter so much that his wife later ordered its destruction. The great tapestry of *Christ in Glory* for Coventry Cathedral (1954–57), hieratic and agonised, is a testament to Sutherland's art which by the time it was unveiled in 1962 had gone into eclipse.

Sutherland went to live in France, a sad, somewhat alienated existence. Henry Moore was never to leave these shores. Aggressively modernist in his early years, looking towards African and ancient Mexican sculpture for his stimulus and regarding the western tradition as a digression, even by 1939 he had gravitated to the natural world, to the examination of branches, pebbles, bones and rocks. After the war his recognition of the western tradition was patent in the long series of noble seated or reclining figures which are landscapes mainly set within actual landscapes. Moore was the ideal consensus sculptor, for whatever his addiction to abstraction he remained fundamentally a romantic, his focus, like Sutherland's, firmly not on modern technology but on man and his natural environment.

The tradition of natural form and preoccupation with landscape continued in the work of Henry Moore, captured here in his Reclining Figure *(external form), 1953-54.*

The aftermath of the war was to work in other ways. As the Cold War became a reality and Russian official art was defined as socialist realist, abstraction, which had held little appeal for the British, began to take off as a style now seen to embody the freedom of the West. The St. Ives School, a group of artists who settled in Cornwall, had their greatest exponents in Barbara Hepworth and Ben Nicholson. Nicholson, influenced by both Braque and Picasso in the thirties, passionately believed in the universality of abstract form, but typically that form for him emerged from landscape. Hepworth, who again responded in her sculpture to continental giants like Brancusi and Arp, nonetheless found her inspiration in the great standing stones of British prehistory.

At the same time that many artists were locked into the landscape tradition others responded directly to what had happened during the war, in works of art which showed man in his diminished state, vulnerable and vanquished. Reg Butler's *Unknown Political Prisoner* (1955–56), never constructed for fear of offending the Russians, is an eerie mesh of cage, watch-tower and guillotine. Elisabeth Frink's sculptures reflect similar themes of repression and violation in threatening images of the male figure or dead wingless birds. The self-taught painter Francis Bacon even more dwells on the degradation and brutality of the late twentieth century, in canvases in

A lost masterpiece. Reg Butler's model for a monument to the Unknown Political Prisoner, 1955-56, *was never constructed due to political pressures. No other work of art summed up so potently the sense of utter despair and helplessness which permeated the decades of the Cold War.*

which humanity disintegrates screaming or rent asunder before the viewer's gaze. His is an art which proffers no hope to humankind, neither does that of his friend Lucien Freud whose figures remain strangely isolated, obliquely observed, with bodies turned away and eyes downcast or averted. Confidence in man is seen to be eradicated in what is above all an art of despair.

But the sixties generation was to be very different. Richard Hamilton's collage *Just what is it that makes today's homes so different, so appealing?* (1956) encapsulates a love affair with the modern media and technology. What was to be Pop-art was succinctly defined by him a year later: 'Popular (designed for a mass audience), Transient (short-term solution), Expendable (easily forgotten), Low cost, Mass produced,

Young (aimed at youth), Witty, Sexy, Gimmicky, Glamorous, Big Business.' This was the supreme style of the sixties with David Hockney as its star. Fusing the iconography of popular culture, often American, with abstractionism it produced a style which was immediately recognisable and wholly urban.

Humanity into bestiality. Francis Bacon's terrifying Three Studies for Figures at the Base of a Crucifixion, *c. 1944, casts man as a roaring savage predator.*

Up until the sixties the teaching of art in the schools and colleges had been immutable, firmly grounded in mastering skills and techniques with a high priority placed on the ability to draw. Then, in 1960, a committee chaired somewhat surprisingly by the Euston Road School painter William Coldstream precipitated a revolution. Traditional teaching methods were abrogated and replaced by a set of modernist principles which put an emphasis on student creativity. The need to draw or the idea that painting and sculpture emanated from centuries-old traditions was thrown out as students were encouraged to experiment in 'mixed media' with virtually anything that came to hand. The result of this has been aesthetic fragmentation and chaos on a scale that makes it impossible to perceive how the future might judge what has since been produced. In the context of everything which had gone before this would seem to be the disintegration of a civilisation. For those in the vanguard, on the contrary, it was hailed as a long-awaited creative liberation from the burden of the past.

The revolution can be followed in the person of Anthony Caro who began his career as an assistant to Henry Moore but who, in 1960, was converted to Abstract

Expressionism. He abandoned age-old sculptural tech-
niques in favour of welding together miscellaneous ind-
ustrial pieces which were then painted. As a teacher he
declared sculpture could be anything, so his followers
promptly responded by, for instance, the placement of
hardly worked raw materials or digging holes or going

New directions. Richard Hamilton's
Just what is it that makes today's
homes so different, so appealing?,
1956, is the harbinger of a new art
movement, Pop, one which was firmly
based on the artefacts of the new
consumer society.

for walks, or indeed declaring themselves to be living art. Minimal Art, Performance
Art, Body Art, Conceptual Art, the succession of transitory movements continues
never-ending to the present, most of them committed to either left wing or ecological
ideologies and all equally bewildering.

This was where those engaged in the visual arts had reached by 1980, fragmented, mosaic-like, with no trace of a unified or collective aesthetic, and little if any concession to the onlooker. Indeed, like architecture, all artists kept going by State subsidy had succeeded in producing was an art which was incomprehensible and at variance with the democracy whose taxes so largely sustained it. Under the aegis of government the accumulated expertise of centuries had been jettisoned. Equally there was an extreme distaste by artists for the spiralling importance of the trade in modern art as an investment commodity, something which drove them to seek forms which were fugitive and transient. Nothing, however, was to stop the inevitable coupling of art and mammon, one which was to be consummated in the eighties.

Performance Art was one of those transient visual art forms which slipped over into theatre, whose direction too was to be radically affected by the advent of State subsidy. At the close of the war a fifth of all London theatres had been either damaged or destroyed. Although a ten per cent entertainment tax bit deep, for the commercial theatre it was back to normal, that is, taking off where it had left things in 1939, reinstating the era of the well-made play in a box set. These continued to be supplied by the likes of Noël Coward, Terence Rattigan and J. B. Priestley with an admixture of neo-Romantic verse-plays by T. S. Eliot and the young Christopher Fry.

State subsidy went to the Old Vic and its newly acquired satellite, the Bristol Old Vic (1946) and to what in 1960 was re-named the Royal Shakespeare Company at Stratford-upon-Avon. In 1949 government agreed to build a National Theatre which indeed did eventually go up and open in 1976. Before that date the company itself came into existence in 1962 with Laurence Olivier as its first director. The Old Vic Company was dissolved as the new company moved into its theatre during the interim years. Theatre was therefore dominated by these two major companies and the sense of rivalry was only increased when the RSC opened a London base at the Aldwych in 1960, later, in 1982, moving to the Barbican. Both companies developed what was director's theatre headed by, or making use of, such figures as Peter Hall and Peter Brook, with a heavy emphasis on ensemble playing, a direct response to the London season in 1956 of Bertolt Brecht's Berliner Ensemble. Neither company could sustain quite such dedication from its members, but the shift away from the old star system and the concern with the interpretation of any play less in terms of the time when it was written than in those of its relevance for today's audience was marked. That development was fortunate enough to coincide with the great pre-war generation of actors reaching the height of their powers, followed by a worthy second generation headed by such luminaries as Judi Dench, Ian McKellen, Maggie Smith and Kenneth Branagh.

This was people's drama in a democracy and theatre architecture was swift to reflect the change as new theatres, built with State and municipal funding, arose in the regions, such as the Belgrade in Coventry (1958) and the Royal Exchange in Manchester (1976). Seating ceased to reflect class divisions and the barrier between actor and audience was dissolved as the proscenium theatre gave way to variants of the theatre-in-the-round of Shakespeare's day, of which the first instance was at Chichester (1962).

In terms of the drama three events were to radically affect playwrights. The first was the production in 1955 of the Irish dramatist Samuel Beckett's *Waiting for Godot*, the work of a non-realist exponent of continental existentialism. This was a play about inaction, about two tramps waiting for someone who never comes. Its abstract effect rendered the well-made play an anachronism. The second event was the abolition of stage censorship in 1968, by which time anyway it had largely been abrogated but whose demise signalled the exploration on stage of virtually anything that a dramatist could think of that an audience might endure. The third event was another play, this time by a young twenty-four year old called John Osborne.

Look Back in Anger was staged by the English Stage Company at the Royal Court Theatre in 1956. The company had been deliberately formed by George Devine with the aim of bringing to an end the long reign of Coward and Rattigan. The play

A theatrical landmark. John Osborne's Look Back in Anger *at the Royal Court Theatre, London 1956.*

itself was conventionally structured and centred on the relationship of a working class meritocrat to his middle class wife. But it was the hero's tirades against middle class *mores* which crossed new boundaries, triggering a stream of rude and exuberant successors written by authors who had never considered the theatre before. Osborne's was an unruly, unkempt talent but he was the herald of a galaxy of playwrights including Arnold Wesker, Shelagh Delaney, John Arden and Brendan Behan, whose work it is far too early to assess. *Look Back in Anger* broke the mould of drama as a middle class preserve presenting a middle class world. The new writers could be working class and depict accurately their own world, but the audiences remained still that shifting and expanding section of the population given the blanket label of middle class, albeit of a younger meritocratic generation.

Harold Pinter perhaps can claim to be the most original of the new sixties playwrights. Influenced by Brecht, Ionesco, Kafka and strongly by Beckett, his plays are still realistic dramas albeit his characters are always viewed from a very unusual angle, making use of speech patterns and silences to create atmospheres of a peculiarly tense and menacing kind.

Virtually all this new wave drama was committed to the left, spawning an underground alternative theatre dedicated to social revolution and the liberation of the masses. That mission bore no relation to political reality and both playwrights and alternative companies were soon happily accepting State subsidy, their works ending up often as part of the repertoires of the national companies. These were plays which depended more often than not on spectacle and the deployment of physicality rather than on the power of language. By 1980 what had been an explosive period in the history of the British theatre was over, as the theatre of consensus gave place to that of the marketplace.

The pattern in theatre was to be repeated largely in literature where there was a similar flurry of activity in the middle of the fifties. Here it is even more difficult to perceive what will be of lasting value, particularly when it has to be set against what had preceded it, a period which is universally recognised as one of the greatest in the history of the nation's literature. Like the artists, writers too had an overwhelming feeling of social and cultural disintegration. Humanistic values were eroded leading to scepticism as to whether man had any right at all to cast himself as a moral being. Gloom descended in the face of the nuclear threat and also at the failure of government as the country sank into decline. One of the consequences of this was for a whole raft of writers to start looking back over the century trying to anatomise what had gone wrong. Joyce Cary, Anthony Powell, Henry Green, C. P. Snow and L. P. Hartley all contributed panoramas. The acknowledged great writer of the post-war

era was Graham Greene, a left wing Catholic who moved around the globe delineating the collapse of what had once been colonial hegemonies.

The books comparable in impact to *Look Back in Anger* were Kingsley Amis's *Lucky Jim* (1954) and Colin Wilson's *The Outsider* (1956). Wilson was not to progress beyond this first book, but together they launched a new wave which was to include Angus Wilson, John Braine and Iris Murdoch. All dealt with issues thrown up by the new post-war democracy, often choosing the university campus for the settings of what in the main were tales of provincial life. Like Osborne's plays they could be destructive tirades against the conventions and inequalities of society, but they offered no alternative ideology to replace the one which they demolished. What they did represent was the extension of literature, in the wake of Lawrence, to explore lower middle and working class life. To that in the sixties could be added the ever more vociferous voices of the women's movement and exploration of the female psyche.

In the case of poetry revolt had stirred earlier when Kingsley Amis in his role as poet declared in 1951: 'Nobody wants any more poems about philosophers or painting, or novelists or art galleries or mythology or foreign cities or other poems. At least I hope nobody wants them.' He spoke for a group of lower middle class grammar school boys who had won scholarships to Oxbridge, John Wain, Donald Davie and Philip Larkin among them. Collectively they were designated as the Movement, although it was one devoid of any unified voice or stance other than a turning away from the prevailing neo-Romanticism of the war and post-war eras, opting for a freer, easier, more colloquial style. T. S. Eliot still reigned supreme but as far as the poetry-reading public was concerned it was the more accessible verse of the Welsh neo-romantic Dylan Thomas which captured them, in works like his verse-play *Under Milk Wood* (1954), or John Betjeman's combination of middle class nostalgia and insular humour which made his *Selected Poems* (1948) a bestseller.

The poet Ted Hughes.

That in many ways was a pointer to the future for poetry, as a consequence of modernism, had lost its audience. Now with a new generation of poets writing accessible verse they were to regain it. Philip Larkin and Ted Hughes were to be in the vanguard of a poetic renaissance which took poetry out of the closet, turning it into a performance art attracting large audiences. Poetry from the sixties onwards became part of popular cul-

ture, an outlet whereby writer, reader and listener could register present crises and seek reassurance in the absence of religious belief or any accepted ethical framework. Larkin's poem 'Church Going' vividly catches this sense of bereavement:

Once I am sure there's nothing going on
I step inside, letting the door thud shut.
Another church: matting, seats, and stone,
And little books; sprawlings of flowers, cut
For Sunday, brownish now; some brass and stuff
Up at the holy end; the small neat organ;
And a tense, musty, unignorable silence,
Brewed God knows how long. Hatless, I take off
My cycle-clips in awkward reverence . . .

Poetry was not the only art form to benefit from the catastrophic decline in religion after 1960. Ballet was another means whereby an aesthetic experience could replace a spiritual one and ballet companies multiplied throughout the country. In 1966 Marie Rambert's company went over to modern dance which was a success, spawning yet more groups. At the Royal Opera House, Sadler's Wells, in its new guise as the Royal Ballet, reached an apogee in the work of two great choreographers, Frederick Ashton and Kenneth MacMillan, both of whom epitomised the Janus nature of consensus culture, for both found no contradiction in utilising the neo-romantic or modern modes according to need. This polarity is caught in two of Ashton's masterpieces, the abstract *Symphonic Variations* (1945) and the nostalgia-haunted *Enigma Variations* (1968) two decades later. At the same time a succession of British dancers emerged, like Antoinette Sibley and Anthony Dowell, and the ballet world was enlivened by the defection from Russia of the great dancer Rudolf Nureyev. Within three decades of its foundation the Royal Ballet had attained international status, and ballet had advanced from being a minority art form to one attracting mass audiences ever hungry to see the great classics.

That reflected something else which was true of these decades, the fact that audiences found it difficult to come to terms with music outside the diatonic language which prevailed from about 1600 to 1900. That had embodied a particular view of humanity which modernism and atonality rejected. Composers could no longer work from the old premise of a series of separable, individual personalities who grew through time from birth to death because they started from the premise of life as meaningless. Contemporary music therefore was to spend much of its time looking for an audience, much as poetry had done in its high modernist phase.

British music, however, remained basically conservative in its forms, opting, for example, for the traditional one of opera. The first night of Benjamin Britten's *Peter Grimes* on 7 June 1945 was a landmark, regarded by many

as England's first real opera, a dramatisation of an episode from a poem by George Crabbe in which a fisherman suspected of murdering his apprentices is hounded to death. The opera established the composer as the dominant figure in post-war music. Britten was a child prodigy before the war, composing already at an early age. He balanced a dedication to the native musical tradition with a passion for Stravinsky, Mozart and Schubert, and an interest in Far Eastern music. In the thirties he had associated with left wing intellectuals like W. H. Auden who wrote the text for *Our Hunting Fathers* (1936), a work whose subject reflected Britten's hatred of the treatment of animals, his pacifism, and his fear of the coming storm. Although he went to America in 1939 he returned three years later at the height of the war. *Peter Grimes*

was soon to be followed by other operas, including *Billy Budd* (1951) for the Festival of Britain and *Gloriana* (1953) for the coronation. His *War Requiem* (1961) inaugurated that temple to consensus, Coventry Cathedral, and his last opera, *Death in Venice*, was staged in 1973. Britten's output was prodigious in all fields, orchestral, chamber and solo, and in his lifelong partnership with the tenor Peter Pears he revitalised English song, unforgettably setting many great texts. He also composed works for leading performers of the time, including the horn player Dennis Brain, the singer Janet Baker, and the guitarist Julian Bream.

Only Michael Tippett challenged the long reign of Britten. He too was a pacifist committed also to the insular tradition, making his earliest mark in 1945 in the oratorio *A Child of Our Time* which he said 'arose out of the general situation in Europe before 1939'. Casting himself as both socialist and prophet he opted for opera as his major medium, notably *The Midsummer Marriage* (1952) and *The Knot Garden* (1966–69).

As in the case of the other arts a shift was noticeable in the fifties when a younger generation of composers emerged to question the rule of diatonic harmony and symphony and concerto forms. A motley array of influences from Schoenberg and Stockhausen to medieval and oriental music affected a group which mainly came out of Manchester headed by Peter Maxwell Davies, Harrison Birtwistle and Alexander Goehr.

The popularity of opera continued to grow. A national company was established at Covent Garden in 1947, one of three which were cast as catering for the vagaries of the class system: Glyndebourne for the upper classes, Covent Garden for the upper and middle classes and Sadler's Wells Opera (later English National) for the middle and lower middle classes. As time passed other companies took the art form across the island: the English Opera Group (1946–76), Welsh National Opera (1962), Scottish Opera (1962), Kent Opera (1976) and Opera North (1978). Like the ballet companies, a great part of the repertoire consisted of nineteenth century classics.

That equally applied to orchestral music. Mass musical culture and the advent of the long-playing gramophone record only enhanced the centrality of the classics. So too did the Third Programme which broadcast sixteen hours a day of classical music. That unease with the new fuelled the exploration of other periods, medieval, renaissance and baroque music being revived and recorded on period instruments. Orchestras and orchestral groups multiplied to meet the increasing demand. At the close of the war all four of London's orchestras were reinstated, the City of Birmingham Symphony Orchestra was re-formed and the Royal Liverpool Philharmonic and the Manchester Hallé became permanent.

There was, however, one profoundly original musical phenomenon, pop music which had its origins in American rock music of the fifties. This exploded on to the scene with an uninhibited youthful energy which crossed the social classes in the sixties. The incredibly successful Liverpool group The Beatles (1962–70) were almost alone in producing resourceful compositions, even having Stockhausen appearing on one of their record sleeves. Their work has already attained the status of folk classics but in fact the pop music phenomenon was important in the long run for a very different reason. It made millions for those involved in it and it received no State subsidy. Although its exponents often extolled free love, drugs and social revolution,

Pop art meets pop music. Peter Blake's record sleeve for the Beatles' Sergeant Pepper's Lonely Hearts Club Band, *1967.*

it was capitalist art reborn, wholly dependent on the market-place. This was consumer culture driven from the bottom and not led by any guiding guru at the top. It was the harbinger of all that was to come.

What can finally be said about the State subsidised arts of democracy? Across the board they were overwhelmingly conservative, the re-enactment and transmission to a wider spectrum of the community of the achievements of a vanished aristocratic society. In a sense such performances provided an aura of continuity and stability despite the updated gloss which could be applied to some of the works to make them relevant to the present age. The idea of a nucleus of classics which set standards of ex-

cellence to which all should aspire remained unchallenged. The canon embraced items from the European tradition, universally acknowledged as masterpieces, enhanced by a core of what were seen as indigenous to the island's culture. In opera Mozart, Puccini and Verdi had their opposite numbers in Purcell, Britten and Tippett. In ballet those of imperial Russia, *Swan Lake* or *Nutcracker*, together with ones from the Diaghilev repertoire were matched by Ashton's *The Dream* or MacMillan's *Manon*. Equally the music of Beethoven, Tchaikovsky and Brahms had a parallel stream in Elgar, Holst and Britten. In theatre England led the world with the plays of Shakespeare, Ben Jonson, Sheridan and Wilde on to which could be grafted the renaissance of Osborne and Pinter. So too could the novels of a Graham Greene or an A. S. Byatt be seen to descend from Jane Austen and Dickens. What the creators of consensus culture set out to achieve could in a sense be said to have been achieved, the preservation and transmission of the old aristocratic and bourgeois culture. The pattern was always the same, the deliberate attempt to create or continue a native tradition but one firmly grounded within the wider context of Western European civilisation.

In this quest the visual arts form an exception. Architecture turned on its inheritance, tossing it away in favour of submission to the doctrinaire ideologies of Le Corbusier and Mies van der Rohe. The result was a social disaster evoking universal revulsion on a scale unique in the island's architectural history. Only in the 1970s was some attempt made to pick up the threads snapped in 1945, post-modernism opening the door to the riches of the past once more. In the case of painting and sculpture there has been a similar violation of the native neo-romantic tradition, this time largely under the impact of the USA. The result has been incomprehension and aesthetic chaos together with a loss of technical and graphic skills that it will take decades to put back should the volition ever occur. These traditions still survive in the output of artists whose work is ignored by those who pronounce upon what is, and what is not, current art.

Consensus culture was already breaking down as it entered its seeming heyday. In 1967 the pound was devalued and by 1970 the country was recognised to be in radical economic decline. Three years later the oil crisis brought world recession and then inflation, leading to insecurity and social unrest. In 1976 Britain was forced to go cap in hand to the International Monetary Fund and the 1978–79 'winter of discontent' culminated with the dead lying unburied and the streets piled high with refuse. This brought Margaret Thatcher and a Conservative government back into power with a political programme which worked from the premise that consensus politics had ruined the country.

Simultaneously during the seventies other items came on to the agenda. In 1973

there was a formal agreement that Britain should join what was to become the European Union. Nationalism arose in Scotland and Wales, both of which had undergone separate cultural renaissances with roots back before the inter-war years. But this accelerated after 1945. England, her language and her arts, were now cast as imperial aggressors suppressing the culture of the Celtic fringe.

As social turbulence increased it only stoked the desire to look backwards, negating the forward thrust which had been such a strong feature of the years immediately after 1945. The Welfare State was now increasingly viewed with suspicion as having created a culture of dependency on the State, and that included the arts. The old aristocratic civilisation with its shrine, the country house, assumed a golden glow as it ascended to take on the symbol of all that had been achieved and could now be lost. The proposal of a wealth tax by the Labour Party threatened the very survival of these emblems of the country's cultural greatness and those who visited the exhibition at the Victoria & Albert Museum in 1974, *The Destruction of the Country House*, often stood weeping over what had been destroyed. So the scene was set for the recovery, restoration and reproduction of everything that pre-democratic England had created.

Even the left, which had been the prime progenitor of State subsidised art, supported moves towards lessening the burden by promoting sponsorship from the world of commerce. The idea of the high arts and of luminaries guiding the masses towards the light had by then gone to the wall. Instead they were guided steadily towards becoming paying customers. At the same time the idea that there was any objective basis for assessing cultural value was attacked by both structuralists and post-structuralists. No such thing as the unified judging individual was held to exist. All that we had were decentred captives of language afloat on an ocean of ideology. With that modernism, whose reception had caused such angst, collapsed into the black hole of post-modernism. Consumption moved in as the arts were left to tout for custom in the marketplace. Hierarchy vanished. Whether it was the State funded Royal Opera or commercial arena opera it was now all the same, a product to be glossily packaged, promoted, preferably also sponsored, but most definitely sold.

Chapter Thirty-Seven

LORD CIVILISATION: KENNETH CLARK

'I am convinced that a combination of words and music, colour and movement can extend human experience in a way words alone cannot do.' In this way Kenneth Clark, by then a newly ennobled peer of the realm and member of the prestigious Order of Merit, introduced the published scripts of his thirteen-part television series, *Civilisation*. 1969, the year of its screening in Britain, was Clark's *annus mirabilis*. The programmes had taken three years to make and for them he had travelled some eighty thousand miles, taking in eleven countries utilising a hundred and thirty different locations. The results were greeted with critical acclaim, the writer J. B. Priestley seeing them as 'a contribution to civilisation itself.' In retrospect the novelist Anita Brookner perceptively described them as 'one of the most influential undertakings in popular education that has been seen in this country in the last fifty years.'

Clark's triumph was not confined to Britain for his success was repeated on American television, the book selling a million copies there. *Civilisation* represented the apogee in populist terms of how the arts were viewed in the post-war consensus. Here was an acclaimed member of the intellectual élite with impeccable upper class credentials, titled, rich and famous, yet bending to make accessible to the new democratic masses the cornucopia of Western culture. The series was made without compromises, totally devoid of any lowering of tone or the least trace of vulgarity. This was high art to high purpose. The irony was that it was screened at precisely the moment when such a view of the arts was to begin to go into sharp eclipse and the very notion of the role of the intellectual élite was to come under fire as populism and materialism increased their hold. To a great extent in the life of Kenneth Clark can be traced the rise and fall of this idea in terms of a single person who personified it.

Clark was born on 13 July 1903, the son of Kenneth Mackenzie Clark and Margaret Alice McArthur. Both families came from trade, his father owing his vast for-

Two worlds: High art and Pop culture. The cover of Radio Times *for 22-28 February 1969 launching Kenneth Clark's television series,* Civilisation, *and yet the page is dominated by the face of a pop singer.*

Radio Times February 20, 1969
London and South-East FEBRUARY 22-28

EIGHTPENCE

Radio Times

BBC tv

Lulu

invites you to choose the UK's Song for Europe
SATURDAY BBC 1

Civilisation

Sir Kenneth Clark
a new
thirteen week series
Sunday BBC 2
(see centre pages)

ALSO THIS WEEK

NORTHERN IRELAND GENERAL ELECTION
Expert comment and election map
SEE PAGE 27

★

TREVOR PHILPOTT
introduces his new series of documentaries
SEE PAGE 33

tune to the manufacture of cotton thread in Paisley. Gregarious and mercurial by nature, Kenneth senior formed a sharp contrast to his reticent wife, so withdrawn that she was incapable of expressing emotion even towards what was to be their only child.

The Clarks were out and out Edwardian *nouveaux riches*. In 1904 they purchased Sudbourne Park near Aldeburgh in Suffolk, an eleven thousand acre estate with a house with thirty-six bedrooms. At its height it called for seventy servants. The year was lived in the grand manner: Sudbourne with large shooting parties from October until the end of January, then the French Riviera (the Clarks had two yachts) followed by Marienbad, back to London to Grosvenor Square for the Season and then, in early August, north to a mansion in Perthshire for the shoot.

Clark junior was the lonely art-struck child of ambitious parents anxious for their heir to rise to a position in society to which they, on account of trade, could not aspire. In order to achieve this Kenneth proceeded through the acknowledged channel of ascent, in his instance a snobbish preparatory school followed by Winchester and Oxford. In none of these does he seem to have particularly shone, school being a monument to the uneventful and the stoic. At Trinity he read history but left with a second class honours degree. By then his aesthetic leanings were beginning to be much more overt, for he had already begun to collect and he had attracted the eye of the Keeper of Fine Art at the Ashmolean Museum, C. F. Bell, who allowed him to work his way through the museum's superb collection of old master drawings. Bell had sensed at once that Clark had an eye.

Of his brilliance there can be no doubt and he was to assume and cultivate all those attributes which made him one of the mandarins of the age. Thin, and dressed with understudied elegance, his head exhibited a broad brow and a beaky nose which seemed to sniff the air around him as though to check whether it was up to par. He is always described as being arrogant and having no hesitation in putting people down, but he softened with age and his charm was undeniable. His effect on women was such that they found him irresistible. This was an ambitious man who loved the limelight and who developed a latent theatricality of manner which made him first an enthralling public lecturer and later a superb communicator on radio and television. To these must be added an ability to write in a lucid, clear and accessible style. All of this converged to single him out as the ideal apostle for the high arts in the new democratic age.

Another ingredient set him even more apart. He was fabulously rich. Clark never had to worry about money, living in a style few in the arts world could aspire to. That wealth gave him an independence of action denied to others as well as an entrée to

the highest social circles which he exploited to the full. In addition, it enabled him to collect pictures, furniture, sculpture, china and other works of art. His houses were hung with works by Tintoretto, Raphael, Bellini, Turner,

Visual arts quartet: Graham Sutherland, John Piper, Henry Moore and Kenneth Clark with a nude by Moore.

Bonnard, Seurat, Matisse and Cézanne. But such acquisitions did not only epitomise his taste and his love of art, they also represented to him money in the bank against a rainy day. He was, however, generous, setting up, during the impecunious 1930s, a Trust Fund for Artists to aid some of the many who found themselves lacking commissions and in distressed circumstances.

Through that he was able to encourage and directly help those whom his eye selected as representing the future of British art. He spotted Henry Moore at his first exhibition in 1928 and never ceased to support him. The same is true of John Piper who, with his wife, passed the war in the Clarks' house in the country. Another was Victor Pasmore, but the painter Clark considered the prime genius was Graham Sutherland who, in 1939, had his overdraft guaranteed so that he could stop teaching and

paint. This captures something of Clark's ability to identify those who were the important artists of the day. It also caught his taste, which was one firmly based in the Western European classical tradition. He was never to have time for abstraction.

Clark probably visualised himself as the century's equivalent of Ruskin or Pater but in that sense he was never quite to deliver. He spent some of the late fifties and early sixties searching for a new aesthetic but failed to find one. Things had already fragmented. Like them he was to become art personified for his own period. That vision was aided by contact with two other major figures, Roger Fry and Bernard Berenson. He was dazzled by Fry at Oxford and was to know him until his death in 1934. Fry had lived with Helen Anrep who wrote to Clark after that event casting him as the great critic's successor in enlightening a wider public on art.

Berenson was to play an even larger role. He was the giant of Italian art history and Clark was to meet him shortly after he left Oxford. On his first encounter Berenson was so struck by the young man that he immediately asked him to assist him in revising his catalogue of Florentine drawings. Berenson too was a mandarin, enshrined in his Tuscan villa, I Tatti, where he literally held court attended by young art historian acolytes. Berenson was also harnessed to the art trade and its greatest dealer, Lord Duveen, taking 25% of every deal on a work of art he vetted. Clark now entered this charmed circle, travelling with the Berensons around the galleries of Europe and, on his return to London, acting as a scout for pictures in the sale rooms and art trade.

In January 1927 he married an Irish girl, Jane Martin, whose background like his was trade. Jane was to worship her husband, turning herself into the ideal hostess, dressing like a perpetual fashion plate and entertaining in a way which was deemed flawless, but behind the immaculately preserved exterior lay a woman who was moody and impulsive, sharp and argumentative, characteristics which grew with the years.

With every advantage a man could have Clark foolishly accepted the post of being Bell's successor at the Ashmolean, realising almost at once his mistake. But by 1934 when he was thirty, thanks to his friendship with the great collector Lord Lee of Fareham, he was made Director of the National Gallery. His strength lay in the fact that his social milieu was that of his own trustees like Lord Duveen and Sir Philip Sassoon rather than that of his indigent staff. Taking a house in Portland Place, Clark and his wife played their new role for all it was worth. Huge chandelier-hung rooms lined with old master paintings and banked with fresh flowers formed a backdrop for lunches, dinners and parties to which they welcomed members of the royal family and the political world, including the prime minister, as well as artists and members of smart society.

At the gallery Clark introduced electric light, started purchasing Impressionist pic-

tures and established a scientific laboratory with infra-red, X-ray and other equipment for examining paintings which he now started to clean. Not everything was a glittering success. Two dud purchases provoked public outcry and his staff were set against him. But by then he was unassailable. The same year that he walked into the National Gallery he became Surveyor of the King's Pictures followed three years later by a knighthood. Simultaneously he began to publish a steady stream of books including *The Gothic Revival* (1928), a catalogue of the drawings of Leonardo da Vinci in the Royal Collection (1935) and a book on the artist (1938). All were received with acclaim.

Then came the war and a curtain descended. Jane evacuated to Upton House in Gloucestershire with the children and Clark embarked on the first of a long series of amours, although there was never any question of divorce.

The war meant Clark overseeing the evacuation of the gallery's masterpieces to mines in Wales and also initiating the celebrated series of concerts by Dame Myra Hess, which brought solace to the blitzed citizens of the metropolis. Clark became Chairman of the War Artists Committee ensuring that work was given to Paul Nash, Sutherland, Moore and Piper. Later he was to be head of films in the Ministry of Information, but these were in fact wasted years.

Clark's problem was that he had been too successful too young. Not lacking for cash he could afford to resign both his pre-war posts in 1945 and set out to become a full-time writer. In 1946 he became Slade Professor of Fine Art at Oxford delivering a series of lectures on landscape. He had chosen the subject deliberately to attract the young which he did, the audiences rising to as many as five hundred. The two key books which came out of this period were *Landscape into Art* (1949) and *The Nude* (1956). Both retain their place as classics within a period. But what was that period? It was still one in which art history could be written in an accessible prose style by someone who was also recognised as an outstanding scholar. It was also one when such huge topics had not fragmented and when it was not considered foolhardy for a single mind to range across them.

One day someone will trace in detail Clark's intellectual history encapsulating as it does changes in attitude to the arts during the middle decades of the century. Clark was an unashamed highbrow. Art, he passionately believed, could only ever be a minority interest. Democracy he saw as spewing out quantity not quality, resulting in the middle-brow, which was poles away from the standards of excellence looked for by intelligentsia like himself. During the war he had started to write a piece whose title is revealing: 'To Hell with Materialism: An Aesthetic for Democracy'. He realised that if private patronage failed, the State would need to take over the support of what

he viewed as non-egalitarian art. Art as he conceived it should never be taken down to the level of the masses. Their task was to ascend to it. And his role was to facilitate such an ascent.

But how? Writing and lecturing only reached so many. He believed that through the Arts Council he might be able to reach more. He therefore accepted its chairmanship in 1953 (he had wanted it in 1946) and went on for seven years in what he soon found was a rubber-stamping uncreative post. Mary Glasgow, who was at one time the Council's secretary-general, provides perhaps the most incisive portrait of Clark ever written:

> 'He is an intellectual giant, with a well-stocked mind and administrative powers to match. He ought to have taken a leading part in the affairs of this country at large, let alone the cultural ones. Yet whenever he has approached the centre of things . . . he has shied away, saying to himself something like, "All this is dust and ashes; I must devote myself to things of the mind." Then he would retire, and think, write and contemplate; until the pendulum swung back and he would say: "What am I doing in a vacuum? I must go back into the arena." '

His way out of the Council was to be one he quickly regretted. In 1954 he accepted the chairmanship of the new Independent Television Authority which was to introduce commercial television. For three years he found himself fronting an organisation which heralded everything he loathed, the culture of crass materialism.

This inability quite to focus one way or the other in some respects is an index of failure. And a love of the limelight led Clark to accept positions on too many committees. In addition to the Arts Council and the Independent Television Authority there was the British Museum, the Victoria & Albert Museum, the National Art-Collections Fund, the Conseil Artistique des Musées and the London Library. This longing to be part of the establishment network wasted his talents. As the committees multiplied the quality of his written work declined.

Clark purchased Saltwood Castle in Kent in 1953 and for the last thirty years of his life he divided his time between that and an apartment in London. *Civilisation* in 1969 brought him every public honour but he was never to repeat its success. Jane died in 1976, he was to remarry in 1977, and died, aged seventy-nine, on 21 May 1983, having at the end converted to Roman Catholicism.

Perhaps that acceptance in death of the gift of faith is some clue to the man for he viewed his own age as flawed by its lack: 'The trouble with our present civilisation is that we have lost touch with our spiritual roots, our sense of human scale, our sense of man's place in the frame of nature.' Civilisation, Clark argued '. . . is actually quite

fragile. It can be destroyed. What are its enemies? . . . fear of war, fear of invasion, fear of plague and famine . . . And fear of the supernatural . . . And then exhaustion, the feeling of hopelessness which can overtake people even with a high degree of material prosperity . . . Of course, civilisation requires a modicum of prosperity . . . But far more, it requires confidence – confidence in the society in which one lives, belief in its philosophy, belief in its laws, and confidence in one's own mental powers.' His view of the future was pessimistic, although that was not perceived at the time, and his closing words were these: 'The moral and intellectual failure of Marxism has left us with no alternative to heroic materialism, and that isn't enough. One may be optimistic, but one can't exactly be joyful at the prospect before us.' That perhaps remains as true thirty years on as when the first peer of the realm created in recognition of his services to the arts uttered it.

Chapter Thirty-Eight

EPILOGUE:
CONSUMER CULTURE

So it was in 1969 that Kenneth Clark saw the barbarians of commercialism already at the gates of civilisation. By 1980 those gates had not only been flung wide by government but a welcome accorded to what henceforth were to be billed as the 'cultural industries'. Mammon was to be the new icon in the temple of art.

In 1979 Margaret Thatcher swept to power in a government by which the very term consensus was seen as a dirty word. The new radical right pushed through monetarist policies which were rigidly adhered to in order to bring down an inflation rate which, a few years before, had reached as high as 24%. The social consequences were the virtual demise of the manufacturing base of the country in favour of service industries, and some three million unemployed. Not even the arrival of what is now billed as a New Labour government in May 1997, subsequent to the fall of Thatcher and the premiership of John Major, was to shift what has been the fixed objective of every successive administration, to avoid at all costs hyper-inflation. In order to achieve that there has had to be an ever-vigilant control on public spending and that was to have a profound impact on the arts.

Already in 1975 stasis had set in for Arts Council funding. In 1980–81 grants had formed 45% of a client's revenue but by 1988–89 that had fallen to 35%. In 1983 the National Audit Act established that key phase of the era, 'value for money', as an official policy. Arts institutions had no alternative but to embrace the tenets of consumerism or go under. Suddenly every organisation began to adopt the rigmarole of modern commercial management techniques with tight financial controls and strategic plans and targets. Boards which hitherto had been made up of cultured aristocrats and the élite of academe were now filled with businessmen whose prime task was to see that the new ideology was implemented. The ability to raise money became a key attribute for appointment rather than knowledge of the institution's aesthetic function. Government made it clear that any enlargement of arts activity would henceforth have to be met from the private sector. The development and sponsorship office became

The Angel of the North, 1997. Anthony Gormley's vast sculpture near Gateshead arises like some apocalyptic vision on the landscape.

an integral part of arts management. Arts administration itself became a university degree subject.

In order to curry favour with governments that no longer recognised the provision of art to the masses as an ethical duty, this activity was recast as the 'arts industry', stress being laid on its revenue engendering virtues in the form of tourism, audiences and customers. The shift in attitude is summed up in the title of a paper government commissioned from the Policy Studies Institute in 1988: *The Economic Importance of the Arts in Britain*. We have arrived in a cultural ethos which Maynard Keynes, not to mention T. S. Eliot, would have found deeply distasteful.

This revolution was matched by the most dramatic restructuring of arts administration since 1946. In 1982 the arts were put together with the heritage, sport, film and tourism as the Department of National Heritage, a title which reflected what was to be an initial emphasis on traditional and conservative values. That was recast under New Labour in 1997 and became the Department for Culture, Media and Sport. Britain had arrived where most European countries had reached decades before, with a full-blown culture ministry as an arm of government. Whatever lip service was paid to the old 'arm's length principle', the arts were now wholly in the service of whichever political party happened to be in power, able to harness them in whatever direction it was thought might appeal to the electorate. So the age of the élite guiding the masses gave way to that of an army of politicians and bureaucrats. The prime considerations of the past, excellence and the preservation of the inherited art forms of what had been highly privileged and also highly educated minorities, ceased to be a major objective. Instead in the future the arts would be driven in the direction of whatever a not over-educated mass electorate demanded, or rather was thought to demand.

Simultaneously the Arts Council began its descent to redundancy and irrelevance. In 1984 devolution to the Regional Arts Associations began. Nine years later the funding of the Scottish and Welsh Arts Councils was made direct, reducing the Arts Council of Great Britain to only the Arts Council of England, with a role stripped down to looking after a few rump clients like the major national performing companies. In 1993 the Lottery Act, which was to produce in its early phases the vast sum of five billion pounds a year for capital arts projects, was to assign to the truncated Arts Council the function of vetting bids. But its great days had gone. Its founding ideology had vanished, the high arts reduced to being just one item, a niche product, in the marketplace. The Department for Culture had in effect cancelled it out, whatever was strenuously said to the contrary. Government now overtly inherited the mantle which had been worn by the church, the monarchy, the aristocracy and the bourgeoisie. What this new era in the arts will achieve it is still too early to judge but

it has already taken on recognisable characteristics which set it firmly apart as a new phase in the dialogue between art and society in an era of democracy.

Central to it is the citizen as consumer, as taxation was moved from being direct to indirect. Money was now placed in the pockets of the customer to spend as he chose. There was no longer any question of, 'We will give you what we think is good for you.' The line between high and popular art has gone and the distinction between professional and amateur, unrecognised anyway by the Regional Arts Associations, is likewise in a state of dissolution. The arts are viewed from the Department's remit as only one activity among many from which the citizen might choose, ones which range from visiting an historic site to going to a football match.

Historic art, the heritage, has likewise been transformed into an industry. In 1980 after a series of crises over country houses, and works of art leaving the country, the National Heritage Act created a fund to save such things for the nation. Three years later a second act set up English Heritage, harnessing the state's historic monuments to commercial enterprise. Museums and galleries at the same time began introducing entry charges and embarking into the world of commerce in response to the State screw of declining subsidy.

That also engendered a frenzied pursuit of sponsorship from the private sector. In 1976 the Association for Business Sponsorship of the Arts (ABSA) was set up and by 1979 four million pounds came from that sector. By 1992 that had risen to sixty-five million and there were notable public benefactions like the Clore Wing at the Tate Gallery and the Sainsbury Wing at the National Gallery. But the impact on arts organisations of this obsession with raising money was that those running them were appointed more for their fund raising and managerial abilities than for their achievement in the arts. The effect on flagship high art institutions, like the Royal Opera House, which had embodied the summit of post-war consensus aspirations, was to be catastrophic.

Wooing both audiences and cash meant adopting the whole commercial range of public relations and marketing techniques. The boundaries of dignity and restraint went, as élitist institutions such as the Victoria & Albert Museum billed itself as 'an ace caff with quite a nice museum attached.' The temptation to dumb down to the lowest common denominator by appealing to sex and sensation in order to sell was almost irresistible. Such an approach was not helped either by government ministers of the kind who held that the impoverished lyrics of a pop singer were the equal of an ode by Keats. Accessibility, which in 1964 had meant inviting everyone to climb a pleasurable mountain in what called for intellectual and aesthetic effort, was recast in the interests of demolishing the mountain to the level of the often ill-informed customer.

By the eighties, however, the post-war policies had been bearing fruit in an ever-expanding demand for the arts. As a result they began to be seen as a raft upon which to set about regenerating the country's decaying industrial cities. Conservationists, developers, local authorities and artists drew together in an effort to put pleasure back into urban life. Birmingham was in the forefront, building a new concert hall, attracting as a permanent company what was once Sadler's Wells Touring Ballet now named the Birmingham Royal Ballet, and constructing a new city square adorned with major sculpture commissions. Glasgow began a similar ascent, resulting in 1990 in its being designated European City of Culture. A major art commission began to be seen as an assertion of positive identity. Hovering above the motorway, Gateshead's monolithic *The Angel of the North* (1997) by Anthony Gormley is inescapable. The north has now its Statue of Liberty.

The National Lottery has triggered an unprecedented number of capital projects which have in the main yet to come to fruition. What has happened is a welcome multiplication of venues and facilities and also a restoration of what was a decaying arts infrastructure of old buildings. What remains to be seen is whether all these extended facilities can be funded to operate successfully.

It is far too early to even attempt to describe the arts activities of these final decades. We are living them as I write. Meanwhile the arts themselves are devoid of any collective aesthetic as they dissolve into each other, each creator doing what he wills. The increasing pursuit of structuralism and linguistic materialism holds out little hope. The writer Peter Ackroyd wrote his *Notes for a New Culture: An Essay on Modernism* (1976) with the avowed aim 'to counter the general malaise of English literature and literary studies' by drawing attention to the 'emergence of *language* as the content of literature and as a form of knowledge'. In this post-modernist scenario we no longer construct language; it constructs us. Reality as a consequence is seen to be unknowable. The result has been a departure from the apocalyptic vision held out by modernism to no vision at all. All around there is a complete collapse of belief in any coherent system and a total dissolution of all traditional art forms. The result is seen in phenomena like 'installations', amalgams of natural and constructed materials which can put together film, video and slides as well as make use of sound. The new millennium is approached by those in the arts seemingly devoid of hope, just with an all-pervading sense of fatalism.

How this will be viewed in retrospect there can be no way of knowing, nor how will be rated the work of contributors to the new era as varied as the architects Norman Foster and Richard Rogers, the writers Salman Rushdie and Tom Stoppard, the artists Richard Long and Damien Hirst, to mention but a few. In another context

there arises the problem thrown up by the deconstruction of the idea of Britain. In this scenario those on the Celtic fringe cast England into the role of an imperialist cultural aggressor, suppressing and weakening indigenous native civilisations. It could equally be argued that England sank its own identity in order to create an all-embracing whole drawing in other peoples and other countries. Be that as it may, devolution to Scotland and Wales heralds the break-up of the island along federal lines and poses the question what then is England?

In a sense the reader by now is firmly in his or her own age and quite capable of reflecting on the arts and making any judgement from experience. The indications are that in the future no such thing as a narrative history of the arts in Britain can be written as it will no longer exist beyond its role as a geographical entity. It has to be admitted that Scotland, Wales and Ireland (up until the twenties, part of the United Kingdom) have not figured much in this book, nor for that matter have other cultures which stem from England like the United States, Canada, New Zealand and Australia. Each in fact deserves its own separate story. As one by one they have achieved, or seek to achieve, their own separate cultural and political identity from what was once the mother country, it leaves the latter in painful need of reassessing its place. That urgency is also equally a fruit of the renewed formal ties with the mainland in the shape of the European Union which recalls the old medieval Holy Roman Empire. Being reduced back to where the country was on 24 March 1603, the day on which Queen Elizabeth I died, may in fact be not such a bad thing, for it was in that age more than any earlier one that England's cultural identity as such was first formulated.

Looking back, this book is essentially the story of England and the English, of the rise and in a sense the fall of a culture which went round the globe. The roots of that culture throughout have been the classical tradition as it stemmed down in Western Europe from antiquity. Equally it belongs to the Christian tradition. Both have suffered from erosion in our own century rendering those links ever more tenuous and remote. Continued erosion could render them incomprehensible. Whether that happens depends entirely on the contents of the educational system and that, like the arts themselves, is the creature of politicians and the State. In the neglect of teaching national history and of the great classics of our literature, both common furniture of the educated mind in times past, we can already see that happening. Milton's *Paradise Lost*, if it is read at all, is read as a poem with a storyline which today is new to the vast majority of its readers.

As globalisation becomes ever more a reality and the speed of change accelerates, with things like the internet and genetic engineering becoming a reality, more than ever before people will need a familiar rock to cling to. That should be provided by a

mutual celebration regardless of class, colour or creed, of the island's achievements in the arts and of those aspects of them which have set us apart. And one not rewritten around misplaced political correctness. What is it then in the arts of England which has set us apart, endowing things English with that fugitive and elusive element that we recognise whenever we come up against it? That is the question which has crossed my mind constantly as I have written this book.

At the top of the list of attributes would come conservatism, a love of tradition, an instinctive yearning to look backwards to the past, even if that past is an imagined one. And such glances have as equally been instrumental to going forward. The great houses of Elizabethan England are secular versions of late medieval churches, depending as much on being glittering palaces of glass and penetrating the skyline with a myriad of turrets and pinnacles. Even that most bourgeois of eras, the Victorian, was haunted by the panoply and romance of the age of chivalry. Thus it was that a lady in a crinoline and a man in a stove-pipe hat found no problem in casting themselves as knight and damsel. Even classical architecture was a journey backwards, for Inigo Jones fervently believed that the classical orders had been part of Ancient British architecture which he was reviving. A century later we find John Wood basing his elegant King's Circus in Bath on Stonehenge. And what about the Arts and Crafts movement and its obsession with vernacular Tudor and Stuart England, a passion which lingers still today as any new housing estate bears testimony to with its applied 'ancient' timbers and leaded windows? Nor should we ignore the post-modernists, who dip deep once again into the dressing-up box of past styles.

So much of our literature is voyaging back. Spenser's *Faerie Queene* and Sidney's *Arcadia* are romances of chivalry. The great novelists too are all time-conscious, whether it is taking the reader through a lifetime like Samuel Richardson or George Eliot, or even a single day like Virginia Woolf. Composers also constantly echo back, be it Byrd lamenting the demise of old Catholic England or Vaughan Williams reworking a theme by Thomas Tallis. Everywhere one looks there is always that exploration backwards, questing, searching, analysing and seeking inspiration from what has gone before. Change has forever been dressed up in the clothes of yesterday.

The landscape looms large, and yet ironically England's economic greatness was owed to the sea, to maritime endeavour, but there is no great literature of the sea, nor great school of marine painters. Instead our eyes have been lifted up unto the hills, turned inwards to the land. Piers Plowman stands four-square on the Malvern Hills as much as William Wordsworth four centuries later was to contemplate the romantic ruins of Tintern Abbey from the wooded slopes that gently led down to the Wye. The hypnotic hold of English landscape painting stems from the fundamental belief that

at its heart, when a painter depicted the countryside he was painting a mnemonic for England, her richness and her beauty. Thus it is understandable that the works of Constable, Turner and Gainsborough have such a compulsive hold on the English imagination. They are patriotic emblems. The irony of course is that this is the first truly urbanised society in Western Europe but it has never been able to shed its predilection for the rural. It remains an immovable vision, a deeply reconciling one, peaceful and pastoral, one in which man places himself atune to the seasons and the elements in their eternal round.

Nor should it be forgotten that such landscape was in the main man-made, fashioned by the demands of agriculture and art, expressed as vividly in the pattern of hedgerows and clumps of trees as much as in the artifice of 'Capability' Brown's majestic creations or, on a far smaller scale, a garden by Lutyens and Jekyll. That dialogue with the natural world is so compulsive that it can be the only explanation for such land-prodigal ideas as the garden city whose hold is still seen in the millions of detached and semi-detached houses, each with its own plot of land, which despoil the very country they in a sense pay tribute to. Public parks, too, pay homage to this eternal fixation in which the wish still remains for Everyman to have his own plot of God's earth to sow and sit in.

But the natural landscape is not merely ecology, for it takes on its own character. In no other literature does landscape assume such a role whether it is James Thomson delineating the beauties as perceived from Richmond Hill as *Felix Britannia* or the bleak passion-imbued moors of the Brontës' Yorkshire, or the lowering leaden skies of Thomas Hardy's Wessex. The deepest psychological emotions, love and hate, hope and despair, happiness and grief, are interwoven into each hill and dale, tree and rivulet, tremulous flower or fleeting cloud formation. It begets a native eye which instinctively meshes the fruits of nature into the blossom-bedecked embroidery of Gloriana's age as much as in the bold contours of a sculpture by Henry Moore, in which both man and his environment are seen as mutual primeval form.

These images haunt the inner eye, reminding us that the English vision can be a mystical one. It is a land given to strange encounters, to the heavens as it were parting, as in the great seventh century poem *The Dream of the Rood* in which Christ's cross is seen jewel-bedecked 'blazing in splendour'. That glimpse sits easily with the apocalyptic epiphanies of William Blake during the Regency. There always seems to have been space for those who push open a door, a bit like Lewis Carroll's Alice, into another world. The great fourteenth century mystic, Mother Julian of Norwich, whose consoling phrase, '. . . and all shall be well', is one in a gallery which brings in the Anglican pieties of Henry Vaughan and Thomas Traherne as they sought God in

the desolate Welsh border country during the Protectorate. And what of Stanley Spencer through whose Thameside village of Cookham Christ rides in glory and the dead arise from their graves for the Last Judgement? Or, for that matter, the glorious procession of church music whether Dunstable or Tavener or the oratorios of Handel and of Elgar? All conjure up a beyond, sometimes so potently that in the case of the mighty Hallelujah Chorus in *Messiah* the audience, led by the king, rose to its feet in response to this glimpse of the divine.

These strange, wild and passionate glimpses into unknown worlds lurk in the English psyche which always finds space for the quirky, the eccentric and the nonconformist. This is one aspect of an obsession with people. No other nation, bar the United States and Australia (and that only recently), has a National Portrait Gallery, a great parade of faces across the centuries staring out at us. It epitomises our desire to see things in terms not of ideas or great events but of individuals. That fixation with character is there from the start, staring down at us in the roof bosses and corbels of many a cathedral and church, but it gains momentum in the visual arts with the advent of painted portraiture. For most of our history painting equals portrait painting and sculpture was tomb and effigy manufacture. The earliest pictures to enter any great house were those of the monarch and the owner's family and friends, growing and extending through time so that they flood up along staircases and corridors into bedrooms, in a way which any visitor finds almost bewildering. The impulse is as strong today as the ubiquitous family snapshot album bears testament to. Nor should heraldry be forgotten as it meanders its way across everything from a ceiling to a leather binding. It is also in a sense a portrait, an abstract diagram of someone who is a human being. So much music is portrait painting in sound as well, like the melancholy strains of John Dowland's *Lachrymae* or the more overt *Enigma Variations* of Elgar, subtitled 'My Friends Pictured Within.'

And where would literature be without its great characters, heroes, heroines and villains. It is one long cavalcade: Hamlet, Lear, Tom Jones, Clarissa, Evelina, Emma, Don Juan, Oliver Twist, Nicholas Nickleby . . . The list is unending; this is a country fascinated by people both high and low, for it also revels in the arts of satire and caricature. Here bubbles to the surface a love of pricking the balloon, one of robust humour, rollicking as much with the wife of Bath and her five husbands as with the turmoil of Ben Jonson's cutpurses, pimps, whores and charlatans at Bartholomew Fair. Such grotesques froth over like a tidal wave frolicking along the borders of medieval manuscripts or staring out at us from misericords in choir stalls. On stage they are the homely shepherds in the miracle plays, Shakespeare's Bottom and his crew, pot-bellied, carousing foolish Falstaff, as much as Goldsmith's Tony Lumpkin, Sheri-

dan's Mrs Malaprop or Wilde's Miss Prism. They are stage manifestations of types we can as equally enjoy in Hogarth's *Rake's Progress*, Rowlandson's rumbustious crowd scenes, Frith's *Derby Day*, or the Pop Art world of David Hockney. And then there is the sharper-edged satire of a Dryden, Pope or Swift, evidence of an unending delight in the vanities of humankind and of exposing the foibles of the great, for what else could explain in our own era the success of a television cartoon series like *Spitting Image*, in which the politics of the age of Thatcher were gleefully anatomised, or the cartoons of Gerald Scarfe?

And yet within another perspective it is animals which catch the eye, above all horses and dogs. One recalls the obedient hounds couched at the feet of recumbent medieval effigies or Queen Elizabeth's favourite, old Sir Henry Lee, standing by his faithful hound Bevis. Chaucer's prioress comes to mind too nursing her little lap dog as much as Hogarth's defiant placing of his pug Trump in the foreground of his self-portrait. And then there are the cats, Samuel Johnson's Hodge and Edward Lear's Foss. They remind us indeed that this is the country where the stables of a great house often equal in size the great house itself, and this is the country also which gave birth to the Royal Society for the Prevention of Cruelty to Animals. Animals attend their owners in portrait after portrait, standing meekly to one side, or in the case of dogs sometimes leaping up with affection and excitement. In Van Dyck's famous canvas of the children of Charles I, the great British mastiff dominates the picture's surface, dwarfing the future Charles II. And did any other artist paint a more entrancing canine gallery than Thomas Gainsborough? By then animal painting had become a genre of its own in the unforgettable canvases of George Stubbs in which we can almost breathe the crisp morning air and run with the horses.

England is a country which has a preference always for the horizontal rather than the vertical. The great cathedrals have long naves much in the same way that a Palladian house extends its wings outwards across the earth. Even in the twentieth century, when the pressure has been relentlessly to go ever upwards, that deep aversion to height remains, the preference being for a single exclamation mark arising from a conglomeration of lower buildings, a formulation which remains as true for the spire of Salisbury Cathedral arising above the surrounding low-lying medieval city as for Cesar Pelli's skyscraper, soaring above the 1980s development of Canary Wharf in the Docklands of the East End.

That feeling for horizontality is matched by an equal one in favour of the two-dimensional. The English rarely seem able to look in three dimensions. That might account for how few great sculptors the island has produced, most of them carving pieces which are in flat relief or to be viewed only from one angle. It explains the im-

portance attached to silhouette in architecture and the desire to perforate the skyline with pinnacles, turrets, cupolas, chimney stacks, balustrading, urns or anything else which will catch the eye against the sky. No wonder modernism with its cult of the drear flat roof met with such distaste. That concern with flat surfaces breeds pattern and a love of decoration and is central to all English art from the intertwining patterns of the Celts to those in the Lindisfarne Gospels, from the interlacing of a Perpendicular ceiling to the scrolled excesses of Georgian rococo silver, and on down to the wallpapers and textiles of Morris. The abrogation of pattern was again one of the main reasons modernism made so little headway. Even the humblest occupant of a muted modernist council house will engulf it with floral fabric and wallpaper.

And that leads on to something else, a deep sense of the organic. There is an inbuilt aversion to everything being in its place, unchanged and perfect. The desire to alter, add, and change something piecemeal never goes away. Something is always being tacked on, a new chapel or a tomb effigy in a church, a wing to a house, a gateway, a window, anything, so that the result is an accretion, a motley of centuries and styles as often as not mimicking each other. Things linger on in England, consigned to dark corners and recesses, back passages and attics. And, unlike the French, the English mix old and new, within a single interior furniture, pictures and textiles of different countries of origin and different periods being placed cheek by jowl without any sense of indecorum. That is true even in the most modest of homes. And can we say as much for English literature as well, which loves the rambling and discursive, or why else the *Canterbury Tales*, or the sprawling epics of the Elizabethans, or the work of Victorian novelists which could, in the case of a Trollope, extend over a whole series of volumes in which the same characters recur?

Possibly that comes back to the strong hold of memory, the desire to cling fast to what is there, for what else could account for the torrent of preservation legislation? That desire to hold on, rather than move on, to return to familiar safe ground, becomes the stronger the greater and quicker the changes. Where violent and traumatic breaks have occurred, rare aberrations like the Reformation and the Republic or, on a smaller scale, the gutting of our cities in our own century, it has been followed sooner or later by a mourning for what has been lost and a concern with how to put it back. More perhaps than in any other century our own has been permeated with this kind of grief, together with an overwhelming awareness of departed glory, our writers forever analysing why things have become as they are.

One final point needs to be made in an era dominated by misplaced political correctness. English culture on the whole has been remarkably inclusive. Wave after wave of different peoples have found their way to the island from the Romans to the

Normans, from the Huguenots to the Jews, from West Indians to Pakistanis. Each has brought, and still brings, its own contribution to enrich an existing indigenous tradition and each, at least until recent years, has been expected to don the mantle of the island's prevailing culture also, as their own by adoption. English civilisation has always had to be multi-cultural. The rock on which it has built has remained the same nonetheless, an inherited core of great classics in the visual arts, literature, music, theatre and the dance which make up a shared achievement accessible to all through galleries and museums, books and journals, the concert hall, the opera house, the theatre, television and radio. But that unifying core will only be sustained into the future if the education system and the cultural milieu within the home make their contribution to its transmission. Today we are faced all too often with an attitude that the path of ascent towards the appreciation of these great treasures, a path up which generations have toiled in initiation, should be flattened out, eliminating anything not immediately comprehensible to the lowest common denominator. The combination of this attitude along with no seeming attempt to furnish the average mind with the commonplaces of a religious and ethical tradition, could spell the end of the civilisation delineated in these pages.

Perhaps some small voice will at last cry that art is not a cultural industry, nor wholly just a product for the marketplace, nor indeed merely a means whereby to manipulate the minds of a gullible populace with bread and circuses. Gathered together in this book are what have been and will continue to be the touchstones of our identity, a moving, rich and incredible achievement. Cumulatively they make up a shared higher experience expressive of man's deepest inner aspirations, marriages of virtuoso technical skill with a unique and timeless inner vision. Together the result has always been something which could only ever bear the label, 'Made in England.' May that ever be so.

SELECTED
FURTHER READING

General Works and Series

There is such a mountain of literature on almost every aspect of the arts covered in this book that no single human being could essay anything but a fraction of it. The material moreover quickly fragments into each medium and then fragments yet again into periods, and progressively deeper and deeper into specialisation on a scale which can only leave the general reader in a state of total bewilderment. The writers who attempt to strike out and provide readable overviews are few and often this task falls into the hands of the turgid or popularisers. My own approach has been to attempt as far as possible to read whatever is latest in the field. One relatively recent format which could easily be overlooked and which opens doors is the museum exhibition catalogue. In the last twenty years or so it has changed dramatically. Exhibitions attract the finest scholars but they are compelled, by the nature of the medium of exhibition, to crystallise their knowledge and communicate in a form which the visitor will understand. In writing this book I have found museum catalogues invaluable.

The only series which attempts to cover the ground which I have in this one volume is the far more extensive nine-volume *The Cambridge Cultural History of Britain* (1992), originally issued as *The Cambridge Guide to the Arts in Britain* (1988), ed. Boris Ford. Each volume contains chapters by various authors which accounts for their variable quality, but overall they make up an excellent guide further into the subject and each volume contains an extensive bibliography which hugely expands on what I give here.

Beyond that we embark into series or single volumes under medium. What is so striking here is that only literature is well served with a quite extraordinary number of series by various publishers: *The Pelican Guides to English Literature*, ed. Boris Ford; *The Bloomsbury Guides to English Literature*; the *Sphere History of Literature*, Sphere Reference; *The Longman Literature in English* and the *Macmillan History of English Literature*. All of these are more or less current and I have used most of them. But if I had to choose a beginner's volume it would be the excellent *The Oxford Anthology of English Literature*, ed. Frank Kermode and John Hollander, Oxford, (1973). I have also found useful Andrew Sander's *The Short Oxford History of English Literature,* Oxford, (1994). Nothing, however, replaces reading the actual texts or anthologies of them.

In the case of theatre it would be difficult to beat *The Revels History of Drama in English*, ed. Lois D. Potter and T. W. Craik, Methuen. I have relied on that throughout. For a more general introduction try Simon Trussler's *Cambridge Illustrated History: British Theatre*, Cambridge, (1994).

It is an extraordinary fact that the visual arts are far less well served. The absence of authoritative modern survey books which cover the whole field is distressing. The volumes of the *Oxford History of English Art* certainly remain useful but are extremely dated (the earliest is 1949, the latest 1978) and their format daunting in an age which expects plates and texts to be integrated and colour the norm. It is surprising also not to have seen replaced what were the once magisterial volumes which cover large periods of creativity in the Pelican History of Art series. These are E. K. Waterhouse, *Painting in Britain 1530–1790* (1953), John Summerson, *Architecture in Britain 1530–1830* (1953), and Margaret Whinney, *Sculpture in Britain 1530–1830* (1964). The most comprehensive coverage remains *The Connoisseur's*

Complete Period Guides to Houses, Decoration, Furnishing and Chattels of the Classic Periods, ed. Ralph Edwards and L. G. G. Ramsey, The Connoisseur, (1968). This is a single-volume issue of what was once a multi-volume project covering 1500–1860. In the case of architecture there is a recent good new introductory series *The Buildings of Britain*, ed. Alastair Service, Barrie & Jenkins. No one seriously interested in the visual arts should miss looking at a printed version of what was a revelatory exhibition, F. Saxl and R. Wittkower, *British Art and the Mediterranean*, Oxford, (1948).

Music for those devoid of the skill to either read or play it is far less easy of access. For a general introduction I recommend *Fairest Isle: BBC Radio 3 Book of British Music*, ed. David Fraser, BBC Books, (1995). Again any general histories are very dated: Eric Blom, *Music in England*, Pelican, (1942); Percy Young, *A History of Music*, Benn, (1967), and Ernest Walker, *A History of Music in England*, 3rd ed., revised by J. A. Westrup, Oxford, (1952). A new general history of British music is desperately called for.

For gardens I still think Miles Hadfield's *A History of British Gardening*, John Murray, (1960) is a splendid introductory read. More up to date is Christopher Thacker's *The History of Gardens in Britain and in Ireland*, Weidenfeld & Nicolson, (1994), with bibliography.

The focus of this book is on the motivating forces which have created and changed the arts through successive periods so that inevitably the attention has not been so much on single individuals. Occasionally I list a book on an individual but generally not, so that the reader will not find listed below, for example, biographies of Chaucer or books on Thomas Gainsborough.

The Celts and Romans

The most exciting approach to Roman art I found was Martin Henig's *The Art of Roman Britain*, Batsford, (1995). Also useful was Jennifer Laing's *Art and Society in Roman Britain*, Sutton Publishing, (1997). Two earlier books retain status: Sheppard Frere's *Britannia: A History of Roman Britain*, Book Club Associates ed., (1974), and J. M. C. Toynbee's *Art in Roman Britain*, Phaidon, (1962), with a magnificent collection of plates.

The Celts attract much attention these days with many recent books: Charles Thomas, *Celtic Britain*, Thames & Hudson, (1997); *Celtic Art: From its Beginnings to the Book of Kells*, ed. Ruth and Vincent Megaw, Thames & Hudson, (1989); and Ian Stroud, *Celtic Art in Britain before the Roman Conquest*, British Museum Press, (1996 ed.).

The Anglo-Saxons

By far the best introductory account is by James Campbell, Eric John and Patrick Wormald, *The Anglo-Saxons*, Penguin, (1991). But yet for an inspiring and beautiful read try Peter Hunter Blair's *The World of Bede*, Cambridge, (1970). The period has been the subject of two major British Museum exhibitions whose catalogues cover the period brilliantly and comprehensively: *The Making of England: Anglo-Saxon Art and Culture A.D. 966–1066*, ed. J. Backhouse and L. Webster, (1991), and *The Golden Age of Anglo-Saxon Art 966–1066*, (1984). To these add David M. Wilson, *Anglo-Saxon Art from the Seventh Century to the Norman Conquest*, Thames & Hudson, (1984), with a handsome collection of plates.

The Middle Ages

For an up-to-date introduction to the whole intellectual background see Marcia L. Colish, *Medieval Foundations of the Western Intellectual Tradition*, Yale, (1997). To this add: Georges M. C. Duby, *The Age of the Cathedrals: Art and Society 980–1420*, (1981); R. W. Southern, *Scholastic Humanism and the Unification of Europe*, Blackwell, (1995), and Jacques Le Goff, *Intellectuals in the Middle Ages*, Blackwell, (1993).

For architecture I found the work of Colin Platt excellent and readable, especially *The Architecture of*

Medieval Britain, Yale, (1990), with stunning plates, and *The Parish Churches of Medieval England*, Secker & Warburg, (1981). For sculpture see L. Stone, *Sculpture in Britain in the Middle Ages*, 2nd ed., (1972) and for painting Margaret Rickert, *Painting in Britain in the Middle Ages*, 2nd ed., (1965), both in the Pelican History of Art series.

Turning to areas covered by particular chapters. On the twelfth century Renaissance C. H. Haskins's *The Renaissance of the Twelfth Century*, Harvard, (1927), retains its status as a classic. To this add Christopher Brooke, *The Twelfth Century Renaissance*, (1969), and R. W. Southern, 'The Place of England in the XIIth Century Renaissance', *History*, new series, 44–45, 1959–60, pp.210ff.

The Romanesque is best approached through the splendid exhibition catalogue *1066: English Romanesque Art 1066–1200*, Arts Council, Hayward Gallery, (1984). See also *Art and Patronage in the English Romanesque*, ed. Sarah Macready and F. H. Thompson, Society of Antiquaries, Occasional Paper (New Series), VIII, (1986).

When it comes to the thirteenth and fourteenth centuries the best introduction is the glorious exhibition catalogue *Age of Chivalry: Art in Plantagenet England 1200–1400*, ed. Jonathan Alexander and Paul Binski, Royal Academy of Arts, (1987). There is much to be learnt still from John Harvey's *Gothic England. A Survey of a National Culture*, 2nd. Ed., Batsford, (1948). Easy of approach too are *Age of Chivalry: Art and Society in Late Medieval England*, ed. Nigel Saul, A History Today Book, Collins & Brown, (1992). See also *English Court Culture in the Later Middle Ages*, ed. V. J. Scattergood and J. W. Sherborne, Duckworth, (1983); *England in the Thirteenth Century*, Proceedings of the 1984 Harlaxton Symposium, ed. W. M. Ormrod, University of Nottingham, (1985); Maurice Keen, *English Society in the Later Middle Ages*, Penguin, (1990), Richard Barber and Juliet Barker, *Tournaments: Jousts, Chivalry and Pageants in the Middle Ages*, The Boydell Press, (1989); Juliet Vale, *Edward III and Chivalry: Chivalric Society and its Context 1270–1350*, The Boydell Press, (1982). For the emergence of the universities see V. H. H. Green, *A History of Oxford University*, Batsford, (1974) and Damien Reihl Leader, *A History of the University of Cambridge*, I, *The University to 1546*, Cambridge, (1988).

For the last phase of medieval England covering popular festival, piety and the mystery plays see Ronald Hutton, *The Rise and Fall of Merry England: The Ritual Year 1400–1700*, Oxford, (1994), William Tydeman, *English Medieval Theatre 1400–1500*, Routledge & Kegan Paul, (1986), and Glynne Wickham, *Early English Stages 1300 to 1660*, Routledge and Kegan Paul, (1980 ed.). I also used the *York Mystery Plays: A Selection in Modern Spelling*, ed. Richard Beadle and Pamela M. King, Clarendon Press, Oxford, (1984). The most important book of all for understanding the context of late medieval art is Eamon Duffy's quite outstanding *The Stripping of the Altars: Traditional Religion in England 1400–1580*, Yale, (1992).

For William of Wykeham see Peter Partner, 'William of Wykeham and the Historians' in *Winchester College. Sixth-centenary Essays*, ed. Roger Custance, Oxford, (1982), pp. 1–36; John Harvey, 'The Buildings of Winchester College' in *ibid.*, pp. 77–127; Sir William Hayter, *William of Wykeham, Patron of the Arts*, Chatto & Windus, (1970); R. L. Storey, 'The Foundation and the Medieval College 1379–1530' in *New College, Oxford, 1379–1979*, ed. John Buxton and Penry Williams, Oxford, (1979), pp.3–43; Gervase Jackson-Stops, 'The Building of the Medieval College' in *ibid.*, pp. 147–92.

On the development of monarchical magnificence see Charles Ross, *Edward IV*, Eyre Methuen, (1974), Scott McKendrick, 'Edward IV: An English Royal Collector of Netherlandish Tapestry', *Burlington Magazine*, 129, ii, pp.521–23; Gordon Kipling, *The Triumph of Honour. Burgundian Origins of the Elizabethan Renaissance*, Leiden U.P., (1977); the same author's 'Henry VII and the Origins of Tudor Patronage' in *Patronage in the Renaissance*, ed. Guy Fitch Lytle and Stephen Orgel, Princeton U.P., (1981); pp.117–64; Simon Thurley, *The Royal Palaces of Tudor England: Architecture and Court Life 1460–1547*, Yale, (1993).

The Sixteenth Century

There have been no recent general books covering the whole period but one can still read with profit J. Lees-Milne's *Tudor Renaissance*, Batsford, (1951), and John Buxton, *Elizabethan Taste*, (1963), re-issued New Jersey: Humanities Press and Sussex: Harvester Press, (1983). Add to those A. L. Rowse's *The Eliza-bethan Renaissance: The Cultural Acheivement*, Charles Scribner's Sons, New York, (1972).

For Cardinal Wolsey see Peter Gwyn, *The King's Cardinal: The Rise and Fall of Thomas Wolsey*, Barrie & Jenkins, (1990), *Cardinal Wolsey: Church, State and Art*, ed. S. J. Gunn and P. G. Lindley, Cambridge, (1991), Tom Campbell, 'Cardinal Wolsey's Tapestry Collection', *The Antiquaries Journal*, 76, 1996, pp.73–137. *Thomas Wolsey late Cardinal his Life and Death written by George Cavendish his gentleman-usher*, ed. Roger Lockyer, The Folio Society, (1962) makes a riveting contemporary read.

Renaissance humanism as a topic is well covered: R. Weiss, *Humanism in England during the Fifteenth Century*, Basil Blackwell, Oxford, (1941); Richard J. Schoeck, 'Humanism in England' in *Renaissance Humanism: Foundations, Forms and Legacy, II, Humanism Beyond Italy*, ed. Albert Rabil, Jr., U. of Pennsylvania Press, (1988), pp. 5–38; Retha M. Warnicke, 'Women and Humanism in England' in *ibid.*, pp. 39–54; Denys Hay, 'The Early Renaissance in England' in *Renaissance Essays*, The Hambleden Press, (1988), pp. 151–67; the same author's 'England and the Humanities in the Fifteenth Century' in *ibid.*, pp. 169–231; Maria Dowling, *Humanism in the Age of Henry VIII*, Croome Helm, (1988); J. B. Trapp and Hubertus Schulte Herbruggen, *'The King's Good Servant': Sir Thomas More 1477/8–1535*, National Portrait Gallery exhibition catalogue, (1977). The impact of printing is dealt with in H. S. Bennett, *English Books and their Readers 1475 to 1557*, Cambridge, (1969).

The iconoclast movement and its consequences for the arts is now well covered: John B. Phillips, *The Reformation of Images: Destruction of Art in England, 1535–1660*, U. of California Press, (1973); Robert Whiting, *The Blind Devotion of the People: Popular Religion and the English Reformation*, Cambridge, (1989); Roy Strong, *Lost Treasures of Britain: Five Centuries of Creation and Destruction*, Viking, (1990). Eamon Duffy's *The Stripping of the Altars* cited above remains also fundamental.

The culture of the court of Henry VIII is perhaps best covered in the exhibition catalogues *Henry VIII. A European Court in England*, ed. David Starkey, National Maritime Museum, Collins & Brown, (1991), and *The Renaissance at Sutton Place: An Exhibition to mark the 450th anniversary of King Henry VIII's Visit to Sutton Place*, The Sutton Place Heritage Trust, (1983). But see also Sydney Anglo, *Spectacle, Pageantry and Early Tudor Policy*, Oxford, (1969), and the same author's 'The Courtier. The Renaissance and Changing Ideals' in *The Courts of Europe: Politics, Patronage and Royalty*, ed. A. G. Dickens, Thames & Hudson, (1977), pp. 33–53. For the king's great building projects see Simon Thurley's book cited earlier and Maurice Howard, *The Early Tudor Country House: Architecture and Politics 1490–1550*, George Philip, (1987). On Holbein see John Rowlands, *Holbein: The Paintings of Hans Holbein the Younger*, Phaidon, (1985); *Holbein and the Court of Henry VIII*, The Queen's Gallery, (1978–79) and Roy Strong, *Holbein and Henry VIII*, Routledge, (1967).

For the Elizabethan age the image of the queen remains central for which see Roy Strong, *Gloriana: The Portraits of Queen Elizabeth I*, Thames & Hudson, (1987) and the same author's *The Cult of Elizabeth: Elizabethan Portraiture and Pageantry*, Thames & Hudson, (1977). Much too can be learned from Frances A. Yates, *Astraea: The Imperial Theme in the Sixteenth Century*, Routledge, (1975). On architecture see Mark Girouard, *Robert Smythson and the Elizabethan Country House*, Yale, (1983) and Timothy Mowl, *Elizabethan and Jacobean Style*, Phaidon, (1993). On painting Roy Strong, *The English Icon: Elizabethan and Jacobean Portraiture*, Routledge, (1969), and the exhibition catalogue *Dynasties: Painting in Tudor and Jacobean England 1530–1630*, Tate Gallery, (1995). For miniatures see Roy Strong, *The English Renaissance Miniature*, Thames & Hudson, (1983) and the same author and J. V. Murrell's exhibition catalogue *Artists of the Tudor Court: The Portrait Miniature Rediscovered 1520–1620*, Victoria & Albert Museum, (1983). A great deal on the visual arts is included in the first two volumes of Roy Strong, *The Tudor and Stuart Monarchy: Pageantry, Painting and Iconography*, Boydell & Brewer, (1995). For gardening in this period

and down to 1642 see the same author's *The Renaissance Garden in England*, Thames & Hudson, (1979).

In the case of the drama Volume III, *1576–1613*, by J. Leeds Barroll, Alexander Leggatt, Richard Hosley and Alvin Kernan of *The Revels History of Drama in English* provides by far the best general introduction. The bibliography on the drama knows no end but nothing yet has replaced E. K. Chambers, *The Elizabethan Stage,* Clarendon Press, Oxford, (1923). The general reader will enjoy C. Walter Hodges, *The Globe Restored: A Study of the Elizabethan Theatre*, Oxford, (1968).

The Seventeenth Century

The period divides itself into three, before the Civil War, then up to the Restoration, and finally a baroque phase which takes us past the turn of the century.

For the first period covering the reigns of James I and Charles I see Malcolm Smuts, *Court Culture and the Origins of a Royalist Tradition in Early Stuart England,* U. of Pennsylvania Press, (1987); Graham Parry, *The Golden Age Restor'd: The Culture of the Stuart Court,* Manchester U.P., (1981); Roy Strong, *Van Dyck: Charles I on Horseback,* Viking, (1972), reprinted in the third volume of the same author's *The Tudor and Stuart Monarchy,* Boydell & Brewer, (1997); Vaughan Hart, *Art and Magic in the Court of the Stuarts,* Routledge, (1994). For Van Dyck see Christopher Brown, *Van Dyck,* Phaidon, (1982), and for Inigo Jones, John Summerson, *Inigo Jones,* Penguin, (1966), and John Harris, Stephen Orgel and Roy Strong, *The King's Arcadia: Inigo Jones and the Stuart Court*, Arts Council Exhibition, (1973). For architecture also see Oliver Hill and John Cornforth, *English Country Houses: Caroline 1625–1685*, Country Life, (1966). Again for the drama I would refer the reader to the relevant volume in *The Revels History of Drama in English*, this time Volume IV, *1603–1660* by Philip Edwards, Gerald Eames Bentley, Kathleen McLuskie and Lois Potter. The best introduction to the literature of the period is Graham Parry's *The Seventeenth Century: The Intellectual and Cultural Context of English Literature,* Longman, (1989).

The Earl of Arundel has been the subject of lively attention. The standard biography remains Mary F. S. Hervey, *The Life, Correspondence and Collections of Thomas Howard, Earl of Arundel,* Cambridge, (1921). But in terms of cultural context it has been replaced by David Howarth, *Lord Arundel and his Circle*, Yale, (1985). See also D. E. L. Haynes, *The Arundel Marbles*, Oxford, Ashmolean Museum, (1975), *Patronage and Collecting in the Seventeenth Century: Thomas Howard, Earl of Arundel,* exhibition catalogue, Ashmolean Museum, Oxford, (1985–86).

The scientific revolution is covered in Charles Webster, *The Great Instauration: Science, Medicine and Reform 1626–1660*, Duckworth, (1975), and the same author's *From Paracelsus to Newton. Magic and the Making of Modern Science,* Cambridge, (1982). See also A. Rupert Hall, *The Revolution in Science 1500–1750*, Longman, (1983); Paolo Rossi, *Francis Bacon: From Magic to Science*, Routledge, (1968), and, for a very easy general introduction, Hugh Kearney, *Science and Change 1500–1700*, World University Library, Weidenfeld & Nicolson, (1971).

The period of the civil wars, republic and commonwealth are dealt with in Christopher Hill, *Intellectual Origins of the English Revolution*, Panther Books, (1972) and the same author's *Milton and the English Revolution*, Faber, (1977), Stephen Porter, *Destruction in the English Civil Wars*, Alan Sutton, (1994), A. L. Rowse, *Reflections on the Puritan Revolution*, Methuen, (1986); Graham Parry, *Seventeeth Century Poetry: The Social Context*, Hutchinson, (1985), Roy Sherwood, *The Court of Oliver Cromwell*, Croome Helm, (1977) and John Bold and John Reeves, *Wilton House and English Palladianism*, H.M.S.O., (1980).

The last Restoration and baroque phases of the century have three good general books: Michael Foss, *The Age of Patronage: The Arts in Society 1660–1750*, Hamish Hamilton, (1971); Judith Hook, *The Baroque Age in England*, Thames & Hudson, (1976), and Mary Ede, *Arts and Society under William and Mary*, Stainer & Bell, (1979). The demise of the court is traced in R. O. Bucholz, *The Augustan Court: Queen Anne and the Decline of Court Culture*, Stanford U.P., (1993).

Theatre is excellently covered in Volume V, *1660–1750*, by John Loftis, Richard Southern, Marion Jones and A. H. Scouten in *The Revels History of Drama in English.* Purcell has an up-to-the-minute survey

in Peter Holman, *Henry Purcell*, Oxford, (1994). Architecture is covered in *Baroque and Rococo: Architecture and Decoration*, ed. Anthony Blunt, Paul Elek, (1978), James Lees-Milne's *English Country Houses of the Baroque 1685–1715*, Country Life, (1970), and above all in Giles Worsley, *Architecture in Britain: The Heroic Age*, Yale, (1995). For gardens see David Jacques and Arend van der Horst, *The Gardens of William and Mary*, Christopher Helm, (1988) and David Green, *Gardener to Queen Anne*, Oxford, (1956). The painters are best approached through exhibition catalogues: Oliver Millar, *Sir Peter Lely 1618–80*, National Portrait Gallery, (1978), and J. Douglas Stewart, *Sir Godfrey Kneller*, National Portrait Gallery, (1971).

The Eighteenth Century

By far the most important book to open the door into this period is John Brewer's *The Pleasures of the Imagination: English Culture in the Eighteenth Century*, HarperCollins, (1997). Its comprehensiveness is curiously marred only by the omission of architecture. Other general books to be read with profit are J. H. Plumb's *Georgian Delights*, Weidenfeld & Nicolson, (1980), and the same author's *The Pursuit of Happiness: A View of Life in Georgian England*, exhibition catalogue, Yale Center for British Art, New Haven, (1977); *Rococo Art and Design in Hogarth's England*, exhibition catalogue, Victoria & Albert Museum, (1984), and Philip Ayres, *Classical Culture and the Idea of Rome in Eighteenth-Century England*, Cambridge, (1997).

For Lord Burlington and William Kent see James Lees-Milne's *Earls of Creation: Five Great Patrons of Eighteenth Century Art*, Hamish Hamilton, (1962); John Harris, *The Palladian Revival: Lord Burlington, His Villa and Garden at Chiswick*, Yale, (1994); *Lord Burlington: Architecture, Art and Life*, ed. Toby Barnard and Jane Clark, The Hambleden Press, (1995); *A Tercentenary Tribute to William Kent*, exhibition catalogue, Ferens Art Gallery, Hull, (1985); Michael Wilson, *William Kent: Architect, Designer, Painter, Gardener. 1685–1748*, Routledge, (1984); John Dixon Hunt, *William Kent, Landscape Garden Designer*, Zwemmer, (1987); *Apollo of the Arts: Lord Burlington and His Circle*, ed. Dana Arnold, exhibition catalogue, Nottingham University Art Gallery, (1973); *Belov'd of Ev'ry Muse: Richard Boyle, 3rd Earl of Burlington and 4th Earl of Cork (1694–1753)*, The Georgian Group, (1994).

The numerous books by Pat Rogers on Alexander Pope and his era cover the literature: *An Introduction to Pope*, Methuen, (1975), *The Augustan Vision*, Methuen, (1974), and *Essays on Pope*, Cambridge, (1993). See also Felicity Rosslyn, *Alexander Pope: A Literary Life*, Macmillan, (1990). On the advent of the novel see Ian Watt, *The Rise of the Novel*, The Hogarth Press, (1987 ed).

For Handel see Donald Burrows, *Handel*, Oxford, (1994), Christopher Hogwood, *Handel*, Thames & Hudson, (1994), and *Handel: A Celebration of his Life and Times 1685–1759*, exhibition catalogue, National Portrait Gallery, (1986).

In the case of Hogarth Jenny Uglow has provided us with a wonderful biography *Hogarth: A Life and a World*, Faber, (1997). But see also *Manners and Morals: Hogarth and British Painting 1700–1760*, exhibition catalogue, Tate Gallery, (1987), and David Bindman, *Hogarth and His Times*, exhibition catalogue, British Museum, (1997).

The Grand Tour has been the subject of much recent study: Christopher Hibbert, *The Grand Tour*, Thames Methuen, (1987); Jeremy Black, *The Grand Tour in the Eighteenth Century*, Sutton Publishing, (1992); *Grand Tour: The Lure of Italy in the Eighteenth Century*, ed. Andrew Wilton and Ilaria Bignami, exhibition catalogue, Tate Gallery, (1997); Ian Jenkins and Kim Sloan, *Vases and Volcanoes: Sir William Hamilton and His Collection*, exhibition catalogue, British Museum, (1996); *The Treasure Houses of Britain: Five Hundred Years of Private Patronage and Art Collecting*, ed. Gervase Jackson-Stops, exhibition catalogue, National Gallery of Art, Washington, (1985).

The consequences of the tour can be traced in Julius Bryant, *Robert Adam: Architect of Genius*, English Heritage, (1992); Steven Parissien, *Adam Style*, Phaidon, (1992); John Harris, *Sir William Chambers, Knight of the Polar Star*, Zwemmer, (1970); *Reynold*, ed. Nicholas Penny, exhibition catalogue, Royal

Academy, (1986); David H. Solkin, *Richard Wilson: The Landscape of Reaction*, exhibition catalogue, Tate Gallery, (1982); David Irwin, *English Neoclassical Art: Studies in Inspiration and Taste*, Faber, (1966).

The creation of a national culture is traced in Linda Colley, *Britons: Forging the Nation 1707–1837*, Yale, (1992); Howard D. Weinbrot, *Britannia's Issue: The Rise of British Literature from Dryden to Ossian*, Cambridge, (1993); Michael Dobson, *The Making of the National Poet: Shakespeare, Adaptation and Authorship, 1660–1769*, Clarendon Press, Oxford, (1992); William Weber, *The Rise of Musical Classics in Eighteenth Century England: A Study in Canon, Ritual and Ideology*, Clarendon Press, Oxford, (1992); Murray G. H. Puttock, *Inventing and Resisting Britain: Cultural Identities in Britain and Ireland 1685–1789*, Macmillan, (1997), and the same author's *Poetry and Jacobite Politics in Eighteenth Century Britain and Ireland*, Cambridge, (1994). For the landscape and garden aspect see David Jacques, *Georgian Gardens: The Reign of Nature*, Batsford, (1983), David C. Stuart, *Georgian Gardens*, Robert Hale, (1979), and John Martin Robinson, *Temples of Delight: Stowe Landscape Gardens*, National Trust, (1996).

Sensibility impinges on the whole cultural scene, painting, literature, theatre and gardens: Maximillian E. Novak, *Eighteenth Century English Literature*, Macmillan, (1983); Desmond Shawe-Taylor, *The Georgians: Eighteenth-Century Portraiture and Society*, Barrie & Jenkins, (1990); for theatre Volume VI, *1750–1880*, by Michael R. Booth, Richard Southern, Frederick and Lise-Lone Marker and Robertson Davies in *The Revels History of Drama in English*; Cecil Price, *Theatre in the Age of Garrick*, Basil Blackwell, (1973); and *The Georgian Playhouse: Actors, Artists, Audiences and Architecture 1730–1830*, exhibition catalogue, Arts Council, (1975).

For Horace Walpole and Gothic see Wilmarth Lewis, *Horace Walpole*, Rupert Hart-Davis, (1961); Timothy Mowl, *Horace Walpole: The Great Outsider*, John Murray, (1996); Terence Davis, *The Gothick Taste*, David & Charles, (1974); Michael McCarthy, *The Origins of the Gothic Revival*, Yale, (1987); Clive Wainwright, *The Romantic Interior*, Yale, (1989); Brian Fothergill, *The Strawberry Hill Set: Horace Walpole and His Circle*, Faber, (1983).

For the Scottish Enlightenment see *A Hotbed of Genius: The Scottish Enlightenment 1730–1790*, ed. David Daiches, Peter Jones and Jean Jones, Edinburgh, (1986), David Daiches, *The Paradox of Scottish Culture: The Eighteenth Century Experience*, Oxford, (1964); Charles Camic, *Experience and Enlightenment: Socialisation for Cultural Change in Eighteenth Century Scotland*, Edinburgh, (1986); *The Origins and Nature of the Scottish Enlightenment*, ed. R. H. Campbell and Andrew S. Skinner, John Donald, (1982), Bruce Lenman, *Integration, Enlightenment and Industrialisation. Scotland 1746–1832*, Edward Arnold, (1981); Maurice Lindsay, *History of Scottish Literature*, Robert Hale, (1977), John MacQueen, *The Enlightenment and Scottish Literature*, I, *Progress and Poetry*, Scottish Academic Press, (1982).

The Nineteenth Century

Romanticism is an academic industry. The most helpful introduction to this complex period I found to be Marilyn Butler's *Romantics, Rebels and Reactionaries: English Literature and its Background*, Oxford, (1981). I also used the *Cambridge Companion to British Romanticism*, Cambridge, (1993); Maurice Cranston, *The Romantic Movement*, Blackwell, (1994); *Romanticism in National Context*, ed. Roy Porter and Mikulas Teich, Cambridge, (1988); *A Companion to Romanticism*, ed. Duncan Wu, Blackwell, (1988). For Constable and Turner see Michael Rosenthal, *Constable: The Painter and his Landscape*, Yale, (1983); *Turner 1775–1851*, exhibition catalogue, Tate Gallery, (1975); Leslie Parris, *Landscape in Britain c.1750–1850*, exhibition catalogue, Tate Gallery, (1973), and Ronald Paulson, *Literary Landscape: Turner and Constable*, Yale, (1982).

The most helpful introduction to the Victorian period I found was Robin Gilmour's *The Victorian Period: The Intellectual and Cultural Context of English Literature 1830–1890*, Longman, (1993). Equally enlightening was his *The Novel in the Victorian Age: A Modern Introduction*, Edward Arnold, (1986). To this add Raymond Williams, *Culture and Society 1780–1950*, Chatto & Windus, (1958), and David Morse, *High Victorian Culture*, New York U.P., (1993). In the case of poetry Isobel Armstrong, *Victorian*

Poetry: Poetry, Poetics and Politics, Routledge, (1993).

For the visual arts see John Steegman, *Victorian Taste. A Study of the Arts and Architecture from 1830 to 1870*, The M.I.T. Press, Cambridge, Mass., (1971) (originally as *Consort of Taste 1830–70*, Sidgwick & Jackson, 1950), and Bernard Denvir, *The Early Nineteenth Century: Art, Design and Society*, Longmans, (1984). There is no lack of books on Victorian painting: *The Pre-Raphaelites*, exhibition catalogue, Tate Gallery/Penguin, (1984), Kenneth Bendiner, *An Introduction to Victorian Painting*, Yale, (1985), Julian Treuherz, *Victorian Painting*, Thames & Hudson, (1993), and *The Victorians: British Painting 1837–1901*, exhibition catalogue, National Gallery of Art, Washington, (1997). On architecture see Kenneth Clark, *The Gothic Revival: An Essay in the History of Taste*, Pelican, (1964); Megan Aldrich, *Gothic Revival*, Phaidon, (1994); Mark Girouard, *The Victorian Country House*, Clarendon Press, Oxford, (1971); J. Mordaunt Crook, *The Dilemma of Style: Architectural Ideas from the Picturesque to the Post-Modern*, John Murray, (1987).

For the Victorian cult of the British past see Roy Strong, *And When Did You Last See Your Father?: The Victorian Painter and British History*, Thames & Hudson, (1978), and Peter Mandler, *The Fall and Rise of the Stately Home*, Yale, (1997). For Victorian theatre see George Rowell, *The Victorian Theatre 1792–1914. A Survey*, Cambridge, (1978).

For the later Victorian and Edwardian periods see Samuel Hynes, *The Edwardian Turn of Mind*, Princeton, (1968); Jose Harris, *Private Lives, Public Spirit: Britain 1870–1914*, Penguin Books, (1994); Martin Weiner, *English Culture and the Decline of the Industrial Spirit, 1850–1980*, Penguin, (1992), and Georgina Boyes, *The Imagined Village: Culture, Ideology and the English Folk Revival*, Manchester U.P., (1993). For architecture see Mark Girouard, *Sweetness and Light: The 'Queen Anne' Movement 1860–1900*, Clarendon Press, Oxford, (1977), and *Lutyens: The Work of the English Architect Sir Edwin Lutyens (1869–1944)*, exhibition catalogue, Arts Council, (1981). *Art Treasures of England: The Regional Collections*, exhibitions catalogue, Royal Academy, (1998) describes the development of regional museums and galleries. For the musical renaissance see Michael Trend, *The Music Makers: Heirs and Rebels of the English Musical Renaissance: Edward Elgar to Benjamin Britten*, Weidenfeld & Nicolson, (1985), and Peter J. Pirie, *The English Musical Renaissance*, Victor Gollancz, (1979).

The Twentieth Century

Modernism is a bewildering and difficult topic but try Malcolm Bradbury and James McFarlane, *Modernism: A Guide to European Literature 1890–1930*, Penguin, (1991 ed.). Its most important impact in England was on literature for which see Christopher Gillie, *Movements in English Literature 1900–40*, Cambridge, (1975); *The Context of English Literature 1900–1930*, ed. Michael Hall, Methuen, (1980) and Quentin Bell, *Bloomsbury*, Phoenix, (1986). For the visual arts see Frances Spalding, *British Art since 1900*, Thames & Hudson, (1986), and J. Mordaunt Crook's *The Dilemma of Style* cited earlier.

The period 1945–80 has attracted more overviews than the first half of the century: Arthur Marwick's *Culture in Britain since 1945*, Basil Blackwell, (1991), *British Society since 1945*, The Penguin Social History of Britain, (1996 ed); Robert Hewison's *Culture and Consensus: England, Art and Politics since 1940*, Methuen, (1995), *Too Much: Art and Society in the Sixties 1960–75*, Oxford, (1987), and *In Anger: Culture in the Cold War 1945–60*, Oxford, (1981); Andrew Sinclair, *Arts and Cultures: The History of the 50 Years of the Arts Council of Great Britain*, Sinclair-Stevenson, (1995); Bryan Appleyard's *The Pleasures of Peace: Art and Imagination in post-war Britain*, Faber, (1989), *The Culture Club: Crisis in the Arts*, Faber, (1984); Alan Sinfield's *Literature, Politics and Culture in Postwar Britain*, Basil Blackwell, (1989) and as editor *Society and Literature 1945–1970*, The Context of English Literature, Methuen, (1983).

For Kenneth Clark see Meryle Secrest, *Kenneth Clark: A Biography*, Weidenfeld & Nicolson, (1984); his own two volumes of autobiography *Another Part of the Wood: A Self-Portrait*, John Murray, (1974) and *The Other Half: A Self-Portrait*, John Murray, (1977), and his *Civilisation: A Personal View*, BBC & John Murray, (1969).

PICTURE CREDITS

INDEX

NOTE: page numbers in *italics* refer to illustrations

abbeys, 46, 51-2, 59
Abbotsford (house), 506
Abel, Carl Friedrich, 444
Academy of Ancient Music, 380, 425
Academy of Vocal Music, 380
Ackroyd, Peter, 678
Act of Uniformity (1559), 147
actors and acting, 208-9, 378, 420-1, 442-3, 477, 580-1, 656, *see also* drama; theatres
Adam, James, 404
Adam, Robert, 399, 401-4, 408-9, 452, 463; *Works in Architecture*, 404, *406*
Adamson, Robert, 544
Addison, Joseph, 361-3, 365-6, 371, 415; *Remarks on Several Parts of Italy*, 396
Adelard of Bath, 44
Adelphi, London, 404
Admiralty Arch, London, *574*
Aelred of Rievaulx: *Mirror of Chastity*, 59
Aesthetic Movement, 568-9, *569*, 587-8
Aethelbert, Kentish king, 23
Aethelred, King of the English, 35
Aethelstan, King of the English, 34
Aethelwold, St., Bishop of Winchester, 21, 34-5
agnosticism, 547
Agricola, Julius, 12
agriculture: revolution (18th century), 428-9, 431, 477; late Victorian depression, 563
Aidan, St., 25
alabasters, *105*, 107
Albert, Prince Consort, 544, 548, *549*, 550-1, *552*, 553-4, 556-8, 560
Albert Hall, London, 566, 576
Albert Memorial, London, 537, *549*
Alberti, Leone Battista, 225
Albury, Surrey, *250*
Alciati, Andrea: *Emblemata*, 178
Alcuin of York, 31
Aldeburgh Festival, 644
Aldhelm of Malmesbury, St., 31
Alexander, Sir George, 581-2, *583*
Alfred (the Great), King of Wessex, 34, 417
All Saints, Margaret Street, London, 536, *537*
Alleyn, Edward, 206, 208
Alma-Tadema, Sir Lawrence, 564, 587
Alnoth, 49
Amadei, Filippo, 347
American colonies: loss of, 394, 426
Amesbury abbey, 300, *300*
Amis, Sir Kingsley: *Lucky Jim*, 659
Ancient Monuments Act (1882), 570
André, Bernard, 118
Andrewes, Lancelot, Bishop of Winchester, 268-9
Angevin empire, 46

Anglo-Saxon language, 34
Anglo-Saxons: art and literature, 22-35, *26-7*, *29*, 56; monasteries, 30-1; defeat by Normans, 37, 39
'Angry Young Men', 641
animals, 683
Annandale, James Johnston, 2nd Marquess of, 400
Anne Boleyn, Queen of Henry VIII, 128, 139, 142, 147, 156, 158, *163*, 165, 170
Anne of Denmark, Queen of James I, 206, 218, 245, 259
Anne, Queen, 331-2, 361, 380, 392
Anrep, Helen, 670
Anselm, St., 43
antiquities: interest in and collection of, 241, 244-6, *246*, 248-9; studied and collected on Grand Tour, 398-9, 410-11
Aquinas, St. Thomas, 112, 134
Arabs: and learning, 41, 66-7
Arcadia: nostalgia for, 263-4
Archer, Thomas, 330, 343
architecture: Renaissance, 225, 229-30; neo-classical, 401-4, *405*, *406*, *407*, 408; and modernism, 629-32, 664; state, 644-9
Arden, John, 658
Ariosti, Attilio, 383
aristocracy: relations with monarchy, 330; power of, 333; patronage by, 361; and Grand Tour, 385, 394-5, 402, 422; and virtues of antiquity, 426; Victorian view of, 520-1; decline of power, 563; attitude to industry, 567
Aristotle, 41, 66, 72, 112, 134
Arles, Council of (AD 314), 18
Armitage, Edward: *Caesar's Invasion of Britain*, 555
Arne, Thomas, 379-80, 384, 422
Arnold, Matthew, 516, 530; *Culture and Anarchy*, 567; *Dover Beach*, 529
Arran, Earl of, 264
Arrighi, Ludovico degli, 134
art collecting: royal, 228, 245, 254, 261-2, 294; Buckingham's, 233; Arundel's, 239, 241, 244-51; personal, 262; Burlington's, 347; and Grand Tour, 400-1
art deco, 627-8, *628*, 631
art education, 494-6, 654
Art Journal, 539
Art Nouveau, 592
Art Workers' Guild, 596
Artari, Giuseppe, 309
Artists International Association, 626-7
Arts Council, 612, 641-2, 672, 674, 676
Arts and Crafts Exhibition Society, 596
Arts and Crafts movement, 534, 570, 573, 593-4, 596-7, 629-30, 680
Arundel House, 241, 245, 248, *249*, 290,

401
Arundel, Aletheia, Countess of (*née* Talbot), 241-2, *242*, 245, 250
Arundel, Philip Howard, 1st Earl of, 140, 241
Arundel, Thomas Howard, 2nd Earl of, 229, 239, *240*, 241-51, 394
Arundel, Thomas Howard, 14th Earl of, 267
Arup, Ove, 606, 629
Ashbee, Charles Robert, 573, 596
Ashcroft, Dame Peggy, 620
Ashton, Sir Frederick, 620, 636, 660, 664
Asquith, Herbert Henry, 1st Earl, 576
Asser, Bishop of St. David's, 34
Association for Business Sponsorship of the Arts (ABSA), 677
astrolabe, 44
astrology, 276, 286
astronomy, 28, 42, 67, 276, 282, 285
Atkinson, William, 506
Attaventi, Attavante degli, 134
Atterbury, Francis, Bishop of Rochester and Dean of Wesminster, 348
Aubert, David, 116
Auden, Wystan Hugh, 614, 616, *616*, 661
Audley End, Essex, 236
Augustan age, 371, 376
Augustine, St., 19, 23, 60, 514; Gospels, *24*
Austen, Jane, 486-7, 664
Austen, Ralph: *A Treatise of Fruit-Trees*, 281
Averroes, 66
Avicenna, 66

Babbage, Charles, 556
Bach, Johann Christian, 444
Bacon, Francis, 248, 254, 279-81, 283, *283*, 284, 302-3, 417; *Advancement of Learning*, 280; *Essays*, 187; *Instauratio Magna*, 275; *Novum Organum*, 273, 279; *Of Travel*, 394
Bacon, Francis (painter), 653; *Three Studies for Figures at the Base of a Crucifixion*, 654
Bacon, Roger, 66
Bagutti, Giovanni, 309
Baker, Dame Janet, 662
Baldwin, Stanley, 608
Bale, John, 145
ballet, 620, *622*, 636, 641, 660, 664, 678
Balmoral, Scotland, 551
Baltzar, Thomas, *317*
Balzac, Honoré de, 565, 604
Bancroft, Marie Effie, Lady, 581
Bancroft, Sir Squire, 581-2
Banister, John, *317*
Bank of England, 502, 508, *510*
Bantock, Granville, 580
Barbican Centre, London, 648
Barbirolli, Sir John, 622
baroque style, 308-12, 315-16, 328, 333, 336, 342-3
Barrett, Thomas, 459
Barrie, Sir James Matthew, 585

Barry, Sir Charles, 536, 553
Barry, Elizabeth, 378
Basevi, George, 505
Basing House, Hampshire, 292
Bassano family (musicians), 162
Bath: Roman (Aquae Sulis), 14, 16; Royal
 Crescent, *407, 408, 680*; as social/cul-
 tural centre, 445; Georgian building,
 502; Festival, 644
Batoni, Pompeo, 392, 397
Baudelaire, Charles, 568
Bauhaus, 627, 632
Bawden, Edward, 626
Bax, Sir Arnold, 580
Bayeux Tapestry, 37, *37*
Baylis, Lilian, 619-20
Beardsley, Aubrey, 565; *The Toilet of
 Salome*, *565*
Beatles, The, 663, *663*
Beaufort, Margaret, Countess of
 Richmond, 134
Becket, St Thomas, 44, 63, 87, 143
Beckett, Samuel, 657-8
Beckford, William: builds Fonthill, 501;
 Vathek, 486
Becon, Thomas, 190
Bede, Venerable, 21, 28, 30, 44;
 Ecclesiastical History of the English People,
 21, 30
Bedford, Francis Russell, 4th Earl of, 267
Bedford, John of Lancaster, Duke of, 107
Bedford Park, *572*
Bedford Square, London, 408
Bedingfield family, 348
Beecham, Sir Thomas, 579, 622
Beethoven, Ludwig van, 476
Behan, Brendan, 658
Behn, Aphra, 323
Bell, C.F., 668, 670
Bell, Clive, 610, 624
Bell, Vanessa, 610, 624, 626
Bellin, Nicholas, 160-1
Bellori, Giovan Pietro, 308
Belvoir Castle, Rutland, 506, *507*
Benedict Biscop, abbot of
 Monkwearmouth and Jarrow, 30
Benedict, St.: Order, 28, 34-5, 54, 56, 58
Benedictional of St. Aethelwold, *20*, 35
Bennett, Sir William Sterndale, 577
Bentley, Richard, 451-3
Bentley, Thomas, 398, 408
Beowulf (epic poem), 23
Berenson, Bernard, 670
Bernard, Oliver P., 628
Bernini, Giovanni Lorenzo, 312, 328, 343
bestiaries, 43, *45*
Betjeman, Sir John, 659
Betterton, Thomas, 324, 378
Beveridge Report (1942), 638
Beverley, Yorkshire: mystery plays, 109
Bewcastle, Cumberland, 31, *32*
Bewick, Thomas, 632
Bible, Holy: as revealed word of God,
 41-2; as authority, 66; English versions,
 89, 141, 144, 220; and humanism, 134;
 Latin and Greek translations, 138;
 popular influence, 107; meanings, 178;
 scientific study of, 514-15; in common
 culture, 609
Birmingham: Symphony Orchestra, 662;
 concert hall, 678
Birmingham Royal Ballet, 678
Birtwistle, Sir Harrison, 662
Black Death, 74-5, 92
Blackwood's Magazine, 485

Blaise Hamlet, near Bristol, 507
Blake, Peter, 663
Blake, William, 296, 476, 489-90, 494,
 497, 500, 632, 681; 'London', *488*;
 'Jerusalem', 577
Blast (magazine), *624*, 625
Blenheim Palace, Oxfordshire, 309, 332,
 332, 333, 337, 429
Bliss, Sir Arthur, 621
Blomfield, Reginald, 573
Bloomsbury Group, 610-11, 624, 641
Blore, Edward, 551
Blount, Martha, 373
Blow, John, 316; *Venus and Adonis*, 324
Blunt, Wilfrid Scawen, 602
Boethius: *The Consolation of Philosophy*, 40
Bolingbroke, Henry St John, Viscount, 367
Bomberg, David, 625
Bononcini, Giovanni, 347, 378, 383
Book of Common Prayer, 144, 147-8, 295,
 300, 609
Book of Hours, 107
Book of Sports, 291
book trade: and early universities, 65; and
 printing, 107; and copyright, 422
Boothby, Sir Brooke, 436, *437*
Borcht, Hendrik van der, 246
Bordoni, Faustina, 383, *383*
Boswell, James: *Life of Samuel Johnson*, 442
Boswell, John, 190
Boudicca, Queen of the Iceni, 11
Boughton, Rutland, 580
Boult, Sir Adrian, 622
Bowood, Wiltshire, 404
Bowyer's Historic Gallery, 495
Boyce, William, 379, 384
Boydell, John, 494-5, 555
Boyle, Robert, 282-3, *284*
Brain, Dennis, 662
Braine, John, 659
Branagh, Kenneth, 656
Breuer, Marcel, 645
Brian, Havergal, 580
Bridge, Frank, 621
Bridgeman, Charles, 352, 367
Briggs, Henry, 278
Brighton Pavilion, 501, *501*
Bristol: St Mary Redcliffe church, 103, 108;
 St Mary le Port church, 635
Bristol, Frederick Augustus, 4th Earl of,
 Bishop of Derry, 410
Bristol Old Vic, 656
Britannia (figure), *18*, *18*
British Broadcasting Corporation (BBC),
 612, 622-3, 642-3; Third Programme,
 636, 637, 642, 662
British Council, 642
British Museum, 501-2, 505
Britten, Benjamin, Baron, 661-2, *661*, 664;
 War Requiem, 648, 662
Brixworth church, Northamptonshire, 33
Brome, Richard, 268; *The Love-Sick Court*,
 270
Brontë, Emily, Charlotte and Anne, 527
Brook, Peter, 656
Brooke, Rupert, 610
Brookner, Anita, 666
Brouncker, William, 2nd Viscount, 283
Brown, Ford Madox: *Work*, 544
Brown, Lancelot ('Capability'), 415,
 429-30, 539, 681
Browne, Sir Thomas, 297
Browning, Elizabeth Barrett, 530
Browning, Robert, 530
Bruce, Charles, 1st Baron, 350

Bruges, 115
Brummell, George ('Beau'), 482
Brunel, Isambard Kingdom, 534
Brutus (grandson of Aeneas), 418
Buccleuch, Henry Scott, 3rd Duke of, *434*,
 470
Buchanan, George, 462
Buchell, Arend van, 206
Buckenham, Anne, 107
Buckingham, George Villiers, 1st Duke of,
 232-3, *234-5*, 243, *254*; assassinated,
 243, 248, 255
Buckingham Palace, 501, *502*, 551, 553,
 564, 574
Bull, John (musician), 228
Bunbury, Lady Sarah, *411*
Bunyan, John: *The Pilgrim's Progress*, 302,
 302
Burbage, James, 206, 208
Burbage, Richard, 206
Burghley House, Northamptonshire, *334*,
 429
Burghley, William Cecil, Baron, 173, 176,
 195, 294
Burgundy, 99, 112-13, 115-16, 118, 151
Burke, Edmund, 365, 442, 443; *On the
 Sublime*, 428-9, 432, 434, 451, 458;
 Reflections on the French Revolution, 431,
 479
Burlington House, Piccadilly, London, 350,
 401
Burlington, Dorothy, Countess of (neé
 Savile), 347
Burlington, Richard Boyle, 3rd Earl of,
 344, 345, 346-52, 354, 358, 371, 381,
 388, 390, 402, 420, 446
Burne-Jones, Sir Edward, 588
Burney, Charles, 442; *A General History of
 Music*, 431
Burney, Fanny, 486
Burns, Robert, 465-6
Burton Agnes, Yorkshire, *194*
Burton-on-Humber: St Peter's Church, 36
Butler, Reg: *Unknown Political Prisoner*,
 653, *653*
Butler, Samuel (1612-1680): *Hudibras*,
 325-6
Butler, Samuel (1835-1902), 600
Butterfield, William, 536, 537
Byatt, A.S., 664
Byland abbey, Yorkshire, 59
Byrd, William, 190-2, 380, 424
Byres, James, 398
Byron, George Gordon, 6th Baron, 481,
 489, 491-2, *491*; *Manfred*, *474-5*
Byzantine Empire, 67; art, 47, *47*, 56

Cabbala, 275
Caedmon, 32
Caerleon, 14
Caesar, Julius, 1
calendar, 44
Calvinism, 462-3, 466, 468
Cambridge Platonists, 342
Cambridge University: beginnings, 64-5;
 King's College, 95, 127, 134;
 humanism in, 134; St. John's College,
 134; Emmanuel College, 170; and
 natural sciences, 278, 281; Fitzwilliam
 Museum, 505
Camden, William, 250
Cameron, Julia Margaret, 544, 547
Campbell, Colen, 350; *Vitruvius
 Britannicus*, 343, 349
Campbell, Mrs Patrick, 583

Campeggio, Cardinal Lorenzo, 129
Canaletto, Antonio, 367
Canary Wharf, London, 683
Canterbury: diocese established, 23-5;
 Christ Church, 56
Canterbury Cathedral: origins, 18;
 building, 46, 47, 47, 54, 70, 96; Gothic
 rebuilding, 59; shrine of St. Thomas,
 63-4, 143; desecrated by Puritans, 292,
 293
Canute, King of the English, 35
Cape, Jonathan, 618
Carew, Thomas, 263-4, 290; Coelum
 Britannicum, 258, 260
Carleton, Sir Dudley, 242, 248
Carlisle, Charles Howard, 3rd Earl of, 333,
 336
Carlisle House, Soho Square, 444
Carlyle, Thomas, 517, 519, 521, 546
Carmeliano, Pietro, 133
Caro, Anthony, 654
Carroll, Lewis, 597, 681
Carthusian Order, 58, 99
Cary, Joyce, 658
Cassilis, David Kennedy, 10th Earl of, 404
Cassiodorus, 29-30; Institutiones, 28
Castell, Robert: Villas of the Ancients, 354
Castiglione, Baldassare: The Courtier, 137,
 164-5
Castle, Barbara, Baroness, 646
Castle Howard, Yorkshire, 333, 336, 336
castles: building of, 46, 48-9, 51; Welsh,
 69; as residences, 86; 19th-century
 building of, 506
Castrucci, Pietro, 347
Cat, Christopher, 366
cathedrals: building of, 33, 46, 51-2, 54,
 69-70, 72, 82, 84; shrines, 63; as
 symbols of faith, 66-9; wealth, 70, 72;
 desecrated by Puritans, 292-4, 293;
 design, 683; see also individual
 cathedrals
Catherine of Aragon, Queen of Henry VIII,
 117-18, 120, 133
Catherine Parr, Queen of Henry VIII, 159
Catholic Emancipation Act (1829), 511,
 516, 518
Catholicism: 19th-century revival, 516-17
Catuvellauni (tribe), 14
Caus, Isaac de, 260, 299
Caus, Salomon de, 227-8
Cavendish family, 174
Cavendish, George, 121, 125
Caxton, William, 116-17
Cecil family, 174
Celts: and Romans, 9-14, 16, 19;
 Christianity, 25; literature, 423-4;
 culture, 482, 679, 684; and modern
 nationalism, 679
censorship: abolished under Protectorate,
 298; returns under Restoration, 300,
 319, 321; ceases after lapse of Licensing
 Act, 362; reintroduced (1843), 581; lit-
 erary, 597; abolished for stage (1968),
 639
Central School of Arts and Crafts, 596
Central School of Speech and Drama, 582
Ceolfrith, abbot of Jarrow, 29
ceramics, 408-9, 408
Chalgrove, Oxfordshire: St. Mary parish
 church, 68
Chambers, Geoffrey, 134
Chambers, Sir William, 401-3
Chandos, James Brydges, Duke of, 381
Chantmarle House, Dorset, 195

Chantrey, Sir Francis, 588
Chapel Royal, 116, 126, 154, 156, 162,
 190, 192, 206, 295, 298, 316-17, 340,
 424-5
Chapman, George, 211, 228
Charlemagne, Emperor, 31
Charles the Bold, Duke of Burgundy, 113,
 115
Charles Edward Stuart, Prince (the Young
 Pretender), 390
Charles I, King: aesthetic interests, 221;
 marriage, 222, 231; and Buckingham,
 243; art collection, 245; reign and
 court, 252, 253, 254-5, 254, 256-7, 259,
 267, 351; executed, 261, 291, 294, 299;
 and religious status, 270; in Civil War,
 290; perceived as papist, 295; and Inigo
 Jones, 349; children, 683; Eikon
 Basilika, 303
Charles II, King: and Royal Society, 282,
 283; restoration, 300, 302; state entry
 into London, 306, 308, 308; pictured,
 307, 683; and baroque, 309, 311-12,
 328; status as monarch, 309, 315-16;
 and music, 316-17; and theatre, 319,
 321; attempts to establish opera, 323-4;
 death, 324; Dryden celebrates, 326
Charlotte, Princess (daughter of George
 IV), 550
Chartism, 518-19
Chatsworth House, Derbyshire, 328, 329,
 330, 333, 356, 401
Chatterton, Thomas, 440
Chaucer, Geoffrey, 87-8, 91, 422, 684;
 Works, 594
Chelsea Hospital, London, 315
Cheltenham, 503
Chepstow Castle, 48
Chermayeff, Serge, 606, 629
Chester, 14; Castle, 503
Chicheley, Henry, Archbishop of
 Canterbury, 95
Chichester theatre, 656
children: literature for, 597
Chippendale, Thomas, 408
Chipping Campden, 292
Chiswick House, 350-2, 350, 351, 353,
 355, 446
chivalry: and world of knights, 48, 49, 50,
 74, 76-7, 77, 78, 79; and monarchy,
 80-1; learned, 112-13, 116, 118;
 Elizabethan, 173, 176; and portraiture,
 222; Stuart, 227
Christian IV, King of Denmark, 224
Christianity: introduction to Britain, 2,
 18-19, 23-5; and monastic life, 21-2,
 28; Anglo-Saxon, 22-31; and revival and
 preservation of learning, 25, 28, 41;
 early art, 30; architecture, 31, 66-7;
 and Gothic art, 60, 62; and classical
 learning, 66; and personal devotion,
 88-90, 89, 98-100, 105, 107; and
 dramatic re-enactment, 107-10; and
 State, 110, 112; and humanism, 137,
 see also Church; Church of England
Christie, John, 623
Christina, prioress of Markyate, 56
chronology, 44
Church: preserves early learning, 22;
 feasts, 28; and scholasticism, 39; and
 State, 44, 51; and dedication of art, 51;
 hierarchy, 51; wealth, 75, 99; and
 worship, 100, 103, 105; and humanist
 reform, 137, 139; and Reformation,
 139, 140-9; rites and liturgy, 52, 141,

 144-5, 149; and
 iconoclasm, 142, 143-7, see also
 Christianity; monasteries
Church of England: founded, 147; and
 music, 190-2, 424-5; ceremonial, 220,
 261, 268-70; during Civil War, 274;
 Puritan assault on, 291, 295; Parliament
 dismantles, 292; reconstituted under
 Restoration, 300; and rebuilding after
 Great Fire of London, 312, 314;
 acceptance of Bible as historical text,
 515; relations with State, 516
churches: Anglo-Saxon, 31, 35, 36, 58;
 post-Conquest, 50, 54-6, 58; liturgical,
 52, 64, 69; as symbols of Christian faith,
 66-8; parish reform, 72; redesigned,
 72; decoration and enrichment, 103-4;
 music in, 104-5; in Reformation, 144;
 Puritan desecration of, 269, 291-2;
 rebuilding under 1710 Act, 332; 19th-
 century building of, 503-4, 536-7
Churchill, Sir Winston: Sutherland portrait
 of, 652
Chute, John, 448, 452
Cibber, Colley, 373, 378
cinema, 566, 612
Cirencester (Corinium), 14
Cistercian order, 44, 58-9
Civil War (1642-6), 241, 251, 272, 274,
 288, 290-1
Clare, John, 489, 494
Clarence, Albert Victor, Duke of: tomb,
 592, 592
Clarendon, Edward Hyde, 1st Earl of, 239
Clark, Jane, Lady (née Martin), 670-2
Clark, Kenneth (later Baron), 633, 666,
 667, 668-74, 669; Civilisation (TV series),
 666, 672
Clarke, Jeremiah, 361
class (social): 18th-century composition,
 360-4; and cultural life, 365-6, 445;
 and Grand Tour, 395; and sensibility,
 437-9, 445; and French Revolution,
 476; and technological/industrial revo-
 lution, 477-8; and upward mobility,
 518, 521
classicism: in architecture, 167-9, 501,
 506; under Stuarts, 224, 232, 258;
 readopted in 18th century, 357, 371;
 Pope and, 377; and Grand Tour, 396-
 401
Claude Lorraine, 396, 412, 497, 508
Clayton, Thomas, 382
Clifton Suspension Bridge, 534
Cliveden, Buckinghamshire, 536
Clopton, John, 103
Clouds (house), Wiltshire, 573
Clough, Arthur Hugh: 'Easter Day', 516
clubs, 366-7, 504-5
Cluny, France, 34, 54, 56
Coates, Eric, 623
Coates, Wells, 612, 632, 633
Cobbett, William, 485
Cobham, Richard Temple, Viscount, 357,
 415, 417
Cockerell, Charles Robert, 503, 504-5
Cockpit Theatre, Drury Lane, 299, 319
Codex Amiatinus, 29, 30
coffee houses, 366
Cogidubnus, 16
coinage: Celtic, 11; Roman, 17-18, 18
Coke, Daniel Parker, 438
Coke, Rev. D'Ewes and Hannah, 438
Coke, Thomas, 350
Colchester, 16

Coldstream, Sir William, 616, 627, 654
Cole, Sir Henry, 556-7
Coleridge, Samuel Taylor, 473, 489-91
Coleridge-Taylor, Samuel, 580
Colet, John, Dean of St. Paul's, 130, 134, 136, *136*, 138
Collenuccio, Pandolfo: *Apologues*, 135
Collier, Jeremy: *Short View of ... the English Stage*, 338
Collins, Wilkie, 528
Collins, William, 439
Columba, St., 25
Commonwealth, 638
communism, 608
Compton-Burnett, Dame Ivy, 610
Concert of Ancient Music, 426
Congreve, William, 337-8
Coningsby, Thomas, Earl, 338
Conisborough, near Sheffield, 49
Connell, Amyas, 629, 632
Connoisseur (magazine), 362
Conrad, Joseph, 599, 606, 617
conservatism: as national characteristic, 680
Conservative Party: postwar governments, 664, 674
Constable, John, 497, 499-500, 632, 681; *Salisbury Cathedral from the Meadows*, 499
Constantine I (the Great), Roman Emperor, 4, 6, 18
Conwy Bridge, 509, *511*
Cooke, Henry, 317
Cooper, Samuel, 298, 310
Cope, Charles West: *The First Trial by Jury*, 555
Coperario, John, 236
Copernicus, Nicholas, 276, 285
Copley, John Singleton, 435; *Siege of Gibraltar*, 495
copyright, 362, 422, 582
Corn Laws: repealed (1846), 518
Cornbury, Henry Hyde, Viscount, 392
Corneille, Pierre, 323
Cornhill Magazine, 524
Cornyshe, William, 163
Corpus Christi (feast), 109
Corpus Hermeticum, 274
Corsham Court, Wiltshire, 400
Cotes, Francis, 436
cottages, 506-7, *506*, *554*
Cottingham, L.N.: *Working Drawings for Gothic Ornaments*, 456
Cotton, Sir Robert, 248-9
Council for the Encouragement of Music and Arts (CEMA), 634, 641
Council of Industrial Design, 650
Counter-Reformation, 222
country houses: post-Reformation, 167; Elizabethan, 192, 195-6, 199; Renaissance, 231, 300; as icon and heritage, 232, 608, 665, 680; baroque, 333; and Grand Tour, 394; neo-classical, 403-4; and picturesque, 505-9; closure and demolition of, 563
countryside *see* landscape; Nature
Courant (Scottish journal), 468
court (royal): as centre of art and culture, 74, 80, 85-6, 111-13, 115-18, 164-6
courtly love, 50, 76, 374
Covent Garden: development, 267
Covent Garden theatre, 383, 443
Coventry: mystery plays, 109; Cathedral, 648, *648*, 652, 662; Belgrade Theatre, 657
Coward, Sir Noël, 619, 656-7

Cowley, Abraham, 291, 325
Cowper, William: 'Charity', 419; 'Friendship', 439-40
Crabbe, George, 661
Crafts Council, 650
Cragside, Northumberland, 572
Craig, Edward Gordon: *The Art of Theatre*, 586
Craig, James, 470-1
Crane, Walter, 568, 596
Cranmer, Thomas, Archbishop of Canterbury, 142, 144, 148, 190
Crashaw, Richard, 296-7
crime: increase (14th century), 75
Critical Review, 362
Cromwell, Oliver, 297-300
Cromwell, Richard, 300
Cromwell, Thomas, 127, 143-4
Croome Court, Worcestershire, 404
crosses (Christian), 28, 29, 31-2, *32*
Crown *see* monarchy
Crozier, Eric, 661
Crusades, 38, 47-8, 50, 62, 72
Crystal Palace, London, 536, 539, 548, 557, 560, 576
Cubism, 623
Cubitt, Thomas, 551
Cullen, Dr William, 469
Culzean Castle, 404
Cumberland, George Clifford, 3rd Earl of, 179
Cunningham, Allan: *Lives of the Most Eminent British Painters, Sculptors and Architects*, 586
Curzon, Clifford, 622
Cuthbert, St.: cross, 28, 29; remains and relics, 54, 62, 143
Cuzzoni, Francesca, 383, *383*

Daily Mail, 567
Danby, Henry Danvers, Earl of, 262
dance: and world view, 210, *see also* ballet
Dance, George, 504
Daniel, Samuel: *The Civil Wars*, 185
Dark Ages, 19, 22
Darwin, Charles: *The Origin of Species*, 514
D'Avenant, Sir William, 264, 268, 299, 319; *The Platonick Lovers*, 270; *The Siege of Rhodes*, 299, *299*
David I, King of Scotland, 58-9
Davie, Donald, 659
Davies, Sir Peter Maxwell, 662
Davies, Sir Walford, 580, 623
Davis, Moll, 324
Deanery Garden, Sonning, Berkshire, *575*, 576
Decker, Paul: *Gothic Architecture Decorated*, *452*
Dee, John, 278
Defoe, Daniel, 361-2, 374-5; *Moll Flanders*, 374; *Robinson Crusoe*, 374; *A Tour of the Whole Island of Britain*, 358; *True Born Englishman*, 418
de la Mare, Walter, 600
Delaney, Shelagh, 658
Delius, Frederick, 579-80
Denby, Elizabeth, 632
Dench, Dame Judi, 656
Denham, Sir John: 'Cooper's Hill', 271-2
Dennis, John, 321
Department of National Heritage (*later* Department for Culture, Media and Sport), 642, 676
Department of Practical Art, 558

Derngate (no.78), Northampton, *573*
Descartes, René, 279, 284; *Discourse on Method*, 277
Design and Industries Association, 628
de Valois, Dame Ninette, 620, 622, 636
Devine, George, 657
Devonshire, William Cavendish, 4th Earl and 1st Duke of, 328
Diaghilev, Serge, 620
Dickens, Charles, 523, 525-6, 664; *The Pickwick Papers*, 525, *525*, 526
Dieussart, François, 250
Digby, Sir Kenelm, 262
Dio Cassius, 11
Disraeli, Benjamin, 520, 526; *Vivian Gray*, 486
Dobson, Frank, 626
Dobson, William, 288, 290
Dolin, Anton, 620
Dominican Order, 88
Donne, John, 236, 238, 258, 264
Dormer, General James, 357
Dostoevsky, Fedor, 565
Douglas, Gavin, 462
Dowell, Anthony, 660
Dowland, John, 191; *Lachrymae*, 190, 682
Downton Castle, Herefordshire, 508
Dowsing, William, 292
Drake, Sir Francis, 417
drama: religious, 107-10, 147-8; Elizabethan, 202, 204-6, 209-17; Puritan opposition to, 204, 291-2; companies, 206-7; under Stuarts, 268; under Restoration, 319, 321-2, 337; post-Restoration, 337-8, 340; elevation of, 420-1, *see also* masques; theatres
Drayton, Michael, 228; *Poly-Olbion*, 185
Dream of the Rood, The (poem), 32-3, 681
Dresser, Christopher, 558
Drury Lane theatre, 379, 442-3
Dryden, John: on Shakespeare, 213; translates Bellori, 308; on fancy, 310; and symphony anthems, 317; plays, 321, 323; and opera, 324, 341; poetry, 325-6, 376, 422, 683; and suppression of theatre, 338; Tonson publishes, 366; Handel and, 384; in English canon, 422-3; *Absalom and Achitophel*, 326; *The Conquest of Granada*, 323; *Marriage à la Mode*, 322; *Threnodia Augustalis*, 326
Dublin: Abbey Theatre, 586
Dubois, Nicholas, 349
Dughet, Gaspard, 412
Dulwich Art Gallery, 505, 508
du Maurier, George, 569
Dunbar, William, 462, 465
Duns Scotus, 75, 134
Dunstable, John, 104, 116, 682
Dunstan, St., Archbishop of Canterbury, 34
Dürer, Albrecht, 125
Durham cathedral, 54
Durrow, Book of, 25, *26-7*
Duveen, Joseph, Baron, 670
Dyce, William, 555; *Pegwell Bay*, 514, *515*
Dyfed, Wales, 58

Eadfrith (monk), 29
Easter: date, 28
Eastlake, Sir Charles, 540
Eastlake, Elizabeth, Lady, 540
Edgar, King of the English, 34-5
Edgeworth, Maria, 486
Edinburgh: neo-classical architecture in (New Town), 404, 408, 470-1, *471*; Dilettanti society, 445; as Scottish

capital, 463; as centre of learning, 468-9
Edinburgh Festival, 644
Edinburgh Magazine, 485
Edington, William of, Bishop of Winchester, 91
Edis, Robert, 594
Edmund, St., King of East Anglia: shrine, 63, 143
education: at court, 85-6; and humanism, 133-4, 136-7; 17th-century, 280; in Scotland, 462, 468; art, 494-6, 654; and working class, 566-7, 597; general secondary, 607; post-war, 640
Education Acts: (1870), 567, 587, 597; (1944), 638
Edward, Black Prince, 81
Edward the Confessor, King of the English, 35, *37*, 63, 70, 376
Edward the Elder, King of the Angles and Saxons, 34
Edward I, King, 67-9, 79, 86, 423
Edward III, King, 74, 76, 79-81, 85-6, 91, 111, 116, 119
Edward IV, King, 115-17, 119, 133
Edward VI, King, 133, 144-5, *146*, 159, 168
Edward VII, King, 561, 564, 601
Edwardes, George, 585
Edwards, Edward, 426
Eglinton Tournament (1839), 520-1, *521*
Einstein, Albert, 604
Eleanor of Castile, Queen of Edward I, 69
Eleanor Crosses, 69, 292
Elgar, Sir Edward, 576, 578-80, *579*, 599, 621, 664, 682; *Pomp and Circumstance Marches*, 561, 577
Elgin Marbles, 496
Elgin, Thomas Bruce, 7th Earl of, 496
Eliot, George, 514, 516, 523, 527, 680
Eliot, Thomas Stearns, 606, 609, 613-15, *615*, 617, 640, 656, 659, 676; 'Little Gidding', 634
Elizabeth I, Queen: humanist education, 133; and Reformation, 147, 149; cult and reign, 149, 170, *171*, 173-7, 179, *180*, *181*, 185, 192, 199, 222; and architectural style, 168; parsimony, 169; and music, 190-1; and theatre, 205-6; death, 241, 679; Accession Day celebrated, 261; and status of monarchy, 270; in Stowe Temple of British Worthies, 417
Elizabeth, Princess (*later* Queen of Bohemia), 243
Elizabeth of York, Queen of Henry VII, 115, 128, 164
Elizabethan Stage Society, 585
Ellesmere, Francis Egerton, 1st Earl of, 553
Elliott, Sir Gilbert, of Minto, 465
Eltham palace, 294
Ely cathedral, 82, 83
Elyot, Sir Thomas: *The Boke Called the Governour*, 137
emblems and mottoes, 177-9, *178*, 199
embroidery, 37, *37*, *173*
Empire, British, 419, 477, 564-5, 600, *see also* Commonwealth
Encyclopaedia Britannica, 461
English Heritage, 677
English language: Latin elements, 19; at royal court, 86; as vernacular, 86-7; literary beginnings, 87; and spread of literacy, 107; standardisation of, 176; 18th-century literary, 370-1; as global

language, 614
English National Opera, 620, 662
English Opera Group, 662
English Stage Company, 657
Enlightenment, 287, 434-5, 481; in Scotland, 463-71
Epicurus, 277
Epstein, Sir Jacob, 606, 625-6, 648; *The Rock Drill*, 625, *625*
Erasmus, Desiderius, 130, *131*, 133, 136, 138, 141, 163; translation of Greek New Testament, *138*; *The Institution of a Christian Prince*, 137; *Praise of Folly*, 138
Esher Place, Surrey, 452-3
Essex, James, 452
Essex, Robert Devereux, 2nd Earl of, 170
Este family (of Ferrara), 132
Etherege, Sir George, 321; *The Man of Mode*, 322
Eton College, 95, 136; choir book, 105
Euclid: *Elements*, 41
European Union, 665, 679
Euston Road School (painters), 627, 654
Eutherius (Roman official), 6
Evangelicalism, 516, 523
Evans, Dame Edith, 620
Evelyn, John, 243-4, 281, 297, 306, 394, 449
Evening Standard, 484
Everyman (drama), 109
Exeter, John Cecil, Earl of, 333
Exeter, John Holland, Duke of, 86
Exeter, Thomas Cecil, 1st Earl of, 244
Eyck, Jan van, 99

Fabian Society, 640
Fairfax, Thomas, 3rd Baron, 297
Falkland, Lucius Cary, 2nd Viscount, 291
fancy (concept), 310
Farinelli (castrato singer), *383*
Farquhar, George, 337-8
Farrar, Nicholas, 634
fascism, 608, 611
Fayrfax, Robert, 162
Felbrigg Hall, Norfolk, 400
Fenton, Roger, 544
Ferdinand, Emperor, 243
Fergusson, Robert, 465-6
Ferrabosco, Alfonso, 162
Festival of Britain (1951), 643-4, *643*
festivals (popular): dwindle under Reformation, 148, 199-200; suppressed, 291; 18th-century decline, 365
Ficino, Marsilio, 179, 274
Field of Cloth of Gold (1520), 119, *119*, 163
Fielding, Henry, 374-5, 378, 525; *Amelia*, 375; *Joseph Andrews*, 375; *Tom Jones*, 360, 375
Fildes, Luke, 588
Fine Arts Commission, 553-4
Firbank, Ronald, 610
First Bishops' War (1638), 243
Fishbourne, near Chichester, Sussex, 16
Fisher, John, Bishop of Rochester, 134, 139
Fitzgerald, Edward, 531
fitzOsbern, William, 48
Flamsteed, John, 282
Flaxman, John, 409-10
Flemming, Robert, Dean of Lincoln, 133
Fleury (abbey), France, 34-5
Flodden, battle of (1513), 462
Florschütz, Christoph, 550
Flower, Bernard, 11, 125

folk culture, 199-200, 365
Folk Song Society, 570
folklore, 570
Fontainebleau, France, 159, 160-1
Fonteyn, Dame Margot, 620, 636
Fonthill Abbey, Wiltshire, 501
Forbes, Stanhope, 591; *A Fish Sale on a Cornish Beach*, 590
Forster, E.M., 611, 618; *Howards End*, 564, 618
Fortescue, Sir John, 85; *Governance of England*, 111
Foster, Sir Norman, 678
Foulis brothers (Edinburgh), 468
Foundling Hospital, London, 389
Fountains Abbey, Yorkshire, 59, 545
Fox, Richard, Bishop of Winchester, 134
Foxe, John: *Actes and Monuments*, 148, 273, 290
France: Gothic architecture, 69-70; cultural influence, 151, 160-1, 391; peace treaty with (1527), 151; wars with, 330, 333, 360, 384, 418, 479; on Grand Tour, 395; modern art influence, 590
franchise: extended, 426, 481, 511, 517, 519, 563, 566, 607, 612
Francis of Assisi, St., 73
Francis I, King of France, 119, 159, 160-1, 163
Franciscan Order, 88
Franco-Prussian War (1870), 563
Fraser, Claude Lovat, 619, 627
Fraser, Eric, 636
Frazer, Sir James George, 605
Frederick, Prince of Wales, 355
Free, John, 133
freemasonry, 348
French Revolution, 391, 394, 431, 434, 445, 473, 476, 478, *478*, 479, 482, 484, 487
Freud, Sigmund, 597, 604-5, 617, 623
Frink, Dame Elisabeth, 653
Frith, William Powell, 534, 540-1, 683
Frogmore, Windsor Great Park, 560
Froissart, Jean, 74, 76, 81, 92
Fry, Christopher, 656
Fry, Maxwell, 632, 645
Fry, Roger, 602, 610, 624, 627, 670
furniture, 408
Fuseli, Henry, 495-6
Fynes, Sir Colard, 78

Gabo, Naum, 626
Gaiety Theatre, 585
Gainsborough, Thomas, 432, 434, 436, 496, 587, 681, 683; *The Morning Walk* (painting), 432, *433*
Galeot of Mantua, Sir, *79*
Galileo Galilei, 276, 280
Galsworthy, John, 584
garden cities, 630-1
gardens: Tudor, 158-9; perspective in, 224; Renaissance, 248, 300; Evelyn and, 297; country house, 299-300, 328, 330, 336-7, 415; under Charles II, 311; and landscape, 352, 428-9, 502; Pope's, 352, 354, 377; William Kent's, 353-5, 357; urban, 539; and modern architecture, 576
Garrick, David, 420-2, 441-3, *444*
Garter, Order of, 74, 80, *81*, 107, 115, *152-3*, 312
Gaskell, Elizabeth Cleghorn, 526
Gaudier-Brzeska, Henri, 606, 625

Gaunt, John of, 2, 86
Gay, John, 361, 367, 482; *The Beggar's Opera*, 359, 379, *379*, 388, 619
General Strike (1926), 607
Gentleman's Magazine, 362
Geoffrey of Monmouth: *History of the Kings of Britain*, 43
George I, King, 361, 381
George II, King, 347, 361, 449
George III, King, 360, 381, 402, 428, 449
George IV, King, 487, 506, 550
George, St., 2, *2*
Gerbier, Balthasar, 233
Germany, 563, 606
Gheeraerts, Martin, 224
Gibberd, Frederick, 645, 647
Gibbon, Edward, 442; *Decline and Fall of the Roman Empire*, 419
Gibbons, Christopher, 299
Gibbons, Grinling, 309, 312, 333, 341
Gibbons, Orlando, 236
Gibbs, James, 367, 463
Gielgud, Sir John, 620
Gilbert, Alfred, 592
Gilbert, Sir W.S. and Sir A.S. Sullivan, 564, 569, 578
Gilbert, William: *De Magnete*, 278
Gill, Eric, 626
Gilling Castle, Yorkshire, 192
Gillray, James, 478, 479
Gilpin, William: *Observations on the Wye and South Wales*, 431
Gissing, George, 600
Glasgow: Royal Infirmary, 469; School of Art, 574; as European City of Culture, 678
Glasgow, Mary, 672
Glastonbury Abbey, 79
Glazier, Thomas, 96, 97
Globe theatre, London, *203*, 206; demolished (1642), 291
Glorious Revolution, 519
Gloucester Cathedral, 84
Glyndebourne, Sussex, 623, 662
Godeman (monk), 21
Godwin, William, 479, 492
Goehr, Alexander, 662
Goldfinger, Ernö, 645
Goldsmith, Oliver, 411, 442, 683
Gollancz, Sir Victor, 618
Gonzaga family (of Mantua), 132, 262
Gordon, Col. William, of Fyvie, *392*
Gordon, Gavin, 622
Gorges, Sir Thomas, 195
Gormley, Anthony: *The Angel of the North*, *675*, 678
Gosford, Archibald Acheson, 4th Earl of: daughters, *562*
Gothic style: architecture, 55-6, 59, 60, 66-70, 73, 82, 84-5, 357; art, 60; and Renaissance, 161; Walpole's revival of, 446, 449, 451-6; in novel, 456-9, 485; 19th-century revival, 501, 505, 507, 534, 536
Gould, Robert, 326
Goupy, Louis, 347
Government School of Design, London, 556, 558
Gowan, James, 649
Gower, John: *Confessio Amantis*, 87
Grabar, Louis: *Albion and Albanius*, 324
Grahame, Kenneth, 597
grammar: in education, 28, 42, 65-6
Grand Tour, 346-7, 352, 382, 385, 391, 392, 394-402, 410-12, 414, 418, 422, 448, 470

Grandisson, John, Bishop of Exeter, 90
Grant, Duncan, 611, 624, 626
Granville-Barker, Harley, 584-6
Gratian: *Decretum*, 42
Gray, Thomas, 448; 'The Bard', 391, 423; *Elegy in a Country Churchyard*, 438-9, *451*; *The Progress of Poesy*, 422
Great Exhibition (1851), 517, 548, 557-8, 559, 560
Great Tradition (painting), 385-6, 390
Great War (1914-18), 564, 602, *603*, 604, 606-8, *607*, 618, 622; poetry of, 614
Greathead, Bertie, 458
Greece (ancient): influence, 1-2, 41
Greek language: in education, 137
Green, Henry, 658
Greene, Graham, 659, 664
Greene, Maurice, 379, 384
Greene, Robert, 206, 209
Greenwich, *313*; Queen's House, *228-9*, 229-30, 294, 331; Royal Observatory, 277, 282; naval hospital, 331
Greenwich Palace, 118, 151, 155, 159, 311-12, 402
Gregory, Augusta, Lady, 586
Gregory the Great, Pope, 23, 24, 60; *Pastoral Rule*, 34
Grenville-Temple family, 415
Gresham College, 278, 282
Gresham, Sir Thomas, 278, 417
Grew, Nehemiah: *Philosophical History of Plants*, 284
Grey, William, Bishop of Ely, 133
Grieg, Edvard, 580
Griffiths, Sir Henry, 195
Grimbald, Bishop of Rheims, 34
Grimsthorpe Castle, Lincolnshire, 336
Grocyn, William, 130, 134
Gropius, Walter, 629
Grose, Francis: *Antiquities of England and Wales*, *457*; *Specimens of Gothic Architecture*, 456
Grosseteste, Robert, Bishop of Lincoln, 66-7
Grosvenor Gallery, London, 588
Grosvenor, Sir Richard, 358
Grove, Sir George, 576-7
Grüner, Ludwig, 553, 560
Guarino of Verona, 133
Guild of Handicraft, 596
Guildhall School of Music, 577
Guthrie, Sir Tyrone, 620, 634
Guthrum, 34
Gwynn, Eleanor ('Nell'), *322*

Habsburg monarchy, 252, 261
Hadrian, Roman Emperor, *15*, 18
Hadrian's Wall, 14, *17*
Hadrian (scholar), 24
Hailes, Gloucestershire, 62-3
Hakluyt, Richard, 187
Hales, Stephen: *Vegetable Statistics*, 284
Hall, Edward, 161; *Union of the Noble and Illustre Fameli es of Lancaster and York*, 167
Hall, Sir Peter, 656
Hallam, Arthur, 512, 530
Hallé Orchestra, 662
Hallé, Sir Charles, 577
Halley, Edmund, 285
Hamilton, Emma, Lady, 398
Hamilton, Gavin, 367, 398
Hamilton, Hamish, 618

Hamilton, Richard, 653, 655
Hamilton, Sir William, 397-8
Hammeline Plantagenet, 49
Hammond, Joan, 623
Hampden, John, 300
Hampton Court, Herefordshire, 339
Hampton Court, Middlesex: Wolsey and, 122-6, *125*, *126*; Henry VIII takes, 129; royal Court at, 155-6; enlarged, 158; and Tudor building, 192; under Protectorate, 298; garden, 311; rebuilt under William III, 330-1, *331*; opened to public, 522
Handel, George Frederick, 360-1, 370, 378, 380-1, 383, 424-6, 682; commemorated, 425-6, *427*, 428; *Messiah*, 384, 682; *Teseo*, 346, 383
Hanover, House of, 360, 390, 425
Hardwick Hall, Derbyshire, 173, 195, *198*, 199
Hardy, Thomas, 597-8, *598*, 621, 681
Harewood House, Yorkshire, 403
Harleston Park, *508-9*
Harlow New Town, *647*
Harold, King of the English, 35, 37
Harrow school, 505
Hartley, L.P., 658
Hartlib, Samuel, 281
Harvey, William, 250, 279
Hastings, battle of (1066), 37
Hatchards (booksellers), Piccadilly, 422
Hatfield House, Hertfordshire, 236
Hatton, Sir Christopher, 173, 195, 294
Hawes, Stephen, 118
Hawkins, Sir John: *A General View of the Science and Practice of Music*, 431
Hawksmoor, Nicholas, 309, 333, 350
Haydn, Joseph, 444, 476
Haydon, Benjamin Robert, 480, 495
Hayman, Francis, 366, 444
Heal, Ambrose, 628
Heckington, Lincolnshire: St Andrew's church, *108*
Heidegger, John James, 383, *383*, 388
Helpmann, Sir Robert, 620
Henri IV, King of France, 259
Henrietta Maria, Queen of Charles I, 222, 229-31, *254*, 255, *256-7*, 258-9, 261, 263-4, 300, 311
Henry II, King, 44, 46, 58
Henry III, King, 69-70
Henry IV, King, 78
Henry V, King, *81*, 103
Henry VI, King, 63, 95, 111, 118
Henry VII, King, 117-18, 122, 128, 133, 164
Henry VIII, King: marriage to Catherine of Aragon, 117, 120, 128; character and qualities, 118-20, *120*; and Wolsey, 122-4, 128-9; French wars, 123; divorce from Catherine of Aragon, 128, 139, 142; marriage to Ann Boleyn, 128, 142; education, 133; and humanism, 134; and Reformation, 139, 144; pilgrimage to Walsingham, 140; court and ceremonial, 151, *153*, 154-6, *155*, 164, 220; residences and possessions, 156, 158-61; musical interests, 162, *162*, 165; and painters, 163-4; progresses, 166; patronage, 169; and Elizabeth I, 170
Henry of Huntingdon, 51
Henry of Reyns, 70
Henry, Prince of Wales (son of James I), 221, *221*, 226-9, 245
Henryson, Robert, 462, 465

Hepworth, Barbara, 626, 653
Her Majesty's Theatre, London, 583
heraldry, 77-9, *78, 113*
Herbert, Sir Charles, 264
Herbert of Cherbury, Edward Herbert, 1st
 Baron, 187
Herbert, George, 268-9, 295, 531
Herland, Hugh, 82, 93, 96
Herrick, Robert, 233, 290; *Hesperides*,
 263-4
Herschel, Sir John Frederick, *546*
Hertford, William Seymour, 1st Marquess
 of, 300
Hervey, John, Baron, 351
Hess, Dame Myra, 622, 671
Hexham, 31
Heytesbury, William, 134
Heywood, John, 204
Hickes, Sir Baptist, *292*
Highmore, Joseph, 359
Hill, David Octavius, 544
Hill, Oliver, 631
Hilliard, Nicholas, 170, 173, 199, 200
Hinton St Mary, Dorset, 19
Hirst, Damien, 679
history: monastic writing of, 43-4
Hitler, Adolf, 608
Hoadly, Benjamin: *The Suspicious Husband*,
 444
Hoare, William, 428
Hobbes, Thomas, 282, 310; *Leviathan*, 324
Hockney, David, 654, 683
Hogarth, William, 360, 364, 366, 379,
 386-7, 389-90, 496, 687; *The Analysis of
 Beauty*, 386, *387*; *A Harlot's Progress*,
 388-9; *Marriage à la Mode*, 389, *390*;
 Masquerades and Opera, *387*, *388*; *A
 Rake's Progress*, 389, 683
Hoggart, Richard, 640
Holbein, Hans, 151, 156, 163-4, 245-6;
 designs, *157, 158*
Holdenby, Northamptonshire, 195, 294
Holinshed, Raphael, 210; *Chronicles*, 187
Holkham Hall, Norfolk, 350, 353, *400*,
 401
Holland, Henry Fox, 1st Baron, 451
Hollar, Wenceslaus, 205, 249, 250
Holst, Gustav, 621, 664
Home House, Portman Square, London,
 404
Home, John: *Douglas*, 468
Honorius, Roman Emperor, 19
Honthorst, Gerrit van, 254
Hooke, Robert, 282-3
Hooker, Richard, 190; *The Laws of
 Ecclesiastical Politie*, 269
Hopetoun (house), Lothian, *400*
Hopkins, Gerard Manley, 600-1
Hopton, Susan, 296
Hor Apollo, 178
Horace, 233; *Odes*, 232
Hornebolte, Gerard, Lucas and Susanna,
 163
Horniman, Annie Elizabeth, 586
Houghton (house), Norfolk, 353
Houghton, William Stanley, 586
houses (residences): development, 149,
 166-7, 571-2, *see also* country houses
Housesteads, Northumberland, *17*
Housman, A.E., 600, 621
Howard of Effingham, Charles Howard,
 2nd Baron, 170, 206
Howard, Ebenezer: *Garden Cities of
 Tomorrow*, 630
Howard, Philip, 243

Howard, Sir Robert, 321; *The Indian Queen*
 (with Dryden), 323, 341
Howard, Thomas Howard, 4th Duke of,
 190
Howard, Lord William, 245
Hoxne, Suffolk, 4
Hudson, Thomas, 410
Hugh, Bishop of Lincoln, 63
Hugh of St. Albans, 84
Hughes, Ted, 659, *659*
Hulme, Thomas Ernest, 625
humanism, 128, 130-4, 136-9, 141, 229,
 280
Humbert, Albert Jenkins, 560
Hume, David, 463, *464*, 465, 469-70; *An
 Enquiry Concerning Human Understanding*,
 432, 434; *History of England*, 469
Humfrey, Pelham, 316-17
Humphrey, Duke of Gloucester, 132-3
Hunsdon, Henry Carey, 1st Baron, 173
Hunstanton, Norfolk, 649
Hunt, William Holman, 529, 541; *The
 Awakening Conscience*, *513*, 544; *The
 Finding of the Saviour in the Temple*, 543,
 543
Hunter, John, 464
Hunter, William, 464
Hunterian Museum, Glasgow, 464
Hurley, William, 82
Huxley, Aldous, 618
Huxley, Thomas Henry, 547

Ibsen, Henrik, 565, 584
Ickworth, Suffolk, 410
Iliad: Pope translates, 377
Illustrated London News, 539
imagination, 365, 481, 492
Imagism, 613
immigrants, 685
Imperial College, London, 548, 560
imprese, *179, 179*, 199, 200
Impressionism, 590-1, 600, 602, 623
Independence, Declaration of (USA, 1776),
 426
Independent Television Authority, 672
Independent Theatre Club, 584
Industrial Revolution, 477, 482-3, 546,
 556, 567
Institute of British Architects (*later* Royal),
 507
Institute of Civil Engineers, 509
Institution of a Gentleman (1555), 167
interior decoration, 350, 354, 595, 596,
 596
Inwood, W. and H.W., 504
Iona, 25
Ipswich, 124, 127, 129
Ireland, John, 621
Iron Acton, Gloucestershire, 167
Irving, Sir Henry, 582-3, 585
Italy: Renaissance humanism in, 132-3,
 136; cultural influence, 161; architectur-
 al influence, 244; Arundel visits, 244-5;
 and Grand Tour, 347, 352, 394-402,
 410, 448; opera in, 382
ivories: Anglo-Saxon, 35

Jacobitism: rebellions (1715 & 1745), 348,
 384, 465; popular sympathy for, 390-1;
 fades, 426
James I, King (James VI of Scotland): and
 artistic renaissance, 173, 204; and
 masques, 218; and royal status, 220,
 252; and Protestantism, 222; entry into
 London (1604), 223, 306; and

Banqueting Hall paintings, 236, 238;
 favours Howard family, 241; death,
 243; marriage, 259; and theatre, 268;
 acquires Theobalds, 294; and Scottish
 throne, 462-3, 469
James II, King (*earlier* Duke of York), 315,
 318-19, 324, 326-7, 341, 463
James IV, King of Scotland, 462
James V, King of Scotland, 462
James, Henry, 598-9, 606
James of St. George, 69
Jane Seymour, Queen of Henry VIII, 164
Jarrow, 21, 28-31
jazz, 612
Jekyll, Gertrude, 574, 576, 681
Jenkins, Thomas, 398
Jervas, Charles, 346
Jervaulx abbey, Yorkshire, 59
Jewel, John, Bishop of Salisbury: *Apology*,
 148
Joan of Navarre, Queen of Henry IV, *78*
Joan, Princess ('the Fair Maid of Kent'), 81
John, Archcantor of St Peter's, Rome, 30
John, Augustus, 626
John, Gwen, 626
John of Ford, 58
John of Salisbury, 38-9
John of Saxony, 34
Johnson, Samuel, 394, 411, 440-2, *441*;
 Dictionary of the English Language, 441;
 Journey to the Western Islands of Scotland.
 441, 442; *Lives of the Poets*, 423; *Works of
 the English Poets*, 431
Jones, David, 614
Jones, Inigo: designs masques, 218, 223-5,
 226, 259, 264, 266, 308; architecture,
 225, 229, 230, 231, 266, 267, 293, 300,
 343, 680; and Charles I, 227, 349;
 influence, 241; rift with Jonson, 255;
 on Stonehenge, 258; recommends de
 Caus, 260; stripped naked in Civil War,
 292; and John Webb, 299; W. Kent and,
 349-50; in Temple of British Worthies,
 417-18
Jones, Owen, 558
Jonson, Ben: plays, 210-11, 213, 582, 664;
 masques, 218, 223-5, 226; and court
 culture, 223; dismisses medievalism,
 231; on Penshurst, 232; literary
 dominance, 236; rift with Inigo Jones,
 255; and public poetry, 326; influence
 on Pinero, 582; *Chloridia* (masque),
 255, 264, 266; *The Masque of Blackness*,
 218, *219*, 220, 223
Joseph of Arimathea, St., 2
Joyce, James, 617
Julian of Norwich, Mother, 681
Junius, Francis: *The Painting of the Ancients*,
 249

Kant, Immanuel, 481
Kean, Edmund, 580
Keats, John, 482, 489, 492, 494, 511; 'Ode
 to a Nightingale', *493*
Kedleston, Derbyshire, 404
Kemble, Charles, 580
Kemble, John Philip, 477, 580
Kemp, Will, 209, *209*
Kenilworth School, Borehamwood, 645
Kensington Palace, 330, 353
Kent Opera, 662
Kent, William: accompanies Burlington to
 Italy, 347; interiors, 350, 354, *354*,
 gardens, 352-6, 371, 428; drawing of
 A. Pope, *373*; Hogarth satirises, 387,

388; designs Temple of British Worthies, 417, 420; and Gothic, 451-2; *The Designs of Inigo Jones*, 349
Kenwood House, Middlesex, 404
Keppel, Admiral Augustus, 1st Viscount, 410, *410*
Ketelbey, Albert, 623
Keynes, John Maynard, Baron, 641, 676
Killigrew, Thomas, 319
King's Lynn: mystery plays, 109
King's Theatre, Haymarket (*earlier* Queen's), 366, 378, 383-4
King's Works, Office of, 155, 312
Kingsley, Charles, 526
Kipling, Rudyard, 564, 600
Kirkstall Abbey, Yorkshire, 59
Kit-Kat Club, 366
Knight, Charles, 523
Knight, Sir Richard Payne, 451, 496, 508
knights *see* chivalry
Knole, Kent, 522
Knolle, Robert: *The Generall History of the Turkes*, 212
Knox, John, 462
Komisarjevzky, Theodore, 619
Kratzer, Nicolaus, 151
Kyd, Thomas, 206; *The Spanish Tragedy*, 209, *209*

Labour Party: beginnings, 563; post-war governments, 636, 640, 642, 665, 674
Lacock Abbey, Wiltshire, 168
Lacy, James, 442
Laguerre, Louis, 309, 333
Lamb, Charles, 510
Lancelot du Lac (romance), 77
landscape: as national *leitmotif*, 428-31, 680-1; in painting, 437, 497; and romanticism, 482-3
Landseer, Sir Edwin, 540-1, 551, 555; *The Monarch of the Glen*, 541, *542*
Lane, Allen, 618
Lanfranc, Archbishop of Canterbury, 52
Langland, William: *Piers Plowman*, 87, 680
Langley, Batty, 451, 453
Langton, Cardinal Stephen, Archbishop of Canterbury, 42
Larkin, Philip, 659; 'Church Going', 660
Larkin, William, 234, 236
Lasdun, Sir Denys, 649
Lassels, Richard: *Voyage or Compleat Journey through Italy*, 394
Lassus, Orlando de, 191
Latin language: introduced by Romans, 12, 14; influence on English, 19; replaced by vernacular, 22; and monastic learning, 28; neglect in Dark Ages, 34; in court culture, 86; and spread of literacy, 107; in school education, 136-7
Laud, William, Archbishop of Canterbury, 269-70, 290
Lavery, Sir John, 592
Lawes, Henry, 299
Lawn Road Flats, Hampstead, 632, *633*
Lawrence, David Herbert, 606, 610-11, 614, 617-18
Lawrence, Sir Thomas, 436, 497, 544
Layer Marney Hall, Essex, 167
Leach, Bernard, 650
Leavis, F.R., 640
Le Corbusier, 645, 649, 664; *Vers une architecture*, 632
Lee, Jennie, Baroness, 642
Lee (of Fareham), Arthur Hamilton,

Viscount, 670
Lee Priory, Kent, 459, *459*
Left Review, The, 608
Leicester, Robert Dudley, Earl of, 176, 183
Leicester, Thomas Coke, 1st Earl of, 395, 400
Leicester University, 649, *649*
Leighton, Frederic, Baron, 587, 592
Lely, Sir Peter, 310
Le Nôtre, André, 311
Leonardo da Vinci: *Mona Lisa*, 568
Letchworth, Hertfordshire, 630, *631*
Lethaby, William Richard, 573, 596-7, 628
Leverhulme, William Hesketh Lever, 1st Viscount, 631
Lewes, George Henry, 527
Lewes, Sussex: priory, 54
Lewis, Matthew ('Monk'), 459
Lewis, Wyndham, 606, 615, 624, 625
Leys Wood, Kent, *571*, 572
liberal arts (seven), 28, 42, 65, 342
libraries: monastic and cathedral, 56, 143-4; country house, 370; subscription and circulating, 370, 484, 524; public, 523
Licensing Act (publishing; 1695), 362
Lilly, William, 276
Linacre, Thomas, 130, 133-4
Lincoln: St. Paul in the Bail, 18
Lincoln, Henry Fiennes-Clinton, 9th Earl of (*later* 2nd Duke of Newcastle), 446, 448
Lincoln's Inn Fields theatre, 378
Lindisfarne, 25, 29-30
Lindisfarne Gospels, 29, *29*, 684
Lionel of Antwerp, 1st Duke of Clarence, 80
literacy: non-clerical, 107; and administrative needs, 132; Elizabethan, 175-6; spread in 18th century, 361-2, 370; popular, 484; Victorian expansion, 523-4, *see also* education
Literary Club (Johnson's), 442
Little Theatre, Haymarket, 378
Liverpool: St. George's Hall, 503; Anglican Cathedral, 574
Liverpool Garden Suburb, 631
Locke, John, 370, 373, 386, 417; *Essay Concerning Human Understanding*, 363
Locke, Matthew, 299, 317, 324
logical positivism, 639
Lollards, 89, 99
London, *203*, 205; diocese established, 24; theatres, *203*, 206, *207*, 208; City Fathers, 204; expansion and building, 222, 266-7, 358, 501-5, 564; as commercial and cultural centre, 268, 333, 358-60, 444-5; Great Fire (1665), 276, 302, 312; churches, 312, 314, *314*; rebuilt under Wren, 312, *see also* individual buildings
London County Council, 646
London, George, 312, 328, 337, 338
London Symphony Orchestra, 577
Long Melford church, Suffolk, 98, 103
Long, Richard, 679
Longford Castle, Wiltshire, 195
Longleat House, Wiltshire, 168-9, *169*, 337; landscape, 429, *430*
Lonsdale, Harvey, 503
Lord Chamberlain, 378, 565, 581, 584
Lords, House of: powers curtailed, 563
Lorimer, Robert, 573
l'Orme, Philibert de, 169

Lottery Act (1993), 676
Loudon, John Claudius, 539
Louis IX, St., King of France, 70
Louis XIV, King of France, 282, 309, 311, 315-16, 360
Loutherbourg, Philip de, 443
Lovelace, Richard, 263-4, 290
Low Ham, Somerset, 7, 8
Lubetkin, Berthold, 629, 632, 645
Lucian: *Dialogues*, 135
Lucretius, 277; *De Rerum Natura*, 12
Lullingstone, Kent, 4, 7
Lumley, John, 1st Baron, 245
Lunar Society, Birmingham, 445
Lupicinus (Roman general), 6
Luther, Martin, 139
Lutyens, Sir Edwin, 574, 576, 681
Lyceum Theatre, London, 582
Lydgate, John, 86
Lyell, Sir Charles: *Principles of Geology*, 514
Lyly, John, 209; *Endymion*, 211; *Eupheues and his England*, 187
Lyly, William, 136
Lyndsay, Sir David: *The Thrie Estaitis*, 462
Lyons, Council of (1274), 90
Lyric Theatre, Hammersmith, 619
Lytton, Edward Bulwer-, 1st Baron, 486
Lyveden New Bield (house), 195

Macaulay, Thomas Babington, Baron, 519
MacCarthy, Sir Desmond, 610
McKellen, Sir Ian, 656
Mackenzie, Henry, 466; *Man of Feeling*, 478
Mackintosh, Charles Rennie, 573-4
Macklin, Thomas, 495
MacMillan, Sir Kenneth, 660, 664
MacNeice, Louis, 616
Macpherson, James, 423
Macready, William Charles, 580
madrigals, 191
magazines: in 18th century, 362-3, 370; in romantic era, 484-5; Victorian, 523, 539; popular, 567
magic: and science, 274, 276, 278, 286
Maiano, Giovanni da, 124, 125, 161
Major, John, 674
'Makars' (Scottish poets), 462, 465-6
Malatesta, Sir Pandolf, 79
Malory, Sir Thomas: *Morte d'Arthur*, 116
Malthus, Rev. Thomas, 470
Malverne, John, 91
Manchester: Literary and Philosophical Society, 445; Art Treasures Exhibition (1857), 523, 553, 587; Assize Courts, 537, *538*; music in, 577; Gaiety Theatre, 586; Royal Exchange theatre, 656
Manchester Guardian, 484
Mancini, Francesco: *Idaspe* (opera), 382
Mann, Horace, 396, 446
manor houses, 86
Mansart, François, 312, 328
Mantegna, Andrea: *The Triumph of Caesar*, 298
manuscript illumination: early Christian, 25, *26-7*, 29-30, *29*; Anglo-Saxon, 35; and legends, 43; Gothic, 62; 15th century, *106*, *114*; humanist, *135*
Marble Arch, London, 501
Margaret, Duchess of Burgundy, 113, 115-16
Marlborough, George Churchill, 4th Duke of: family, 412, *413*
Marlborough, John Churchill, 1st Duke of, 332, 337

Marlborough, Sarah, Duchess of, 309, 333
Marlowe, Christopher, 206, 210-12, *212*;
 Dr Faustus, 211-12; *Tamburlaine*, 211-12
Marney, Henry, 1st Baron, 167
Marot, Daniel, 330
marriage: women's choice in, 374-5
Marshall, William: *Primer*, 142
Marston, John, 211
Martial, 12
Martin, John, 473, 500
Martin, Roger, 98, 103
Marvell, Andrew, 272, 291, 297-8, 325
Marx, Karl, 567
Mary I (Tudor), Queen, 133, 147, 168
Mary II, Queen, 327, 330-1, 340
Mary, Queen of Scots, 154, 462, 469
Mary, Virgin, 42, 50, *50*, 64, 96, 98-9, 105,
 142
masques, 218-20, 223-7, *226*, 233, 254-5,
 259-61, 263-4, 298-9, 302, 379
Massinger, Philip, 268
Massys, Quentin, 131
Maturin, Charles, 459
Maugham, Somerset, 584
May, Hugh, 328
medicine: study and development of,
 278-9, 281; in Scotland, 469
Mellor, David (silversmith), 650
Melrose abbey, 59
Membury, Simon of, 93
Menai Bridge, 509
Mendelsohn, Eric, 629
Meredith, George, 531, 600
Meres, Francis, 176
Messel, Oliver, 636
metalwork: Celtic, 10-11, *10*, *11*; in Sutton
 Hoo treasure, 22, *22*
Michael of Canterbury, 82
Middle Ages: in Victorian England,
 519-21, *520*, *522*, 534
Mies van der Rohe, Ludwig, 645, 649, 664
Mildenhall, Suffolk, 4, 6
Mildmay, Sir Anthony, *172*
Mill, John Stuart, 517
Millais, Euphemia (*formerly* Ruskin; 'Effie'),
 533
Millais, Sir John Everett, 533, 541, 543
millenarianism, 273, 288, 290, 298
Miller, Sanderson, 451
Mills, Peter, 300
Milton Gallery, 495
Milton, John: blank verse, 165; works
 away from court, 264; and science,
 282, 302; life and career, 302-5, *304*;
 Tonson publishes, 366; allusions in,
 372; Thomson imitates, 376; Handel
 and, in Temple of British Worthies,
 417-18, 422; monument in Poets'
 Corner, 420; in English canon, 422-3;
 Areopagitica, 183; *Comus*, 302, 379,
 554; *Eikonoklastes*, 303; *Paradise Lost*,
 302-4, 373, 609, 679; *Paradise Regained*,
 303; *Samson Agonistes*, 304
Milton Keynes, 647
miracle plays *see* mystery and miracle plays
Moderatism (Scotland), 468
Modern Architectural Research Group
 (MARS), 632, 645
modernism, 564, 601, 604-6, 608-9,
 612-13, 616-18, 623-32, 684
Moholy-Nagy, László, 629
Moller family, 311
monarchy: status, 111-12, 220, 227, 270-2;
 and divine right, 220; absolutism, 224;
 dismembered by Puritans, 294; after

Restoration, 309, 315-16; displaced by
 State, 328, 330-2, 361; Albert modifies,
 551
monasteries: established, 21-2, 30-1; and
 preservation of learning, 25, 28; under
 Anglo-Saxons, 34; migration from, 39;
 and writing of history, 43; and dedica-
 tion of art to God, 51; as mediators,
 51-2; libraries, 56, 143-4; buildings and
 life in, 59; fall out of favour, 99; disso-
 lution, 140, 143; adapted into houses,
 166
Mondrian, Piet, 626
Monkwearmouth, 21, 28, 29-31
Monmouth, James Scott, Duke of, 324,
 326
Montagu, Lady Mary Wortley, 400
Monthly Magazine, 362
Moore, Albert, 587
Moore, George Edward, 610
Moore, Henry, 626, 633, 652, 654, 669,
 669, 671; *Reclining Figure*, 652
More, Sir Thomas, 130, 134, 138-9, 142,
 163-4, 179; *Utopia*, 130, 138
More, The (house), Hertfordshire, 124
Moretti, Egidio, 245
Morley, Daniel, 41
Morley, Thomas, 191; *A Plain and Easy
 Introduction to Practical Music*, 187
Morris, Marshall, Faulkner & Co., 594
Morris, William: writes romances, 531;
 and decorative arts, 534, 567, 588,
 593-4, 627, 629, 650, 684; politics,
 567, *568*; and heritage, 570; house
 design, 5723; *News from Nowhere*, 521
Mortlake: tapestry works, 231, 262, *262*
mosaics, 8, 16, 18
motoring, 567, 604, 608
Mountford, E.W., 574
Movement poets, 659
Moya, John Hidalgo, 644
Mozart, Wolfgang Amadeus, 444
Mudie's circulating library, 524
Munnings, Sir Alfred, 627
Munro, Alexander, 469
Muntz, Johann Heinrich, 452
Murdoch, Dame Iris, 659
music: in churches, 104-5; polyphonic,
 116, 126; popular, 126-7, 663; under
 Wolsey, 126-7; at Tudor court, 161-3,
 165; Elizabethan, 187, 190-2, 210; and
 world view, 210; rise of secular, 236,
 340-2; suppressed under Puritans, 295;
 under Protectorate, 298-9; revived
 under Restoration, 316-18, *317*; under
 Queen Anne, 361; concerts and halls,
 367, 380-1, 444, 566, 576-7, 623; and
 18th-century theatre, 379-80; Handel
 and, 380-4; national canon established,
 424-6; London's late 18th-century
 dominance, 444; decline in England,
 476-7; late Victorian/Edwardian,
 576-80; education, 577; printing, 577;
 modernist, 620-1; conductors, 622;
 post-war, 661-2
musical comedy, 585
musical instruments, 191, *193*, 236, 316
music-hall, 612
Mussolini, Benito, 608
Muthesius, Hermann, 572
mystery and miracle plays, 89, 109, 147-8
Mytens, Daniel, 231, 241, 245, 250

Napoleon I (Bonaparte), Emperor of
 France, 330, 479

Nash, John, 501-4, *502*, 507-8, 522
Nash, Paul, 626, 671; *We are making a
 New World*, 607
Nash, Richard, 446
National Gallery, London: founded, 497,
 501, 505, 553; and Tate bequest, 593;
 Clark appointed Director, 670-1;
 Sainsbury Wing, 677
National Lottery, 678
National Portrait Gallery, 682
National Theatre, London, 592-3, 649,
 649, 656
National Trust, 570
National Vigilance Association, 597
natural history, 281
Nature: and science, 273, 276, 363; and
 country house living, 337; and sublime,
 428-9; and romanticism, 482-3, 490;
 Pre-Raphaelites and, 541-2; cult of,
 570-1; as national theme, 680-1
Needham Market, Suffolk: St. John the
 Baptist, *104*
Nelson, Admiral Horatio, Viscount, 480,
 480
neo-classical style, 399, 401-8
Neo-Pagans, 610
Neo-Platonism, 179, 182, 233, 274, 276
New Church Act (1710), 332
New English Art Club, 592
New Statesman (journal), 608
New Towns, 647
Newbury, battle of (1643), 291
Newby Hall, Lincolnshire, 401
Newman, John Henry, Cardinal, 517, 579;
 Apologia pro vita sua, 517; *An Essay on
 the Development of Christian Doctrine*,
 515
Newmarket: Prince's Lodging, 229, 231,
 231, 300
newspapers, 362, 370, 484, 567
Newton, Ernest, 573
Newton, Sir Isaac, 273-4, 284-5, *286*, 287,
 363, 394
Nicholson, Ben, 653
Nicholson, John, 125
Nietzsche, Friedrich, 605
Nonsuch palace, Surrey, 156, 159-61, *160*
Norfolk, Dukes of, 103, 243
Norfolk, Thomas Howard, 4th Duke of,
 241
Normans: Conquest, 39, 46-8; and
 religion, 52; church architecture and
 design, 54-5
North, Roger, 298
Northcliffe, Alfred Harmsworth, Viscount,
 567
Northumberland, Earls of, 86
Northumberland, Henry Percy, 9th Earl of,
 199, *201*
Northumberland, Hugh Percy, 1st Duke of,
 404
Norton, Thomas and Thomas Sackville:
 Gorboduc, 204
Norwich cathedral, 54
Notari, Angelo, 228
novel: beginnings, 340, 373-6; 19th-
 century development, 485-7, 523-8,
 613; realistic, 597-8; 20th-century,
 616-18
Nureyev, Rudolf, 660
Nys, Daniel, 262

Oatlands palace, Surrey, 294
Obscene Publications Acts: (1857), 597;
 (1859), 639

Observer (newspaper), 484
Oceanus Dish (Mildenhall treasure), 6, 6
Ockham, William *see* William of Ockham
Odo, Bishop of Bayeux, 37
Odyssey: Pope translates, 377
Offa, King of the Mercians, 49
Old Bailey, London, 579
Old Sarum, 51
Old Vic theatre, 619, 656
Oldenburg, Henry, 282
Oliver, Isaac, 187
Olivier, Laurence, Baron, 443, 620, 622, 634, 656
Omega Workshops, 627
O'Neill, George Bernard, 523
opera, 318, 324, 340, 366, 378-84, *382, 383*, 387-8, 623, 661-2, 664, 665
Opera North, 662
Opie, John, 436
Opus Dei (ritual), 21, 28, 52, 58
oratorio, 383-4
Orchard, Chorley Wood, Hertfordshire, *573*
orchestras, 577, 622, 662
Orford, Suffolk, 49
Osborne House, Isle of Wight, 551, 553
Osborne, John: *Look Back in Anger*, 657-9, *657*, 664
Ossian, 423-4, 457, 465, 482
Oswald, Bishop of Worcester, 34
Oswald, Northumbrian king, 25
Oswald, St., 63
Ottery St. Mary, Devon, 90
Otway, Thomas: *Venice Preserved*, 323, 391
Oughtred, William, 250
Ovid, 12; *Metamorphoses*, 7
Owen, Wilfred, 614
Oxford: Ashmolean Museum, 251, 505, 668, 670; St Mary's church, 270, *271*; in Civil War, 290
Oxford, Edward Harley, 2nd Earl of, 358
Oxford Movement, 516-17, 519-20, 536
Oxford University: beginnings, 44, 64-5; New College, 93-6; All Souls College, 95; Cardinal (*later* Christ Church) College, 124, 127-9, 134, 349; acquires Duke Humphrey's Library, 133; Corpus Christi college, 134; humanism in, 134; and natural sciences, 278, 281

Paine, Thomas: *The Rights of Man*, 466, 479
Painter Stainers Company, 385
painting: revival in 18th century, 384-90, 409-10, 436; historical, 494-5; 20th-century movements, 526-7; Victorian, 540-4; watercolour, 553; 'British School', 586-7, *see also* portraiture
Palestrina, Giovanni Pierluigi da, 380
Palladio, Andrea, 244, 266, 343, 344, 347-51, 354; *Four Books of Architecture*, 349
Palmer, Samuel, 500, 632, 652; *Ruth Returning from Gleaning, 500*
Palmerston, Henry John Temple, 3rd Viscount, 536
Pantheon, Oxford Street, 444
pantomime, 378
Papworth, John Woody, 503
Paracelsus, 278
Paris, 39, 41, 67; Treaty of (1763), 394
Parker, R.B., 631
parks (municipal), 539
Parliament: conflict with Crown, 270-1; Victorian Gothic rebuilding, 535, 536,

553, *see also* franchise
Parry, Sir Hubert, 577, 620
Pasmore, Victor, 627, 669
Pater, Walter, 568-9, 670
Patmore, Coventry, 531
Patrick, St., 25
Patriots (political group), 415
patronage (of arts), 75, 166, 176, 190, 361, 540
Paxton, Sir Joseph, 534-6, 539, 557
Peacham, Henry, 215; *The Compleat Gentleman*, 248, 251
Peacock, Thomas Love, 486, 510
Peake, Robert, 221
Pears, Sir Peter, 662
Pearson, John Loughborough, 536
Peel, Sir Robert, 554
Peele, George, 209
Pelli, Cesare, 683
Pembroke, Henry Herbert, 9th Earl of, 350
Pembroke, Mary Herbert, Countess of, 173, 183
Pembroke, Philip Herbert, 4th Earl of, 260, 262, 299-300
Penguin Books, 618
Penny Magazine, 523
Penshurst Place, Kent, 232, 522, *522*
Pepperell, Sir William and family, *435*
Pepusch, J.C., 379
Pepys, Samuel, 316, 319, 449
Percy, Thomas: *Reliques of Ancient English Poetry*, 423, 457
performance art, 656
Perpendicular style (architecture), 84, 93, 95-6, 103, 107, 118
perspective, 223-4, 228
Peter the Lombard: *Sentences*, 42
Peterborough, Henry Mordaunt, 2nd Earl of, 289
Petipa, Marius, 636
Petrarch, 185; *Triumphs of Chastity*, 180
Petty, William, 246, 248
Petworth House, Sussex, *341*, 401
Pevsner, Sir Nikolaus, 629
Peyton family, 104
Philip the Good, Duke of Burgundy, 116
Philippa of Hainault, Queen of Edward III, 81, 85
'Phiz' (Hablot Knight Browne), 525
phonograph, 567
photography, 544, 553
Pick, Frank, 628
Pico della Mirandola, Giovanni, 179, 274
picturesque, 501, 505-8
Pilgrimage of Grace (1536), 145
pilgrimages and shrines, 38, 137, 140, 143
Pinero, Sir Arthur Wing, 581-3
Pinter, Harold, 658, 664
Piper, John, 633, 634, 648, 669, *669*, 671
Pirckheimer, Willibald, 248
Pitt, Thomas, 452
Pitt, William, the Younger, 426, 470
plague *see* Black Death
Plague, Great (1666), 276, 302
Plato, 41, 66
Playfair, Sir Lyon, 556
Playfair, Nigel, 619
pleasure gardens, 367, 368-9, 370
Plegmund, Archbishop of Canterbury, 34
Pliny the Younger, 352, 354
Plot, Robert, 281
Plutarch, 12
Pocklington, Capt. Samuel Sharpe and

Pleasance, *439*
Poel, William, 585
Polden Hills hoard, Somerset, *10*
Policy Studies Institute: *The Economic Importance of the Arts in Britain* (1988), 676
'polite' society, 364-5
Political Register, 485
Pond, Arthur, 362
Poole Pottery, 627
Poore, Richard, Dean of Salisbury, 64
pop music, 663
Pope, Alexander: and Burlington, 344, 348, 352; Catholicism, 348, 391; garden, 352, 354, 377; opposes Walpole, 360; success as professional writer, 361, 377; Tonson publishes, 366; in grotto, *373*; poetry, 376-7, 492, 683; and Hogarth, 386; in Temple of British Worthies, 417, 422; edits Shakespeare, 420; Ramsay imitates, 465; and landscape, 482; *Dunciad*, 373; *Essay on Criticism*, 349, 377; *Essay on Man*, 363, 377; *Imitations of Horace*, 376; *The Rape of the Lock*, 372-3, 377
population: decline after Black Death, 75; doubles (1730-1830), 477
Port Sunlight, 630
Porter, Endymion, 262
portraiture: 17th century changes, 222, 231, 233, 236; and 18th century sensibility, 436; and history, 682
Post-Impressionists, 623; Exhibitions, First (1910), 602, 624; Second (1912), 624
Potter, Beatrix, 597
Pound, Ezra, 609, 613-14, 625
Powell, Anthony, 658
Power, Lionel, 104, 116
Poynter, Sir Edward, 588
Poyntz, Nicholas, 167
Praemonstratensian Order, 58
Pre-Raphaelite Brotherhood, 530, 541-3, 569
Preston: Harris Museum and Art Gallery, 566
Price, Sir Uvedale, 451; *Essay on the Picturesque*, 501
Priest, Joseph, 324
Priestley, J.B., 656, 666
Prince of Wales Theatre, London, 581
printing: invention, 99
prints, 362, 539
Prior, Matthew, 361, 376
Pritchard, Hannah, *444*
Pritchard, Jack, 632
Promenade Concerts, 576-7, 623
Propertius, 12
Protectorate, 298-9, 303
Protestantism: ends mystery plays, 109, 147-8; and English Reformation, 139, 142; cultural changes, 147-9; and literacy, 175; hostility to Charles I's court, 261, 263; and British tradition, 418
Public Health Act (1848), 538
Public Libraries Act (1850), 523
public schools, 518, 567, *see also* individual schools
publishing: in 18th century, 362; 20th-century, 618
Pugin, Augustus Welby, 519, 534, 536
Pullen, Robert, 39
Pulteney, Sir John, 86
Purcell, Henry, 316-18, *318*, 340-1, 380, 425-6, 620, 664

Puritanism: hostility to beauty, 142; hostility to drama, 204, 291-2; opposes festivals and revelry, 263; opposes Anglican ceremony, 268-70; eschatology, 280; collapses, 281; religious oppression and desecration, 291-5; and rise of the novel, 374
Puttenham, George, 165; *The Art of English Poesie* (attrib.), 182
Pye, David: *The Nature and Art of Workmanship*, 650

Quarterly Review, 485
Queen's Hall Orchestra, 577
Queensberry, James Douglas, 2nd Duke of, 460
Quilter, Roger, 621
Quin, James, 378

Radcliffe, Anne, 459
radicalism, 479, 481, 484, 490-1, 519
radio, 612
Raeburn, Sir Henry, 497
Raedwald, King of East Anglia, 22
railways: development, 478, 518
Raleigh, Sir Walter, 170, 174, 184, 202, 228
Rambert, Dame Marie, 620, 660
Ramsay, Allan (painter), 464, 467
Ramsay, Mrs Allan (painter's wife), 467
Ramsay, Allan (poet), 465-6, 468
Ranelagh gardens, London, 370, 380
Raphael Sanzio: cartoons, 298
rationalism (reason), 278, 342, 434, 489
Rattigan, Sir Terence, 619, 656-7
Ravenna, 31, 32
Ravilious, Eric, 626
Ray, John, 282-3
Read, Sir Herbert, 606; *Art and Industry*, 627
reading, 362-3, 370, 484-5, 485, 597, *see also* literacy
Red House, Bexley Heath, 573, 593
Redgrave, Richard, 556
Redgrave, Samuel: *A Century of British Painters*, 587
Reeve, Clara: *The Old English Baron*, 458
Reform Acts: (1832), 481, 511, 517, 519; (1867), 517
Reformation, 2, 60, 127-8, 139, 140-9, 190, 273; in Scotland, 462
Regent Street, London, 501-2, 503
Regent's Park, London, 502
Regional Arts Associations, 676-7
relics (sacred), 62-4, 63, 137, 144
religion: and scientific revolution, 273-4, 277-8; exclusions ended, 511, 518; 19th-century challenges to, 514-16; undermined by modernism, 604-5; 20th-century decline, 609, 639, 660, *see also* Christianity; Church
Renaissance: and humanism, 130, 132, 136; and visual arts, 139; architecture, 161, 225, 260; climax in England, 170; and cult of emblems, 177-8; and drama, 210-11, 213, 217; Arundel promotes, 241; gardens, 248, 300; science in, 274
Rennie, John, 509
Repton, Humphry, 502, 508, 509
Restoration (1660), 300, 311
Revelation, Book of, 273
Revels, Office (and Master) of the, 118, 154, 205, 321
Revett, Nicholas, 399

Reynolds, Sir Joshua, 386, 410-12, 436, 441-2, 494, 496, 540, 587
Rhymers' Club, 614
Rich, John, 378
Rich, Penelope, Lady, 185
Richard I, King, 47, 50
Richard II, King, 2, 2, 82, 85, 92, 213
Richard III, King, 215, 456
Richardson, Jonathan, 344, 366, 385-6
Richardson, Sir Ralph, 620, 634
Richardson, Samuel, 374-5, 680; *Clarissa*, 375, 432; *Pamela*, 359, 375; *Sir Charles Grandison*, 375
Richborough, Kent, 16
Richmond, Frances Stuart, Duchess of, 310
Richmond Palace, 116-17, 117-18, 124, 158-9, 192
Rievaulx abbey, Yorkshire, 59
Ringland, Norfolk: St. Peter's church, 142
Ripon, 31
roads, 478
Roberts, William, 625
Robertson, Thomas William, 581
Robertson, William, 469
Robinson, Henry Peach, 544
Robinson, Sir Thomas, 355
Robinson, William, 452
Rochester, John Wilmot, 2nd Earl of, 321, 325, 326
Rochester, Kent, 23
Rocque, John, 353
Roe, Sir Thomas, 248-9
Roehampton Estate, 646, 646
Roger, Bishop of Salisbury, 51
Rogers, Claude, 627
Rogers, Sir Richard, 678
Roman Club, 386
Roman de la Rose, 114
romances, 76-7, 77, 118
Romanticism, 440, 473, 481-4, 489-92, 500, 531
Rome (ancient): influence, 1-2; conquest and occupation of Britain, 2, 4, 6-12; culture and administration, 12-19; army, 13-14; withdrawal, 19; Empire collapses, 22; influence on Christian Church, 30
Rome (modern): and Grand Tour, 394, 396-7, 397, 401-2, 410
Romney, George, 436, 497
Romsey abbey, Hampshire, 59
Rooke, Laurence, 282
Root and Branch Bill (1642), 292
Rosa, Salvator, 396
Rose theatre, London, 206
Rosenberg, Isaac, 614
Rossetti, Christina, 531
Rossetti, Dante Gabriel, 519, 531, 541, 543-4, 587; *Mona Vana*, 545; *The Tune of the Seven Towers*, 520
Roubiliac, Louis François, 370, 409, 421
Rousham, Oxfordshire, 357
Rousseau, Jean-Jacques, 391, 434, 436; *Émile*, 435
Rovezzano, Benedetto da, 128
Rowlandson, Thomas, 528, 683
Royal Academy of Arts: founding, 386, 410-11; at Somerset House, 402; status, 494; exhibitions, 523, 539, 586-7; dominance and conservatism, 565, 588, 590, 624; moves to Burlington House, 586; and 'British School', 587-8; and modern art, 591-3
Royal Academy of Dramatic Art, 582
Royal Academy of Music, 381, 383

Royal Armouries, 161
Royal Ballet Company, 620, 660
Royal College of Art, London, 558, 596
Royal College of Music, London, 577, 592
Royal Court Theatre, London, 584, 657
Royal Designers for Industry, 629
Royal Exchange, London, 360
Royal Liverpool Philharmonic orchestra, 662
Royal Opera Arcade, London, 504, 504
Royal Opera House, Covent Garden, 636, 638, 641, 662, 665, 677
Royal Philharmonic Society, 476
Royal Shakespeare Company, 656
Royal Society, 250, 279, 281-3; *Philosophical Transactions*, 282
Royal Society of Arts, 556-7
Royal Society for the Prevention of Cruelty to Animals, 683
Royal Works, 69, 154, 294, 333, 343, 350
Rubens, Sir Peter Paul, 233, 234, 236, 238, 241, 242, 250, 252, 255, 258, 261-2
Rugby school, 505
Rushdie, Salman, 678
Ruskin, John, 523, 532-4, 533, 540-3, 560, 567, 588, 670
Russell family, 174
Russell, Gordon, 628, 650
Russia: Revolution (1917), 473; Soviet state in, 608
Ruthwell, Dumfries, 31-2
Rutland, John Henry Manners, 5th Duke of, 506
Rymer, Thomas: *The Tragedies of the Last Age Consider'd*, 323
Rysbrack, Michael, 367, 409

Sade, Donatien Alphonse François, marquis de, 565
Sadler's Wells Ballet, 636, 638, 660
St. Albans abbey, 54
St. Albans Psalter, 56
St. Augustine's church, Kilburn, 536
St. Bartholomew's Hospital, London, 389
St. George, College (and Chapel) of, Windsor, 80, 115-16, 118
St. Giles church, Staffordshire, 536
St. James's Hall, London, 576, 578
St. James's Palace, London, 161, 228, 330; Chapel, 229, 231
St. James's Park, London, 311
St. James's Theatre, London, 581
St. John, Oliver, 300
St. Luke's Church, Chelsea, 504
St. Mary Fownhope, Herefordshire, 50
St. Mary, Monmouth: altar cross, 55
St. Pancras Church, London, 504
St. Paul's Cathedral, London: old, 266-7, 267, 293; rebuilt by Wren, 314-15, 315, 340, 358; music in, 380, 425
St. Paul's church, Covent Garden, 267, 350
St. Paul's School, London, 136
Salisbury Cathedral, 63, 70, 499, 500, 683
Salisbury, Katharine, Countess of, 76, 80
Saltram (house), Devon, 400
Sandwich, John Montagu, 4th Earl of, 426
Sansovino, Jacopo, 244
Sargent, John Singer, 563, 564, 588
Sargent, Sir Malcolm, 622
Sassoon, Sir Philip, 670
Sassoon, Siegfried, 614
satire, 371-3
Savoy Theatre, London, 585, 586

Saxe-Coburg, 550
Sayes Court, Deptford, 297
Scamozzi, Vincenzo, 244, 300
Scarfe, Gerald, 683
Scheemaker, Peter, 420
Schiller, J.C.F. von, 476
scholasticism, 38-9, 41-4, 64-6, 128, 134, 136-7
Schon, Erhard, 125, 126
schools see education; public schools
science: and scholasticism, 44; experimental, 66; 17th-century revolution in, 273-4, 276-85, 363, 417; and control of nature, 273, 276, 363; and literary style, 370-1; 18th-19th century advances, 477-8; effect on Victorians, 514; and manufacturing art, 556-8
Science Museum, London, 558
Scotland: rebellion in (1640), 260; Union with England, 365, 417-18, 460, 463; and Stuarts, 391; cultural identity, 460, 462-3, 465-6; Enlightenment in, 463-5, 468-71; law in, 463; modern art movements in, 592; nationalism, 665, 679
Scott, Sir George Gilbert, 536-7, 548
Scott, Sir Giles Gilbert, 574
Scott, M.H. Baillie, 631
Scott, Sir Walter, 486-7, 506, 511, 519
Scottish Opera (1962), 662
Scriblerus Club, 367
sculpture: revival of, 592, 625-6, 652-3; and two-dimensional, 683
Seaton Delaval, Northumberland, 336
Second Coming, 288, 290, 295, 302
Second World War, 632-4
Segar, William, 136
Selden, John, 249
Semper, Gottfried, 558
Senesino (castrato singer), 383, 383
sensibility, 432, 434-40, 442-5, 487
Serlio, Sebastiano: Regole generali di architettura, 161, 168
Servi, Constantino de', 227
Seven Years War (1756-63), 418
Seymour, Lt. Col. Francis, 550
Sforza family (of Milan), 132
Shadwell, Thomas, 324
Shaftesbury, Anthony Ashley Cooper, 1st Earl of, 326
Shaftesbury, Anthony Ashley Cooper, 3rd Earl of, 346, 385; Characteristics, 342; Letter Concerning the Art and Science of Design, 349
Shaftesbury, Anthony Ashley Cooper, 7th Earl of: statue (Eros), 592
Shakespeare Gallery, 494-5
Shakespeare Memorial Theatre, Stratford upon-Avon, 593
Shakespeare, William, 420, 421; chronicle plays, 85; education, 137; blank verse, 165; sonnets, 186; achievements, 210-11, 213-17; Dryden on, 213; adapted and modified, 323-4, 419-20; cult of, 379, 419-24; in Stowe Temple of British Worthies, 417-18, 422; Jubilee (1769), 421-2, 424; 20th-century productions, 585-6, 664; characters, 682-3; Coriolanus, 215; Hamlet, 211, 215, 217; Julius Caesar, 215, 583; King Lear, 211, 215, 323; Macbeth, 202, 215, 268, 495; A Midsummer-Night's Dream, 215; Othello, 215; Pericles, 216; Richard II, 213; Richard III, 213; Romeo and Juliet, 215; The Tempest, 177, 216, 324; Timon of Athens, 215; Titus Andronicus, 211,
214, 215; Troilus and Cressida, 215, 323; Twelfth Night, 215, 585
Shaw, George Bernard, 576-7, 584
Shaw, Richard Norman, 571, 572, 594
Sheepshanks, John, 540
Shelley, Mary, 492; Frankenstein, 482, 486
Shelley, Percy Bysshe, 481-2, 489, 492, 531
Shenstone, William, 439
Sheridan, Richard Brinsley, 442, 444, 664, 683
Ship Money, 259, 300
Shirley, James, 268, 290; Cupid and Death (masque), 298-9
Shobdon, Herefordshire: St John the Evangelist church, 450
Shrewsbury, Elizabeth Talbot, Countess of ('Bess of Hardwick'), 173, 195, 199, 242
Shrewsbury, Gilbert Talbot, 7th Earl of, 244
shrines see pilgrimages and shrines
Sibley, Dame Antoinette, 660
Sickert, Walter, 591; The Gallery of the Old Bedford, 591
Siddal, Elizabeth, 531
Siddons, Sarah, 477
Sidney, Sir Philip, 137, 173, 174-5, 175, 182-4, 236, 295; Apologie for Poetrie, 177; Arcadia, 183-4, 680; Astrophel and Stella, 183, 185
Sir Gawain and the Green Knight (poem), 87
Sitwell family, 610, 621
Skelton, John, 118, 133
Smart, Christopher, 439-40
Smellie, Dr William, 464
Smiles, Samuel: Self-Help, 518
Smirke, Sir Robert, 505
Smith, Adam, 464, 556; The Wealth of Nations, 470
Smith, John, 398
Smith, Dame Maggie, 656
Smith, William (architect), 551
Smith, William Henry, 524
Smithson, Peter and Alison, 649
Smollett, Tobias, 396, 464, 525
Smyth, Dame Ethel, 580
Smythson, Robert, 195-6, 199
Snow, Charles P., Baron, 658
Soane, Sir John, 504-5, 507-8, 510
socialism: Victorian beginnings, 521, 531, 563, 567; and modernism, 609; and post-war architecture, 644-8
Socialist Democratic Federation, 567
Socialist League, 567
Society of Antiquaries, 456
Society of Dilettante, 411
Society of Industrial Artists, 629
Society of Painters in Watercolours, 496
Society for the Protection of Ancient Buildings, 570
Society for the Protection of Animals, 541
Somer, Paul van, 231
Somers, John, Baron, 346, 365
Somerset, Charles Seymour, 6th Duke of, 341
Somerset, Edward Seymour, Duke of, 168
Somerset, Robert Carr, Earl of, 245
Somerset House, London, 168, 168, 245, 264, 266, 300; chapel sacked, 294; demolished and rebuilt by Chambers, 402, 403
sonnets, 185-6
South Kensington: museums, 548, 553, 558
South Leigh Church, Oxfordshire, 100
Southey, Robert, 476, 489, 491
Southwark, 205
Southwell Minster, 73
Spain: relations with England, 151, 174, 222
Spanish Armada (1588), 170, 174, 182
Spectator (magazine), 362-3, 365-6, 371, 385
Spelman, Sir Henry, 250
Spence, Sir Basil, 648-9
Spence, Joseph, 354
Spencer, Stanley, 626, 682; The Resurrection of the Soldiers, 603
Spender, Sir Stephen, 616
Spenser, Edmund, 137, 184, 236, 295, 384, 422-3; Amoretti, 186; Epithalamion, 184; The Faerie Queen, 170, 173, 183-5, 302-3, 357, 609, 680; The Shepheardes Calendar, 182, 184, 185
Spitting Image (TV programme), 683
Sprat, Thomas: History of the Royal Society, 282
Stage Licensing Act (1737), 377-9, 419
Stalin, Josef V., 608
Stanford, Sir Charles Villiers, 577, 620
State: power of, 110; and cultural initiatives, 330; and social morality, 366; as patron of arts, 496-7, 592, 609; and Church, 516; and manufacturing arts, 556; post-war subsidising of art, 636, 641, 656, 665, 671, 674, 676-7; and architecture, 644-50
Stationers' Company, 362
Steele, Richard, 338, 340, 363-6; The Conscious Lover, 378
Steer, Philip Wilson, 592
Stephen, Sir Leslie, 610
Stephen, Thoby, 610
Sterne, Laurence: A Sentimental Journey, 375, 432; Tristram Shandy, 375-6
Stevenson, Robert Louis, 597
Stirling, James, 649
Stockmar, Baron Christian, 550
Stone, Nicholas, 248
Stonehenge, 258
Stoppard, Sir Tom, 678
Stourhead, Wiltshire, 428, 456
Stow, John, 187
Stowe, Buckinghamshire, 357, 415, 416; Temple of British Worthies, 417, 420, 422
Strachey, Lytton, 610-11
Strand Palace Hotel, 628, 628
Strauss, Friedrich: Das Leben Jesu, 514
Strawberry Hill, Twickenham, 446, 447, 448-9, 452-6, 453, 455, 459, 570
Strode, John, 195
Stuart dynasty: court culture, 222-4; and Jacobitism, 348-9, 351, 390-1, 465; and music, 425
Stuart, Lady Elizabeth, 243
Stuart, James ('Athenian'), 399
Stubbs, George, 436-7, 439, 683
Studley Royal, Yorkshire, 456
Suckling, Sir John, 264, 290
Suger, Abbot of St. Denis, 55, 63, 67, 96
Sunday observance, 199, 263, 291
Sunday Times, The, 484
Surrealism, 604, 623
Surrey, Henry Howard, Earl of, 165
Surtees, Robert, 528
Sutherland, Graham, 633, 648, 651-2, 669, 669, 671; Thorn Cross, 651
Sutton Hoo, Suffolk: hoard, 22, 22, 23, 29

Sutton Place, Surrey, 167
Swan theatre, London, *207*, 208
Swift, Jonathan, 360, 367, 371-2, 683;
 Gulliver's Travels, 371-2
Swinburne, Algernon Charles, 531, 568
Swineshead, Richard, 134
Swithin, St., 63
Sydenham Park, *5*39, 576
Symbolism, 600, 614-15
Syon Park, Middlesex, 404, *405*

Tacitus, 12
Talbot, William Henry Fox, 544
Tallis, Thomas, 190-1, 380, 424, 680
Talman, John, 392
Talman, William, 309, 328, 392
tapestries, *122*, 125-6, *127-9*, 231, 262,
 262
Tarlton, Richard, 209, *209*
Tate Gallery, London, 587-8, 593, 677
Tate, Sir Henry, 593
Tate, Nahum, 323
Tatler (magazine), 362-3, 365
Tavener, John, 682
Taverner, John, 104, 127,
taxation, 75, 259, 300, 563
technology: developments, 477-8
telegraph, 518
telephone, 567
television, 639, 643
Telford, Thomas, 477, 509, 511
Tennyson, Alfred, 1st Baron, 523, 529-30,
 547; *Idylls of the King*, 519; *In
 Memoriam*, 512; *The Lady of Shalott*,
 529, *529*
Terry, Ellen, 583
Test and Corporation Acts (1828), 511
Thackeray, William Makepeace, 524, 528
Thatcher, Margaret, Baroness, 664, 674,
 683
Theatre Royal, Drury Lane, 319
Theatre Royal, Haymarket, 581
Theatre, The, Shoreditch, 206
theatres, *203*, *205*; closed (1642-1660),
 205; development, 206-8; under
 Restoration, 319, *320*, 321-2;
 immorality in, 338; in Hanoverian
 England, 367; and Stage Licensing Act,
 377-9, 419; Garrick's reforms of, 443;
 and spectacle, 476-7; late
 Victorian/Edwardian, 580-4; censorship
 in, 581; education, 582; private clubs,
 584; and modern stage design, 586;
 repertory, 586; and Great War, 618-19;
 subsidised, 634, 656; censorship
 abolished (1968), 639; provincial, 657;
 working-class, 658; achievements, 664;
 see also drama
Theobald, Archbishop of Canterbury, 44
Theobalds, Hertfordshire, 195, 294
Theodore of Tarsus, Archbishop of
 Canterbury, 24-5, 31
Thetford, Norfolk, 19
Thistle, Order of the, 463
Thomas, Dylan, 659
Thomas, Edward, 614
Thomson, James, 384, 423, 463, 465, 471,
 681; 'Liberty', 471; *The Seasons*, 371,
 376, 483
Thornhill, Sir James, 332, 352, 382
Thorpe Hall, Northamptonshire, 300
Thorpe, John, 196
Three Choirs Festival, 425-6
Thynne, Sir John, 168, 169
Times, The, 484

Tippett, Sir Michael, 662, 664
Tit-Bits (magazine), 567
Titian: *The Mocking of Christ*, *247*, 248
Tivetshall, Norfolk: St. Margaret's church,
 150
Tolstoy, Count Leo, 565
Tomkins, Thomas, 191, 236, 298
Tonson family, 422
Tonson, Jacob, 366
torcs, 10-11
Tories: and baroque, 343; clubs, 367
Torrigiano, Pietro, 128
tournaments, 50, *78*, 79-80, *79*, 115, 119,
 120, 151
Tourneur, Cyril, 211
Tower of Babel, *53*
Tower of London, 522
Townley, Charles, 398, 399
towns: and development of scholasticism,
 39, 42; under Plantagenets, 50-1;
 building development, 502-3; parks,
 538-9; postwar planning and building,
 644-8
Trades Union Congress, 563
Traherne, Thomas: *The Centuries of
 Meditation*, 296-7, 682
Transitional style (architecture), 59
Tree, Sir Herbert Beerbohm, 583, 585, 592
Tregothnan, Cornwall, *505*
Tresham, Sir Thomas, 195
Triumphs of Oriana, The (musical
 collection), 191
Trollope, Anthony, 528, 684
Tubbs, Ralph, 644
Tudor dynasty, 117-18, 133-4, 137-8
Tudor style (architectural), *505*, 506
Tudway, Thomas, 316, 340
Turner, Joseph Mallord William, 497-500,
 507, 532, 632, 681; *The Fighting
 Téméraire*, *497*, *498*; *Mercury and
 Argus*, *1*
Turquet de Mayerne, Theodore, 278
Tyers, Jonathan, 361, 367, 389
Tyndale, William, 141

Udall, Nicholas, 204
Union, Act of (1707; England-Scotland),
 417-18, 460, 463, 465
Unit One, 626
Universal Magazine, 362
universities: beginnings, 42-4, 64-5, *64*; in
 Scotland, 462, 468; postwar, 649, *649*
'University Wits', 209
Unwin, Sir Raymond, 631
Ure, Andrew, 556
Utopianism, 280-1

Vanbrugh, Sir John, 309, *332*, 333, 336-8
Van Dyck, Sir Anthony, 231, 241, 250,
 252, 263, 264, 351, 683; death, 272,
 290
Vaughan, Henry, 288, 682; 'Silex
 Scintillans', 295, *296*, 297
Vaughan Williams, Ralph, 620-2, 680
Vauxhall pleasure gardens, 361, 367,
 368-9, *370*, 380
Vergilius Romanus, *5*, 9
Verrio, Antonio, 306, 309, 312, 326, 328,
 333
Versailles, 309, 311, 315, 328, 331, 391,
 396
Vertue, George, 346, 350, 456
Verulamium (St Albans), 14
Vicarius, 44
Victor (Mauretanian soldier), *13*

Victoria and Albert Museum, London,
 548, 560, 677; *The Destruction of the
 Country House* (exhibition, 1974), 665
Victoria, Queen, 544, 548, 550-1, 553,
 554, 564; Memorial, 574
Vikings, 33-4
Villiers, Lady Mary (*later* Herbert), *265*
Vindolanda (Chesterholm,
 Northumberland), 7
Virgil, 12, 398; *Aeneid*, *7*, 8, 11, 165, 372,
 390, 428; *Eclogues*, 1-2, 357; *Georgics*,
 232, 483
Visscher, Nicolas Janszoon, 204
Vitruvius, 208, 225, 258
Vives, John, 128
Voltaire, François Marie Arouet de, 391
Vorticism, *624*, 625
Voysey, C.F.A., 573
Vyne, The, Hampshire (house), 452

Wadsworth, Edward, 625
Wain, John, 659
Walcher, prior of Malvern, 44
Wales: conquest and suppression of, 423;
 nationalism, 665
Walker, Sir Edward, 239, 244, 246, 294
Walker, Robert, 298
wall paintings: Roman, 16
Wall Street crash (1929), 608
Waller, Edmund, 264, 290
Wallis, John, 281
Wallop, Sir John, 161
Walpole, Horace (*later* 4th Earl of Orford):
 on Arundel, 251; on Burlington, 346;
 on Rousham, 357; on Versailles, 396;
 criticises Adam, 404; builds Strawberry
 Hill, 446, 448-9, 451-6, 459, 570; and
 Gothic revival, 446, 449, 451-8;
 qualities and character, 446, 448-9;
 writings, 449, 456; *Anecdotes of Painting
 in England*, 431, 456; *The Castle of
 Otranto*, 456-9, *458*, 485; *A Description
 of ... Strawberry Hill*, *453*
Walpole, Sir Robert, 348, 360, 375, 378,
 384, 415, 417-18, 420, 448
Walsingham, Norfolk, 62, 140
Walsingham, Sir Francis, 171
Walton, Sir William, 620-1, *621*
War Artists Advisory Committee, 633
Ware, Samuel, 504
Warner, William: *Albion's England*, 200
Wars of the Roses, 111
Warton, Thomas, 423; *History of English
 Poetry*, 431
Warwick, Ambrose Dudley, Earl of, 183
Warwick, Richard de Beauchamp, Earl of,
 79, *81*
Water Newton, Huntingdonshire, 19
Waterhouse, Alfred, 537, 538
Watson, James: *Choice Collection of Scottish
 Poems*, 465
Watts, George Frederic, 588; *Caractacus
 Led in Triumph*, 555
Waugh, Evelyn, 608, 618
Waynflete, William, Bishop of Winchester,
 95
Webb, Sir Aston, 564, 574
Webb, John, 299-300, 311-12, 331, 349
Webb, Philip, 572, 593
Webster, John, 211; *The Duchess of Malfi*,
 217
Wedgwood, Josiah, 398, 408-9
Weelkes, Thomas, 191, 236
Welch, Robert, 650
welfare state, 636, 638, 641, 665

Wellington, Arthur Wellesley, 1st Duke of, 480
Wells, Herbert George, 599
Wells, Somerset: Cathedral, *61*, 67; St. Cuthbert's church, *145*
Welsh National Opera, 662
Welwyn Garden City, 631
Wenhaston Church, Suffolk, *101*
Wesker, Arnold, 658
Wessex, 34
Westminster Abbey: founded, 35; shrines, 63; medieval painting in, 69, *71*; building and design, 70; Tudor chapel, 118; music in, 380; Poets' Corner, 420; Handel commemoration (1784), *427*, 428
Westminster Hall, *82*, 85, 93
Westminster, Palace of: St Stephen's Chapel, 81-2, 84, *84*
Westminster School, 348
Weston, Sir Richard, 167
Weymouth, Thomas Thynne, 1st Viscount, 337
Wheldon, Sir Huw, 643
Whigs: and Palladianism, 343; and Hanoverian England, 360, 363, 366; satirised, 378; and history, 519
Whistler, James McNeill, 588, 590; *Symphony in White No.1, 589*
Whistler, Rex, 622
Whitby, Synod of (AD 664), 25
Whitehall Banqueting House, 229-30, *230*, *237*, 238, 308, 350
Whitehall Palace, 129, 155-6, 158, 298, 311, 326, 330
Whitelocke, Bulstrode, 294
Whitney, Geoffrey: *Choice of Emblemes*, 178-9
Wilde, Oscar, 444, 565, 569, 581-3, 597, 664, 682
Wilfrid, St., 31
Wilkie, Sir David, 541
Wilkins, William, 505
William I (the Conqueror), King, 37, 39
William III (of Orange), King, 327, 328, 330, 340-1, 343, 463
William II, King of Sicily, 47
William of Malmesbury, 43, 52

William of Ockham, 75, 134
William of Sens, 59
Williams, Raymond, 640
Williams, W.E., 641
Williams-Ellis, Sir Clough., 631
Willoughby, Sir Francis, 195, 196
Wilson, Sir Angus, 659
Wilson, Colin: *The Outsider*, 659
Wilson, Colin St. John, 649
Wilson, Richard (painter), 412, 414, 496, 587
Wilton Diptych, *2*, *2*, *3*, 85
Wilton House, Wiltshire, *260*, 299-300, *301*, 312, *414*
Wilton, Joseph, 409
Wimbledon House, 294
Winchester, 35; Cathedral, 63, 96, 298; palace planned, 315, 328
Winchester Bible, 56
Winchester College, 92-3, 95-6, *95*, 96, 136
Winchester Psalter, 56, *57*
Winckelmann, Johann, 394
Windsor Castle, 74, 80, 86, 91, 115, 309, 312, 506
Wise, Henry, 328, 337
Witt, Johannes de, 206
Woburn Abbey, Bedfordshire, 401
Woffington, Peg, 378
Wollaton Hall, Nottinghamshire, 195, *197*
Wollstonecraft, Mary: *A Vindication of the Rights of Women*, 479
Wolsey, Thomas, Cardinal, 120, 121-9, *126*
women: and courtly love, 50, 76; church access, 52; and humanist education, 133, 137; literacy rates, 175; dramatists, 323; choice in marriage, 374; in fiction, 375; and sensibility, 436; rights for, 479-80, 517; reading, 486; enfranchised, 607; and feminism, 639
Wood, Christopher, 626
Wood, Sir Henry, 561, 577
Wood, John, the Younger, 406, 408, 502, 680
Wood, Robert, 399
Woodchester, Gloucestershire, *7*
Woodstock, Oxfordshire, 44, 47, 65;

palace, 294, 309
wool trade, 113
Woolf, Leonard, 610
Woolf, Virginia, 601, 606, 610, *611*, 616, 618, 680
Wootton, John, 367
Worcester Cathedral: library, 144
Worcester, John Tiptoft, Earl of, 133
Wordsworth, Dorothy, 490
Wordsworth, William, 473, 489-90, 680
working class: enfranchised, 563, 566; cultural activities, 566, 570; post-war prosperity, 639
Wotton, Sir Henry, 248
Wren, Sir Christopher: and Greenwich rebuilding, 277, 331; and Royal Society, 282; aesthetic, 309; directs Royal Works, 312, 328, 333, 343; designs St. Paul's Cathedral, 314-15; and rebuilding of Hampton Court, 330-1; baroque style, 350
Wrest, Bedfordshire, 429
Wright, Edward, 228; *Certaine Errours in Navigation*, 278
Wright, Joseph, of Derby, 436-8
writing: development of cursive, 65
Wulfric (priest), 58
Wyatt, James, 459
Wyatt, Sir Thomas, the Elder, 156, 165, 166
Wycherley, William, *The Country Wife*, 322
Wyclif, John, 89
Wykeham, William of, Bishop of Winchester, 91-7, *94*, 96, 127
Wynford, William, 93, 96
Wyngaerde, Anthonis van, 117

Yeats, William Butler, 586, 614, 617
Yevele, Henry, 93, 95-6
Yonge, Nicholas: *Musica Transalpina,* 191
York: Roman legionary base at, 14; cathedral school, 31; mystery plays, 109-10, 147; Assembly Rooms, 350
Young England (political group), 520
youth culture, 639

Zola, Emile, 565, 604